**AIGA
GRAPHIC
DESIGN
USA: 3**

The
Annual
of
**The
American
Institute
of Graphic
Arts**

Written by
David R. Brown
Designed by
Miho
WATSON-GUPTILL
PUBLICATIONS/
NEW YORK

First published 1982 in New York by Watson-Guptill Publications,
a division of Billboard Publications, Inc.,
1515 Broadway, New York, N.Y. 10036

ISBN 0-8230-2143-2

Manufactured in U.S.A.

First Printing, 1982

Distributed outside the U.S.A. and Canada by
Fleetbooks, S.A.
c/o Feffer & Simons, Inc.
100 Park Avenue
New York, New York 10017

1 2 3 4 5 6 7 8 9/87 86 85 84 83 82

Contents

Acknowledgments

During the competition process, one is struck by the ephemeral nature of the pieces being judged. Most are destined to deliver a message, and disappear. *AIGA Graphic Design USA* provides a particular kind of satisfaction for those involved and interested in graphic design by counteracting this course. It offers the opportunity to "stop time"—a chance to look again, to appreciate graphic design not only for its ability to communicate, but also for the sheer pleasure of its esthetic appeal. It is also satisfying to know that what has served as an important reference for contemporary graphic design will, in the future, provide an invaluable resource on the history of graphic design in America for generations to come.

The Institute is in debt to all those who participated in its competitions: entrants, chairmen, and jurors, each of whom made a vital contribution. We would also like to thank David R. Brown, author; Paul Rand, who designed the jacket; and James Miho, who designed the book. Working with them has been a pleasure. In addition, we would like to thank Ellen McNeilly, whose efforts on behalf of the publication of this volume have been impressive, and heartening. Shelley Bance coordinated the publication of the book for the AIGA, with the help of Deborah Trainer, Nathan Gluck, and Glenngo King. Watson-Guptill was represented by Marsha Melnick, Judith Royer, Jay Anning, and Ellen Greene, who was responsible for the book's production.

Last, but not least, I would like to thank our membership, without whose support all our efforts would be impossible.

Caroline Hightower
Executive Director

The American Institute of Graphic Arts

The American Institute of Graphic Arts is a national nonprofit organization of graphic design and graphic arts professionals. Founded in 1914, AIGA conducts an interrelated program of competitions, exhibitions, publications, educational activities, and public service efforts to promote excellence in, and the advancement of, the graphic design profession.

Members of the Institute are involved in the design and production of books, magazines, and periodicals, as well as corporate, environmental, and promotional graphics. Their contribution of specialized skills and expertise provides the foundation for the Institute's program. Through the Institute, members form an effective, informal network of professional assistance that is a resource to the profession and to the public.

Founders include publisher William B. Howland; printer and typeface designer Frederic W. Goudy; Alexander W. Drake, art editor of *Century Magazine*; Major George H. Putnam, publisher; artists Will Bradley and Hal Marchbanks, founder of the Marchbanks Press.

Initially, AIGA exhibitions focused on lithography, etching, and design. The Fifty Books of the Year exhibition, for which the AIGA became well known, was established in the early 1920s. Later the exhibition schedule was broadened to include a wide spectrum of printed matter. The exhibition schedule at the Institute's Gallery now includes five annual competitive exhibitions. Of these, the Book Show and a Communication Graphics exhibition, which incorporates Advertising, are held each year. Three other exhibitions may include Illustration, Photography, Covers (book jackets, magazines, periodicals, record albums), Insides (design of the printed page), Signage, and Packaging.

The exhibitions travel nationally and internationally. Each year, the Book Show is donated to the Rare Book and Manuscript Library of Columbia University, which houses the AIGA collection of award-winning books dating back to the 1920s. Other exhibitions are sent to the Popular and Applied Graphic Arts Department of the Library of Congress.

This year, the AIGA has received a grant from the National Endowment for the Arts to compile a listing of archival source materials on the history of graphic design. This compilation will be by subject and location, and will include materials such as films, videotapes, slides, original artwork, and correspondence.

A variety of special publications has included: a voluntary *Code of Ethics and Professional Conduct* for AIGA members, outlining principles to govern professional activities and including such topics as fees and the designer's responsibility to clients; *Symbol Signs Repro Art*, a portfolio containing 50 passenger/pedestrian symbols and guidelines for their use, developed for the U.S. Department of Transportation; the guide *Graphic Design for Non-Profit Organizations*, for the National Endowment for the Arts; and a *Graphic Design Education Directory*, which provides basic information about schools throughout the United States and Canada offering courses in graphic design.

Board of Directors 1981–1982

President
David R. Brown

Executive Director
Caroline Hightower

Executive Committee
Robert Bach
Walter Bernard
Colin Forbes
Steff Geissbuhler
Howard Glener
Marjorie Katz
Elton Robinson

Saul Bass
Bill Bonnell
Bill Caldwell
Richard Danne
James Fogleman
John Follis
Richard Greenberg
Eugene Grossman
Joseph Hutchcroft
Doug Johnson
Helmut Krone
Ellen McNeilly
Tomoko Miho
Gianfranco Monacelli
Martin Moskof
Thomas Ockerse
B. Martin Pedersen
Arnold Saks
Paula Scher
Lorna Shanks
Jerry Siano
James Stockton
Thomas Suzuki
Bradbury Thompson
Michael Vanderbyl
Massimo Vignelli

Staff
Deborah Trainer, Associate Director
Nathan Gluck, Competitions Coordinator, Archivist
Shelley Bance, Managing Editor
Allison Schacter, Membership and Chapter Affairs
Glenngo King, Exhibitions Coordinator

The AIGA is indebted to the following organizations and individuals whose support has made our program possible.

Corporate Sponsors
American Broadcasting Co.
American Cancer Society
Atlantic Richfield Co.
N.W. Ayer & Sons, Inc.
Baldwin Paper Co.
Carnegie Mellon University
CBS Broadcast Group
Chermayeff & Geismar Assoc.
Container Corporation of America
Crafton Graphic Co.
Danne & Blackburn, Inc.
Doubleday & Co.
Dow Jones & Co., Inc.
Doyle Dane Bernbach, Inc.
Group 243 Design, Inc.
Hearst Books/Business Publishing Group
Herman Miller, Inc.
Holt, Rinehart & Winston, Inc.
Houghton Mifflin Co.
Knoll International, Inc.
Lehigh Press, Inc.
McGraw-Hill Book Co.
Mead Paper Corp.
Metropolitan Museum of Art
Mohawk Paper Mills
Parsons School of Design
Penney Co., Inc.
Random House, Inc.
Arnold Saks, Inc.
Simon and Schuster, Inc.
St. Martin's Press
The Design Organization, Inc.
Time, Inc.
Town & Country
Tri-Arts Press, Inc.
Vignelli Assoc.
Western Publishing Co.
John Wiley & Sons, Inc.

Patrons
Cook and Shanosky Assoc.
Champion International Corp.
Exxon Corp.
General Foods Corp.
Harper & Row Publishers, Inc.
IBM Corp.
International Typeface Corp.
SmithKline Corp.

Contributors
Tom Bentkowski
Eddie Byrd
Case-Hoyt Corp.
Champion International Corp., Paper Division
Anne Chesnut
Seymour Chwast
Collier Graphic Services
Davis & Warde, Inc.
David Seham Associates, Inc.
James Fogleman
Haber Typographers
Nigel Holmes
Mergenthaler Linotype Co.
Martin Moskof
Arnold Saks, Inc.
Ingo Scharrenbroich
S.D. Scott Printing Co., Inc.
The Seven Graphic Arts
Stephenson, Inc.
Sunlight Graphics
Nino and Neven Telac
Tri-Arts Press, Inc.
TypoGraphics Communications, Inc.
Henry Wolf

Introduction

The American Institute of Graphic Arts is the nation's largest, oldest, and most prestigious association of graphic design and graphic arts professionals. Now and in the years to come, AIGA seeks to encourage the growth and development of designers and their profession.

In keeping with the economic trend toward service and information-management businesses, graphic design today is a small, but rapidly expanding, growth industry. It is gaining in size and number, in recognition and influence. But few outside the profession (and not many within it) understand the impact that creators and producers of designed communications have on our country's businesses, institutions, and people. As the only national organization whose chief interest is excellence in design, AIGA gives a high priority on its future agenda to professional recognition.

In many ways, graphic design today is a profession in pursuit of itself. The individual and collective yearning for professional recognition and respect runs as a deep and strong current through the practitioners of contemporary graphic design.

If measured against the strict, dictionary definition of "profession," graphic design qualifies: it requires specialized knowledge and often long and intensive academic preparation; the people who practice it, in general, conform to technical and ethical standards; and designers generally participate for their livelihood in a field of endeavor often engaged in by amateurs. The trouble arises because designers are aware of this, but others are not, at least for the time being. Building awareness of design in the mind of an essentially indifferent public is a challenge to be met with concerted effort and the passage of time.

Competitions are part of the professional recognition process. So are the creation and consistent administration of awards and special honors to people and institutions that hew to the highest standards of professional achievement, culminating in the physical fact of this volume, the third edition of *AIGA Graphic Design USA.*

Unlike most professionals, graphic designers subject their work to the criticism and praise of their peers at the drop of a "call for entry." Their peers are demanding, too, especially at the national level of AIGA competitions. As a rule, something on the order of one piece in twenty submissions is judged of sufficient merit to earn a place in an AIGA exhibition and in the pages of this book. The stringency of the criteria, the swelling tide of entries, and the enthusiasm with which designers seek the judgment of their peers indicate a profession as vital, energetic, and success-and-recognition-bound as any in America.

When the AIGA created and introduced its Design Leadership Award last year, the hope was to broaden the recognition of design excellence. For more than sixty years, the Institute has awarded its Gold Medal to individuals who have made superior contributions to design and the profession. The work done by these men and women, which earned them positions in the first rank of the profession, was for the most part not created in a vacuum. On the other side was a client who also recognized the worth of superior design and allowed it to happen. Consistent with the gradual increase of design thinking within our institutions, the Design Leadership Award honors and encourages intelligence about design from an institutional perspective; the AIGA Gold Medal honors the individual accomplishment. They should be seen as a pair that act as bookends for the nature and function of design in our economy, society, and culture.

Happily, this year's awards recipients are represented on quite a different spectrum, as well.

Saul Bass, the 1981 AIGA Gold Medalist, has through his long, distinguished, and far-ranging career created a body of work and a language of design communication that is humanistic, accessible, and understandable. You don't have to know the difference between serif and sans-serif—or even what a designer is or does—to be touched by and appreciate communication designed by Saul Bass.

Bass's unique talent in this regard has earned him a prominent place in the lives of most Americans. We're surrounded by Saul Bass design in a wide range of media: from packaging in the kitchen to film titles in the movie theater; from the airplanes we travel on to the telephone calls we make; from the books and magazines we buy to the charities to which we give. Through his work runs a respect and innate understanding of how design should work with, and for, people.

The Massachusetts Institute of Technology (MIT) follows the IBM Corporation, last year's recipient, in receiving the AIGA Design Leadership Award. The citation to MIT includes the Design Services office, MIT Press, and Visible Language Workshop. Specifically and in general, MIT's demonstration of excellence in design in work that has flowed from it over the past fifty years is quite different from the work of Saul Bass in both intent and content. The contrasts are clear even to the casual eye. But what's more important than their differences is their common message about the vigor of design and its ability not only to accommodate such divergence, but to honor it as the best the profession has to offer. Represented are two radically different environments; different problems to solve, with wildly different pressures and constituencies; two strong and consistent "looks"; and even two different coastlines. But together they make a convincing argument for the power and value of fine design.

After AIGA's Cover Show competition, but before this volume went to press, *Newsweek* magazine chose a nude by painter William Bailey to illustrate an article on the new realism in art. The outcry was instant and ferocious, although the modern, Mona Lisa-like "Portrait of S" was tame compared to the figures that adorn the so-called "men's market" magazines. A cover is an instant communication, symbolic of both a publication's content and its purpose. A nude was out of context on *Newsweek*'s cover, at least out of the context that the magazine has built for itself. A cover is a most challenging design problem. It is one part that must stand for the whole; it must integrate a variety of design elements; and it must compete with all the covers around it, for seldom is a cover seen in isolated splendor. Covers are one of the main points of contact between the public and what's happening in graphic design. Back-to-the-basics seems to be what's happening in the best cover designs, including the increasing use of illustration.

Rare is the review of a design competition—from a local art directors club or a national publication—that doesn't begin with the sentence, "This year's entry was the largest ever . . ." and this year's AIGA Communication Graphics competition is no exception. Year to year, Communication Graphics is the only competition conducted by a nonprofit professional society that attempts to take a snapshot in time of the state of design in the United States. The 1982 edition suggests that design, in general, is on a rising vector of competence, control of production elements, and outright handsomeness. Communication design may also be getting a bit predictable. One judge comments on this possibly troubling direction by labeling it "style," suggesting that attention paid to style may overwhelm the twin commitment to content and communication.

Properly and fairly defining "style" in graphic design can be elusive. After all, one historical role the graphic designer has played is to combine a multitude of visual elements to achieve a communication larger and more powerful than any of its parts. This cumulative process of interpreting and adding to, and the selection of those added elements, their handling and eventual mass production, inevitably involve questions of style. Style changes from being a necessary part of the design process to something artificial when the "style" in question becomes imitative, rather than original. And it cannot be disputed that much of the Communication Graphics entry and part of the selection itself are clearly derivative. But if it is derivative, it is at a very high level of accomplishment.

The book design competition dates back to the beginning of the Institute. Times have changed rapidly in the book business, accelerated by the twin tormentors of competing technology and brutal, cost-push economics. Economic pressure on the publishing industry has inevitable impact on book design, which, perhaps more than other forms of design for print, depends for its success on an intelligent and flexible relationship between the designer and the various production functions on which he or she depends. Those partnerships have been squeezed by the bitter reality of the marketplace, leading to book design that is defensive—idiot-proof typography, printing and binding—with the result that under-par suppliers have little room or reason to muddle the book designer's vision. In book design, the little things count. A finely designed book emerges from the successful accumulation of detail and subtle, well-made decisions, adding up to something that feels right as a book. Included herein are 78 books that feel and look "right"—the best submitted of the year.

Each season, AIGA attempts to explore some new territory in the graphic arts, through a special competition or exhibition. This year, the subject was Graphic Explanations—charts, diagrams, maps, technical illustrations, graphs, and so on—whose function is to deliver information and look good in doing so. Our society and economy are now producing and accumulating information at an astounding rate: more than half the work force is now classified as "information workers." Much of what is generated is numerical, statistical, or scientific. More and more, print media will need skilled "graphic explainers." The electronic media already has them.

It is often easy and all too inviting to look upon a volume like this as a historical artifact, freezing in time the highest output of one year in the life of the graphic design industry. If there is a weakness in the judgment-by-peers methodology, that is it. More than most, the business/practice of graphic design is highly process-oriented and dependent for outstanding success on the nature and quality of relationships among people. Behind every one of the superior examples of design pictured in the following pages, there have been top-notch *people* whose intelligence and talent inform the work and make it work. To them, and to their high standards of professionalism, this volume should be dedicated.

The AIGA Medal

For sixty-one years, the Medal of the American
Institute of Graphic Arts has been awarded to
individuals in recognition of their distinguished
achievements, services, or other contributions
within the field of the graphic arts. Medalists are
chosen by a committee, subject to approval by the
Board of Directors. Past recipients have been:

Norman T.A. Munder, 1920
Daniel Berkeley Updike, 1922
John C. Agar, 1924
Stephen H. Horgan, 1924
Bruce Rogers, 1925
Burton Emmett, 1926
Timothy Cole, 1927
Frederic W. Goudy, 1927
William A. Dwiggins, 1929
Henry Watson Kent, 1930
Dard Hunter, 1931
Porter Garnett, 1932
Henry Lewis Bullen, 1934
J. Thompson Willing, 1935
Rudolph Ruzicka, 1936
William A. Kittredge, 1939
Thomas M. Cleland, 1940
Carl Purington Rollins, 1941
Edwin and Robert Grabhorn, 1942
Edward Epstean, 1944
Frederic G. Melcher, 1945
Stanley Morison, 1946
Elmer Adler, 1947
Lawrence C. Wroth, 1948
Earnest Elmo Calkins, 1950
Alfred A. Knopf, 1950
Harry L. Gage, 1951
Joseph Blumenthal, 1952
George Macy, 1953
Will Bradley, 1954
Jan Tschichold, 1954
P.J. Conkwright, 1955
Ray Nash, 1956
Dr. M. F. Agha, 1957
Ben Shahn, 1958
May Massee, 1959
Walter Paepcke, 1960
Paul A. Bennett, 1961
Willem Sandberg, 1962
Saul Steinberg, 1963
Josef Albers, 1964
Leonard Baskin, 1965
Paul Rand, 1966
Romana Javitz, 1967
Dr. Giovanni Mardersteig, 1968
Dr. Robert L. Leslie, 1969
Herbert Bayer, 1970
Will Burtin, 1971
Milton Glaser, 1972
Richard Avedon, 1973
Allen Hurlburt, 1973
Philip Johnson, 1973
Robert Rauschenberg, 1974
Bradbury Thompson, 1975
Henry Wolf, 1976
Jerome Snyder, 1976
Charles and Ray Eames, 1977
Lou Dorfsman, 1978
Ivan Chermayeff and Thomas Geismar, 1979
Herb Lubalin, 1980
Saul Bass, 1981

The AIGA Medalist 1981: Saul Bass

Beneath theory and rhetoric, and well beyond
technique and jargon, the reason for design is to
speak to people in a language that is familiar, but
also new, to entice people to understand an old thing
in a new way, or grasp a new thing in an old way.
There has never been a designer who can do this
better than Saul Bass.

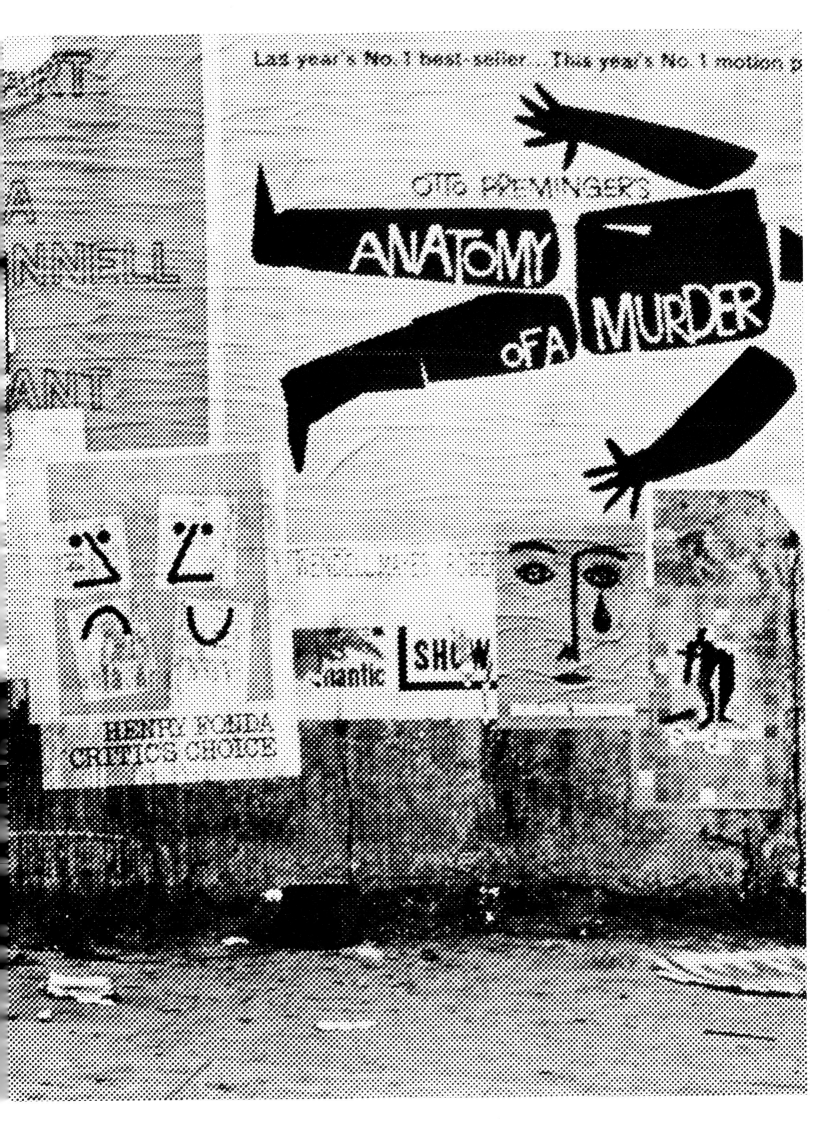

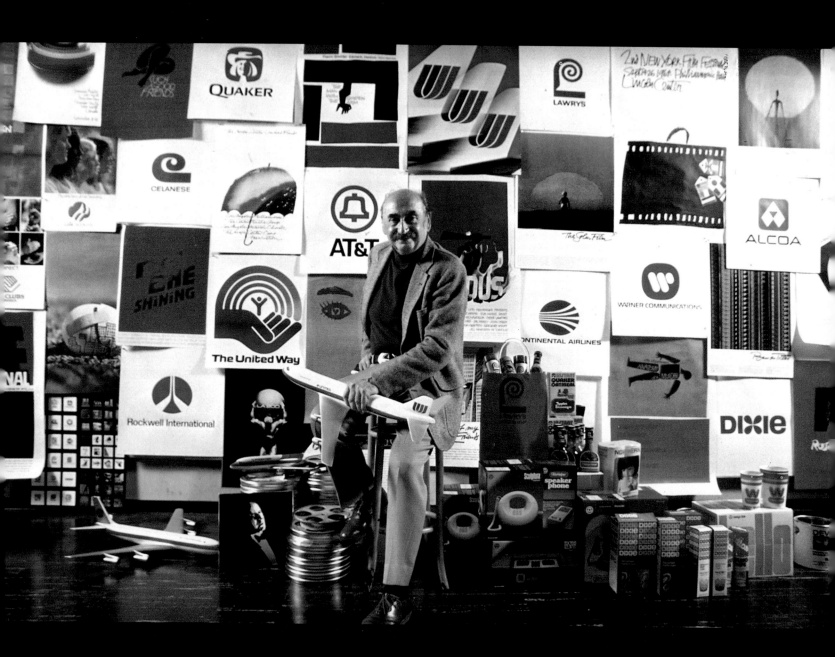

Beneath theory and rhetoric, and well beyond technique and jargon, the reason for design is to speak to people in a language that is familiar, but also new, to entice people to understand an old thing in a new way, or grasp a new thing in an old way. There has never been a designer who can do this better than Saul Bass, who adds the 1981 AIGA Medal to his long and quite extraordinary list of honors and achievements. Saul Bass honors this award.

Saul Bass's work touches people. Not just designers, or students, or observers of design, or those who know and can explain what a designer is and does, but simply people—many, many people.

The movie *Grand Prix* introduced Bass to me, though it took twenty years for me to discover that. As an average high school kid with predictable interests, growing up in an average suburban town, I went to the movie *Grand Prix* with the guys to see the cars race. Saul Bass must have understood this, because he got most of the exposition of the rather thin (as I recall) plot out of the way beneath the introductory titling and credits. Then, when the movie really started, the cars *raced.* And they raced in perfectly new and immensely satisfying ways: in multiple images, in speed-distorted images, in blurs and shimmering telephoto compression, in pictures of whole cars and in extreme close-up—exhaust manifolds and the scream-pitched barks of revving Formula I engines.

Saul Bass also touched this perfectly normal high schooler with his compression of the emotion of *Exodus* into a single image of a half-dozen reaching hands and a rifle. Why were there more hands than rifles? Were they celebrating victory? Were they defiant in the face of overwhelming odds? Were some hands trying to take the rifle from another?

Later, Saul Bass's opening sequences and closing credits for *West Side Story* convinced the same suburban high schooler that New York City was no place for him. It wasn't the violence or the gangs (we had guys who belonged to gangs). It was the size and density and energy and potential for both great things and utter destruction and despair—all conveyed by the spinning, aerial introduction and the closing credits, graffiti-ed on the decaying surfaces of that alien city.

Years later, working and living happily in New York, I was touched by Saul Bass (still unknown to me) two more times—through North American Rockwell's new corporate emblem, in which I had a genuine if uninformed interest, and through a film for Kaiser, *Why Man Creates.* Without my knowing it, Saul Bass had turned me toward an interest in and lasting association with design communication.

It's a cliché, but Saul Bass really has done it all. Films. Packaging. Products. Architecture. Corporate identification. Graphics. His work surrounds us. Pick up the telephone and you're hard-pressed not to recall Bass's ubiquitous Bell System symbol and look. Take a plane—United, Continental, Frontier: Saul Bass. Go to a film—*Psycho, Anatomy of a Murder, Exodus, Spartacus, The Man With the Golden Arm, Advise & Consent, Such Good Friends:* Saul Bass. In the supermarket or in the kitchen—Wesson, Quaker, Alcoa, Lawry's, Dixie: Saul Bass.

Relax with a magazine, read a book, watch TV, take some pictures—*Saturday Evening Post,* Warner, Minolta: Saul Bass. Give to charity—The United Way, Girl Scouts: Saul Bass. Strike an Ohio Blue Tip match.

He left his native New York for Hollywood in the mid-1940s to find a way to combine his restless, intuitive imagination, and a few years of New York experience working in graphic design, into a career. Before anyone in the film industry, Bass recognized the importance of a movie's first moments: they should do more than warn the audience that a few minutes remain to make a trip to the popcorn stand. He invented the idea of titling movies—either at the beginning or end—with sequences that *added* something in a highly symbolic and evocative way and created print-graphic identification for films that not only title the film, but also serve to unify and drive entire marketing and advertising campaigns.

If part of what design is about is communicating through symbols, Saul Bass and his firm have subsequently created a fair measure of what we now perceive as the modern business and commercial world. Either they have actually created these symbols or contributed mightily to the notion itself.

Bass is the first to disavow the widely held idea that graphic design and film design are closely related disciplines. In medium, time, concept, technique, and technical aspects, they are not. Graphic design is a solitary or small group exercise in creating. Film directing and producing are management efforts of large groups of people, equipment, variables, and ideas. Yet Saul Bass has not only mastered both, he is comfortable in both. And the Bass competence extends along another axis of accomplishment. At one end are designed communications that stem from, and depend on, the crackle of instant insight—both his and yours. These images are too urgent to refine, too strong and emotional in their effect to fuss with. At the distant other end of the axis is the attention to numbing detail and mastery of formidable scale best exemplified by the Bell System program, the largest and one of the most successful corporate identification design programs ever conceived and implemented.

Like many top designers, Saul Bass is an ardent collector. More important than the classifications of what he collects (pre-Colombian figures, Colina rolled-clay figures, Ashanti dolls, Indian fetishes, et cetera) is the intelligence that informs his impulse to collect and what his collections give back to their collector. "These tiny remains of ancient human civilizations, in addition to their intrinsic beauty, bring with them a special kind of mystery—a quality of the distant past, the unknown and unreality of it all. Like the best kind of design or film work, they communicate on two levels: the visceral or emotional level and the more complex intellectual level. The goal, and the ultimate achievement, is to make people feel as well as think."

While Saul Bass listens to and respects the mute, visual language of the ancients, he is very much focused on the here and now, and on the future. Although his record is wide, thoughtful, and deep, it is a prologue: to what's surely to come, and to the man himself.

The new face of Girl Scouting

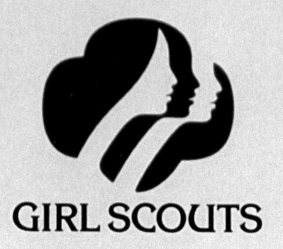

GIRL SCOUTS

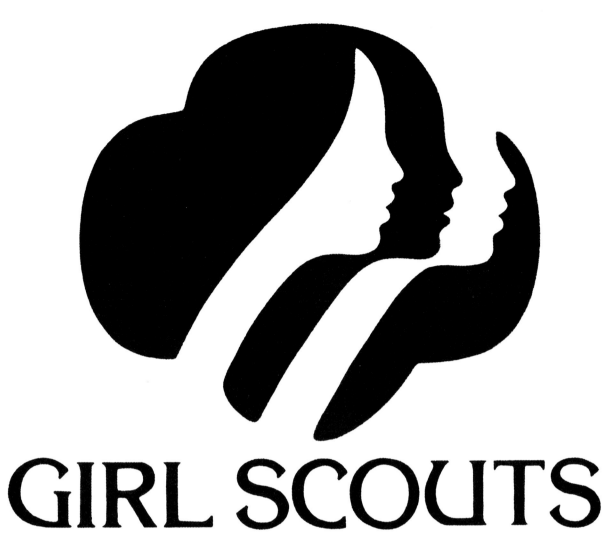

Logo:
Girl Scouts, 1978

GIRL SCOUTS

Package:
Girl Scout cookies, 1977

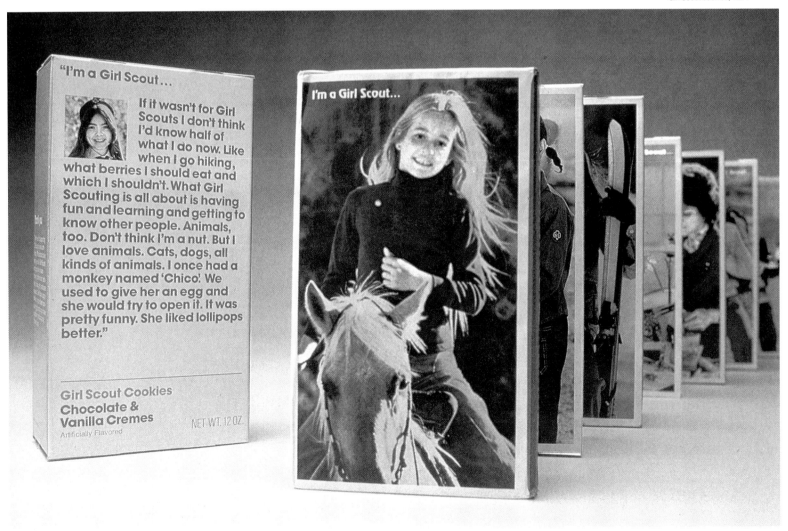

"I'm a Girl Scout...

If it wasn't for Girl Scouts I don't think I'd know half of what I do now. Like when I go hiking, what berries I should eat and which I shouldn't. What Girl Scouting is all about is having fun and learning and getting to know other people. Animals, too. Don't think I'm a nut. But I love animals. Cats, dogs, all kinds of animals. I once had a monkey named 'Chico'. We used to give her an egg and she would try to open it. It was pretty funny. She liked lollipops better."

Girl Scout Cookies
Chocolate & Vanilla Cremes
Artificially Flavored

NET WT. 12 OZ.

I'm a Girl Scout...

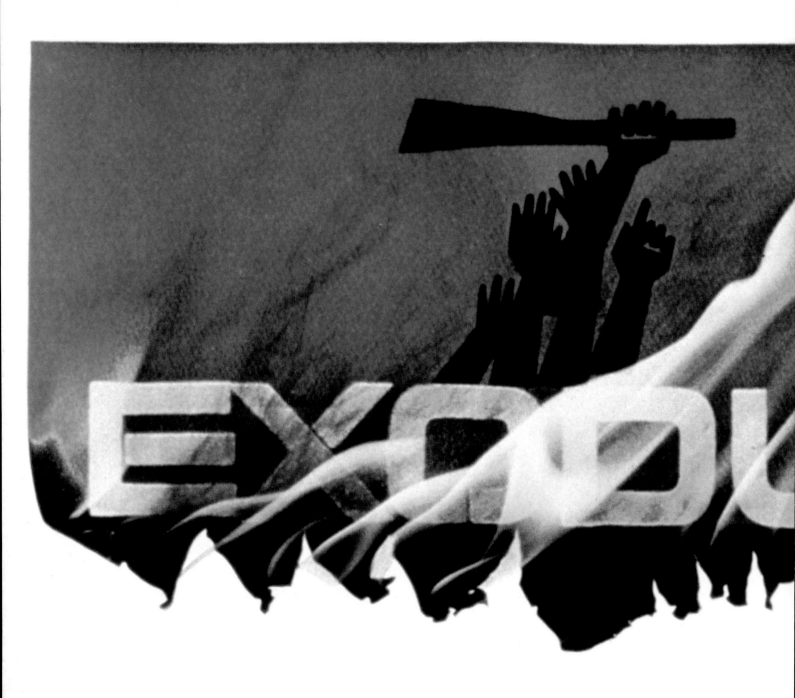

Film Symbol:
Exodus, 1960

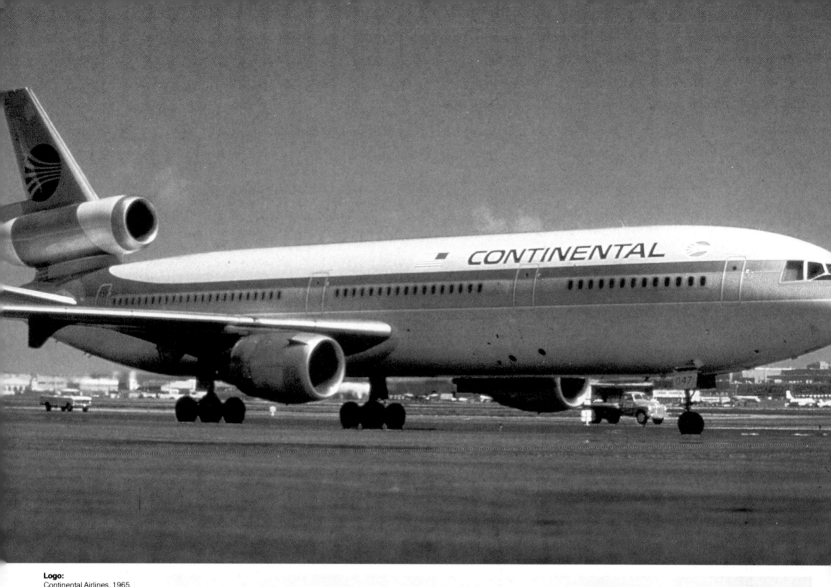

Logo:
Continental Airlines, 1965

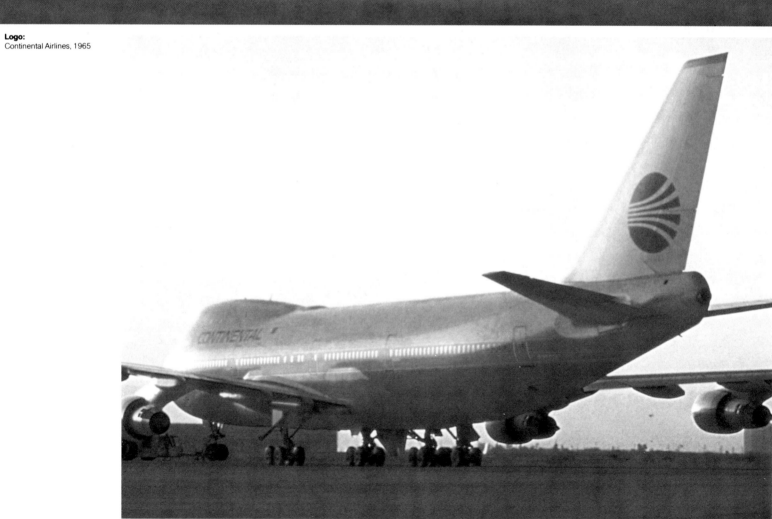

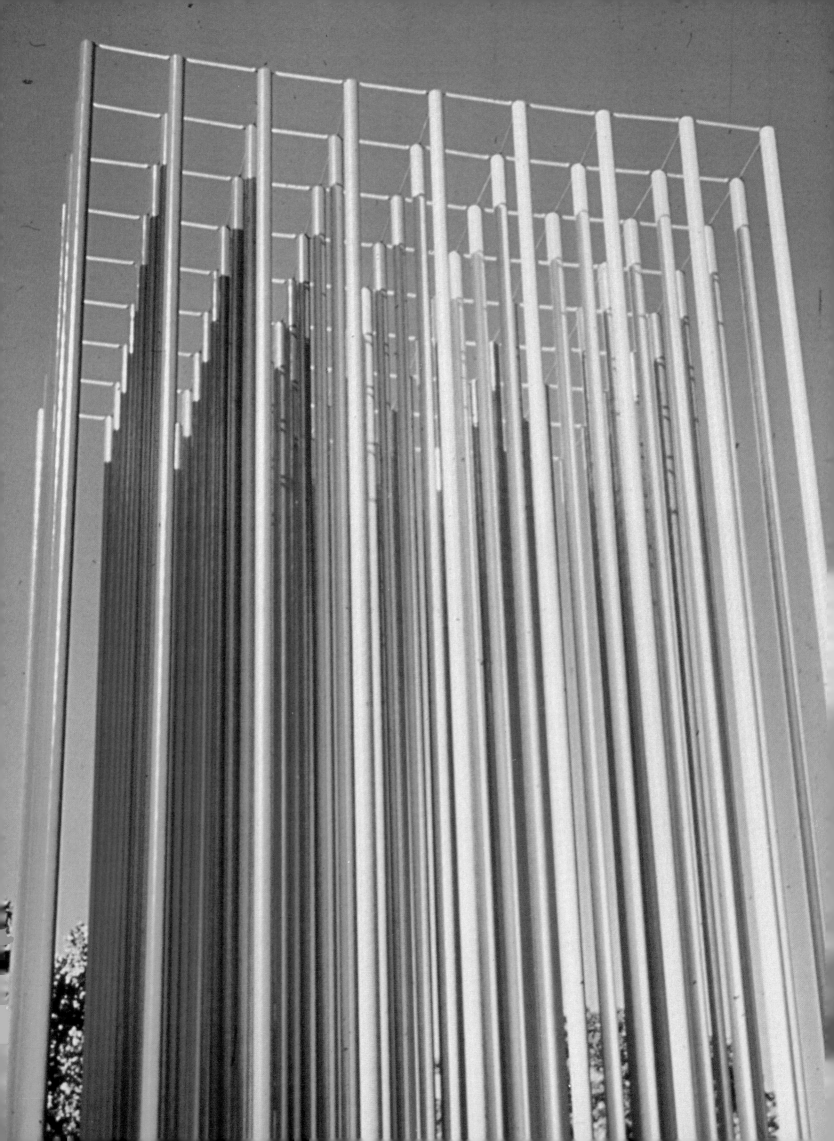

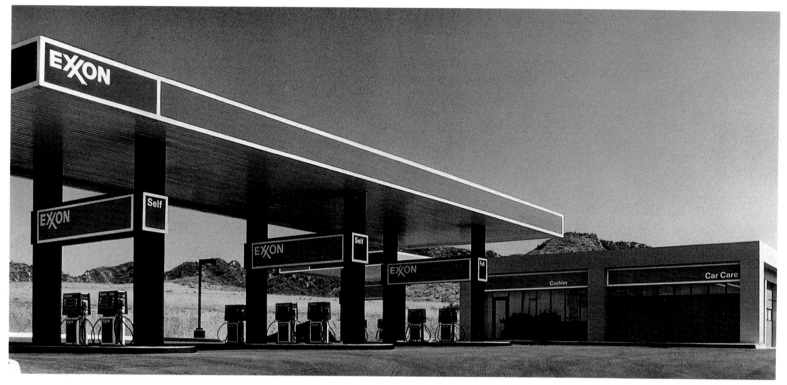

Architecture:
Exxon Gasoline Station,
1981–82

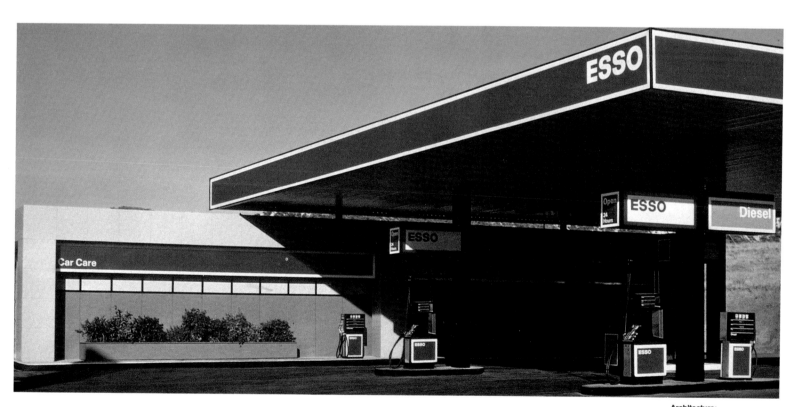

Architecture:
Esso Gasoline Station, 1981–82

Architecture:
Fuller Paint Color Tower

Symbol:
Celanese Symbol Sculpture,
1965

Logo:
Minolta, 1980

Logo:
Avery International, 1977

Package:
Lawry's Salad Dressing, 1978

Package:
Ohio Blue Tip Matches, 1963

Logo:
Dixie, 1969

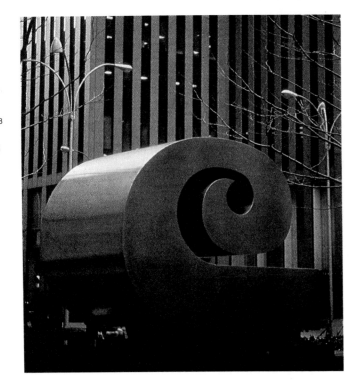

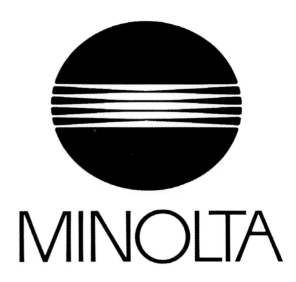

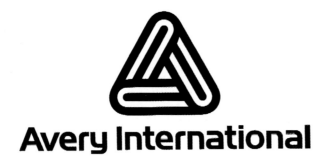

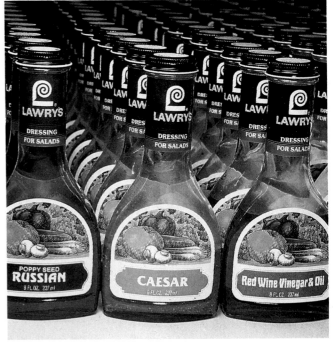

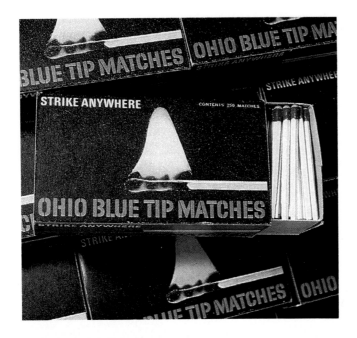

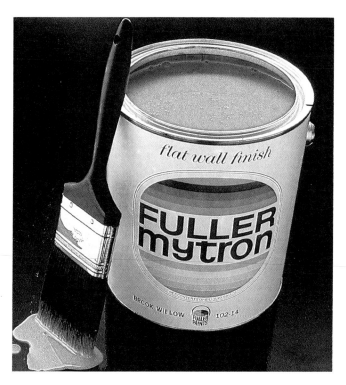

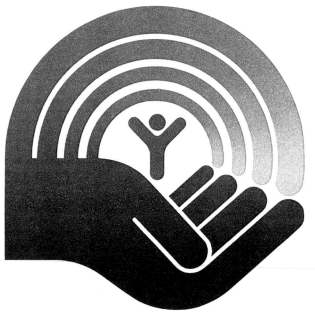

Package:
Fuller Mytron paint, 1971

Logo:
United Way, 1972

Logo:
Rockwell International, 1968

Package:
Dixie Cups, 1969

Package:
Wesson Oil, 1964

Annual Report:
Quaker Annual Report, 1969

United Way

Rockwell International

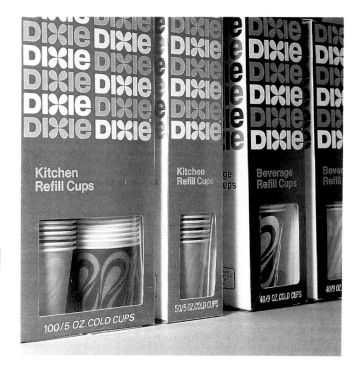

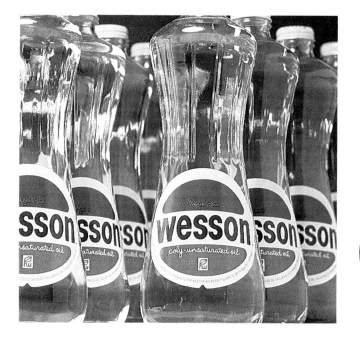

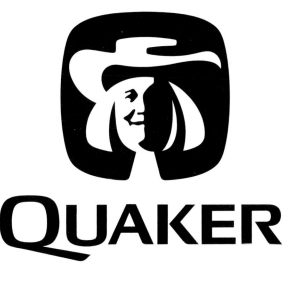

QUAKER

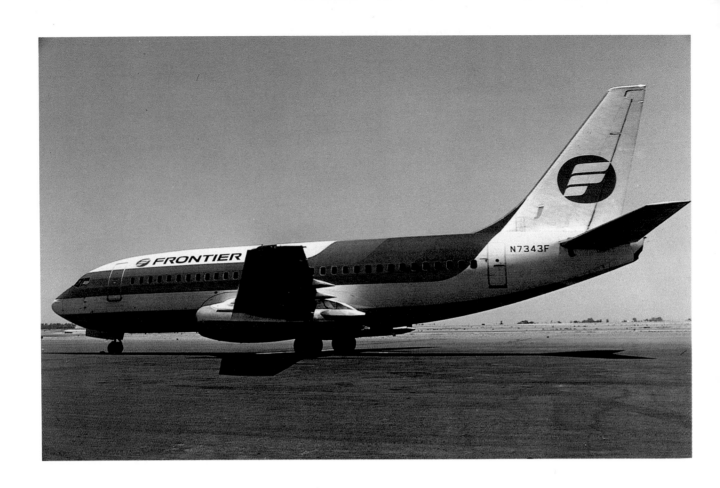

28

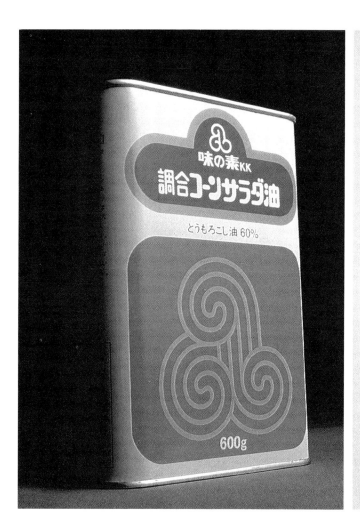

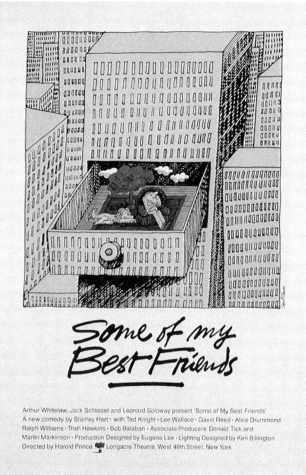

Package:
Ajinomoto cooking oils, 1973

Poster:
Some of My Best Friends, 1977

Some of my Best Friends

Arthur Whitelaw, Jack Schissel and Leonard Soloway present 'Some of My Best Friends'.
A new comedy by Stanley Hart · with Ted Knight · Lee Wallace · Gavin Reed · Alice Drummond
Ralph Williams · Trish Hawkins · Bob Balaban · Associate Producers: Donald Tick and
Martin Markinson · Production Designed by Eugene Lee · Lighting Designed by Ken Billington
Directed by Harold Prince Longacre Theatre, West 48th Street, New York

Package:
Dixie Cups, 1969

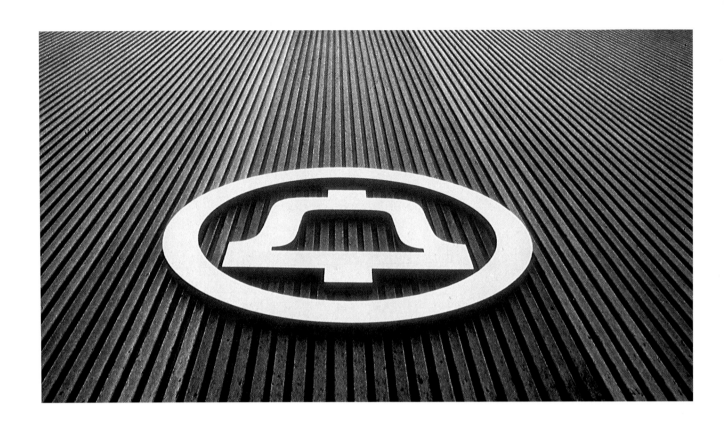

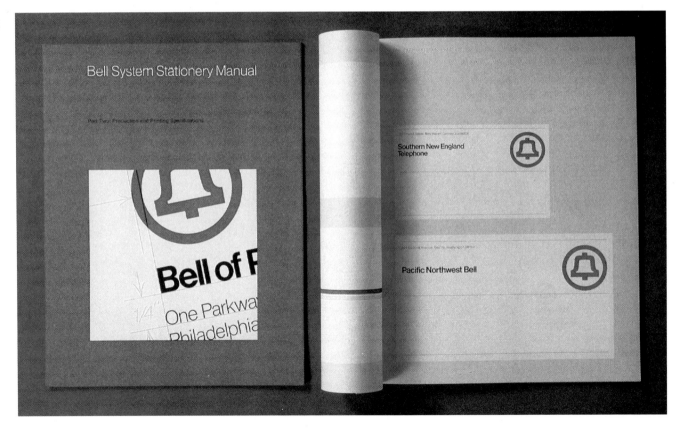

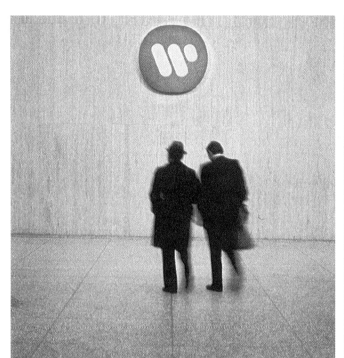

Signage:
Warner Communications, 1974

Stationery:
Warner Communications, 1974

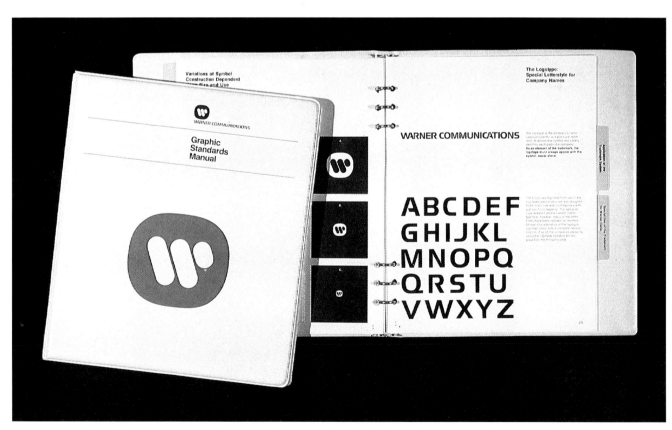

Manual:
Warner Communications Design
Standards Manual, 1974

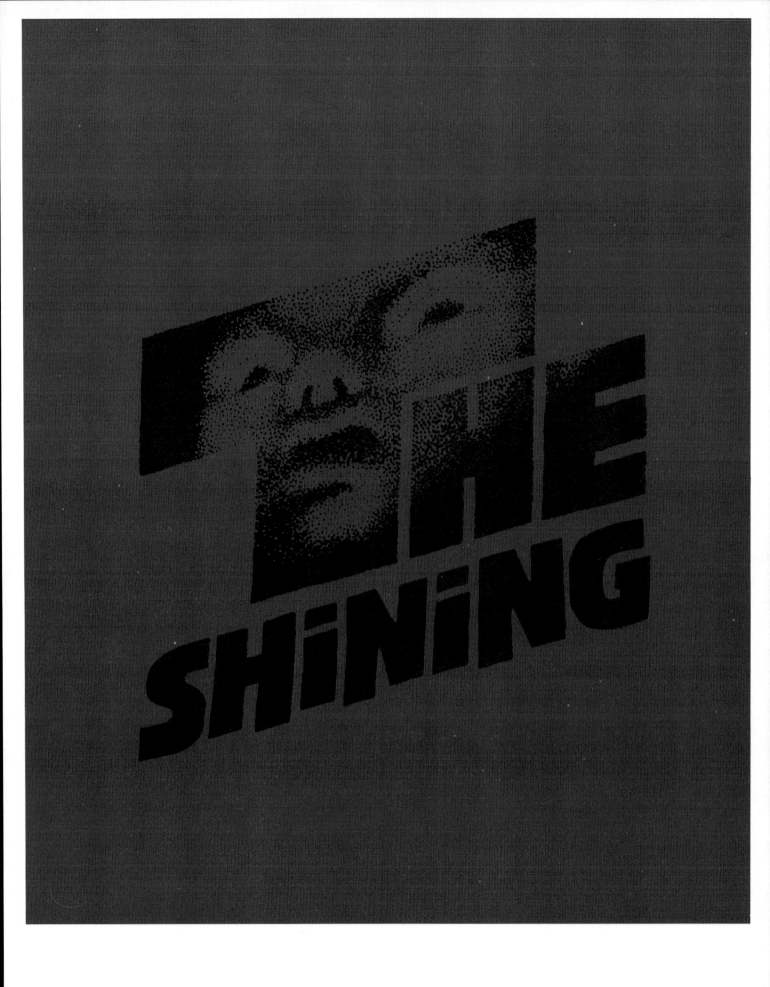

A fascinating compilation of the dynamic images from 10 of the more than 40 main titles created by Saul Bass with comments by Bass on the background and approach in each one.
Titles are from: *Man with the Golden Arm, Seconds, In Harm's Way, West Side Story, It's a Mad, Mad, Mad, Mad World, Big Country, The Victors, Grand Prix, Nine Hours to Rama,* and *Walk on the Wild Side.* In addition to the title sequences, Bass discusses the relationship of each

movie title to its story, his view of the moving image, both graphic and live-action, and the title as a film form.
Saul Bass is an internationally recognized leader in visual communications, and has exerted a strong influence on the visual aspects of films for nearly 25 years. He has directed a feature film, short films, motion picture titles, special sequences, prologues, epilogues, television show openings, and television commercials. His "Why Man Creates" was

awarded an Oscar and the Bass-created "arm" symbol for "The Man with the Golden Arm" created a whole new approach to motion picture advertising and marketing.
Bass on Titles (1977) 35 minutes, color:
Available non-theatrically for sale/rent from
PYRAMID FILMS
Box 1048, Santa Monica, CA 90406 (213) 828-7577

Poster:
Bass on Titles, 1978

MEDALIST

FRANK SINATRA · ELEANOR PARKER · KIM NOVAK

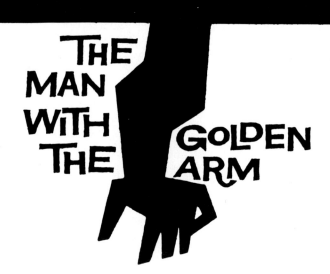

THE MAN WITH THE GOLDEN ARM

A FILM BY OTTO PREMINGER · FROM THE NOVEL BY NELSON ALGREN · MUSIC BY ELMER BERNSTEIN · PRODUCED & DIRECTED BY OTTO PREMINGER

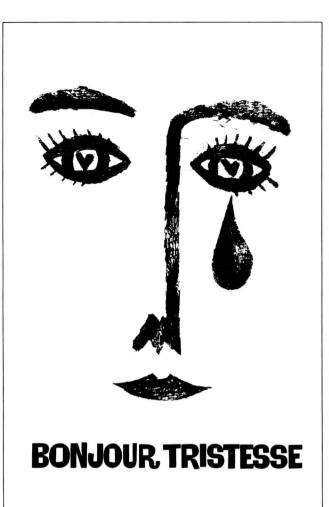

BONJOUR, TRISTESSE

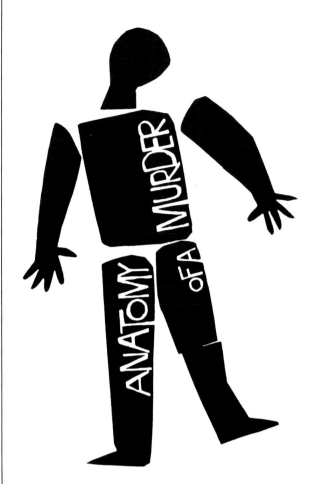

Film Symbol:
The Man with the Golden Arm, 1956

Film Symbol:
Bonjour Tristesse, 1957

Film Symbol:
Anatomy of a Murder, 1959

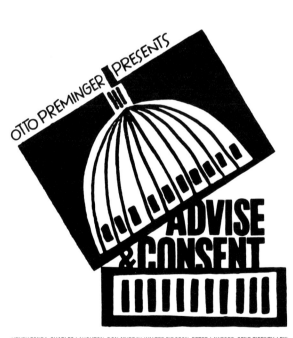

HENRY FONDA, CHARLES LAUGHTON, DON MURRAY, WALTER PIDGEON, PETER LAWFORD, GENE TIERNEY, LEW AYRES, FRANCHOT TONE, BURGESS MEREDITH, EDDIE HODGES, PAUL FORD, GEORGE GRIZZARD, INGA SWENSON SCREENPLAY WRITTEN BY WENDELL MAYES, MUSIC BY JERRY FIELDING, PHOTOGRAPHED IN PANAVISION BY SAM LEAVITT, PRODUCED AND DIRECTED BY OTTO PREMINGER, A COLUMBIA PICTURES RELEASE

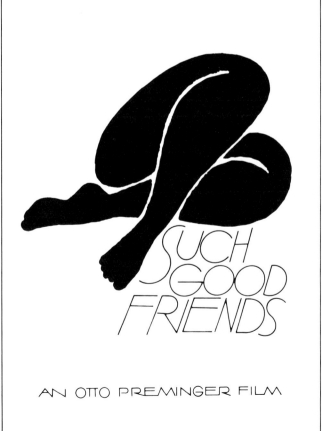

AN OTTO PREMINGER FILM

Film Symbol:
Advise & Consent, 1964

Film Symbol:
Such Good Friends, 1974

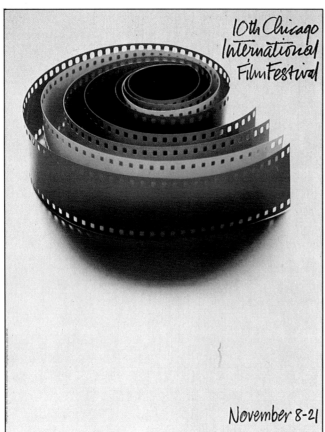

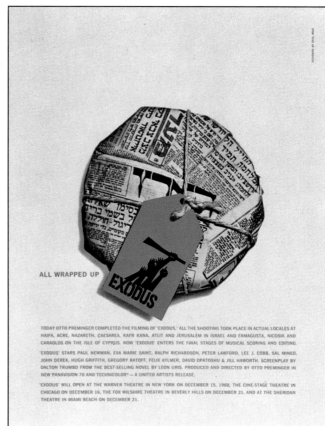

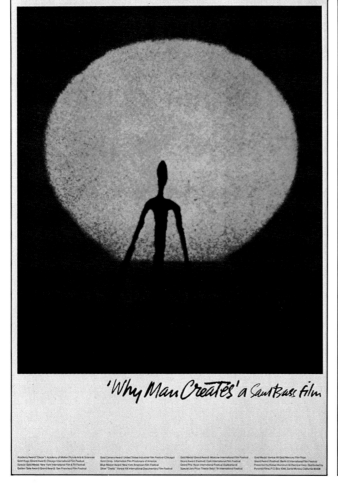

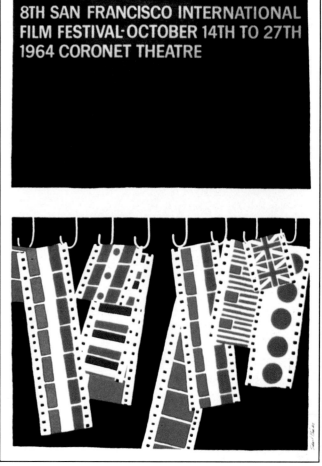

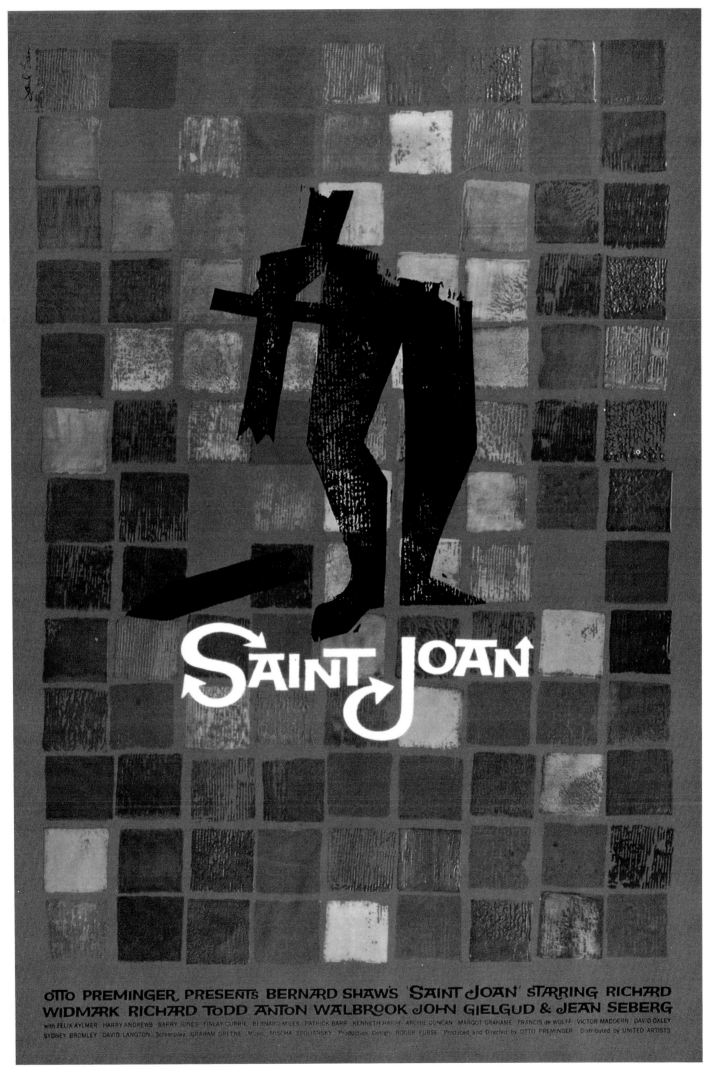

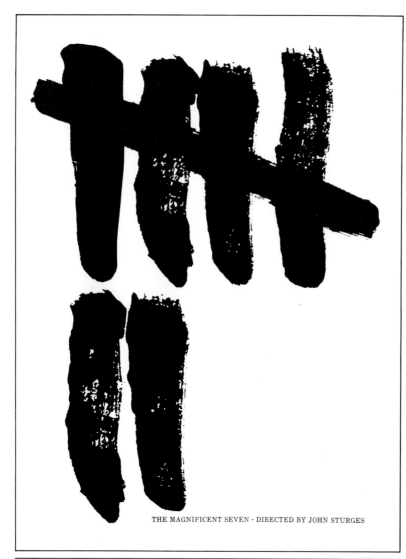

THE MAGNIFICENT SEVEN · DIRECTED BY JOHN STURGES

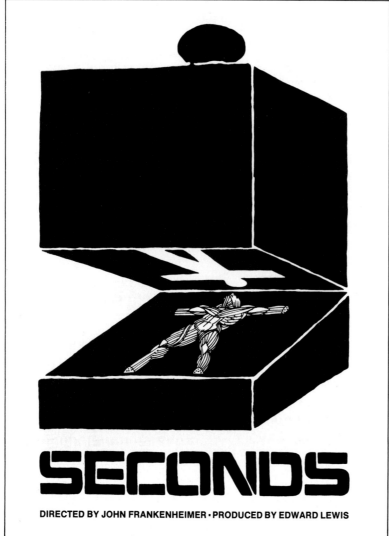

DIRECTED BY JOHN FRANKENHEIMER · PRODUCED BY EDWARD LEWIS

Freedom of the Press

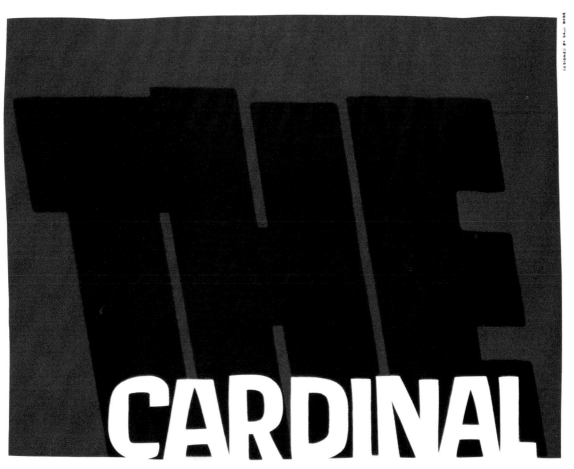

THE
CARDINAL
AN OTTO PREMINGER FILM

THE CARDINAL STARRING TOM TRYON, ROMY SCHNEIDER, CAROL LYNLEY, JILL HAWORTH, RAF VALLONE, JOHN SAXON, JOSEF MEINRAD, BURGESS MEREDITH, OSSIE DAVIS, DOROTHY GISH, TULLIO CARMINATI, MAGGIE McNAMARA, BILL HAYES, CECIL KELLAWAY AND JOHN HUSTON AS GLENNON. ALSO BOBBY (MORSE) & HIS ADORA BELLES ✤ SCREENPLAY BY ROBERT DOZIER. BASED ON THE INTERNATIONAL BEST SELLER BY HENRY MORTON ROBINSON. MUSIC BY JEROME MOROSS. PRODUCTION DESIGNED BY LYLE WHEELER. PHOTOGRAPHED BY LEON SHAMROY IN TECHNICOLOR* AND PANAVISION 70*. PRODUCED AND DIRECTED BY OTTO PREMINGER. A COLUMBIA RELEASE.

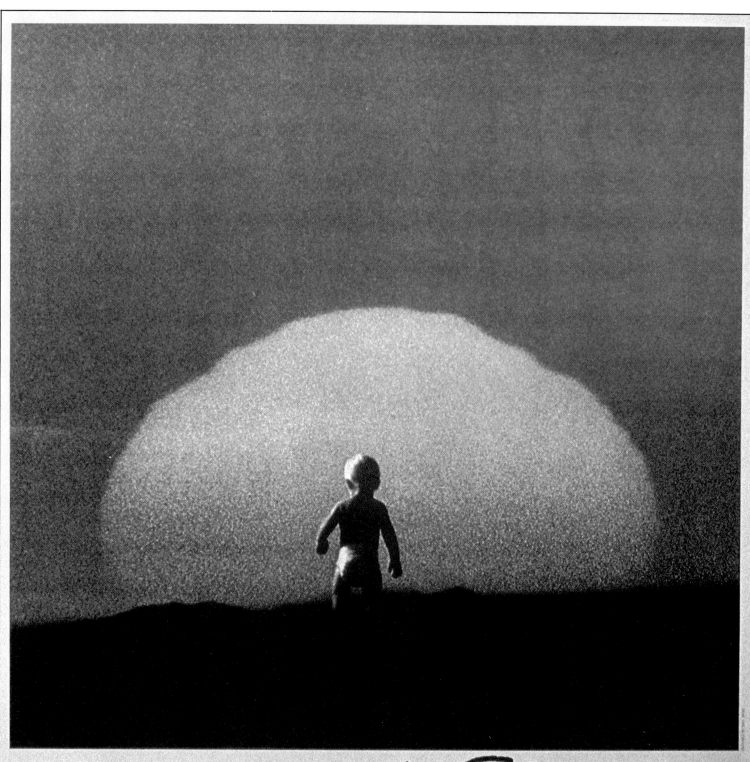

The Sun is the source of all energy on Earth, and of human life as well. It is the Sun that creates the oxygen we breathe, the winds, the tides, and the crops that sustain us. Civilization has been propelled by fossil fuels the Sun provided. And now the fossil fuel period is ending. Natural gas and oil are being exhausted. But the source remains, its renewable power undiminished. Waiting. The Sun, which gave us a world, can give us a future.

Yet, Solar Energy must wait last in line for research and development money. The future demands we rearrange priorities. The Solar Film depicts the fascinating, ancient relationship between the Sun and Man. A fearful, erratic and profound relationship that must now be transformed into a working agreement. The Sun has the power. We have the means. Together we can light the future with hope.

Directed by Saul & Elaine Bass. Executive Producer: Robert Redford
Produced by Saul Bass & Michael Britton. Written by Stan Hart, Saul & Elaine Bass
Presented by Warner Communications Inc. & Norton Simon Inc.
A Wildwood Enterprises Inc. production for Consumer Action Now

For further information write to: C.A.N. Box 777, Canal St. Station, NY 10013

Poster:
The Solar Film, 1980

John Stuart Mill ON THE PURSUIT OF TRUTH

Not the violent conflict between parts of the truth, but the quiet suppression of half of it, is the formidable evil; there is always hope when people are forced to listen to both sides; it is when they attend only to one that errors harden into prejudices, and truth itself ceases to have the effect of truth, by being exaggerated into falsehood. (*On Liberty, 1856*)

would put an end to the evils of religious or philosophical sectarianism. Every truth which men of narrow capacity are in earnest about, is sure to be asserted, inculcated, and in many ways even acted on, as if no other truth existed in the world, or at all events none that could limit or qualify the first. I acknowledge that the tendency of all opinions to become sectarian is not cured by the freest discussion, but is often heightened and exacerbated thereby; the truth which ought to have been, but was not, seen, being rejected all the more violently because proclaimed by persons regarded as opponents. But it is not on the impassioned partisan, it is on the calmer and more disinterested bystander, that this collision of opinions works its salutary effect. Not the violent conflict between parts of the truth, but the quiet suppression of half of it, is the formidable evil; there is always hope when people are forced to listen to both sides; it is when they attend only to one that errors harden into prejudices, and truth itself ceases to have the effect of truth, by being exaggerated into falsehood. And since there are few mental attributes more rare than that judicial faculty which can sit in intelligent judgment between two sides of a question, of which only one is represented by an advocate before it, truth has no chance but in proportion as every side of it, every opinion which embodies any fraction of the truth, not only finds advocates, but is so advanced as to be listened to. We have now recognised the necessity to the mental well-being of mankind (on which all their other well-being depends) of freedom of opinion, and freedom of the expression of opinion, on four distinct grounds; which we will now briefly recapitulate. First, if any opinion is compelled to silence, that opinion may, for aught we can certainly know, be true. To deny this is to assume our own infallibility. Secondly, though the silenced opinion be an error, it may, and very commonly does, contain a portion of truth; and since the general or prevailing opinion on any subject is rarely or never the whole truth, it is only by the collision of adverse opinions that the remainder of the truth has any chance of

ARTIST: SAUL BASS

CONTAINER CORPORATION OF AMERICA

The AIGA Design Leadership Award: Massachusetts Institute of Technology

Very seldom does outstanding graphic design occur in a vacuum. More often than not, design is done on assignment. It is the talented, prepared professional's response to an institution's communications requirements, and requires a good designer *and* a good client. The Award honors an outstanding demonstration of an institutional commitment to design over a substantial period of time in a variety of media.

Chairman
James Fogleman
Corporate Advisor
Communication, Architecture & Design
Raychem Corporation

Committee
Bill Bonnell
President
Bonnell Design Associates, Inc.

Peter Lawrence
Director
Design Management Institute

Philip Meggs
Chairman
Communication Arts & Design
Virginia Commonwealth University

Bradbury Thompson
Designer

The AIGA Design Leadership Award was created in 1981 to recognize the role that organizations and corporations have played in promoting design excellence. Very seldom does outstanding graphic design occur in a vacuum. More often than not, design is done on assignment. It is the talented, prepared professional's response to an institution's communications requirements, and requires a good designer *and* a good client. The Award honors an outstanding demonstration of an institutional commitment to design over a substantial period of time in a variety of media. Last year's Award went to IBM.

It should be no surprise that good design would take root, flower, and flourish at an institution like MIT. Devoted to education in engineering, science, and technology since its founding in 1861, MIT and its graduates have had a formidable impact on the state of technology in this country. MIT has also built a fine, if less well-known, liberal arts curriculum including the humanities, social sciences, and economics.

MIT is, however, the ultimate high-powered school of technology. But as advanced as technology gets, at its core it is nothing less or more than "... a technical method for achieving a practical purpose ..." and very closely related to the notion of design, broadly defined: "... to devise for a specific function or end." In an institutional environment oriented toward technology, this definition of design ought to be readily accepted. And the results, you'd predict, would be oriented away from flights of fancy and more toward the aeronautics of methodical, eminently logical, consistently high-caliber graphic design. This is precisely what happened at MIT.

The idea that an institution's sense of quality and wholeness could be demonstrated and enhanced by good graphic design and typography has been clear at MIT for more than 50 years. MIT's national magazine, *Technology Review*, attained considerable graphic distinction in the 1930s. During that same period, the imprint of many of New England's finest designers and printers appeared in MIT publications.

A new and expanded era in design began with Gyorgy Kepes, who joined the MIT faculty in 1945 to teach visual studies in the Department of Architecture. Muriel R. Cooper, then recently graduated from the Massachusetts College of Art, came to the Institute in 1951 to join the Office of Publications being organized under the direction of John I. Mattill, making MIT one of the first American universities to employ a graphic designer as a staff member with full-time responsibilities for printed communications material. The concept was that the essential character of an institution could be communicated by the *style*—as well as the content—of its messages, and that the force of this communication would be enhanced as more and more of the multitudinous publications which emanate from an academic institution like MIT came to life, exhibiting the appropriate quality and style in a consistently fine way. Muriel Cooper's 30-year career has touched the three main expressions of design at MIT—the Design Services Office, the MIT Press, and the Visible Language Workshop.

Jacqueline S. Casey, who now directs the Office of Design Services, joined the Office of Publications group in 1955 as its second full-time designer. Since 1957, when Ms. Cooper moved from the Office of Publications to the MIT Press, Casey has been the central focus of the evolution of the "MIT style" in MIT publications. Supporting Casey's efforts have been Ralph Coburn, Dietmar Winkler, Nancy Cahners, and Betsy Hacker.

Having launched design services as a vital, functioning expression of design at MIT, Muriel Cooper moved on to become the first art director of the MIT Press, a challenge to which she brought an evolving "MIT style," which remains today the trademark of the press. Perhaps the outstanding early accomplishment was her design for the *Bauhaus* book, published in 1969. Sylvia Steiner, the current art director at the Press, joined Cooper in 1968 while this project was in progress.

The MIT Press publishes approximately 100 titles a year, of which 75 are new books and 25 are paperback reprints from other books. Half of the publishing effort is in science and engineering, the other half in the humanities and social sciences, architecture, and visual communication. Many MIT Press titles have been honored for their design as well as for their editorial quality, and the design problems they present are both diverse and demanding.

Motivated by her sense of the growing implications of the electronic revolution for changing communications systems, industries, and the professions, Muriel Cooper left the Press for yet another challenge. Cooper and Ronald L. MacNeil, now assistant professor of visual studies, have created what they call the Visible Language Workshop—an interdisciplinary, hands-on environment for research, education, and production in the context of the proposed Arts and Media Technology Center at MIT. For students, the VLW work is part of the program for the degree of Master of Science in Visual Studies. The development of the VLW has been supported by a number of artists and friends, from a variety of disciplines: photography, printmaking, graphic design, book design, film, poetry, electrographics, and computergraphic arts.

Professor Cooper's current work and teaching are focused on the design process and the development of the prototype VLW as a complete user-based interactive electronic graphic system. Cooper now holds the rank of associate professor of visual studies in the Department of Architecture.

Technology's prime characteristic is its own continuation. One advance sets in place the foundation for the next. Technology's commitment is to move along. Design at the leading school of technology has been a continuum, too. It began in publication design, evolved into design services for the entire apparatus of the school, extended into fine book design, and now it is reaching into the very future of graphic design itself.

Computer Image:
Untitled, 1981
Designer:
Joel Slayton
Visible Language Workshop

All hard copy from computer
shown in this section is made
possible by the generosity of
Polaroid Corporation.

Computer Image:
DATANETWORK
Sky Art Conference, 1981
From slow-scan video
transmission
Designers:
Joel Slayton,
Visible Language Workshop /
Bernd Kracke,
Center for Advanced Visual
Studies

Computer Image:
newnorth, 1981
Designer:
Francis Olschafskie
Visible Language Workshop

Computer Image:
body poem, 1980
Designer:
Joan Shafran
Visible Language Workshop

Computer Image:
sapphic fragment, 1982
Designer:
Rob Faught
Visible Language Workshop

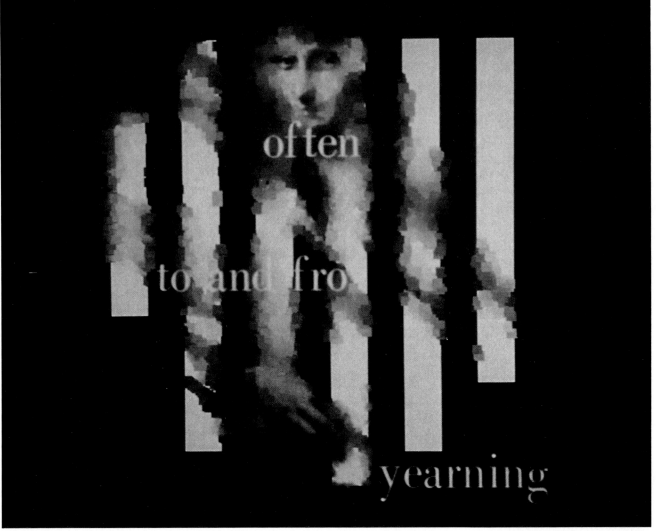

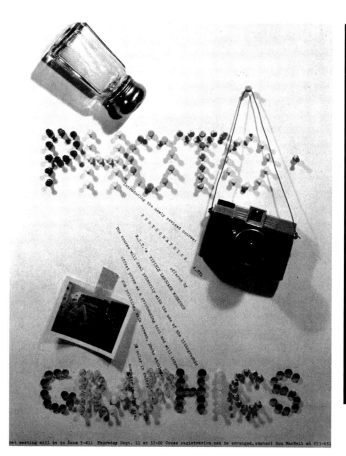

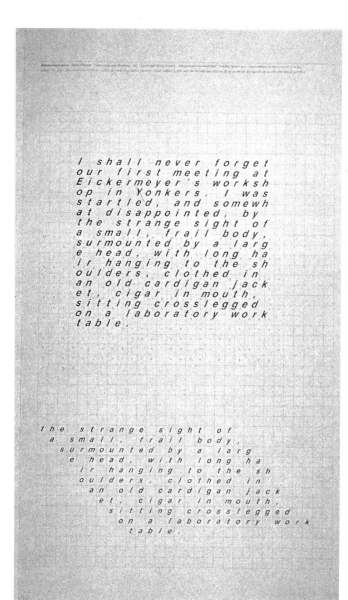

I shall never forget
our first meeting at
Eickermeyer's worksh
op in Yonkers. I was
startled, and somewh
at disappointed, by
the strange sight of
a small, frail body,
surmounted by a larg
e head, with long ha
ir hanging to the sh
oulders, clothed in
an old cardigan jack
et, cigar in mouth,
sitting crosslegged
on a laboratory work
table.

the strange sight of
a small, frail body,
surmounted by a larg
e head, with long ha
ir hanging to the sh
oulders, clothed in
an old cardigan jack
et, cigar in mouth,
sitting crosslegged
on a laboratory work
table.

Poster:
Photo-graphics, 1979
Designer:
Ron MacNeil
Visible Language Workshop

Computer Image:
Untitled, 1980
Designer:
Ron MacNeil
Visible Language Workshop

Typography:
Alphanumeric Array, 1982
Designer:
Nardy Henigan
Visible Language Workshop

Book:
Grandma's Book
1979
Designer:
Laura Blacklow
Visible Language Workshop

Book:
Acquaintances
1981
Designer:
Joel Slayton
Visible Language Workshop

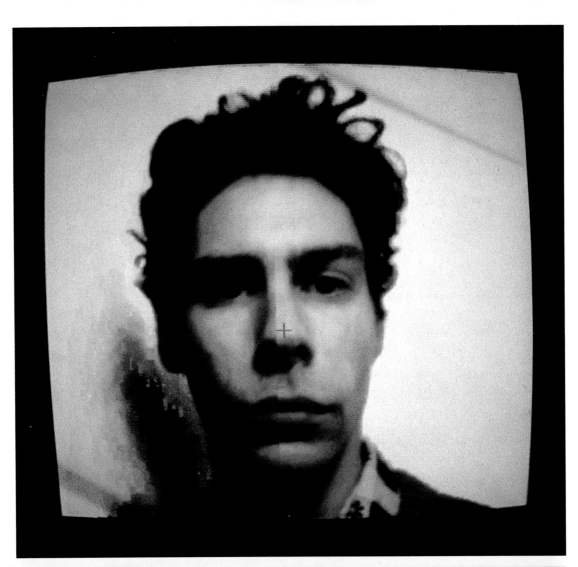

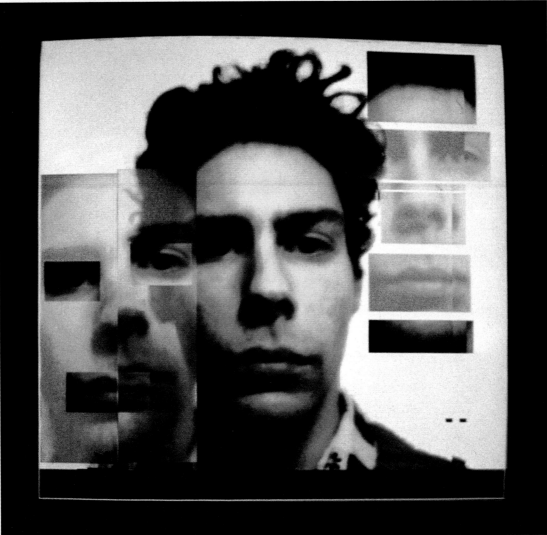

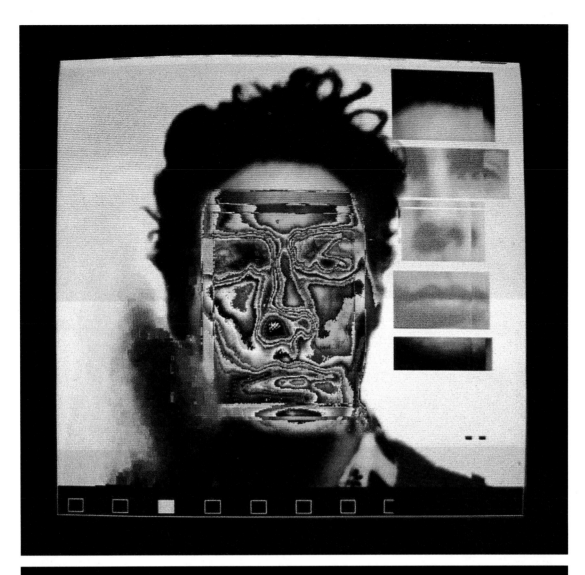

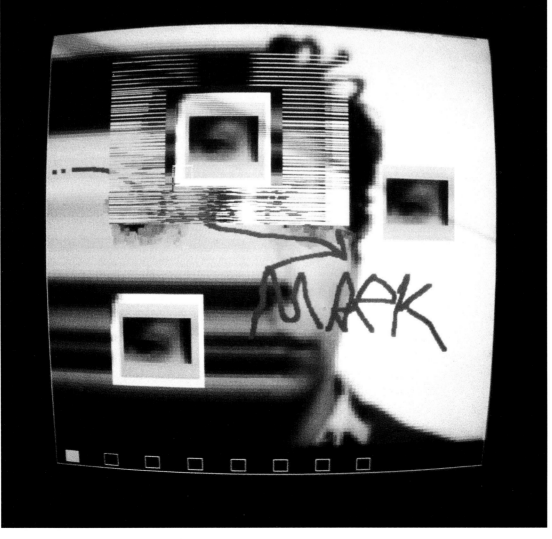

Book:
Group book, 1980
Class project
Laura Blacklow, instructor
Designer:
Rob Haimes
Visible Language Workshop

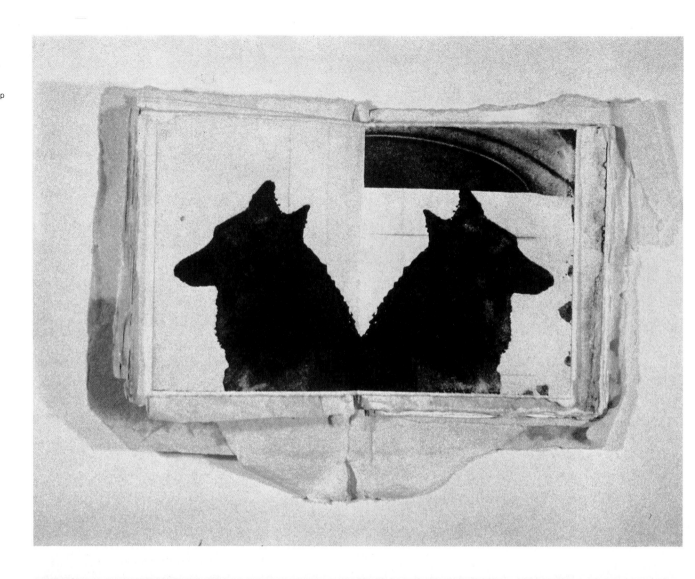

Computer Image:
mtyler, 1982
Designer:
Rob Haimes
Visible Language Workshop

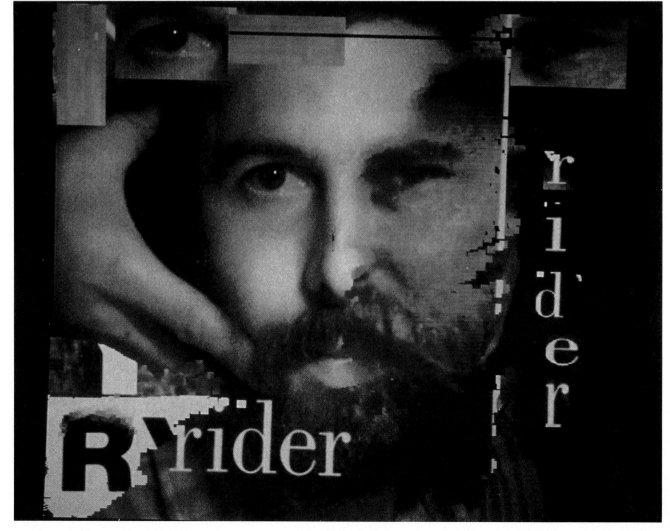

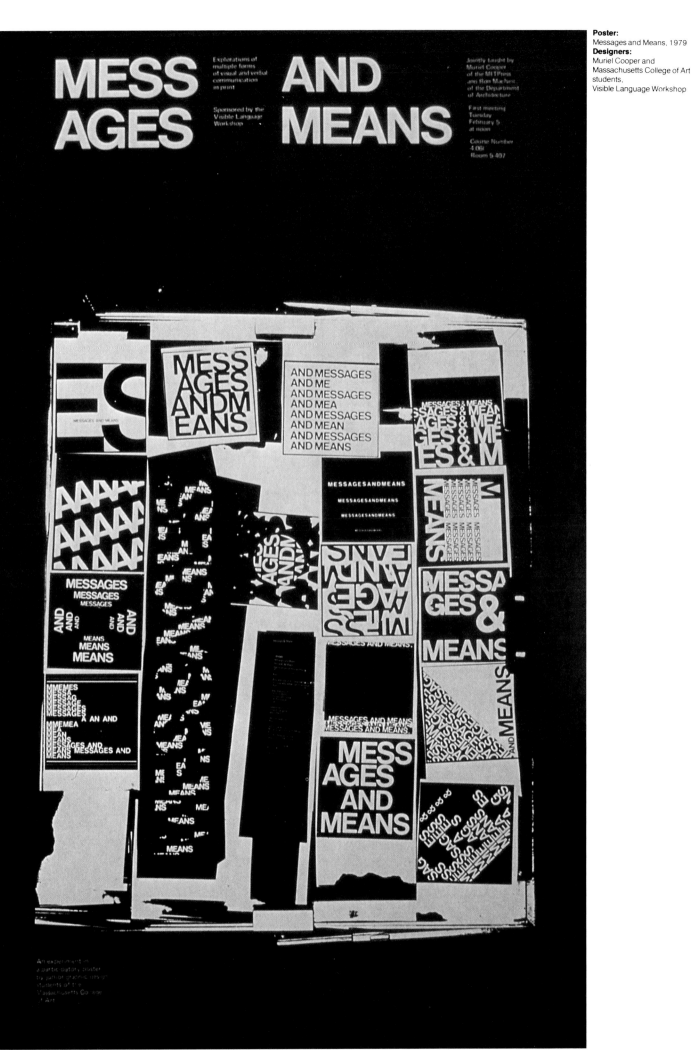

Poster:
Messages and Means, 1979
Designers:
Muriel Cooper and
Massachusetts College of Art
students,
Visible Language Workshop

Computer Image:
rider, 1982
Designer:
Rob Haimes
Visible Language Workshop

Computer Image:
Poster, 1982
Designer:
Nathan Felde
Visible Language Workshop

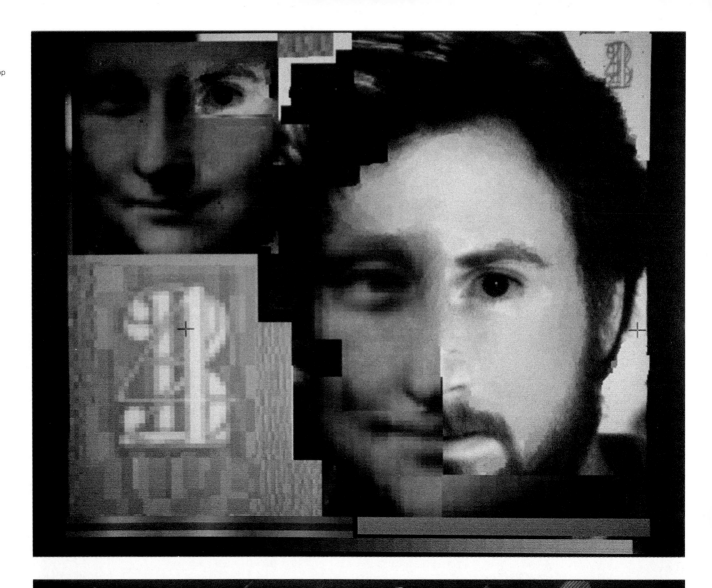

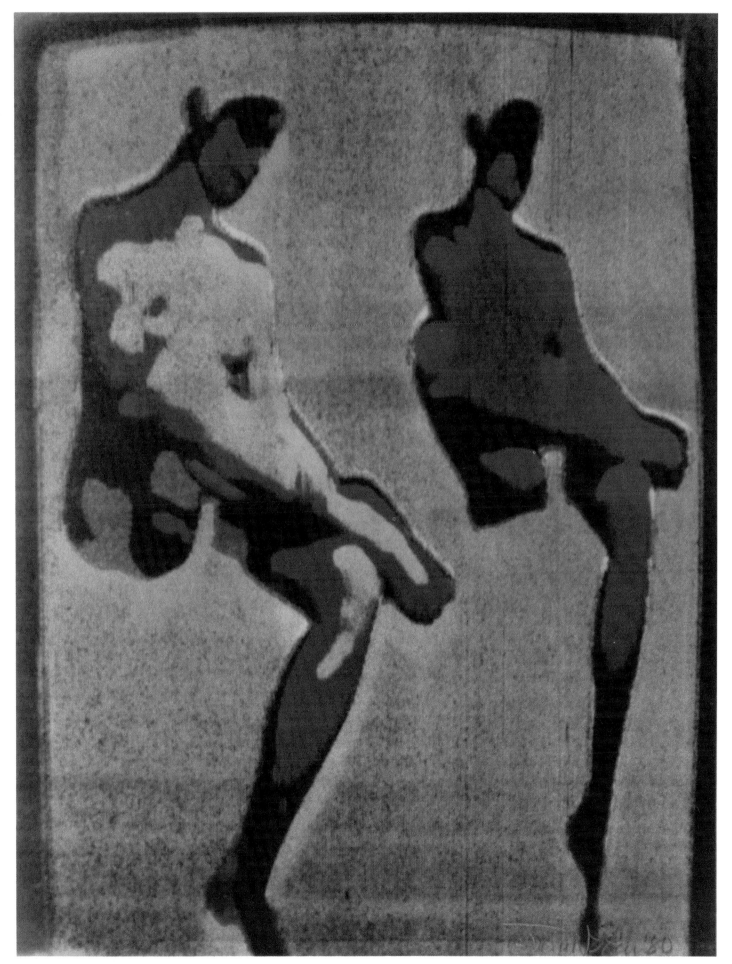

Electrographics:
Two seated figures, 1980
3M Color-in-Color, Video
Synthesizer
Designer:
Tom Norton
Visible Language Workshop

Book:
Buffalo Architecture: A Guide
1981
Designer:
Celia Wilson
M.I.T. Press

Buffalo Architecture: A Guide

Introductions by
Reyner Banham,
Charles Beveridge, and
Henry-Russell Hitchcock

Sponsored by the
Buffalo Architectural
Guidebook Corporation

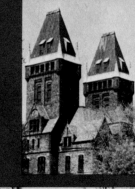

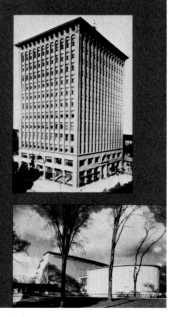

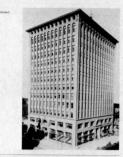

66
Downtown

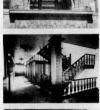

19 Prudential Building, 1895–1896
(formerly Guaranty Building)
28 Church Street
Architects: Adler and Sullivan
National Historic Landmark
(Detail photos show terra-cotta decoration on
window archway; original hallway interior;
stairway.)

The Prudential Building was intended to be
named after Hascal L. Taylor (1830–1894), the
Buffalonian who commissioned Dankmar Adler
(1844–1900) and Louis Sullivan (1856–1924)
to build what he wanted to be "the largest and
best office building in the city." Unfortunately,
he died in November of 1894 just before con-
struction plans were to be publicly announced.

The Guaranty Construction Company of
Chicago, which was to construct the building for
Taylor, bought the property and completed the
project. Construction began in 1895, and the
Guaranty Building was occupied on March 1,

67
Downtown

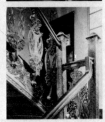

94
Downtown

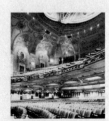

51 Shea's Buffalo Center for the Performing Arts,
1926
646 Main Street
Architects: C. W. and G. W. Rapp
Furnishings: Marshall Field & Company, Chicago
National Register of Historic Places

Shea's is today regarded as one of the finest
movie palaces of its period in the country. The
narrow facade belies the spacious and ornate
auditorium within, which seats more than 3000
people. Originally built by Michael Shea, the
theater underwent restoration beginning in 1974
by a voluntary group, the Friends of Shea's Buf-
falo.

95
Downtown

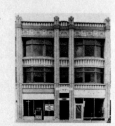

52 Calumet Building, 1906
46–58 West Chippewa Street
Architects: Esenwein and Johnson

This is the most exuberant example of glazed
terra cotta in the city.

53 Federal Office Building, 1968–1973
111 West Huron Street
Architects: Pfohl, Roberts and Biggie
Plaza sculpture: George Segal

LE CORBUSIER SKETCHBOOKS
2 1950-1954

Book:
Le Corbusier Sketchbooks, Vol. 2
1982
Designer:
Sylvia Steiner
M.I.T. Press

Book:
Nominal Accentuation in Baltic
and Slavic
1979
Jacket Designer:
Wendy Richmond
M.I.T. Press

Also from The MIT Press

**Six Lectures on Sound and
Meaning**
by Roman Jakobson
Preface by Claude Lévi-Strauss
*translated from the French by
John Mepham*

This short book is a fine introduction to
the ideas of Roman Jakobson, one of this
century's most important and influential
linguists.

The course of six lectures was given by
Professor Jakobson in 1942, at the Ecole
libre des hautes études, which had
recently been founded in New York by
French and Belgian scholars in exile.
Jakobson, although a public speaker of
considerable reputation, was not at that
time used to speaking in public in the
French language. He therefore wrote out
the lectures in advance: they remained
unpublished until the French edition
appeared in 1976, from which this trans-
lation is made. It gives the original texts,
with only very slight formal changes.

With remarkable clarity and vigor
Jakobson charts the domain of phonetic
studies and makes clear the inadequacy
of traditional approaches to the subject.
He proceeds to lay the foundations for a
science of language considered from the
point of view of sound in its relation to
meaning. In reading these lectures the
reader has the remarkable experience of
witnessing the clearing of the terrain and
the construction of the general frame-
work of a science, all performed with
extraordinary economy of expression,
clarity, rigor, and wit.

As Lévi-Strauss writes: "These
innovatory ideas, towards which I was no
doubt drawn by my own thought, but as
yet with neither the boldness nor the
conceptual tools necessary to organise
them properly, were all the more
convincing in that Jakobson's exposition
of them was performed with that incom-
parable art which made him the most
dazzling teacher and lecturer that I had
ever been lucky enough to hear."

This book is marked by Jakobson's
elegance and demonstrative powers.
Jakobson never pursues the abstract and
sometimes difficult course of his argu-
ment without illuminating it by examples
from a great variety of langauges and
from the arts.

The MIT Press
Massachusetts Institute
of Technology
Cambridge, Massachusetts 02142

ILLNH

Nominal Accentuation
in Baltic and Slavic

Illich-Svitych

**Nominal Accentuation
in Baltic and Slavic**

V. M. Illich-Svitych

Translated by
Richard L. Leed
and
Ronald F. Feldstein

Book:
Dyslexia—Theory and Research
1980
Jacket Designer:
Diane Jaroch
M.I.T. Press

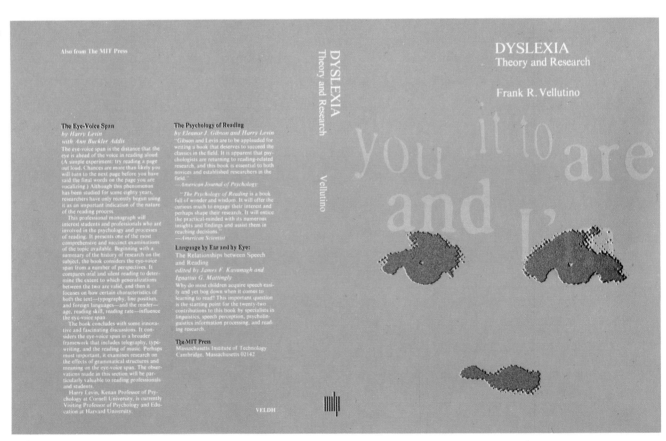

Also from The MIT Press

The Eye-Voice Span
by Harry Levin
with Ann Buckler Addis

The eye-voice span is the distance that the
eye is ahead of the voice in reading aloud
(A simple experiment: try reading a page
out loud. Chances are more than likely you
will turn to the next page before you have
said the final words on the page you have
vocalizing.) Although this phenomenon
has been studied for some eighty years,
researchers have only recently begun using
it as an important indication of the nature
of the reading process.

This professional monograph will
interest students and professionals who are
involved in the psychology and processes
of reading. It presents one of the most
comprehensive and succinct examinations
of the topic available. Beginning with a
summary of the history of research on the
subject, the book considers the eye-voice
span from a number of perspectives. It
compares oral and silent reading to deter-
mine the extent to which generalizations
between the two are valid, and then it
focuses on how certain characteristics of
both the text—typography, line position,
and foreign languages—and the reader—
age, reading skill, reading rate—influence
the eye-voice span.

The book concludes with some innova-
tive and fascinating discussions. It con-
siders the eye-voice span in a broader
framework that includes telegraphy, type-
writing, and the reading of music. Perhaps
most important, it examines research on
the effects of grammatical structures and
meaning on the eye-voice span. The obser-
vations made in this section will be par-
ticularly valuable to reading professionals
and students.

Harry Levin, Kenan Professor of Psy-
chology at Cornell University, is currently
Visiting Professor of Psychology and Edu-
cation at Harvard University.

The Psychology of Reading
by Eleanor J. Gibson and Harry Levin
"Gibson and Levin are to be applauded for
writing a book that deserves to succeed the
classics in the field. It is apparent that psy-
chologists are returning to reading-related
research, and this book is essential to both
novices and established researchers in the
field."
—*American Journal of Psychology*

"*The Psychology of Reading* is a book
full of wonder and wisdom. It will offer the
curious much to engage their interest and
perhaps shape their research. It will entice
the practical-minded with its numerous
insights and findings and assist them in
reaching decisions."
—*American Scientist*

**Language by Ear and by Eye:
The Relationships between Speech
and Reading**
*edited by James F. Kavanagh and
Ignatius G. Mattingly*
Why do most children acquire speech eas-
ily and yet bog down when it comes to
learning to read? This important question
is the starting point for the twenty-two
contributions to this book by specialists in
linguistics, speech perception, psycholin-
guistics information processing, and read-
ing research.

The MIT Press
Massachusetts Institute of Technology
Cambridge, Massachusetts 02142

VELDH

DYSLEXIA
Theory and Research

Vellutino

DYSLEXIA
Theory and Research

Frank R. Vellutino

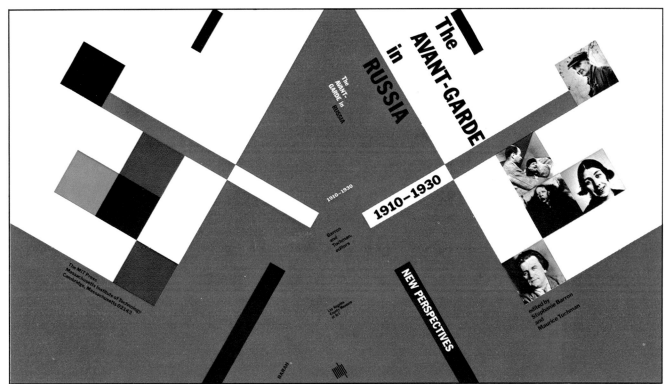

Book:
The Avant-Garde in Russia.
1910-1930. New Perspectives.
1981
Jacket Designer:
Donna Schenkel
M.I.T. Press

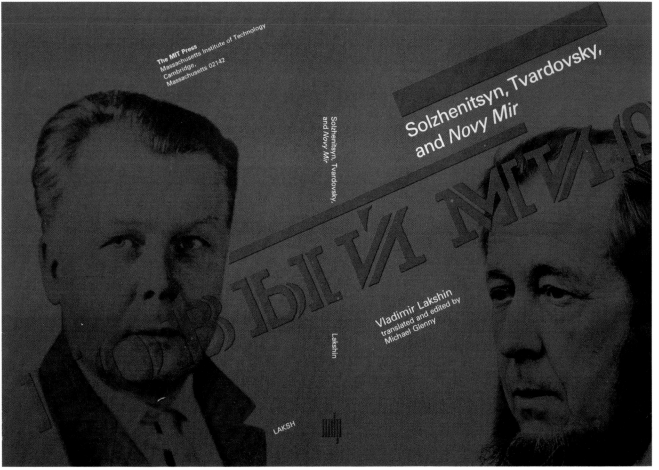

Book:
Solzhenitsyn, Tvardovsky, and
Novy Mir
1980
Jacket Designer:
Diane Jaroch
M.I.T. Press

Poster:
AAUP Book Show, 1981
Designer:
Michael McPherson
M.I.T. Press

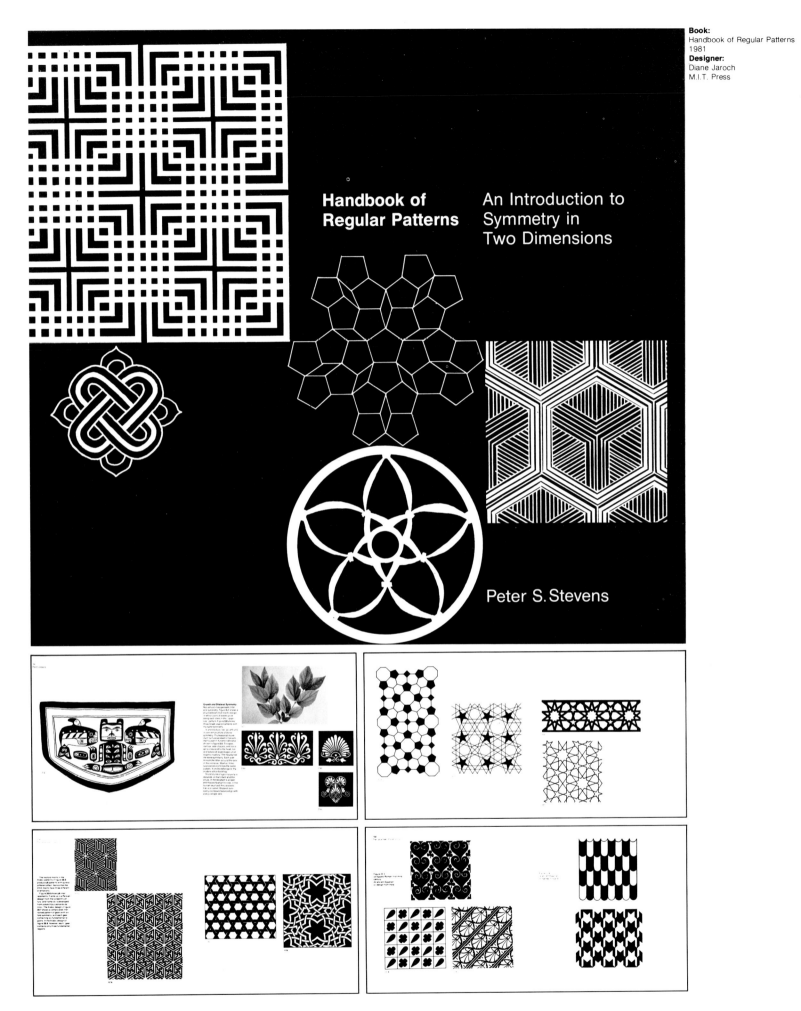

Book:
Handbook of Regular Patterns
1981
Designer:
Diane Jaroch
M.I.T. Press

Handbook of
Regular Patterns

An Introduction to
Symmetry in
Two Dimensions

Peter S. Stevens

BAUHAUS

Book:
Bauhaus
1969
Designers:
Muriel Cooper and Lauri Rosser
M.I.T. Press

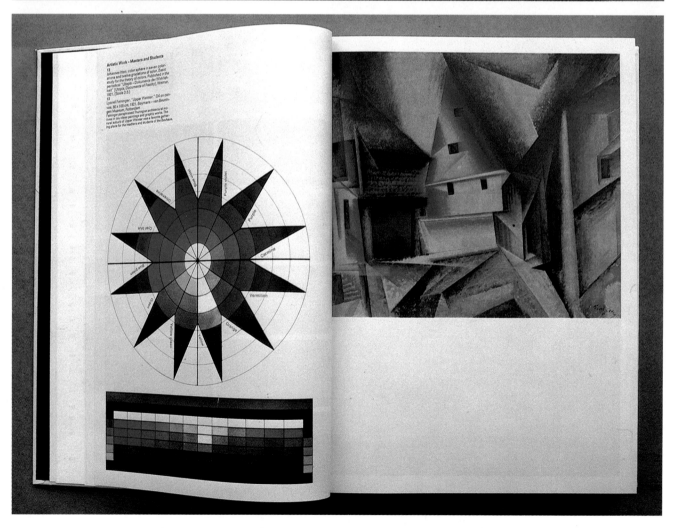

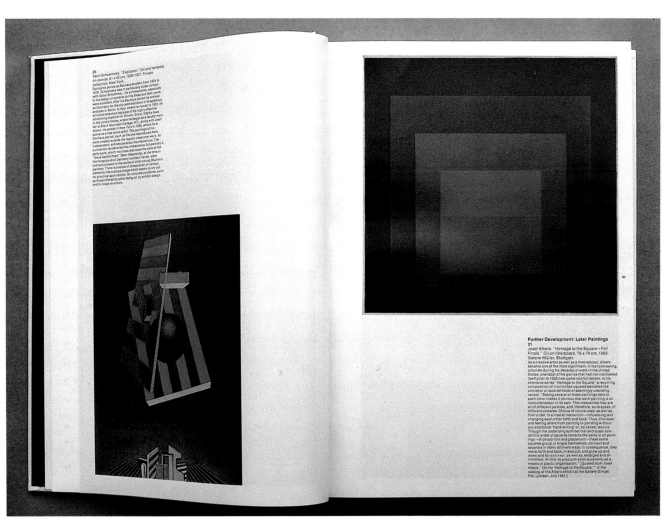

20
Xanti Schawinsky: "Explosion." Oil and tempera on canvas, 61 x 43 cm, 1925-1927. Private collection, New York.
During his period at Bauhaus studies, from 1924 to 1926, Schawinsky was particularly close contact with Oskar Schlemmer. His achievements, especially in the design of exhibits during these and later years, were excellent. After his Bauhaus period he worked as illustrator for the city administration of Magdeburg and also in Berlin. In Italy, where he moved in 1933, he attracted attention because of his highly effective advertising material for Olivetti. Since 1936 he lives in the United States, where he began as a faculty member at Black Mountain College, N.C., along with Josef Albers. He settled in New York in 1936, where he is active as a free-lancer artist. The paintings of his Bauhaus period, such as the one reproduced here, were created outside the regular classroom work, as independent, entirely personal manifestations. The surrealistic tendencies that characterize Schawinsky's early work, which may have disclosed the style of the "Neue Sachlichkeit" (New Objectivity), at the time in the foreground of Germany's artistic trends, were similarly present in the works of other young Bauhaus painters. There is a series of compilation of various elements into a single image which seems to try out, for practical applications, for concrete problems, such as those offered by advertising art, by exhibit design, and by stage structure.

Further Development: Later Paintings
21
Josef Albers: "Homage to the Square—Fall Finals." Oil on fiberboard, 76 x 76 cm, 1963. Galerie Müller, Stuttgart.
As a creative artist as well as a theoretician, Albers became one of the most significant, in fact pioneering, colorists during his decades of work in the United States; one facet of his genius that had not manifested itself prior to 1933 now came into full bloom. In his extensive series "Homage to the Square" a recurring composition of interlocked squares becomes the conveyor of colored fields of seemingly unending variety. "Seeing several of these paintings next to each other makes it obvious that each painting is an instrumentation in its own. This means that they are all of different palettes, and, therefore, so to speak, of different climates. Choice of colors used, as well as their order, is aimed at interaction—influencing and changing each other forth and back. Thus, character and feeling alters from painting to painting without any additional 'hand writing' or, so called, texture. Though the underlying symmetrical and quasi-concentric order of squares remains the same in all paintings—in proportion and placement—these same squares group or single themselves, connect and separate in many different ways. In consequence, they move forth and back, in and out, and grow up and down and far and near, as well as, enlarged and diminished. All this, to proclaim color autonomy as a means of plastic organisation." (Quoted from Josef Albers, "On my 'Homage to the Square,'" in the catalog of the Albers exhibit at the Gallery Gimpel Fils, London, July 1961.)

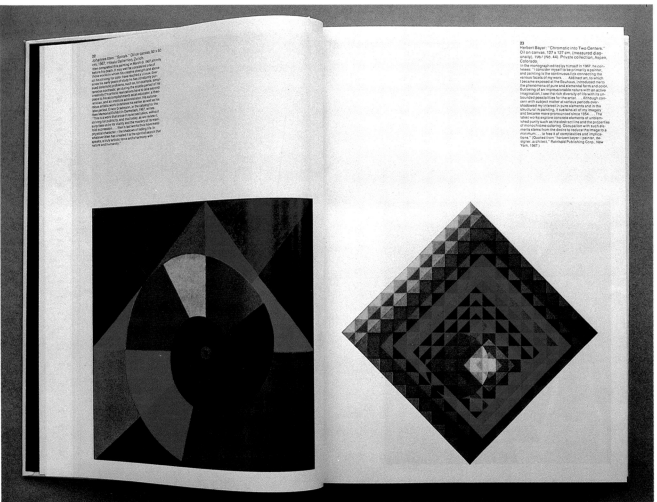

22
Johannes Itten: "Spirals." Oil on canvas, 50 x 50 cm, 1967. Private collection, Zurich.
Itten compared this painting in March of 1967, shortly before his death. It may well be considered one of those works in which his creative strength and above all his striving for color have reached a climax. Ever since his early years of study he has constantly pursued coloristic problems. It can, for example, simultaneous contrasts; yet during the middle period of his creativity the artistic realizations have to take second place to his accomplishments as an educator, a theoretician, and an institute administrator. His autonomous artistic work blossoms in earlier as well as his later period. Erwin Gradmann, in the catalog for the Itten Memorial Exhibit in Darmstadt, 1967, writes: "This is a work that exists in quiet seclusion, without striving for publicity, and that today, as we review it, surprises us by its vitality and the mastery of its bold expression ... Itten's last works thus have metaphysical character—the shadows of fading life in whatever Itten had created it is the spirit of search that speaks, a truly artistic force and a harmony with nature and humanity.

23
Herbert Bayer: "Chromatic into Two Centers." Oil on canvas, 127 x 127 cm, (measured diagonally), 1967 (No. 44). Private collection, Aspen, Colorado.
In the monograph edited by himself in 1967, he confesses: "I consider myself to be primarily a painter, and painting is the continuous link connecting the various facets of my work ... Abstract art, to which I became exposed at the Bauhaus, introduced me to the phenomena of pure and elemental form and color. But being of an impressionable nature with an active imagination, I see the rich diversity of life with its unbounded possibilities for the artist ... Although concern with subject matter at various periods overshadowed my interest in pure elements and in the structural in painting, it sustains all of my imagery and became more pronounced since 1954 ... The latest works explore concrete elements of unblemished purity such as the abstract line and the properties of monochrome coloring. Occupation with such elements stems from the desire to reduce the image to a minimum ... to free it of complexities and implications." (Quoted from "herbert bayer—painter, designer, architect," Reinhold Publishing Corp., New York, 1967.)

MASSACHUSETTS
INSTITUTE
OF TECHNOLOGY
SEA GRANT
COLLEGE PROGRAM

22

managing one of the region's most important fisheries. New research and information sources were introduced at the "Barrier Beach Management Workshop" and the "Waterfront Development Conference." Marine owners, who suffered financial losses from ice damage during the severe 1976-1977 winter, discussed preventive design considerations and technology with researchers from the University of Wisconsin Sea Grant Program, the Cold Regions Research and Engineering Laboratory, as well as engineers and product experts from private industry at a November, 1977 meeting.

One of the most substantial concerns of Massachusetts's coastal residents is erosion which threatens many homes and recreational areas. In 1977-1978, MIT Sea Grant's coastal engineer presented a slide-tape show describing various effective, economical control systems to homeowners and conservation commissions.

One erosion control technique, created by researchers for application in the Chesapeake Bay, is being tried in several locations on Cape Cod, under MIT Sea Grant surveillance. The method, which uses plastic bags, called sill

bags, to raise or perch the beach as sand builds up behind and in front of the bags, may not be adequate in the active, exposed environment of the Massachusetts coastline. A final assessment will not be made, however, until a thorough monitoring program has been completed, and the results evaluated in late 1979.

The Sea Grant Advisory Service staff facilitates the interaction between MIT researchers and Massachusetts constituents. In the past year they played a critical role in the development of the dogfish skinning machine and the testing of a new trawl door for the fishing industry. Planning tools — for assessing the effect of population growth on the groundwater resources of Martha's Vineyard, and for revitalizing the Hyannis waterfront — will be completed and the results disseminated with the assistance of ESGAP agents.

SEA GRANT LECTURE

The Annual Sea Grant Lecture is sponsored each year to highlight major issues that demand the attention and study of, not only the scientific community, but all citizens. Technology is only one part of resource development. Decisions that have far-reaching consequences are made by voters in local, state, and national elections, by owners of private property and business, and by regulatory agencies in the federal governments.

In the 1977 Lecture, Congresswoman Yvonne B. Burke of California, in her lecture, "The Sea and Waterways — The New Frontier," discussed several issues of national and international concern: ratification of the Panama Canal Treaties, "flag-of-convenience" ship registry, and safety standards required to prevent oil pollution in the oceans. An expert panel responding to Congresswoman Burke and the audience included Mr. Erling D. Naess, Chairman, International Association of Independent Tanker Owners; Paul E. Atkinson, President, Sun Shipbuilding and Dry Dock Company; A. Douglas Carmichael, Professor of Power Engineering, MIT Department of Ocean Engineering; and John P. Sheffey, Colonel (ret.), Executive Vice President of the National Association for Uniformed Services.

**COMMUNICATIONS/
INFORMATION SERVICES**

A complement to the Marine Industry Advisory Services and the Extension Sea Grant Advisory Program, the Communications and Information staff publishes reports describing the results of MIT Sea Grant research and translates technical information into forms more easily usable by Sea Grant's constituents.

The Marine Resource Information Center in the Sea Grant offices maintains a collection of reports and publications from MIT, and all other Sea Grant programs. Journals and newsletters covering current marine issues are available. And in addition, topic files, indexes, abstracts, and bibliographies on oceanography, land-use planning, ports, fisheries, water quality control, coastal processes, and environmental regulations are useful reference sources available through the Center.

As the opportunity and need arise, the Communications/Information staff prepares, publishes and distributes guides to information sources, proceedings of important conferences, and reports on program activities. The annual MIT Marine-Related Research Directory guides constituents to the current work at the Institute; a directory to MIT Sea Grant's publications from 1970-1977 reports on the body of information available through the Program.

Communications/Information helps to fulfill the Congressional mandate and the Stratton Commission recommendation that Sea Grant maintain and encourage a continuous flow of information between the Program and all groups involved in ocean and coastal resource development.

One thousand copies of the proceedings, published and distributed by the Communications/Information Service, allow citizens throughout the country to consider differing views of experts on issues of vital concern to the nation.

23

**RESEARCH VESSEL
EDGERTON**

MIT's Research Vessel EDGERTON, maintained under the direction of the Sea Grant advisory service Marine Liaison Officer, is available through charter to researchers from the Institute, industry, and other universities who need to gather data or to test equipment at sea. Compact to provide an economical and flexible oceangoing work platform. The EDGERTON, outfitted and maintain by the Institute, is used for oceangraphic and ocean engineering research along the New England coast and in deeper waters on the continental shelf.

MIT
Accident Prevention
Guide

4

**Energy-Related
Education at MIT**

Massachusetts Institute of Technology

January 1981

WHITE TOWERS

Paul Hirshorn and Steven Izenour

Book:
White Towers
1979
Designer:
Sylvia Steiner
M.I.T. Press

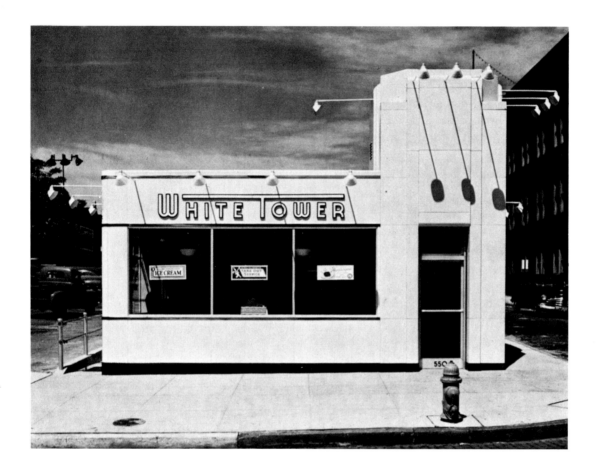

Food display
"The big deal was mass displays. If
you had only one piece of pie up,
you'd never sell it."

Food display
"Put up ten or twelve pies, and
you'll sell it."

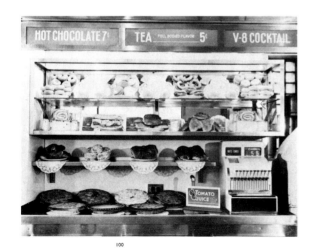

100

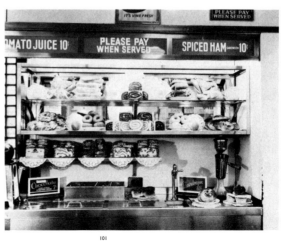

101

Poster:
Miscellaneous Motions of
Kinetic Sculpture, 1967
Designer:
Jacqueline Casey
M.I.T. Design Services

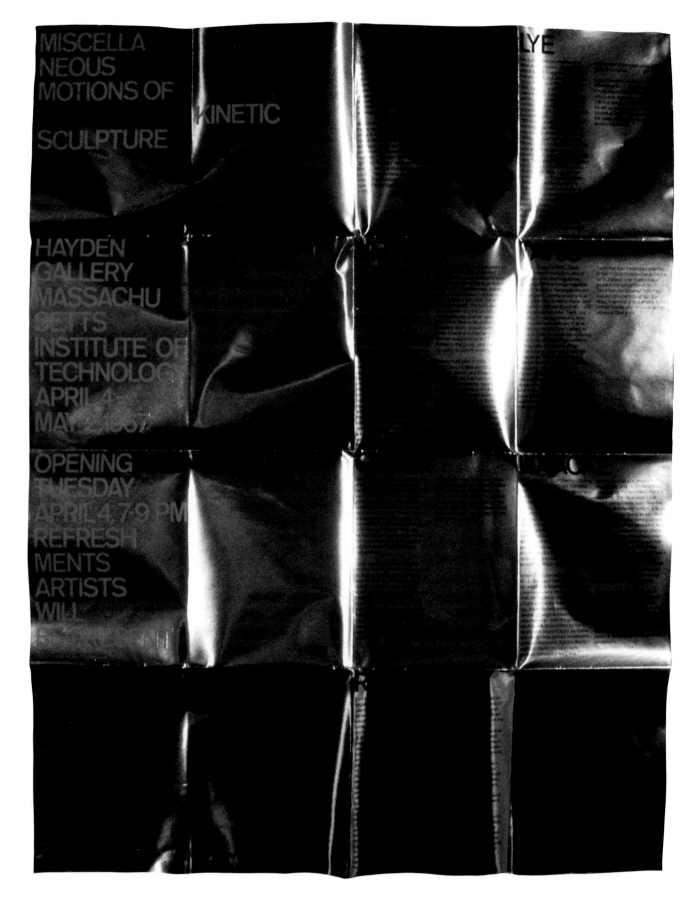

Gregory Tucker

John Buttrick

Poster:
Gregory Tucker / John Buttrick,
1971
Designer:
Dietmar Winkler
M.I.T. Design Services

Massachusetts Institute of Technology
Kresge Auditorium
Monday, February 24, 8:15 pm
Admission free, no tickets required

Bach, Concerto for two pianos in C major
Stravinsky, Concerto for two solo pianos
Bartok, Sonata for two pianos and percussion
Tele Lesbines, Irving Austin, percussion

Brochure:
Computer-Aided Design, 1967
Designer:
Jacqueline Casey
M.I.T. Design Services

Computer-Aided Design

Massachusetts Institute of Technology
August 1-12
Summer Session 1966

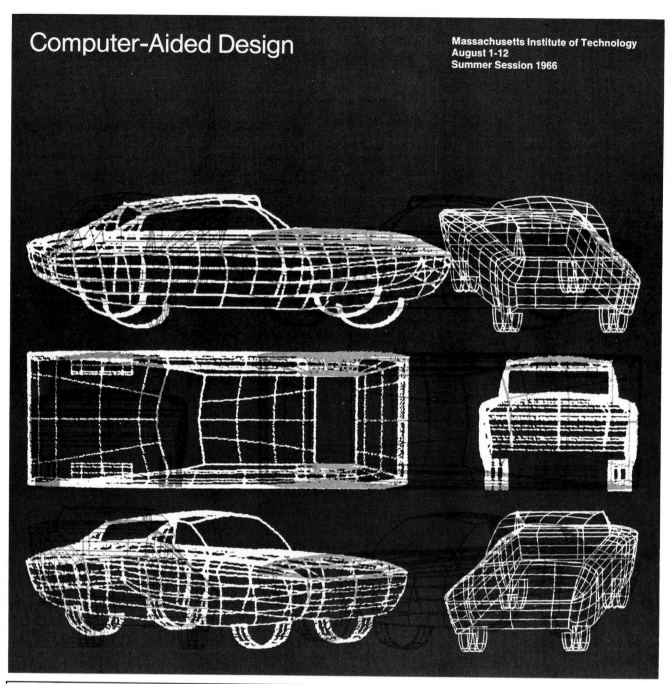

Computer-Aided Design
Monday, August 1,
through Friday, August 12

Outline of the Program

Staff

Within the past few years, new philosophies and fresh objectives have emerged in the computer field. It is beginning to be possible to join man and computer so they may work together in performing creative engineering and scientific tasks. Such new techniques as continuous man-machine interaction, time-sharing (or more properly, computer-system-sharing by many users) graphical capabilities, and human-oriented languages for communication with a computer, are in the process of very rapid development.

This Program will study the internal mechanisms of such man-computer systems, and their external aspects and potentialities. Considerable attention will be given to graphic input-output, and to methods for designing and delineating arbitrary curved surfaces such as airplane fuselages, ship hulls, and automobile bodies.

The following topics will be covered:

An introduction to the design process and the structure of a computer-aided design system.

A brief discussion of computer languages, assemblers, compilers, and interpreters.

Algebraic and symbolic interpretation and manipulation.

Information structures - lists, trees, rings, and more complex associative structures.

Human-oriented language forms for man-computer interaction.

The concept of computer-systems-sharing.

Graphical input-output - SKETCHPAD and derivative systems.

Brief discussion of hardware developments.

Curved surface mathematics for use in computer-aided design, with examples of its implementation in ship lofting, automobile body styling, airplane design, and architecture.

Perspective transformations using matrix methods to produce realistic displays of three-dimensional objects in space.

Abstract graphs.

Three-dimensional stress analysis.

Partial differential equations.

Lectures and demonstrations will be presented each day from 9 a.m. to 12 noon, and from 2 p.m. to 5 p.m.

Tuition for the Program is $350, due and payable upon notification of admission. No academic credit is offered.

The Program will be under the direction of:

Steven A. Coons
Associate Professor of Mechanical Engineering
Massachusetts Institute of Technology

Staff from M.I.T. will include:

Edward L. Glaser
Research Associate
Department of Electrical Engineering and Project MAC

Timothy E. Johnson
Staff Member
Division of Sponsored Research

Robert W. Mann
Professor of Mechanical Engineering
Head of the Design Division

Richard P. Parmelee
Research Associate
Department of Mechanical Engineering

Edgar H. Sibley
Research Assistant
Department of Mechanical Engineering

Coyt C. Tillman, Jr.
Research Assistant
Department of Mechanical Engineering

The guest lecturers will be:

Bertram Herzog
Associate Professor
Department of Industrial Engineering
University of Michigan

M. David Prince
Associate Director of Research System Sciences
Lockheed Georgia Company

Ger Dekkers

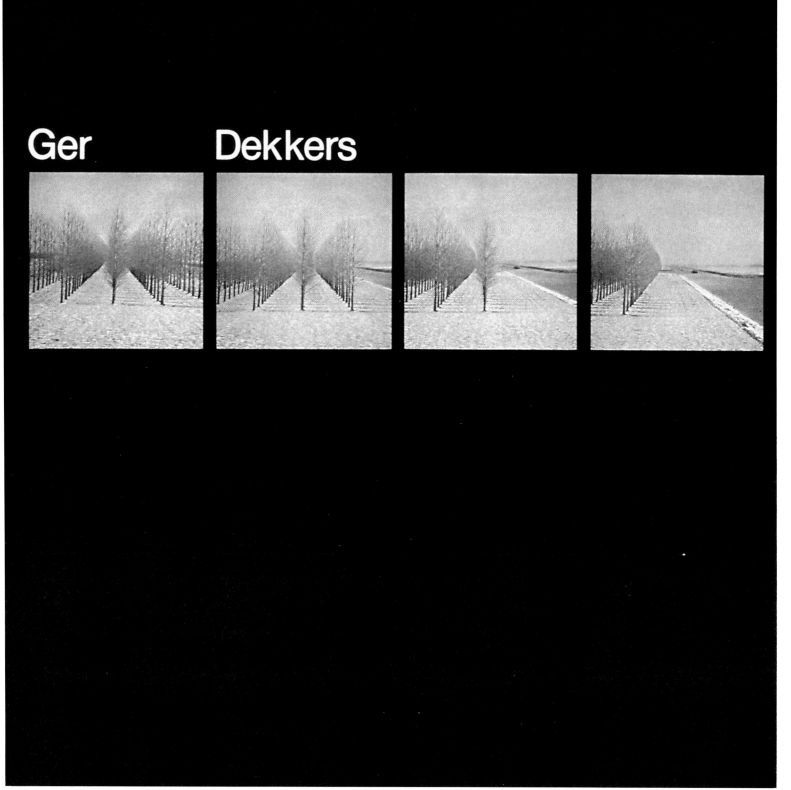

Catalog:
Ger Dekkers: New Dutch
Landscape Catalog, 1979
Designer:
Jacqueline Casey
M.I.T. Design Services

March/April, 1979
Price, $2.00

Technology Review

Edited at the Massachusetts Institute of Technology

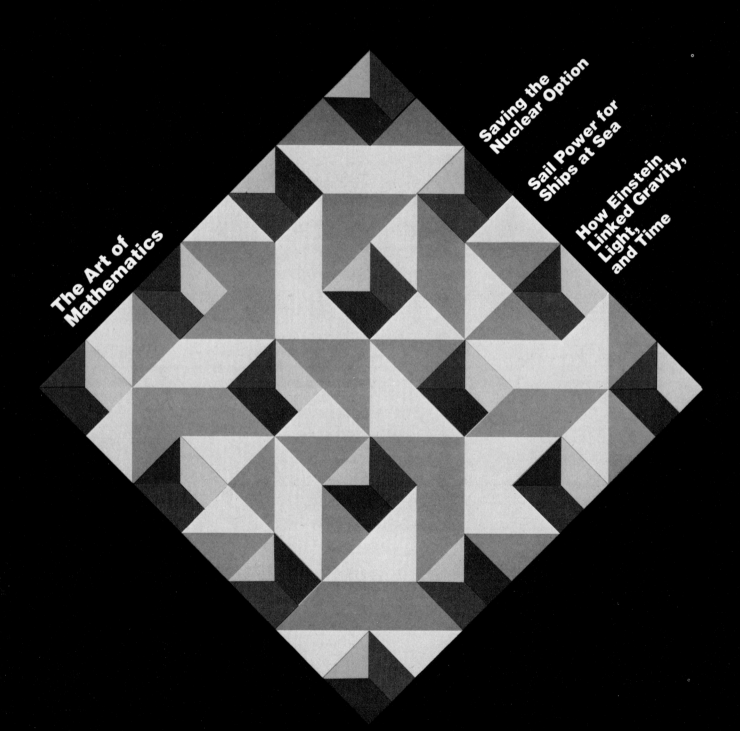

The Art of Mathematics

Saving the Nuclear Option

Sail Power for Ships at Sea

How Einstein Linked Gravity, Light, and Time

Magazine:
Technology Review
March / April 1979
Designer:
Nancy Pokross
M.I.T. Design Services

Magazine:
Technology Review
February 1980
Title:
New Genetic Technologies:
Prospects and Hazards
Designer:
Nancy Pokross
M.I.T. Design Services
Illustrator:
Gary Viskupic

New
Genetic Technologies:
Prospects and Hazards

by Jonathan King

During the past 30 years we have witnessed extraordinary advances in knowledge of fundamental biological processes, particularly at the cellular and molecular level. These advances have derived in large part from the major investment of public funds in the training of biomedical scientists and support for biomedical research, conducted by the governments of the industrialized countries since the end of World War II. The 1978 budget for biomedical research in the U.S. is about 3 billion dollars. This is one thousand times the federal expenditure for biomedical research in 1948.

In the U.S., these programs originated in the pressing need for coordinated biomedical research to deal with the immense damage suffered by soldiers during and after World War II. The federal funding and encouragement of cooperative, organized research ventures was highly successful and continued after the war, when public pressure overcame opposition from the private medical sector.

The well-financed program of training and research has led to: the elucidation of the chemical structure of the genetic material, DNA; the understanding of the organization of the genetic material in linear segments, the genes; the recognition that genes are blueprints for the structure of protein molecules, which form both the building blocks and working parts of cells; the understanding of the roles of the thin membranes that divide cells into different compartments; and enhanced knowledge of the organization and functions of the complex ribosomes, themselves composed of more than 70 different kinds of protein molecules, which serve as the factories for assembling new proteins according to the instructions of the genes. Thus, the mental and physical labors of tens of thousands of laboratory workers have revealed the extraordinary richness and creativity of the mechanisms by which living things

Although
the scientific community
generally views
recombinant DNA technology
as a feature of research,
private corporations
have moved rapidly to
exploit it.

Magazine:
Technology Review, February 1980
Title:
China's New Economics
Designer:
Nancy Pokross
M.I.T. Design Services

China's New Economics

by Karel Kovanda

In developing their national economies, Communist countries have in general followed the lead of the Soviet Union — some, like Yugoslavia, have done so only for a limited time; others, like China, have made serious adjustments to suit their local conditions. The model, however, is usually recognizable. Its main features include state ownership of almost all means of production with little, if any, room for private initiative; priority to heavy industry; centralized decision making, enabling the entire country to be run as a single giant corporation; and economic activity directed by the state plan, with market forces ignored.

Yugoslavia abandoned most features of this model after its rift with the Soviet Union in 1948 and developed its own idiosyncratic ways of building communism. Since the early 1960s, other Eastern European countries, and even the U.S.S.R. itself, have experienced economic problems that led to a reexamination of the system of management and planning and, in several instances, to the introduction of major economic reforms. In all countries, these reforms were aimed at improving the quality of management; in several (most notably in Hungary and Czechoslovakia), they were aimed also at

decentralizing decision making, thereby both decreasing the influence of the state plan and central governmental authorities and increasing the role of supply and demand.

China never adhered to the Soviet model blindly; its own unique qualities could not be ignored. It has been a tradition for the Chinese to critically examine the practices of the Soviet Union before accepting them. In 1956, for example, years before the two countries split openly, Mao Zedong gently criticized the U.S.S.R. for certain mistakes, especially in agriculture. These mistakes, he said, China would not repeat. Nevertheless, despite their reservations, the Chinese have run their economy far closer to the Soviet model than to any other.

Eastern European economic reforms began while China was in the throes of the Cultural Revolution — during the second half of the 1960s. At that time the Chinese considered the Eastern European countries thoroughly "revisionist," and their reforms were summarily rejected as a throwback to capitalism. Sun Yefang, a Chinese economist who in the early 1960s had recommended reforms of a similar type for China, was summarily thrown into prison.

Proposed economic reforms make
realization of China's development goals more likely.
And for would-be foreign
investors, there are grounds for cautious
optimism.

Postage stamps are everywhere vehicles for national propaganda,
but Communist and Third-World nations — China notable among them — have outpaced us all.
The illustrations accompanying this
article show how China has used this medium to celebrate its new
aspirations for technology and industrial development.

Brochure:
City and Regional Planning,
1967
Designer:
Dietmar Winkler
M.I.T. Design Services

City and Regional Planning

**City and Regional Planning
Monday, June 19 through
Friday, June 30**

Outline of the Program

Staff

The problem of institutional expansion in an urban setting will be emphasized during the 29th M.I.T. Special Summer Program on City and Regional Planning. The Program will provide a comprehensive review of the principles of city and metropolitan planning and of the administration of urban planning programs. The approach will be from the viewpoint of the generalist who is concerned more with breadth of interest and with recently developed techniques and practices than with completeness or depth of detail.

Special attention will be paid to the relationship of urban institutional expansion to comprehensive planning. A series of seminars during the second week of the Program will deal with problems of the physical development of universities, medical centers, museums, and other cultural and scientific institutions located within urban areas. In discussing questions of institution-community relationships, consideration will be given to creating community support for development programs and correcting misunderstandings stemming from factors such as tax-exempt status and conflicts between "town and gown." Several case studies of current institutional development programs, which have been coordinated with over-all city plans, will be presented.

The Program will cover such aspects of city and metropolitan planning as land use and density requirements for various activities; criteria for physical design; urban renewal and other forms of governmental assistance; fiscal, administrative, and legal problems; and programs for housing, transportation, recreation, and other elements of urban and rural development.

The Program will consist of seminars providing a general review of current planning techniques and basic planning principles. Topics will include:

Modern concepts of planning

General or comprehensive plans

Economic base studies

Theory of urban form

Land use and transportation planning

Planning for schools and recreation

Planning programs for metropolitan areas

Housing problems and policies

Zoning law and administration

Long-range programming of public works

Seminars will be held each weekday morning and afternoon, and two evening sessions will be planned each week. An all-day field trip to some significant developments in the metropolitan area of Boston is scheduled for Saturday, June 24.

Enrollment in the Program is open to practicing professional planners, to members and staffs of planning commissions and urban renewal agencies, and to men and women in such related fields as architecture, public administration, civil engineering, utilities, real estate, and industrial development who have a specific interest in comprehensive planning. Attendance will be limited.

Tuition is $350, due and payable upon notification of admission. Academic credit is not offered.

The seminars will be under the general direction of Frederick J. Adams, Professor of City Planning, M.I.T. Seminar leadership will be provided by members of the faculty of the M.I.T. Department of City and Regional Planning and guest speakers selected for their ability to make a special contribution to the subjects under discussion.

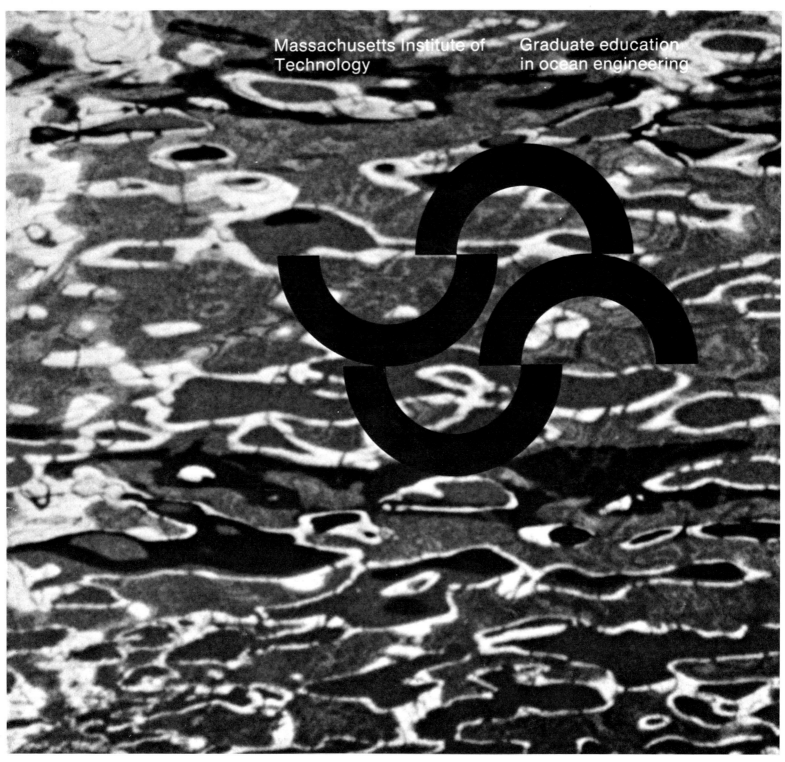

Massachusetts Institute of Technology

Graduate education in ocean engineering

Examples of ocean engineering research at M.I.T. are:

Department of Naval Architecture and Marine Engineering
Research related to the graduate ocean engineering program deals with the hydrodynamic aspects of the motion control of deep submergence rescue vehicles, motion reduction and position keeping of stationary surfaced ocean vehicles, application of parametric design techniques to the structural design of unusual hull forms, stress analyses for waterborne vehicles, experimental and theoretical research on gravity waves, aeolian tones associated with resonant vibrations, and acoustic radiation from panels excited by turbulent pressure fluctuations.

Department of Civil Engineering
The Hydrodynamics and Water Resources Division carries out extensive research in coastal engineering. Examples are: beach erosion, shoaling, pollution and wave damping in harbors, wave breaking in shallow water, dynamic effect of waves on structures, tidal dynamics in estuaries, and sea level canals. Research in other divisions of this department is concerned with deep ocean installations, bottom soil mechanics, materials, structures, and power plants.

Department of Metallurgy and Materials Sciences
Research is carried out on corrosion of metals, welding and joining processes, brittle fracture of metals, development of high strength alloys, effects of high pressure on polymer crystallization. Research is also carried out in chemical metallurgy which could have a bearing on metal extraction from underwater deposits.

Department of Nuclear Engineering
This department is engaged in research on nuclear power sources for application to ships and underwater bottom installations, as well as the wide range of small power sources needed for instrumentation purposes.

Department of Mechanical Engineering
Research in engineering mechanics of interest for ocean engineering includes problems in vibrations, acoustics, and materials. In addition, this department carries out research in power generation and power plants.

Department of Electrical Engineering
Examples of research related to ocean engineering are deep ocean instrumentation, underwater communications, and underwater photography techniques.

Brochure:
Graduate Education in Ocean Engineering, 1967
Designer:
Dietmar Winkler
M.I.T. Design Services

The Cover Show

Covers are a graphic constant in all of our lives: magazine covers, book covers, record jackets, catalogs and direct mail, newspaper front pages provide a continual flow of constantly changing visual information that hopes to tell us in shouts and subtleties about our times, our tastes, our priorities.

Chairman
Seymour Chwast
President
Push Pin Studios

Jury
Ron Coro
Art Director
Elektra/Asylum Records

Diana Graham
Designer and Principal
Gips + Balkind + Associates

Rudolph Hoglund
Art Director
Time, Inc.

Harris Lewine
Art Director, Writer

Richard Mantel
Designer, Illustrator

James McMullan
Illustrator, Writer

Lanny Sommese
Designer, Professor of Graphic Design
Pennsylvania State University

Two years' worth of covers of all kinds were examined in AIGA's 1981 Cover Show, a tradition of the Institute that dates back more than a half century. In a way, a design competition of just covers is an exercise artificial in the extreme. Insides are decisively excluded. Covers—alone—were examined as design, abstract and oddly vulnerable without the reassuring weight and heft of whatever they were formerly covers *of.* Here was theoretical graphic design near its most theoretical: pinioned firmly in two dimensions, surgically removed from a normal environment, weighed and measured pitilessly as nothing but itself.

Unfair? Evaluating excellence in graphic design this way is a little reminiscent of the relationship in mathematics between one of the beautiful, esoteric, highly theoretical fields—say, Boolean algebra—and the rote-learned multiplication tables. The abstract algebra can tell us more about numbers and the way we think about them, and with them, than the mechanical multiplication tables, although the tables themselves are all numbers and, in the algebra, the numbers are distinctly secondary characters.

Besides, the daily, weekly, monthly evolution in cover design is arguably the public's main contact with what's happening in graphic design, although the public is almost certainly not aware of that. So what's good in covers tells the world what's good in graphic design. Most of the cover designs submitted were found wanting: 134 were selected from a submission of about 2,900.

In its thinking and reactions, the jury seemed deeply and seriously oriented toward the basics. The judges searched rigorously for graphic ideas of high quality that were expressed with integrity and cohesion among all elements of their execution. Flash, trash, razzle-dazzle, and shallow, tour-de-force manipulation could not masquerade as quality: hot-stamping in silver or gold, embossing, black-on-black, die-cutting, and other print production extravaganzas were discarded. Kept were covers with simple (not easy) images handled well, all elements thought through and under control, graphics on a traditional flat surface: let the *idea* speak.

Letting the core idea speak well in the demanding environment of a cover is a task whose difficulty is inversely proportional to the amount of physical space within which the designer must work. Anything larger than $8\frac{3}{16}'' \times 10\frac{7}{8}''$ for a magazine cover designer, or larger than $6\frac{1}{2}'' \times 9\frac{1}{4}''$ for a book jacket designer, must look like an inviting, empty football field of room in which to exercise the imagination and craft. Add to the typical limitation of space the requirements of title, author, image, color and, in the case of magazines, the requirements of the issue date, newsstand price, second and third story titles, any consistent graphic element (*Time*'s red-and-white frame, for instance), and last, but not least, the digits and bars of the UPC. No wonder the Covers '81 jury placed such a premium on demonstrated ability to handle and coordinate photographic, typographic, and handgraphic elements well.

You hear a lot about the commercial demands placed on covers: magazines that live or die on newsstand success, books that make it or break it in bookstore sales and book clubs. Not necessarily. *Time* sells 20 copies by subscription for every one off the stand. When was the last time anyone bought a book *only* because of the design of the jacket? Or a recording *only* because of the design on the album cover? Or a newspaper because of the look and layout of its front page? No, a cover is something other than, and something more than, just an advertisement for whatever lies behind it.

Perhaps a cover is a one-shot, visual/verbal distillation of a creative response to content, a response (you hope) to be triggered in other people, as well. Maybe that's too much. Maybe a cover is simply what comes first. And as the torrent of information available to us continues to swell, we're forced to place greater and greater credence in symbols. Covers: symbols of content. Now *there's* power in graphic design.

The heavy preponderance of illustration seen in the Covers '81 selection suggests that covers may be symbolic of content, yes, but symbolic of a couple of other things, as well. The first is called "editorialization," or the function of many covers—especially those of the popular magazines—to establish an immediate context or point of view. While it is true that the use of photographic images does involve interpretation (in selection and so forth), an illustration takes the interpretive function several steps further. Here are handmade images that do more than portray a personage, an event, or an object. They also unequivocally communicate value judgment. The second observation, obviously related to the first, is the notion of hyperreality in illustration. An illustration is not a "real" depiction, but a highly imaginative construct. Yet, paradoxically, it can be more "real"—in terms of its impact on the human eye and mind—than any photograph. And if you reflect for a moment on the cruel fact that print these days must compete with television, you have to conclude that print cannot possibly count on or match the real-time verisimilitude of television to be noticed and to communicate. Print, then, must rely on images that touch emotion through the imagination of a creative translator, and that often suggests illustration. You sense a fellow human being there, something more than a camera and a microphone. Human beings respond to symbols. The rich mix of ideas that simultaneously lies behind and radiates from a superbly realized and crafted visual symbol like a cover gives something special to the public, the graphic designer, and graphic design.

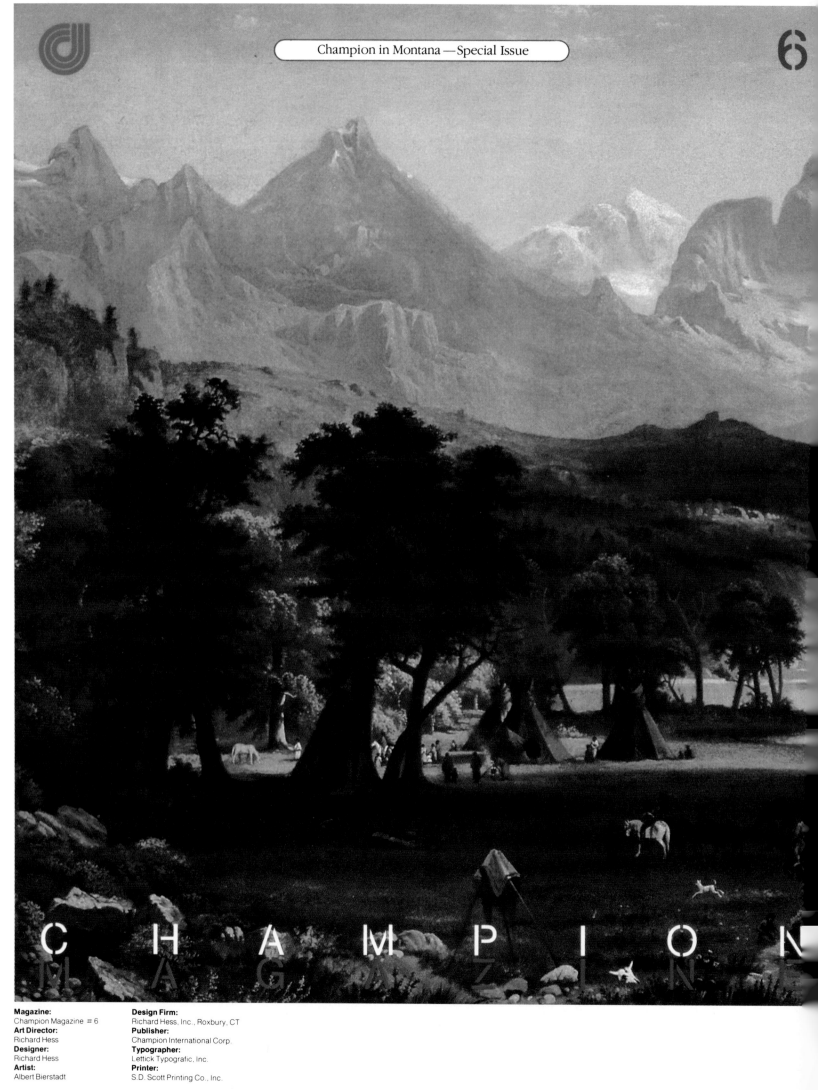

CHAMPION
MAGAZINE

Magazine:
Champion Magazine ⧺6
Art Director:
Richard Hess
Designer:
Richard Hess
Artist:
Albert Bierstadt

Design Firm:
Richard Hess, Inc., Roxbury, CT
Publisher:
Champion International Corp.
Typographer:
Lettick Typografic, Inc.
Printer:
S.D. Scott Printing Co., Inc.

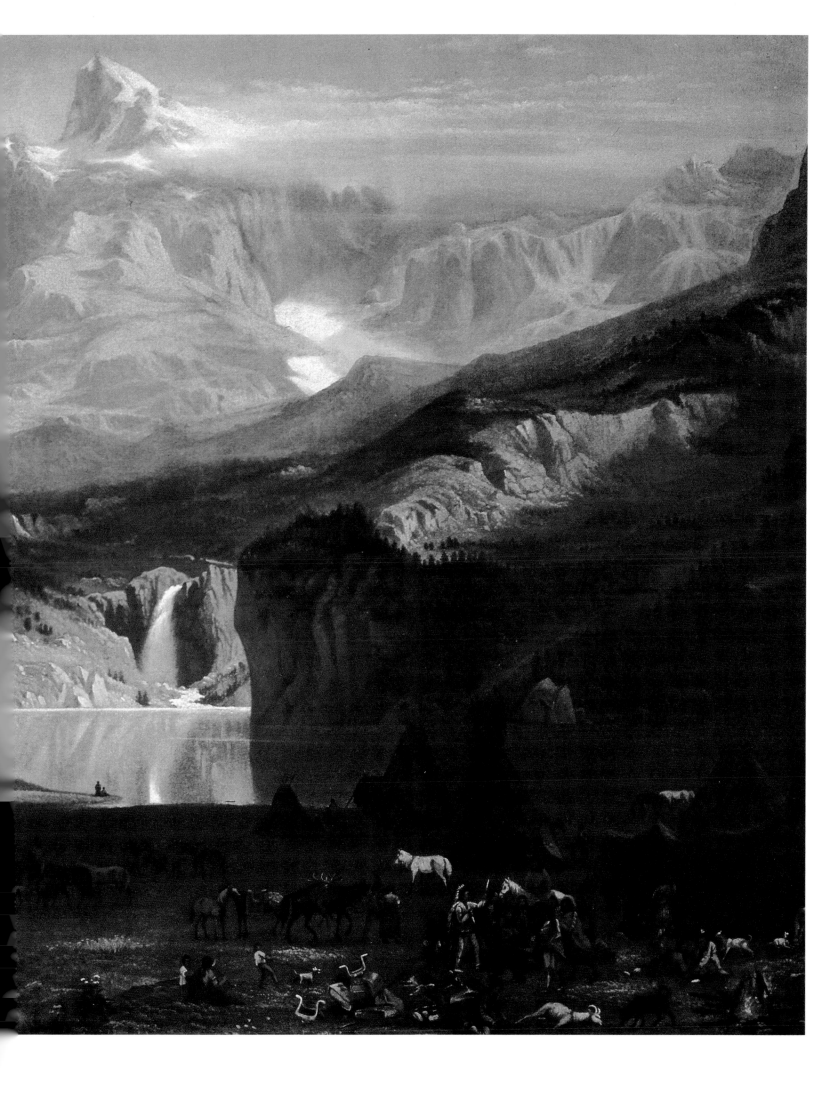

This is <u>not</u> a proposal for just another television documentary about:

S⟂ra\/insky

Corporate Literature:
Stravinsky
Art Director:
Tom Sumida
Designer:
Tom Sumida
Design Firm:
WGBH Design Dept.,
Boston, MA
Publisher:
WGBH Educational Foundation
Typographer:
Wrightson Typographers
Printer:
Artco Offset

Record Album:
Chicago
Art Director:
John Berg
Designer:
John Berg
Artist:
Gerard Huerta
Publisher:
CBS Records, New York, NY
Typographer:
Haber Typographers
Printer:
Shorewood Packaging Corp.

Corporate Literature:
Leonard Street and Deinard
Art Director:
Eric Madsen
Designer:
Eric Madsen
Artist:
Eric Madsen
Design Firm:
Frink Casey & Madsen, Inc.,
Minneapolis, MN
Client:
Leonard Street and Deinard
Typographer:
Dahl & Curry
Printer:
Litho Specialties

Book Jacket:
Covering Islam
Art Director:
Louise Fili
Designer:
Paul Gamarello
Photography:
Courtesy Sygma
Design Firm:
Eyetooth Design, Inc.,
New York, NY
Publisher:
Random House, Inc.
Typographer:
Haber Typographers
Printer:
The Longacre Press

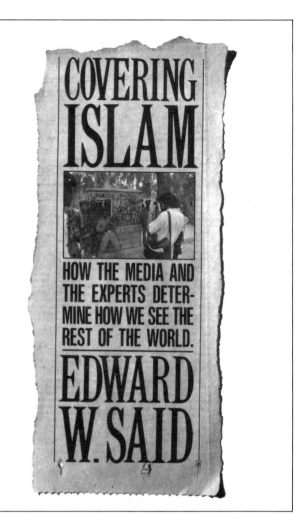

Annual Report:
Olympia Brewing Company
Annual Report 1980
Art Director:
Gary LaComa
Designer:
Cathy Smith
Photographer:
Fred Milkie, Jr.
Design Firm:
David Strong Design Group,
Seattle, WA
Client:
Olympia Brewing Co.
Typographer:
Thomas & Kennedy
Printer:
United Graphics, Inc.

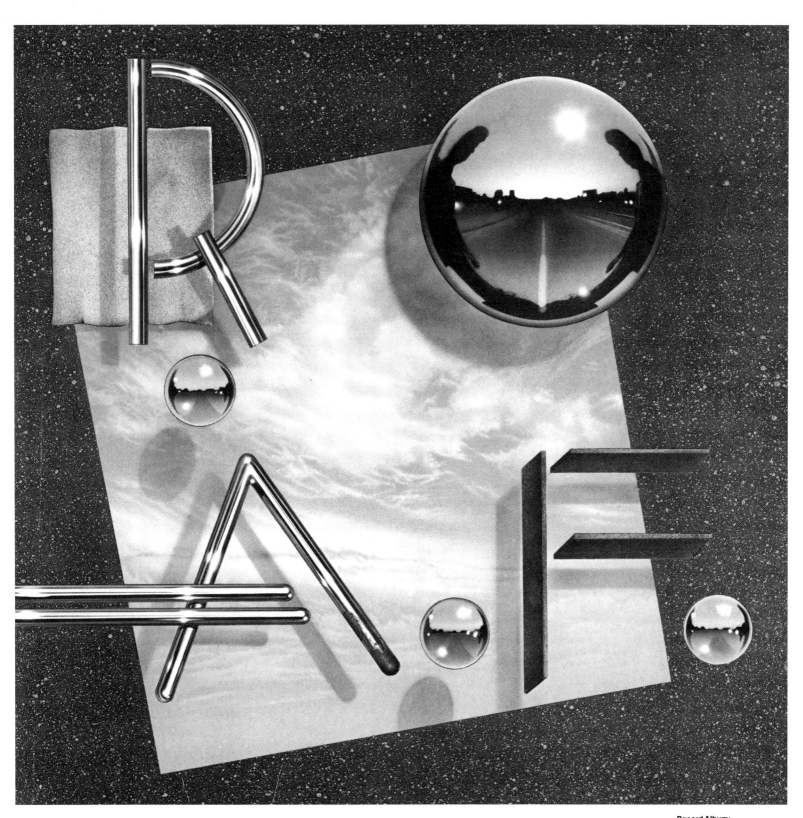

Record Album:
R.A.F.
Art Director:
Chuck Beeson
Designer:
Willardson & White
Artist:
Charles White III
Design Firm:
Willardson & White,
Los Angeles, CA
Publisher:
A & M Records, Inc.

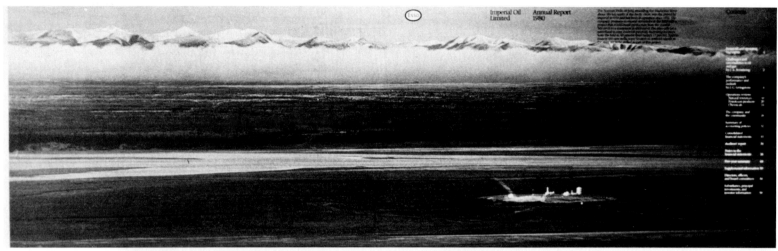

Annual Report:
Imperial Oil Limited
Annual Report 1980
Art Director:
Robert Burns
Designer:
Scott Taylor
Photographer:
Peter Christopher
Design Firm:
Burns, Cooper, Hynes Ltd.,
Toronto, CAN
Client:
Imperial Oil Ltd.
Printer:
Arthur Jones Lithography

Book Cover:
1982
Art Director:
Charles White III
Designer:
Christopher Hopkins
Artist:
Christopher Hopkins
Design Firm:
Willardson & White,
Los Angeles, CA
Publisher:
Margarethe Hubauer

FIRE JOURNAL

March 1980

Magazine:
Fire Journal, March 1980
Art Director:
Paul Teague
Designer:
Nina Pattek
Artist:
Nina Pattek
Design Firm:
Pattek Assoc., Newton, MA
Publisher:
National Fire Protection Assoc.
Typographer:
Typographic House
Printer:
Fidelity Co.

Newspaper:
The New York Times Magazine
February 15, 1981
Art Director:
Ruth Ansel
Designer:
Ruth Ansel
Photographer:
Unknown
Publisher:
The New York Times,
New York, NY
Printer:
The New York Times

The New York Times Magazine

THE PRIVATE
HEMINGWAY

From His
Unpublished
Letters
1918 to 1961

ED KOCH

The Man
Behind
The Mayor

By William H. Honan

Newspaper:
The New York Times Magazine
February 1, 1981
Art Director:
Ruth Ansel
Designer:
Ruth Ansel
Artist:
Robert Grossman
Publisher:
The New York Times,
New York, NY
Printer:
The New York Times

Newspaper:
The New York Times Magazine
August 9, 1981
Art Director:
Ruth Ansel
Designer:
Charles Churchward
Artist:
Robert Grossman
Publisher:
The New York Times,
New York, NY
Printer:
The New York Times

The New York Times Magazine

AUGUST 9, 1981/SECTION 6

COPING WITH CONGRESS

By Hedrick Smith

TIME

Embattled Britain

Prime Minister Thatcher

"We Have to Face the Truth"

Magazine:
Time, February 16, 1981
Art Directors:
Rudolph Hoglund,
Nigel Holmes
Artist:
David Suter
Publisher:
Time, Inc., New York, NY

Magazine:
Time, January 7, 1980
Art Directors:
Rudolph Hoglund,
Walter Bernard
Artist:
Brad Holland
Publisher:
Time, Inc., New York, NY

TIME

The Empire Strikes Back!

STAR WARS

Archvillain Darth Vader

M. Arisman

Magazine:
Time, May 19, 1980
Art Director:
Walter Bernard
Artist:
Marshall Arisman
Publisher:
Time, Inc., New York, NY

Magazine:
Push Pin Graphic Number 86
Art Director:
Seymour Chwast
Designer:
Richard Mantel
Artist:
John O'Leary
Design Firm:
Push Pin Studios, Inc.,
New York, NY
Publisher:
Push Pin Graphic
Typographer:
Haber Typographers
Printer:
Metropolitan Printing Service

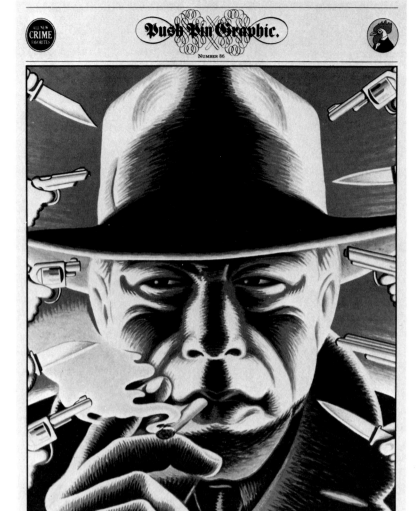

Magazine:
Forbes, December 10, 1979
Art Director:
Everett Halvorsen
Artist:
Seymour Chwast
Design Firm:
Push Pin Studios, Inc.,
New York, NY
Publisher:
Forbes, Inc.

TIME

Soviet Muscle In Asia

THE CURSE OF VIOLENT CRIME

Magazine:
Time, March 23, 1981
Art Director:
Rudolph Hoglund
Artist:
Marshall Arisman
Publisher:
Time, Inc., New York, NY

Program Cover:
CPFA/1979
Art Director:
Lanny Sommese
Designer:
Lanny Sommese
Artist:
Lanny Sommese
Design Firm:
Lanny Sommese Design,
State College, PA
Publisher:
Central Pennsylvania
Festival of the Arts
Typographer:
Commercial Printing Co.
Printer:
Commercial Printing Co.

THE 13TH ANNUAL CENTRAL PENNSYLVANIA FESTIVAL OF THE ARTS, JULY 11-15, DOWNTOWN STATE COLLEGE & THE PENN STATE CAMPUS

COMEDY UNDER COVER

Corporate Literature:
Comedy under Cover
Art Director:
Gaye Korbet
Designer:
Gaye Korbet
Photographer:
James Scherer
Design Firm:
WGBH Design Dept.,
Boston, MA
Publisher:
WGBH Educational Foundation
Printer:
Artco Offset

Magazine:
Time, December 17, 1979
Art Director:
Walter Bernard
Artist:
Gary Panter
Publisher:
Time, Inc., New York, NY

ELVIS

ELVIS BY ALBERT GOLDMAN

Book Jacket:
Elvis
Art Director:
Robert Mitchell
Designer:
Milton Glaser
Artist:
Milton Glaser
Design Firm:
Milton Glaser, Inc.,
New York, NY
Publisher:
McGraw-Hill Book Co.
Printer:
Algen Press

Record Album:
The Doolittle Band:
What Were You Thinking Of?
Art Director:
Carin Goldberg
Designer:
Carin Goldberg, New York, NY
Publisher:
CBS Records
Typographer:
Haber Typographers
Printer:
Shorewood Packaging Corp.

Record Album:
The Romeos
Art Director:
Nancy Donald
Designer:
Nancy Donald, Los Angeles, CA
Publisher:
CBS Records
Typographer:
Andresen Typographics
Printer:
Shorewood Packaging Corp.

Magazine:
Time, May 11, 1981
Art Director:
Rudolph Hoglund
Artist:
Richard Hess
Publisher:
Time, Inc., New York, NY

TIME

BASEBALL '81
It's Incredible!

LEBANON
High-Risk
Conflict

OAKLAND'S BILLY MARTIN

MYSTERY! PRESENTS A NEW SEASON OF
RUMPOLE OF THE BAILEY

Corporate Literature:
Rumpole of the Bailey
Art Director:
Sandra Ruch
Designer:
Seymour Chwast
Design Firm:
Push Pin Studios, New York, NY
Publisher:
Mobil Oil Corp.
Typographer:
Haber Typographers
Printer:
Crafton Graphic Co., Inc.

HERBIE MANN • GERRY MULLIGAN • EARLE WARREN JAY McSHANN THE BIG APPLE BASH DOC CHEATHAM • DICKY WELLS • JOHN SCOFIELD
EDDIE GOMEZ • MILT HINTON • JACK SIX • CONNIE KAY JOE MORELLO • SAMMY FIGUEROA • JANIS SIEGEL

SD 8804

Record Album:
Jay McShann: The Big Apple
Bash
Art Director:
Lynn Dreese Breslin
Designer:
Lynn Dreese Breslin
Artist:
Mark Hess
Publisher:
Atlantic Records Corp.,
New York, NY
Typographer:
Haber Typographers
Printer:
Album Graphics, Inc.

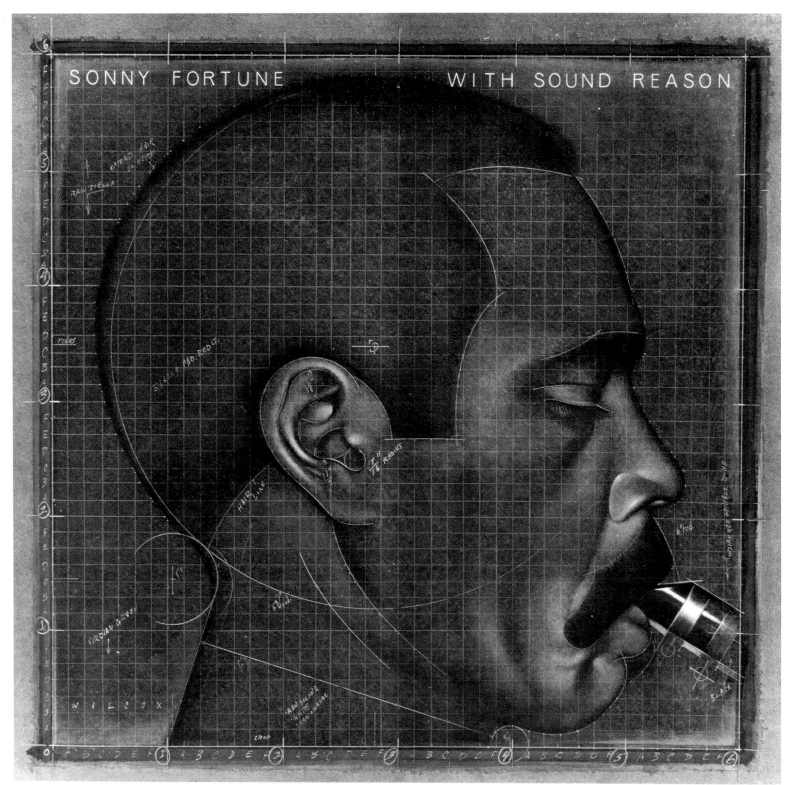

Record Album:
Sonny Fortune: With Sound
Reason
Art Director:
Lynn Dreese Breslin
Designer:
Lynn Dreese Breslin
Artist:
David Wilcox
Publisher:
Atlantic Records Corp.,
New York, NY
Typographer:
Haber Typographers
Printer:
Album Graphics, Inc.

Record Album:
The Modern Jazz Sextet
Art Director:
Katherine Smith
Artist:
Brad Holland
Agency:
Album Graphics, Inc.
Publisher:
Polydor, Inc., New York, NY

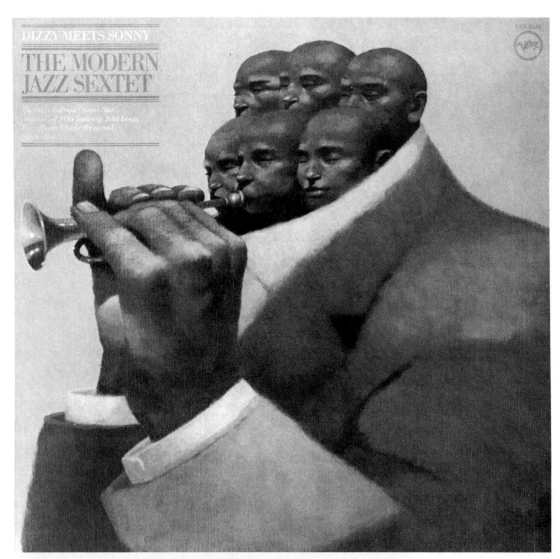

Magazine:
The Boston Monthly, June 1981
Art Director:
Mary Barrett
Designer:
Michael Grossman
Artist:
Oren Sherman
Publisher:
The Boston Monthly,
Boston, MA
Typographer:
The Berkley Monthly
Printer:
Charles River Publishing Co.

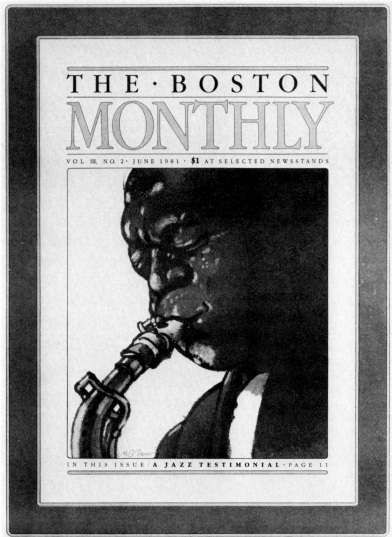

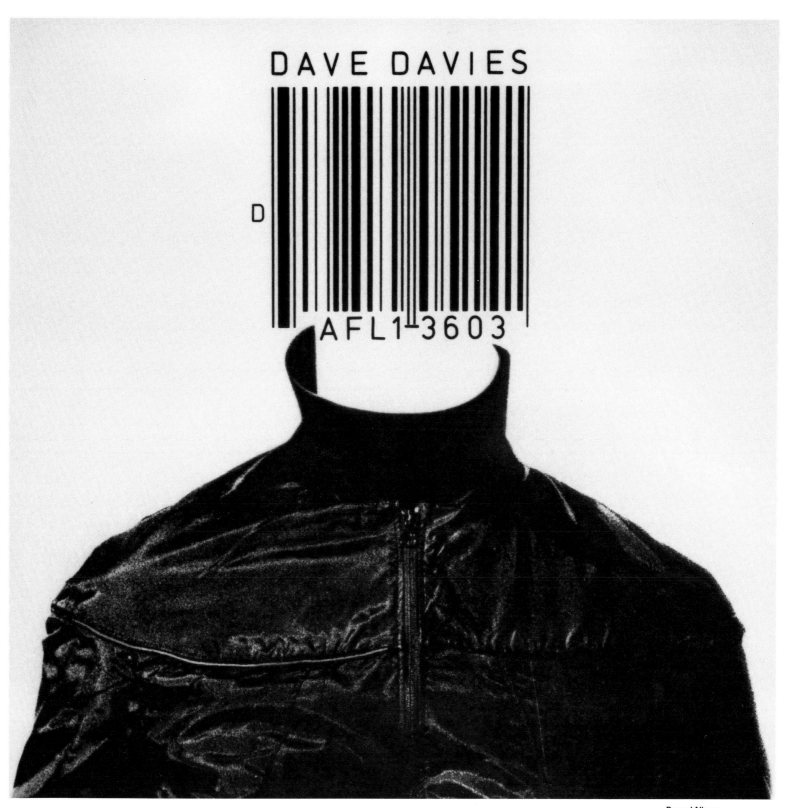

Record Album:
Dave Davies
Art Director:
Joseph Stelmach
Photographer:
Nick Sangiamo
Publisher:
RCA Records, New York, NY
Typographer:
Images
Printer:
Ivy Hill Lithograph Corp.

Record Album:
Ironhorse: Everything Is Grey
Art Director:
Bob Defrin
Designer:
Bob Defrin, New York, NY
Artist:
Braldt Bralds
Publisher:
Scotti Brothers Records
Typographer:
Typographic Images, Inc.
Printer:
Candid Litho Co.

闇逢 闇逢 闇逢 闇逢 闇逢 闇逢 闇逢 闇逢 闇逢 闇逢

BXL 1-3403

Record Album:
Blind Date
Art Director:
Tim Bryant
Designer:
Tim Bryant
Photographer:
Eliot Gilbert
Design Firm:
Gribbitt, Ltd., Los Angeles, CA
Publisher:
Windsong / RCA
Typographer:
Phototype-House
Printer:
Ivy Hill Lithograph Corp.

Record Album:
Ian Gomm: What a Blow
Art Director:
Paula Scher
Designer:
Paula Scher
Publisher:
CBS Records, New York, NY
Typographer:
Haber Typographers
Printer:
Shorewood Packaging Corp.

SUMMER 1981

Corporate Literature:
Adult Video Cassette Catalog
Art Director:
Christopher Garland
Designer:
Christopher Garland
Artist:
Paul Moch
Design Firm:
Xeno, Chicago, IL
Publisher:
Sound Unlimited
Typographer:
Master Typographers
Printer:
Southwest Press

Magazine:
Push Pin Graphic Number 79
Art Director:
Seymour Chwast
Designer:
Richard Mantel
Artists:
Seymour Chwast,
Richard Mantel
Design Firm:
Push Pin Studios, Inc.,
New York, NY
Publisher:
Push Pin Graphic
Typographer:
Haber Typographers
Printer:
Metropolitan Printing Service

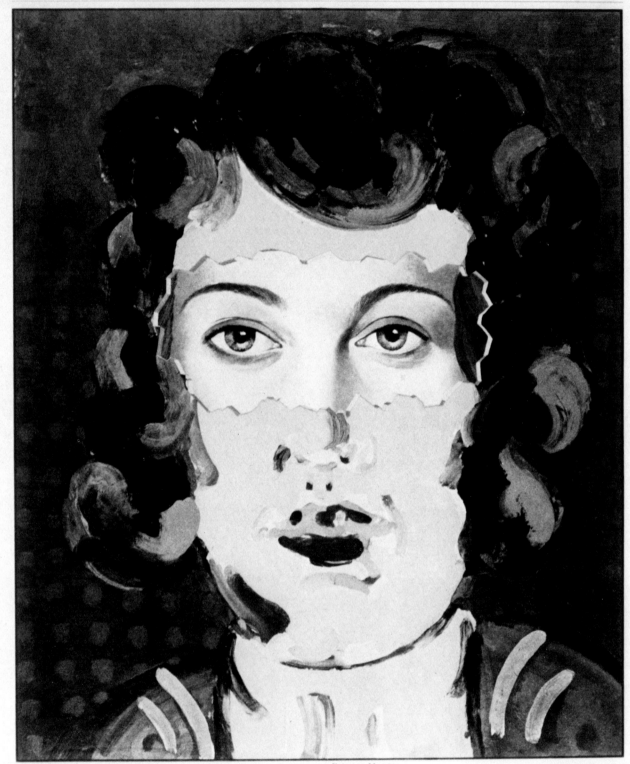

ISAAC STERN
THE CLASSIC MELODIES OF JAPAN
HOZAN YAMAMOTO
SHAKUHACHI

ENSEMBLE NIPPONIA

MASTER
WORKS
CBS
35872

Record Album:
Isaac Stern:
The Classic Melodies of Japan
Art Director:
Henrietta Condak
Designer:
Henrietta Condak
Artist:
Barbara Nessim
Publisher:
CBS Records, New York, NY
Typographer:
Haber Typographers
Printer:
Shorewood Packaging Corp.

Magazine:
TV Guide, April 4-10, 1981
Art Director:
Jerry Alten
Designer:
David Wilcox, Jerry Alten
Artist:
David Wilcox
Publisher:
TV Guide Magazine, Radnor, PA

Newspaper:
The Boston Globe Magazine
October 19, 1980
Art Director:
Ron Campisi
Designer:
Ron Campisi
Artist:
Mark Fisher
Publisher:
Globe Newspaper Co.,
Boston, MA
Typographer:
Headliners of Boston
Printer:
Providence Gravure Co.

Book Cover:
L.A. Workbook
Art Director:
Craig Butler
Designer:
Betsy Rodden
Photographers:
Rick Wolin-Semple,
Lee Bowers
Publisher:
L.A. Workbook,
Los Angeles, CA
Typographer:
Skill-Set Typographers
Printer:
George Rice & Sons

Book Jacket:
Illuminations
Art Director:
Louise Fili
Designer:
Fred Marcellino
Artist:
Fred Marcellino
Publisher:
Pantheon Books, New York, NY
Typographer:
TGI/Typographic Innovations,
Inc.
Printer:
The Longacre Press

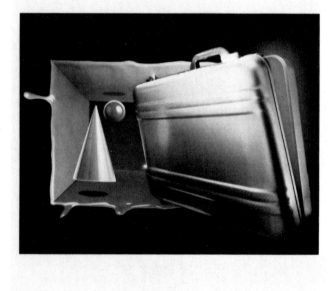

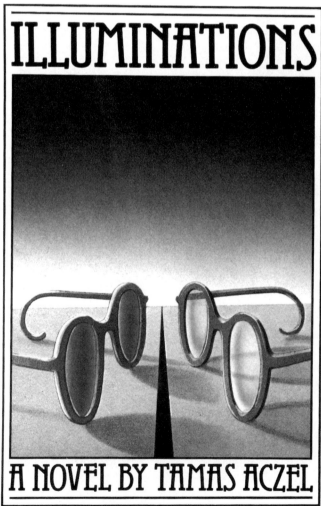

FETISH

The Magazine of the Material World

Spring 1981

MADE IN JAPAN

Motorcycles Kansai
Oriental pinball

$3.00
SPECIAL ISSUE Bunraku puppets Love Hotels Godzilla

MADE IN JAPAN

Magazine:
Fetish, Spring 1981
Art Directors:
Jane Kosstrin,
David Sterling
Photographer:
Jere Cockrell
Design Firm:
Doublespace, Inc.
Publisher:
Fetish: The Magazine of the
Material World, New York, NY
Typographer:
Gendell Graphics, Inc.
Printer:
Wilcox Press

Calendar Cover:
TWOS/The Museum of Modern
Art Calendar 1982
Art Director:
Tony Drobinski
Designer:
Nora Sheehan
Artists & Photographers:
Various
Publisher:
The Museum of Modern Art,
New York, NY
Typographer:
Custom Composition, Inc.
Printer:
The Arts Publisher, Inc.

TWOS/THE MUSEUM OF MODERN ART CALENDAR/1982

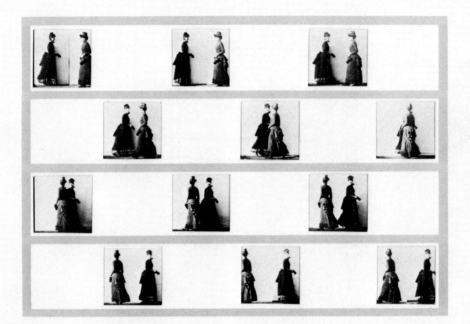

TWOS/THE MUSEUM OF MODERN ART CALENDAR/1982

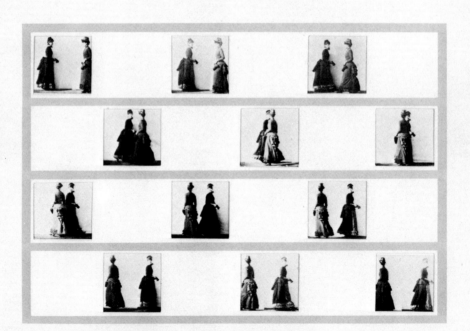

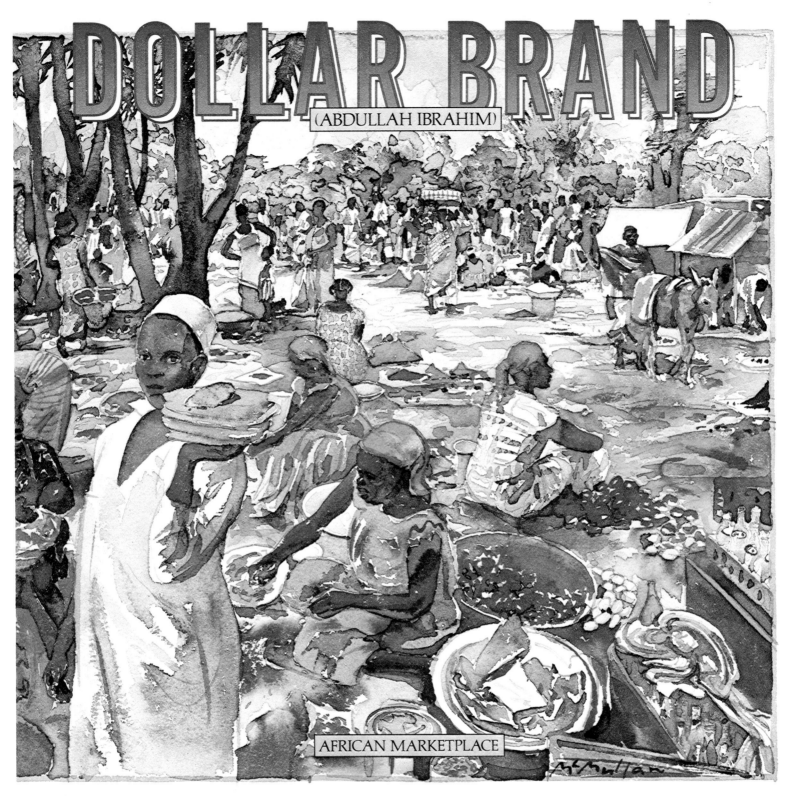

DOLLAR BRAND
(ABDULLAH IBRAHIM)

AFRICAN MARKETPLACE

Record Album:
Dollar Brand
Art Directors:
Ron Coro, Johnny Lee
Designers:
Ron Coro, Johnny Lee
Artist:
James McMullan
Design Firm:
Visible Studio, Inc.
Publisher:
Elektra/Asylum/Nonesuch
Records, Los Angeles, CA
Typographer:
Andresen Typographics
Printer:
Queens Lithographing Corp.

Annual Report:
The E.F. Hutton Group, Inc.
Annual Report 1980
Art Director:
Robin Davis
Designer:
Robin Davis
Photographer:
Cheryl Rossum
Design Firm:
E.F. Hutton, New York, NY
Publisher:
The E.F. Hutton Group
Typographer:
M.J. Baumwell Typography
Printer:
Rapaport Printing Co.

THE E.F. HUTTON GROUP INC. ANNUAL REPORT 1980

"Hutton's 77 years of uninterrupted profits are unmatched in the securities industry."

昭和55年7月1日発行・第28巻・第4号・通巻161号(隔月1日発行)昭和28年6月17日・国鉄東局特別扱承認雑誌〔第2566号〕

IDEA161/1980.7

International Advertising Art ★ 世界のデザイン誌 ★ 誠文堂新光社

Magazine:
Idea: 161
Art Director:
Yoshihisa Ishihara
Artist:
Elwood Smith
Design Firm:
Push Pin Studios, Inc.,
New York, NY
Publisher:
Seibundo Shinkosha
Printer:
Nishiki Printing Co., Ltd.

Newspaper:
The Plain Dealer Magazine,
October 26, 1980
Art Director:
Greg Paul
Designer:
Greg Paul
Artist:
Mark Andresen
Publisher:
The Plain Dealer Publishing Co.,
Cleveland, OH
Printer:
Art Gravure, Inc.

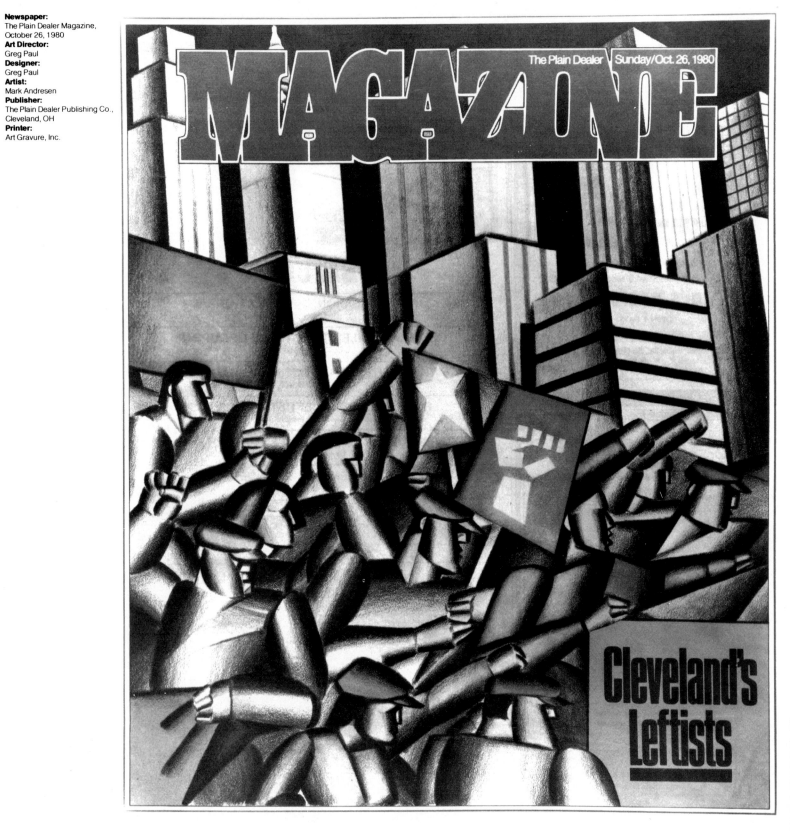

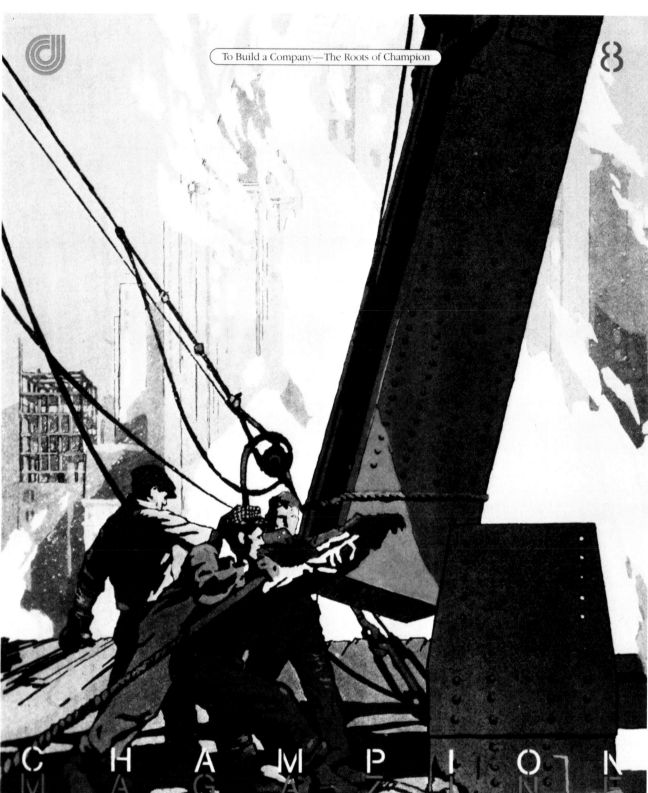

CHAMPION
MAGAZINE

Magazine:
Champion Magazine # 8
Art Director:
Richard Hess
Designer:
Richard Hess
Design Firm:
Richard Hess Design, Inc.,
Roxbury, CT
Publisher:
Champion International Corp.
Typographer:
Set to Fit
Printer:
Case-Hoyt Corp.

Magazine:
Boraxx
Art Director:
Christopher Garland
Designer:
Christopher Garland
Photographer:
Natasha Falda-Robert
Design Firm:
Xeno, Chicago, IL
Publisher:
McDavitz Publishing
Typographer:
Xeno Type
Printer:
Newsweb Corp.

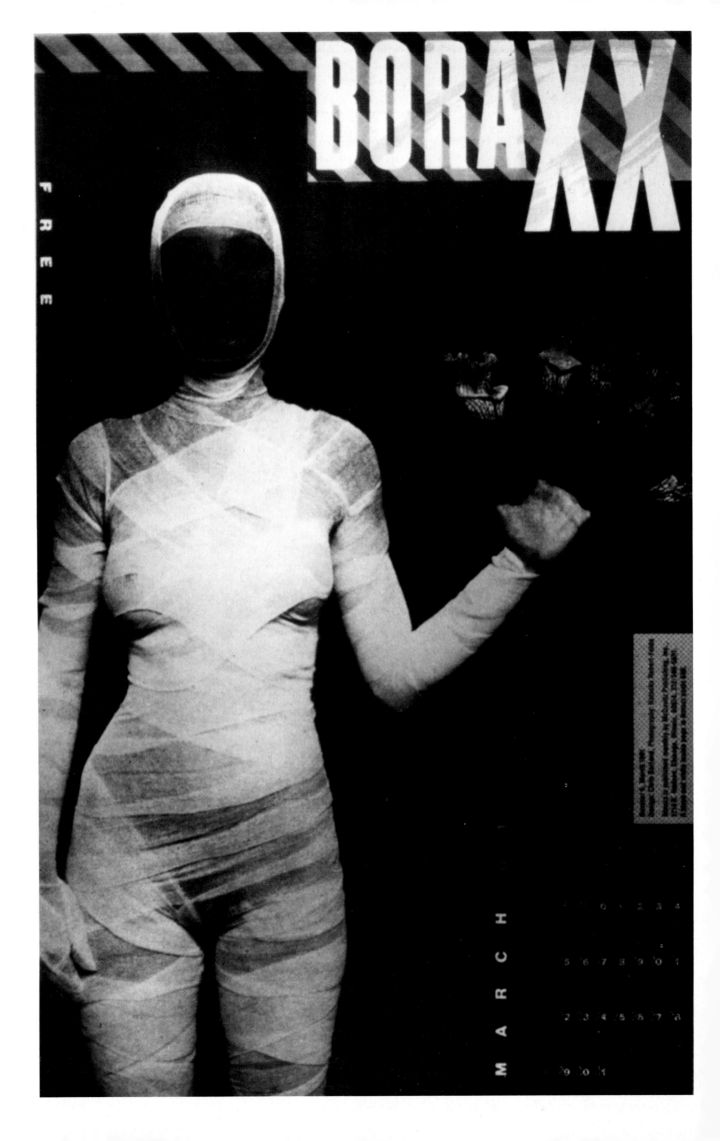

122

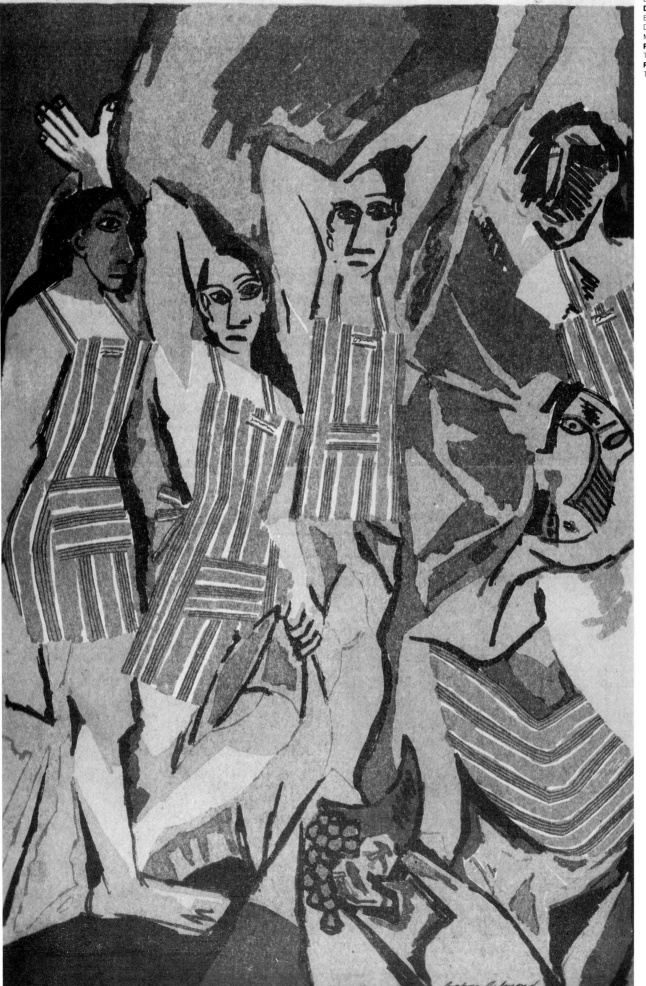

Newspaper:
Taste / For Women Only
The Minneapolis Star
February 20, 1980
Art Director:
Barbara Redmond
Designer:
Barbara Redmond
Artist:
Barbara Redmond
Design Firm:
Barbara & Patrick Redmond,
Design, Inc.
Minneapolis, MN
Publisher:
The Minneapolis Star
Printer:
The Minneapolis Star

Magazine:
National Lampoon, July 1981
Art Director:
Skip Johnston
Designer:
Skip Johnston
Photographers:
Aerographics/Dean Janoff,
Richie Williamson
Publisher:
National Lampoon,
New York, NY

Magazine:
Rolling Stone, January 22, 1981
Art Directors:
Mary Shanahan, Bea Feitler
Photographer:
Annie Leibovitz
Publisher:
Straight Arrow Publishers,
New York, NY
Printer:
Mid-America Printing Co.

Corporate Literature:
Ivy School of Professional Art
Art Director:
Dennis P. Moran
Designers:
Ellen Bernstein,
Dennis P. Moran
Artists:
Nancy Gray, Frank Sparrow,
Joe Georg
Photographer:
M. Perrot
Design Firm:
Adam, Filippo & Moran,
Pittsburgh, PA
Client:
Ivy School of Professional Art
Typographer:
Cold Comp
Printer:
Superior Printing Co.

IVY SCHOOL OF PROFESSIONAL ART

Book Jacket:
Big Bob
Art Director:
Rubin Pfeffer
Designer:
Bascove, New York, NY
Artist:
Bascove
Publisher:
Harcourt Brace Jovanovich, Inc.
Printer:
New England Book
Components

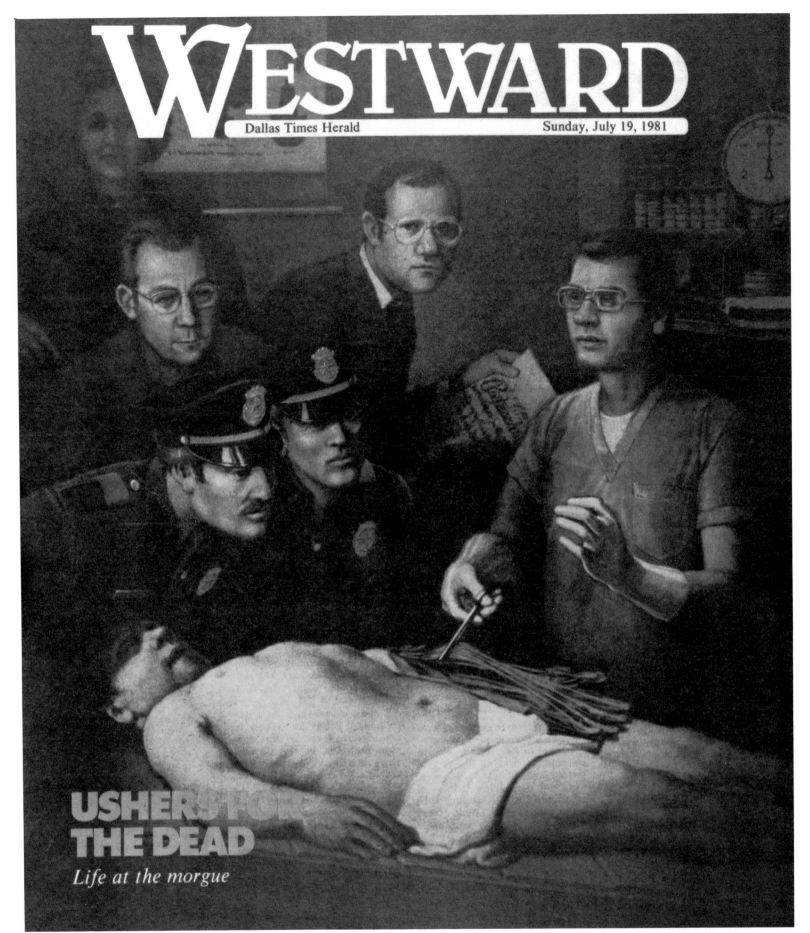

WESTWARD

Dallas Times Herald

Sunday, July 19, 1981

USHERS FOR THE DEAD

Life at the morgue

Newspaper:
Westward: Dallas Times Herald
July 19, 1981
Art Director:
James Noel Smith
Artist:
Stephen Pietzsch
Publisher:
Dallas Times Herald, Dallas, TX

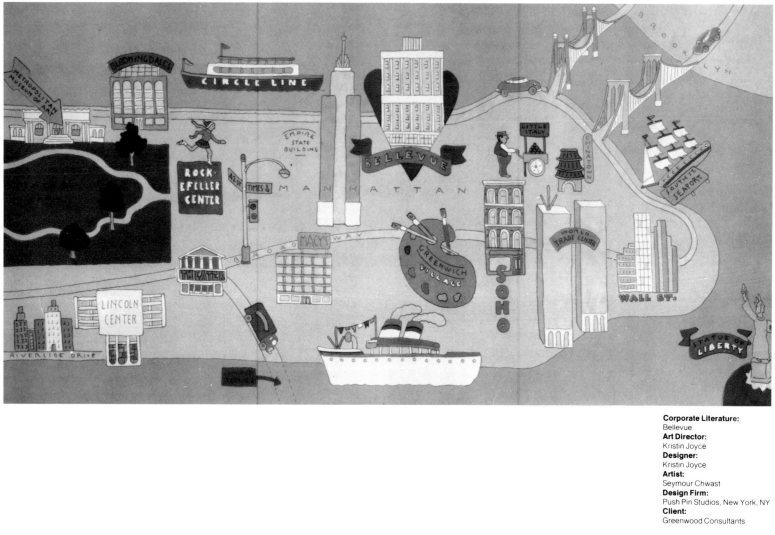

Corporate Literature:
Bellevue
Art Director:
Kristin Joyce
Designer:
Kristin Joyce
Artist:
Seymour Chwast
Design Firm:
Push Pin Studios, New York, NY
Client:
Greenwood Consultants

Paperback:
The Innocence of Dreams
Art Director:
Louise Fili
Designer:
Louise Fili
Photographer:
Rene Groebli
Publisher:
Pantheon Books, New York, NY
Typographer:
Haber Typographers
Printer:
The Longacre Press

THE INNOCENCE OF DREAMS

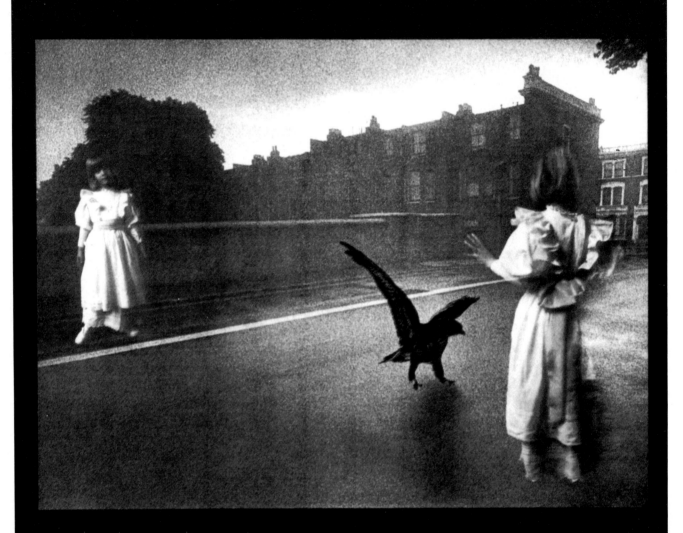

A NEW APPROACH TO THE STUDY OF DREAMS
BY CHARLES RYCROFT

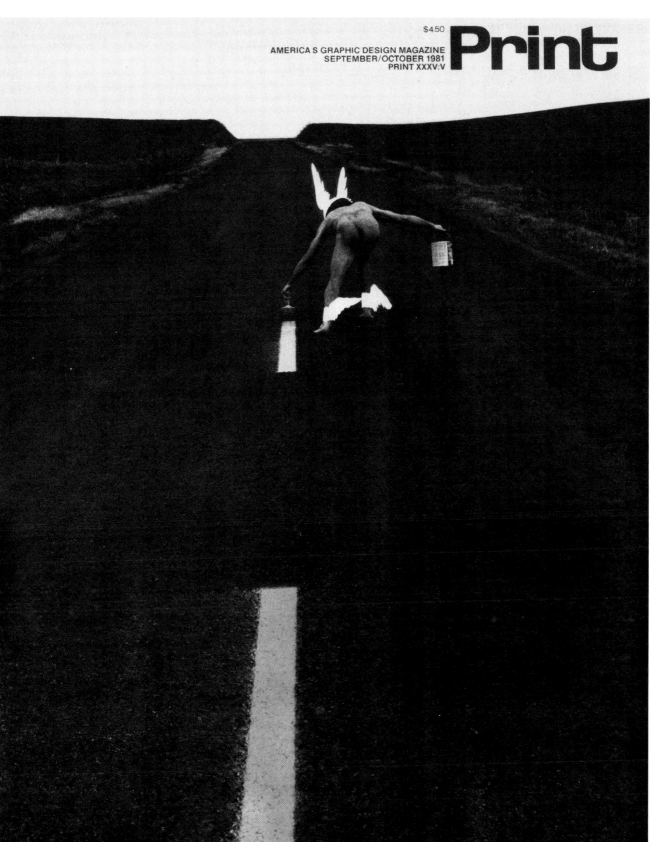

$4.50

AMERICA'S GRAPHIC DESIGN MAGAZINE
SEPTEMBER/OCTOBER 1981
PRINT XXXV:V

Print

Magazine:
Print, September/October 1981
Art Director:
Andrew Kner
Designer:
Kalvyn Hinatsu
Publisher:
R.C. Publishing Co.,
New York, NY
Typographer:
Type Trends, Inc.
Printer:
Lucas Litho, Inc.

Magazine:
Print, September/October 1981
Art Director:
Andrew Kner
Designer:
Kalvyn Hinatsu
Publisher:
R.C. Publishing Co.,
New York, NY
Typographer:
Type Trends, Inc.
Printer:
Lucas Litho, Inc.

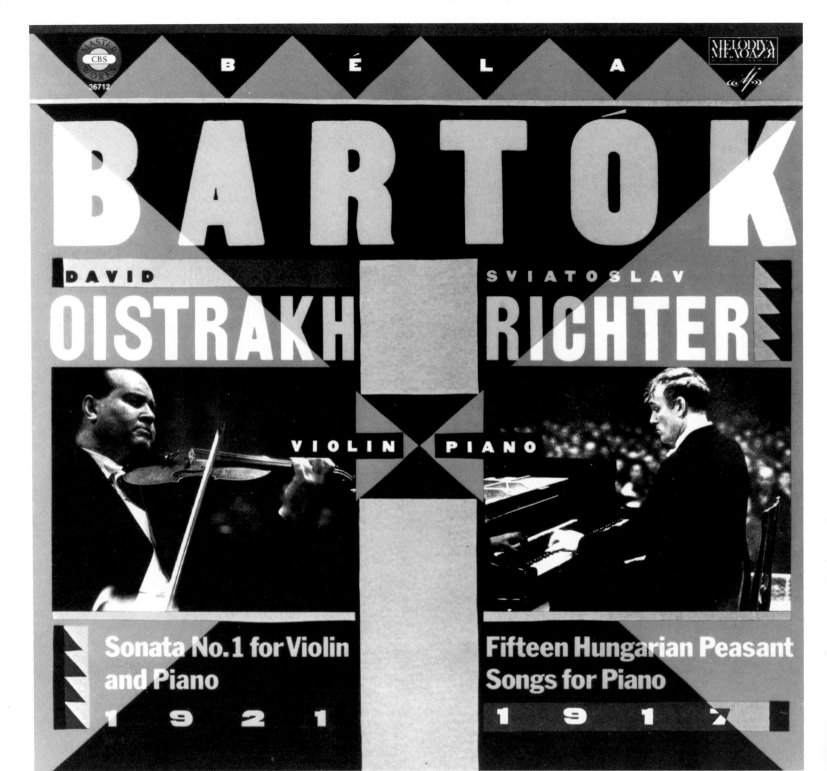

Record Album:
Bartok: Oistrakh / Richter
Art Director:
Christopher Austopchuk
Designer:
Christopher Austopchuk,
New York, NY
Photographer:
Photos courtesy of
G.D. Hackett
Publisher:
CBS Records
Typographer:
Haber Typographers
Printer:
Shorewood Packaging Corp.

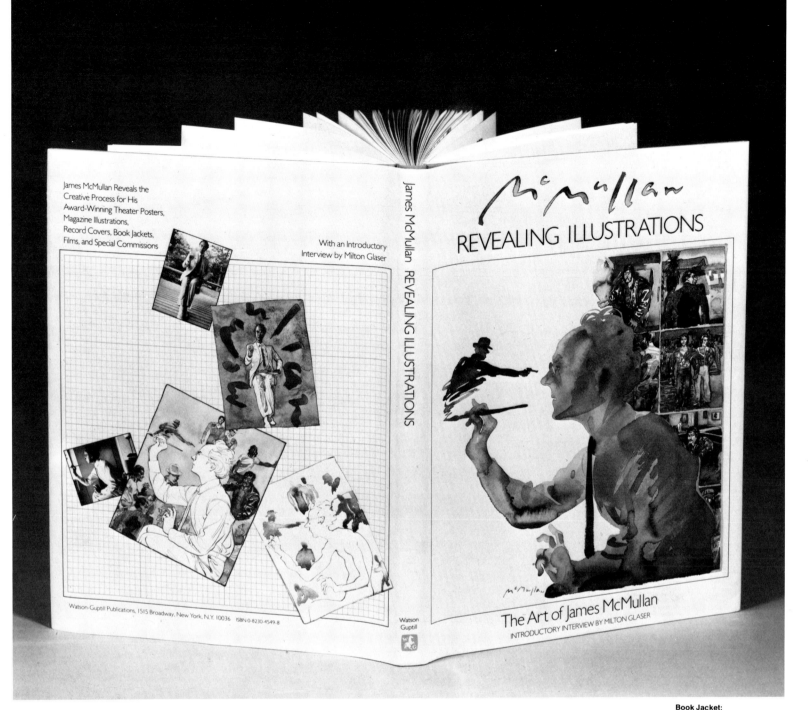

Book Jacket:
McMullan: Revealing
Illustrations
Art Director:
Robert Fillie
Designer:
James McMullan
Artist:
James McMullan
Design Firm:
Visible Studio, New York, NY
Publisher:
Watson-Guptill Publications
Typographer:
Publishers Graphics, Inc.
Printer:
Toppan Printing Co.

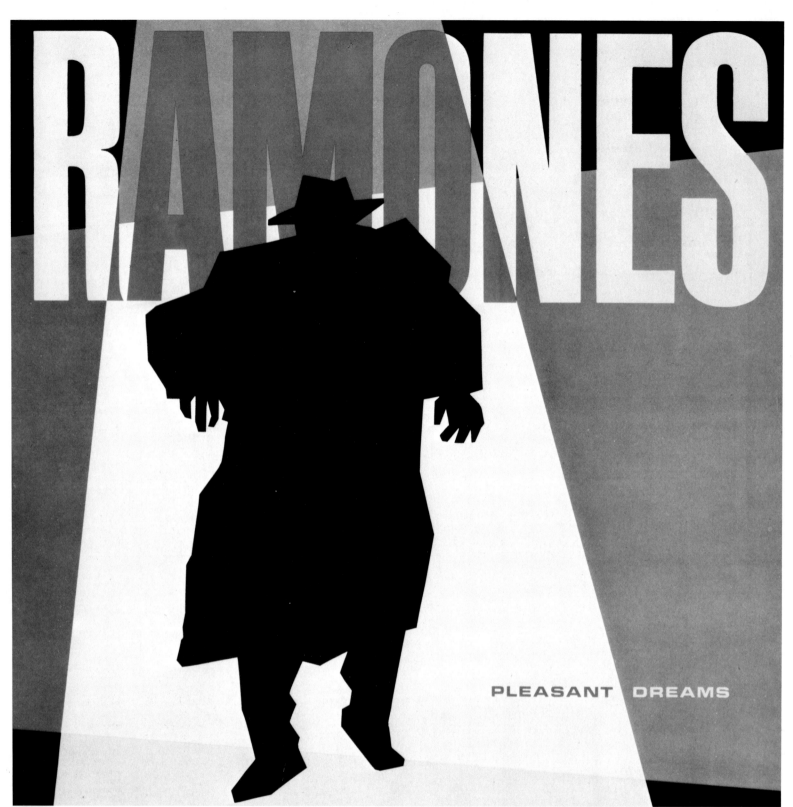

Record Album:
Ramones
Art Directors:
Carol Bokuniewicz,
Tibor Kalman, Guy Juke
Designer:
Carol Bokuniewicz
Artist:
Carol Bokuniewicz
Design Firm:
M & Co., New York, NY
Publisher:
Sire/Warner Bros. Records, Inc.
Typographer:
M & Co.
Printer:
Queens Lithographing Corp.

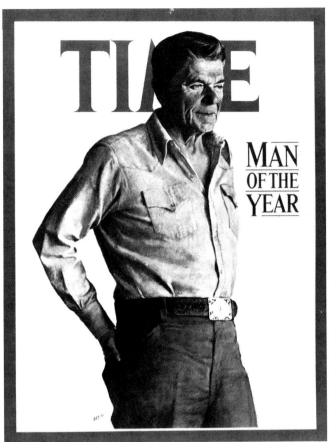

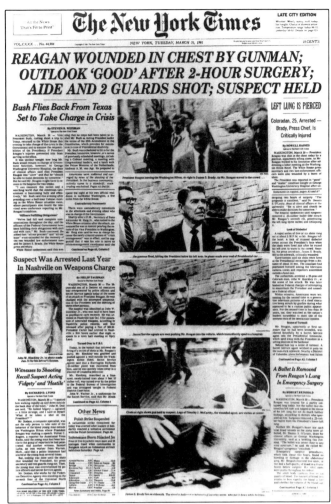

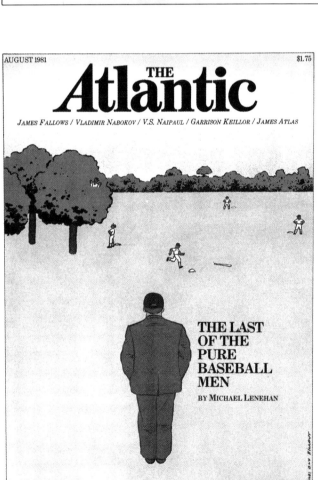

Magazine:
Time, January 5, 1981
Art Director:
Rudolph Hoglund
Artist:
Aaron Shikler
Publisher:
Time, Inc., New York, NY

Newspaper:
The New York Times
March 31, 1981
Art Directors:
Editors of The New York Times
and A.M. Rosenthal, Executive
Editor
Photographers:
ABC News, A.P., NBC News
Publisher:
The New York Times,
New York, NY
Printer:
The New York Times

Magazine:
Metro Magazine,
December/January 1981
Art Director:
Thomas Ingalls
Artist:
Michael Schwab
Design Firm:
Thomas Ingalls & Assoc.,
San Francisco, CA
Publisher:
Neal Elkin
Typographer:
Ann McCue
Printer:
Alonzo Printing Co.

Magazine:
The Atlantic Monthly,
August 1981
Art Director:
Judy Garlan
Designer:
Judy Garlan
Artist:
Guy Billout
Publisher:
The Atlantic Monthly,
Boston, MA
Typographer:
Typographic House
Printer:
Rumford Press

Annual Report:
Boy Scouts of America
Sam Houston Area Council
1980 Annual Report
Designers:
Chris Hill, Betty Thomas
Photographer:
Arthur Meyerson
Design Firm:
Loucks Atelier, Houston, TX
Publisher:
Sam Houston Area Council
B.S.A.
Typographer:
Typeworks, Inc.
Printer:
Grover Printing Co.

Magazine:
Time, April 28, 1980
Art Director:
Walter Bernard
Artist:
Edward Sorel
Publisher:
Time, Inc., New York, NY

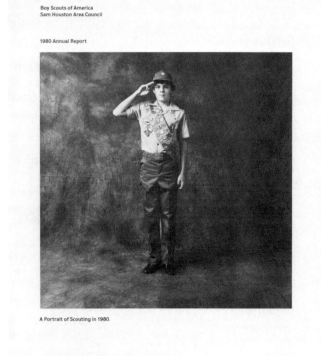

Boy Scouts of America
Sam Houston Area Council

1980 Annual Report

A Portrait of Scouting in 1980.

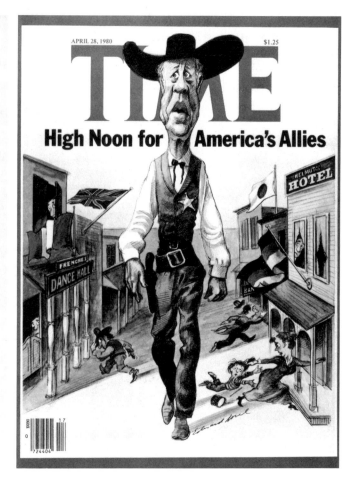

Book Jacket:
Saki
Art Director:
Frank Metz
Designer:
Louise Fili
Photography:
Tinted by Beatrice Fassell
Design Firm:
Louise Fili Design, New York, NY
Publisher:
Simon & Schuster, Inc.
Typographers:
Louise Fili,
Haber Typographers
Printer:
The Longacre Press

Record Album:
Quarter Flash
Art Directors:
Tommy Steele,
Chris Whorf / Art Hotel
Designer:
Tom Steele
Photographer:
Mike Mitchell
Design Firm:
Art Hotel, Los Angeles, CA
Publisher:
Geffen Records
Typographer:
Andresen Typographics
Printer:
Ivy Hill Lithograph Corp.

NBC BASEBALL 1981

Corporate Literature:
NBC Baseball 1981
Art Directors:
C. Blake, E. Zeitsoff,
V. Kalayjian
Designer:
Steve Gansl
Publisher:
NBC Television Network,
New York, NY
Typographer:
Tom Carnase
Printer:
Crafton Graphic Co., Inc.

SUPER BOWL '81:
THE INSIDE STORY
Page 19

TV GUIDE

Local Programs
Jan. 24-30, 1981
40¢

Magazine:
TV Guide, January 24-30, 1981
Art Director:
Jerry Alten
Designer:
Jerry Alten
Artist:
Brad Holland
Publisher:
TV Guide Magazine, Radnor, PA

Newspaper:
Sports Monday
The New York Times
June 23, 1980
Art Director:
Patrick Flynn
Designer:
Patrick Flynn
Photographers:
A.P., The New York Times,
Vic DeLucia
Publisher:
The New York Times,
New York, NY
Printer:
The New York Times

HARNESS RACING

Can anyone beat
the pacer Niatross? P. 6

TENNIS

Wimbledon:
Borg goes for
5th in row, P. 8

AUTO RACING

Bobby Unser wins
a big one at Pocono, P. 6

Sports Monday

The New York Times

Copyright © 1980 The New York Times MONDAY, JUNE 23, 1980

L
C1

The Highs and Lows Of the Up-and-Down Mets

Steve Henderson's
hitting has been a big
plus factor in an erratic
season for the Mets.

By MALCOLM MORAN

LOS ANGELES

AFTER more than five years in the minor leagues and nearly a month on the bench, José de los Santos Moreno appeared in the starting lineup of a major league baseball team for the first time last Wednesday afternoon. He had become versatile enough in the minors to play the outfield, second base and third. But fate, and a lineup card signed by Manager Joe Torre, had done a nasty thing. In his moment of glory, José Moreno had been placed at a position haunted by ghosts.

He was playing third base for the New York Mets, the 66th person to try in the team's 18 years. It was not the best place to start a career, something it took just two innings to discover. In San Francisco's windy Candlestick Park, Moreno settled in foul territory under a bright sun, a blue sky and a pop fly. Which dropped to the ground next to him. After the ball had landed, Moreno continued walking toward the dugout, to get the sunglasses he had forgotten to wear. The episode was an embarrassing if harmless lesson in a loss to the Giants.

For this team, this was just another in a long line of lessons learned. Baseball, the Mets discovered again last week, is played between the ears as much as between the white lines.

In a season that lasts from April to October, the idea is to make the ebb and flow as smooth as possible. They know that the highs should not be wildly celebrated and that the lows should not be depressing. They know, but they can't help it.

They have watched a hallucinating home stand become an exasperating road trip. They left Shea Stadium a week ago having won 8 of 13 games there, having come from behind in 7 of those victories. After six days on the road, at San Diego, San Francisco and Los Angeles, there was a seven-game losing streak, which ended yesterday with a 9-6 victory over the Dodgers, in which Claudell Washington hit three home

Continued on Page C4

José Moreno,
in his first start,
found himself at
a position haunted
by ghosts.

The New York Times and Associated Press

Mets end slide as Washington clouts 3, P. 4

A's Halt Yankee Streak, 5-2

By MURRAY CHASS

In remolding the hapless, lifeless Oakland A's in his image, Billy Martin has turned them into a running, base-stealing, bunting bunch of players. In cutting off the Yankees' winning streak at nine games yesterday, the A's even used a rarely seen bunt double.

Ricky Henderson, at 21 years old the A's youngest regular, is the man who got the bunt double and it led to one of the runs in the A's 5-2 victory.

"I've seen that once before," Martin said after the game. "Rizzuto did it in Chicago. Ferris Fain, the first baseman, charged in and he pushed it past him for a double."

Oakland's Matt Keough pitched his 12th complete game, tops in the league. He yielded 10 hits in gaining his eighth victory against seven defeats.

A crowd of 45,745 turned out yesterday, bringing the three-game total attendance for the Oakland series to 143,278, the largest in the American League this season. Combined with unusually large crowds that saw the teams play the previous weekend in Oakland, the attendance for the two series was 264,642.

That, in turn, means that Charlie Finley, by hiring Martin at $125,000 a year, generated ticket receipts for the two weekends totaling about $1.3 million. Adding concessions, the total take was closer to $1.5 million.

Even George Steinbrenner can accept that kind of revenue, because his share gives him considerably more than the $150,000 he agreed to pay Martin to settle his contract. It also helps soothe whatever frustrated feelings the owner might have suffered from the two games the Yankees lost to their former manager in the seven played.

The A's were aided in winning yesterday by a shortage of usable players on the Yankee bench. Willie Randolph was given complete rest for his stiff and sore left knee and Bobby Murcer was absent because of the death of his father in Oklahoma.

Randolph's absence left the Yankees with Columbus infielders at second

Continued on Page C3

Anderson on Howser, P. 3

Oakland's Dave McKay knocking aside Rick Cerone to score in seventh inning

Associated Press

Cosmos Win, 2-0, Before 70,312

By ALEX YANNIS

Special to The New York Times

EAST RUTHERFORD, N.J., June 22 — In desperate search for a victory after two consecutive losses, the Cosmos gave an uninspiring performance but still achieved their goal in a 2-0 triumph over the Fort Lauderdale Strikers before 70,312 at Giants Stadium today.

Playing cautiously and conservatively after a goal in the fourth minute of the game by Vladislav (Bogie) Bogicevic, the Cosmos were unable to score again until the 86th minute, when Giorgio Chinaglia got his 17th goal and assured the Cosmos of their 12th triumph in 16 North American Soccer League games.

"After we scored early we thought 1-0 against Fort Lauderdale was good," said Bogicevic, who put the ball in the net with a flick of his left foot after a well-placed pass by Franz Beckenbauer. "Hennes told us we must win before the game, so we were careful."

Strikers Clog Midfield

"Our responsibility was to win and we won two-nil," said Hennes Weisweiler, the coach of the Cosmos, who did not seem too upset because his players misdirected too many passes and did not attack en masse when in possession.

"Normally, when the team is winning, 1-0, against a good team with an excellent goalkeeper, you stay back and play safe and sure," Weisweiler said. "Tactically, it was very difficult for us to play against such an opponent because they play with so many midfielders."

Coached by Cor van der Hart, the Strikers employed five midfielders and just one man, usually Teofilo Cubillas,

Continued on Page C8

Jon Pot of the Strikers tripping over Giorgio Chinaglia chasing a loose ball

The New York Times / Vic DeLucia

ARTS/ENTERTAINMENT: George Eliot Finally Makes It to the Abbey C13/Books: Korean Pair C16

Newspaper:
Sports Monday
The New York Times
May 26, 1980
Art Director:
Patrick Flynn
Designer:
Patrick Flynn
Photographers:
A.P., U.P.,
The New York Times
Publisher:
The New York Times,
New York, NY
Printer:
The New York Times

CYCLING

Heiden 19th as Doughty wins Tour of Nutley, P. 8

BOXING

Cooney stops Young, P. 2

TRACK AND FIELD

Paige wins 800; Wszola jumps record 7-8½, P. 5

HOCKEY

Islanders sharing glory, P. 3

Sports Monday

The New York Times

Copyright © 1980 The New York Times MONDAY, MAY 26, 1980 C1

Rutherford, in Chaparral, Captures Indy 500 Third Time

By MALCOLM MORAN

Special to The New York Times

INDIANAPOLIS, May 25 — The machine's official name is the Pennzoil Chaparral, and its unofficial name, given by another race driver, is the Yellow Haze. Whatever it is called, Johnny Rutherford had learned that his machine, with its complex engineering, was supposed to be much better than everyone else's in the Indianapolis 500.

That is why it was no surprise to Rutherford that his 9-year-old daughter, Angela, got her wish to have her picture taken with him in Victory Lane today at the Indianapolis Speedway. Despite 13 caution flags that stayed up for 60 of the 200 laps and kept the field bunched, and despite the controversial limitations of power that helped equalize the field, Rutherford won the race for the third time in seven years. He also became the first driver in the 64 years of the event to win it twice from the pole position.

The yellow lights helped hold the winning speed, which becomes official tomorrow, to an average of 142.862 miles an hour, the slowest since 1962, when Rodger Ward won with 140.293.

"We were running like turtles," said A.J. Foyt, a four-time winner, who dropped out on the 178th lap with a valve problem and later questioned whether the many thousands of people had come to see cars run at 130 miles per hour. The crowd was later estimated at 380,000.

Other drivers did not agree with Foyt. "We're all running like turtles," said Dick Simon, who lost a wheel after 58 laps. "But we're close. I think it's a better race now."

The restriction to 48 inches of manifold pressure, some drivers said, was responsible for some accidents that eliminated six of the 33

Continued on Page C6

Johnny Rutherford giving another driver, Tim Richmond, a lift on the victory lap yesterday at the Indianapolis 500 after Rutherford won the race, and the trophy, for the third time.

Shortstops Catching a Lot of Attention

By GEORGE VECSEY

Dave Concepción
Larry Bowa
Bucky Dent
Garry Templeton

WHEN artificial turf was introduced to baseball in the 1960's, it threatened one of the classic plays ever developed at that classic baseball position — shortstop.

Wherever artificial turf spread, like some ominous lawn disease, shortstops could not easily lunge to their right, stab a hot grounder backhanded, and make a long throw to first base. The ball either rocketed past them, or they could not plant their feet on the synthetic surface.

"Going into the hole," a classic shortstop maneuver, was going down the drain.

But shortstops, being a superior breed, are developing new techniques to combat the menace of artificial turf. The latest ploy has been advanced by Dave Concepcion of the Cincinnati Reds, who will sometimes throw the ball on one bounce to first base when he manages to snare it in the hole and cannot risk a direct throw.

This graceful resourcefulness is what makes shortstop one of the premier defensive positions of any sport. The shortstop cannot rely on mere strength or tenacity, as some other defensive players can, but must have innate smoothness before the first junior-league coach ever points a finger and says: "you — play shortstop."

After more than a decade of coping with cement-like infields (nine of 26 parks currently use ar-

Graceful resourcefulness is what makes shortstop one of the premier defensive positions in sports.

Continued on Page C4

John fails in bid for 200th victory as Blue Jays beat Yankees, 9-6, P. 4

The New York Times, Associated Press and United Press International

Mets Sweep Braves On Swan's Shutout

By JOSEPH DURSO

Craig Swan and Phil Niekro, a pair of $3 million pitchers, staged a solid exhibition of the ancient art of throwing a baseball yesterday at Shea Stadium.

Then, still scoreless in the eighth inning, the New York Mets broke through Niekro's knuckleballs for three runs, a 3-0 victory over an old antagonist and a sweep of their weekend series with the Atlanta Braves.

"We are getting things together," Manager Joe Torre suggested as he headed the Mets toward St. Louis and three games against the Cardinals, who replaced the Mets last week in last place in the National League's East. "It has been difficult, sometimes agonizing. But they are maturing and, best of all, the pitchers are now pitching."

Swan, the No. 1 man on Torre's staff, signed a five-year contract for $3 million in March and has been trying to earn his keep ever since. He responded yesterday with a three-hitter that included only one walk, and he pitched to 32 batters, only five more than the minimum.

Niekro a Match Two Ways

But he was matched all afternoon by the 41-year-old Niekro, a man who had beaten the Mets 21 times in his career. And Niekro also was no slouch in financial matters, having signed a contract that will pay him $3.2 million in large chunks over the next 30 years.

Their duel ended suddenly and controversially with one down in the bottom of the eighth. Frank Taveras whistled a double down the left-field line for his fourth hit of the game, giving him 24 for 51 during a rampage of nearly two weeks. Then Lee Mazzilli fouled out, and Niekro needed one more out to escape.

But, before he got it, John Stearns lined a double into right field for the first run of the afternoon. And then Mike Jorgensen lifted a high drive past

Continued on Page C5

Lee Mazzilli after hitting a high pop up yesterday at Shea Stadium.

ARTS/ENTERTAINMENT 'Post-Impressionism' in Capital C11/Books: Psychohistory Indicted C16

Corporate Literature:
Mountain Lid Woolens
Art Director:
Michael Vanderbyl
Designer:
Michael Vanderbyl
Design Firm:
Vanderbyl Design,
San Francisco, CA
Client:
Mountain Lid Woolens
Typographer:
Headliners / Identicolor
Printers:
Interprint,
Dai Nippon

Magazine:
The Boston Monthly,
August 1981
Art Director:
Suzanne Anderson
Artists:
Tim McCarthy,
Michael Grossman
Publisher:
The Boston Monthly,
Boston, MA
Typographer:
The Berkley Monthly
Printer:
Charles River Publishing Co.

Corporate Literature:
Pharmascan: Poisons from the
Sea
Art Director:
Larry Stires
Designer:
Larry Stires
Artist:
David Montiel
Design Firm:
CIBA-GEIGY Pharmaceuticals,
Advertising Dept., Summit, NJ
Publisher:
CIBA-GEIGY Corp.
Typographer:
Empire Typographers
Printer:
Color Press

Annual Report:
Victoria Station
Annual Report 1981
Art Director:
Dawson Zaug
Design Firm:
Unigraphics, San Francisco, CA
Publisher:
Victoria Station
Typographer:
Rapid Type
Printer:
Anderson Lithographic Co.

Corporate Literature:
Release Two
Art Director:
Bob Defrin
Designer:
Bob Defrin
Photographer:
David Kennedy
Publisher:
Atlantic Records Corp.,
New York, NY
Typographer:
Typographic Images, Inc.
Printer:
Candid Litho Co.

Corporate Literature:
The Overlook Press
Art Director:
Milton Glaser
Designers:
Milton Glaser,
Marlese Lopez
Artist:
Milton Glaser
Design Firm:
Milton Glaser, Inc.,
New York, NY
Client:
The Overlook Press

Record Album:
Cats
Art Directors:
Ron Coro, Johnny Lee
Designers:
Ron Coro, Johnny Lee
Artist:
David Wilcox
Publisher:
Elektra / Asylum / Nonesuch
Records, Los Angeles, CA
Typographer:
Andresen Typographics
Printer:
Album Graphics, Inc.

Corporate Literature:
Puffin Books, 1981
Art Directors:
Craig Bernhardt,
Janice Fudyma
Designer:
Kevin Thompson
Design Firm:
Bernhardt Fudyma Design
Group, New York, NY
Publisher:
Viking / Penguin
Typographer:
Ad Agency Headliners
Printer:
Hampshire Press

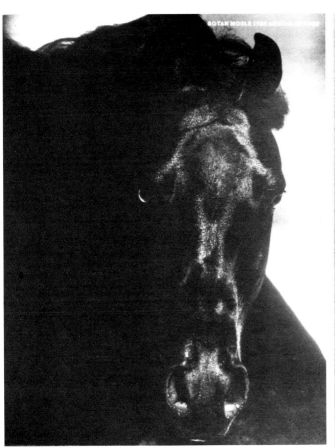

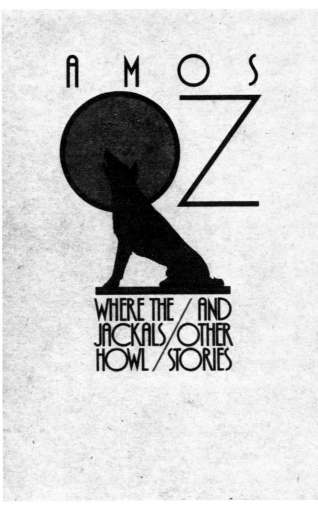

Annual Report:
Rotan Mosle 1980 Annual
Report
Art Director:
Ben Carter
Designer:
Maggie Cuesta
Photographer:
Arthur Meyerson
Design Firm:
Ben Carter & Assoc.,
Houston, TX
Publisher:
Rotan Mosle
Printer:
Grover Printing Co.

Book Jacket:
Where the Jackals Howl
Art Director:
Rubin Pfeffer
Designer:
Paul Gamarello
Artist:
Paul Gamarello
Design Firm:
Eyetooth Design, Inc.,
New York, NY
Publisher:
Harcourt Brace Jovanovich, Inc.
Typographer:
Haber Typographers
Printer:
The Longacre Press

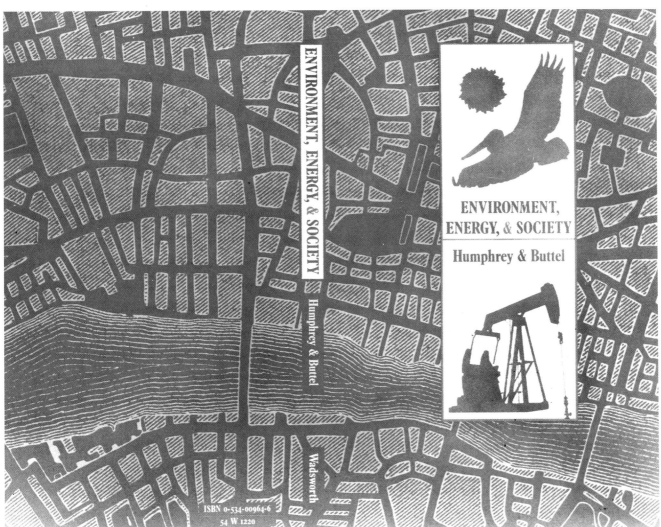

Paperback:
Environment, Energy & Society
Art Director:
Patricia Dunbar
Designer:
Dare Porter
Artist:
Dare Porter
Publisher:
Wadsworth Publishing Co.,
Belmont, CA
Typographer:
Helvetica Typographers
Printer:
Maple Press

Record Album:
Ralph MacDonald:
Universal Rhythm
Art Director:
Paula Scher
Designer:
Paula Scher
Artist:
David Wilcox
Publisher:
CBS Records, New York, NY
Typographer:
Haber Typographers
Printer:
Shorewood Packaging Corp.

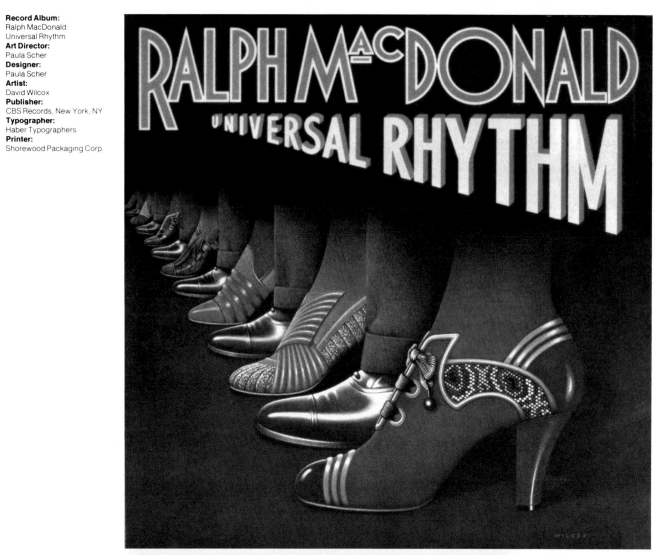

Magazine:
Metro Magazine, Summer 1981
Art Director:
Thomas Ingalls
Artist:
Lance Anderson
Design Firm:
Thomas Ingalls & Assoc.,
San Francisco, CA
Publisher:
Neal Elkin
Typographer:
Ann McCue
Printer:
Alonzo Printing Co.

Zoetrope

FREE IN CHICAGO $1.00 elsewhere

ISSUE 80

The Publication of Commercial and Experimental Concepts

no. 7

NON MALE ISSUE

Ag

Magazine:
Zoetrope # 7
Art Director:
Christopher Garland
Designer:
Christopher Garland
Artist:
April Greiman
Photographer:
Jayme Odgers
Design Firm:
Xeno, Chicago, IL
Publisher:
Zoetrope Assoc.
Typographer:
Omega Studios
Printer:
Regional Publishers

Paperback:
Windhover
Art Director:
Marc Stephens
Designer:
Marc Stephens
Artist:
Marc Stephens
Design Firm:
Marc Stephens Design,
New York, NY
Publisher:
North Carolina State University
Typographer:
Marc Stephens
Printer:
Hunter Publishing Co.

Magazine:
Your Health, Spring 1981
Art Director:
Marty Lapham
Designer:
Marty Lapham
Design Firm:
Lapham / Miller Assoc.,
Boston, MA
Publisher:
Union Hospital
Typographer:
Together Graphics
Printer:
Emco Printers

Corporate Literature:
VOS Product Price List
and Specifications
Art Director:
Michael Vanderbyl
Designer:
Michael Vanderbyl
Design Firm:
Vanderbyl Design,
San Francisco, CA
Client:
Modern Mode, Inc.
Typographer:
Headliners / Identicolor
Printers:
Lithosmith, Inc.
Lithographics, Inc.

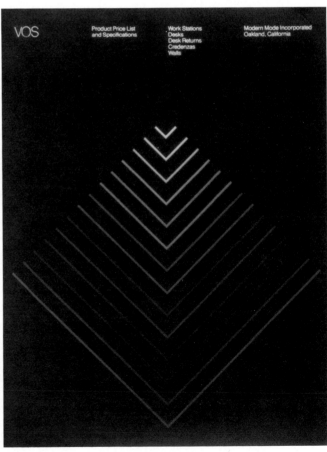

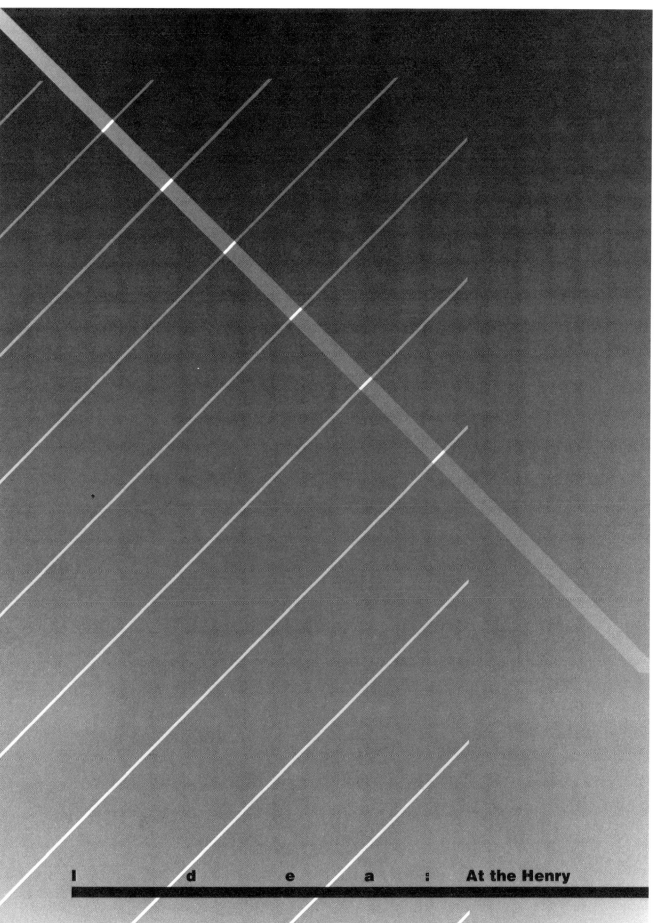

I d e a : At the Henry

Corporate Literature:
Idea: At the Henry
Art Director:
John Whitehill-Ward
Designer:
John Whitehill-Ward
Design Firm:
Design Collaborative,
Seattle, WA
Publisher:
Henry Art Gallery
Typographer:
University of Washington
Printer:
University of Washington

Corporate Literature:
Champion: Capacity, Expanding
Art Director:
Aubrey Balkind
Designer:
Phil Gips
Design Firm:
Gips + Balkind + Assoc.,
New York, NY
Client:
Champion International Corp.
Typographer:
Innovative Graphics
International
Printer:
Crafton Graphic Co., Inc.

Magazine:
Idea: Special Issue
Art Director:
Chermayeff & Geismar Assoc.
Designer:
Ivan Chermayeff
Artist:
Ivan Chermayeff
Photographer:
Gustavo Candelas
Design Firm:
Chermayeff & Geismar Assoc.,
New York, NY
Publisher:
Seibundo Shinkosha
Printer:
Nishiki Printing Co., Ltd.

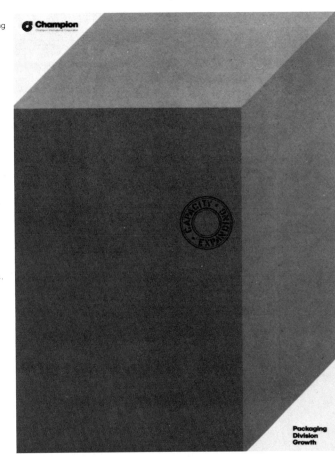

Record Album:
Graf
Art Director:
Carin Goldberg
Designer:
Carin Goldberg, New York, NY
Photographer:
Robert Lewis
Publisher:
CBS Records
Typographer:
Haber Typographers
Printer:
Shorewood Packaging Corp.

Record Album:
McCoy Tyner:
La Leyenda de la Hora
Art Director:
Carin Goldberg
Designer:
Carin Goldberg
Artist:
James McMullan
Design Firm:
Visible Studio, New York, NY
Publisher:
CBS Records
Typographer:
Haber Typographers
Printer:
Shorewood Packaging Corp.

Magazine:
The Atlantic Monthly, May 1981
Art Director:
Walter Bernard
Designer:
Walter Bernard
Artist:
Andre Thijssen
Publisher:
The Atlantic Monthly,
Boston, MA
Typographer:
Typographic House
Printer:
Rumford Press

Book Jacket:
To China and Back
Art Director:
Louise Fili
Designer:
Louise Fili
Artist:
Susannah Kelly
Publisher:
Pantheon Books, New York, NY
Typographer:
Haber Typographers
Printer:
Phillips Offset

Corporate Literature:
Freightliner
Art Director:
David Strong
Designer:
Gary LaComa
Photographer:
Jim Felt
Design Firm:
David Strong Design Group,
Seattle, WA
Publisher:
Freightliner Corp.
Printer:
Graphic Arts Center

Corporate Literature:
Pentagram Papers 8:
Views from Pentagram
Art Director:
Colin Forbes
Designer:
John McConnell
Artist:
Herman Bollman
Pictorial Maps, Inc.
Design Firm:
Pentagram Design,
New York, NY
Publisher:
Pentagram Design
Typographer:
Expertype
Printer:
Sanders Printing Corp.

STRUCTURAL
ENGINEERING
for ARCHITECTS

KENNETH R. LAUER

Book Cover:
Structural Engineering for Architects
Art Director:
Chuck Carson
Designer:
Chuck Carson
Artist:
Anne Canevari Green
Publisher:
McGraw-Hill Book Co.,
New York, NY
Printer:
Auto Screen Co.

Magazine:
The Yale Architectural Journal
Art Director:
Lazin & Katalan
Designer:
Lazin & Katalan
Photographer:
Jack Katalan
Design Firm:
Lazin & Katalan, New York, NY
Publisher:
MIT Press Journals
Typographer:
G & S Typesetters
Printer:
Rae Publishing Co.

The Yale Architectural Journal

Perspecta 17

The magazine of
South Street Seaport Museum
Summer 1981, Two dollars

seaport

Magazine:
Seaport, Summer 1981
Art Director:
Richard Danne
Designer:
Richard Danne
Artist:
Mural by Richard Haas
Photographer:
Enrico Ferorelli
Design Firm:
Danne & Blackburn, Inc.,
New York, NY
Publisher:
South Street Seaport Museum
Typographer:
Typographic Images, Inc.
Printer:
S.D. Scott Printing Co., Inc.

Magazine:
Progressive Architecture
August 1981
Art Director:
George W. Coderre,
Stanford, CT
Photographer:
Steve Rosenthal
Publisher:
Reinhold Publishing Co.
Printer:
Connecticut Printers, Inc.

Corporate Literature:
Zurek: Photography
Art Director:
Michael Manwaring
Designer:
Michael Manwaring
Artists:
Betty Barsamian,
Brian Walima
Photographer:
Nikolay Zurek
Design Firm:
The Office of Michael
Manwaring,
San Francisco, CA
Client:
Nikolay Zurek
Typographer:
Omnicomp
Printers:
Advance Litho,
Interprint

Corporate Literature:
The Masters
Art Director:
David November
Designers:
David November,
Trudi Gershenov
Artist:
Gregory Hergert
Design Firm:
CBS Entertainment
Advertising & Promotion Dept.
New York, NY
Publisher:
CBS Sports
Typographer:
Typographic Communications
Printer:
ABC Printing

Annual Report:
Ramtek Annual Report 1979
Art Director:
Lawrence Bender
Designer:
Linda Brandon
Photographer:
Tom Tracy
Design Firm:
Lawrence Bender and Assoc.,
Palo Alto, CA
Publisher:
Ramtek Corp.
Typographer:
Franks Type, Inc.
Printer:
George Rice & Sons

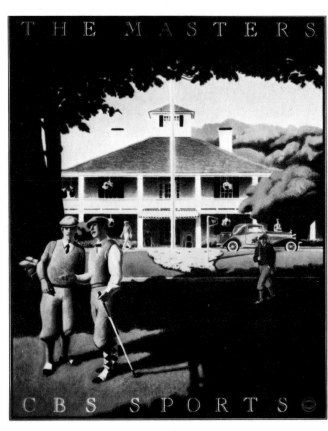

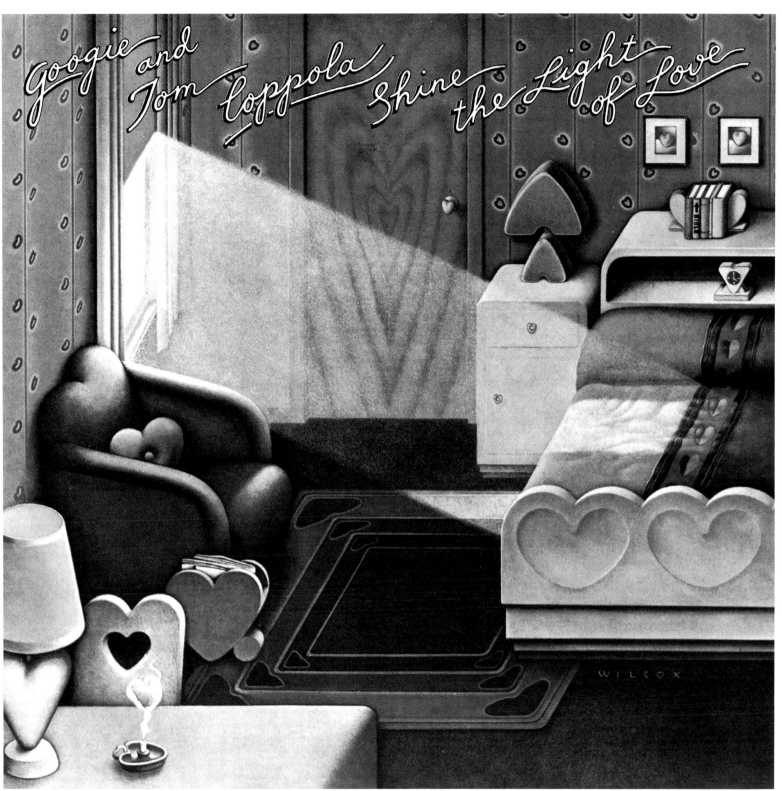

Record Album:
Googie and Tom Coppola:
Shine the Light of Love
Art Director:
Paula Scher
Designers:
Paula Scher, Gene Greif
Artist:
David Wilcox
Publisher:
CBS Records, New York, NY
Typographer:
Haber Typographers
Printer:
Shorewood Packaging Corp.

Book Jacket:
The Meaning of Flowers
Art Director:
Julie Runk
Designer:
Barry Zaid
Design Firm:
Barry Zaid, Boulder, CO
Publisher:
Shambhala Publications, Inc.
Typographer:
Barry Zaid

Magazine:
The Boston Monthly,
September 1979
Art Director:
Michael Grossman
Artist:
Karen Watson
Publisher:
The Boston Monthly,
Boston, MA
Typographer:
The Berkley Monthly
Printer:
Charles River Publishing Co.

Corporate Literature:
The Great Chefs of France 1981
Art Director:
Michael Manwaring
Designer:
Michael Manwaring
Artist:
Betty Barsamian
Design Firm:
The Office of Michael
Manwaring,
San Francisco, CA
Client:
The Great Chefs of France
Typographer:
Omnicomp
Printers:
Waller Press,
Interprint

Magazine:
The Heirloom Vegetable Garden
Designers:
Frederick Murrell,
Nancy Finneran Hazlett
Design Firm:
Cornell University Media
Services/Visual Communication
Group, Ithaca, NY
Publisher:
Cornell University
Typographer:
Utica Type
Printer:
Cayuga Press

AVENUE

MAY 1981/ THREE DOLLARS

Magazine:
Avenue, May 1981
Art Director:
Mary K. Bowman
Photographer:
Hughes Colson
Publisher:
Avenue Magazines, Inc.,
New York, NY
Printer:
City Printing Co.

Corporate Literature:
Release Three
Art Director:
Bob Defrin
Designer:
Bob Defrin
Photographer:
Allen Levine
Publisher:
Atlantic Records Corp.,
New York, NY
Typographer:
Royal Composing Room
Printer:
Candid Litho Co.

Book Jacket:
Hearts
Art Director:
Michael DiCapua
Designer:
Fred Marcellino, New York, NY
Artist:
Fred Marcellino
Publisher:
Farrar Straus & Giroux
Printer:
Hallmark Press

Release no. 3 from Atlantic, Atco, Cotillion and Custom Labels.

Book Jacket:
A Night of Serious Drinking
Art Director:
Julie Runk
Designer:
Barry Zaid
Design Firm:
Barry Zaid, Boulder, CO
Publisher:
Shambhala Publications, Inc.
Typographer:
Barry Zaid

Corporate Literature:
Design
Art Director:
Steve Jenkins
Designer:
Steve Jenkins
Artist:
Steve Jenkins
Design Firm:
Steve Jenkins Design,
New York, NY
Publisher:
Steve Jenkins Design
Printer:
North Carolina State University
School of Design

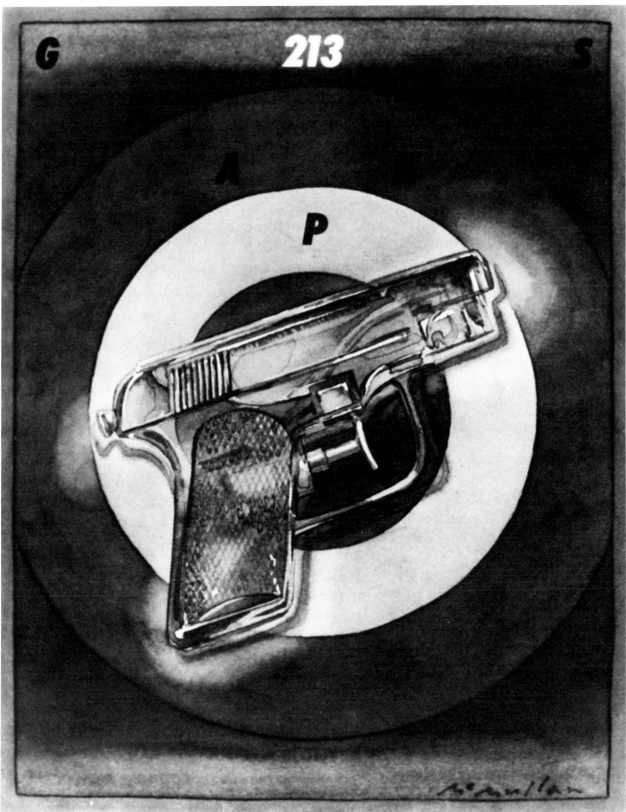

Magazine:
Graphis 213
Art Director:
Walter Herdeg
Designer:
James McMullan
Artist:
James McMullan
Design Firm:
Visible Studio, Inc.,
New York, NY
Publisher:
The Graphis Press

Magazine:
Audubon, March 1981
Art Directors:
Daniel J. McClain, Les Line
Photographer:
Daniel J. McClain
Publisher:
The Audubon Society,
New York, NY
Typographer:
Rochester Monotype
Printer:
Case-Hoyt Corp.

Photograph by Glenn Van Nimwegen

AUDUBON

March Nineteen Eighty-One • Three Dollars

3
·
81

Corporate Literature:
Communicating with
the Chinese Market
Art Director:
Hoi Ling Chu
Designer:
Hoi Ling Chu
Design Firm:
Hoi Ling Chu, New York, NY
Client:
Hoi Ling Chu
Typographer:
Zimmering & Zinn Typography
Printer:
Sanders Printing Corp.

Magazine:
Push Pin Graphic Number 82
Art Director:
Seymour Chwast
Designer:
Richard Mantel
Artist:
Richard Mantel
Design Firm:
Push Pin Studios, Inc.,
New York, NY
Publisher:
Push Pin Graphic
Typographer:
Haber Typographers
Printer:
Metropolitan Printing Service

Magazine:
Time, August 20, 1979
Art Director:
Rudolph Hoglund
Artist:
Eraldo Carugati
Publisher:
Time, Inc., New York, NY

Record Album:
Gary Portnoy
Art Director:
Paula Scher
Designer:
Paula Scher
Photographer:
Brian Hagiwara
Publisher:
CBS Records, New York, NY
Typographer:
Haber Typographers
Printer:
Shorewood Packaging Corp.

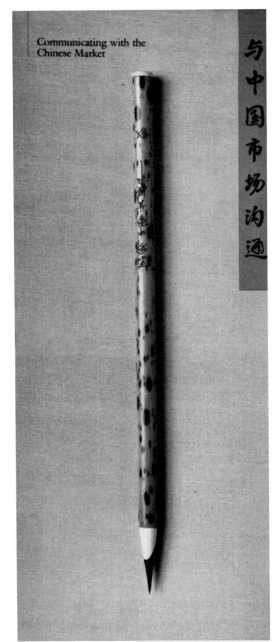

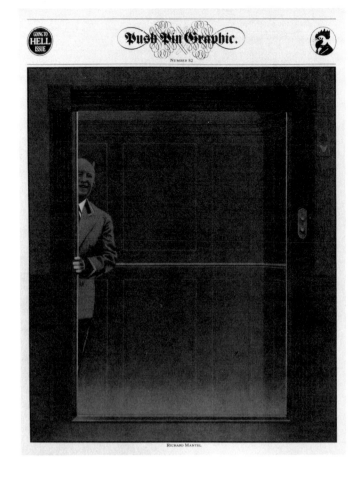

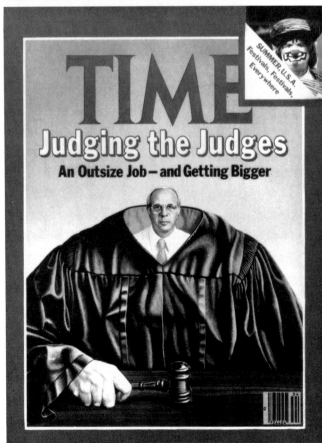

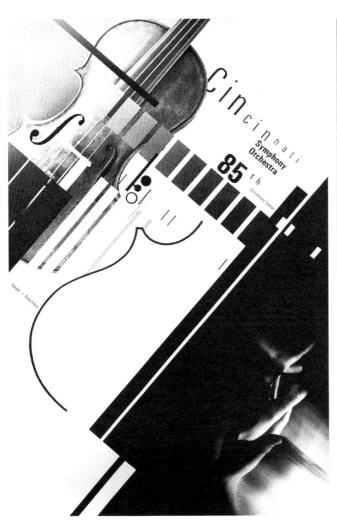

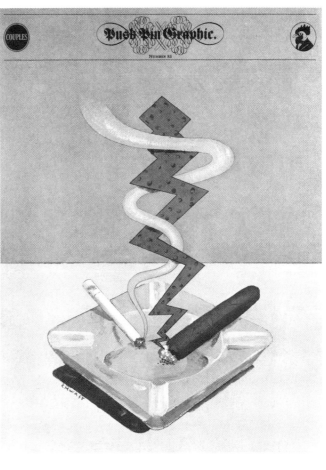

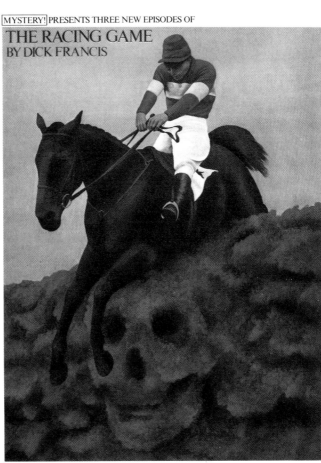

Program Cover:
Cincinnati Symphony
Orchestra,
85th Anniversary Season
Art Director:
Mike Zender
Designer:
Mike Zender
Artist:
David Steinbrunner
Design Firm:
Zender & Assoc., Inc.
Publisher:
Cincinnati Symphony
Orchestra, Cincinnati, OH
Typographer:
Craftsman Type
Printer:
Young & Klein

Magazine:
Push Pin Graphic Number 83
Art Director:
Seymour Chwast
Designer:
Richard Mantel
Artist:
Seymour Chwast
Design Firm:
Push Pin Studios, Inc.,
New York, NY
Publisher:
Push Pin Graphic
Typographer:
Haber Typographers
Printer:
Metropolitan Printing Service

Annual Report:
Advanced Micro Devices
Annual Report 1980
Art Director:
Lawrence Bender
Designer:
Lawrence Bender
Artist:
Karen Olsen
Design Firm:
Lawrence Bender & Assoc.,
Palo Alto, CA
Publisher:
Advanced Micro Devices
Typographer:
Franks Type
Printer:
Anderson Lithographic Co.

Corporate Literature:
The Racing Game
Art Director:
Sandra Ruch
Designer:
Richard Mantel
Artist:
Richard Mantel
Design Firm:
Push Pin Studios, New York, NY
Publisher:
Mobil Oil Corp.
Typographer:
Haber Typographers
Printer:
Crafton Graphic Co., Inc.

Catalog Cover:
Books: The Museum of Modern
Art
Art Director:
Tony Drobinski
Designer:
Melissa Feldman
Photographer:
Brian Albert
Publisher:
The Museum of Modern Art,
New York, NY
Typographer:
Concept Typographic Services,
Inc.
Printer:
Eastern Press, Inc.

I·M·A·G·E·S
A BOOK OF CONTEMPORARY CANADIAN REALISM

EDITED BY MARCI LIPMAN AND LOUISE LIPMAN
LESTER & ORPEN DENNYS LTD., PUBLISHERS, TORONTO 1980

Paperback:
Images: Contemporary
Canadian Realism
Art Director:
Paul Hodgson
Designer:
Paul Hodgson
Artist:
Mary Pratt
Design Firm:
Fifty Fingers, Inc., Toronto, CAN
Publisher:
Lester & Orpen, Dennys Ltd.
Typographer:
M & H Typography

Paperback:
Joseph Cornell
Art Director:
Pat Cunningham
Designers:
Pat Cunningham, Keith Davis
Artist:
Joseph Cornell
Publisher:
The Museum of Modern Art,
New York, NY
Typographer:
M. J. Baumwell Typography
Printer:
The Arts Publisher, Inc.

Magazine:
American Craft
August/September 1980
Art Director:
Kiyoshi Kanai
Designer:
Paul Eluard
Artist:
Man Ray
Photographer:
Joel Gordon
Design Firm:
Kanai, Inc., New York, NY
Publisher:
American Craft Council
Typographer:
Cardinal Type Service
Printer:
Judd Printing Co.

Magazine:
The Museologist
Art Director:
Bill Kinser
Designer:
Bill Kinser
Design Firm:
Design Practicum / Pennsylvania
State College, State College, PA
Publisher:
Northeast Museums
Conference
Typographer:
Commercial Printing /
Pennsylvania State College
Printer:
Commercial Printing /
Pennsylvania State College

Communication Graphics

An overpowering collective communication of this exhibition is style. Has "style" begun to reign? And if "style" is the solution, how may we define the problem?

Chairman
Eddie Byrd
President
Byrd Graphic Design, Inc.

Jury
Jack Beveridge
President
Beveridge & Associates, Inc.

Thomas Geismar
Principal
Chermayeff & Geismar Associates

Eugene Grossman
Principal
Anspach Grossman Portugal, Inc.

Joseph Hutchcroft
Manager of Design Communications
Container Corporation of America

George Tscherny
Designer
George Tscherny, Inc.

Of all the professional competitions held each year by AIGA, Communication Graphics is the broadest, attracts the most entries (more than 3,000 this year), represents the greatest geographical diversity (submissions from almost every state in the nation), and is the best indicator of the state of graphic design.

The trend of significant improvement in the total submission continues to be strong. The levels of conceptual competence, design literacy, and production capability are rising steadily. You can attribute this phenomenon to better designers, better clients (or perhaps, more clients who understand better and support more), and better technical processes. We might also add more competition: for staff jobs, for consulting arrangements, for recognition.

The impact of the 1980–1982 recession is not yet apparent. The CG competition and the publication of this volume lag behind what's currently happening in design by about a year. What's more, economic impact on the creation and production of design communication itself lags behind other indicators. We'll see next year and the year following what effects, if any, the stagnant economy has had on graphic design. For the 1982 edition of Communication Graphics, there is no dearth of six-color-plus-varnish printing, premium coated papers, lavish photography, and top-notch illustration.

Most of the anticipated forms of contemporary communications design and the major stylistic directions are well represented in Communication Graphics 1982. Calendars include CCA, Stephenson, Saga, Paris (Willi Kunz), and a special effort by Jack Summerford on behalf of Heritage Press which is more fun than a calendar should be, and more about months and seasons than about being a calendar.

Recruiting brochures are included from the University of Pittsburgh, Ciba-Geigy, Citicorp, Peat Marwick, and IBM Tucson.

Annual reports are traditional (Champion, Northwest Energy, Norlin, Condec, Cetus, Technicolor); some are built on a keel of borrowed interest (Foremost McKesson, Omega Optical); some are in unusual sizes and/or formats (Houseman, Sadlier, Dow Jones, Science Management); and there is even a relatively New Wave annual report (Best).

Product and services literature describes Steelcase office furniture, Corgan Associates architecture, John Hansen builders, Chicago illustration and photography, Bang & Olufsen stereo gear, Esprit clothing, and office space at Houston's "Galleria." Two special citations in this group, both quizzical: the CBS piece on television programming for children uses illustrations of a book within the pages of a brochure to talk about television shows; Martex uses aluminum (yes, the metal itself) for covers on a brochure intended to sell the soft luxury of fine sheets and towels.

School and university material in low-cost, but earnestly inventive formats is shown from California College of Arts and Crafts, University of Utah, and Philadelphia College of Art.

There are examples of superb, understated typography in symposia reports and recognition booklets; a few very competent company magazines, again including Best's publication in a bright broadside format; a fair selection of clever letterheads, print ephemera, new corporate marks and logotypes; a sprinkling of elaborate production engineering feats (Formica, Schumacher, and some kind of final word on corporate identification programs by a French company that produced theirs on—or embedded in—plastic at demure dimensions of 16½" × 12½" × 4.5 pounds).

On balance, the 1982 CG work looks strong, controlled, competent, and confident. But— generalizing—it also looks heavily *styled*. Granting the inherent weakness of the jury process—that is, separating a design effort from its creator(s), its environment, its audience, the "problem," pressures, budgets—the attention to *style* may be the cumulative message here. Wrote one of the competition's judges: "What bothers me is that, as a group, the winning entries have much to do with 'graphics,' but very little to do with 'communication.' There are almost no images of human beings, no copy of any interest, no type larger than 12 point, no subject matter concerning ideas, news, human affairs or social issues, no attempt to convey complex information in an understandable way, no attempts to make an audience laugh or cry. There is plenty of . . . style, style, style. The show was certainly chosen fairly and squarely by the judges, all of whom worked diligently. But does it fairly reflect the scope of the best of 'communication graphics' in the U.S. today?"

There can be little doubt that the work included in this year's edition of CG reaches a new level of sophistication in terms of production, technical execution, design values. But much of this excellent design work seems to be about *design* itself, as well as its subject matter.

Identifying emerging trends is always tricky business. It is made more tricky (if no more urgent) today because design and designers have been around long enough, have grown confident enough in the history of the profession, have become relatively integral enough to the functioning of business and other institutions, so that plumbing the past is now permissible. We have "neo-conservatives" (and now even "neo-liberals") in politics, so why not a "neo-" something in graphic design?

One of the stoutest intellectual underpinnings of modern graphic design—in its teaching, training, practice, criticism—is the doctrine of "problem-solution." The best kind of design is that which succeeds in meeting a specific need by embodying a "solution" developed from the essence and individual characteristics of a given "problem." The dialectic is neat, satisfyingly symmetrical, and comfortably unassailable. It's an effective counter to the dreaded "my taste vs. your taste" trap that all working designers and design managers contend with nearly all the time. Most important, "problem-solution" has worked—and worked exceedingly well. It has produced an extraordinary amount of fine communication and has been useful in explaining to nondesigners what the design process is about.

An overpowering collective communication of this exhibition is style. Has "style" begun to reign? And if "style" is the solution, how may we define the problem?

Poster:
Black and The National Look
Art Director:
Mark Anderson
Designers:
Michael Kunisaki,
Steve Tolleson
Artists:
David Monley, Antony Milner
Design Firm:
Mark Anderson Design
Palo Alto, CA
Publisher:
The National Press
Typographer:
Frank's Type
Printer:
The National Press

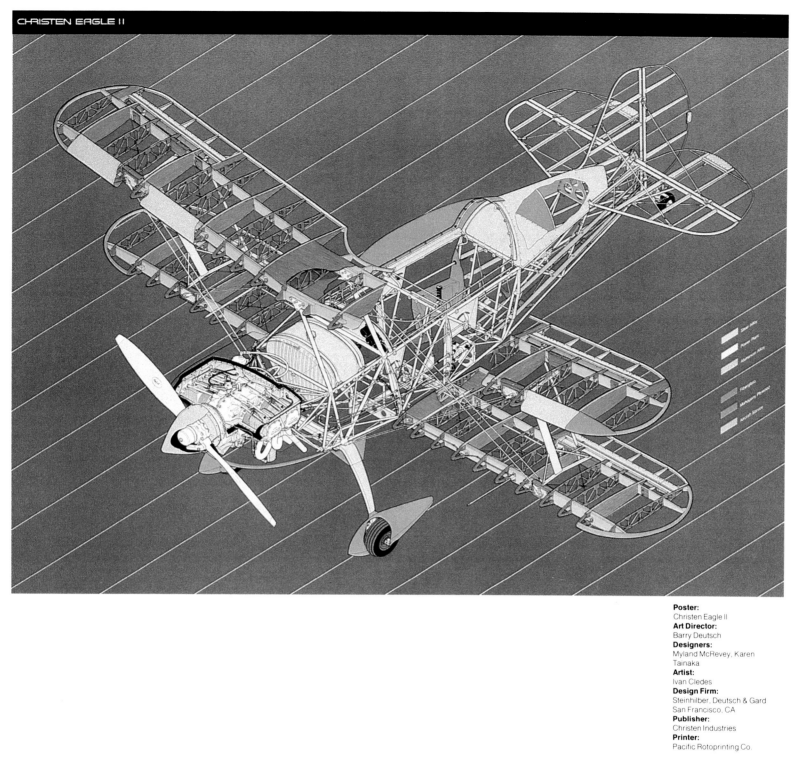

Poster:
Christen Eagle II
Art Director:
Barry Deutsch
Designers:
Myland McRevey, Karen
Tainaka
Artist:
Ivan Cledes
Design Firm:
Steinhilber, Deutsch & Gard
San Francisco, CA
Publisher:
Christen Industries
Printer:
Pacific Rotoprinting Co.

Poster:
Make a Masterpiece
Art Director:
Jeff Barnes
Designer:
Jeff Barnes
Calligrapher:
Tony di Spigna
Design Firm:
Container Corporation of
America Communications
Chicago, IL
Publisher:
Container Corporation of
America Container Division
Typographer:
Ryder Types, Inc.
Printer:
Accurate Silkscreen Co.

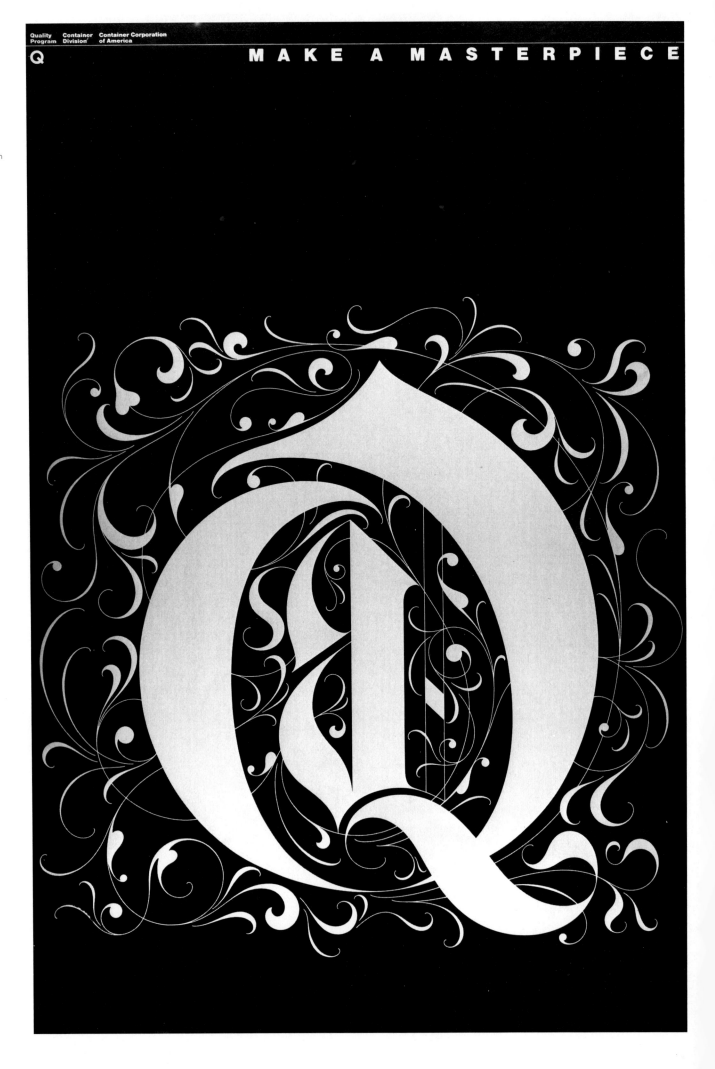

Poster:
Focus on Quality First
Art Director:
Jeff Barnes
Designer:
Jeff Barnes
Artist:
Jeff Barnes
Design Firm:
Container Corporation of
America Communications
Chicago, IL
Publisher:
Container Corporation of
America Container Division
Typographer:
Ryder Types, Inc.
Printer:
Accurate Silkscreen Co.

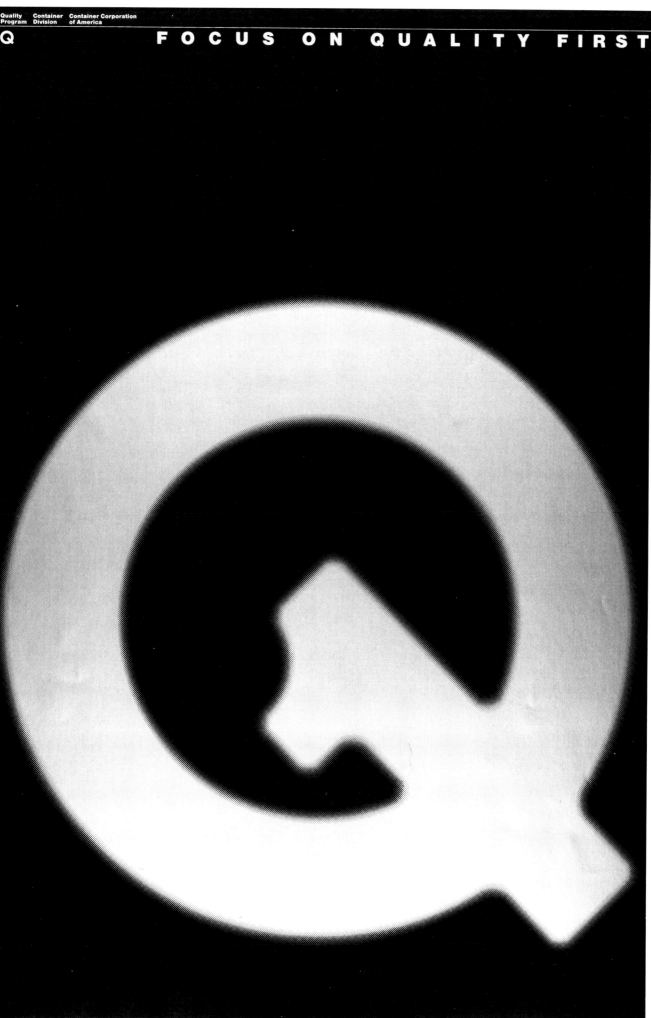

Poster:
Space Party
Art Director:
Michael Vanderbyl
Designer:
Michael Vanderbyl
Design Firm:
Vanderbyl Design
San Francisco, CA
Publisher:
Modern Mode, Inc.
Typographer:
Headliners/Identicolor
Printer:
Litho Smith

S P A C E

A P P L E

Poster:
Space Apple
Art Director:
Michael Vanderbyl
Designer:
Michael Vanderbyl
Design Firm:
Vanderbyl Design
San Francisco, CA
Publisher:
Modern Mode, Inc.
Typographers:
Headliners / Identicolor
Printer:
Litho Smith

Poster:
Garfunkel
Art Director:
John Berg
Designer:
John Berg
Photographer:
Jim Varriale
Design Firm:
CBS Records, New York, NY
Publisher:
CBS Records
Typographer:
Haber Typographers, Inc.
Printer:
Great Lakes Press

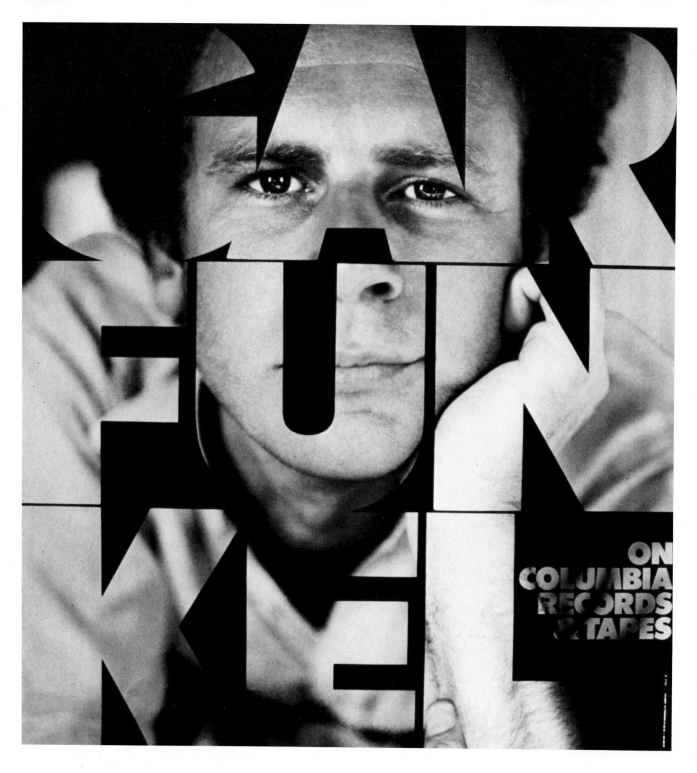

BORROMINI PIRANDELLO BARBERINI VIGNELLI
MORAVIA BOCCIONI COLOMBO PUCCINI RADICE
CROCE DE CARLO PERUZZI CIMABUE PALLADIO
AULENTI GALILEO BRAMANTE BALLA ARMANI
RAGGI MENOTTI FELLINI MENDINI PININFARINA
PAGANINI GIORGIONE NOORDA BERNINI VASARI
CARAVAGGIO BURRI PIRANESI PIERO GIUGIARO
MADERNO NERVI NERONE PASOLINI DONIZETTI
ROSSI TOSCANINI LEOPARDI AGNELLI FERRARI
ORSINI VERDI DONATELLO CENCI SAVONAROLA
FIORUCCI ZEFFIRELLI LIPPI GREGOTTI GUCCI
MAZZEI BRION CERATTO VOLTA SPQR ZANUSO
STRADIVARI GIURGOLA VALENTINO PETRARCA
BRUNELLESCHI BOTTICELLI SCOLA BOCCACCIO
MODIGLIANI CARUSO MANGIONE DE BENEDETTI
GRUCCI CASTAGNOLI PIANO LEONARDO CELLINI
SOTTSASS BERTOLUCCI FERMI CHIGI CASANOVA
BORGIA MARINETTI VALLE ANTONIONI MEDICI
MASACCIO ZEVI ALBERTI WOJTYLA CICERONE
CESARE GARIBALDI BELLINI RESPIGHI MAZZINI
SARTOGO VESPUCCI BENE FALLACI BORGHESE
MACHIAVELLI BARZINI CANOVA SOAVI NICOLAO
FARNESE GIOTTO LOLLOBRIGIDA ECO ROSSINI
CASSINA MARCONI TIZIANO MISSONI ARBASINO
TINTORETTO VILLAGIO VIVALDI QUILICI PESCE
BUGATTI LIONNI BILLESI PECCEI MONTESSORI
RAFFAELLO BODONI OLIVETTI MICHELANGELO
DANTE ETCETERA ETCETERA **THE ITALIAN IDEA**

INTERNATIONAL DESIGN CONFERENCE IN ASPEN 1981 / JUNE 14 TO 19

for information, write:
IDCA
P.O. BOX 664
ASPEN, CO 81611

Poster:
International Design Conference
in Aspen, 1981
Art Director:
George Sadek
Designer:
George Sadek
Photographer:
Thomas Kluepfel
Design Firm:
The Center for Design and
Typography of The Cooper
Union, New York, NY
Publisher:
International Design Conference
Aspen
Typographer:
The Mergenthaler Group of
Companies
Printer:
Sanders Printing Corp.

Poster:
School of Visual Arts
Art Director:
Silas Rhodes
Designer:
Richard Wilde
Artist:
Robert Giusti
Publisher:
School of Visual Arts
New York, NY
Typographer:
Saxon Graphics, Inc.

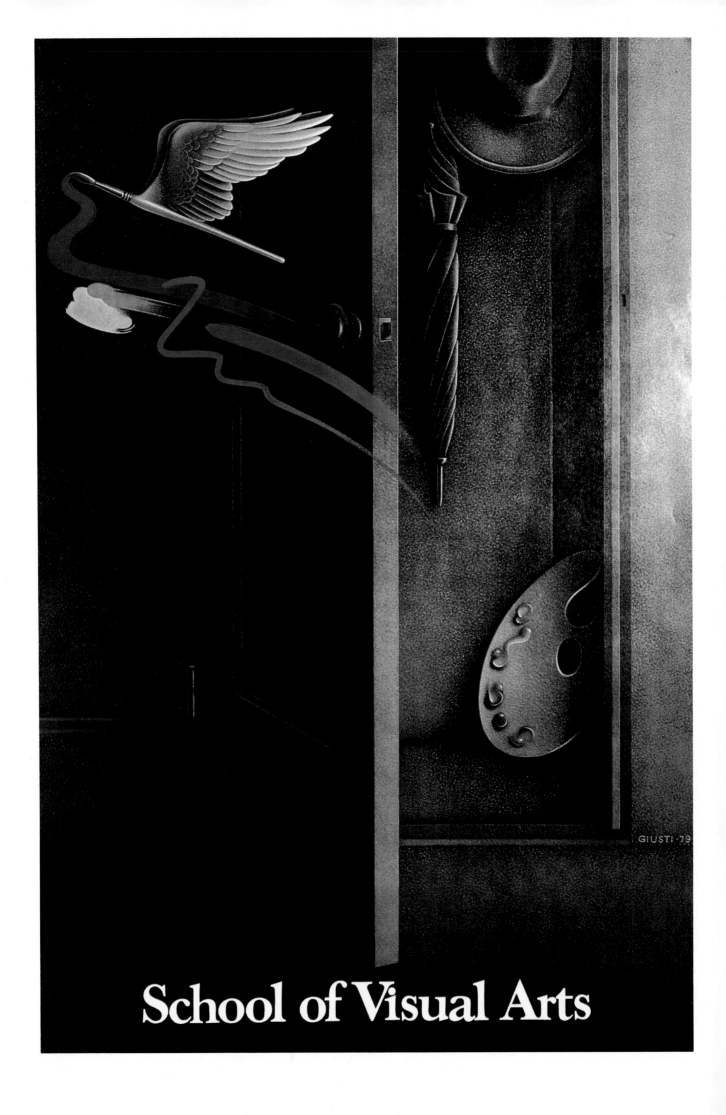

School of Visual Arts

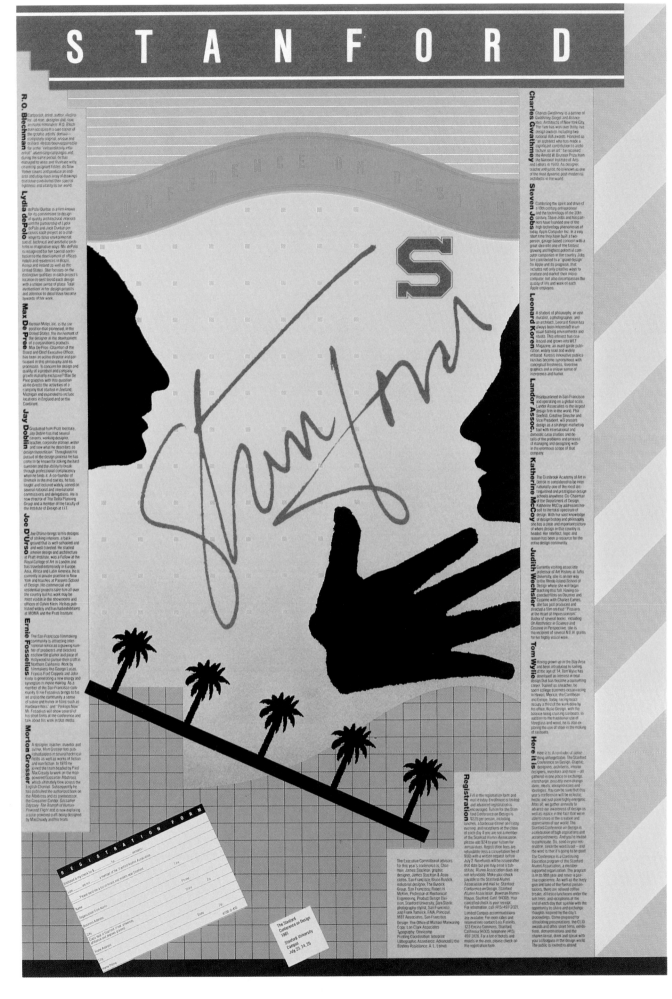

Poster:
The Stanford Design Conference
Art Director:
Michael Manwaring
Designer:
Michael Manwaring
Artists:
Michael Manwaring, Betty Barsamian, Bill Chiaravalle, Karen Fenlon
Design Firm:
The Office of Michael Manwaring, San Francisco, CA
Publisher:
Stanford Alumni Assn.
Typographer:
Omnicomp
Printers:
Advanced Litho, Interprint

Poster:
Fast Start in '82
Art Director:
Bob Salpeter
Designer:
Bob Salpeter
Design Firm:
Bob Salpeter, Inc.
New York, NY
Client:
IBM World Trade Americas /
Far East Corp.
Printer:
P & J Printing Co.

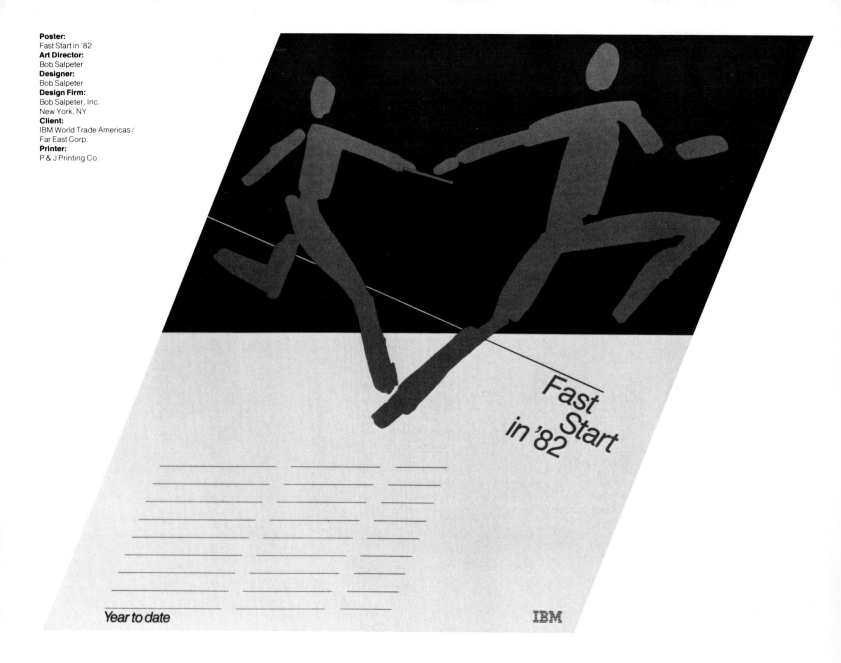

The Impact of Excellence

A symposium
in celebration
of 150 years of
photography
and design:

Peter Bunnell
Cornell Capa
Dr. Harold Edgerton
Morton Goldsholl
Allen Hurlburt
Nathan Lyons
Sidney Rapoport
Pete Turner
Henry Wolf

May 14 & 15
Rochester
Institute
of
Technology

George H. Clark
Memorial
Gymnasium
Rochester, N.Y.

Sponsored by Rochester Institute of
Technology and Eastman Kodak
Company in cooperation with
Professional Photographers of America, Inc.

Poster:
The Impact of Excellence
Art Director:
Henry Wolf
Designer:
David Blumenthal
Photographer:
Henry Wolf
Design Firm:
Henry Wolf Productions
New York, NY
Publisher:
Rochester Institute of
Technology
Typographer:
Haber Typographers, Inc.
Printer:
Rochester Institute of
Technology

Poster:
Trust Elvis
Art Director:
Paula Scher
Designer:
Paula Scher
Design Firm:
CBS Records, New York, NY
Publisher:
CBS Records
Typographer:
Haber Typographers, Inc.
Printer:
Typographic Communications,
Inc.

TRUST

COSTELLO on COLUMBIA

ELVIS

Poster:
California Public Radio
Art Director:
Michael Vanderbyl
Designer:
Michael Vanderbyl
Design Firm:
Vanderbyl Design
San Francisco, CA
Publisher:
California Public Radio
Typographer:
Headliners / Identicolor
Printer:
Pischoff Co.

Poster:
American Film Market
Art Director:
Brian D. Fox
Designer:
Mark Matsuno
Artist:
Delana Bettoli
Design Firm:
B.D. Fox & Friends, Inc.
Hollywood, CA
Publisher:
American Film Market Assn.
Typographer:
Cliff Typographers, Inc.
Printer:
Kater Lithograph Co.

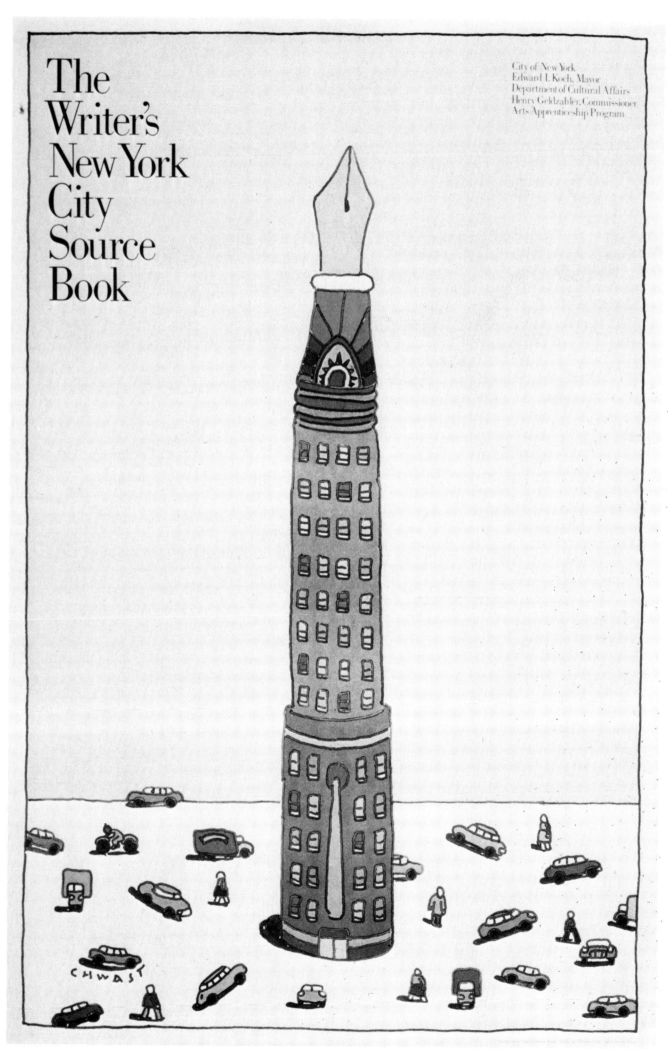

The
Writer's
New York
City
Source
Book

City of New York
Edward I. Koch, Mayor
Department of Cultural Affairs
Henry Geldzahler, Commissioner
Arts Apprenticeship Program

Poster:
The Writer's New York City
Source Book
Art Director:
Toshiaki Ide
Designer:
Seymour Chwast
Artist:
Seymour Chwast
Design Firm:
Push Pin Studios, Inc.
New York, NY
Publisher:
New York City Department of
Cultural Affairs
Typographer:
Toshiaki Ide
Printer:
Collier Graphic Services

Poster:
Voyager at Saturn—The Rings
Art Directors:
Ken White, Tak Kiriyama
Designer:
Ken White
Photographer:
National Aeronautics and
Space Administration
Design Firm:
Ken White Design Office,
Inc., Los Angeles, CA
Publisher:
NASA / Jet Propulsion
Laboratory
Typographer:
N. & S. Typographics
Printer:
The Ink Spot

Voyager at **Saturn**

The Rings

Saturn's rings encircle the planet with elegant precision. At top, the shadow of Saturn falls across the rings, while below left, the shadow of the rings falls across Saturn. At right, the color-enhanced images showing the underside of the rings reveal previously unknown detail. Voyager discovered that Saturn's rings are composed of hundreds of tiny ringlets.

NASA
National Aeronautics and
Space Administration
Jet Propulsion Laboratory
California Institute of Technology
Pasadena, California

Poster:
Weltspartag (World Savings Day)
Art Director:
Ivan Chermayeff
Designer:
Ivan Chermayeff
Photographer:
Gustavo Candelas
Design Firm:
Chermayeff & Geismar Assoc.
New York, NY
Client:
Sparkasse Bank, Germany
Typographer:
Haber Typographers, Inc.

The Mountain People

For thousands of years, Colorado's mountains and western slope, as well as nearby parts of Utah and Wyoming, were the home of the Ute. The people we call the Ute were actually several groups of people who spoke different forms of the same language and lived in peace with each other. The map below shows the names of some of these groups and where they lived. Each of these groups was made up of smaller groups of people who camped together in their favorite areas.

The Ute people were nomads. They made their living according to the season: when animals were plentiful, they hunted; when berries were ripe, they gathered them, and so on. During the warm months of the year, the Ute traveled in the mountains, hunting and gathering food. In winter, they moved into the warmer valleys to live. By drying some of the meat and plants they collected, the Ute stored enough food to last through the long snows.

The Ute felt they lived a pleasant life in their beautiful environment. The rough, rocky ground of the mountains made it difficult for enemies to find and attack them. Their ideas about government were not strict; if you were unhappy with your chief, you were free to move to another group. And because the Ute believed it was unlucky to own many things, no one was looked upon as rich or poor.

The Ute enjoyed sports very much. When Spanish people began to bring horses to North America about 300 years ago, the Ute became great horse racers and gamblers and often traveled long distances to hold contests with other tribes.

Poster:
Colorado's Native Americans
Posters: The Mountain People
Poster #3
Art Directors:
Katherine and Michael McCoy
Designers:
Katherine and Michael McCoy
Design Assistants:
Tony Woodward, Karen Krieger
Photographers:
Katherine McCoy,
William Henry Jackson
Design Firm:
McCoy & McCoy
Bloomfield Hills, MI
Publishers:
Denver Art Museum, Barbara
Thompson and Richard Conn
Typographer:
Lettergraphics, Inc.
Printer:
Signet, Inc.

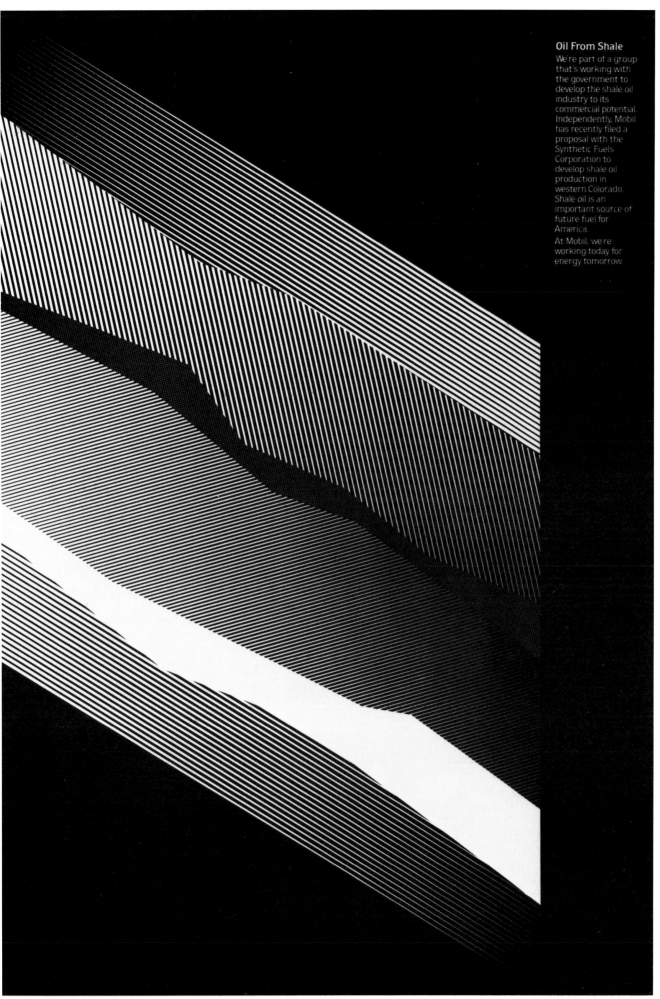

Oil From Shale

We're part of a group
that's working with
the government to
develop the shale oil
industry to its
commercial potential.
Independently, Mobil
has recently filed a
proposal with the
Synthetic Fuels
Corporation to
develop shale oil
production in
western Colorado.
Shale oil is an
important source of
future fuel for
America.

At Mobil, we're
working today for
energy tomorrow.

Poster:
Oil from Shale
Art Director:
Ilona Sochynsky
Designer:
Ilona Sochynsky
Design Firm:
Ilona Sochynsky Assoc.
New York, NY
Publisher:
Mobil Oil Corp.
Typographer:
M.J. Baumwell Typography
Printer:
Crafton Graphic Co., Inc.

Poster:
Cloud Hands II
Art Director:
Joseph M. Essex
Designer:
Joseph M. Essex
Artist:
Joseph M. Essex
Design Firm:
Burson-Marsteller Design
Group, Chicago, IL
Publisher:
Cloud Hands
Typographer:
Shore Typographers
Printer:
Nu-Tone Printing

Poster:
Katz & Dogs
Art Director:
Woody Pirtle
Designer:
Woody Pirtle
Photographer:
John Katz
Design Firm:
Woody Pirtle, Inc.
Dallas, TX
Client:
John Katz Photography
Typographer:
Southwestern Typographics,
Inc.
Printer:
Williamson Printing Corp.

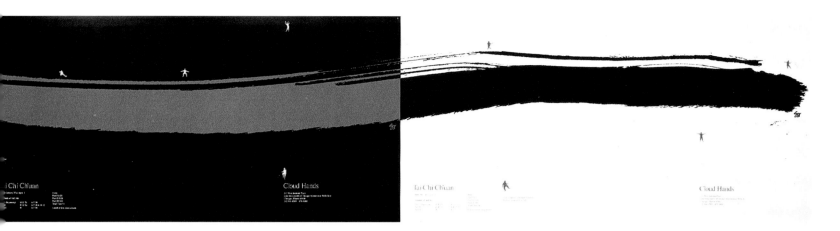

i Chi Ch'üan

Cloud Hands

Tai Chi Ch'üan

Cloud Hands

"Put Your Money Where Your House Is... Invest at Hechinger" or "The Hechinger Cure for Inflation and High Interest Costs: Have a New Home at your Old Address." In response to skyrocketing fuel bills and the need to conserve energy we have run ad campaigns on conservation and energy saving items, with special emphasis on merchandise that qualifies for Federal Tax credits under the IRS Residential Energy Credit Provision. Last summer many Americans were forced to spend their vacations at home due to the cost of gasoline and the cost of living. We encouraged them to "Have a Gas Saving Backyard Vacation"–offering specials on items ranging from barbecues and lounge

furniture to all the materials needed to build or remodel patios and decks.

Hechinger has been the Household word in the Washington, D. C., Metropolitan Area for 70 years, but as we expand away from our original base, we face the problem of telling our new customers who we are, where we are, and what we carry. The introduction into a new market area is one of the most challenging and important jobs of an advertising and promotion plan. Our two primary advertising vehicles–the tabloid and run-of-paper ads–are key ingredients in the success we have had so far. They are both microcosmic Hechinger stores in print. These in combination with the radio promos, local community promo-tions (contests, ceremonies, etc.) have made our acceptance and penetration into new communities extremely successful.

Real Estate and Construction
The Hechinger Company's Real Estate and Construction operations stress market dominance in the selection of convenient and highly visible locations and construc-tion of safe, efficient and inviting stores.

In terms of expansion, 1980 was partic-ularly exciting and eventful. The Company marked its initial entry into two major new markets. In September we opened our first store in Richmond, Virginia. The site, located near a major regional mall on U.S. Route 60, features a prototype Hechinger store plus 24,000 square feet of small tenant space.

Construction began on our first two stores in the Philadelphia market. Our first store, located along a major retail corridor just north of Jenkintown, Pennsylvania, opened in March of this year. The second store is located in Buck's County, Pennsyl-vania, adjacent to the Oxford Valley Mall, and is scheduled for a Spring 1981 opening.

We opened a new store in Bethesda, Maryland, across from the highly successful Montgomery Mall. The Montgo-mery Mall store is complemented with 34,000 square feet of small tenant space.

Construction was completed on a full-sized prototype store which opened in February in the Hechinger Mall. Scheduled for a Spring opening, this new inner-city mall is located at the site of our former Headquarters in Northeast Washington, just 15 blocks from the Capitol, and will service one of the most exciting upwardly mobile areas of any urban area, Capitol Hill.

Plans for 1981 are already in the works. Design has been completed on a second Richmond store; construction begins in the

spring. Additional stores in the Baltimore and Philadelphia Metropolitan Areas are now in the planning stages.

The Real Estate and Construction Departments continue to meet the challenge of providing locations and store plans that will meet our high standards for efficient operation and quality customer service.

Credit
Because we are interested in meeting the very different needs of our customers, we offer an extensive range of credit and payment plans. In the stores, customers have the option of paying with the Hechinger Charge Card, Visa, Master Card, and the new Choice Card. Having a Hechinger Charge Account provides a customer with great flexibility in his payment plans. For example, major purchases may be added to a 36-month

level payment account, with lower terms than the regular option account. We are able in Hechinger Builders to offer 15-year terms for major remodeling and home improvement projects–an ability which gives us dominance in that field. And, despite the economic pressures of inflation and increasing energy costs, we have experienced very little increase in our percentage of delinquent accounts. Our homeowner customers are a very stable population–a reason why our industry, in general, and Hechinger, in particular, has been called recession resistant.

Oil base paint and oil base paint brushes, latex paints and latex brushes, flat brushes, thin brushes, enamel paint and flat brushes for masonry, brushes for stains, rollers, trays, painting pads, foam rubber applicators, edging tools... We have in our Paint Department over 200 different kinds of painting tools and varieties of paints, stains and finishes non-paint, in national and Hechinger brands. There is no faster or simpler way a person can put his or her own stamp on a house than with a coat of paint. So if a person has always wanted a purple porch, a chartreuse bathroom or a pink recreation room, he can find no more thorough or professional paint store than the Hechinger paint department. Possibly our professionals might even discourage that purple porch.

Annual Report:
Hechinger Co. Annual Report
Year Ended January 31, 1981
Art Director:
Ivan Chermayeff
Designer:
Steve Jenkins
Photographer:
Chris Jones
Design Firm:
Chermayeff & Geismar Assoc.
New York, NY
Client:
Hechinger Co.
Typographer:
Cardinal Type Service, Inc.
Printer:
Sanders Printing Corp.

Poster:
Ink Tank
Art Director:
Seymour Chwast
Designer:
Seymour Chwast
Artist:
Seymour Chwast
Design Firm:
Push Pin Studios, Inc.
New York, NY
Publisher:
Ink Tank
Typographer:
Haber Typographers, Inc.
Printer:
Appleton Press

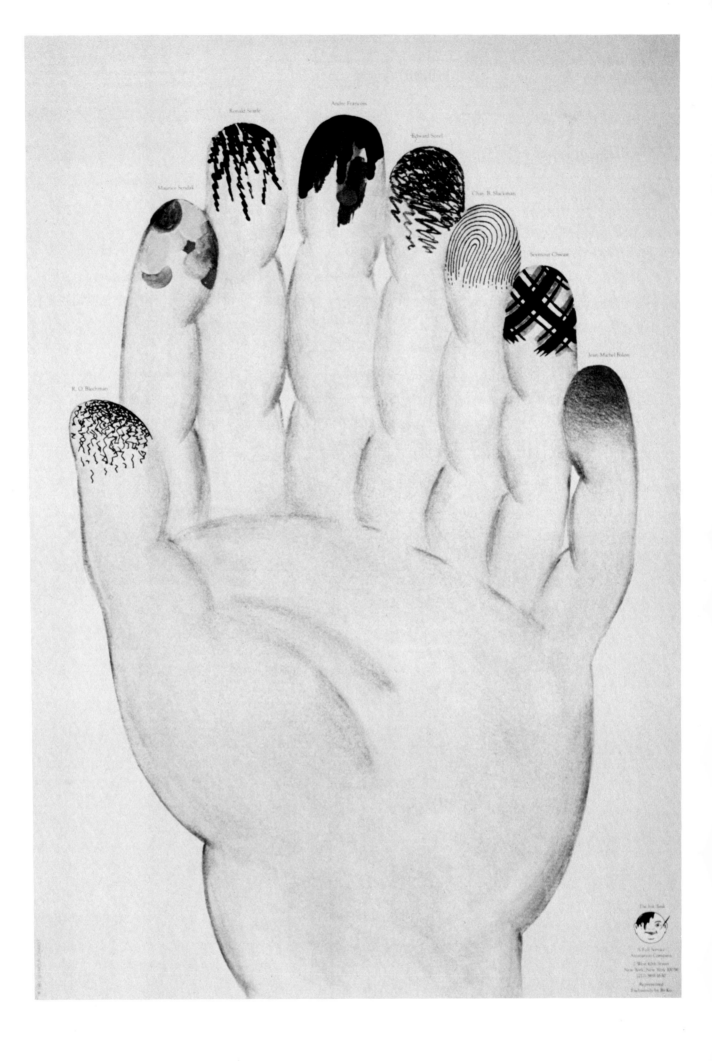

THE ORIGINAL DALLAS BISTRO IS STILL THE BEST OF THE BUNCH. THE GRAPE. 2808 GREENVILLE AVENUE. DALLAS, TEXAS 75206 (214) 823-0133

T
H
E

G
R
A
P
E

Poster:
The Grape
Art Director:
Woody Pirtle
Designer:
Woody Pirtle
Artist:
Woody Pirtle
Design Firm:
Woody Pirtle, Inc.
Dallas, TX
Client:
The Grape Restaurant
Typographer:
Southwestern Typographics,
Inc.
Printer:
Inky Fingers

Poster:
Dogwood Arts Festival
Designer / Artist:
Rebecca Inman
Publisher:
Knoxville Dogwood Arts
Festival, Knoxville, TN
Sponsor:
Mobil Oil Corp.
Printer:
Accurate Silkscreen Co.

Poster:
Prudence . . . Conserve
Art Director:
Kurt W. Gibson
Designer:
Kurt W. Gibson
Photographer:
Balfour Walker
Design Firm:
IBM Tucson Design Center
Tucson, AZ
Publisher:
IBM Corp.
Typographer:
Tucson Typographic Services,
Inc.
Printer:
Woods Lithography Co.

Poster:
Gary Myrick
Art Director:
Carin Goldberg
Designer:
Carin Goldberg
Design Firm:
CBS Records, New York, NY
Publisher:
CBS Records
Typographer:
Haber Typographers, Inc.
Printer:
Gramercy Lane Offset, Inc.

Poster:
One Night Stand
Art Director:
Allen Weinberg
Designer:
Allen Weinberg
Artist:
David Wilcox
Design Firm:
CBS Records, New York, NY
Publisher:
CBS Records
Typographer:
Haber Typographers, Inc.
Printer:
Atwater Press

Poster:
Industrial Design
Excellence Awards 1981
Art Director:
Bart Crosby
Designer:
Bart Crosby
Photographer:
Georg Bosek
Design Firm:
Crosby Associates, Inc.
Chicago, IL
Publisher:
Industrial Designers
Society of America
Typographer:
King Typographic Service
Printer:
Rohner Printing Co.

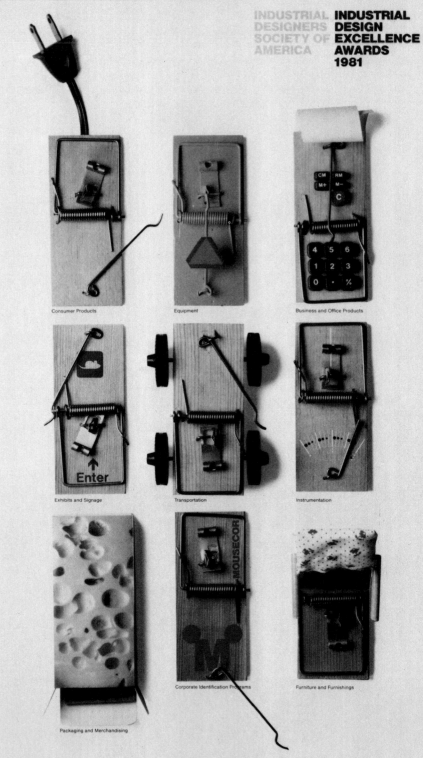

The Oakland Ballet 1981

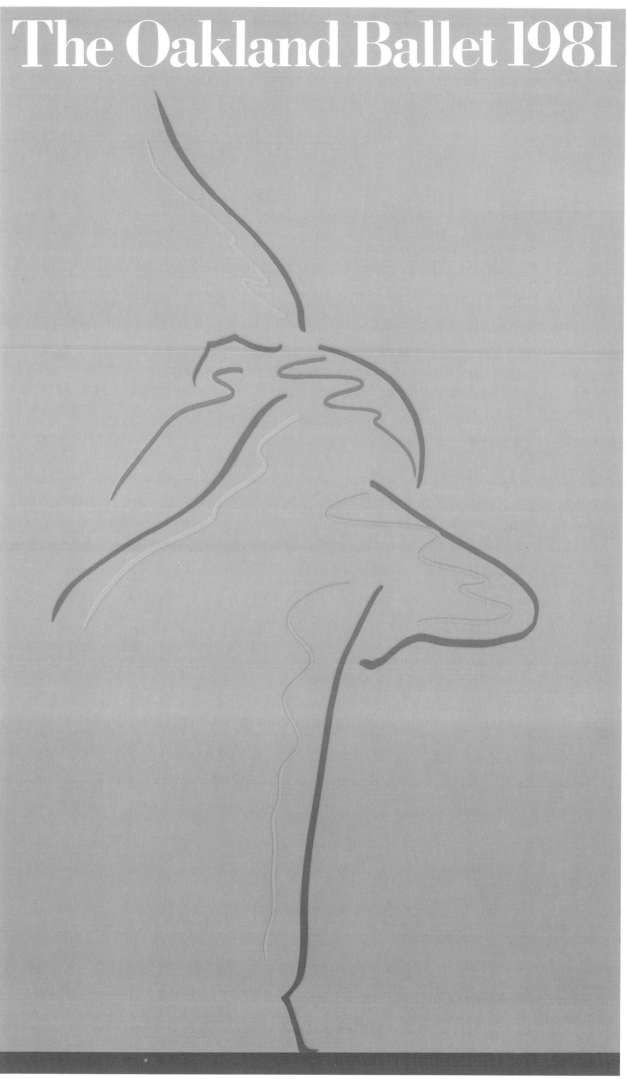

Poster:
Oakland Ballet 1981
Art Director:
John Casado
Designer:
John Casado
Artist:
John Casado
Design Firm:
Casado Design
San Francisco, CA
Publisher:
Oakland Ballet Co.
Typographer:
Reprotype Advertising
Typography
Printer:
Clyde Engle Silkscreen Co.

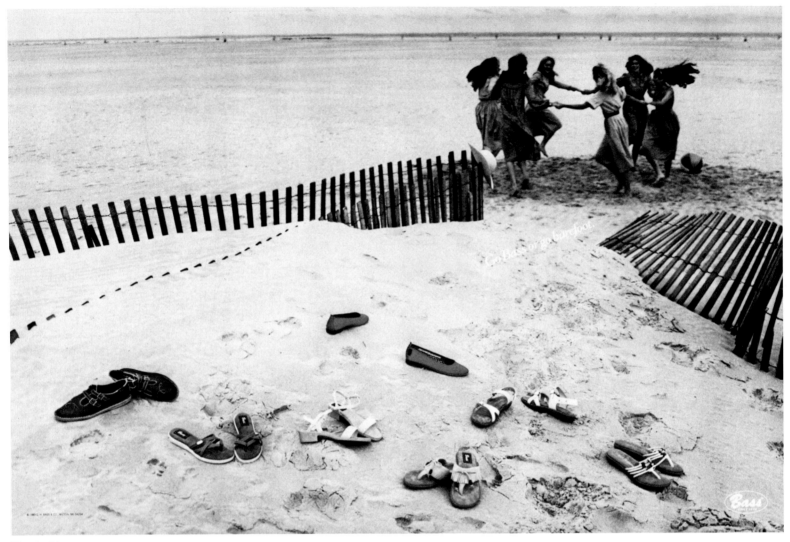

Magazine Ad:
Go Bass or Go Barefoot
Art Director:
Susan Casey
Designer:
Susan Casey
Photographer:
Barry Lategan
Design Firm:
Lord, Geller, Federico, Einstein,
Inc., New York, NY
Client:
G.H. Bass & Co.
Typographers:
Techni-Process Lettering, Inc.,
The Type Group, Inc.
Printer:
Sterling Regal, Inc.

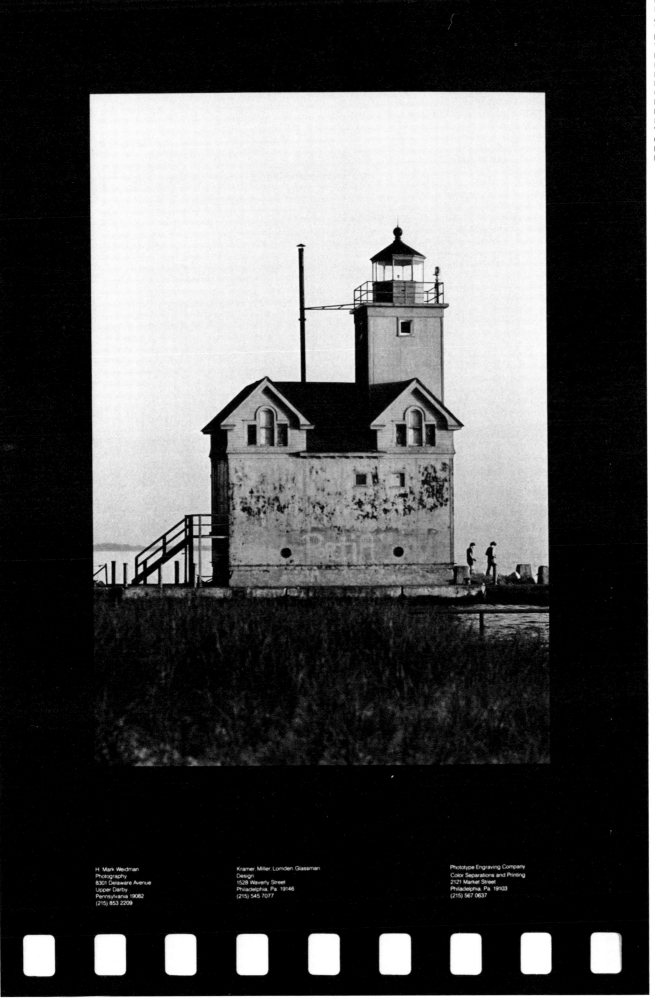

Poster:
Portia
Art Director:
Ted Miller
Designer:
Ted Miller
Photographer:
H. Mark Weidman
Design Firm:
Kramer, Miller, Lomden,
Glassman Designs
Philadelphia, PA
Publisher:
Phototype Engraving Co.
Typographer:
Composing Room
Printer:
Phototype Engraving Co.

H. Mark Weidman
Photography
8301 Delaware Avenue
Upper Darby
Pennsylvania 19082
(215) 853 2209

Kramer, Miller, Lomden, Glassman
Design
1528 Waverly Street
Philadelphia, Pa. 19146
(215) 545 7077

Phototype Engraving Company
Color Separations and Printing
2121 Market Street
Philadelphia, Pa. 19103
(215) 567 0637

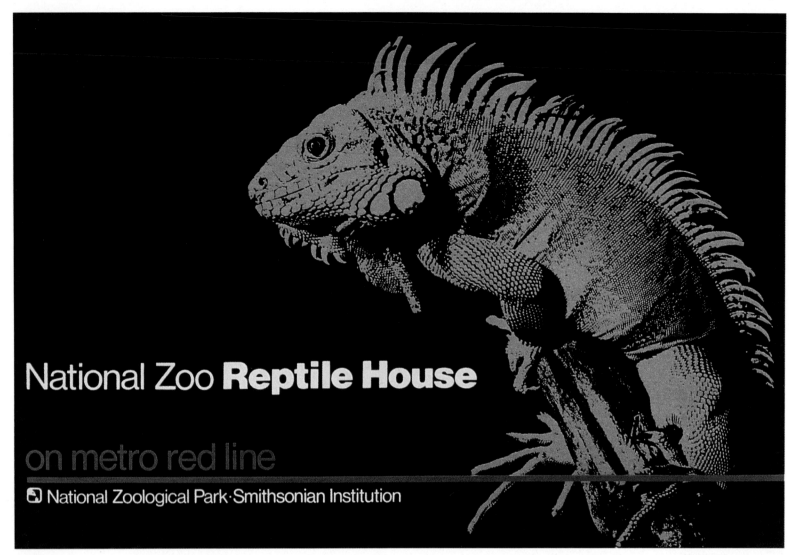

National Zoo **Reptile House**

on metro red line

National Zoological Park·Smithsonian Institution

Poster:
Iguana
Art Directors:
Robert Mulcahy,
Virginia Mahoney
Designer:
Ramona Hutko
Artist:
Jessica Cohen
Design Firm:
Smithsonian Institution,
Office of Graphics & Exhibits,
Washington, DC
Publisher:
National Zoological Park
Typographer:
Artisan Typographers
Printer:
Smithsonian Institution,
Office of Graphics & Exhibits

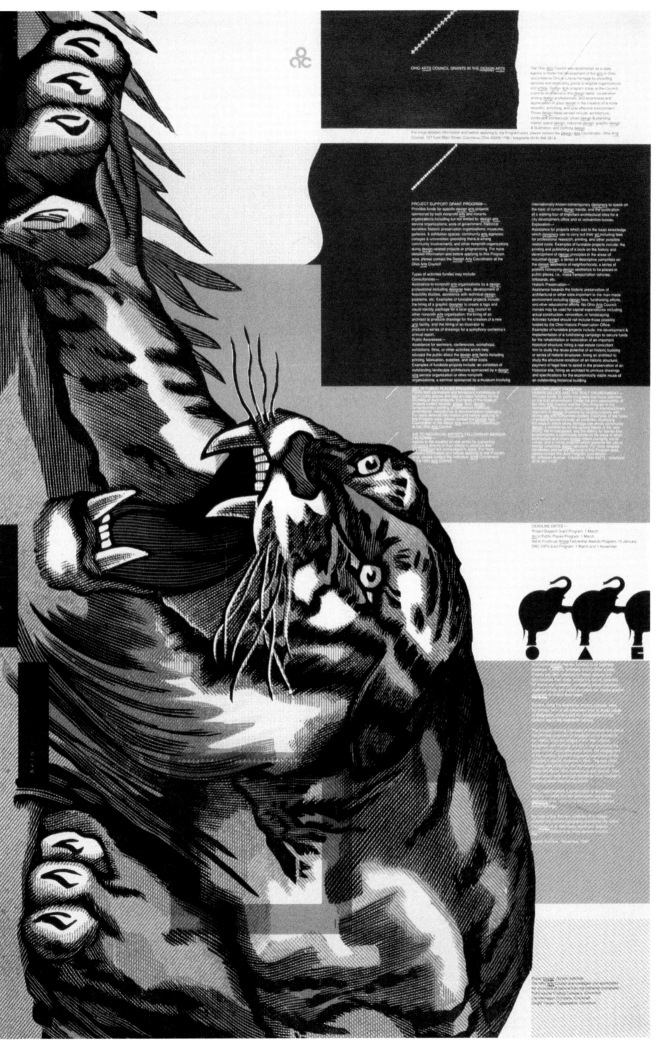

Poster:
Ohio Arts Council Grants in the
Design Arts
Art Director:
Gordon Salchow
Designer:
Gordon Salchow
Artist:
Unknown
Design Firm:
Gordon Salchow Design
Cincinnati, OH
Publisher:
Ohio Arts Council
Typographer:
Dwight Yaeger
Printers:
The Hennegan Co.,
The Enquirer Printing Co.

Poster:
Pente
Art Director:
Woody Pirtle
Designer:
Woody Pirtle
Photographer:
Chuck Untersee
Design Firm:
Woody Pirtle, Inc.
Dallas, TX
Publisher:
Pente Games, Inc.
Typographer:
Southwestern Typographics, Inc.
Printer:
Williamson Printing Corp.

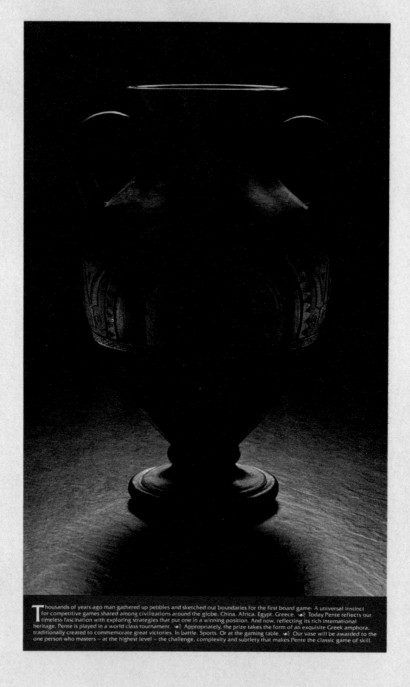

Thousands of years ago man gathered up pebbles and sketched out boundaries for the first board game: A universal instinct for competitive games shared among civilizations around the globe. China. Africa. Egypt. Greece. ❧ Today Pente reflects our timeless fascination with exploring strategies that put one in a winning position. And now, reflecting its rich international heritage, Pente is played in a world class tournament. ❧ Appropriately, the prize takes the form of an exquisite Greek amphora, traditionally created to commemorate great victories. In battle. Sports. Or at the gaming table. ❧ Our vase will be awarded to the one person who masters — at the highest level — the challenge, complexity and subtlety that makes Pente the classic game of skill.

P E N T E

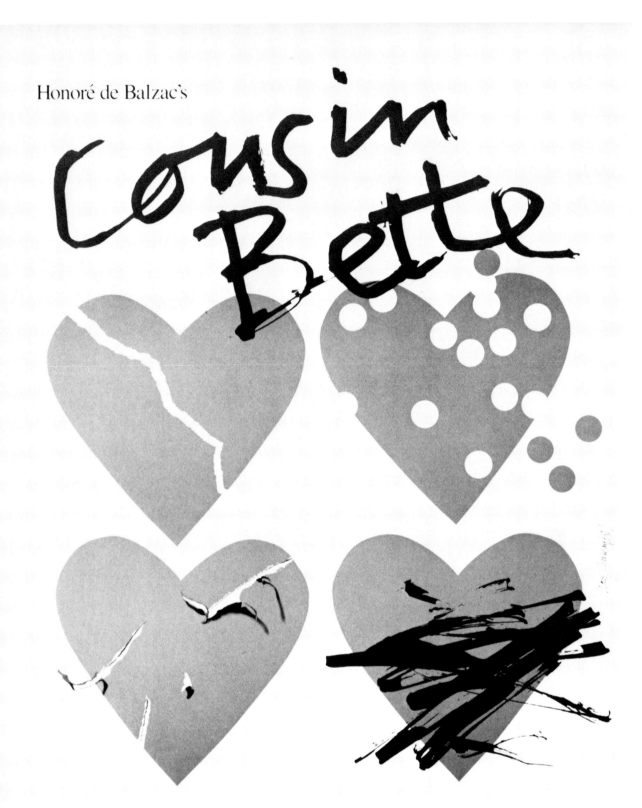

Honoré de Balzac's

Cousin Bette

'Sweet Cousin Bette'
thought only of her family-
and their destruction

Mobil Masterpiece Theatre Festival of Favorites

A five-part television series beginning June 14
Sundays at 9 PM Channel 13 PBS

Mobil

Poster:
Cousin Bette
Art Director:
Ivan Chermayeff
Designer:
Karen Lewis
Artist:
Ivan Chermayeff
Design Firm:
Chermayeff & Geismar Assoc.
New York, NY
Client:
Mobil Oil Corp.
Typographer:
Print and Design
Printer:
Crafton Graphic Co., Inc.

Promotional Literature:
The Color Grid:
The Chromatics
Art Directors:
Michael Abramson,
Lawrence Wolfson
Designer:
Lawrence Wolfson
Design Firm:
Michael Abramson & Assoc.,
Inc., New York, NY
Client:
Formica Corp.
Typographer:
Concept Typographic
Services, Inc.
Printer:
Alfred Walker AG

The Chromatics

The Neutrals

The Color Grid

The Chromatics

The Neutrals

Formica Corporation

Annual Report:
Corning Glass Works
Annual Report 1981
Art Directors:
Juan Pablo Lopez-Bonilla,
William Kessler
Designer:
Juan Pablo Lopez-Bonilla
Photographers:
William Farrell, Jerry
Sarapachiello
Design Firm:
Corporate Design
Corning Glass Works
Corning, NY
Publisher:
Corning Glass Works
Typographer:
Partners Composition
Printer:
Thorner Sidney Press

OMEGA
OPTICAL
CO., INC.
ANNUAL
REPORT
1980

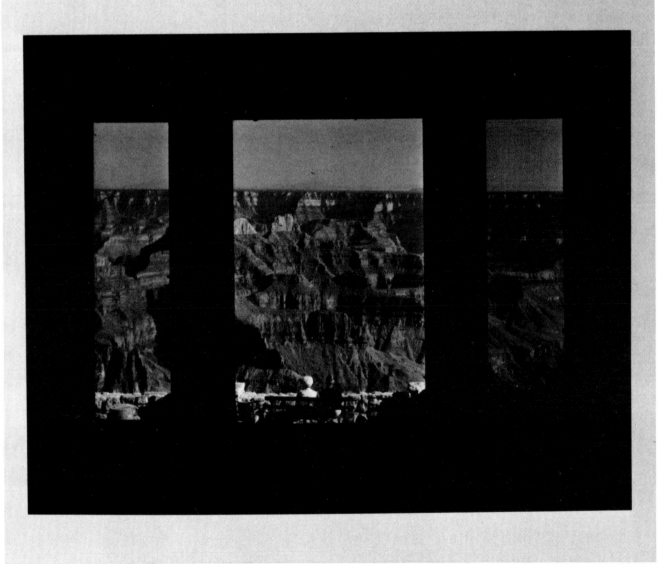

Annual Report:
Omega Optical Co., Inc.
Annual Report 1980
Art Director:
Woody Pirtle
Designer:
Woody Pirtle
Photographer:
John Pfahl
Design Firm:
Woody Pirtle, Inc.
Dallas, TX
Client:
Omega Optical Co., Inc.
Typographer:
Southwestern Typographics, Inc.
Printer:
Williamson Printing Corp.

Annual Report:
Norlin Annual Report for 1980
Art Directors:
Ivan Chermayeff,
Steff Geissbuhler
Designer:
Steve Jenkins
Photographer:
Chris Jones
Design Firm:
Chermayeff & Geismar Assoc.
New York, NY
Client:
Norlin Corp.
Typographer:
Haber Typographers, Inc.
Printer:
Sanders Printing Corp.

Annual Report for 1980

Norlin

Dayton Hudson Corporation

Community Giving: 1966–1980
A Fifteen Year Report

Annual Report:
Dayton Hudson Corp.
Communal Giving 1966–1980
15-Year Report
Art Director:
Kevin Bernstein Kuester
Artist:
Ivan Chermayeff
Design Firm:
Chermayeff & Geismar Assoc.
New York, NY
Client:
The Dayton Hudson Foundation

Annual Report:
Macmillan 1980 Annual Report
Art Directors:
Philip Gips, Aubrey Balkind
Designers:
Philip Gips, Jane Cullen
Photographers:
John Hill, Greg Edwards
Design Firm:
Gips + Balkind + Assoc., Inc.,
New York, NY
Client:
Macmillan, Inc.
Typographer:
Innovative Graphics
International
Printer:
S.D. Scott Printing Co., Inc.

Macmillan

1980 Annual Report

Macmillan's publishing operations produce elementary, high school, and college textbooks and instructional materials; professional reference books; general books; home reference materials and specialized data and information services for the education, consumer, and business markets.

Macmillan publishes many books for children. The Acorn Magic Readers is a unique series which enables parents to help young children learn word recognition.

Merit Students Encyclopedia, a 20-volume reference work, is aimed at elementary and junior high school students.

The Macmillan School Division launched a major effort to expand its position in the high school textbook market. A four-year English program, Grammar and Writing, was successfully introduced in 1980.

| (dollars in millions) | | |
Sales		% of total
1980	$240.0	42.4%
1979	224.6	42.4
1978	200.4	42.5

School

Macmillan is an industry leader in textbook publishing for elementary and high-school markets. Sales of textbooks and instructional materials account for the largest share of the Company's total publishing revenues.

Over the past few years many school districts have focused efforts on improving or solidifying basic core curriculum at the elementary school level. With its *SERIES r* (reading), *SERIES m* (mathematics), and *SERIES E* (English), Macmillan has well-developed, comprehensive programs that meet this ongoing demand. Basic elementary-level textbooks and instructional programs constitute the single most important area of Macmillan's School Division sales.

SERIES E has continued to generate favorable response throughout the country since its introduction in 1979. The English program received approximately one-half the adoptions by California school districts for 1981.

SERIES r, a multi-component reading series first marketed in 1975 and revised substantially in 1980, was adopted with the number one rating by the Texas State Textbook Committee last year.

SERIES m, introduced in 1976 and revised initially in 1978, is undergoing a major revision for 1982. The basal mathematics program has performed well in all states and has contributed successfully to gains in sales since its inception.

Also contributing to record revenues in 1980 were *Macmillan Social Studies,* an elementary-level program, *The Spectrum of Music,* and four school dictionaries.

In 1980 the Macmillan School Division launched a major effort to expand its position in the high school market. The Division established new programs for this market, including *Grammar and Writing,* a four-year English program, *Global Geography,* and

Macmillan Biology. Also issued was the tenth edition of *A History of a Free People,* a major American history text.

College

The Macmillan College Division publishes textbooks and related supplementary materials for undergraduate and graduate courses in almost all academic disciplines. With sales in international as well as domestic markets, the Division completed a successful year in 1980.

During the past few years, the College Division has placed an emphasis on developing textbooks for specific career-oriented courses in areas that are benefiting from recent enrollment increases, such as engineering, nursing, and business. Among the new titles included in the 1980 college publishing program are: Muvdi and McNabb, *Mechanics of Materials;* Smith, *Management;* and Atkinson, *Understanding the Nursing Process.* The Division also produced its first textbooks for real estate courses with the publication of Hines, *Real Estate Investment* and Stellmacher, *Cases in Real Estate Practice.*

The 1980 list included new editions of book titles that have become leaders in their individual markets over the years, including Giesecke et al., *Technical Drawing;* McMichael, *Anthology of American Literature;* Owen, *Natural Resource Conservation;* Beach, *Personnel;* Goodman, *Analytic Geometry and the Calculus;* and Noss, *Man's Religions.*

Professional

Macmillan's Professional Books Division publishes books and other instructional materials for use by professionals in business, government, academia, and private practice. Major titles published in 1980 included:

Basic elementary school programs in reading, English, and mathematics are the School Division's most important areas. In 1980 the SERIES r reading program was adopted with the number one rating by the Texas State Textbook Committee.

Annual Report:
Dow Jones & Co., Inc.
Annual Report 1980
Art Director:
Bruce Blackburn
Designers:
Gary Skeggs, Bruce Blackburn
Photographer:
Bob Colton
Design Firm:
Danne & Blackburn, Inc.
New York, NY
Client:
Dow Jones & Co.
Typographer:
Pastore DePamphilis
Rampone, Inc.
Printer:
Raleigh Lithograph Co.

Dow Jones & Company, Inc.

Annual Report 1980

**Community
Involvement**
Publishers and editors
at Ottaway Newspapers, the company's
community newspaper
publishing subsidiary,
stay in close touch with
readers and local civic
leaders. Scott Ringstead, left, publisher of
The Cape Cod Times in
Hyannis, Mass., and

editor William Breisky,
right, are shown here
discussing a redevelopment project with
Hyannis citizens. Second from left is Tom
Vetorino, a local fisherman; at center is W. Van
Northcross, executive
director of the Downtown Hyannis Association, second from right
is Rob Nelson, a
Hyannis businessman.

**International
Newswires**
AP-Dow Jones, the
company's international
business and economic newswire service operated with The
Associated Press, is
sold in some 40 countries throughout the
world.

**International
Marketing**
Dow Jones International Marketing
Services has two
responsibilities. It sells
advertising for Dow
Jones publications in
foreign countries, and
its personnel represent
foreign publications in
the U.S. and other
countries.

**Modern Plants,
Offices**
New offices and publishing plants being built
by Dow Jones are modern, cost-efficient and
tastefully designed.
Special attention is paid
to being a good corporate citizen in the communities where Dow
Jones has operations.

**College Textbook
Publishing**
Richard D. Irwin, Inc.,
Dow Jones' textbook
publishing subsidiary,
initiated a number of
moves in 1980 to stay in
the forefront of the
industry. To meet the

changing needs of college students, books
were published in new
sizes and formats,
with lively graphics and
easy-to-read, more
practical content. For
the decade ended with
the 1979-79 academic
year, the number of students taking degrees in
business and management subjects — Irwin's

principal area of specialty — increased by
127.7%, compared with
a rise of only 51.5%
in overall academic
degrees.

**Advances At
Barron's**
Barron's, Dow Jones'
business and financial
weekly, continued to
post gains in 1980. New
coverage was added
as the magazine moved
to build on its strength
as a publication that
reports on investment
markets. Circulation
at year-end stood at a
record 264,100.

**Equipment
Maintenance**
Highly skilled Dow
Jones technicians
based in 68 cities in the
U.S. and Canada service teleprinters, video
terminals and similar
communications equipment owned by Dow
Jones and nearly 20
other companies.

16

17

**In Touch
With Readers**
Dow Jones publications
strive to stay in touch
with readers. In Hyannis,
Mass., for example, the
Cape Cod Times in 1980
introduced an ombudsman column to answer
reader inquiries about
the paper's policies,
news coverage and

other matters. Robert
Boles, seated, originated the column; it is
now written by Anne
Farrow, standing.

**Satellite
Communications**
Dow Jones will own
two transponders
on a Westar V satellite
scheduled to be
launched in 1982. These
transponders eventually
will connect 17 Wall
Street Journal printing
plants and also be used
for other Dow Jones
communications needs.

**Newsprint
Ventures**
Dow Jones has an
equity interest in two
newsprint mills, one in
Quebec and another
near Richmond, Va. The

mills assure an important source of supply to
the company and provide a hedge against
rising newsprint prices
in that an increase in
paper costs for Dow
Jones publications is in
part offset by higher
earnings from the newsprint mills.

**Ottaway
Newspapers**
The 20 community
newspapers published
by Ottaway Newspapers have long been

dedicated to excellence
in local news coverage.
In 1980, total circulation
of Ottaway Newspapers
passed the 500,000
mark for the first time,
reflecting the group's
commitment to editorial
quality and reader
service.

**Technological
Advances**
Technology, which plays
a key role in Dow
Jones' ability to publish
newspapers and deliver
timely services, continued to advance in 1980.
Work is under way in
Dow Jones labs to
develop a laser scanner
that will speed the production process. Such
advances are expected
to help pave the way
for even greater efficiencies in newspaper production.

**Innovative Sales
Techniques**
Dow Jones publications
use imaginative selling
techniques, such as
radio and television ads
that invite people to
subscribe by calling an
800 telephone number.
Such commercials are
paid for by giving the
stations commissions
on subscriptions sold.

**Strong
Circulation Gains**
The Wall Street Journal's year-end circulation of 1,930,400—an
increase of 162,000 from
the end of 1979—is attributed to several factors. One is the increasing editorial quality of
the newspaper. Others
include strong selling
efforts and dependable
distribution.

20

21

Annual Report:
Hauserman, Inc.
Art Director:
Massimo Vignelli
Designers:
Peter Laundy,
Vignelli Associates
Photographer:
Bill Pappas
Design Firm:
Vignelli Associates
New York, NY
Client:
The E.F. Hauserman Co.
Typographer:
Typographic Directions
Printer:
Emerson Press

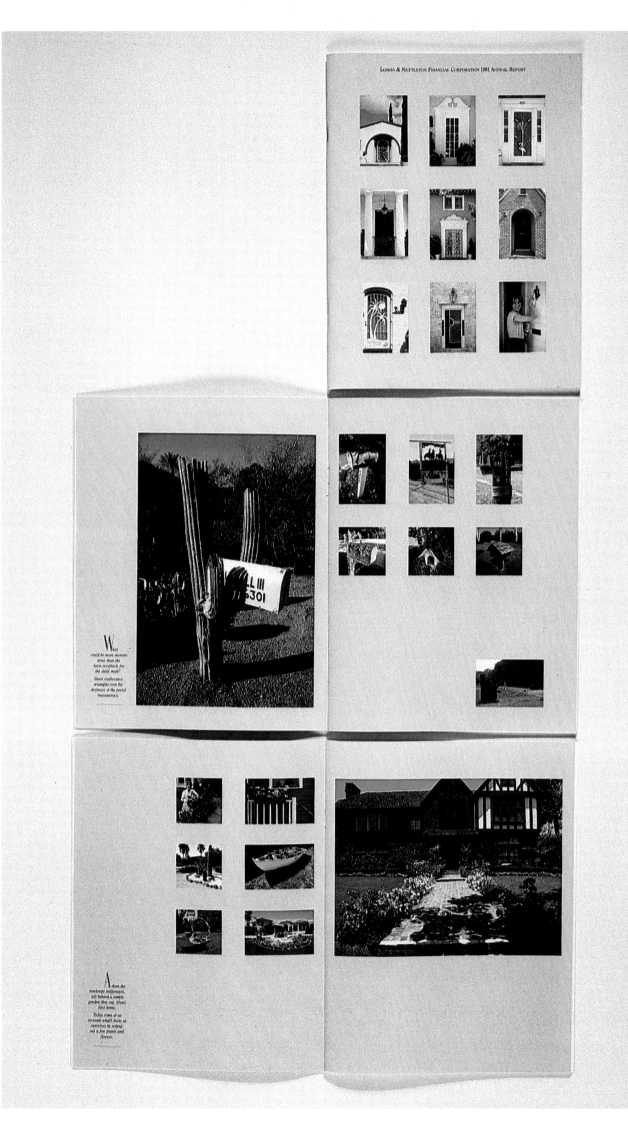

Annual Report:
Lomas & Nettleton Financial
Corporation 1981 Annual
Report
Art Director:
Stephen Miller
Designer:
Stephen Miller
Photographer:
Gregg Booth
Design Firm:
Richards, Sullivan, Brock &
Assoc. / The Richards Group
Dallas, TX
Client:
Lomas & Nettleton Financial
Corp.
Typographer:
Southwestern Typographics,
Inc.
Printer:
Heritage Press

Brochure:
"Why Peat Marwick?"
Art Director:
Eugene J. Grossman
Designers:
Don Durg, Ken Godat
Photographer:
Arnold Newman
Design Firm:
Anspach Grossman Portugal
New York, NY
Client:
Peat Marwick Mitchell
Typographer:
Print and Design
Printer:
Crafton Graphic Co., Inc.

Annual Report:
Cetus Corp.
1981 Annual Report
Art Director:
Lawrence Bender
Designers:
Linda Brandon,
Lawrence Bender
Photographer:
Tom Tracy
Design Firm:
Lawrence Bender & Assoc.
Palo Alto, CA
Client:
Cetus Corp.
Typographer:
Frank's Type, Inc.
Printer:
Anderson Lithograph Co.

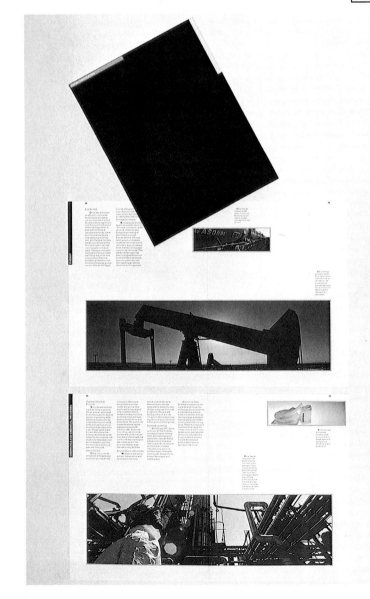

Summary of significant accounting policies

Five-year comparison of selected supplementary financial data
restated to average fiscal 1980 dollars (except for historical amounts)

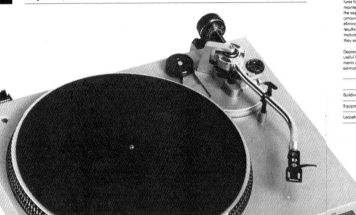

					Fiscal year ended June
	1980	1979	1978	1977	1976
Net sales (in thousands):					
As reported	$841,803	$696,830	$526,068	$402,197	$295,001
Adjusted for general inflation	841,803	789,537	651,977	531,916	412,682
Cash dividends per common share:					
As reported	0.22	0.16	0.11	—	—
Adjusted for general inflation	0.22	0.18	0.14	—	—
Market price per common share at year-end:					
Historical amount	23.38	23.25	23.76	14.76	11.00
Adjusted for general inflation	23.38	26.34	29.45	19.52	15.39
Average consumer price index	232.5	205.2	187.6	175.8	166.2

Fiscal year
The Company's fiscal years end on the last Saturday in June. Fiscal 1980 ended on June 28, 1980 and included 52 weeks. Fiscal 1979 ended on June 30, 1979 and included 53 weeks.

Principles of consolidation
The financial statements include the accounts of Best Products Co., Inc. and all wholly-owned subsidiaries. All significant intercompany transactions and balances have been eliminated in consolidation.

Segment information
The Company is engaged in one line of business, the sale of merchandise through catalog showrooms. Accordingly, data with respect to industry segments has not been separately reported herein.

Merchandise inventories
The Company values its inventories at the lower of cost (last-in, first-out — LIFO) or realizable market value.

Property and equipment
Additions to property and equipment, other than capital leases, are recorded at cost. Capital leases are recorded at the lesser of fair value or the discounted present value of the minimum lease payments. Expenditures for additions and betterments are capitalized. Expenditures for maintenance and repairs are charged to operations in the year in which the expense is incurred. Cost of assets sold or retired and the related amounts of accumulated depreciation and amortization have been eliminated from the accounts in the year of sale or retirement and the resulting gain or loss has been reflected in operations. As capital leases mature, the Company's policy is to exercise purchase options where they exist.

Depreciation is computed on the straight-line method over the estimated useful lives of the various assets. Capital leases and leasehold improvements are amortized by the straight-line method over the shorter of their estimated useful lives or the term of the lease. Estimated useful lives are:

	Life-years
Buildings and improvements	5-50
Equipment and fixtures	3-10
Leasehold improvements	3-30

Aladdin Stanley 1-Quart Steel Thermos Bottle.
Unbreakable stainless steel liner. 3 lbs.

Technics Semi-Automatic Direct-Drive Turntable.
Automatic return/shutoff. B-FG servo control motor for quick start-up. Strobe cueing, pitch anti-skate controls. Audio isolator legs. Rumble 75dB (DIN-B), wow/flutter 0.03% (WRMS). 19 lbs.

Income taxes
Deferred income taxes result from timing differences between earnings reported for financial statement purposes and earnings reported for income tax purposes. The principal differences arise from differing treatment of certain capital leases and the use of accelerated depreciation methods for income tax purposes. Investment tax credits, arising from both the purchase and lease of assets, are accounted for as a reduction of income tax expense under the flow-through method.

Pre-opening expenses
Direct expenses related to the opening of new showrooms are charged to operations over the remaining portion of the half of the year in which the showroom opens.

Net earnings per common share
Net earnings per common share for each year are based on the weighted average number of common shares outstanding during the year. The effect of stock options on earnings per common share for fiscal 1980 and 1979, was either anti-dilutive or insignificant. Net earnings applicable to common shares is computed after deducting annual dividends on the 6% cumulative preferred stock.

Reclassification of accounts
Certain fiscal 1979 account balances have been reclassified to conform with the fiscal 1980 presentation.

Common stock
Shares of Best Products Co., Inc. common stock are listed and traded on the New York Stock Exchange (symbol BES).

Form 10-K
Copies of the Company's annual report to the Securities and Exchange Commission on Form 10-K may be obtained without charge by writing to: James J. Spencer, Secretary, Best Products Co., Inc., P.O. Box 26303, Richmond, Virginia 23260.

Annual meeting
The annual meeting of the stockholders of Best Products Co., Inc. will be held at 11:00 a.m. on Thursday, November 6, 1980, in the auditorium of the Corporate Headquarters located at Parham Road and Interstate 95 North, Richmond, Virginia.

Independent certified public accountants
Touche Ross & Co.
21st Floor, F&M Center
Richmond, Virginia 23277

General counsel
McGuire, Woods & Battle
Ross Building
Richmond, Virginia 23219

Transfer agent and registrar
United Virginia Bank
9th & Main Streets
Richmond, Virginia 23219

Heuer Trackmaster
1/5-second stopwatch. 60-minute register. 60-second dial. Precision Swiss jeweled movement. Non-magnetic. Blue.

Annual Report:
Best Products
Annual Report 1980
Designers:
Rob Carter, Meredith Davis,
Robert Meganck, Greg
Prygrocki
Photographer:
George Nan
Design Firm:
Communication Design, Inc.
Richmond, VA
Client:
Best Products Co., Inc.
Typographer:
Riddick Advertising Art
Printer:
W.M. Brown & Sons

Annual Report:
General Defense Corp.
Annual Report 1981
Art Director:
Jack Hough
Designer:
Russ Tatro
Photographer:
Jerry Sarapochiello
Design Firm:
Jack Hough Assoc.
Stamford, CT
Client:
General Defense Corp.
Typographer:
Lettick Typographic, Inc.
Printer:
Lebanon Valley Offset Co.

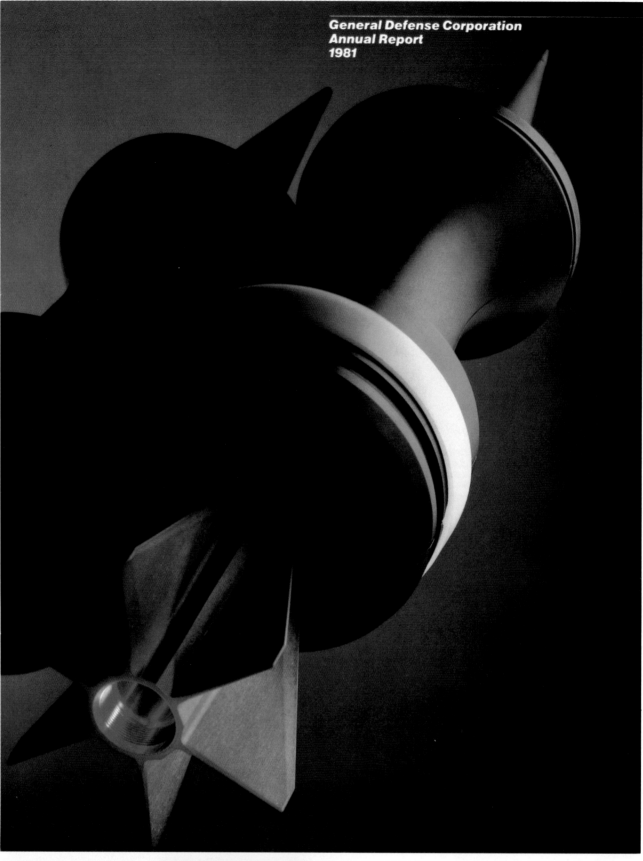

General Defense Corporation
Annual Report
1981

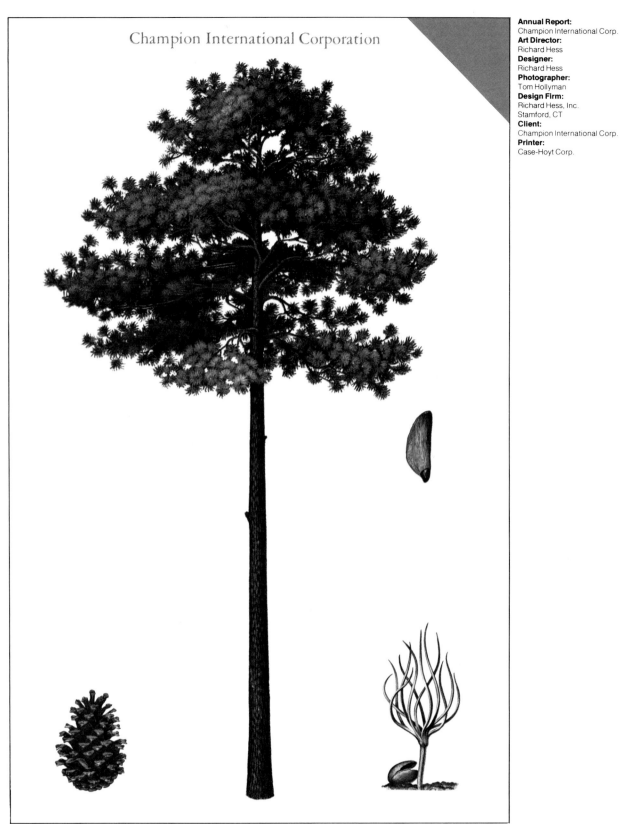

Champion International Corporation

Annual Report:
Champion International Corp.
Art Director:
Richard Hess
Designer:
Richard Hess
Photographer:
Tom Hollyman
Design Firm:
Richard Hess, Inc.
Stamford, CT
Client:
Champion International Corp.
Printer:
Case-Hoyt Corp.

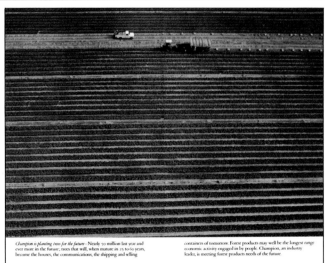

Champion is planting trees for the future.—Nearly 50 million last year and ever more in the future; trees that will, when mature in 25 to 60 years, become the houses, the communications, the shipping and selling containers of tomorrow. Forest products may well be the longest range economic activity engaged in by people. Champion, an industry leader, is meeting forest products needs of the future.

Annual Report:
Northwest Energy Co.
Annual Report for 1980
Art Director:
Arnold Saks
Designer:
Ingo Scharrenbroich
Photographer:
Burk Uzzle / Magnum
Design Firm:
Arnold Saks Assoc.
New York, NY
Client:
Northwest Energy Co.
Typographer:
Tri-Arts Press
Printer:
Case-Hoyt Corp.

Northwest
Energy
Company

Annual
Report for
1980

N orthwest Energy Company
is committed to the development of energy
resources. One of Northwest Energy's
subsidiaries, Northwest Alaskan Pipeline
Company, is operating partner for the
group that will construct the Alaskan seg-
ment of the transportation system de-
signed to bring Alaskan North Slope natu-
ral gas to the lower 48 states. Another
subsidiary, Northwest Pipeline Corporation,
owns and operates an interstate pipe-
line network that supplies natural gas to
eight western states. Other subsidiaries
are involved in oil and gas exploration
and developing western coal reserves. This
report reviews Northwest Energy's pro-
gress during 1980 and explains how the
Company will meet the challenges
and take advantage of the opportunities
that lie ahead.

T here must
be a massive
order to control
the power of
giants. To con-
tain the incredi-
ble forces we are
releasing from
their natural
storage vaults
putting them to
man's use.

Annual Report:
Sadlier Annual Report 1980
Art Director:
Willi Kunz
Designer:
Willi Kunz
Photographer:
Robert Rotella
Design Firm:
Willi Kunz Assoc., Inc.
New York, NY
Client:
William H. Sadlier, Inc.
Typographer:
Typogram
Printer:
Crafton Graphic Co., Inc.

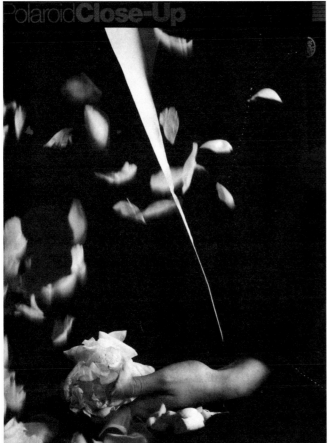

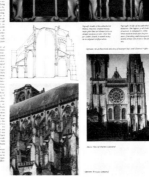

REVIEWS

William Wegman, Wag Photographer
by Owen Edwards

Promotional Literature:
Polaroid: Close-Up
Art Director:
Victor Cevoli
Designer:
Victor Cevoli
Photographers:
Various
Design Firm:
Cevoli Design, Walpole, MA
Publisher:
Polaroid Corp.
Typographer:
Acme Printing Co.
Printer:
Acme Printing Co.

Annual Report:
Technicolor , Inc.
Annual Report '81
Art Director:
Robert Miles Runyan
Designer:
Jim Berte
Photographer:
Steve Kahn
Design Firm:
Robert Miles Runyan &
Assoc., Playa del Rey, CA
Client:
Technicolor, Inc.
Typographer:
Composition Type
Printer:
George Rice & Sons

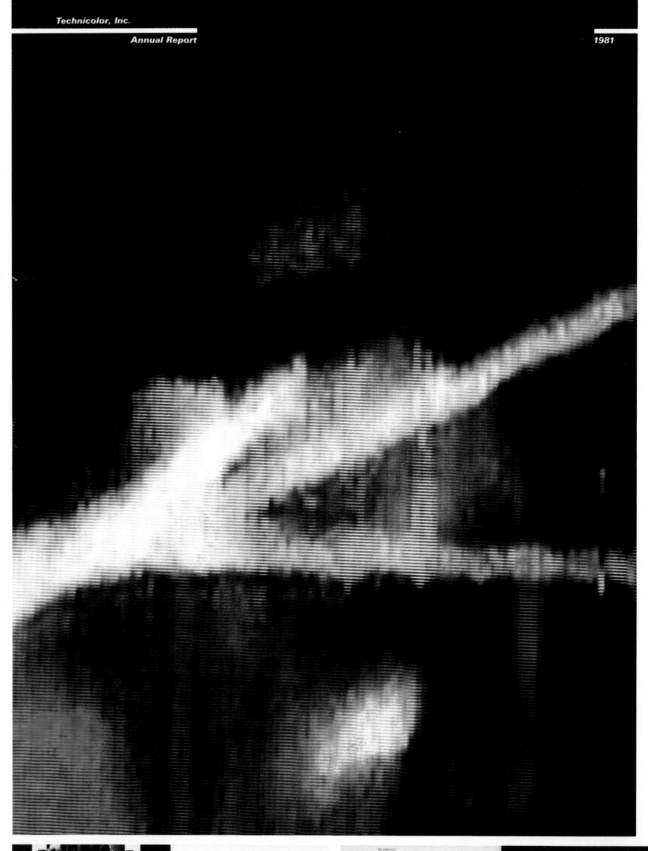

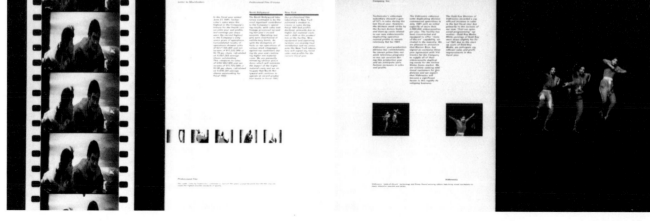

Managing for Growth:
Foremost-McKesson's Strategy for the '80s

1981 Annual Report

Annual Report:
Managing for Growth: Foremost McKesson's Strategy for the '80s 1981 Annual Report
Art Directors:
Neil Shakery, Barbara Vick
Designers:
Neil Shakery, Barbara Vick
Artist:
Jean Michel Folon
Design Firm:
Jonson Pedersen Hinrichs & Shakery, San Francisco, CA
Client:
Foremost McKesson
Typographer:
Reardon & Krebs
Printer:
Graphic Arts Center

For these two groups, these advanced information systems will provide expanded and more timely market data on product movement to aid our sales and marketing efforts, improve inventory management and enable us to compute valuable product movement data for our suppliers.

Our second priority in our 1981–1985 growth program will focus on the marketing of new products and services to our current customers.

The Drug & Health Care Group has moved strongly into cosmetics and perfumes and has in pilot testing or under study the addition of several new categories to its current product lines. Among these new groups are costume jewelry, toys, automotive products, small appliances and products for use in the home health care market, including durable medical equipment. Among the fastest growing sales categories in the typical drugstore, these product groups are showing gains of 15% to 20% yearly.

One way to think about our priorities is that they represent a strategic direction of growing outward in expanding concentric circles from our current strong business core.

Expansion of the Drug & Health Care Group's product lines is also helping us to take advantage of an important national trend toward one-stop shopping. Changing consumer habits are blurring the distinctions among traditional retail outlets such as drug, food and liquor

8

9

Annual Report:
Condec Corporation
Annual Report 1981
Art Director:
Stephen D. Chapman
Designer:
Stephen D. Chapman
Photographer:
Tom Tracy
Design Firm:
Jack Hough Associates
Stamford, CT
Client:
Condec Corporation
Typographer:
Set-To-Fit, Inc.
Printer:
Acme Co.

Condec Corporation

Annual Report 1981

Annual Report:
Financial Federation, Inc.
1980 Annual Report
Art Director:
Thomas Ohmer
Designer:
Koji Takei
Artists:
Koji Takei, Don Oka
Design Firm:
Advertising Designers, Inc.
Los Angeles, CA
Client:
Financial Federation, Inc.
Typographer:
Aldus Type Studio
Printer:
Anderson Lithograph Co.

Financial Federation Inc.

1980 Annual Report

It all began in 1959, when stockholders' equity was $16 million. Twenty years later, it was $189 million. Then came the merger offer in 1980 for $230 million. In that same period, total assets went from $272 million to just under $2.4 billion. Growth in size and strength

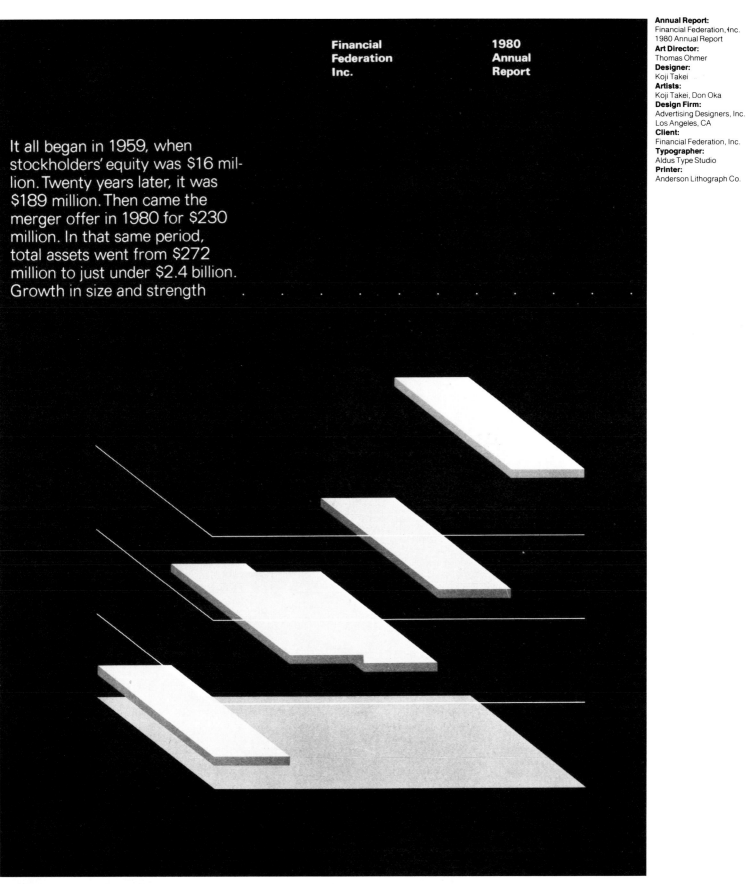

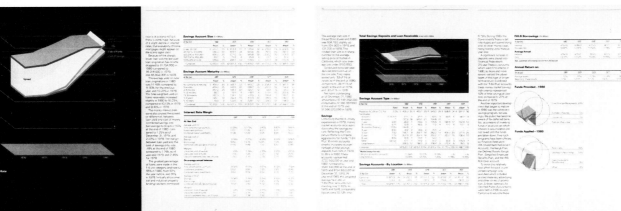

Promotional Booklet:
Three Houses
Art Director:
James Sebastian
Designers:
James Sebastian,
Michael Lauretano
Photographer:
Joe Standart
Design Firm:
Designframe, Inc.
New York, NY
Publisher:
Martex / West Point Pepperell
Typographer:
Haber Typographers, Inc.
Printer:
Crafton Graphic Co., Inc.

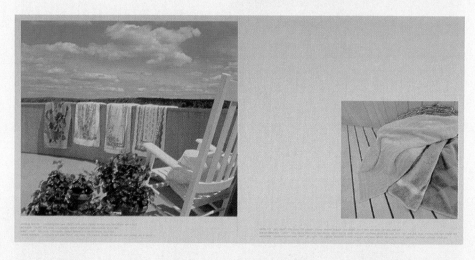

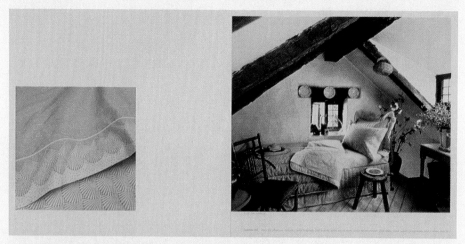

232

Promotional Booklet:
Counterpoint
Art Director:
James Sebastian
Designers:
James Sebastian, Michael
Lauretano
Photographers:
Joe Standart, Elizabeth Heyert
Design Firm:
Designframe, Inc.
New York, NY
Publisher:
Martex/West Point Pepperell
Typographer:
Volk Huxley, Inc.
Printer:
Crafton Graphic Co., Inc.

233

Booklet:
Simmons: Peritonitis and Intra-
abdominal Abscesses
Art Director:
Mark Woolwage
Designer:
Mark Woolwage
Artist:
Dan Cutler
Design Firm:
Mark Woolwage, Inc.
Muskegon, MI
Publisher:
The Upjohn Co.
Typographer:
Howe Assoc.
Printer:
The Upjohn Co.

Booklet:
The Proceedings of a
Symposium Update on
Anaerobic Infection
Art Director:
Mark Woolwage
Designer:
Mark Woolwage
Design Firm:
Mark Woolwage, Inc.
Muskegon, MI
Publisher:
The Upjohn Co.
Typographer:
Howe Assoc.
Printer:
The Upjohn Co.

Career Opportunities
for Sales Representatives at
Geigy

Brochure:
Career Opportunities for Sales
Representatives at Geigy
Art Director:
Bob Paganucci
Photographer:
Larry Stein
Design Firm:
CIBA-GEIGY Corp. Summit, NJ
Publisher:
CIBA-GEIGY Corp.
Typographer:
Arrow Typographers, Inc.
Printer:
Color Press

Brochure:
Continental Group
Typewriting Manual
Art Directors:
Kenneth D. Love, Vern Ford
Designer:
Roger van den Bergh
Design Firm:
Anspach Grossman Portugal,
Inc., New York, NY
Client:
The Continental Group, Inc.
Typographer:
Typographic Images, Inc.
Printer:
S.D. Scott Printing Co., Inc.

Magazine:
Champion Magazine #8
Art Director:
Richard Hess
Designer:
Richard Hess
Artists:
Various
Photographers:
Various
Design Firm:
Richard Hess, Inc.
Roxbury, CT
Publisher:
Champion International Corp.
Typographer:
Set To Fit, Inc.
Printer:
Case-Hoyt Corp.

**Steam Turbine-Generator
Technology Symposium**

Availability Enhancement
in the 80's

Cocktails and hors d'oeuvres

Gazpacho Soup

Caesar Salad

Cabernet Sauvignon

Roast Tenderloin of Beef
Sauce Perigueune

Bouquetiere of Vegetables

Duchesse Potatoes

Baked Alaska Flambé

Coffee, Tea

Jeanne Steele

Jeanne Steele has entertained presidents, kings and queens—
and the 4-H kids of America! Her father says, "She sang before
she could talk"—and she's been singing ever since.

At the age of eleven, she became a regular on the WCBM's
Children Theatre of the Air in her hometown of Baltimore, Mary-
land. Later she wore the crown of Miss Maryland in the
Miss America Pageant. She was a Pennsylvanian with Fred
Waring, and went on to star in many hit shows on Broadway.

Jeanne Steele travels thousands of miles today—from Hartford
to Hong Kong—spreading her song and her sunshine.
Whether sharing the bill with Bob Hope or Bill Cosby—or star-
ring alone—Jeanne Steele is "Simply Sensational!"

Dr. Ronald L. Willoughby

Psychiatrist and lecturer, Dr. Willoughby is the author of the
forthcoming book, *How to Laugh at Your Neurosis.*

Promotional Literature:
Brochure: Westinghouse Steam
Turbine-Generator Division,
Orlando
Art Director:
Eddie Byrd
Designer:
Eddie Byrd
Design Firm:
Byrd Graphic Design, Inc.
Pittsburgh, PA
Client:
Westinghouse Steam Turbine-
Generator Division
Typographer:
Davis & Warde, Inc.
Printer:
Stephenson, Inc.

Promotional Literature:
Menu: Westinghouse Steam
Turbine-Generator Division,
Orlando
Art Director:
Eddie Byrd
Designer:
Eddie Byrd
Design Firm:
Byrd Graphic Design, Inc.
Pittsburgh, PA
Client:
Westinghouse Steam Turbine-
Generator Division
Typographer:
Davis & Warde, Inc.
Printer:
Stephenson, Inc.

**Steam Turbine-Generator
Technology Symposium—**

Availability Enhancement
in the 80's

You are cordially invited
to participate in the
**Westinghouse Steam Turbine-Generator
Technology Symposium—**

Availability Enhancement
in the 80's

Promotional Literature:
Pad: Westinghouse Steam
Turbine-Generator Division,
Orlando
Art Director:
Eddie Byrd
Designer:
Eddie Byrd
Design Firm:
Byrd Graphic Design, Inc.
Pittsburgh, PA
Client:
Westinghouse Steam Turbine-
Generator Division
Typographer:
Davis & Warde, Inc.
Printer:
Stephenson, Inc.

Promotional Literature:
Invitation: Westinghouse
Steam Turbine-Generator
Division, Orlando
Art Director:
Eddie Byrd
Designer:
Eddie Byrd
Design Firm:
Byrd Graphic Design, Inc.
Pitsburgh, PA
Client:
Westinghouse Steam Turbine-
Generator Division
Typographer:
Davis & Warde, Inc.
Printer:
Stephenson, Inc.

Bulletin:
California College of Arts
& Crafts
Designers:
Thomas Ingalls,
David Holbrook
Design Firm:
Thomas Ingalls & Assoc.
San Francisco, CA
Publisher:
California College of Arts
& Crafts
Typographer:
Gestype
Printer:
Alonso Printing Co.

Catalog:
Broad Spectrum
Art Director:
Hans-U. Alleman
Designer:
Hans-U. Alleman
Photographer:
Wayne Gozzolino
Design Firm:
Hans-U. Alleman Design
Philadelphia, PA
Publisher:
Philadelphia College of Art
Typographer:
Composing Room (PA)
Printer:
Consolidated/Drake Press

Booklet:
IBM: Corporate Recognition
Banquet
Art Director:
Richard Rogers
Designer:
Richard Rogers
Photographers:
Herb Levar, Various IBM Staff
Design Firm:
Richard Rogers, Inc.
New York, NY
Client:
IBM Corp.
Typographer:
Southern New England
Typographic Service
Printer:
S.D. Scott Printing Co., Inc.

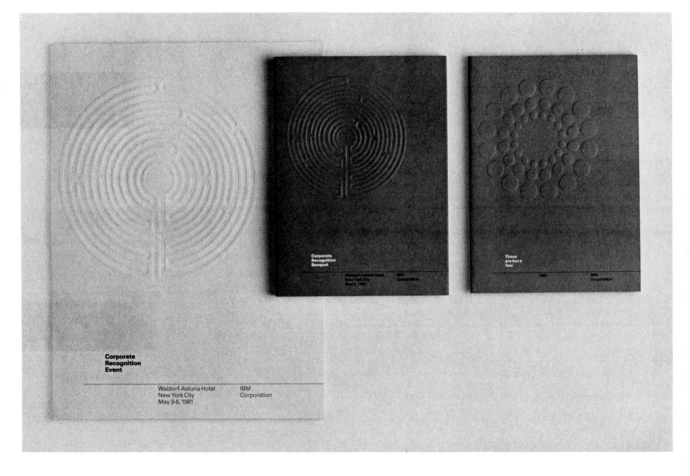

Promotional Literature:
Corgan Associates, Inc.
American Airlines Southern
Reservations Office
Art Director:
Woody Pirtle
Designer:
Woody Pirtle
Photographer:
Mike Haynes
Design Firm:
Woody Pirtle, Inc.
Dallas, TX
Client:
Corgan Assoc., Inc.
Typographer:
Southwestern Typographics,
Inc.
Printer:
Williamson Printing Corp.

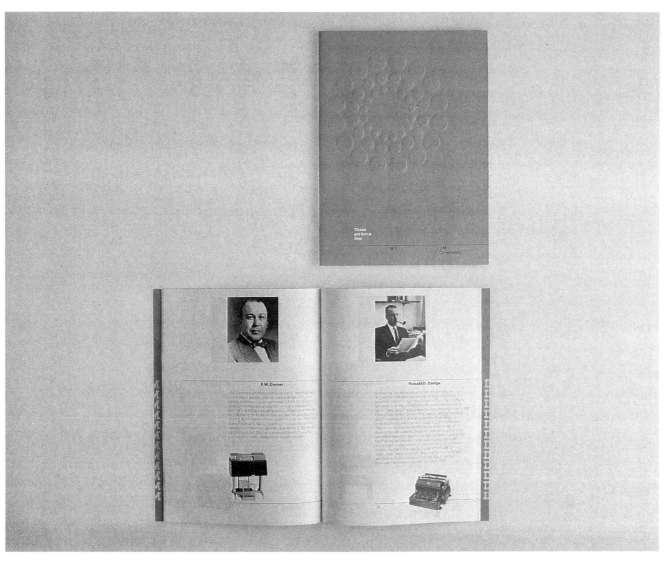

Booklet:
IBM: These Are But a Few
Art Director:
Richard Rogers
Designer:
Richard Rogers
Photographers:
Various IBM Staff
Design Firm:
Richard Rogers, Inc.
New York, NY
Client:
IBM Corp.
Typographer:
Southern New England
Typographic Service
Printer:
S.D. Scott Printing Co., Inc.

Brochure:
CBS and Children
Art Director:
Arthur Congdon
Designer:
Arthur Congdon
Photographer:
CBS Staff
Design Firm:
Congdon MacDonald, Inc.
New York, NY
Client:
CBS Television Network
Typographer:
Typographic Innovations, Inc.
Printer:
Eastern Press

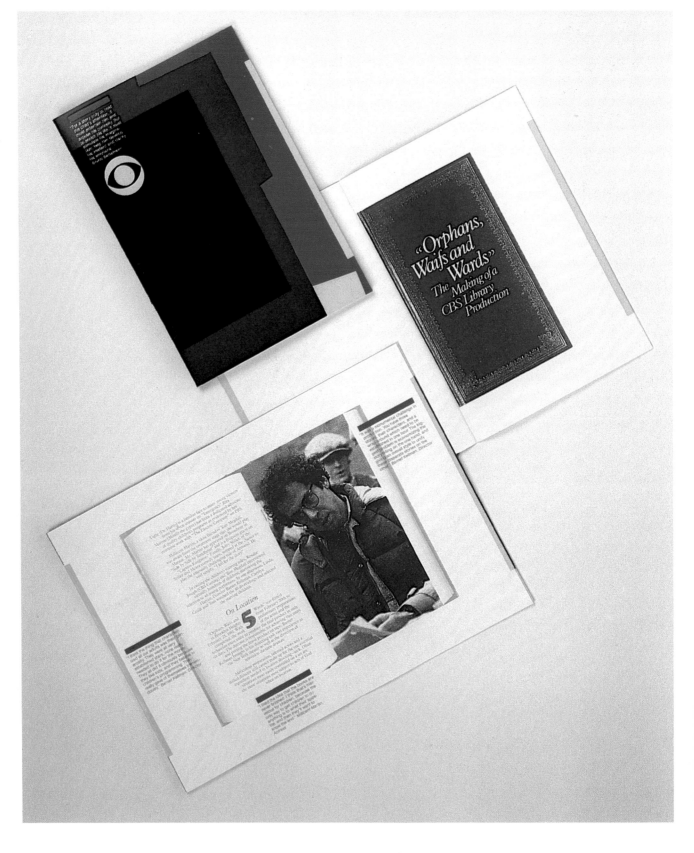

Brochure:
Pre View
Designer:
Jeff Barnes
Artists:
Various
Design Firm:
Barnes Design Office
Wheaton, IL
Publisher:
Chicago Talent, Inc.
Typographer:
Typographic Arts
Printer:
Photopress, Inc.

Catalog:
Cutting Edge
Art Director:
Julius Friedman
Designer:
Julius Friedman
Photographer:
Warren Lynch
Design Firm:
Images, Louisville, KY
Publisher:
Kentucky Arts Commission
Typographer:
Lettergraphics, Inc.
Printer:
Pinaire Lithographing, Inc.

Mark Diamond
Houston, Texas
Stone
steel, silver, gold, enamel, ebony
24.5 cm. L x 11.1 cm. W x 10.4 cm. H

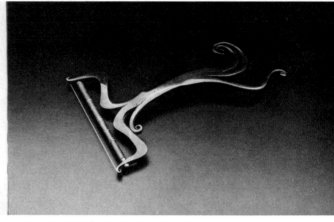

Joel A. Schwartz
Owensboro, New York
Cheese Cutter
steel
20 cm. L x 11.5 cm. W x 2 cm. H

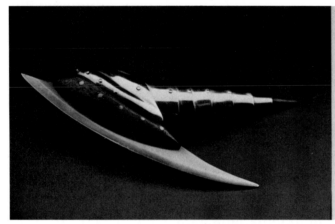

Bob Coogan
Smithville, Tennessee
Garlic Knife
silver, brass, d2 steel, mahogany
15.5 cm. L x 3 cm. W x 4.5 cm. H

JURIED SECTION

Music Set Free

Brochure:
Music Set Free
Art Director:
Hayward Blake
Designer:
Rebecca Michaels
Photographers:
Rhodes Paterson,
Dave Jordano
Design Firm:
Hayward Blake & Co.
Evanston, IL
Client:
Bang & Olufsen
Typographer:
Design Typographers
Printer:
Bruce Offset Co.

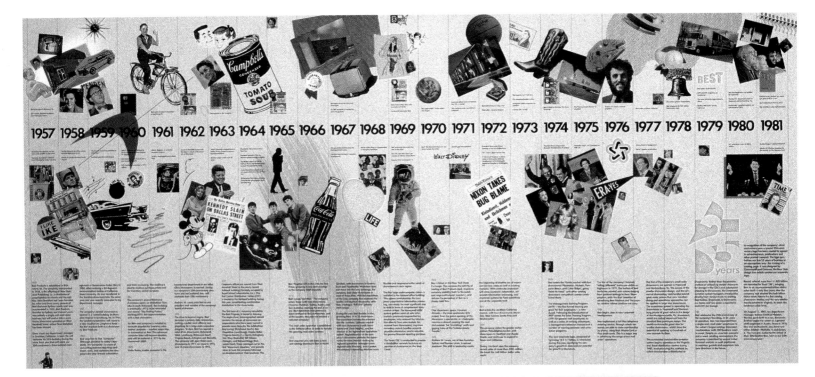

1957 1958 1959 1960 1961 1962 1963 1964 1965 1966 1967 1968 1969 1970 1971 1972 1973 1974 1975 1976 1977 1978 1979 1980 1981

Promotional Literature:
Best Times
Designers:
Rob Carter, Tim Priddy
Design Firm:
Best Products Design Dept.
Richmond, VA
Publisher:
Best Products Co., Inc.
Typographer:
Riddick Advertising Art
Printer:
W.M. Brown & Sons

25th anniversary issue and poster
winter 1981

best times

25 years

Miracle on Marshall Street?

growing from one showroom to one hundred

"I can remember the original showroom ...it had a back door and you kind of felt like you were going into a speakeasy. We usually had some stock in the beginning — we tried to have 'one to show and one to go.' If we sold an item, we bought another."

Diane Wallerstein
Senior buyer

Mrs. Wallerstein could hardly envision, as she worked in various jobs at the Best Products West Marshall Street showroom in Richmond more than twenty years ago, that by 1981 — in the company's 25th Christmas selling season — she would be a member of a large merchandising department. Or that she would be buying silver for 100 showrooms in eleven states. She could hardly have envisioned that the company's annual sales would surpass the one billion dollar mark.

Whether or not one believes in Santa Claus, however, it was no miracle on Marshall Street that generated the successful growth of Best Products. Rather, it was a sound concept — to sell nationally advertised, name-brand merchandise through a catalog; it was a strong belief — that the customer comes first; and it was the fundamental strength of the company's employees — their dedication to their work, their willingness to innovate, and their realization that their own growth is linked directly to the growth of their company. And the successful growth of Best can also be attributed to the commitment of shareholders, vendors, and customers who have supported the concept and performance of the company.

Best has opened eight new showrooms this fall — representing three basic design prototypes — to take advantage of the company's 25th Christmas selling season.

The Montgomeryville showroom, in the Philadelphia suburbs, marks the debut of the first Best showroom to include features of the standard large scale "A" prototype and the more recent catalog sales center. The combination creates a distinctive new look and numerous operational efficiencies.

Departmental configurations have been rearranged and consolidated. Toys and baby goods, traditionally self service areas, have been combined with sporting goods.

Merchandise in the housewares department is displayed in custom-designed, wood-panelled showcases.

"Displays in Showrooms Mark Radically New Best," declared the headline in the October 6 issue of Discount Store News.

The jewelry department has been brought out front and center to greet customers when they enter the showroom, and to generate maximum traffic flow.

In late October, the company's third "D-type" showroom, or sales center, was opened in Plano, Texas (near Dallas) to round out the fall schedule of openings.

Other showrooms which opened included Bradenton, Florida; Anaheim and Pleasanton, California; Toms River and Eatontown, New Jersey; and Huntington, West Virginia. The opening of the Huntington showroom marked the company's entry into West Virginia.

The evolution and growth of Best Products has been no "miracle." It is the earned result of experimentation and innovation — exemplified through the hard work of thousands of new and experienced employees.

Teamwork:

looking back (and ahead) with werner, riley and hiner

In September of 1966, David Hiner began to reap some of the rewards that came from a year of perseverance.

The then-20-year-old was hired to work in the jewelry warehouse of what was at that time a hustling, if relatively small, Richmond-based retailer: Best Products.

"A few of my friends had worked there during Christmas and said it was a good place to work. So for a year, I pestered the general manager for a job," Hiner said in a recent interview.

The company was operating two Virginia showrooms in 1966; sales volume for the year was about $7.5 million. Although these figures held no special significance for him at the time, Hiner was impressed by the motivation, drive and camaraderie shared by Best employees.

In fact, once hired and inside the showroom, he was overwhelmed. "At the time, I was working in jewelry receiving. I was amazed at the volume of merchandise and the number of customers — and at the attitudes of the employees. Everyone and everything there was geared to the customer's needs. The customer was the most important part of everyone's job. If it meant more time or longer hours, that was all right because it meant serving the needs of the customer.

"One day I opened up my big mouth and said I wanted to go out on the sales floor," Hiner recalled. "After that day, I always looked forward to getting to work — back then, it was exciting, partly because we never knew which department we'd be working in."

It was this kind of excitement which brought Hiner, now vice president—field operations, to realize that he was "hooked" on Best Products. "It was fun because it was a challenge. It became a game. It was work, but not a drudgery."

His enthusiasm was fueled in part by the showroom manager's attitude toward his employees — be they manager trainees, sales counselors, or jewelry warehouse workers. "It didn't take Al Werner long to walk over and introduce himself to me. That kind of gesture impressed me," said Hiner.

Werner had arrived in Richmond almost a year before Hiner began his career with Best. A native of Brooklyn, Werner had come to Best to run the West Marshall Street showroom's jewelry department.

"The first day that I met the Lewises, I knew I wanted to work for them," Werner recalled. "They knew what they were doing. They knew what they wanted. They were willing to share their enthusiasm and their opportunities with others. I didn't see that anywhere else."

Werner, now executive vice president—operations and merchandising, came to Best during a season which, for New York retailers, was a heavy traffic period. He was surprised to find October and early November not to be an especially strong selling period at Best, compared to New York. "I found traffic in October very moderate — I was waiting and waiting for the traffic. Later, what really impressed me as unique about Best was the extremely strong selling season which didn't really begin until after Thanksgiving."

Werner had brought with him from New York a special attitude that has become a central theme in all Best showrooms: that every sale is an important sale, and that every customer is an important customer. "In New York, you wanted every customer — there were too many competitors to let a customer or a sale go by."

Werner also delivered to Best employees a strong appreciation for the team effort — now the backbone of any successful Best showroom's operation. He describes it as a "give-and-take...a realization that you can help me learn the business if I listen to you, and that I can learn also if I am willing to listen to you."

These two ideals, imported from a frantic, highly competitive New York retailing environment, have "hooked" Dave Hiner and thousands of other employees on Best Products, including Dick Riley, now senior vice president for merchandising. Riley came to Best as a sales counselor in the West Marshall Street showroom's sporting goods department in April of 1967.

"After about a month of work, I realized that there was a tremendous amount of opportunity here. There wasn't a lot of formal training — it was all on-the-job training — but you knew that if you worked hard, you would have a future with the company," said Riley. So he worked hard. Riley wanted a future, and he wanted it to be part of the team effort he found at Best Products.

"That desire, that team effort, in the early days of the company, was exhibited by a lot of people," said Werner. "At first, we ran the business the best way we could for that day. We'd come in and say: 'Jewelry is behind — what do we do?' And what we did to clear up the problem was get the whole showroom

continued on page 5

244

TENNECO
HEALTH & FITNESS CENTER
JANUARY 1982

Poster:
Tenneco Health and Fitness
January 1982
Art Director:
Peter Good
Designer:
Peter Good
Artist:
Peter Good
Design Firm:
Peter Good Graphic Design
Chester, CT
Publisher:
Tenneco Chemicals
Typographer:
Eastern Typesetting Co.
Printer:
Finlay Printing Co.

Brochure:
Citicorp Careers
Art Director:
Jim Jarratt
Designer:
Dana Jones
Photographers:
Burgess Blevins,
Ed Eckstein
Design Firm:
The Creative Dept., Inc.
Philadelphia, PA
Client:
Citibank/Citicorp
Typographer:
Stallone Typographic Services
Printer:
Consolidated/Drake Press

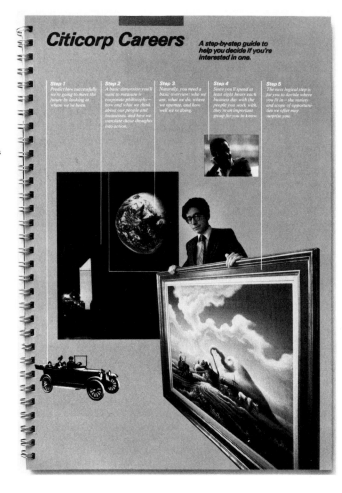

Brochure:
Understanding Taxes 1982
Art Director:
Don Lynn
Designer:
Charles R. Gaillis
Artist:
John Pack
Design Firm:
Internal Revenue Service Design
Group, Washington, DC
Publisher:
Internal Revenue Service
Taxpayer Service Division
Typographer:
Rocappi, Inc.
Printer:
Alco Gravure Co.

Promotional Literature:
Class Edition: Spring
Art Director:
Micheal Richards
Designers:
Micheal Richards,
Bill Swensen
Artists:
Glade Christensen, Scott Grear,
Bill Swensen, Dung Ngyuyen,
Theresa Fitzpatrick
Design Firm:
University of Utah Graphic
Design Group, Salt Lake City,
UT
Publisher:
University of Utah Continuing
Education
Typographer:
University Services
Printer:
Spectrum Press

RECREATION AND PARK MANAGEMENT

National Outdoor Leadership School

RECREATIONAL CAMPING AND OUTDOOR LIVING

WILDERNESS SURVIVAL

RECREATIONAL CAMPING AND OUTDOOR LIVING

RECREATION AND LEISURE IN MODERN SOCIETY

RECREATION AND LEISURE IN MODERN SOCIETY

RECREATION AND LEISURE SERVICE FOR THE DISADVANTAGED

LEISURE EXPERIENCE: COMPASS ORIENTEERING

LEISURE EXPERIENCE: RECREATION MUSIC GUITAR

LEISURE EXPERIENCE: OUTDOOR COOKING

LEISURE EXPERIENCE: ETHNIC EMBROIDERY

LEISURE EXPERIENCES: PATCHWORK/QUILTING (ALL LEVELS)

LEISURE EXPERIENCE: THE UNSELFISH LIFE IN NATURE

LEISURE EXPERIENCES: MASTERY OF CHESS

LEISURE EXPERIENCE: FRILUFTSLIV/NATURE LIFE—THE UNSELFISH LIFE IN NATURE

LEISURE EXPERIENCE: OUTDOOR COOKING (BACKPACKING)

LEISURE EXPERIENCES: PRIMITIVE SURVIVAL SKILLS

LEISURE EXPERIENCE: VOLUNTEERISM IN THE FINE ARTS

INTRODUCTION TO UTAH BIRDS AND OTHER UNIDENTIFIED FLYING OBJECTS

WILDLIFE SKETCHING

LEISURE EXPERIENCE: REDISCOVER THE CRAFT OF BRASS RUBBING

MOVEMENT AS A TOOL FOR THERAPEUTIC RECREATION

LEISURE EXPERIENCES: TRADITIONAL PATCHWORK, APPLIQUE, AND QUILTING—INTERMEDIATE CLASS

LEISURE EXPERIENCE: PERSONAL GROWTH THROUGH HIGH STRESS RECREATIONAL ACTIVITIES

WILDERNESS AND LEISURE

MANUAL COMMUNICATION

THERAPEUTIC RECREATION FOR SPECIAL POPULATIONS

METHODS AND SKILLS IN ARTS AND CRAFTS

COMMERCIAL RECREATION

CAMP COUNSELING

MANAGING TRAVEL RESOURCES

UTAH RESOURCES INSTITUTE

THERAPEUTIC RECREATION: AFFECTIVE DOMAIN PSYCHO-SOCIAL FUNCTIONING

SOCIAL WORK

SOCIAL WORK PRACTICE: GROUP WORK

CDP: GROUP WORK IN MENTAL HEALTH SETTINGS

CDP: MULTI-PROBLEM FAMILIES

CDP: GROUP WORK WITH ALCOHOLICS

CDP: POLICY PLANNING IMPLEMENTATION

CDP: GROUP WORK LABORATORY

CDP: POLICY DEVELOPMENT AND ANALYSIS

SW PRACTICE: ADMINISTRATION I

ACP: POLICY PLANNING I

ACP: POLICY DEVELOPMENT AND ANALYSIS

RESEARCH: INDIVIDUAL/GROUP PROJECT

RESEARCH: INDIVIDUAL/GROUP PROJECT

SOCIAL WORK PRACTICUM I

SOCIAL WORK PRACTICUM II

SOCIAL WORK PRACTICUM III

Brochure:
John Hansen Investment Builder
Art Director:
Paula Andell
Designer:
Paula Andell
Photographer:
Jim Sims
Design Firm:
Savage Design Group, Inc.
Houston, TX
Client:
John Hansen Investment Builder
Typographer:
Professional Typographers
Printer:
Grover Printing Co.

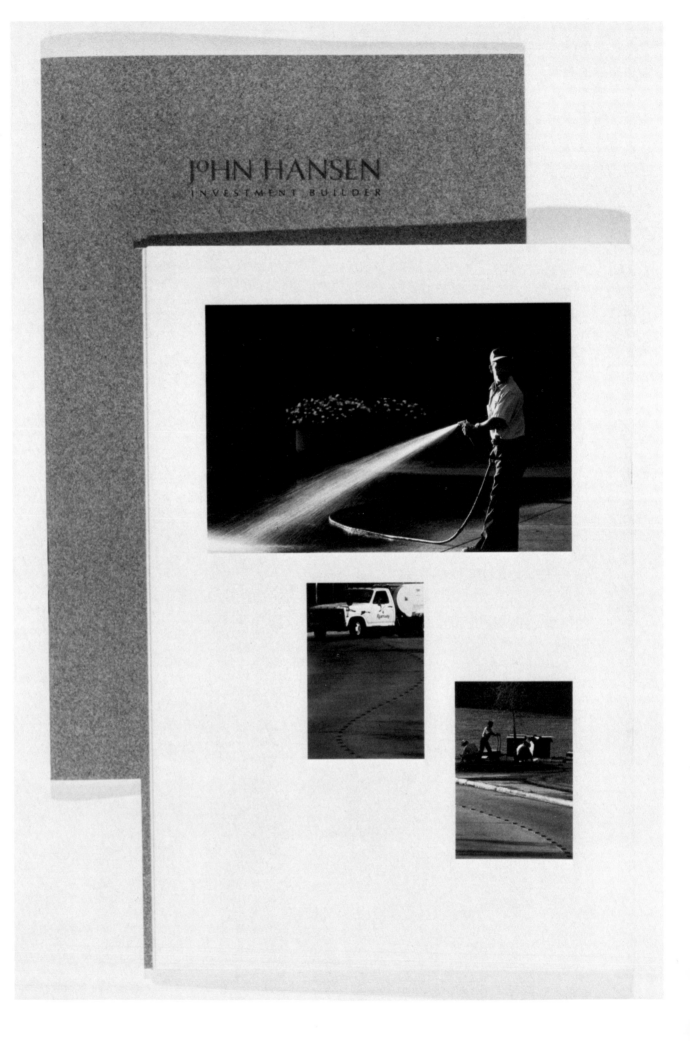

Promotional Book:
Austin
Art Director:
Dick Mitchell
Designer:
Dick Mitchell
Photographer:
Gregg Booth
Design Firm:
Richards, Sullivan, Brock & Assoc. / The Richards Group
Dallas, TX
Client:
Richards Direct Marketing
Typographer:
Chiles & Chiles
Printer:
Williamson Printing Co.

THE PLEASANTEST PLACE Austin alone among Texas cities was founded on beauty — the sudden inspiration of an impulsive poet who was to become President of the Republic of Texas. Mirabeau Buonaparte Lamar, the poet, had barely arrived in the Province of Texas when the rebellion against Mexico broke out in 1835. But the 36-year-old Georgia widower threw himself into the fight with such passionate intensity that in the first election held by the Republic of Texas he was named Vice President under Sam Houston. As it turned out, President Houston and Vice President Lamar hadn't much love for one another. Houston was a doer and a realist; Lamar a dreamer and a romantic. With President Houston's ego at the helm a vice president had little to do. One fall Lamar decided to take a break from the politics of the capital (then at Old Sam's new fledgling namesake city) and go on a buffalo hunt. Someone suggested the prairies above Bastrop on the Colorado River, where an outpost called Fort Colorado might furnish an escort-guard for the Vice President. So Lamar and his private secretary, the Reverend Edward Fontaine, set out for that Indian-haunted frontier. They got via rangers from the fort and rode west beside the Colorado to where Jacob Harrell had created a little stockade settlement of three families along the north side of the river at the mouth of Shoal Creek. Harrell told Lamar there were few other people around: three German families downriver at a place called Montopolis, and the William Barton family across the river on Spring Creek, where three gushed forth two mighty springs which Uncle Billy Barton had named Parthenia and Eliza, after his daughters. Early next morning the hunters were wakened by Harrell's little son, who excitedly told them the prairie was full of buffalo. The Vice President and his party were soon in the saddle and away for the kill. One of the rangers said later that Lamar brought down the biggest buffalo bull ever seen, right where Congress Avenue and Seventh Street would someday cross. Later in the morning the successful hunting party was assembled by a topler on the hill where the Capitol now stands. Lamar, stirred by the magnificent surroundings, turned to his saddle and exclaimed to Fontaine: "This should be the seat of future Empire!" Under the Constitution of the Republic, a president could not succeed himself. Thus Sam Houston had to step down. Anti-Houston forces then nominated Lamar for the office, so it was understandable that Old Sam threw his support to Lamar's opponents, James Collinsworth and Peter Grayson, both his close friends. But then history took an insane turn: both Collinsworth and Grayson committed suicide before the election. Thus, in September 1838, Mirabeau B. Lamar, the poet-politician, was elected to be the next President of the Republic of Texas. Almost no one save the local merchants (and possibly Sam Houston) was satisfied with Houston as capital city of Texas. It was too far from the center of Texas, and its climate was objectionable. Three Congressional conventions, however, had failed to agree on a more likely spot. One of Lamar's first deeds as President was to approve, January 1839, an act "For the Permanent Location of the Seat of Government." This act stipulated the new capital, wherever located, should be named in honor of Stephen F. Austin and that the site should be "at some point between the Trinidad (Trinity) and the Colorado and above the Old San Antonio Road." A five-man commission would do the searching. There can be little doubt

Woodlawn, a residence built in 1853 for State Comptroller James State, situated to the northwest of downtown Austin in the section now called Enfield. It was purchased by Governor Pease in 1859, remaining in Pease family hands for almost a century before being bought in 1957 by another Texas governor, Allan Shivers. Austin blossomed with such charm that Frederick Law Olmsted, a designer of New York City's Central Park, noted in his 1854 book, A Journey Through Texas, "Austin . . . [is the] pleasantest place we have seen . . . in Texas." In the 1857 gubernatorial election, Hardin R. Runnels handed Sam Houston his first (and only) political defeat. But "Old Sam Jacinto" came back to defeat Runnels in 1859. That campaign, hot with union and secession embroilment, was probably the most bitter in Texas history. The state was pro-secession, but Houston, as governor, continued his outspoken pro-union sentiments. The 1860 census count of 3,494 pushed Austin into the upper ranks of the state's cities. The national election in November named Abraham Lincoln to be President of the United States, and the South scripted. Secessionists and pro-slavery politicos in Texas demanded Governor Houston call a Secession Convention, but he refused. In December the group took it on itself, setting a gathering in Austin for January 28, 1861. Quite a number of Austin's leaders were Unionists, including former Governor Pease, State Supreme Court Justice James H. Bell, and A. J. and Morgan Hamilton. Unionist George Hancock had a big store at Pecan and Congress, and early in 1860 he had put up a ninety-foot-tall flagpole at what was called Hancock's Corner. He flew the U.S. flag daily until the firing on Fort Sumter, when by war compelled to take his flag down. The Secession Convention — of doubtful legality — met in January and quickly passed a resolution "that the State of Texas should separately recede from the Federal Union" by a vote of 166 to 8. When James (Old Leatherneck) Throckmorton cast one of the nay votes, a hiss was heard from the packed gallery. Old Leatherneck shouted back, "When the rabble hiss, well may patriots tremble!" A statewide vote on secession in February saw Texas approve, three to one, leaving the union. However, Austin and Travis County opposed secession 704-456, and the surrounding counties of Bastrop, Gillespie, Mason, and Williamson also voted against it. The Secession Convention reconvened and formally declared that as of March 2, 1861 Texas was again "a sovereign and independent State . . . her people absolved from all allegiance to the government of the United States of America." March 5 the Convention adopted a resolution joining Texas with the Confederacy and on March 16 began administering the Confederate oath of allegiance to state officials. Houston quit his Secretary of State, E. W. Cave, refused to take the oath, and the Convention declared their offices vacant. Old Sam went home to Huntsville and retired forever from public life. Although Austin had voted against secession, it was too positively affected a city to leave the mainstream of public policy. And not all Austin leaders were Unionists, by any means. For example, the Right Reverend Alexander Gregg, Episcopal Bishop of the Diocese of Texas, preached a fiery sermon at St. David's Church, as soon as the conflict began, the title being, "The Duties Growing Out of It, and the Benefits to Be Expected From the Present War," Austin's Dixie faction sentiments)

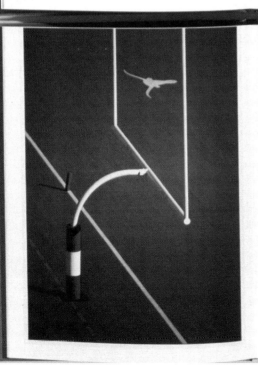

Brochure:
Galleria: One Galleria Tower
Art Director:
Lowell Williams
Designers:
Lowell Williams, Lance Brown
Photographers:
Ron Scott, Bob Harr, Jim Sims
Design Firm:
Lowell Williams Design, Inc.,
Houston, TX
Client:
Gerald D. Hines Interests
Typographer:
Typeworks, Inc.
Printer:
Heritage Press

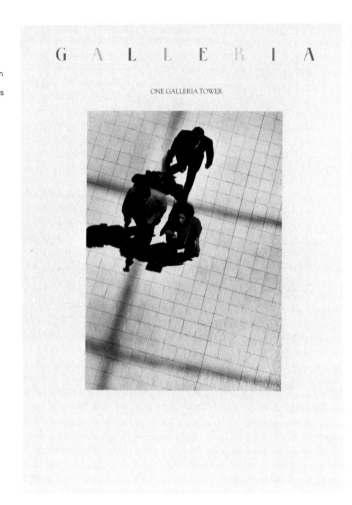

GALLERIA

ONE GALLERIA TOWER

Brochure:
Harbert Corporation
Art Director:
Robert Miles Runyan
Photographers:
Various
Design Firm:
Robert Miles Runyan &
Assoc., Playa del Rey, CA
Client:
Harbert Corp.
Typographer:
Composition Type
Printer:
Lithographix

Harbert
Corporation

Catalog:
Schumacher Images
Art Directors:
Raymond Waites, Cheryl Lewin
Designer:
Cheryl Lewin
Photographer:
Bruce Wolf
Design Firm:
Gear Design, New York, NY
Client:
Schumacher
Typographer:
Gerard Assoc.
Printer:
Davis Printing Corp.

Publication:
Rules: Typographic,
Vol 13, #1, June 1981
Art Director:
Jack Summerford
Designer:
Jack Summerford
Artist:
Jack Summerford
Design Firm:
Summerford Design, Inc.
Dallas TX
Publisher:
Typographers International
Assn.
Typographer:
Typography Plus
Printer:
Evergreen Press

Promotional Literature:
WGBH Educational Foundation
Art Director:
Douglass Scott
Designers:
Douglass Scott,
Lorraine Ferguson
Design Firm:
WGBH Design Dept. Boston, MA
Publisher:
WGBH
Printers:
WGBH, Beckler Press, Inc.

Annual Report:
Heizer Corporation
Annual Report 1981
Art Director:
Norman Perman
Designer:
Norman Perman
Photographer:
Michael Mauney
Design Firm:
Norman Perman, Inc.
Chicago, IL
Client:
Heizer Corp.
Typographer:
J.M. Bundscho, Inc.
Printer:
Fine Arts Printing Co.

Folder:
How Big Is Big
Art Director:
Lowell Williams
Designer:
Bill Carson
Photographer:
Jim Sims
Design Firm:
Lowell Williams Design, Inc.,
Houston, TX
Client:
The Office of Pierce Goodwin
Alexander
Typographer:
Typeworks, Inc.
Printer:
Wetmore Co.

Announcement:
Stars
Art Director:
Nancy Hoefig
Designer:
Nancy Hoefig
Artist:
Nancy Hoefig
Design Firm:
Richards, Sullivan, Brock &
Assoc. / The Richards Group
Dallas, TX
Client:
Richards Direct Marketing
Typographer:
Chiles & Chiles
Printer:
Williamson Printing Co.

Brochure:
Management of Acne
Art Director:
Phil Kunze
Designer:
Norman Perman
Artist:
Norman Perman
Design Firm:
Norman Perman, Inc.
Chicago, IL
Client:
The Upjohn Co.
Typographer:
Typehouse, Inc.

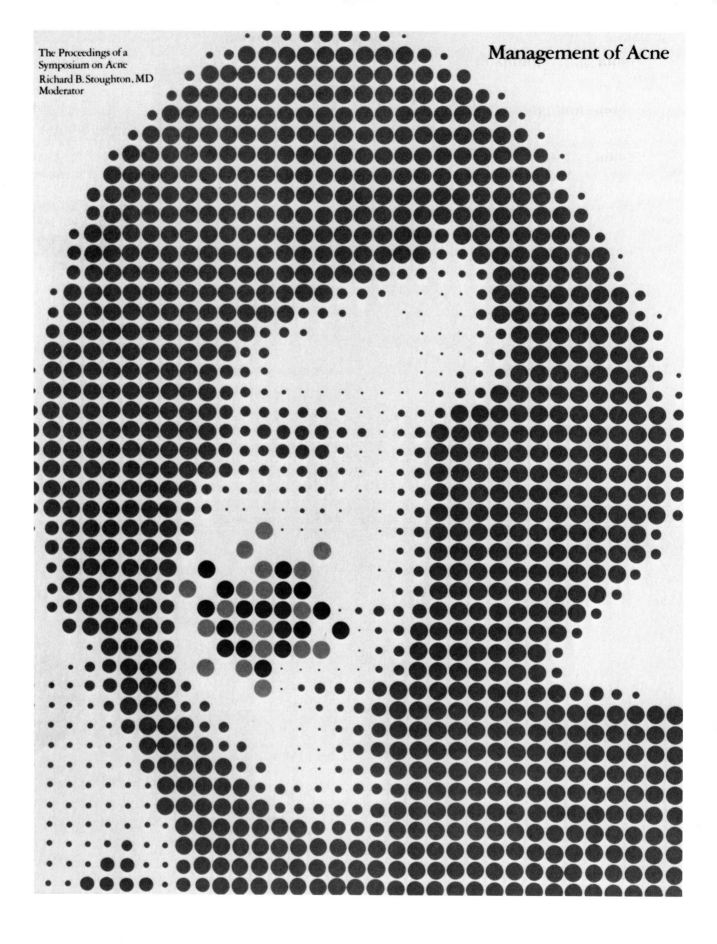

The Proceedings of a
Symposium on Acne
Richard B. Stoughton, MD
Moderator

Management of Acne

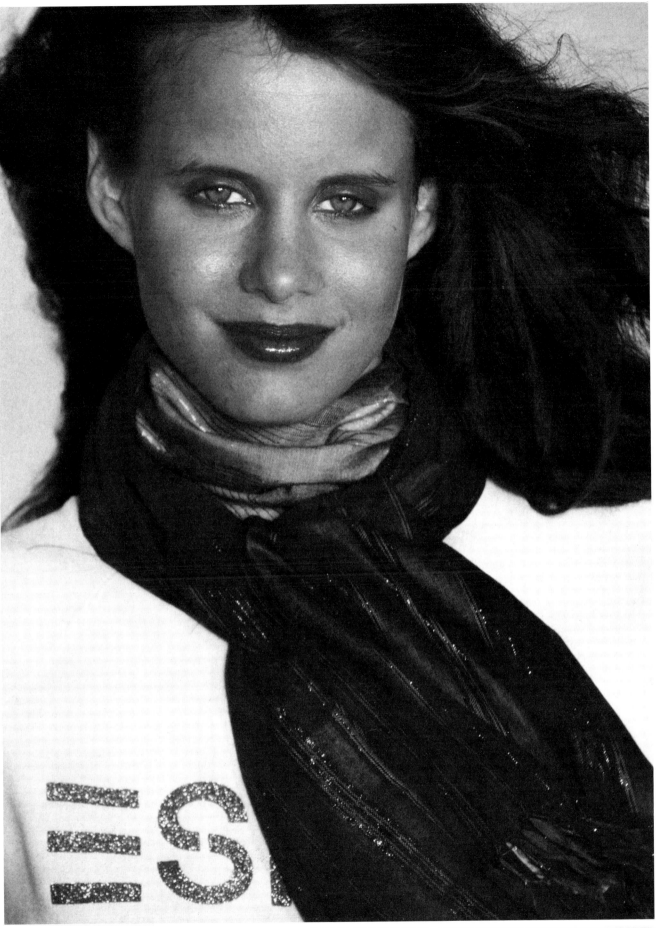

Brochure:
Esprit: Holiday '81
Art Director:
John Casado
Designer:
John Casado
Photographer:
Oliviero Toscani
Design Firm:
Casado Design
San Francisco, CA
Client:
Esprit de Corp
Typographer:
Reprotype Advertising
Typography

255

Brochure:
Steelcase: Series 424 Seating
Art Director:
David Perkins
Designers:
Roger Sliker, David Perkins
Photographer:
New Dimensions
Design Firm:
David Perkins & Assoc.
Grand Rapids, MI
Client:
Steelcase, Inc.
Typographer:
Typehouse, Inc.
Printer:
Etheridge Printing Co.

Brochure:
Champion: Capacity Expanding
Art Director:
Philip Gips
Designers:
Philip Gips, Denys Gustafson
Photographer:
Tom Hollyman
Design Firm:
Gips + Balkind + Assoc., Inc.,
New York, NY
Client:
Champion International Corp.
Typographer:
Innovative Graphics
International
Printer:
Crafton Graphic Co., Inc.

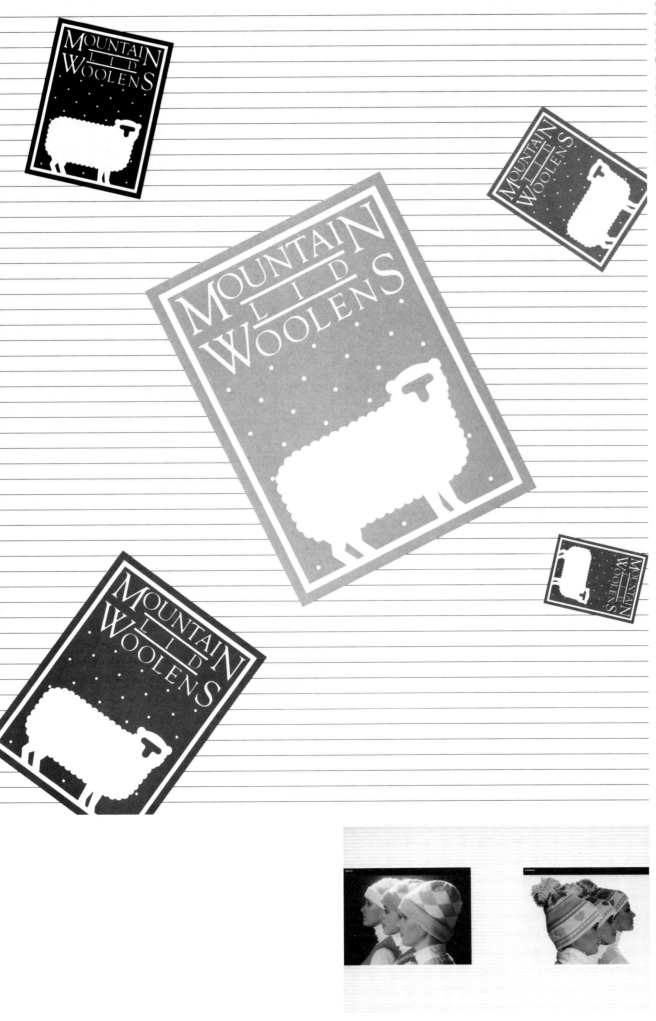

Brochure:
Mountain Lid Woolens
Art Director:
Michael Vanderbyl
Designer:
Michael Vanderbyl
Photographers:
Light Language,
David Inocencio
Design Firm:
Vanderbyl Design
San Francisco, CA
Client:
Mountain Lid Woolens
Typographer:
Headliners / Identicolor
Printer:
Interprint

Annual Report:
Pabst Brewing Co.
1980 Annual Report
Art Director:
Jerry Leonhart
Designers:
Nicholas Sidjakov,
Michael Mabry
Photographer:
Paul Fusco
Design Firm:
Sidjakov Berman & Gomez
San Francisco, CA
Client:
Ogilvy & Mather
Publisher:
Pabst Brewing Co.
Typographer:
Omnicomp
Printer:
Wetzel Bros., Inc.

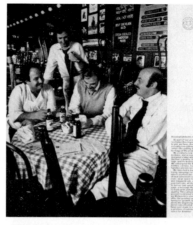

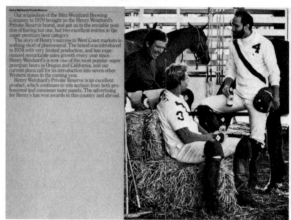

Annual Report:
Science Management Corp.
Annual Report 1980
Art Director:
Peter Harrison
Designer:
Kaspar Schmid
Photographer:
Mickey Kaufman
Design Firm:
Pentagram, New York, NY
Client:
Science Management Corp.
Typographer:
M.J. Baumwell Typography
Printer:
Froelich/Green
Litho Corp., Inc.

Newspaper Ad:
Christmas Lingerie
Art Director:
Barbara Richer
Photographer:
Gosta Peterson
Design Firm:
Henri Bendel, Inc. New York, NY
Client:
Henri Bendel, Inc.

Bendel's arcade—our place for private-life dressing—is currently crammed to its charming arches with the kind of lingerie, sleepwear and at-home clothes that christmas-night dreams are made of/ from very innocent white cotton voile to very sophisticated black silk satin / from swiss silk-knit underwear to english wool-knit bedjackets/ barely-there teddies and tap pants to bear-hug flannel grannygowns/ entertaining ideas in velour to period pieces in crepe de chine/ and a rotunda-full of remarkable robes/ so come make someone's dream come true on 3 at 10 west 57th—where everyone is wide-awake—and welcoming—monday thru friday from 10 o'clock until 8, until 6 o'clock on saturday

HENRI BENDEL

HENRI BENDEL

Newspaper Ad:
Ruffs
Art Director:
Jeff McKay
Photographer:
Gosta Peterson
Design Firm:
Henri Bendel, New York, NY
Client:
Henri Bendel, Inc.

Collectively speaking, we're all set up for the party season
on the street of shops/with a cornucopia of collars, a jackpot
of jewelry, a bevy of evening bags, a constellation of coloured tights,
a boodle of bangles, a marathon of marvelous pumps, a nexus of necklaces,
a seraglio of scarves, a brouhaha of belts, a sensation of scents—and
a galaxy of other night-life goodies, collected now on 1 at 10 west 57th

Magazine Ad:
Help
Art Director:
Seymon Ostilly
Designer:
Seymon Ostilly
Photographer:
Richard Hernandez
Design Firm:
Lord, Geller, Federico,
Einstein, Inc., New York, NY
Client:
IBM Corp.
Typographer:
Royal Composing Room
Printer:
Pioneer-Moss, Inc.

How simple life would be if help were just a push-button away. It is. On some of IBM's newest computers and office systems.

It's called a HELP button and it's just one of the ways we're making our machines easier to learn and easier to use.

Push it, and our machine will explain itself, flashing easy-to-follow messages on the display screen. It will tell you what other buttons on the keyboard mean, what they do, and how to use them. Instantly.

It's like taking instruction manuals off the shelf and putting them at your fingertip. To teach a beginner. Or refresh the memory of an old pro.

Of course, some people may never need any help.

But it's nice to know it's just a push-button away. **IBM**

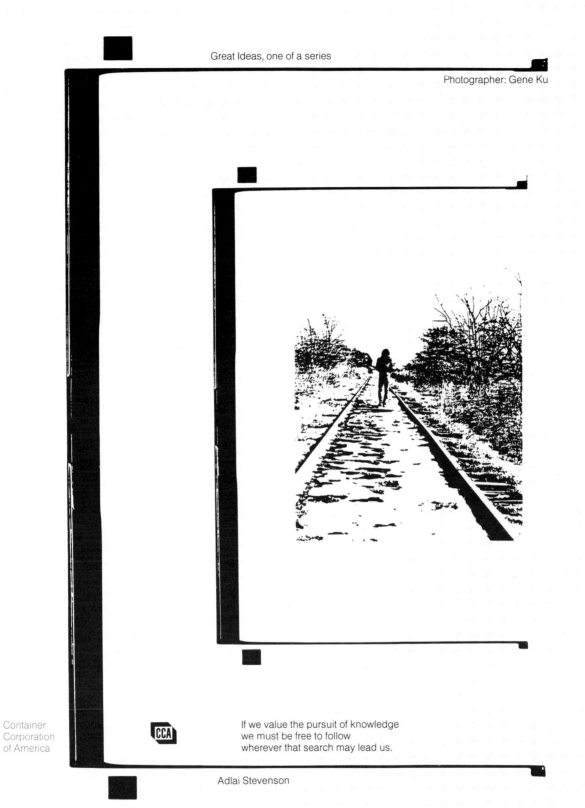

Great Ideas, one of a series

Photographer: Gene Ku

Container
Corporation
of America

CCA

If we value the pursuit of knowledge
we must be free to follow
wherever that search may lead us.

Adlai Stevenson

Magazine Ad:
Great Ideas
Art Director:
John Massey
Designer:
John Massey
Photographer:
Gene Ku
Design Firm:
Container Corporation of
America Communications
Chicago, IL
Client:
Container Corporation of
America
Typographer:
Ryder Types, Inc.

Logo:
Kids Lids
Art Director:
Michael Vanderbyl
Design Firm:
Vanderbyl Design
San Francisco, CA
Client:
Mountain Lid Woolens
Typographer:
Headliners / Identicolor

Poster:
Methanol to Gasoline
Art Director:
Ilona Sochynsky
Designer:
Ilona Sochynsky
Design Firm:
Ilona Sochynsky Assoc.
New York, NY
Publisher:
Mobil Oil Corp.
Typographer:
M.J. Baumwell Typography
Printer:
Crafton Graphic Co., Inc.

Magazine Ad:
A to B
Art Director:
Gary Goldsmith
Designer:
Gary Goldsmith
Design Firm:
Doyle Dane Bernbach
New York, NY
Client:
Volkswagen

Ra bbit

The cheapest way to go from a to b

Diesel
45 **EPA est. mpg.**
58 **EPA est. highway mpg.**

The best mileage car in America

Use "estimated mpg" for comparison. Mileage will vary with speed, trip length, weather. Actual highway mpg will probably be less.
© 1981 VOLKSWAGEN OF AMERICA

Calendar:
1982 Appointments Calendar:
Stephenson, Inc.
Art Director:
Jack Beveridge
Designer:
Jack Beveridge
Photographers:
Various
Design Firm:
Beveridge & Assoc., Inc.
Washington, DC
Publisher:
Stephenson, Inc.
Typographer:
Harlowe Photo Typography, Inc.
Printer:
Stephenson, Inc.

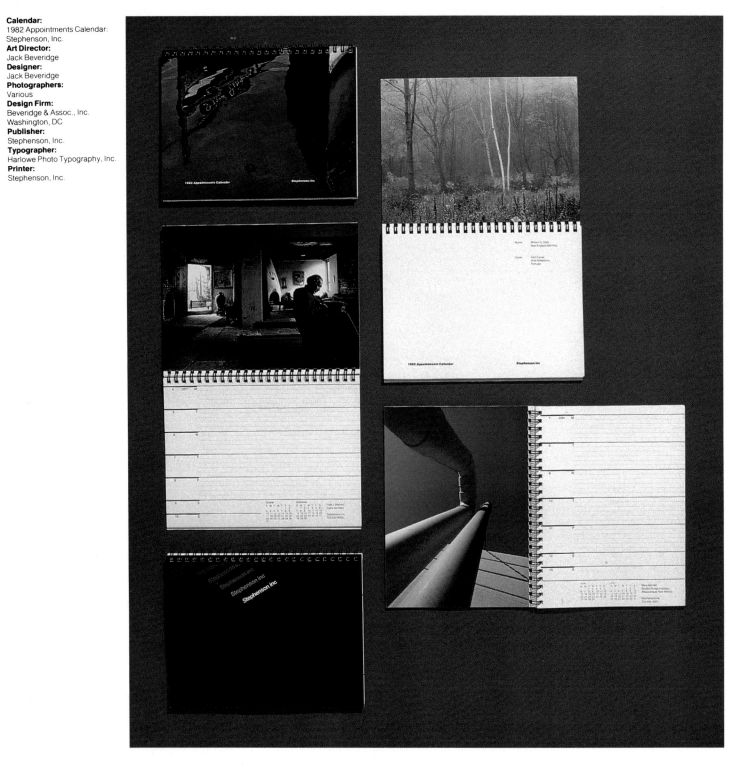

Calendar:
1982 Saga Calendar
Art Director:
Keith Bright
Designer:
Julie Riefler
Photographer:
Bret Lopez
Design Firm:
Bright & Assoc.
Los Angeles, CA
Client:
Saga Corp.
Typographer:
Andresen Typographics
Printer:
George Rice & Sons, Inc.

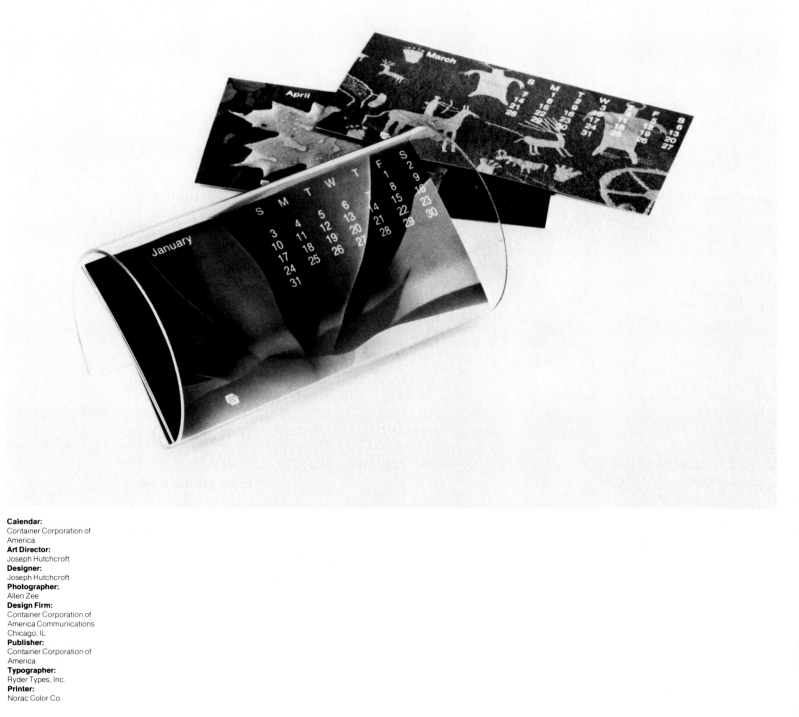

Calendar:
Container Corporation of
America
Art Director:
Joseph Hutchcroft
Designer:
Joseph Hutchcroft
Photographer:
Allen Zee
Design Firm:
Container Corporation of
America Communications
Chicago, IL
Publisher:
Container Corporation of
America
Typographer:
Ryder Types, Inc.
Printer:
Norac Color Co.

Calendar:
A New Year Emerges . . .
Art Director:
Jack Summerford
Designer:
Jack Summerford
Artist:
Jack Summerford
Photographers:
Keith Wood, Gary McCoy, Philip Prosen, Matthew Savins, John Katz
Design Firm:
Summerford Design
Dallas, TX
Publisher:
Heritage Press
Typographer:
Southwestern Typographics, Inc.
Printer:
Heritage Press

Calendar:
Paris, 1982
Art Director:
Willi Kunz
Designer:
Willi Kunz
Photographer:
Frederich Cantor
Design Firm:
Willi Kunz Assoc., Inc.
New York, NY
Publisher:
Frederich Cantor
Typographer:
Typogram
Printer:
Carlos Acuna

1982 Calendar

Photographs by
Fredrich Cantor

P A R I S

Sunday		5	12	19	26
Monday		6	13	20	27
Tuesday		7	14	21	28
Wednesday	1	8	15	22	29
Thursday	2	9	16	23	30
Friday	3	10	17	24	31
Saturday	4	11	18	25	

DECEMBER 1982

Calendar:
A Quality Year
Art Director:
Jeff Barnes
Designer:
Jeff Barnes
Design Firm:
Container Corporation of
America Communications
Chicago, IL
Publisher:
Container Corporation of
America, Container Division
Typographer:
Typographic Arts
Printer:
Rohner Printing Co.

A Quality Year

Container Division

Container Corporation

of America

Q 82

Stationery:
Arnold Harwell McClain &
Assoc., Inc.
Art Director:
Woody Pirtle
Designer:
Frank Nichols
Artist:
Frank Nichols
Design Firm:
Woody Pirtle, Inc.
Dallas, TX
Client:
Arnold Harwell McClain &
Assoc., Inc.

Menu:
Dalts To Go
Art Director:
Woody Pirtle
Designer:
Woody Pirtle
Artist:
Woody Pirtle
Design Firm:
Woody Pirtle, Inc.
Dallas, TX
Client:
T.G.I. Friday's, Inc.
Typographer:
Southwestern Typographics,
Inc.
Printer:
Allcraft Printing Co.

Invitation Booklet:
IBM: Tucson: Invitation to
Excellence
Art Director:
Kurt W. Gibson
Designer:
Kurt W. Gibson
Photographers:
Gill Kenny, Jeff Hamilton, Peter
Kresan, Garry Morris
Design Firm:
IBM/Tucson Design Center
Tucson, AZ
Publisher:
IBM Corp.
Typographer:
Tucson Typographic Services,
Inc.
Printer:
Frederic Printing Co.

Promotional Literature:
MBA Program
Art Director:
Eddie Byrd
Designer:
Eddie Byrd
Design Firm:
Byrd Graphic Design, Inc.
Pittsburgh, PA
Client:
University of Pittsburgh,
Graduate School of Business
Typographer:
Davis & Warde, Inc.
Printer:
Hoechstetter Printing Co.

Coordination de l'image de marque de la Compagnie Française des Isolants

A Corporate-Identity System for Compagnie Française des Isolants

Standards Manual:
Compagnie Française des Isolantes
Art Director:
John R. Rieben
Designer:
John R. Rieben
Design Firm:
Raychem Corp.
Menlo Park, CA
Publisher:
Campagnie Française des Isolantes
Typographer:
Draeger & Mount
Printer:
Dacus, Inc.

Logo:
Campagnie Française des Isolantes
Art Director:
John R. Rieben
Designer:
John R. Rieben
Design Firm:
Raychem Corp.
Menlo Park, CA
Client:
Compagnie Française des Isolantes

Logo:
Last Chance Garage
Art Director:
Gene Mackles
Designer:
Gene Mackles
Design Firm:
WGBH Design, Boston, MA
Client:
WGBH-TV

Logo:
Texaco
Art Director:
Kenneth D. Love
Designers:
Richard Felton, Don Kline
Design Firm:
Anspach Grossman Portugal,
Inc., New York, NY
Client:
Texaco, USA

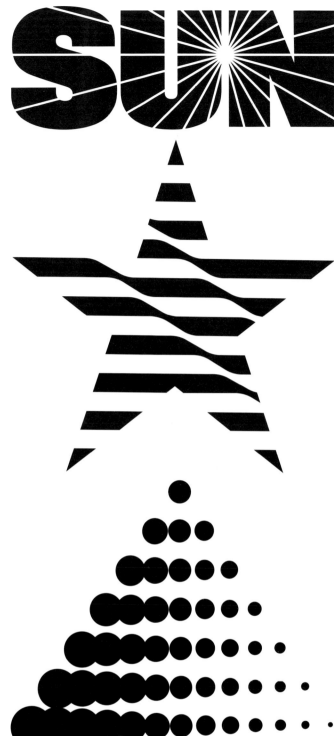

Logo:
Sun
Art Director:
Kenneth D. Love
Designer:
Richard Felton
Design Firm:
Anspach Grossman Portugal,
Inc., New York, NY
Client:
Sun Co., Inc.

Logo:
Marina Bay
Art Director:
Michael Vanderbyl
Designer:
Michael Vanderbyl
Design Firm:
Vanderbyl Design
San Francisco, CA
Client:
City of Richmond / Tecon Realty

Logo:
VentureGraphics
Art Director:
Michael Vanderbyl
Design Firm:
Vanderbyl Design
San Francisco, CA
Client:
VentureGraphics
Typographer:
VentureGraphics
Printer:
VentureGraphics

Stationery:
Orlando HQ Relocation,
Westinghouse Steam Turbine-
Generator Division
Art Director:
Eddie Byrd
Designer:
Eddie Byrd
Design Firm:
Byrd Graphic Design
Pittsburgh, PA
Client:
Westinghouse Steam Turbine-
Generator Division
Typographer:
Davis & Warde, Inc.
Printer:
Stephenson, Inc.

Logo:
Orlando HQ Relocation,
Westinghouse Steam Turbine-
Generator Division
Art Director:
Eddie Byrd
Designer:
Eddie Byrd
Design Firm:
Byrd Graphic Design, Inc.
Pittsburgh, PA
Client:
Westinghouse Steam Turbine-
Generator Division
Typographer:
Davis & Warde, Inc.
Printer:
Stephenson, Inc.

«New Day
Dawning»

Stationery:
Index Incorporated
Art Director:
Glenn A. Kroepil
Designer:
Marilyn Van Cleave
Design Firm:
Intergraphic Design, Inc.
Houston, TX
Client:
Index, Inc.
Typographer:
Typeworks, Inc.
Printer:
Allen Printing Co.

Stationery:
Robert Miles Runyan &
Associates
Art Director:
Robert Miles Runyan
Designer:
Steve Sieler
Design Firm:
Robert Miles Runyan &
Assoc., Playa del Rey, CA
Client:
Robert Miles Runyan &
Assoc.

Announcement:
Roland Pierre and J. Julia
Art Directors:
Jack Katalan, Alyssia Lazin
Designer:
Lazin & Katalan
Design Firm:
Lazin & Katalan
New York, NY
Client:
Schwartz & Benjamin, Inc.
Printer:
Dubin & Dubin

Announcement:
GNUSTON
Art Directors:
Richard Burns, John Clark
Designer:
John Clark
Artist:
Sandra Short
Design Firm:
The GNU Group, Sausalito, CA
and Houston, TX
Publisher:
The GNU Group
Printer:
Interprint / Paragraphics

Stationery:
Chicago City Theatre Co.
Art Director:
Joseph M. Essex
Designer:
Joseph M. Essex
Artist:
Joseph M. Essex
Design Firm:
Burson-Marsteller Design
Group, Chicago, IL
Client:
Chicago City Theatre Co.
Typographer:
King Typographic Service
Printer:
Nu-Tone Printing

Announcement:
Gwyneth Is as Cute as a Button
Art Director:
Gary Templin
Designer:
Gary Templin
Design Firm:
Richards, Sullivan, Brock &
Assoc. / The Richards Group
Dallas, TX
Client:
Dave Gravelle
Typographer:
Southwestern Typographics,
Inc.
Printer:
Heritage Press

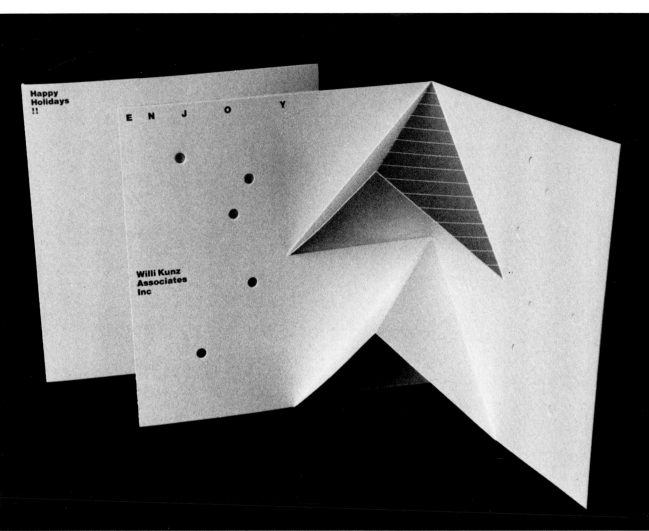

Christmas Card:
Happy Holidays!!
Art Director
Willi Kunz
Designer:
Willi Kunz
Artist:
Willi Kunz
Design Firm:
Willi Kunz Assoc., Inc.
New York, NY
Client:
Willi Kunz Assoc., Inc.
Typographer:
Typogram
Printer:
Circle Press Co., Inc.

Greeting Cards:
Christmas and New Years Cards
Art Director:
Kenneth R. Cooke
Designer:
Eric Scott
Artist:
Lynn Swickard
Design Firm:
Landor Assoc., New York, NY
Publisher:
Landor Assoc.
Typographer:
Haber Typographers, Inc.

Stationery:
Cynthia Branch
Art Director:
Woody Pirtle
Designer:
Woody Pirtle
Artists:
Woody Pirtle, Frank Nichols
Design Firm:
Woody Pirtle, Inc.
Dallas, TX
Client:
Cynthia Branch & Assoc.
Typographer:
Southwestern Typographics,
Inc.
Printer:
Heritage Press

Stationery:
The Glenwood School
Art Director:
Woody Pirtle
Artist:
Woody Pirtle
Design Firm:
Woody Pirtle, Inc.
Dallas, TX
Client:
The Glenwood School
Typographer:
Southwestern Typographics,
Inc.
Printer:
Williamson Printing Corp.

Certificate:
Union Carbide Stock Certificate
Art Director:
Eugene J. Grossman
Designer:
Eugene J. Grossman
Design Firm:
Anspach Grossman Portugal,
Inc., New York, NY
Client:
Union Carbide Corp.

The Book Show

The jury placed a high degree of emphasis on design integrity: all components of a design being "of a piece" and internally consistent.

Chairman
Martin S. Moskof
Principal
Martin S. Moskof & Associates

Jury
Irwin Glusker
Principal
The Glusker Group, Inc.

Paul Hanson
Art Director
Workman Publishing Company

Amy Hill
Senior Designer
Holt, Rinehart & Winston

Dana Levy
Principal
Dana Levy Associates

Laurie Lewis
Head of the Design Unit
University of Toronto Press

Gianfranco Monacelli
Chairman and President
Rizzoli International Publications

Tom Suzuki
Art Director
Time-Life Books

Virginia Tan
Senior Designer
Alfred A. Knopf, Inc.

"Hard Times in Hardcover Country," proclaimed a March 1982 *Time* magazine article that examined the woes of the American book publishing industry. The cause, *Time* said, was a familiar one: economics. Rising costs of book manufacturing and distribution, plus a decline in the buying public's willingness to pay increased costs that must be passed through to preserve already paper-thin margins, spell trouble. The mighty, mass-market paperback (which itself was once thought to be the harbinger of death to the trade book business, but was, in fact, its temporary savior) is suffering, too. Average prices have pushed the cost of paperbacks up so far that their sales volume is off, profits have plunged, and the financial linchpin of the industry—sales of rights down through the system—is cracking.

The familiar hardcover book is already seen by some as an anachronism. The economics of publishing point the sorry way from class to mass, from the enduring to the ephemeral, from the library to the throwaway potboiler/romance.

Economic pressure of this scale on the industry has inevitable impact on the design of books. Increasingly, the relationship between the designer and the production staff is no longer an intelligent partnership—it's adversarial, and sometimes bitterly so. "Defensive design," a juror commented, "is the order of the day."

Like the jury for the Covers exhibition, this group of professionals placed a high degree of emphasis on design integrity: insisting that all components of a design be "of a piece" and internally consistent. Design that called attention to itself, design that was intrusive, insistent, or inappropriately idiosyncratic, was judged toughly and was found wanting. Quality consisted of attention to details which had been integrated successfully into a unified whole.

Typical of an industry in economic disarray, the negative impact of negative profit-and-loss statements falls most heavily on the vast middle. Inexpensive and expensive product lines do well. (Toyotas sell and so do Mercedes; Buicks don't.) In this competition, expensive didn't often equal excellence and acceptance. In fact, professional judgment ran against the "overproduced" book, both conceptually and physically extravagant. A book is a promise, in a way, and a large, expensive book makes a big promise—so big, in fact, that few can fulfill it.

More than 800 books were submitted to this year's competition; 78 were selected for exhibition. More than is typical for any juried exhibition, there were strong feelings that the overall quality of the submissions was disappointing. Close to 40,000 titles were published last year. (That boxcar number includes *everything* from the hundreds of Harlequin romance titles released to the $1,000-a-copy handset edition of *Moby Dick*.) Simple division reveals that one book of every 50 published was submitted for consideration. Compared to submissions to other AIGA competitions, this doesn't seem terribly out of line statistically. (There were about 250 annual reports submitted to Communication Graphics, or about 1 in 50 for all publicly owned American companies.) What happens when you gather a group of extremely discerning designers, whose senses and sensibilities are highly refined, is that the evaluative environment becomes supercharged. Things that may look good when browsed through in a bookstore, compared to the mediocrity surrounding them, pale a little in the company of other submissions.

Several of the jurors agreed that some of the best, most innovative work in book design occurs at thousands of small, private presses, where editions of no more than a handful are the rule. Another area of book design lies in artists' limited editions, where the boundaries between books-about-art and books-as-art become blurred. Unfortunately, neither one of these two areas of energetic book design is adequately represented, either in the submissions or the final selections. And what's most interesting about private-press and artist-published books is that they regain—indeed, depend on—the traditional marriage between art and craft, design and production.

So, for the most part, the selection here represents, from a design standpoint, the best a shaky industry has to offer. And considering the pressures, the caliber is high.

Book Title:
Man as Art
Author:
Malcolm Kirk
Editor:
Barbara Burn
Art Director:
Michael Shroyer
Designer:
One Plus One Studio
Photographer:
Malcolm Kirk
Publisher:
Studio Books
The Viking Press
New York, NY
Typographer:
Adroit Graphic
Composition, Inc.
Printer:
Dai Nippon Printing Co., Ltd.
Production Manager:
Peter H. Grant
Papers:
U-lite Matte Coated 106 #
Jyoshitsu Uncoated 106 #
Binder:
Dai Nippon Printing Co., Ltd.
Jacket Designer:
One Plus One Studio
Jacket Photographer:
Malcolm Kirk

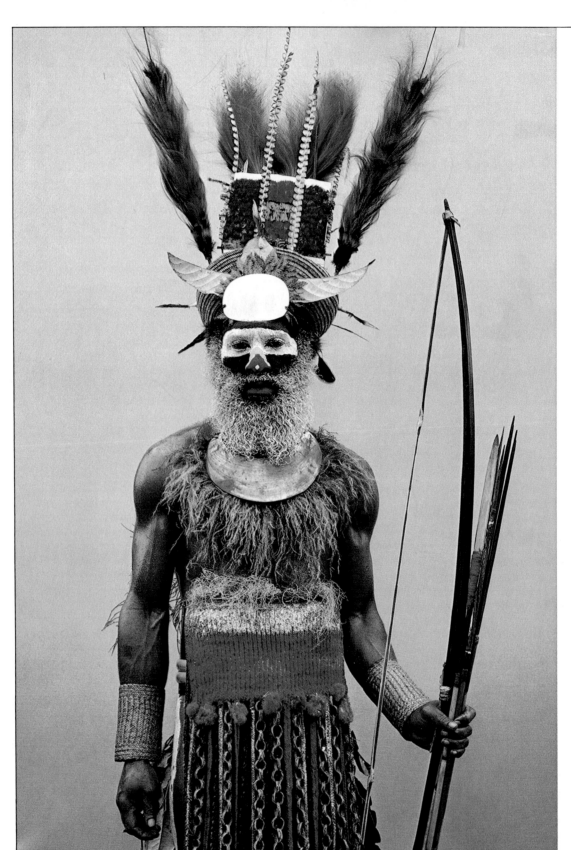

64

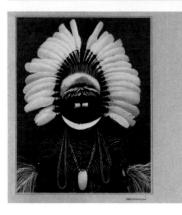
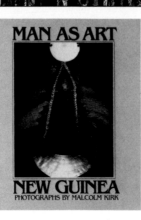
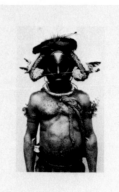

284

Book Title:
Western Views and Eastern Views

Author:
Eugene Ostroff

Editor:
Andrea Stevens

Art Director:
Leon Mullen

Designer:
David Franek

Illustrators:
Various

Publisher:
Smithsonian Institution Traveling Exhibition Services (SITES) Washington, DC

Typographer:
Harlowe Typography, Inc.

Printer:
Eastern Press, Inc.

Production Manager:
Andrea Stevens

Paper:
Sonata Natural Vellum, Warren's Lustro Offset Enamel Dull

Binder:
Mueller Trade Bindery

Jacket Designer:
David Franek

Jacket Illustrator:
William Henry Jackson

7A. "Old Pueblo Ruins, Cañon de Chelle, N.M."
Stereograph by Timothy H. O'Sullivan (Wheeler survey), 1873
4" x 7"
From Division of Photographic History, Smithsonian Institution

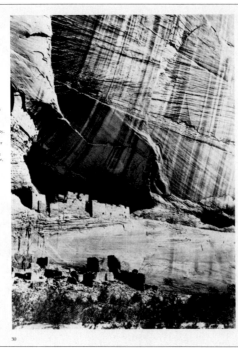

6. "Ancient Ruins in the Cañon de Chelle, N. M. In a niche 50 feet above present Cañon bed"
"White House" ruins, west Canyon de Chelle, Canyon de Chelle National Monument, Apache County, Arizona
By Timothy H. O'Sullivan (Wheeler survey), 1873
From 1873 O'Sullivan series, mount imprinted No. 11 (No. 10 in Wheeler, *Photographs*, 1873)
14" x 11" on 19¾" x 15½" mount
From Denver Public Library

7B. "Ruins of an old Pueblo in the Cañon of Chelly—Sept. 8th"
This drawing was done more than a decade before photography played a role in documenting the Far West. Also see fig. 8B.
Lithograph by R. H. Kern from J. E. Johnston and others, *Reports of the Secretary of War, with Reconnaissances of Routes from San Antonio to El Paso...*, Washington, 1850, Plate 53
7¼" x 4⅝"
From Smithsonian Institution Libraries

30

31

74. "Palace Butte Park, Gallatin Mt's., M.T." (in negative)
Probably Hyalite (formerly Middle) Creek, upstream from present Middle Creek Reservoir; Palace Butte is west of Hyalite Creek, Gallatin County, Montana
By William Henry Jackson (Hayden survey), ca. September 15, 1872. Probably 1872 series (11" x 14" negatives), No. 57. See also 1872 stereoscopic series, No. 587; 1872 series (8" x 10" negatives), No. 476 (Jackson catalog, pp. 38, 45, 47).
16¾" x 13½" on 15½" x 20" mount
From Denver Public Library

75. "Grand Cañon of the Yellowstone" (in negative) (Wyoming)
By either William Henry Jackson (W.H. Jackson & Co., Denver) or John K. Hillers (U.S. Geological Survey), 1883 or 1885 (similar orientation in Jackson's 1871 series (8" x 10" negatives), No. 248 (Jackson catalog, p. 28))
13" x 9⅜" on 20" x 16" mount
From U.S. Geological Survey

76. "Canyon River??" (pencil on mount)
Inner gorge of the Grand Canyon of the Colorado River, Grand Canyon National Park, Arizona
By John K. Hillers (Powell survey), 1872 or later
17⅜" x 21⅜" on 21⅜" x 28" mount
From U.S. Geological Survey

84

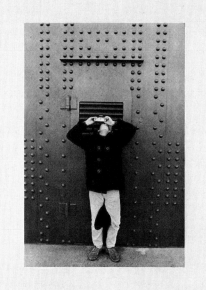

25
Chimney pots, Castle Street, 1946

26
Eric, south tower, Golden Gate
Bridge, 1969

Book Title:
Leo Holub Photographer
Foreword:
Wallace Stegner
Editor:
Della Van Heyst
Art Director:
James Stockton
Designer:
James Stockton
Photographer:
Leo Holub
Publisher:
Stanford Alumni Association
Stanford, CA
Typographer:
Mercury Typography Co.
Printer:
Dai Nippon Printing Co., Ltd.
Production Manager:
Ken Coburn, Interprint
Paper:
Ulite Matte Coated 100 #
Binder:
Dai Nippon Printing Co., Ltd.
Jacket Designer:
James Stockton
Jacket Photographer:
Leo Holub

86
MFA seminar at Bleeker, John and
Elizabeth, 1969

87
Graduate art seminar, another
look, 1968

Book Title:
A Century of Japanese
Photography
Author:
Japan Photographers
Association
Introduction:
John W. Dower
Editor:
Tom Englehardt
Designer:
Elissa Ichiyasu
Photographers:
Various
Publisher:
Pantheon Books, New York, NY
Typographer:
Typographic Images, Inc.
Printer:
Arcata Graphics
Production Managers:
Karen Bendelstein, Peter
Mollman
Paper:
Mountie Matte 70 #
Binder:
Arcata Graphics
Slipcase Designer:
Elissa Ichiyasu

Book Title:
A Visit With Magritte
Author:
Duane Michals
Editor:
Charles Traub
Designer:
Arne Lewis
Photographer:
Duane Michals
Publisher:
Matrix Publications, Inc.
Providence, RI
Typographer:
Marvin Kummel Productions,
Inc.
Printer:
Dynagraph, Inc.
Production Manager:
Robert Tow
Paper:
Cameo Dull 100 #
Binder:
Sendor Bindery
Jacket Designer:
Arne Lewis
Jacket Photographer:
Duane Michals

Book Title:
Knoll Design
Authors:
Eric Larrabee, Massimo Vignelli
Art Director:
Massimo Vignelli
Designer:
Massimo Vignelli
Photographers:
Various
Publisher:
Harry N. Abrams, Inc.
New York, NY
Typographer:
Knoll Graphics
Printer and Binder:
Amilcare Pizzi, S.p.A.
Jacket Designer:
Massimo Vignelli

Hans Knoll did not leave people neutral or unmoved; he made an impression. Few who knew him fail to comment on his charm, his persuasiveness, though sometimes they became disenchanted with it. He remarked on occasion that he was his company's best salesman, and this was true. He had a gift for picking good people and getting their best work out of them. He could see ahead, he knew what he wanted, and he was tireless in pursuing it. Knoll International properly bears his name because it is unimaginable without him.

He was born in Stuttgart, Germany, on May 8, 1914. His father, Walter C. Knoll, was one of the pioneer manufacturers of modern furniture in Weimar Germany, knew Gropius, Breuer, Mies van der Rohe; and made some of the early Bauhaus furniture for them. His younger son Hans was educated in England and Switzerland. They did not get on well: Walter Knoll was an autocrat of the old school. "Hans was not able to work with my father," his older brother Robert has said. "Hans was not a student. He didn't like going to school. He was always a problem." Hans Knoll broke away first to England, where he started Plan, Ltd., an interior design firm, and in 1937 accomplished his aim of coming to New York. The following year, in a single second-storey room on 72nd Street, he constituted himself the Hans G. Knoll Furniture Company, bravely nailing up a sign which read: Factory No. 1.

"He had one good chair that he brought over from Germany," says Florence Knoll. "The design is no longer in existence. I don't think there are any photographs of it. It was an excellent design. It had a marvelous spring system which has never quite been equalled. We were not able to produce it in the beginning because the steel needed for the spring system was not available. It was the wartime period."

Florence Schust and Hans Knoll met during the war. After finishing graduate school at Cranbrook she had attended the Architectural Association in London and taken a degree there, but she could not be licensed to practice in the United States without an American degree, so she had gone to study with Mies van der Rohe at what was then the Armour Institute in Chicago—"a year, a very valuable year." Afterward she was working in architectural offices in Boston for Gropius and Breuer and in New York for "Wally" Harrison when Hans Knoll offered her the task of designing an office for Secretary of War Henry L. Stimson. Half-humorously, she now says this was the beginning of Knoll's subsequent success in designing offices. Soon she "started moonlighting, doing extra job on my own time for Hans Knoll as an interior space planner and designer." This was 1943.

Hans Knoll's essential perception was that modern architects would eventually need modern furniture. Florence Schust did not think of herself then as a

Hans and Florence Knoll.

Mrs. Knoll's dog, Cartree, appeared in some of the early Knoll ads.

Hans Knoll's father, Walter, manufactured such furniture as this in prewar Germany.

Hans

18 19

After leaving the Bauhaus, Breuer traveled and practiced as an architect in Europe, then in England when Hitler's regime made modern architecture anathema in Germany. In 1937, invited by Gropius to teach at Harvard, he came to the United States. At Harvard Breuer taught hundreds of today's American architects, among them many of the leaders—I.M. Pei, Paul Rudolph, Philip Johnson, Edward Larrabee Barnes, John Johansen, Ulrich Franzen, Eliot Noyes. His furniture did not come into the Knoll line until 1968, with the acquisition by Knoll Associates of the Gavina firm in Italy. "Dino Gavina," says Breuer, "is a very interesting fellow, full of pep and temperament. I didn't know him when he looked me up at my New York office. We talked and I asked him to produce my furniture. Gavina took over production of my furniture and really put it on the map."

Gavina said to Breuer that his pieces ought to have names. What kind? asked Breuer. "You told me once that Wassily Kandinsky was the very first person who saw the first experimental chair," said Gavina. "Why don't we call it the Wassily?" Fine, said Breuer. "You have a daughter," said Gavina. "What's her name?" It was Italian, said Breuer, Francesca, but they called her Cesca. "Let's call the other chairs Cesca," said Gavina, "Then those benches. Do you have a nickname?" Breuer said that while he used Marcel officially his middle name was Lajko, which many of his friends called him by. So they named the table and the benches Lajko, but Gavina got it wrong and the catalog turned up with the spelling of "Laccio," which it has to this day.

Along with Breuer in the Gavina group came other designers of international distinction—Cini Boeri, Tobia Scarpa, Kazuhide Takahama, and Roberto Sebastian Matta—but he remains unique in his achievement not only as a designer but as an architect and teacher of a new generation.

Breuer's influence on his students has been described by Ed Barnes, who was one of them. "We had, of course," said Barnes, "heard and read about the new weltanschauung developed at the Bauhaus. But now we saw this new world. We saw it in Breuer's apartment at Cambridge. The walls were all white and there was the expected chrome furniture. But it was all bright and cheerful with primary color. There were paintings by Paul Klee and marvelous Hungarian peasant things and Japanese matting. There were many photographs of pretty girls and a lot of the things that you used to find at Design Research, but that we had never seen before. I guess I had expected something almost somber, like a Mondrian painting. But what we saw was more like a Paul Klee, only that Klee is often gloomy. Breuer and his art are happy."

"There was," he added, "a magic about Breuer . . . and that is something you can't theorize about."

A reclining chair with laminated wood frame, designed by Marcel Breuer in 1925.

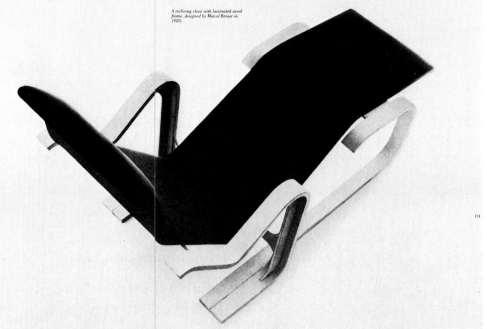

172 173

The designs of Wolf Bauer from Germany—Fragment, Collage, Delta, and Stones—initiated a new print program for Knoll in 1969. This collection was printed by silk screen on silk and cotton velvet.

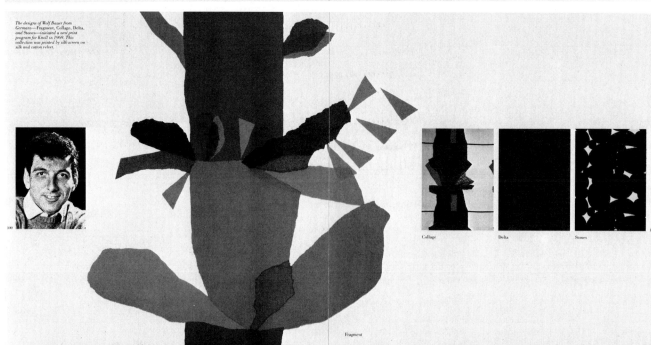

Collage Delta Stones

Fragment

100 101

290

Bottle Capper

Book Title:
Objects / John Gruen
Author:
John Gruen
Art Director:
R.D. Scudellari
Designer:
R.D. Scudellari
Photographer:
John Gruen
Calligraphy:
John Gruen
Publisher:
Alfred A. Knopf, Inc.
New York, NY
Printer:
Union Camp Corp.
Production Manager:
Ellen McNeilly
Paper:
Quintessence Dull 100 #
Binder:
Publishers Book Bindery
Slipcase Binder:
R.D. Scudellari
Jacket Photographer:
John Gruen
Jacket Calligrapher:
John Gruen

Spools and Bottles

Book Title:
For the Hundredth Time
Gabberjabb Number Five
Author:
Walter Hamady
Editor:
Walter Hamady
Art Director:
Walter Hamady
Designer:
Walter Hamady
Illustrator:
Walter Hamady
Publisher:
The Perishable Press Ltd.
Mt. Horeb, WI
Typographer:
Walter Hamady
Printer:
Walter Hamady
Production Manager:
Walter Hamady
Paper:
Shadwell Handmade
Binders:
Walter Hamady, Mary Hamady,
Kathy Kuehn
Jacket Designer:
Walter Hamady
Jacket Illustrator:
Walter Hamady

*97&

*98

You(r Bub A Sus Tut A Rur Dud **Tut** i Tut Lull E **Pupp** A Gugg E)* Ør,
if your maiden name is not Brinker from Keokuk, then ½ **title** page but

since there is not (s'not) even ¼ of the title here we might as well make
this the official ²⁷⁄₃½ nds page or the ⧺²⁄₂ ths podge or just nds & ths pudge*

AND after the dilemma
of where to deposit the "NatureMade"¹²⁴ ammo(a)nia:
Cana lily bed or herb garden—
Chose the latter(§) for my bladder
and post-crepuscularly looked at the sky—

overcast/Cast over to westward and
better than a ½ moon¹²⁵ glowing but not apparent.

Instead, I was looking S/Eastward
and rising, snow-covered, were mountains ↟↟↟
the HIMALAYAS (Him A Lay Uhz
 (Him All Yuhzz)
me, THERE in India—gazing across a plain with hills—
plane hills ➤➤➤ the plain of the Ganges ➤➤➤
 S E E I N G ¹²⁶¹²⁷

these **I M M E N S E** snow colored mountains!

who was it said "By sitting still, you can go everywhere?"

(5. StAnza) Clause & (bréak)

Hats
& Glasses,

Two Essays by Arthur Hove
The first essay was read over Madison's WHA radio in 1979.

Illustrated with Vintage
Zinc Halftone Cuts Selected by John Thos Bennett
The plates were first used for normal newspaper purposes by the Wisconsin State Journal.

The Gardyloo Press, at Gorham & Butler Streets, Madison, 1981

Book Title:
Hats & Glasses
Author:
Arthur Hove
Art Director:
John Thos Bennett
Designer:
John Thos Bennett
Publisher:
John Thos Bennett
The Gardyloo Press,
Elm Grove, WI
Typographer:
John Thos Bennett
Printer:
John Thos Bennett,
The Gardyloo Press
Production Manager:
John Thos Bennett
Paper:
Arches Text Wove, Fabriano
Roma
Binder:
Sheryl Bennett
Jacket Designer:
John Thos Bennett

Other
people
may not be
as theatrical,
but they too use
glasses to call
attention to themselves.
The glasses are chosen
to match one's self-perception.
Horn-rim or tortoise shell
for the scholarly & businesslike,
wire-rimmed for the adventurous or
the self-effacing — depending on whether
the wearer wants to look like an aviator or a
working person. Color and designer shapes are for
those who aspire to glamor. Not only the frames, but
lenses, ranging from square to oval, are a part of the design.

I have,
during the
past two winters,
taken to wearing a hat.
This development has come
from a grudging acknowledgement
of two immutable facts: 1– I am
sliding into middle age, & 2– a hat keeps
my head warm. In the summer, a hat
keeps the sun out of my eyes. When I was
younger & thought it essential to prove my manhood,
I seldom wore a hat — even on the coldest days. Practicality & a
lust for survival have since replaced idealism as the most important
considerations in my life. Nevertheless, vanity has not completely
departed the scene. It took some searching, for example, to find what I
thought were appropriate winter and summer hats. Both had to possess what I
considered to be a certain style — something compatible with my image of myself.

Book Title:
Homage to the Alphabet
Authors:
Phil Baldus, Harold Baldus
Art Director:
James Hellmuth
Designer:
James Hellmuth
Illustrators:
John Burwell, Andrew Bartlett,
James Hellmuth, Steve Smith
Publisher:
Phil's Photo, Inc.
Washington, DC
Typographer:
Phil's Photo, Inc.
Printer:
Wolk Press, Inc.
Production Manager:
Bob Bair
Paper:
Patina Matte Text 70 #
Binder:
Excelsior Bindery
Jacket Designer:
James Hellmuth
Jacket Illustrator:
James Hellmuth

assive amounts of it pass before our eyes every day, and we don't see it.

Even the Big Eye doesn't infiltrate so many aspects of our lives. While we babble on about television and quarks and prime lending rates, nobody, outside of a small group of fanatics with vested interests, even thinks about type.

We think it's time for typography to have a wider audience. People should use their eyes and appreciate what's under their noses!

Compare the round thin ones with the straight fat ones and the curved slanted ones. Why there are so many kinds we haven't the foggiest, but we love it. It's almost as if humankind has embarked on a vast experiment to find out how many variations on 26 simple forms the mind can recognize. At what point does an I cease to be an I and become something else? Check out Lys Calligraph and Discus. The crossover point is very subtle.

Or try looking at type as a sort of heiroglyphic history of the last 300 years. See how it moves gradually away from handwritten forms as the machine age advances. Notice how the growing faith in technology as the great healer of all ills is accompanied by the almost complete elimination of the human hand in the sans serifs and notice how the hand is creeping back in now that we're not so sure.

Or why not have some of the pleasure of comparing the little idiosyncrasies of type faces in the ampersands and various dingbats? Often the type designer really enjoys himself down at the end of the font where nobody's looking too hard.

We could go on, but you get the idea. Anyhow, one of the fun things about type is finding your own games to play with it.

Philosophizing aside, *Homage to the Alphabet* masquerades by day as a working tool. To begin the agony and the ecstasy—the type selection process—we like to flip through the alphabetical showing until something pops out. Here, too, unexpected juxtapositions sometimes ring a bell. Then, assuming one has the rest of *Homage* in hand, the categorical book can be used to compare others of similar characteristics.

Leafing through the main book, though time-consuming, can also be rewarding. We find that the clumped style of setting reveals hidden character by allowing each letter to socialize with its compatriots.

That's the most help we can give. Of course we hope we can also help when you get down to setting the type. Our business is to serve fellow lovers of letters in the most efficient and sympathetic way possible.

CONDENSED

Advertisers Gothic ADVERTIS	Benguiat BENGUIAT	Cheltenham CHELTENHAM
Allegro ALLEGRO	Benguiat BENGUIAT	Cheltenham CHELTENHAM
Alternate Gothic ALTERNATE G	Benguiat BENGUIAT	Cheltenham CHELTENHAM
American TYPEWRITEF	Benguiat BENGUIAT	Cheltenham CHELTENHA
American TYPEWRITE	Benguiat BENGUIAT	Cheltenham CHELTEN
American TYPEWRI	Bernase BERNASE	Cheltenham CHELTE
ANTIETAM	Bernhard BERNHARD	Cheltenham CHELTENHAM
Anzeigen ANZEIGEN	Beton BETON	Cheltenham CHELTENHAM
Argent ARGENT	Beton BETON	Cheltenham CHELTENH
Argent Open ARGENT OPEN	Block Engraving BLOCK	Clarex CLAREX
Aurora AURORA AURORA	Bodoni BODONI	Compacta COMPACTA
Aurora AURORA	Bradley BRADLEY	Compacta COMPACTA
Avant Garde AVANT GARDE	California CALIFORNIA	Compacta COMPACTA
Avant Garde AVANT GARDE	California CALIFORNIA	Consort CONSORT
Avant Garde AVANT GIRDE	California CALIFORNIA	Craw Clarendon CRAW CLA
Avant Garde AVANT GARDE	California CALIFORNIA	Cucumber CUCUMBER
BALLOON	Century Litho CENTURY L	Cushing CUSHING
Benguiat BENGUIAT	Cheltenham CHELTENHAM	DOULOS BLOCK
		Egyptian EGYPTIAN
		EGYPTIAN PATRIOT

EGYPTIAN EGYPTIAN	Gill Sans GILL SANS	Jenson JENSON
Enge Etienne ENGE ETIENNE	Globe Gothic GLOBE GOTHIC	Joric Joric JORIC JORIC
Fat Face FAT FACE	Goudy GOUDY	Kabel KABEL
Fat Face FAT FACE	GRECIAN	Karnak KARNAK
Franklin Gothic FRANKLIN	Grotesque No.9 GROTESQU	Lafayette LAFAYETTE
Franklin Gothic FRANKLIN GOTHIC	Harry HARRY	Lightline LIGHTLINE
Franklin Gothic FRANKLIN GOTHI	Helvetica HELVETICA	Macbeth MACBETH MACB
FREDERICKSBURG	Helvetica HELVETICA	MACHINE
Futura FUTURA	Henrietta HENRIETTA	MACHINE
Futura FUTURA	Henrici HENRICI	MADISON MADISON
Futura FUTURA	Herold Reklame HEROLD REKLAME	Manchester MANCHE
Garamond GARAMOND	Howland HOWLAND	MARBLEHEART
Garamond GARAMOND	HUXLEY VERTICAL	MOORE LIBERTY
Garamond GARAMO	Impact IMPACT	Neptune NEPTUNE
Garamond GARAMO	Impact IMPACT	News Gothic NEWS GOTHIC
Garamond GARAMOND	INFORMAL GOTHIC INFORMAL	Olive Antique OLIVE ANTIQU
Garamond GARAMON	Insert Grotesk INSERAT GROTESK	OLYMPIA OLYMPIA
Garamond GARAMOND	IVY LEAGUE	Onyx ONYX
Garamond GARAM	Jana JANA	Othello OTHELLO
GETTYSBURG	Jay Gothic JAY GOTHIC	Permanent Headline PERMANENT HEAD
Gill Sans GILL SANS	Jay Gothic JAY GOTHIC	Permanent Headline PERMANENT HEA

CONDENSED

CONDENSED

Venture
ABABCDEFG
HIJKLMN
OPQRSTUV
WXYZ&R
(.,:;"?!-]abcd
eFghijklm
nopqrstuvw
xyz$123
4567890¢/$
£%

Venus Medium
ABCDEFG
HIJKLMNOPQ
RSTUVW
XYZ&(.,:;"")?!-ab
cdefghijklmn
opqrstuvwxyz
$123456
7890¢/£%‰

**Venus Extra
Bold AB**
CDEFGHIJK
LMNOP
QRSTUVW
XYZ&(.,:;"")
?!-abcdefgh
ijklmnopq
rstuvwxyz
$123456
7890¢/£%/$

Veronese
ABCDEFGH
IJKLMNO
PQRSTUV
WXYZ&
(.,:;)?![-]abcdef
ghijklmnop
qrstuvwxyz$1
$123456789
0¢£

Veronese
Semi-Bold ABC
DEFGHIJ
KLMNOPQ
RSTUVW
XYZ&(.,:;)?!-[-]
abcdefghijk
lmnopqrstuv
wxyz$123
4567890¢£

Veronese Bold
ABCDEF
GHIJKLMN
OPQRST
UVWXYZ&
(.,:;)?![.,:;-]?!-ab
cdefghijklmn
opqrstuv
wxyz$123456
7890¢£

To make this categorical index easy to use for both typophiles and novices, traditional categories have been eliminated in favor of ones which better catch the "feel" of a typeface.

It was felt that borderline faces should be included in all possible categories to allow you the option of comparison. Thus Joric, which is a condensed, ultra bold, evenly weighted sans serif, stencil face is displayed in four categories.

In addition to classifying the serifs (or lack of them), workhorse categories such as "Ultra bold" allow for quick and easy comparison of the blackest of the blacks. Faces of narrow proportions have been grouped together, but it should be remembered that any face can be condensed to your specifications at an additional charge. Subheads have been inserted in some categories to help you zero in on their most telling traits.

likely that this was the "John Hage" who emigrated from Derbyshire in 1774 and the following year, as Joseph Hague, petitioned the Pennsylvania Assembly for a premium for his jenny, not least because in November 1787 the British consul in Philadelphia, Phineas Bond, reported to his foreign secretary the rumor that Hague could be arrested at "a Place called Simonthly, near Hayfield in Derbyshire."[41] This time, the Hague in question succeeded in obtaining the design of Arkwright's rotary carding machine. On January 19, 1788, Thomas Wood, a member of the Pennsylvania Society's Manufacturing Committee, reported that he had "engaged with John Hague of Alexandria in Virginia to make [a carding machine] on their joint Acct. & Resque."[42] By March 12 the machine was completed. Carding cotton at the rate of fifty pounds a day, it was displayed in the grand federal procession that summer.

New Englanders also exhibited a strong interest in procuring Britain's new labor-saving textile machinery during the 1780s. One prime mover in Massachusetts was the immigrant Hugh Orr.

1.1 One of the first American spinning jennies, built in 1775 by Christopher Tully. Compared with Hargreaves's patented English jenny of 1770, Tully's machine incorporated a number of improved features: a driving wheel on a horizontal axle (O); power transmission to spindles by a tin layshaft (E); wheels and an opening mechanism in the clasp (F,R); activation of the faller wire from the carriage clasp; friction-reducing glass bases under the spindles; tensioning devices for both the driving wheel and the layshaft; and an adjustable roving box. (Source: *Pennsylvania Magazine*, 1775. Courtesy American Antiquarian Society.)

Trained as a gunsmith in Scotland, he continued his trade after emigrating in 1740 and during the Revolution set up a cannon foundry at East Bridgewater. Through his energies, the brothers Robert and Alexander Barr came to Bridgewater from Scotland in 1786 to set up cotton carding, roving, and spinning machinery, including, evidently, Arkwright's water frame. The sponsorship of the Massachusetts legislature, in which Orr was a senator, brought the three or four machines into the public domain; deposited in Orr's house, they stood open to public inspection and became known as "the State Models."[43]

That was in May 1787. Shortly before, a weaver, Thomas Somers, had arrived in Massachusetts with descriptions and models of carding and spinning machines he had collected in England the previous summer. Somers emigrated to America before 1785 because in that year an association of Baltimore tradesmen and manufacturers had dispatched him on a machine-collecting expedition to England. On his return, he found his promoters unenthusiastic, so he headed north for Boston, presumably because its manufacturers' circular of 1785 had inspired his sponsorship by the Baltimore group. Under Orr's eye, Somers performed some trial work, which made a group of Boston merchants sufficiently confident to sponsor the famous Beverly Cotton Manufactory, incorporated by the state of Massachusetts in 1789. The technical side of the manufactory was in the hands of Somers and another British immigrant, James Leonard. Visitors to the factory between 1788 and 1790, including George Washington, observed one Arkwright roller card (carding fifty pounds of cotton a day), four jennies (one of eighty-four spindles), a twisting mill, a

V
Reverse Flows

13
The Movement of American Innovations in Cotton and Woolen Manufacturing Technologies to Britain

When I speak of improvements, there are two things I include in the word; the first is an improvement in the machinery itself, the other is the improvement in working this machinery. Now if we had not made any improvements in the latter, namely in working the machinery, we should have found it very difficult, up to this moment, to stand against foreign competition. . . . The other matters, which are the improvements in the machine itself, . . . have been the inventions of America, and they will come in, no doubt, to enable us to produce the goods cheaper, but they may perhaps, in time, be conveyed to foreign countries, which may, perhaps, in time, work them as well as we can do.[1]

So Kirkman Finlay, a Scottish merchant in the American trade, testified before the Select Parliamentary Committee on Manufactures, Commerce and Shipping in 1833. Compared with westward flows of industrial textile technology, the reverse movement tended to be more rapid. As the first industrial nation, Britain presented special attractions to foreign inventors. Numerous machine shops in London and the manufacturing districts—Manchester, Leeds, and Glasgow—offered an unrivaled reservoir of machine building experience and skill, resting on intense specialization of labor and on a new range of machine tools. In them, new inventions might be built in the most approved manner and further refined.[2] And Britain's manufacturing districts made up one of the world's largest markets for capital goods.[3] Large-scale manufacturers, many of whom pioneered industrial technology in Britain, remained interested in adopting new advances in powered and mechanized techniques, as the rising number of patented inventions suggested. Aware of this sort

of potential, Moses Brown of Providence, Rhode Island, in summer 1792 advised Samuel Dorr to take his rotary cloth shear to England. In Brown's opinion, the machine was too complicated and expensive for American woolen manufacturers and was much better suited to circumstances in England's woolen industry.[4]

The most used channel of technology transfer from the United States to Britain was in the form of British patents of American inventions. Nearly 10 percent of the textile patents in the period 1790–1830 studied came from foreigners living abroad; by the late 1820s the proportion was over 14 percent (see table 3.3). Table 13.1 demonstrates the frequency with which Americans brought or sent their textile innovations to Britain. Every major American innovation in textile technology before 1815 was apparently patented in Britain. After 1815 the expansion of American manufacturing and the reshaping of American technology made the practice unnecessary in some cases. So Paul Moody's patents, his company's property, were built and perfected in the Boston Manufacturing Company's machine shop and used in the northern New England mills, which provided an adequate capital goods market. Conversely the Rhode Island cap and ring spindles and the Matteawan woolen power

13.1 Samuel Dorr's British patent of 1793 for his cloth shearing machine. Most notable are Dorr's efforts to find new rotary movements for the shear blades. Whereas he registered a wheel of blades in his American patent of the previous year (illustration 12.1), his British design reveals a groping toward the ultimately successful form of the lawnmower (sec. 4th). (G. B. patent 1945; courtesy Boston Public Library.)

Book Title:
Transatlantic Industrial Revolution
Author:
David J. Jeremy
Editor:
Paul Bethge
Designer:
Diane Jaroch
Illustrators:
Various
Publisher:
The MIT Press, Cambridge, MA
Typographer:
Achorn Graphic Services
Printer:
Halliday Lithograph Corp.
Production Manager:
Rachel Mathews
Paper:
Mohawk 60 #
Binder:
Halliday Lithograph Corp.
Jacket Designer:
Diane Jaroch

Scheherazade Retold

Yawning, she said, "I am too sleepy to remember what happens next. But I will think of it tomorrow and finish the tale tomorrow night if Your Highness wishes."

By this time the Sultan was very eager to hear the story's ending, so he agreed to this request.

The next evening, Scheherazade finished the tale and began another. Again she broke off before the end, pleading that she was too sleepy to remember the rest of the story.

"Very well, you may take your rest now," said the Sultan, quite disappointed. "Tomorrow you must try to remember the rest of the story. I want to know how it ends."

Scheherazade continued each evening in the same way. The nights of her storytelling stretched on and on and on to one thousand and one, while the townspeople rejoiced in the success of Scheherazade's efforts to save the young women of the city.

. . .

What happened to Scheherazade after the one thousand and one tales were told?

One storyteller would have us believe that at this point Scheherazade and the wicked Sultan fell in love and lived happily ever after. Another narrator tells us that Scheherazade, having born three babies during this period, cast herself at the Sultan's feet, begging for her life for the sake of her soon-to-be-orphaned children. The Sultan, entranced by the discovery of three male heirs—which he apparently had not known about—at once became a reformed man. Repenting of his earlier cruel treatment of the other maidens, he spared our heroine's life. Needless to say, in this version they also lived happily ever after.

Those readers who can accept that the clever, courageous Scheherazade ended her days in this fashion may choose either of the above endings to the tale.

THE MAID OF THE NORTH

FEMINIST FOLK TALES FROM AROUND THE WORLD

ETHEL JOHNSTON PHELPS

ILLUSTRATIONS BY LLOYD BLOOM

Holt, Rinehart and Winston New York

Book Title:
The Maid of the North
Author:
Ethel Johnston Phelps
Art Director:
Joy Chu
Designer:
Joy Chu
Illustrator:
Lloyd Bloom
Publisher:
Holt, Rinehart & Winston, Inc.
New York, NY
Typographer:
Adroit Graphic
Composition, Inc.
Printer:
The Book Press
Production Manager:
David Nettles
Paper:
Finch Opaque Vellum 60 #
Binder:
The Book Press
Jacket Designer:
Joy Chu
Jacket Illustrator:
Lloyd Bloom

32

25 MARK CATESBY *The Natural History of Carolina, Florida, and The Bahama Islands.* London: Printed for Benjamin White, 1771

When William Strahan, the well-known London printer, filled his first order from the Library Company in 1752, he sent everything requested except "Catesby's Carolina Coloured, . . . as it is a very dear Book." Although the directors were not successful in their attempt to acquire a copy of the first edition, they did persevere. Twenty years later they wrote to Franklin, then in London, instructing him to secure a copy of the recently published third edition of the handsome work on American plant and animal life.

Catesby had spent the years 1712–19 and 1722–26 in America, travelling through the southern colonies collecting specimens and making drawings of the flora and fauna. Upon his return to England he began the arduous task of translating his researches into a finished work. The 200 plates of birds, fish, reptiles, mammals and plants, almost all etched by Catesby himself, were issued in two large folio volumes in 1730–43. An appendix of twenty plates was finished in 1747.

The Natural History won immediate acclaim, in 1754 and 1771 went through two posthumous editions using the original plates, and appeared in a Latin-German translation. Though the drawings betray Catesby's lack of training, his descriptions of the flora and fauna became the basis of their classification by the great Linnaeus. In addition, the British naturalist introduced a new genre of bird art, being the first to depict them in characteristic settings, combining ornithological and botanical details. There is, moreover, a Philadelphia flavor to Catesby's labors, for he received specimens from John Bartram. Our members valued their copy of the huge work, restricting its use from the time of its arrival in 1772.

research; his method was repeatable. A physician, he combined physiological observations with standards of utility and aesthetics to produce an all-inclusive description of the "voice." His colleagues were slow to accept his work. It was a transplanted Englishman, Dr. Jonathan Barber, who first took up Rush's system and introduced it at Harvard and Yale in the 1830s. Eventually some American teachers of elocution did adopt and adapt his ideas, but Rush continued to complain of neglect until his death. The peevish physician would be pleased to know that the *Philosophy of the Human Voice* has admirers in the 20th century; it is still in demand by specialists in the field of speech. His "First Outline," "Printer's Copy," and subsequent stages of the text of the work are part of the massive archive of personal papers Rush bequeathed to the Library Company in 1869.

206

207

296

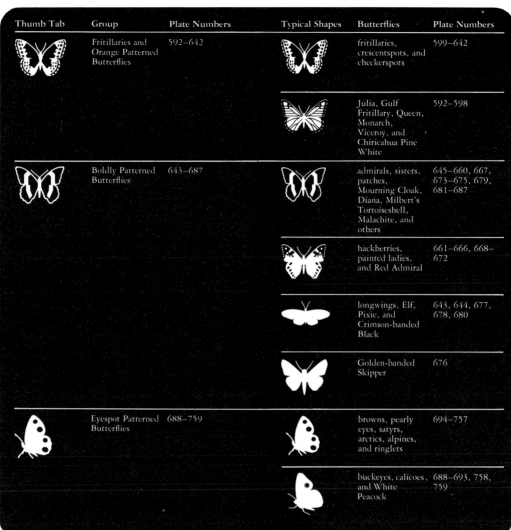

Thumb Tab	Group	Plate Numbers	Typical Shapes	Butterflies	Plate Numbers
	Fritillaries and Orange Patterned Butterflies	592–642		fritillaries, crescentspots, and checkerspots	599–642
				Julia, Gulf Fritillary, Queen, Monarch, Viceroy, and Chiricahua Pine White	592–598
	Boldly Patterned Butterflies	643–687		admirals, sisters, patches, Mourning Cloak, Diana, Milbert's Tortoiseshell, Malachite, and others	645–660, 667, 673–675, 679, 681–687
				hackberries, painted ladies, and Red Admiral	661–666, 668–672
				longwings, Elf, Pixie, and Crimson-banded Black	643, 644, 677, 678, 680
				Golden-banded Skipper	676
	Eyespot Patterned Butterflies	688–759		browns, pearly eyes, satyrs, arctics, alpines, and ringlets	694–757
				buckeyes, calicoes, and White Peacock	688–693, 758, 759

The Audubon Society Field Guide to North American Butterflies

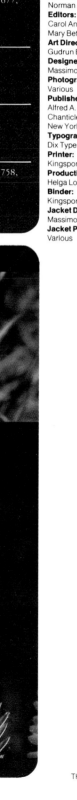

Book Title:
The Audubon Society Field Guides to North America: Seashells; Mushrooms; . Butterflies, Seashore Creatures
Authors:
Harold A. Rehder, Gary H. Lincoff, Robert Michael Pyle, Norman A. Meinkoth
Editors:
Carol Anne Slatkin, Jane Opper, Mary Beth Brewer
Art Director:
Gudrun Buettner
Designer:
Massimo Vignelli
Photographers:
Various
Publishers
Alfred A. Knopf, Inc., Chanticleer Press, New York, NY
Typographer:
Dix Typesetting Co.
Printer:
Kingsport Press
Production Manager:
Helga Lohse
Binder:
Kingsport Press
Jacket Designer:
Massimo Vignelli
Jacket Photographers:
Various

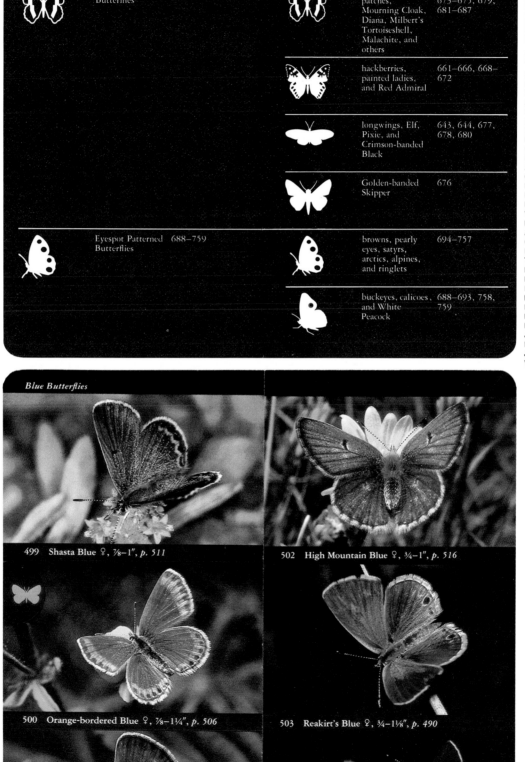

Blue Butterflies

499 Shasta Blue ♀, ⅞–1″, *p. 511*

502 High Mountain Blue ♀, ¾–1″, *p. 516*

500 Orange-bordered Blue ♀, ⅞–1¼″, *p. 506*

503 Reakirt's Blue ♀, ¾–1⅛″, *p. 490*

501 Orange-bordered Blue ♀, ⅞–1¼″, *p. 506*

504 Antillean Blue ♀, ¾–1″, *p. 489*

Book Title:
Cooking by Degrees; The
Boston University Cookbook
Authors:
Laura Freid, Terence Janericco
Editors:
Laura Freid, Terence Janericco
Art Director:
Douglas Parker
Designer:
Joseph Kredlow
Letterer:
Joseph Kredlow
Publisher:
CBI Publication Co., Boston, MA
Typographer:
Monotype Composition Co., Inc.
Printer:
R.R. Donnelley & Sons Co.
Production Manager:
Sheryl Avruch
Paper:
Bergstrom Booklight
Binder:
R.R. Donnelley & Sons Co.
Jacket Designer:
Joseph Kredlow
Jacket Illustrator:
Joseph Kredlow

The Boston University Cookbook

COOKING BY DEGREES

Edited by
Laura Freid
and
Terence Janericco

Published in association with
BOSTONIA MAGAZINE
CBI

CBI Publishing Company, Inc.
51 Sleeper Street
Boston, Massachusetts 02210

Contents

Vegetables 6

Molded Vegetable Casserole

2 tablespoons butter
1 cup unflavored bread crumbs
½ cup minced parsley
4 tomatoes, cut in wedges
½ cup olive oil
3 eggs, lightly beaten
salt and pepper, to taste
¼ lb. mozzarella, thinly sliced
2 small zucchini, thinly sliced
1 potato, thinly sliced
1 eggplant, ½ inch slices

Jessica Harstian
Dr. Harry A. Harstian
SED '67/'73
Lincoln, Massachusetts

Preheat oven to 375°. Butter a 2 quart round casserole or soufflé dish. Sprinkle with crumbs and remove excess crumbs. Combine crumbs with parsley. Arrange tomato wedges on bottom of dish and drizzle with 2 tablespoons of oil, 2 tablespoons of egg and add salt and pepper. Cover with a layer of cheese. Sprinkle with parsleid bread crumbs. Top with the zucchini, repeat oil, egg and cheese; then add a layer of potatoes, repeating oil, egg and cheese; then add a layer of eggplant. Sprinkle with parsleid bread crumbs and drizzle on olive oil and remaining egg. Bake 45 minutes. Let rest 10 minutes before unmolding. Can be kept in refrigerator for 24 hours before baking. Serves 6 to 8.

Irish Raisin Bread

Elizabeth A. Kelley
SON '71
West Roxbury,
Massachusetts

4 cups flour
1 cup sugar
4 teaspoons baking soda
½ teaspoon salt
1½ to 2 cups milk
1 tablespoon vinegar
2 eggs, beaten
3 tablespoons butter, softened or melted
2 cups raisins

Preheat oven to 350°. Mix flour, sugar, baking soda and salt. Add vinegar to milk to sour it. Add eggs, butter, milk and raisins to dry ingredients. Knead lightly on floured board or mix with a spoon until a soft dough is formed. (Add the extra ½ cup milk if too dry.) Shape into round loaf. Place in deep, greased 9 inch round pan. Mark a cross on top with sharp knife. Bake 1 hour or until bread tests done. Can be frozen. Makes 1 large loaf.

Spicy Zucchini Nut Bread

Diane M. Dodendorf
SON '72
Omaha, Nebraska
Phyllis Forman SFA '75
New York, New York

3 eggs
2 cups sugar
1 cup oil
1 tablespoon vanilla
2 cups raw grated zucchini, drained
3 cups flour
3 teaspoons cinnamon
2 teaspoons baking soda
1 teaspoon salt
½ teaspoon baking powder
1 cup finely chopped walnuts

Preheat oven to 350°. Beat eggs until frothy. Beat in sugar, oil and vanilla until mixture is thick and lemon colored. Stir in zucchini. Stir in flour, cinnamon, soda, salt and baking powder. Blend well. Fold in nuts. Pour batter into 2 greased and floured 8x3x2 inch bread pans. Bake 1 hour. Can be frozen. Makes 2 small loaves.

Pumpkin Tea Bread

As with any tea bread, this one improves with age.

Barbara Lanciani SED '66
Cookbook Committee
Leominster, Massachusetts

3 cups sugar
1 cup salad oil
3 eggs
15 oz. canned pumpkin
3 cups flour
1 teaspoon baking soda
½ teaspoon salt
½ teaspoon baking powder
1 teaspoon cinnamon
1 teaspoon clove
1 teaspoon nutmeg

Preheat oven to 350°. Blend sugar and oil. Add eggs and pumpkin. Mix well. Stir in flour, baking soda, clove, cinnamon, nutmeg, salt and baking powder. Pour into greased tube cake pan. Bake 1 hour and 15 minutes. Cool bread in pan. Freezes well. Makes 1 cake.

Orange Graham Cracker Loaf

2½ cups graham cracker crumbs
½ teaspoon baking soda
½ teaspoon baking powder
½ teaspoon salt
½ cup orange juice
½ cup butter
½ cup sugar
3 eggs, beaten
rind of 1 orange, grated
1 cup chopped walnuts
1 cup raisins

Mary Ellen Curnir
SED '73/SFA '78
Lynnfield, Massachusetts

Preheat oven to 350°. Butter a 9x5x3 inch loaf pan. Combine crumbs, soda, powder and salt. In another bowl, combine juice, butter, sugar, eggs and rind. Add to dry mixture. Stir in nuts and raisins. Bake 50 minutes. Cool. Can be frozen. Serves 8.

Book Title:
Quick Fox—Recipe Card Books
Authors:
Herbert H. Wise, Cecile Lamalle
Editors:
Herbert H. Wise, Cecile Lamalle
Art Director:
Joseph L. Santoro
Designers:
Joseph L. Santoro, Sophia
Bilynsky
Photographer:
Herbert H. Wise
Publisher:
Quick Fox, Inc., New York, NY
Typographers:
F.A.C.T., C.T.I.
Printer:
Dai Nippon Printing Co., Ltd.
Production Manager:
Irwin Wolf
Paper:
Gloss Coated Cover
Binder:
Dai Nippon Printing Co., Ltd.
Jacket Designer:
Joseph L. Santoro
Jacket Photographer:
Herbert H. Wise

Stuffed Shoulder of Pork

Method
Combine bread crumbs, onion, sage, salt and pepper and stuff the cavity in the pork shoulder. Roast in a preheated 325° oven 35 minutes per pound. Increase the heat to 375° and roast an additional 30 minutes to brown the outside.
4 to 6 servings

Ingredients
¾ cup bread crumbs
1 medium onion, chopped
½ teaspoon sage, rubbed to a powder
¼ teaspoon salt and freshly ground pepper to taste
3-pound boned pork shoulder

30

Caciotta

Caciotta
is a one- to two-pound disc of sheep's cheese from Italy's Tuscany (Toscano) region, considered "The most Italian" by my favorite writer, Waverly Root. This area includes Florence, Siena and Lucca. Caciotta is married to Chianti, from the same region. Not a fancy cheese, Caciotta is meant to be eaten with any rustic accompaniment: Gaeta olives, Sicilian anchovies, tomatoes and roasted peppers, pears and figs, and good fresh bread. The high butterfat content is characteristic of sheep's milk which makes the richest of all cheeses. The rind is naturally buff-colored or, if the Caciotta is from Livorno, orange or rust-colored from the saffron rubbed into it. It is firm cheese, not brittle, literally weeping with an oily flavor. Remember, this is the land of olive oil and fava beans, where flavors roll smoothly in concert none outplaying the other. A meal is a salad of twice-peeled favas, diced Altopascio Caciotta, unfiltered fresh olive oil and just-broken black peppercorns.

20

Grilled Lamb Chops

8

Manhattan

Manhattan
1¾ oz. bourbon
½ oz. sweet vermouth
Pour over ice cubes and stir.
Strain into cocktail glass.
Garnish with cherry.

Dry Manhattan
1¾ oz. bourbon
½ oz. dry vermouth
Pour over ice cubes and stir.
Strain into cocktail glass.
Garnish with green olive.

Perfect Manhattan
1¾ oz. bourbon
¼ oz. sweet vermouth
¼ oz. dry vermouth
Pour over ice cubes and stir.
Strain into cocktail glass.
Garnish with lemon twist.

New Yorker
1¾ oz. bourbon
½ oz. dry vermouth
¼ oz. sweet vermouth
1 tablespoon lemon juice
Pour over ice cubes and stir.
Strain into cocktail glass.
Garnish with lemon twist.

Americano
1 oz. Campari
1 oz. sweet vermouth
Club soda
Pour Campari and vermouth into collins glass over ice cubes. Fill glass with soda. Garnish with lemon twist.

35

Book Title:
McClane's North American Fish Cookery
Author:
A.J. McClane
Art Director:
Robert Reed
Designer:
Robert Reed
Photographer:
Arie de Zanger
Publisher:
Holt, Rinehart & Winston, Inc.
New York, NY
Typographer:
Maryland Linotype Composition
Co., Inc.
Printer:
R.R. Donnelley & Sons Co.
Production Manager:
Tricia West
Paper:
Midtech Lithofect Suede 70 #
Binder:
R.R. Donnelley & Sons Co.
Jacket Designer:
Robert Reed
Jacket Photographer:
Arie de Zanger
Jacket Calligrapher:
David Gatti

COD PUDDING

1½ pounds fresh cod, skinned and boned
1 tablespoon butter, softened
2 tablespoons dry bread crumbs
½ cup light cream
1 cup heavy cream
2 teaspoons salt
4 teaspoons corn flour

Coat the inside of a 4-cup mold with the softened butter and sprinkle with bread crumbs. Tip the mold from side to side to spread the crumbs evenly. Tap out any excess crumbs. Mix light and heavy cream together. In a blender, puree the cod with a small amount of cream; continue adding cream until you have a smooth blend. Place the pureed mixture in a large bowl and add the salt and corn flour. Beat vigorously until light and fluffy. Pour the puree into the mold. Gently shake and tap the mold sharply to remove any air pockets. Cover the mold with a sheet of buttered aluminum foil and set in a baking dish with sides deep enough to hold a water level three-quarters of the height of the mold. Place in the middle of a 350°F. preheated oven, and bake for 1 to 1¼ hours. Check occasionally, making certain the water is just simmering (if it boils, the molded fish will become perforated). Serve pudding either hot or cold, with or without a suitable sauce, such as lobster, dill, caper, or egg sauce.

MAKES 4 SERVINGS.

NOTE: *Leftovers are good on a bun with chili sauce.*

71

Book Title:
California Wine Label Album
Author:
Terry Robards
Editor:
Barbara Plumb
Art Director:
Paul Hanson
Designer:
Paul Hanson
Publisher:
Workman Publishing Co.
New York, NY
Typographer:
Scarlett Letters
Printers:
George Banta Co., Inc.,
Longacre Press
Production Manager:
Wayne Kirn
Paper:
Butte Des Morts, 70 #
Binder:
Sloves Mechanical Bindery, Inc.
Jacket Designer:
Paul Hanson

S U S H I

Book Title:
Sushi
Author:
Mia Detrick
Editor:
Susan Brenneman
Art Director:
Michael Patrick Cronan
Designer:
Michael Patrick Cronan
Photographer:
Kathryn Kleinman
Publisher:
Chronicle Books
San Francisco, CA
Typographer:
Robert Sibley
Printer:
Dai Nippon Printing Co., Ltd.
Production Manager:
Andrew Fluegelman, The
Headlands Press
Binder:
Dai Nippon Printing Co., Ltd.
Jacket Designer:
Michael Patrick Cronan
Jacket Photographer:
Kathryn Kleinman

KANSAI-STYLE SUSHI

Book Title:
Le Corbusier Sketchbooks,
Vol. 2

Author:
Le Corbusier

Editor:
Julianne Griffin

Art Director:
Sylvia Steiner

Designer:
Sylvia Steiner

Artist:
Le Corbusier

Publishers:
The MIT Press, The Architectural
History Foundation
Cambridge, MA

Typographer:
DEKR

Printer:
Imprimeries Réunies

Production Manager:
Julianne Griffin

Paper:
Matte Coated 120 gm

Binder:
Mayer & Soutter

Jacket Designer:
Sylvia Steiner

In the "sorup shed" where famous Chessers Island cane syrup has been made for generations,
Mattie Chesser stands near the tub and Elma and Elsie Rider tend the syrup kettle. April 1933.

· 120 ·

Maggie Mizell grinds corn for the chickens in a "steel mill" at Owen Thrift's. Note Uncle Owen's
mud-and-stick chimney. May 1930.

· 121 ·

Book Title:
Okefinokee Album

Authors:
Frances Harper, Delma E.
Presley

Editor:
Karen Orchard

Designer:
Richard Hendel

Photographer:
Francis Harper

Publisher:
The University of Georgia Press
Athens, GA

Typographer:
G. & S. Typesetters, Inc.

Printer:
The Haddon Craftsmen, Inc.

Production Manager:
Sandra Strother Hudson

Paper:
Perkins & Squier Hi Opaque
60 #

Binder:
The Haddon Craftsmen, Inc.

Jacket Designer:
Richard Hendel

Jacket Photographer:
Francis Harper

A VISIT TO WILLIAM BLAKE'S INN

POEMS FOR INNOCENT AND EXPERIENCED TRAVELERS

BY NANCY WILLARD

ILLUSTRATED BY
ALICE AND MARTIN PROVENSEN

HARCOURT BRACE JOVANOVICH
NEW YORK AND LONDON

Book Title:
A Visit to William Blake's Inn
Author:
Nancy Willard
Editor:
Anna Bier
Art Director:
Barbara DuPree Knowles
Designer:
Barbara DuPree Knowles
Illustrators:
Alice and Martin Provensen
Publisher:
Harcourt Brace Jovanovich,
Inc., New York, NY
Typographer:
Fuller Typesetting
Printer:
Princeton Polychrome Press
Production Managers:
Ray Ferguson, Tracy Devine
Paper:
Mead Matte 80 #
Binder:
The Book Press
Jacket Designer:
Barbara DuPree Knowles
Jacket Illustrators:
Alice and Martin Provensen

THE MARMALADE MAN
MAKES A DANCE TO MEND US

Tiger, Sunflowers, King of Cats,
Cow and Rabbit, mend your ways.
I the needle, you the thread—
follow me through mist and maze.

Fox and hound, go paw in paw.
Cat and rat, be best of friends.
Lamb and tiger, walk together.
Dancing starts where fighting ends.

36

Book Title:
The Photography of Max Yavno
Author:
Ben Maddow
Editor:
Robert Zachery
Designer:
Carl Seltzer
Photographer:
Max Yavno
Publisher:
The University of California
Press, Berkeley, CA
Typographer:
Central Typesetting Co.
Printer:
Gardner Fulmer Lithograph Co.
Production Manager:
Czeslaw Jan Grycz
Paper:
Centura Gloss Book 100 #
Binder:
Hiller Industries
Jacket Designer:
Carl Seltzer
Jacket Photographer:
Max Yavno

Contents

MAX YAVNO

Pictures by Max Yavno Text by Ben Maddow

Designed by Carl Seltzer

UNIVERSITY OF CALIFORNIA PRESS
Berkeley Los Angeles London

New York: 1938–1941

O city, cities!
We walked in all weathers on the wrinkled back
Of that great lizard, the metropolis; streets were far
Between our longing and the window of our loves …
A camera was already wound in our heads:
We had seen the young old women of Dorothea Lange,
Ben Shahn's tough children in their father's hats,
Dusty windshields of the inner migration.
We were persuaded: "Art is a weapon, too!"

1. *Underneath Third Avenue El, c. 1938*

FALKLAND ROAD
PROSTITUTES OF BOMBAY

PHOTOGRAPHS AND TEXT BY

MARY ELLEN MARK

ALFRED A. KNOPF ✧ NEW YORK 1981

Book Title:
Falkland Road
Author:
Mary Ellen Mark
Editor:
Victoria Wilson
Art Director:
Betty Anderson
Designer:
Holly McNeely
Photographer:
Mary Ellen Mark
Publisher:
Alfred A. Knopf, Inc.
New York, NY
Typographer:
The Press of A. Colish, Inc.
Printer:
American Printers and
Lithographers
Production Manager:
Ellen McNeilly
Paper:
Quintessence Dull 80 #
Binder:
American Book-Stratford Press
Jacket Designer:
Gun Larson
Jacket Photographer:
Mary Ellen Mark

Late afternoon.

On Falkland Road some of the prostitutes attract customers from cages
on the street level. The brothel rooms are above.

Book Title:
Yale Seminars in Architecture
Coordinator:
Cesar Pelli
Art Directors:
Kristie Williams, Lorraine Wild
Designers:
Kristie Williams, Lorraine Wild
Publisher:
Yale School of Architecture,
New Haven, CT
Printers:
Yale Printing Service, Screen
Tek
Production Manager:
Martha Parker
Binder:
Mueller Trade Bindery
Jacket Designers:
Kristie Williams, Lorraine Wild

Yale Seminars in Architecture
Coordinated by Cesar Pelli

Volume 1

Kenneth Frampton

Michael Graves

Charles Jencks

Robert A.M. Stern

Stanley Tigerman

Robert Venturi

Richard Weinstein

suggest ways to integrate ornament with architecture.
Now, in your own work it seems that in Guild House and
in your mother's house, ornament is integrated. But
looking at your recent projects last night, I see your
decoration has tended toward more of a separation
between building and plan. Your square in Washington,
for example, where the skyline and ground plan have a
tension--or in the Brandt house. That seems to be the
evolution of your work, certainly. In terms of what I
expect from ornament, you are possibly moving toward
this kind of separation, which is interesting.

I think right now everyone is naive about ornament and its use.
We have forgotten how to use it, as I have said. Let me think
about ornament I used early in my work. In our first building,
the North Penn Visiting Nurses' Center in Ambler, Pennsylvania,
I applied moldings around the windows that was bigger and a
little different in proportion from that of the windows to enhance
the scale of the building. I also included a nonstructural arch
over triangular brackets at the door to symbolize the entrance.
When I did that many years ago an architect friend took me aside
and said like an uncle: "You're doing very nicely, but that
ornament--you should be careful about moldings." Then on my
mother's house there was the exterior dado and the molding in
the shape of an arch superimposed on the real lintel at the
entrance. Actually these elements were not integral. Also they

rate it, She stuck a little furniture in it, and some drapery,
and selected the carpets and ashtrays and typewriters and
things. Suddenly they had the Knoll look because the architec-
ture was neutral and the letter openers were in the right spot.
Recently they asked me to redo what Florence Knoll did because
they thought it was time for a change. Bill Hauserman walked
in to the new fabric display which we were in the midst of
finishing and said, "My God, if I'd known it was going to turn
out like this, we would never have hired him for Cleveland!"
Quickly, Cadwallader took him aside and told him to be patient--
it would grow on him and everything would be alright. I was
really surprised, you know. Up to that point, I had had a very
easy time with my clients, none of whom had much exposure to
architecture. As you know, I have described them as a tennis
bum, an insurance salesman, and a philosopher at Princeton.
Clients come in all shapes and sizes, but their expectations
were entirely different from these two. These two fellows had
been brought up on modern architecture and they expected it.
They wanted it. They never thought they wouldn't get it in
their terms--white architecture, simple architecture, clean
machines. And that was a very new experience for me. I sus-
pect that some of you will encounter the same kind of attitude
in a year or two, and if I am old-fashioned, you are going to be
even more old-fashioned to them because the way that I suspect
you will move through your own work, and what will occur in the

next ten years, will cause some disruptive effect. Where Cesar
Pelli and I used to have people come to us, and say "Do you do
colonial?" you might have somebody come to you and say "Do you
do modern? Do you do white architecture? Do you do architec-
ture like the Five?" Or whatever. That is going to be a very
strange thing. I suspect Bob Venturi had to answer that for
twenty years, in one way or another. He keeps sticking his
neck out in other directions, which still makes him a sort of
"enfant terrible" and equally hard to take for the people that
come to get something acceptably avant garde. Having come to
the end of this story, I'd like to answer some of your ques-
tions.

Comment: Is there a possibility of being able to say "yes,"
you do do Gwathmey as well as doing Venturi, or, in other
words, is the principle of eclectic pulling from all these
things from the past possible?

It's not possible for me, I guess, because I don't understand
all those other codes, all the ones that would be required of
the true eclectic. I'm not that good. God knows the little
text that one uses is hard enough to make as good as possible
without dealing with the several that are available to us. I
think I could do the one that I was brought up on as well as I
could do the rest, but, like the garden metaphor for the Sunar
showroom's fabric opening, to paint it white seemed to leave a
lot out of the architecture and I needed to make the analogy

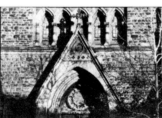

21 **Trinity Episcopal Church, 1886**
371 Delaware Avenue
Architect: Cyrus K. Porter
Christ Chapel: Arthur Gilman
Parish House: 1904, Cram, Goodhue, and
Ferguson, who also remodeled Christ
Chapel in 1913

Trinity Church was originally planned in 1869 as Christ Church. When, in the 1880s, that congregation merged with Trinity, the new parish assumed the name of the larger contingent. In 1869, after several architects, including H. H. Richardson, had submitted designs, Arthur Gilman of Boston was given the commission for a church and chapel. Only the present Christ Chapel (the small, gray stone building at the rear of the courtyard) and the foundations for Gilman's church were constructed at this time. Twenty-five years later, Cyrus K. Porter (1836–1910), a prominent local architect, reworked Gilman's plans and completed the edifice, except for the spire, which was never built.

Trinity Church possesses some of the finest stained glass in America. The five magnificent scenes in the apse and the rose window are by John La Farge, who also did several others, along with Tiffany, in the nave and transept. Especially important is his so-called Watson Window over the altar in the north transept. The subject, drawn from Revelations 7, is "The Sealing of the Twelve Tribes," a mystical event depicted in an otherworldly atmosphere of blue opalescence. The client for the window was Stephen Van Rensselaer Watson, founder of the Erie County Savings Bank, who lived across the street from Trinity in the commodious Second Empire house (1870) that is today the Buffalo Club. La Farge required that Watson allow him to exhibit the window, before sending it to Buffalo, at the 1889 Exposition Universale in Paris, where, he hoped, it would establish his international reputation as a modern master of glass. Greatly impressed by the beauty and originality of the work, the French government awarded La Farge the insignia of the Legion of Honor, the highest honor bestowed upon a foreigner.

Book Title:
Buffalo Architecture: A Guide
Authors:
Reyner Banham, Charles Beveridge, Henry-Russell Hitchcock
Editor:
Cynthia Ware
Designer:
Celia Wilson
Photographers:
Various
Publisher:
The MIT Press, Cambridge, MA
Typographer:
A & B Typesetters
Printer:
Halliday Lithograph Corp.
Production Manager:
Rachel Mathews
Paper:
LOE Dull 70 #
Binder:
Halliday Lithograph Corp.
Jacket Designer:
Celia Wilson

Downtown

1 McKinley Monument

2 City Hall

3 City Court Building

4 Buffalo Athletic Club

5 U.S. Post Office

6 Buffalo State Office Building

7 Statler Hotel

8 Convention Center

9 St. Anthony of Padua Church

10 Shoreline Apartments

11 Waterfront Community Center

12 Illuminating Gas Company

13 WKBW-TV Studios

14 Buffalo Hilton Hotel

15 Title Guarantee Company

16 Old County Hall

17 Rath County Office Building

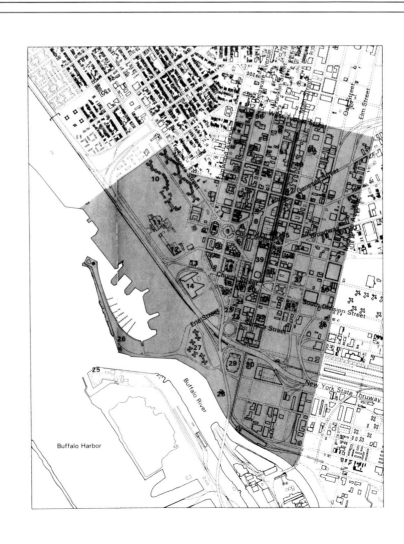

The
Fashionable
Mind

Reflections on Fashion
1970–1981

by

Kennedy Fraser

ALFRED A. KNOPF

NEW YORK 1981

Book Title:
The Fashionable Mind
Author:
Kennedy Fraser
Editor:
Ann Close
Art Director:
Betty Anderson
Designer:
Judith Henry
Publisher:
Alfred A. Knopf, Inc.
New York, NY
Typographer:
Maryland Linotype Composition Co.
Printer:
American Book-Stratford Press
Production Manager:
Andrew Hughes
Paper:
S.D. Warren Antique 55 #
Binder:
American Book-Stratford Press
Jacket Designer:
Louise Fili

Back to Reality

American designers have been showing their fall collections, and any observer who believes that the fashion industry is a mirror rather than a juggernaut must conclude that most women in this country are not merely conservative but reactionary. The balance between the state of women's minds and those who make clothes to match it seems to have tipped, for the present, in the shopper's favor. The true picture of fashion is chaotic and beyond the reach of catchwords, and neither buyer nor seller can honestly attempt a definition of what it is that women now want. But designers realized that some approximation was called for, and have re-created what women used to want before the dark days of last fall, when they stopped spending money. Things are, to this extent, safely back to where they were—in the nineteen-sixties and even the nineteen-fifties. Women's mastery of their hem lengths has been dearly won: the rift between fashions for the young and clothes for the middle-aged is now absolute, and those who demand regression as an end to disorder have betrayed their need to be told exactly what to wear. It is fortunate that they are already quite at home with what they will find in the shops in the fall, because designers, in their eagerness to show how businesslike they are, have learned to renounce authority—lest they be accused of trying to dictate—and artistry, which might appear to have something in common with caprice. Peasants, wartime whores, and experiment are suddenly contemptible. It is fashionable to de-

nounce fantasy and—by implication—fashion. The press, unwilling to be excluded from the new realism and responsibility, has extolled the rebirth of classicism, sanity, and a quality mysteriously referred to as "civilization." In this stern and heady new era, fashion vocabulary—which delights in wrenching words from meanings acquired in such humdrum arenas as books and history—is in over its head. The word "lady" is now synonymous with twin sets; civilization can be charged and sent; and a legion of real women, after long months of oppression, is to come into its own in the fall.

Who are these real women? The new collections suggest that they are those who felt most at ease in pencil skirts, girdles, and bouffant hair styles. They hated the midi because it made them look old, and they hate shorts because shorts make others look young. They like suits, and Lurex and brocade cocktail dresses, and heavy coats with broad, fur-trimmed collars. Their figures are flattered by firmly structured clothes and by stiff fabrics. (All the emphasis given to commonplace fabrics in the shows reflected both this need on their part and the designers' nervousness about line.) One New York department store caught the mood of the day in an advertisement that would not have appeared six months ago. "Glory Be for the Real Woman," ran the headline. "We've Never Forgotten You for a Minute." Beneath the text ("Sick of hearing about diets, exercise, and skinny girls?") was sketched, on suitably willowy forms, a vision of high-waisted corsets, long-legged panty girdles, and midriff-controlling brassieres. Real women, then, look middle-aged and fat. No amount of new wardrobes will really unshackle all those in our society who feel obliged to appear young, fit, and (since protein costs money) rich; this flowery praise of real women isn't going to change the world.

But the new focus on the middle-aged—a group, in the industry's current opinion, quite separate from youth: more powerful, and more willing to spend—is a backward step in the realm of fashion. Freedom from the significance of birthdays was just beginning to take root, and the idea of clothes appropriate to certain ways of life was already less tenacious.

own intrinsic vitality than by the default of competitive influences. Maybe technology and its accompanying calculators, computers, and scientific polls caused the solid, reasoning, "masculine" side of our mind to atrophy, tipping the scale further toward the licensed gadfly that is the intuitive, "feminine" side of our mind—the origin of fashion.

However it develops, the excessive use of fashion as a framework for perception will ultimately warp that perception and, with it, any reasonable picture of the world. The greatest drawback of an overfashionable perception is that fashion is concerned, virtually by definition, with surfaces, images, appearances. This drawback is painfully plain when the fashionable mind is supposedly employed to get at the heart of things, or when the conclusions it reaches may have a lasting effect, as in the reporting or interpretation of national events or the definition of "good" and "bad" art. Fashion is well equipped to pass on to us how things look or seem, and is often good at making assessments peripheral to appearances, such as how much money they are worth, but it is not equipped to tell us what things really are. When the mind surrenders itself to fashion, the first casualty is objective judgment—which is, to all intents, the mind itself. Fashionable perception is incapable of discerning any fixed truth about an object or event, and so leaves the object or event at the mercy of the observer and of the time and circumstance in which it is observed. A fashionable mind is often distracted from thorough concentration on its object by the question of timing, and will wander into self-congratulation on the observer's impeccably fashionable chronological instinct and into overweening claims to have known and appreciated fashions long before they became widely fashionable. These intrusive assertions of pre-fashionable familiarity with a subject—hyperfashionableness, in other words—crop up frequently these days. Fashionable observation is very far from being self-sufficient, and is highly self-conscious about the company it keeps. It is inclined to rove jumpily around the edges of its object, like the eyes of an ambitious guest roving beyond a conversation partner at a cocktail party full of powerful people,

and is distracted by its attempts to encompass the comings and goings of others. To the absolutely fashionable mind, an opinion, a taste, or an enthusiasm is of significance only for a particular, restricted moment—a moment when it is held in common by some right-seeming group of fellow-souls, just before it is adopted by large groups of followers.

Fashion as it exists now, whether in literature or in kitchen equipment, in neckties or in ideas, is intimately connected with money and power. This basis is by no means always apparent, and our careless inherited assumption that fashion is spontaneous, amusing, innocent, and amateurish is likely to keep us from examining or questioning the ways in which it has evolved. The part that commerce plays in fashion is something we are often led to overlook, for the fashionable mind is well practiced in masking a general allegiance to commerce and the status quo behind what seems to an outsider to be an appealingly individualistic enthusiasm for some particular novelty. Fashion is a skillful master of enthusiasm, and of a Pavlovian discernment of certain correspondences—between a current best-seller and a potential successor, for instance—but is an inadequate touchstone in the search for honest, disinterested distinctions. These are born of an isolated, dogged, unfashionable side of the mind—a sort of gawky mental provincialism.

It is important to remain aware of the flaws of the fashionable perception, because that flawed perception is capable of influencing and changing the world it perceives. Fashionable minds and their backers do not just absorb the world passively but, if it is necessary in order to create the trends they seek to promote, actively distort it. Fashions, quite simply, do not exist until a fashionable mind is turned on them. Only in that fashion is free to conjure up the previously nonexistent and is unfettered by the need for consistent loyalty to any client does it distinguish itself from the fancier echelons of the public relations business. In these, as with fashion, underlying commercial and corporate purposes are often suavely concealed beneath a sincere, personal veneer. Fashion and public relations share a charter to turn life to their own advantage, to

Book Title:
Half Off
Author:
Mimi Pond
Editor:
Betsy Davids
Art Director:
Betsy Davids
Designers:
Betsy Davids, Mimi Pond
Illustrator:
Mimi Pond
Publisher:
Rebis Press, Berkeley, CA
Typographers:
MacKenzie & Harris, Inc., Betsy Davids, Mimi Pond
Printers:
Betsy Davids, Mimi Pond
Production Manager:
Betsy Davids
Paper:
Rives Heavyweight
Binders:
Betsy Davids, Mimi Pond, Celia Ramsey

The Art of
ROBERT
BATEMAN

Book Title:
The Art of Robert Bateman
Author:
Ramsay Derry
Designer:
V. John Lee
Artist:
Robert Bateman
Publishers:
Penguin Books Canada Ltd.
The Viking Press, Toronto, CAN
Typographer:
Shervill-Dickson, Ltd.
Printer:
Arthur-Jones Lithographing Ltd.
Production Manager:
V. John Lee
Paper:
S.D. Warren Co., Domtar Fine
Papers
Binder:
Publishers Book Bindery
Jacket Designer:
V. John Lee

Lions

African lions are often lazy and nonchalant and blend in well with the scenery, and, as a result, you sometimes get closer to them than you intend. Driving across the plains you may spot one standing up on a rock and drive over to have a look at it. Then, when you've taken photographs of it and made a few sketches, you start the car engine and suddenly lion heads pop up all around you. In *Pride of Lions*, one lioness is having a look around while three others are still snoozing in the late afternoon sun before setting out on the hunt.

These two lion cubs were part of a pride of twenty-four lions whose favourite haunt was a *kopje* – a granite outcrop rising out of a sea of grass. From it the lions could get a convenient view of the Serengeti Plain and move comfortably in and out of the shade. The two yearlings had found their way around the cliff to this secluded crevice, where they could avoid the fuss of mothers and younger cubs, and survey the world of the Serengeti far below them.

▲ Lion Cubs, acrylic, 24 × 36", 1977
▶ Pride of Lions, Samburu, acrylic, 36 × 48", 1975

Red-tailed Hawk on Mount Nemo

For me, the first thing a painting of an animal must convey is the distinctive personality of the species. Technically, this can be analyzed in terms of proportions and relationships. The emotional effect is harder to analyze, but is equally important if the picture is to be a success.

The expression of a red-tailed hawk has a combination of docility and fierceness and a certain serious dignity, rather like a handsome dog. This is because of the relationship between the eyebrows, which make the hawk look hard and fierce, and the deep brown of the eyes, which suggest softness. In contrast, eagles or vultures have a relentlessly fierce expression. The feathers of red-tailed hawks also have a soft quality; they are not hard and armour-like, like the feathers of eagles, or fussy like those of goshawks.

I'm also very conscious of making sure that the identifying field marks show clearly. This is especially important for hawks and other birds of prey which are hard to distinguish one from the other. However, I don't feel obligated to show all the field marks, nor necessarily the most important. This is where the artist's imagination and power of selection is important. A fellow-artist and friend of mine, George McLean, once had the courage to do a painting of a red-winged blackbird from an angle at which practically all of the red on the wing was obscured.

In this red-tailed hawk, I didn't show much of the red tail, but I did show such distinguishing marks as an overall buffiness in the upper breast, and a light line in the scapular feathers covering the upper part of the wing.

▲ Red-tailed Hawk Head (study)
▶ Red-tailed Hawk on Mount Nemo, oil, 24 × 36", 1980

JESSE HOWARD

Snow Shovel

He That Is Not with Me

OG'' KING OF BASHAN:
BEHOLD: HIS BEDSTEAD WAS A
BEDSTEAD OF IRON: IS IT NOT IN
RABATH OF THE CHILDREN OF
AMMON? NINE CUBITS WAS THE
LENGTH THEREOF: AND FOUR
CUBITS THE BREADTH OF IT: AFTER
THE CUBIT OF A MAN-DEUTER:3:11
QUOTE. FIRE AND HAIL: SNOW: AND
VAPOUR: STORMY WIND FULFI-
LLING HIS WORD-
— PSALMS:148:8-

13*1-

4 WORDS. ONE VERSE. EXD
THOU SHALT NOT STEAL 20:15.
3-NAMES ONE VERSE.
ADAM:SETH: ENOSH:&CHR:

EVERY MAN AGAINST HIS BR-
OTHER. EZ EKIEL. 38=2-1. READ IT.
ACE RTAIN LAWYER. READ LUKE
10= 2 6, AND READ

HE: THAT: IS: NOT: WITH: ME: IS ★
AGAINST: ME: AND: HE: THAT: GATHERETH:
NOT: WITH: ME: SCATTERETH: ST. LUKE. 11:23.
HONOUR: THY: FATHER AND: THY: MOTHER: THAT: THY: DAYS: MAY
BE: LONG: UPON: THE —LAND: WHICH: THE: LORD: THY: GOD: GIVETH: THEE.
—EXODUS: 20:12.

44

45

He That Is Not with Me
Painted metal, c. 1970
13 x 51
Roger Brown

Know Some People Who
Painted wood, c. 1970
12 x 75
Roger Brown

Nixon Windshield
Wood, paint, old station-
wagon rear window, c. 1972
16½ x 50
Roger Brown

Shame Yes Shame
Painted wood, c. 1965
22 x 59
Roger Brown

Snow Shovel
Painted snow shovel, c. 1972
18 x 48
Roger Brown

Woman 104 Years Old
Painted wood, c. 1970
11½ x 36¾
Roger Brown

JH: I would like to say something about Jesse Howard. It is interesting that his signs are collected as art. The printed word is a symbol for the spoken word—a total abstraction. For Howard, the concept, the message is the work. Visual elements are of minor concern to him.

MH: I think that Howard's work accumulates a pertinence in our post-Modern era when word-art or language-art created by mainstream artists like the concrete poet Emmett Williams, the painter Arakawa, and the conceptualist Gerald Ferguson have all reinforced the space where Howard works.

Book Title:
Transmitters: The Isolate Artist in America

Authors:
Elsa S. Weiner, Marcia Tucker, Richard Flood, Michael and Julie Hall

Editor:
Elsa S. Weiner

Art Director:
Joel Katz

Designers:
Joel Katz, Jerome Cloud

Artists:
Various

Publisher:
Philadelphia College of Art
Philadelphia, PA

Typographer:
Leon Segal Typesetting, Inc.

Printer:
Harrison Color Process

Paper:
Cameo Dull Text and Cover,
100 #

Binder:
Oxford Bookbinding Co.

MH: Archuleta is an authentic heir to the *santero* sculpture tradition. Felipe, of course, doesn't make votive images, but he grew up surrounded by *retablos* and *bultos*. He constructs his animals using techniques that are directly adapted from those developed by his ancestors. His work is constructed out of joined pieces of wood which are then carved down. Next, the surface of each piece is built up and refined with a filler paste that can be modeled and into which found materials are often pressed. Felipe paints the piece to finish it, and in so doing he bows to the great poly-chromed wood-sculpture tradition he was born into.

JH: In Archuleta's pieces I find something I sense in the work of many animal-carvers, and that is the use of the animal form as representation of mankind. I saw this anthropomorphic quality in the Archuleta bear from the Museum of International Folk Art which was exhibited in Brooklyn.* It wears a studded muzzle. The muzzle does not, however, conceal the bear's dangerous looking teeth. In the early 1960s I once saw an itinerant one-man circus. A muscular, stocky, Slavic looking man with a shaven head wrestled a brown bear in a makeshift ring for money. After the contest, the spectators were asked if they would care to try. In these matches the bear always won, and although the animals teeth were rumored to have been pulled, his awesome strength was apparent. Archuleta's bear is this bear, tamed and civilized, and yet an undercurrent of violent independence and ferocity is not far from his surface. I think Felipe is saying in his bear, "This is the way I am." Unprovoked—gentle; provoked—unfettered, as civilization slips away like a shadow. I think that a lot of Archuleta's carvings are actually self-portraits.

MH: A piece like the Baboon in this exhibition captures much of what I would call the "essential baboon." This

FELIPE ARCHULETA

Baboon

Right: Koala Bear

Baboon
Carved wood, painted,
June 2, 1978
43 x 13 x 61½
Herbert Waide Hemphill, Jr.

Cougar
Carved and assembled
cottonwood, painted, with
sawdust-glue emulsion and
found materials
32 x 13½ x 54½, 28 (tail)
Estelle E. Friedman

Koala Bear
Carved and assembled
cottonwood, with applied
details of excelsior metal and
plastic, painted, 1978
26 x 21 x 23
The Hall Collection

Nativity
Mixed media
December 15, 1978
42 x 14½ x 42
Herbert Waide Hemphill, Jr.

14

Book Title:
Under the North Star
Author:
Ted Hughes
Editor:
Barbara Burn
Art Director:
Gael Towey Dillon
Illustrator:
Leonard Baskin
Publisher:
Studio Books
The Viking Press
New York, NY
Typographer:
American-Stratford Services,
Inc.
Printer:
Dai Nippon Printing Co., Ltd.
Jacket Designer:
Leonard Baskin
Jacket Illustrator:
Leonard Baskin

HUGHES • BASKIN

UNDER THE NORTH STAR

VIKING

AMULET • THE LOON • THE WOLVERINE
THE SNOWY OWL • THE BLACK BEAR
AN EVENING SEAL • THE MUSKELLUNGE
A LYNX • THE SNOW-SHOE HARE
WOODPECKER • THE MUSK-OX
THE HERON • THE GRIZZLY BEAR
BROOKTROUT • THE WENDIGO
THE OSPREY • MOOSES
THE ARCTIC FOX • PUMA
SKUNK • GOOSE • WOLF
THE MOSQUITO
EAGLE

ISBN 0-670-73942-1

UNDER THE NORTH STAR

TED HUGHES
DRAWINGS BY
LEONARD BASKIN

THE OSPREY

The fierce Osprey
Prays over the bay.

God hides below
In his shadow.

Let God reveal
His scaly, cold
And shining brow—

Osprey shall fold
His wings and bow
His head and kneel.

34

312

THE HERON

The Sun's an iceberg
In the sky.
In solid freeze
The fishes lie.

Doomed is the Dab.
Death leans above—

But the Heron
Poised to stab
Has turned to iron
And cannot move.

28

EAGLE

Big wings dawns dark.
The Sun is hunting.
Thunder collects, under granite eyebrows.

The horizons are ravenous.
The dark mountain has an electric eye.
The sun lowers its meat-hook.

His spread fingers measure a heaven, then a heaven.
His ancestors worship only him,
And his children's children cry to him alone.

His trapeze is a continent.
The Sun is looking for fuel
With the gaze of a guillotine.

And already the White Hare crouches at the sacrifice,
Already the Fawn stumbles to offer itself up
And the Wolf-Cub weeps to be chosen.

The huddle-shawled lightning-faced warrior
Stamps his shaggy-trousered dance
On an altar of blood.

Book Title:
E.L. Kirchner
Editor:
Alice Adam
Art Director:
David Lawrence
Designer:
David Lawrence
Artist:
Ernst Ludwig Kirchner
Publisher:
Alice Adam Ltd., Chicago, IL
Typographer:
Total Typography, Inc.
Printer:
Unique Printers & Lithographers
Production Manager:
Trudy Rogers
Paper:
Strathmore Grandee Kromekote
Jacket Designer:
David Lawrence

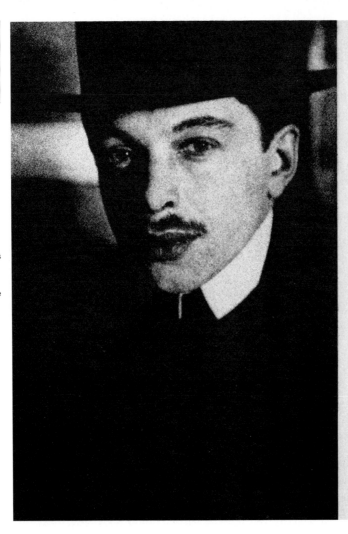

**Ernst Ludwig Kirchner
1880-1938**

1880 Born on May 6 in
Aschaffenburg, Germany

1901 Enters University in Dresden
to study architecture
according to his father's
wishes. Also studies painting
and drawing.

1904 Meets Erich Heckel, a fellow
student of architecture. Sees
exhibition of French
impressionist paintings and
studies Japanese woodblock
prints. First woodcuts, colored
woodcuts and paintings.

1905 Karl Schmidt aus Rottluff
meets Kirchner through
Heckel. On June 7, 1905 they
found the artists association
Die Brücke and have the first
Brücke exhibition of
watercolors, drawings and
woodcuts.

1906 Emil Nolde joins *Die Brücke*.
Kirchner cuts the manifesto
of *Die Brücke* in wood. The
association is enlarged to
include "passive members"
who, for payment of annual
dues, receive a portfolio with
three to four original works.
Max Pechstein and Cuno
Amiet become active members.
First portraits of Kirchner's
girlfriend Dodo, so many
times his model.

2. **Zwei Mädchen im Zimmer
Two Girls in a Room**

Oil on canvas 1914
Catalogue Gordon 419
Signed by the artist on the verso in
red paint "E. L. Kirchner"

On the upper left front corner incised "K"
99 x 73 cm (39 x 28¾")

On the verso is another painting titled
Holzschale, Skulpturen und "Sonnenblumen"
Date: 1913
Catalogue Gordon 419/verso

Ex Collections:
Kirchner Estate
Rüdiger Graf von der Goltz, Düsseldorf

Exhibitions:
Kunstverein, Stuttgart 1956
Kunstverein, Düsseldorf 1960
Marlborough Gallery, London 1964
Palazzo Strozzi, Florence 1964

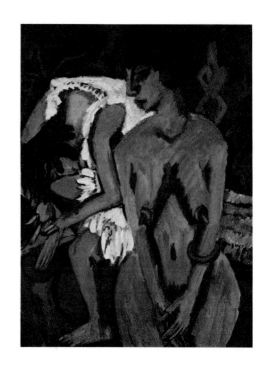

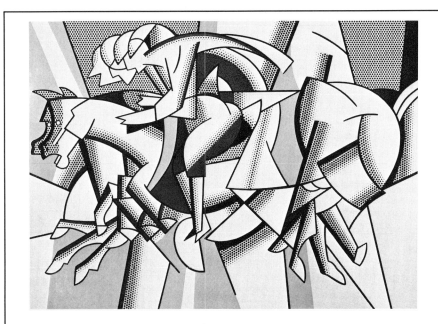

Red Horseman. 1974.
Oil and magna on canvas. 84 × 112".
Museum Moderner Kunst, Vienna. Ludwig Collection, Aachen.

FUTURISM, 1974–76

Of the dozen works in this stylistic suite, *Red Horseman,* 1974, is not only the first, but it is also the largest and most unexpected. In a surprising and risky fashion, Lichtenstein expropriates a subject from Carlo Carrà and endeavors to "complete" the project, making the painting that the Italian Futurist did not. The source is Carrà's 1913 ink and watercolor *The Red Horseman.* The new result is a graphically coded, heroically scaled work in red, yellow, blue and black, moving well beyond any expectations established by the more painterly Carrà watercolor. Lichtenstein's *Red Horseman* is the set piece and a primary key to his aspirations for the second half of the decade, and it establishes the farthest edge of his blatant use of specific known works in art history.

There are, also, illustrations of early Futurist works which serve as the starting points for an unusually large number of the other Lichtenstein Futurist paintings. *Vortex* and *Eclipse of the Sun I* and *II,* all 1975, should be related to Giacomo Balla's *Mercury Passing Before the Sun as Seen Through a Telescope,* 1914. *The Atom,* 1975, may be a mix of Balla with feelings from the Orphism of Robert Delaunay and Frank Kupka. The hands of the violinist and an enstablature behind of Balla's *Rhythm of the Violinist,* 1912, set the theme for Lichtenstein's *The Violinist,* 1975. The violin is isolated in Lichtenstein's *The Violin,* 1976. *Planes of a Lamp,* 1976, evolves from Ardengo Soffici's *Decomposition of the Planes of a Lamp,* 1912, though now deflated, since the Lichtenstein has, by design, little to do with the dynamism of light. *Horse and Rider,* 1976, is an apparent segment relating to the *Red Horseman* theme. *The Conductor,* 1975, is more like an animated Lichtenstein *Modern Head* sculpture of 1969.

Gino Severini's *Self-Portrait,* 1912, is the specific source for the Lichtenstein *Self-Portrait,* 1976. While contemporary Cubist portraits seem assertive and original, for example, Gris's *Portrait of Picasso,* 1912, or Picasso's *The Poet,* 1912, Severini's portrait looks underrealized in Futurist terms. The Lichtenstein self-portraits, the first so telloit firing the viewer to the brink of confusion as to the artist's intentions. They can be viewed, on the one hand, as self-portraits of Lichtenstein but in a historical stylistic mode. On the other hand, they may be replicas of the Severini, that is 'portraits' of another artist's self-portrait.

If Lichtenstein is making his own portrait, however elusively, he has seemingly abrogated his artistic personality and the uniqueness of his representation. If the works are Lichtenstein's renderings of Severini's visions of himself, one sees the artist's commentary about a Futurist so engrossed in stylistic nomenclature that the expected format of self-portraiture is cast into a straight jacket. One would think that Futurist portraiture should incorporate representative action or some kind of anthropomorphic machine, instead of being formally geometric and prismatic. These issues and answers are not mutually exclusive and Lichtenstein is secure in the ambiguities he creates.

The *Red Horseman* and subsequent Futurist works are based on conceptually loaded and intentionally contradictory principles of composition and theme, politics and history. Lichtenstein negates the dynamics of the subject by stabilizing the parts, putting the horse and rider in a net of lines anchored to the picture frame, clarifying the tones, and deromanticizing the bravura Italian Futurist ethos. This and the other compositions are, like stroboscopic animations closer to superimposed, quantified, Eadweard Muybridge photographs. Lichtenstein acknowledges that the choice of Futurism as a theme allowed him to highlight the pretentious manifestos of the anarchistic Futurists, underlying his choice is the irony that this hitherto avant-garde movement became, in the 1920s and 30s, the official state art under Mussolini. The implied but unanswered question remains: what is it about absolutism in new art and its visionary search for the art of the Future which could result in such a politicization of its goals? The apolitical Lichtenstein, however, contradicts this by defusing the subject matter. His futuristic images are not the charged ones of speeding cars, explosions, war, or airplanes, although just such things were the subjects in his Pop paintings. The forms are not dissolved by motion but, rather, are solid, traditional depictions of musicians, conductors, violins, self-portraits, horses, a mute lamp, and a bit of scientific lore in the eclipse and atom paintings. The general effect is a logical evolution of 1950s atomic age modern and Lichtenstein's Art Deco and Cubist works. Whereas his Cubist and Sailboat paintings attempted the effect of magnetic motion, Lichtenstein, in a reverse twist, systematizes Futurism.

91

Book Title:
Roy Lichtenstein 1970–1980
Author:
Jack Cowart
Editors:
Paul Anbinder, Harriet
Schoenholz Bee
Art Director:
Paul Anbinder
Designer:
James Wageman
Artist:
Roy Lichtenstein
Publishers:
Hudson Hills Press
New York, NY / St. Louis Art
Museum
St. Louis MO
Typographer:
U.S. Lithograph, Inc.
Printer:
Toppan Printing Co.
Production Manager:
Paul Anbinder
Binder:
Toppan Printing Co.
Jacket Designer:
James Wageman
Jacket Artist:
Roy Lichtenstein

Study for Portrait. 1977.
Graphite and colored pencil on paper.
sheet: 6¾ × 5½"; image: 3¼ × 2½".
Private collection.

Portrait study. 1978.
Graphite and colored pencil on paper.
sheet: 5½ × 7⅞"; image: 3¼ × 3".
Private collection.

Cheese. 1962.
Oil on canvas. 40 × 40".
Collection Todd Brassner, New York.

Stepping Out. 1978.
Oil and magna on canvas. 86 × 70".
The Metropolitan Museum of Art, New York.

122

Book Title:
Milton Avery
Author:
Bonnie Lee Grad
Editor:
Izora Cohl
Art Directors:
Izora and Sanford Cohl
Designers:
Abby Goldstein, Betty Binns
Artist:
Milton Avery
Publisher:
Strathcona Publishing Co., Inc.
New York, NY
Typographer:
The Press of A. Colish
Printer:
The Press of A. Colish
Papers:
Curtis Vellum 100 # ,
Potlatch Vintage Velvet 110 #
Binder:
Publishers Book Bindery
Jacket Designers:
Abby Goldstein, Betty Binns
Jacket Artist:
Milton Avery

INTRODUCTION

BY GAIL TRAVIS GUILLET

"Whenever I find myself growing grim about the mouth; whenever it is a damp, drizzly November in my soul; whenever I find myself involuntarily pausing before coffin warehouses, and bringing up the rear of every funeral I meet; and especially whenever my hypos get such an upper hand of me, that it requires a strong moral principle to prevent me from deliberately stepping into the street, and methodically knocking people's hats off—then, I account it high time to get to sea ..." Herman Melville, *Moby Dick*

The spiritual malaise which Ishmael escaped by going to sea, Frederick Law Olmsted believed we could escape by going to a park. For this reason, he designed his parks as places of respite from the city, spaces to provide "...a pleasure, common, constant and universal...which results from the feeling of relief experienced by those entering them, on escaping from the cramped, confining and controlling circumstances of the streets of the town...." For Olmsted it was the "...sense of enlarged freedom [which was] to all, at all times, the most certain and most valuable gratification afforded by a park."

The "Art of the Olmsted Landscape," sponsored by the New York City Landmarks Preservation Commission, with funding from the National Endowment for the Humanities and the Arthur Ross Foundation, has as its purpose the increased awareness of and appreciation for the legacy given to this city and to this nation by Frederick Law Olmsted, and his partner, Calvert Vaux.

This publication, which accompanies the exhibition, seeks to identify and explain the concepts we believe constitute the "Art of the Olmsted Landscape." These concepts are set forth by Bruce Kelly, Curator of the exhibition, in the title essay, which is richly illustrated by historic and contemporary photographs. James Marston Fitch then establishes the cultural ambience out of which Central Park developed. Stephen Rettig, an American architect practicing in London, explores the British influences

on Olmsted. Ian R. Stewart, Associate Dean at Cornell University, details the political developments which led to the establishment of Central Park, and which signaled the beginning of the parks movement in the United States. Albert Fein and Geoffrey Blodgett, two eminent historians, examine the same source material, but reach rather different conclusions concerning Olmsted's intentions — one seeing his designs as democratic in the purest sense of the word, the other seeing his work as an example of conservative philosophy. On a different note, Henry Hope Reed, President of Classical America, takes a poetical look at the creation of Central Park and the genius of the designers. Jean Gardner McClintock, an environmentalist, addresses Olmsted's ideas of travel and examines their influence on his design. Finally, Melvin Kalfus presents an avant-garde interpretation of Olmsted and his contemporaries from a psychohistorical perspective.

These essays complement the material in the exhibition and create a forum where diverse ideas can be discussed and our understanding of Olmsted and the period in which he lived enriched. From the essays and from our research, it is clear that Frederick Law Olmsted ranks with the giants of the nineteenth century. We hope to remind people that the parks and parkways created by Frederick Law Olmsted are the result of conscious design decisions growing out of a particular design philosophy, and not the result of nature at work. These parks and parkways constitute a work of art in the truest sense of the term, and as such are fragile environments requiring our consideration and our protection if they are to survive for future generations. We hope that those who see the exhibition or read this book will come to understand that the decisions being made today will have long-range effects, and that alterations to the designers' intentions can never be undone. It is our hope that this exhibition, "Art of the Olmsted Landscape," will instill a wider appreciation of the Olmsted landmarks as one of our nation's great urban resources.

Book Title:
Art of the Olmsted
Landscape
Author:
Jeffrey Simpson
Editor:
Mary Ellen W. Hern
Curator:
Bruce Kelly
Director:
Gail Travis Guillet
Designer:
Murry Gelberg
Photographer:
Carl Forster
Maps:
Gerald Allen, Edward Kozanlian
Publishers:
New York City Landmarks
Preservation Commission
The Art Publisher, Inc.
New York, NY
Typographer:
Volk & Huxley, Inc.
Printer:
W.M. Bown & Son

"...The passing observer is very strongly impressed with the manner in which views are successively opened."

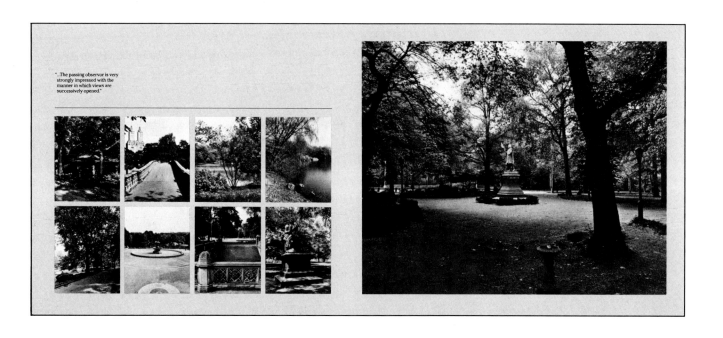

Book Title:
Madhur Jaffrey's World-of-the-
East Vegetarian Cooking
Author:
Madhur Jaffrey
Editor:
Judith B. Jones
Art Director:
Betty Anderson
Designer:
Margaret Wagner
Illustrator:
Susan Gaber
Letterer:
Carole Lowenstein
Publisher:
Alfred A. Knopf, Inc.
New York, NY
Typographer:
Superior Printing Co.
Printer:
The Maple Press
Production Manager:
Dianne Pinkowitz
Paper:
Baldwin Surtone Vellum 50 #
Binder:
The Maple Press
Jacket Designer:
Carole Lowenstein
Jacket Illustrator:
Susan Gaber
Jacket Letterer:
Carole Lowenstein

ILLUSTRATED BY SUSAN GABER Alfred A. Knopf New York 1981

Madhur Jaffrey's World-of-the-East Vegetarian Cooking

Condiments, Dips, Chutneys, and Relishes

"Nice flowers," my daughter said a few days ago as she glanced offhandedly at the dinner table on the way from the front door to her room. They weren't flowers at all but scallions that I had arranged, green side up, in a cut-glass, water-filled tumbler set in the center of our dining table. And the scallions were not decorative, but meant for eating. My mother used to arrange scallions that way. Somehow, I had forgotten about them until just the other day.

Table condiments in Asia can be very simple—scallions, onion slices, green chilies, roasted sesame seeds mixed with salt, salt mixed with Szechuan peppercorns, salt mixed with pepper and roasted cumin seeds, hot oil, red chilies pounded with garlic and salt and then soured with lemon juice, and crushed peanuts. Or they can get very elaborate—you might be served a rare pickle that was ten months in the making. Among the nicest part of Asian meals is just this—the number of condiments, pickles, sauces, dips, chutneys, relishes, and *sambals* that appear miraculously at the table, giving it variety and zest. Vegetarian food in particular gets such a boost from this approach. Each bite of the same food can be made to taste quite different, depending on what you eat it with or what you dip it in.

In Japan, for example, the simplest of bean-curd dishes, Udofu, is served with a heated sauce containing soy sauce, stock, and wine. But there are other condiments at the table as well, such as grated radish, grated ginger, shredded *nori* (laver), and sliced scallions. Each cube of bean curd can be eaten with a new combination of seasonings. Eating becomes quite an adventure.

Simple relishes and everyday chutneys in India may be made out of chopped-up tomatoes and puréed herbs such as Chinese parsley and mint. They are not only supposed to provide the much-needed contrasts of tastes but some very necessary vitamins as well.

Pickles in Asia enjoy an even higher status. Much time and effort goes into preparing them as whole families trim, peel, and cut vegetables. Koreans spend the late fall months making mountains of cabbage *kimchee*, generously flavored with garlic, ginger, scallions, and red pepper. They eat it in generous portions, too, at every single meal. Japanese pickles tend to be much more sedate, and served always in tiny portions. Many meals, all over Japan, end with the felicitous combination of plain rice, pickles, and tea. Indian pickles tend to be very hot and spicy. They sharpen appetites and give lethargic systems a fresh charge. In the Middle East, a great deal of pickling is done in vinegar. The addition of fresh herbs such as mint and dill gives the pickled vegetables an aromatic freshness.

All pickles and chutneys are palate-teasers and flavor-enhancers. They give color to the simplest of meals.

Book Title:
Fat Woman
Author:
Leon Rooke
Editor:
Gordon Lish
Art Director:
Betty Anderson
Designer:
Judith Henry
Publisher:
Alfred A. Knopf, Inc.
New York, NY
Typographer:
American Book-Stratford Press
Printer:
The Haddon Craftsmen, Inc.
Production Manager:
Dennis Dwyer
Paper:
S.D. Warren Offset 55 #
Binder:
The Haddon Craftsmen, Inc.
Jacket Designer:
James Laughlin
Jacket Illustrator:
James Laughlin

FAT WOMAN

LEON ROOKE

Alfred A. Knopf New York 1981

they won't send us a free catalog next year. *Then* what will we use?"

She stood, chuckling, wondering what her boys would say if she took away all their fine winter coats and their Star Wars creatures and fitted them up in longjohns and made them scratch their games in the dirt the way she and Edward had to do. They wouldn't put up with it, they'd howl and raise a stink and probably murder their parents and, likely as not, the Supreme Court would side with them. That's what Edward would say. He'd say they were spoiled rotten, they had no more backbone than a snake, that with them it was all *Gimme Gimme Gimme.*

Still, they were sweet boys and you couldn't fault them none that times had changed.

She came out of her trance to find Eula Joyner's hawk face tacked up and hung over her sink window. Then Eula's fingers came up and rattled on the glass, with a "Yoo-hoo!" thrown in.

Ella Mae went over and raised the window to let Eula stick her head in. Eula would never visit inside a person's house, being afraid she'd be thought of as lazy and no-account, with nothing to do at home. She had a scarf tied around her head, decorated with green flamingos, and Ella Mae could tell by her height that she had on Fred's cowboy boots.

"I got me six thousand Green Stamps," Eula said. "I been counting them all morning but I run out of books. You don't have any, do you?"

Ella Mae pulled up a stool. There was no telling whether her neighbor would stay a minute or three

hours. She said no, she didn't have any spare books, and asked Eula what she planned on getting with her stamps.

"I don't know. Last time I got this scarf which cost only one book. You ought to get yourself one. Of course, if I know Edward he'd raise a stink if he knew you were out getting yourself a nice kerchief when he could be using those same stamps for a wrench or a set of pliers. That's men for you."

"I never said I wanted a scarf, Eula."

"I saw him up at the window. I saw that thing he put up. What's it for?"

Ella Mae watched resentfully as smoke poured from Eula's nostrils. She was always having to defend Edward before this woman. It looked to her like a woman who had a man like Fred to contend with would naturally keep her mouth shut about another woman's husband. But not Eula.

"I told Fred it was tacky, first thing you know it will bring down our property value, that's what I told Fred. Don't it make it kind of dark in your bedroom? Is he going to put one over the boys' window too? That wouldn't keep it from looking tacky, but at least it wouldn't make the house so lopsided-looking. Frankly, I think he's lost his marbles this time."

Ella Mae was in no mood to listen to Eula's opinions. She felt at the mercy of her nerves and knew she'd feel better with something to eat in her hands—though not with Eula Joyner looking on. Eula was skinny as a hand-rail and her little hawk eyes missed nothing. She liked to brag that she didn't weigh a hundred pounds and even that looked heavy on her. "My system's delicate," she'd say. "Can't hold anything down, and never could."

"I see you run into your hedge," she was now saying. "I was looking out the window when you came zigzagging by, and I said to myself at the time, 'Well, Ella

Making A Sacher Torte

nine poems, twelve illustrations
Diane Wakoski & Ellen Lanyon

Contents: 1/Having Replaced Love With Food And Drink (a poem for those who have reached forty); 2/Breakfast; 3/My Mother's Milkman; 4/Making A Sacher Torte; 5/Pamela's Green Tomato Pie; 6/Saturday Night (for Barbara Drake); 7/Ode to a Lebanese Crock of Olives (For Walter); 8/Aunt Libby's deligence in making green olives); 8/Sally Plum; 9/Coprinus Comatus: Evening Mushrooms, Morning Milk · copyright

by the perishable press limited / mount horeb 1981

Book Title:
Making a Sacher Torte
Author:
Diane Wakoski
Editor:
Walter Hamady
Art Director:
Walter Hamady
Designer:
Walter Hamady
Illustrator:
Ellen Lanyon
Publisher:
The Perishable Press Ltd.
Mt. Horeb, WI
Typographer:
Walter Hamady
Printer:
Walter Hamady
Production Manager:
Walter Hamady
Paper:
Shadwell Handmade
Binder:
Bill Anthony

Coprinus Comatus:
Evening Mushrooms, Morning Ink

The evening is a straight line,
the red ribbon stretching from the foggy airport
to the wet leaved olive trees,
dripping moisture over
a stamp-pad lawn.

"Look," says my husband,
a tall lumber-jacketed man
pointing to the spot under the olive trees
which I watch all year
for Shaggy Manes.

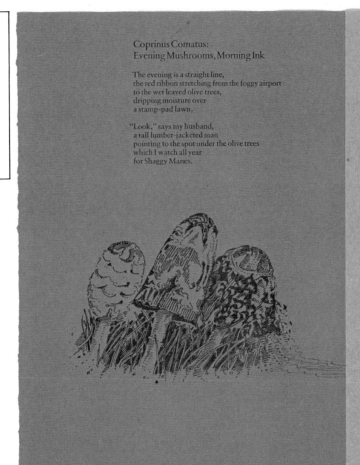

A little city
of mushrooms, their tall oval white bulbs
pushing out of the grass
barky and scaled
crowds the trees.
"I've been waiting all week
to show you."

He parks the car,
carrying my canvas luggage upstairs
and I breathe the familiar green air
of our apartment
after a week's absence.

Then, putting on rubber-soled shoes and slicker,
I take his hand,
and we go out into the silver evening,
and I fill a basket
with these fresh inky caps, leaving those already
black and deliquescing;
the firm delicate white flesh will
be sautéed in yellow butter
some with fresh tarragon,
others with sweet basil.

I have been away all week,
searching for truth and poetry.
It does not surprise me
to return home
and find a clue to the latter.
The cap of darkness grows on my lawn
under olive trees.

Who says the King of Spain
didn't leave the spore
there?

Sally Plum

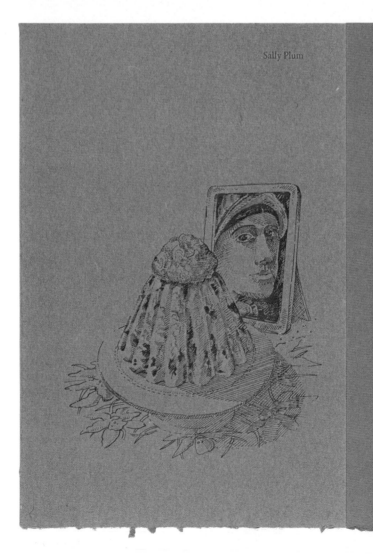

velvet,
soft as a mouse,
but in the color of Satsuma;
mauve silk and seed pearls;
you said you
hate your name
but don't really know of one that suits you.

Tonight I serve
Plum Pudding, soaked in cognac for a month,
its currants plump with boozy waiting.
The hard sauce is as smooth as an egg.
The bombe
in its amber pool of Rémy Martin,
burning,
sustains a cloud
like blue bachelor buttons
or swamp gas,
the will o the wisp caught on a plate.
I think of autumn bonfires
in a world of pumpkins, wheat and sheep.
The reddleman camping
in his van,
a lonely figure walking over a moor,
on a crackling night.

In a drawing room somewhere
with another name,
perhaps Elizabeth or Charlotte or Mirabelle,
you would be wearing your new plum coloured velvet
with a bonnet to match,
and then you would dream of another time
when there would be more to do than
reading
or singing Schumann.
And you would wish your name less staid,
more friendly,
a name like Sally
which might allow you to travel unchaperoned with a man
on a railway carriage, or
would you long
for another culture?
black hair?
rice-white face?
and a name like Satsuma/ Sally Plum?

Book Title:
Handbook of Regular Patterns
Author:
Peter S. Stevens
Editor:
Julie Eastman
Designer:
Diane Jaroch
Illustrators:
Mollie Moran, Various
Publisher:
The MIT Press, Cambridge, MA
Typographer:
Achorn Graphic Services, Inc.
Printer:
Halliday Lithograph Corp.
Production Manager:
Dick Woelflien
Paper:
Quintessence 100 #
Binder:
Halliday Lithograph Corp.
Jacket Designer:
Diane Jaroch

More on Designations
The designation p1 reveals that the corners of the primitive cell p mark points with group-1 symmetry. Later when we draw the lattices of groups p2, pm, and pg, we will find that the corners of primitive cells fall on twofold centers, mirrors, and glide lines—that is to say, on elements 2, m, and g. We will thus use the same procedure to identify each plane group. The designation will indicate the symmetry at the corners of the unit cell.

Unit Cells and Fundamental Regions
After this discussion about the unit cell, can you recall the definition of a fundamental region? It is the smallest piece that can repeat to make the pattern. Do you think that the fundamental region and the unit cell are the same? Your answer should be no. We will thus use the fundamental region can repeat by rotation, reflection, and glide reflection as well as by translation. In contrast, the unit cell can repeat only by translation. Furthermore, the fundamental region can have any shape that joins with itself, whereas the unit cell must be either a parallelogram or a hexagon. Later we will see that

the unit cell frequently contains more than one fundamental region.
In the p1 pattern, however, the unit cell just happens to be a fundamental region. This coincidence occurs because translations alone produce the pattern. Even in the p1 pattern, however, the fundamental region can have shapes other than a parallelogram or hexagon, so while the unit cell is a fundamental region, a fundamental region may not be a unit cell.

Examples of p1
Figures 20.5–20.10 show animal forms arranged in the p1 pattern. The whales and birds in figure 20.5 were produced by the Chilkat Indians of southern Alaska and the Nazca Indians of Peru.
In figure 20.6 the artist M. C. Escher created a background of flying horses that interpenetrated with those in the foreground. Neglecting the difference in color, the horses in the background and foreground are identical, so that the fundamental region consists of only a single horse. The pattern is an exotic jigsaw puzzle in which every piece has exactly the same shape.

20.5b

20.5a

Group 6mm
The intersection of six mirrors produces the 6mm pattern illustrated in figure 10.4 by (a) commas, (b) an Arabian tile design, and (c) an Apache basket design. Whereas the fundamental region for group 6 is a 60° sector of arbitrary shape with two identical sides, the fundamental region for group 6mm is a 30° sector bounded by straight mirror lines.
The hexagonal snowflake belongs to group 6mm. Every snowflake is different, and yet each maintains the same hexagonal symmetry. As a reminder of all the beauty that nature so freely creates and destroys, the sketch in figure 10.5 shows a single flake that happened to be observed before it melted. Every moment of every day in the earth's atmosphere a myriad of these exquisite hexagonal designs come into being and pass away.

10.3a

10.3b

10.4a

10.4b

10.4c

10.5

Growth and Bilateral Symmetry
Not only animals possess bilateral symmetry. Figure 5.7 shows a doubled branch of mock orange in which pairs of leaves grow along each stem in the "opposite" pattern. Figure 5.8 shows three Greek vase ornaments with the same symmetry.
In architecture, too, growth and movement produce bilateral symmetry. Processional movement is incorporated in the symmetric plan of Amiens cathedral shown in figure 5.9. The apse, narthex, side chapels, and transept correspond to the head, tail, and balanced appendages of an organic creature. The facade has the same symmetry. Each side mirrors the other around the axis of the entrance. Most architectural elevations follow the same pattern, from Stonehenge to the modern office building.
The bilateral image everywhere abounds, in the trident and the arrow, in the sergeant's stripes and the archbishop's cross, in the human skull and the parabolic trail of a comet. Bilateral symmetry expresses balanced growth along a single axis.

5.6

5.7

5.8a

5.8b

5.8c

Book Title:
Scholastic Early Childhood
Program Teaching Guide
Authors:
Harriet Ziefert, Helen Myers,
Valerie Jameson
Art Directors:
Mary Mars, Carol Carson
Designer:
Elizabeth Koda-Callan
Illustrators:
Simms Taback, Julie Maas
Publisher:
Scholastic, Inc., New York, NY
Typographer:
American Typecrafters
Printer:
George Banta Co., Inc.
Production Manager:
Nancy De Wolfe Ragolia
Paper:
Howard Sandstone Text 70 #
Binder:
George Banta Co., Inc.
Jacket Designers:
Carol Carson, Elizabeth Koda-
Callan
Jacket Illustrator:
Elizabeth Koda-Callan

MATHEMATICS

SCHOLASTIC
EARLY CHILDHOOD
PROGRAM

TEACHING GUIDE

WEEK TWENTY-SIX

CARDINAL AND ORDINAL NUMBERS

This week's activities center around the children, their stages of growth and their self-awareness. As they think about themselves, activities they enjoy, and their likes and dislikes, children will be encouraged to use ordinal and cardinal numbers to qualify their statements.

LEARNING OBJECTIVES

26a. The child will write the numerals 0 through 9.

26b. The child will identify the appropriate numerals for pictures that illustrate the union and separation of sets.

Note: See pages 361–363 for more activities related to these learning objectives. The assessment activity for this week can be found on pages 31, 32, 33, and 34 of the Teacher's Edition of the Assessment Booklet.

OVERVIEW OF THE WEEK

PROGRAM MATERIALS	INITIAL TEACHING ACTIVITY	Writing Numerals	Tracing Numbers
Counting/Sorting Cards	Thinking About Myself	Numeral Card Pairs Fingerprint Number Pictures Address/Telephone Number Book	Role-Playing Number Stories
Worksheets 44, 45	MORE ACTIVITIES	Matching Cards How Many Things? Writing Numerals	
Button Counters	Number of the Day	Making Numeral Cards	
	A Book About Me		

250

THINKING ABOUT MYSELF

WHOLE CLASS

Needed: Drawing paper (at least two sheets for each child)
Crayons or markers

Prepare for this activity by writing "When I was ___" near the bottom of one piece of drawing paper for each child, and "When I am ___" near the bottom of another piece for the second part of the discussion.

Gather the children together for a class meeting and ask a few of them to tell about something they did when they were very small, perhaps when they were two, three, or four. Ask each child to draw a picture of what he/she might have looked like at that age on the piece of paper with the sentence "When I was ___" written on it. Then help the children print the numeral representing the appropriate age in the blank space.

Discuss how the pictures might be grouped. The children may wish to put all the pictures of class members at age two together, and all those of class members at age three together. Or they might suggest placing the pictures consecutively into a group containing pictures about a one-, two-, three-, and four-year-old child and then repeating the pattern. Emphasize the numeral in each picture and after this lesson mount the pictures on a bulletin board.

Another topic children find interesting is the question "What will you do when you are six or seven?" They often look forward to playing on teams or being in a certain grade because it seems to be more "grown up." Explore these ideas with them and ask them what they think being "grown up" and "really old" is. Is it age twenty? Age forty?

Hand out the second sheet of paper to each child. Ask the children to draw a picture of what they will do when they are the age they would like to be, and have them write that age in the blank space in the statement "When I am ___." These pictures can be added to the bulletin-board display.

251

MORE ACTIVITIES

LOOKING BACK

WHOLE CLASS

Needed: Paper for experience chart
Marker

Ask the children to recall some of the events and activities of the year and list them on an experience chart under the following headings: Things We Made, Games We Played, Places We Visited, Books We Read, Songs We Learned.

You might ask questions about specific times of the year to aid the children in filling in the details of the chart. For instance, ask them what they remember about starting school in September, what happened around Halloween and Thanksgiving, what happened when winter came, and what happened when spring came.

Since the children will probably mention only activities and events that were especially important to them, you might want to remind them of a few things they have left out.

To conclude the lesson, ask the children to vote on a favorite book, game, or song. Then read the book, and lead the children in playing the game or singing the song one last time.

THE YEAR THAT WAS

Things We Made	*Places We Visited*	*Games We Played*
Self-portraits	Local stores	Balancing games
"ME" books	Neighborhood	Wonderball
Pet books	Boiler room	Kickball
Beanbags	Principal's office	Concentration
Picture clocks	Vacant lot	Quick Change
Postcards	Restored village	Indian Chief
Sock puppets		Fire Station
		Hopscotch

Songs We Sang
"Head, Shoulders, Knees, and Toes"
"Put Your Finger in the Air"
"Sweepy, Sweepy, Sweepy"
"Mary Wore Her Red Dress"
"Rig-a-jig-jig"

Books We Read
Jennifer's Photo Album
Benjamin and Tulip
Sylvester and the Magic Pebble
Farm Family
The Story About Ping
The Tenth Good Thing About Barney

MAKING A CLASS YEARBOOK

Making a class yearbook is a four-step process. When the job is completed, each child will have his/her own book about "The Year That Was."

THE CHILDREN'S PAGES

WHOLE CLASS

Needed: Blank spirit masters
Pens

Give each child his/her own spirit master to draw on. Tell each one to remember an event that happened during the year and to draw a picture illustrating that event. When the drawing is finished, write down the child's descriptive comments on the spirit master.

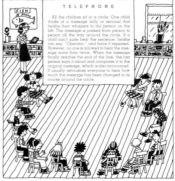

284 / 285

SOCIAL STUDIES

SCHOLASTIC
EARLY CHILDHOOD
PROGRAM

TEACHING GUIDE

OBJECTIVE 15a. The child will identify animals that belong in a land environment.

ANIMAL SORTING

SMALL GROUP

Needed: Learning Poster — The Land (supplied)
Cards from the Animal Lotto Game (supplied)

Children can work on their own or in pairs sorting the cards from the Animal Lotto Game. They can put the animals most likely to live on the land in one pile and those most likely to live in the ocean in the other.

The children may also want to separate the land animals into subgroups such as birds, insects, animals with fur, and all other

animals; or two-legged animals, four-legged animals, and six-legged animals. The children can also look for animals on the cards that match animals on The Land poster.

ADDING TO THE ENVIRONMENT

SMALL GROUP

Needed: Game mats from A Place to Live Game (supplied)
Magazines with nature pictures
Scissors
Tape

Display the game mats from A Place to Live Game, leaving a lot of space in which to post pictures around them on the walls or

bulletin board. Then let the children cut pictures of animals and plants out of magazines and tape them to the wall around the particular environment in which they might be found. For example, a child might tape a picture of a pine tree near the mat showing the deer in the forest. The children can also cut out pictures of different foods and post them around the environments they would be most likely to grow in.

OBJECTIVE 15b. The child will identify animals that belong in a water environment.

SEA TREASURES

WHOLE CLASS

Needed: Seashells and other objects found in the sea
Magnifying glass
Shoe boxes

Bring in a collection of shells, sand dollars, coral, and seaweed to display on a table in the Science Learning Center. Encourage the children to examine the different forms of sea life with a magnifying glass. They can sort the shells into different shoe boxes according to their size, shape, color, and so on. Ask the children what these different types

of shells remind them of and help them make up names for them. If they want to learn the real names of the shells, you may be able to identify some in a guide to the seashore.

VISIT TO A FISH STORE

WHOLE CLASS

Needed: none

Arrange to take the class on a visit to a fish store in the neighborhood. When you get

there, ask the person behind the counter to identify the different types of fish, how and where they were caught—with a net or with a fishing rod, in a river, a pond, an ocean, or a bay. Ask him/her to show you any exotic sea creatures that might be for sale, such as an octopus or a squid. Does the store sell such live shellfish as lobsters or crabs?

Explain to the children that shellfish wear their skeletons outside their bodies instead of inside them. They must be kept alive until they are cooked or they begin to be fresh. Show the children how you can tell a clam or oyster is alive by trying to pry open its shell. What happens?

Perhaps the man or woman in the fish store can show the children some fish eggs.

280 / 281

SCIENCE

SCHOLASTIC
EARLY CHILDHOOD
PROGRAM

TEACHING GUIDE

LANGUAGE GAME OF THE WEEK

TELEPHONE

All the children sit in a circle. One child thinks of a message (silly or serious) that he/she then whispers to the person on the left. The message is passed from person to person all the way around the circle. If a child can't quite hear the sentence, he/she can say, "Operator," and have it repeated. However, no one is allowed to hear the message more than twice. When the message finally reaches the end of the line, the last person says it aloud and compares it to the original message, which is also announced. It usually astonishes everyone to hear how much the message has been changed in its course around the circle.

WEEK TEN

VISUAL DISCRIMINATION

This week's emphasis is on receiving visual messages from the environment, particularly from signs and labels. A variety of activities will sharpen the child's ability to perceive and discriminate among visual stimuli. This focus is essential in the process of preparing children to perceive and discriminate among the differing characteristics of letters and words as they learn to read.

LEARNING OBJECTIVES

10a. The child will identify graphic symbols found in the environment.

10b. The child will discriminate among pictures that differ in small details.

Note: See pages 363–365 for additional activities related to these learning objectives. The assessment activities for this week can be found on pages 11–13 of the Teacher's Edition of the Assessment Booklet.

OVERVIEW OF THE WEEK

PROGRAM MATERIALS	INITIAL TEACHING ACTIVITY	Red Light/Green Light	OTHER
Alphabet Foldout	Noticing Signs	Seeing Small Differences	Language Game—Mother/Father, May I?
Worksheets 15, 16, 17, 18	MORE ACTIVITIES	Games with the Lotto Cards Solitaire	
Activity Cards—Signs, Which Sign Belongs?	Which Sign Belongs?	Lotto Races Free-for-All Rummy Lotto	
Visual Discrimination Lotto Game	Matching Sign Shapes City Streets Game		

122 / 123

LANGUAGE AND READING

SCHOLASTIC
EARLY CHILDHOOD
PROGRAM

TEACHING GUIDE

It has been raining since he got up this morning.

A

B

C

10

Book Title:
Syntax Specific Test: Picture Comprehension
Authors:
Joan Forman, John Albertini
Editors:
Joan Forman, John Albertini
Art Director:
Thomas J. Castle
Designer:
L. Dean Woolever
Illustrators:
Franklin Shaw, Cathy Chou
Publisher:
National Technical Institute for
the Deaf / Rochester Institute of
Technology, Rochester, NY
Typographer:
Sarah J. Perkins
Printer:
ABC Letter Service, Upstate
Litho. Co.
Production Manager:
Willard Yates
Paper:
Finch Opaque
Binder:
ABC Letter Service, Upstate
Litho. Co.
Cover Designer:
L. Dean Woolever
Cover Illustrator:
Cathy Chou

The old man is fearful of cats.

A

B

C

28

Book Title:
In and Out of the Garden
Author:
Sara Midda
Editor:
Sally Kovalchick
Art Director:
Paul Hanson
Designer:
Sara Midda
Illustrator:
Sara Midda
Publisher:
Workman Publishing Co.
New York, NY
Printer:
Dai Nippon Printing Co., Ltd.
Production Manager:
Wayne Kirn
Paper:
Matte Coat 105 #
Binder:
Dai Nippon Printing Co., Ltd.
Jacket Designer:
Sara Midda
Jacket Illustrator:
Sara Midda

324

HOW TO BE TEXAN
by Michael Hicks

Texas
Monthly
Press.

HOW TO BE TEXAN

Book Title:
How To Be Texan
Author:
Michael Hicks
Editor:
Texas Monthly Press
Art Directors:
Michael Hicks, Tom Poth
Designer:
Michael Hicks
Illustrators:
Michael Hicks, Patti Hied, Tom Curry, Tom Ballenger, Richard Krall, Tom Poth, Larry Jolly, Harrison Saunders, Carol Powell
Publisher:
Texas Monthly Press, Austin, TX
Typographer:
G & S Typographers
Printer:
Best Printing Co.
Production Managers:
Cathy Berend, David Shapiro

VEHICLES

Texas is full of pretty isolated places. What this means to a budding Joe Don Juan is that, as gasoline doubles in price, instead of having his choice of all the women in a two-hundred-mile radius, he may only be able to afford to cover a hundred-mile radius. Yankees might view this problem as ridiculous, but in many parts of Texas a hundred-mile radius (or 31,400 square miles) will yield fewer than fifteen women in any particular age group. In these circumstances the price of gas becomes the price of life. It's not a laughing matter.

Speed—Resentment of the 55 mph speed limit is almost universal in Texas. Even the Highway Patrol has little good to say about driving 55. If you're crossing New Jersey, the difference in traveling 55 mph and 70 mph doesn't matter much, but it adds four to five hours to a drive across Texas. And if you relate horses and autos, as we do here in Texas, it's obvious that 55 isn't anywhere close to a gallop in a car that has a top speed of 120 mph. It's more like a trot, and Texans don't like to think of themselves as only being allowed to trot.

Cadillacs—Texans love Cadillacs. Any shape and any size. The newer the better, but better an old Cadillac than a new anything else. It's not that you won't see other luxury cars in the state, it's just that this particular car is a Texas tradition. Even people who don't like Cadillacs will buy one or two as a sign of their success. There are also practical reasons for owning at least one, chief among them being the almost irrefutable fact that you can't break the law while driving a Cadillac. Political clout goes a long way in rural Texas, and nobody wants to bring big-time heat on themselves (especially in the form of a country justice of the peace) because of a minor traffic violation. As long as the rural powers-that-be drive Cadillacs, a certain immunity will be inherent in owning a car of the same make. The only shortcoming about Cadillacs is that you can't carry much besides people in them. Therefore, drivers who have stuff to haul are forced to spend at least some of their road time in pickups. It would seem an easy enough job for GM, knowing this, to produce the ultimate Texas vehicle: a 4x4 Seville pickup with a humpback camper and a steerhide interior.

Trucks, specifically pickups, are an integral part of life in Texas. The only pickups that are absolutely stock from the factory belong to corporations. The rest are fitted with various extras that can tell you much about the profession, tastes, and predilections of the owners. Pickups fall into one of two easily distinguishable categories: country or city. City trucks invariably have a fitted toolbox in the bed. Country trucks have the tools spread around liberally on the floor and dash of the cab for quick access. Rural drivers like to recall events in their lives by the dents in their trucks and will seldom go to the trouble of having one removed, regarding it as a sign of character. City pickup drivers consider a dent to be a defacement. City trucks have four-wheel drive (possibly for negotiating the treacherous parking garage ramps in the Galleria). Rural drivers view four-wheel drive as laughable (if you really get stuck, you'll need a tractor to get you out). City trucks are washed and have heavy-duty everything. Country trucks are much more organic and look as if gypsies and small animals live in them. City trucks have the look of Texas about them. Country trucks have Texas literally stuck all over them.

VEHICLES

City

CB, AM-FM Cassette, Radar Detector
Bucket Seats
Gun Rack, Flashlights, and Spinning Reel
Toolbox
Bumper Stickers Dealing With Beer, Nightclubs, or Armadillos
Driving Lights
Chrome Bumpers
Four-Wheel Drive
Spoked Wheels and Giant Tires
Two-tone, No Dents

Country

Found-Objects Dash Containing Tobacco, Fencing Tools, Hot Sauce, Cigarette Lighters That Don't Work, Trash, Sticky Keys, Tab Tops, Receipts, CB Aerial, Beanbag Ashtrays, Handle to the Driver's Window, Small Pieces of Wire, Old Checkbooks, Three Nickels, and Two Pennies
Bugs and Bug Parts
Bed That Contains Flat Tire, Some Hay, Old Purina Livestock Bag, Two Beer Bottles, Seventeen Beer Cans, Parts of a Styrofoam Cooler, Fishing Pole, Shovel, and Tire Tool for 1964 Ford Falcon
Bass Stickers
Worn-out Shocks
Tires and Wheels That Don't Match
Solid Unrecognizable Color

DRIVE-INS

In Texas the only drive-ins of any consequence are for eating or socializing. This includes both the burger stand and the drive-in movie. In some places there have been enough other competing diversions to keep drive-ins from evolving to their full potential. But not in Texas. Here, drive-ins have developed almost to perfection, becoming state-of-the-art blends of entertainment, sanctuary, and social ritual.

Burger Stands—Don't waste your time with anything that calls itself a "restaurant" or that has the aura of a

franchise. Very good burger stands may have several locations, but usually all are in the same town. One primary rule: you must be able to order, be served, and eat without ever leaving your car. With rare exceptions, the uglier the carhops, the better the food. If you're looking for good food (e.g., ranchburgers, steak fingers, corn dogs), it's best to go about one o'clock in the afternoon. By this time the kitchen has served anything that was left over from the night before and has had the entire lunch rush to get its act together. Don't be afraid to try local specialties: one of

the handiest sources of the true culture of a particular town is its drive-in food. Of course, don't go overboard and order crawfish enchiladas without reserving a burger as a backup. And avoid secret sauces as you would the plague. Just because the carhop will eat it is no reason you should.

Movies—A really great drive-in movie takes the essentials of the burger stand and adds twin screens and a playground for the kiddies. Drive-in movies evolved in Texas to something beyond what they are in most other places. One special

characteristic of better Texas drive-ins is the elaborately painted scenes that decorate the backs of the screens. These giant murals are often the first encounter many folks have with "real ort" and account for more than one Texan's soft spot for neon.

Another variation on drive-in movies is the outdoor theater. It's just like an ordinary drive-in except that the cars are left outside. (Honest.) You simply haul all your junk through the gate with you. It's much like going to an outdoor rock concert. Be sure to take a few

gallons of insect repellent; the mosquitoes in adjoining counties love to go to the movies. Unfortunately, outdoor theaters have by and large fallen on hard times, since any enterprising fellow with a big-screen TV and a barbecue grill can offer serious competition. Many of the regular drive-ins are still flourishing though, representing the last real cheap option for a family in chronic need of a baby-sitter. You just back the pickup into the parking slot, unfold the lawn chairs in the bed, and open your grocery bags of popcorn and your cooler of beer. If you doubt the

popularity of drive-ins, check one out on $2-a-carload night when a Walt Disney feature is showing.

Novices should observe a few courtesies, such as not parking right beside someone else unless you have to and leaving your lights off as you exit (at least until you hit the gate). Don't eat drive-in pizza either, unless everybody in the whole joint is eating some. And, while Texans don't shoot at the screen during westerns anymore, you'll be much happier if you know where to park. There is an almost universal pattern, diagrammed here:

Back Rows: Criminals, heavy drinkers, druggers, and people who can't make up their minds which feature to watch (so they park backward and watch one movie while listening to the other).

Rows 21–25: Serious heavy daters. Frosted-window area. Usually stop at rows 10–15 on the way out to find out what the movie was about.

Rows 16–20: Couples who are just starting to date or who have been married for more than five years. Double daters.

Rows 10–15: Girls with girls, boys with boys, changing combinations. Snack bar area. Also loud and with high car-to-car traffic.

Rows 2–10: Families with large numbers of children. Close access to the playground. High noise area.

Front Row: People who are typically handicapped, who are wearing neck braces locked in an upright position, or who have taken mind-altering drugs and want to "get into" the picture.

Book Title:
Reader's Digest Complete Car
Care Manual
Editor:
Wade A. Hoyt
Art Director:
David Lindroth
Designers:
Ed Lipinski, Joel Musler
Photographer:
Morris Karol
Publisher:
The Readers Digest Association,
Inc., New York, NY
Typographer:
Nortype, City Typographic
Service, Inc.
Printer:
Rand McNally & Co.
Production Manager:
Douglas Spitzer
Paper:
Mead Matte 55 #
Binder:
Rand McNally & Co.
Cover Designer:
David Trooper
Cover Photographer:
Ryszard Horowitz

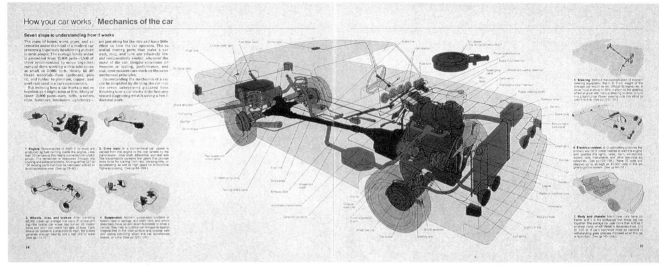

Book Title:
Paper Permanence: Preserving the Written Word
Author:
Charles Hogg
Editor:
Charles Hogg
Art Director:
Herbert Rogalski
Designer:
Herbert Rogalski
Illustrators:
Various
Publisher:
S.D. Warren Co., Boston, MA
Typographer:
Typographic House
Printer:
Thomas Todd Co.
Production Manager:
Fred Dempsey
Paper:
S.D. Warren Olde Style 70 #
Binder:
Robert Burlen & Sons
Jacket Designer:
Herbert Rogalski

The day may come when you can no longer walk into your local library and borrow just any book. We're finding that the paper in an alarming number of them has deteriorated to the point where further handling could destroy it altogether.

And not always are the most heavily circulated books the worst. Some appear to self-destruct, just resting on the shelf.

The Library of Congress, for example, estimates that over a third of its 17,000,000 books are out of service because of the poor condition of their paper. About half of those in the New York City Public Library show signs of decay. At virtually every major university library, the situation is as bad or worse.

Ironically, the older the book, the better it survives. Those that are more than two hundred years old are often in better shape than some that are less than fifty. The problem seems to be with books and documents published since the mid-nineteenth century, which makes it especially serious.

For this period coincides with the so-called "knowledge explosion," meaning that we face the possible loss of a key segment of our cultural record. Classics, of course, will be reprinted. But what of the monographs, reports, and other primary documents that future technical and even social development depend on? Or the popular and practical literature that historians would ordinarily come to know us by? To say nothing of historic documents and first editions of major literary works.

Our very oldest books are sometimes in better condition than those published in the eighteenth and nineteenth centuries. The paper in a Gutenberg Bible, for example, is still pliable and white while in turn-of-the-century novels, it is brittle and yellow.

(Preceding pages) Empty shelves appear in libraries everywhere as deteriorating books are removed from circulation.

2

Book Title:
A Rose for Pinkerton
Author:
Steven Kellogg
Editor:
Phyllis J. Fogelman
Art Director:
Atha Tehon
Designer:
Jane Byers Bierhorst
Illustrator:
Steven Kellogg
Publisher:
The Dial Press Books for Young
Readers, New York, NY
Typographer:
Royal Composing Room
Printer:
Holyoke Lithograph Co., Inc.
Production Manager:
Sherri Johnson Alexander
Paper:
Mohawk Vellum
Binder:
Economy Bookbinding Co.
Jacket Designer:
Jane Byers Bierhorst
Jacket Illustrator:
Steven Kellogg

THE FOX AND THE GRAPES

HEIDI HOLDER

AESOP'S FABLES

THE VIKING PRESS
New York

There was a time when a fox would have searched as diligently for a bunch of grapes as for a shoulder of mutton. And so it was that a hungry Fox stole one day into a vineyard where bunches of grapes hung ripe and ready for eating. But as the Fox stood licking his chops under an especially juicy cluster of grapes, he realized that they were all fastened high upon a tall trellis. He jumped, and paused, and jumped again, but the grapes remained out of his reach. At last, weary and still hungry, he turned and trotted away. Looking back at the vineyard, he said to himself: "The grapes are sour!"

There are those who pretend to despise what they cannot obtain.

·15·

Book Title:
Aesop's Fables
Editor:
Linda Zuckerman
Art Director:
Barbara G. Hennessy
Designer:
Barbara G. Hennessy
Illustrator:
Heidi Holder
Publisher:
Viking Penguin, Inc.
New York, NY
Typographer:
The Press of A. Colish
Printer:
Alithochrome Corp.
Production Manager:
Linda H. Prather
Binder:
A. Horowitz & Sons
Jacket Designer:
Barbara G. Hennessy
Jacket Illustrator:
Heidi Holder

Book Title:
On Market Street
Author:
Arnold Lobel
Editor:
Susan Hirschman
Art Director:
Ava Weiss
Designer:
Ava Weiss
Illustrator:
Anita Lobel
Publisher:
Greenwillow Books
New York, NY
Typographer:
Pastore DePamphilis,
Rampone, Inc.
Printer:
Universal Lithographers, Inc.
Production Manager:
Eugene Sanchez
Paper:
Mead Matte 80 #
Binder:
The Book Press

musical instruments,

noodles,

oranges,

playing cards,

But sweet-tooth Laura spoke in haste:
'Good folk, I have no coin;
To take were to purloin:
I have no copper in my purse,
I have no silver either,
And all my gold is on the furze
That shakes in windy weather
Above the rusty heather.'
'You have much gold upon your head,'
They answered all together:
'Buy from us with a golden curl.'
She clipped a precious golden lock,

Book Title:
Goblin Market
Author:
Christina Rossetti
Editor:
Sarah St. Onge
Art Director:
Sarah St. Onge
Designers:
Anne Chalmers, Diane Nelson
Illustrator:
George Gershinowitz
Publisher:
David R. Godine, Publisher
Boston, MA
Typographers:
Michael and Winifred Bixler
Printer:
Princeton Polychrome Press
Production Manager:
William F. Luckey
Paper:
Potlatch Quintessence
Binder:
A. Horowitz & Sons
Jacket Designer:
Anne Chalmers
Jacket Calligraphy:
G.C. Laurens

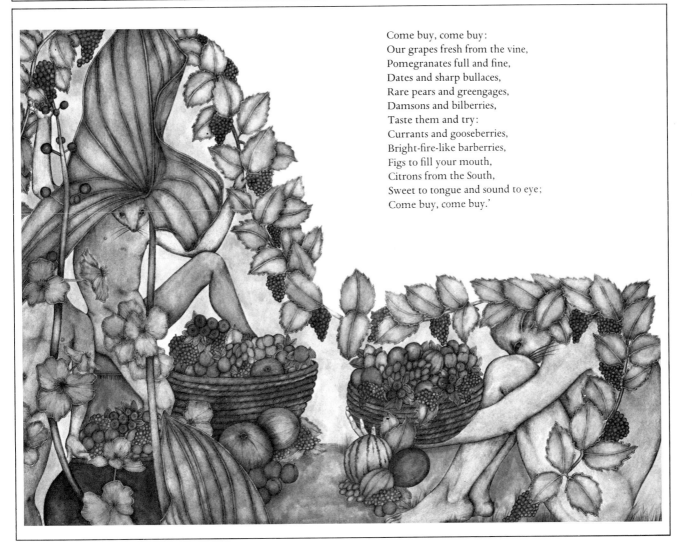

Come buy, come buy:
Our grapes fresh from the vine,
Pomegranates full and fine,
Dates and sharp bullaces,
Rare pears and greengages,
Damsons and bilberries,
Taste them and try:
Currants and gooseberries,
Bright-fire-like barberries,
Figs to fill your mouth,
Citrons from the South,
Sweet to tongue and sound to eye;
Come buy, come buy.'

Book Title:
Nightdances
Author:
James Skofield
Editors:
Charlotte Zolotow, Janet Aldrich
Art Director:
Amelia Lau
Designers:
Karen Gundersheimer, Amelia
Lau
Illustrator:
Karen Gundersheimer
Publisher:
Harper & Row, Publishers, Inc.
New York, NY
Typographer:
Cardinal Typeservices, Inc.
Printer:
General Offset Co., Inc.
Production Manager:
Herman Riess
Paper:
Willco Opaque Vellum 70 #
Binder:
The Book Press
Jacket Designers:
Karen Gundersheimer, Amelia
Lau
Jacket Illustrator:
Karen Gundersheimer

Papa swinging
By his knees,
Playing monkey in the trees.

Dance together.
Dance alone.
Dance nightdances on the lawn—

Until the dance
Grows warm and tired.
Then slow dance, soft dance on inside.

Dance through hallways.
Dance upstairs.
Take off robe and whisper prayers.

at a picture book. The beast liked the blue pajamas she was wearing and the way her hair hung on her shoulders in two long braids.

Smiling to himself, he trotted to the porch and with his sharp, little claws pried open the screen on the front door. Quick and quiet as a mouse he scampered upstairs, running from room to room till he came to the one with a dollhouse in it. He put his suitcase down on the floor and took a big leap onto the bed.

Nice and soft, he thought to himself. I will like sleeping here very much.

All at once he heard footsteps on the stairs.

It's her, thought the beast. And he dove under the covers, giggling with excitement.

The footsteps skipped lightly down the hall and into the

Book Title:
The Beast in the Bed
Author:
Barbara Dillon
Editor:
Elizabeth D. Crawford
Art Directors:
Cynthia Basil, Elizabeth D. Crawford
Designers:
Chris Conover, Cynthia Basil
Illustrator:
Chris Conover
Publisher:
Morrow Junior Books /
William Morrow and Co., Inc.
New York, NY
Typographer:
Pastore DePamphilis,
Rampone, Inc.
Printer:
Rae Publishing Co., Inc.
Production Manager:
Eugene Sanchez
Paper:
Mohawk Vellum 80 #
Binder:
The Book Press
Jacket Designer:
Chris Conover
Jacket Illustrator:
Chris Conover

And that was how the beast came to live with Marcia. Everywhere she went, he went too. Sometimes he was naughty. One day he poured hand lotion down the chimney of the dollhouse. Another time he scribbled with a purple crayon on the bathroom wall. But he was also a lot of fun. He built splendid castles in the sandbox and dribbled delicate turrets along the tops with wet sand. He could whistle beautifully and tell interesting stories. The ones Marcia liked best were about the different children he had lived with. She never tired of hearing what Mary Sue used to have for lunch; how Edmund had fallen from the seesaw and broken his arm; what Amy's mother had said when Amy cut off her little sister's pigtails with the nail scissors.

Sometimes, though, the beast grew sad thinking of all his old friends. "Once they went off to school," he would say with a sigh,

he set off down the street. He just never could get used to saying good-bye.

It began to rain and continued all day long. When the beast's stomach told him it was time for supper, he huddled under a dripping oak tree and opened his suitcase. There wasn't much food left, for he had been nibbling it steadily. He ate the apple and a few crumbs of doughnut, and then he curled up in a ball with his tail tucked around him.

"Camping out is awful!" He shivered. "I'm glad I was never a boy scout." And he closed his eyes and tried to imagine himself safely back in Marcia's room, snoring peacefully at her side.

Next morning he woke up just as the sky was getting light. Raindrops falling through the branches of the oak pelted him like cold, little pebbles.

"Where will I ever find breakfast on a day like this?" he said with a sigh. He stumbled to his feet, stretched once, yawned twice, and trotted out to the road clutching his empty suitcase.

Book Title:
The Wild Swans
Author:
Hans Christian Anderson
Retold by Amy Ehrlich
Editor:
Amy Ehrlich
Art Director:
Atha Tehon
Designer:
Atha Tehon
Illustrator:
Susan Jeffers
Publisher:
The Dial Press Books for Young
Readers, New York, NY
Typographer:
Royal Composing Room
Printer:
Holyoke Lithograph Co., Inc.
Separations:
Rainbows, Inc.
Production Manager:
Sherri Johnson Alexander
Paper:
Karma White
Binder:
Economy Bookbinding Co.
Jacket Designer:
Atha Tehon
Jacket Illustrator:
Susan Jeffers

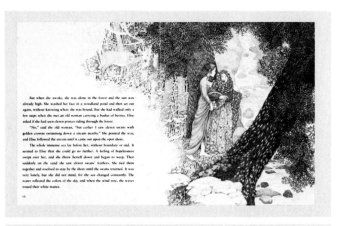

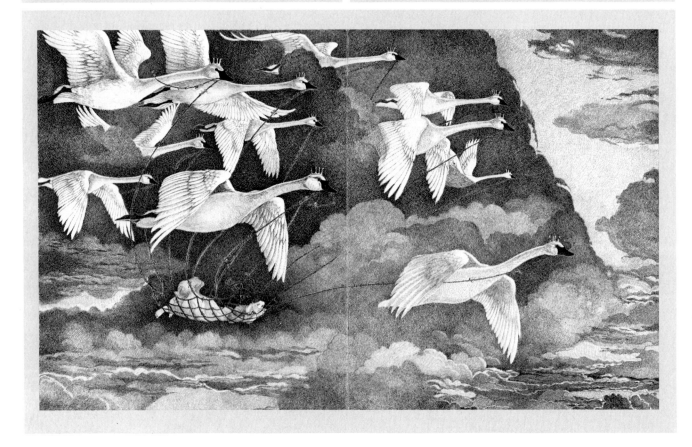

EVERYTHING THAT HAS BEEN
SHALL BE AGAIN

THE REINCARNATION FABLES
OF JOHN GILGUN

WITH NINE WOOD ENGRAVINGS
BY MICHAEL McCURDY

THE BIELER PRESS 1981 ST PAUL

BEAR

SISTERS, LET US PRAY. Though to be reincarnated as a Bear is to suffer a hundred physical indignities every day of your life, we will not complain, O Lord! Though sweat, salt, blood, excrement, fleas, flies and rotten fish plague our lives from birth to death, we will continue to praise you, Omnipotent Being! Though salmon bones, dead bees and bristles from the backs of arrogant, swaggering lovers (never husbands!) stick in our teeth, we will not complain, for we know that your will is just, O Lord! Though our intestines are so extensive that if they

were stretched out full length they would reach to the Great Divide and beyond—and consequently we suffer continually from flatulence, rumbling, grumbling, farting and belching as we plod along over the forest paths—yet we will praise you, for we are wonderfully made.

Though we Bears have never seen you, O Lord, our gross corporeal reality—this greasy mass of graying flesh is proof of your existence. Thank you, thank you! Though hunger bites at our bellies like an alligator gar; though lust nips at our genitals, driving us forward unwillingly to more growling, foul-breathed lovers, more troublesome cubs, more trips on your endless Wheel of Existence (from which, release us in your own good time, O Wise One); though our feet go flat and our thighs grow flabby and our eyes fail us, yet we will continue to cry unto our dying day, "Thank you, thank you, thank you!" This old Bear, this Mother Bear, Sophie the Wise, myself, rises on her splendid golden haunches—for which I offer thanks, O Lord, since you created them—on this magnificent May morning and roars so that not only this small congregation of Bears but the entire forest can hear, "Thank you, thank you, thank you!"

Consider this freshwater clam, O my sisters. Notice how it appeared miraculously between my paws as soon as I expressed gratitude to the Lord. Consider its roundness, the perfection of its shell, its delicate little nose-tweaking scent, the succulence of its pink and pearly inner part. This is no conjurer's trick, for I am not a

14

15

production." I forget who said that. Fourth, Rufus of Greenwich, "You fell because all things fall. Test it with a rock. Toss it in the air and watch it fall. It's universal law." And finally, Denis of Dunstan, "Man did it." "Yes, perhaps he did. But how? We Bears have never been able to find out.

So I say that it is and will remain a sacred mystery. Allow yourselves to rest in the sacred mystery, my cubs, never seeking ultimate answers—there may be none—but content always to contemplate what is ultimately unknowable, the Lord above, whom we have never seen. This is all a bit much for cubs. This is all a bit much for me! When my spirit falls through space, impelled on its way by some power higher than my own; when my next incarnation appears on the horizon, like an island looming up in the distance in the middle of a great lake, as we swim toward it, drowning as we swim; when the Lord looks down, pats the back of my paw and says, "Good Bear! Well done!"; then and only then will I know the answers to the questions which plague us from conception to extinction.

Now Sister Ursula will pass among you with a reed basket. I'm sure there will be generous contributions this morning. Afterwards there are honeycakes for the Cubs and, for you adult Bears, fat, blue-backed grubs, gathered just this morning from a damp place under a decaying log just above Badger Creek. Ah, I can see the saliva forming on your lips right now. So eat, eat, my Sisters! Eat and be joyful. Thank you thank you thank you.

22

COW

AS YOU CAN SEE, MY FRIENDS, I AM A COW. My owner, Mr. Miller, calls me "Thelma." He don't know it, but "Thelma" was my name in my other lifetime too—Thelma R. (for Rita) Hodge of near-Joplin, Missouri. Maiden name—Hubbard, same as the squash. I married John Hodge when I was sixteen and we had eleven kids —Duane, Melanie, Dulcie, Cass, Joan, Tessie, Liz, Ellwood (that was born with the hare lip), Harry, Bud and Bo, my twins. And I always knew I'd come back as a cow. I just never knew what kind I'd be. Well, I'm a

23

FOX

YOU'RE ABSOLUTELY RIGHT, OF COURSE. No fox would ever venture out at night without his mask and his magic talisman. That would be to invite disaster. Fox law states unequivocally, "No mask, no talisman, no night journey." This is my mask; this is my talisman. I'll let you examine them in more detail in a moment. But first, you're a goose, aren't you? Your letter from the newspaper made no mention of that fact. I admit, I'm surprised. No, astonished! Tell me, doesn't it frighten you—given the reputation of foxes, I mean—finding

yourself alone and unprotected in a fox's den? It doesn't? Oh. By the way, would you like a glass of California pinot chardonnay? It's quite good, really. Oh, you don't drink? Well, perhaps some mineral water then? I always have a glass or two of good wine before dinner. It clears the palate as it whets the appetite. The cleansing effect of this particular wine is extraordinary and it has a delicate piquancy which is absolutely divine. And while I'm on the subject of excellence in wine, let me add something about excellence in women. You are the most attractive female goose I've seen in years, my dear. Yes, you are. Now that self-deprecating modesty will get you nowhere here. Your qualities illuminate the room. And I especially admire your courage—maintaining your calm demeanor in the presence of a fox when all the reputation of being—how can I put it? Oh, more than a little experienced with women. Hmm? And your concern for your newspaper is certainly commendable. Of course I'll help you in any way I can. I was honestly touched by the last sentence of your letter. "A newspaper stands or falls by the accuracy of its reporting." So you came directly to the source. You took the risk. Ah, that every reporter possessed that kind of courage! You have nerves of steel, my dear, a quality rare in any creature, but especially rare in a female goose.

I published a newspaper myself before I went into politics, you know. You do know? Ah, you've done research on me, of course. And now that I'm out of office, now that I'm no longer in politics, now that I've been so

32

33

GNAT

I WAS NEVER NOTHING. Before time was, I existed as an idea in the divine mind, as a collection of radiant atoms emanating from cosmic consciousness. But after my millionth death and rebirth, I woke to find myself swimming in seemingly endless circles of pure white light, surrounded by billions of my brothers and sisters, all of whom were singing "Hish-y-shirini" (which can be translated into English as "ecstacy in adoration," though that does not convey the quality of it), and all of whom were being menaced and devoured by that selfsame

white light. Then I realized that I had been reincarnated as a gnat and I was filled with a very great joy, for special things have been promised to gnats, who qualify as creatures who constitute "the very least of these." The light crackled with the terror of birth and violent death, for as billions died, billions more were born, and all within split (no, within shattered!) megaseconds of timeless time so infinitely small no human chronometer could ever have measured it. Then I understood the meaning of "entering in at the narrow gate," but of course there was no gate, only a slight increase in the intensity of the light down at the center of the vortex toward which we were all being drawn. I knew that I was being spared momentarily (if the word "momentarily" can have any meaning in this context), in order to witness a great truth and to pass that truth on to posterity. (Though a thousand generations of my "posterity" were expiring all around me, as I paused there, drawn toward death but tied to life by some force I did not fully understand.) I know you've seen insects—moths, midges, who knows what—crowding around streetlights on summer nights, knocking each other aside in their eagerness to thrust their frail, foolish bodies into the light. They too are truth seekers, but the only truth they uncover is a truth already inherent in the molecular structure of every insect, namely, that we were created in order to be zapped in the light. But my truth was not like theirs. My cells told me, "For you, and for you alone, Nikki, there is no death, and what lies at the center of the vor-

42

43

Book Title:
Everything That Has Been Shall
Be Again
Author:
John Gilgun
Editor:
Sue Rexford
Art Director:
Gerald Lange
Designer:
Gerald Lange
Illustrator:
Michael McCurdy
Publisher:
The Bieler Press, Gerald Lange,
Sue Rexford, St. Paul, MN
Typographer:
Gerald Lange
Printer:
Gerald Lange
Production Assistant:
Sue Rexford
Paper:
Tovil
Binder:
Scott Hudby, Bookbinder

Book Title:
Outside Over There
Author:
Maurice Sendak
Editor:
Ursula Nordstrom
Designers:
Maurice Sendak, Atha Tehon
Illustrator:
Maurice Sendak
Calligrapher:
Jeanyee Wong
Publisher:
Harper & Row, Publishers, Inc.
New York, NY
Printer:
George Rice & Sons
Production Manager:
John Vitale
Paper:
Quintessence Dull 100 #
Binder:
A. Horowitz & Sons
Jacket Designer:
Maurice Sendak
Jacket Illustrator:
Maurice Sendak

The Animal That Changes Color

STRANGE CREATURES
by SEYMOUR SIMON
illustrated by PAMELA CARROLL

FOUR WINDS PRESS
NEW YORK

THERE ARE MORE THAN EIGHTY DIFFER-ent kinds of chameleons. Most of them are found in central and southern Africa. The animals called "chameleons" found in the United States are really anoles, a different kind of lizard. All chameleons can change the color of their skins. They can change from green or yellow to dark gray and they can even show spots or lines. This helps them to match their backgrounds. But chameleons rarely get a perfect blend of every color. The chameleons can change colors because of different color cells in their skins. Some of the cells are yellow, others are whitish, while still others are black. The cells can grow larger or smaller in a short time. As the cells change in size, the lizard's skin seems to change in color. Chameleons are remarkable in other ways as well. A chameleon's tongue has a sticky tip, just right for catching insects. The chameleon can shoot out its tongue with lightning speed when an insect is more than a foot away. Many chameleons have tongues that are longer than their body and tail combined! The chameleon's eyes are housed in little bumps on each side of its head. The two eyes can look in different directions. For example, one eye can look upward while the other eye is looking backward. When the chameleon spots an insect, however, both eyes focus on its prey.

29

Book Title:
Strange Creatures
Author:
Seymour Simon
Editor:
David Reuther
Art Director:
Lucy Martin Bitzer
Designer:
Lucy Martin Bitzer
Illustrator:
Pamela Carroll
Publisher:
Four Winds Press, New York, NY
Typographer:
LCR Graphics, Inc.
Printer:
Halliday Lithograph Corp.
Production Manager:
Doris Barrett
Paper:
Perkins & Squier Offset 70 #
Binder:
The Book Press
Jacket Designer:
Lucy Martin Bitzer
Jacket Illustrator:
Pamela Carroll

The Champion Egg Layer

THERE ARE ONLY A FEW KINDS OF BIRDS that lay eggs larger than the eggs of the New Zealand kiwi. But no other bird or other animal even comes close to the kiwi when you compare the size of the egg to the size of the animal. The kiwi weighs about four pounds, and a kiwi egg weighs about one pound! It takes about seventy-five or eighty days for a kiwi egg to hatch—almost another record. The male kiwi sits on the egg during that time. When a kiwi chick is born, it is fully feathered. But it still takes three or four years for the chick to grow into an adult. The kiwi is a bird that cannot fly. When a kiwi runs about, it wobbles from side to side like a child taking its first steps. About the size of a large farm chicken, the kiwi is covered with long, hairlike feathers. Its wings are only about two inches long, and it has very small eyes. The kiwi gets its name from the peculiar sound it makes during courtship—a whistling noise that sounds like *kee-wee.* The kiwi bird has a long, curved bill that is unlike those of most other birds. There are nostrils at the tip of the bill, and the kiwi has a good sense of smell. The kiwi uses its bill as a probe looking for earthworms, grubs, and insects in the soil.

35

Book Title:
The Honeybee and the Robber
Author:
Eric Carle
Editor:
Ann Beneduce
Art Director:
Sallie Baldwin,
Antler & Baldwin, Inc.
Designers:
Eric Carle, James Roger Diaz,
John Strejan
Illustrator:
Eric Carle
Paper Engineers:
James Roger Diaz, Tor Lokvig,
John Strejan
Publisher:
Philomel Books,
New York, NY
Typographer:
Frost Brothers
Printer:
Carvajal S.A.
Production Manager:
John d'Avino
Paper:
Foldcote 10 pt.
Binder:
Carvajal S.A.
Jacket Designer:
Eric Carle
Jacket Illustrator:
Eric Carle

4 The honeybee flew from flower to flower, gathering nectar.
When she had gathered enough, she started to fly
back to the hive.
A hungry bird swooped down and tried to catch her.
But the honeybee was much too quick!

Then the honeybee was thirsty.
She flew to a pond to drink some water.
A hungry fish and a hungry frog both tried to catch her.
But the honeybee was much too quick for them, too! 5

10 It was a bear trying to break in and steal the honey!
"GR-R-R-R!" he growled, as he scratched at the tree.
The guard bee hadn't seen him. But the honeybee had.

Out flew the little honeybee and stung the big bear right on the nose. 11
"OUCH!" yelled the bear . . .

BO RABBIT
SMART FOR TRUE

Folktales from the Gullah

Retold by Priscilla Jaquith
Drawings by Ed Young

Book Title:
Bo Rabbit Smart for True:
Folktales From the Gullah
Author:
Priscilla Jacquith
Editor:
Joan Knight
Art Director:
Sallie Baldwin, Antler & Baldwin,
Inc.
Designer:
Ed Young
Illustrator:
Ed Young
Publisher:
Philomel Books, New York, NY
Typographer:
Frost Brothers
Printer:
Rae Publishing Co., Inc.
Production Manager:
John d'Avino
Paper:
S.D. Warren White Wove Old
Style 70 #
Binder:
Economy Bookbinding Co.
Jacket Designers:
Sallie Baldwin, Ed Young
Jacket Illustrator:
Ed Young

Bo Rabbit's
Hide-and-Seek

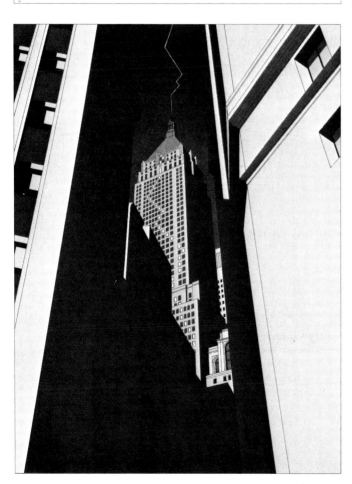

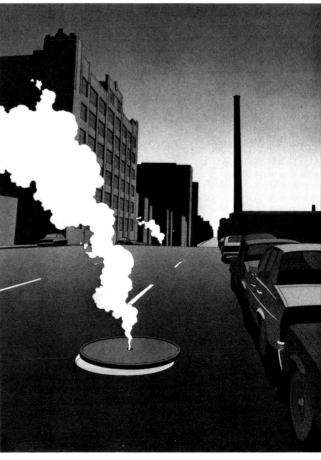

Book Title:
Thunderbolt & Rainbow
A Look at Greek Mythology
Author:
Guy Billout
Editor:
Carol Barkin
Art Director:
Barbara Francis
Designer:
Carl Barille
Illustrator:
Guy Billout
Publisher:
Prentice-Hall, Inc.
Englewood Cliffs, NJ
Typographer:
Elizabeth Typesetting Co.
Printer:
Rae Publishing Co., Inc.
Production Manager:
Donna Sullivan
Paper:
Patina 8011
Binder:
The Book Press
Jacket Designer:
Carl Barille
Jacket Illustrator:
Guy Billout

Book Title:
Fluffy: The Story of a Cat
Author:
Jürg Obrist
Editor:
Jean Karl
Art Director:
Mary M. Ahern
Designers:
Jürg Obrist, Mary M. Ahern
Illustrator:
Jürg Obrist
Publisher:
Atheneum Publishers
New York, NY
Typographer:
Dix Typesetting Co., Inc.
Printer:
Connecticut Printers
Production Manager:
Jin Lau
Paper:
Alpine Opaque 80 #
Binder:
A. Horowitz & Sons
Jacket Designer:
Jürg Obrist
Jacket Illustrator:
Jürg Obrist

She could gaze at autumn's swirling leaves and maybe long to chase after them. And she could appreciate the warmth of the radiator by the window as winter arrived, covering the streets and buildings with snow.

As time passed, the months and years must have seemed all alike to Fluffy. Inside it was always warm and dry. But sitting at the window, she could see the little bushes and trees bloom in the backyards below. She could watch as the hot summer sun glared down on the city's streets and alleys.

Other times she would visit a farm nearby. She watched the farmer milking the cows, the chickens scratching in the yard, or the pigs lying in the sun. But sometimes the farmer's dog chased her, and Fluffy had to run and climb quickly up a tree.

"Matter enough, my mouse so fat!
Oh, dear! Alas! It is the CAT!"

Book Title:
The Maid and the Mouse and the
Odd-Shaped House
Adaptor:
Paul O. Zelinsky
Editor:
Donna Brooks
Art Directors:
Donna Brooks, Paul O. Zelinsky
Designer:
Paul O. Zelinsky
Illustrator:
Paul O. Zelinsky
Publisher:
Dodd, Mead & Co.
New York, NY
Typographer:
Set-Rite Typographers, Inc.
Printer:
Einson Freeman Graphics
Production Manager:
Marion Hess
Paper:
Paloma Matte 80 #
Binder:
Economy Bookbinding Co.
Jacket Designer:
Paul O. Zelinsky
Jacket Illustrator:
Paul O. Zelinsky

Book Title:
Ginn Reading Program: One Potato, Two

Authors:
Theodore Clymer, Richard L. Venezky

Consultants:
Various

Editors:
Tina Miller, Rita Campanella

Art Directors:
Peter Bradford, Gary Fujiwara

Designers:
Peter Bradford, Gary Fujiwara, Linda Post

Illustrator:
Maxie Chambliss

Photographer:
Michael Pateman

Publisher:
Ginn and Co., Lexington, MA

Typographer:
Dayton Typographic Service, Inc.

Printer:
George Banta Co., Inc.

Production Managers:
Patricia Maka, Lorraine B. Peabody

Paper:
Baycoat Velvet 50 #

Binder:
George Banta Co., Inc.

Jacket Designer:
Peter Bradford

Jacket Illustrator:
Peter Bradford

MEALTIME

Book Title:
Words: A Book About the Origin of Everyday Words and Phrases
Author:
Jane Sarnoff
Editor:
Lee Deadrick
Art Director:
Reynold Ruffins
Designer:
Reynold Ruffins
Illustrator:
Reynold Ruffins
Publisher:
Charles Scribner's Sons
New York, NY
Typographer:
Cardinal Type Services, Inc.
Printer:
Halliday Lithograph Corp.
Production Manager:
Marion Glick
Paper:
Alpine Vellum 70 #
Binder:
Halliday Lithograph Corp.
Jacket Designer:
Reynold Ruffins
Jacket Illustrator:
Reynold Ruffins

Belly, Stomach, and Throat

Belly is one of the oldest English words. It started in Old English as *belig*, meaning 'skin bag'. *Belig* was used for a type of skin bag used to carry or store such foods as beans and peas, and for the part of our body now usually called stomach. *Stomach* came from a Greek word meaning 'mouth' or 'opening'. In Old English it was usually used for one of our body openings, the part we now call our throat. Now and then *stomach* was used to mean the belly as well as the throat. In those days the word *throat*, which came from an Old German word meaning 'to push out', meant only the front part of a man's neck where his Adam's apple pushed out. (For Adam's apple, read your Bible.)

In the 1850s the English thought that *belly* was just a little too natural a word, so they used *stomach* instead as a euphemism (see White Meat and Dark Meat, page 44). *Stomach*, since it meant opening, didn't make as much sense as *belly*, but the English thought it sounded much more polite.

42 43

Mystery means something hidden, not explained, not fully understood or clearly seen. The English *mystery* came from the Greek word *mysterion*, which came from an earlier Greek word meaning 'to have closed eyes and lips'. When *mysterie* entered English in the 1300s, it had the Greek meaning of a religious truth that is held by faith, but not really understood. Later the word came to mean anything that was not understood.

Clue

A *clue* is a fact or an object that leads to the solution of a mystery. But when *clue*—spelled *clew*[*] until the 1400s—was first used in English, it meant a 'ball of thread'. *Clue* came to English from the Old Dutch *kluwen*, but may be traced back to a Greek word. The Greek word was used for the thread that helped to guide people through the giant maze on the island of Crete. When a clue was found, it was the end of the thread that led out of the maze. So then, as now, a clue was something that helped solve a mystery.

[*] Many words that ended in "ew" in Old and Middle English were changed to end in "ue" when French ways of speaking and spelling increased: *clew* to *clue; blew* to *blue; trew* to *true; hew* (as in color) to *hue; dew* to *due.*

57

Book Title:
My Mom Travels a Lot
Author:
Caroline Feller Bauer
Editor:
Meredith Charpentier
Art Directors:
Meredith Charpentier, Roni
Rosenzweig
Designer:
Kathleen Westray
Illustrator:
Nancy Winslow Parker
Publisher:
Frederick Warne & Co., Inc.
New York, NY
Typographer:
Cyber-Graphics, Inc.
Printer:
Rae Publishing Co., Inc.
Production Manager:
Roni Rosenzweig
Paper:
White Patina Matte 80 #
Binder:
A. Horowitz & Sons
Jacket Designer:
Kathleen Westray
Jacket Illustrator:
Nancy Winslow Parker

Book Title:
The Flying Grandmother
Author:
Naomi Kojima
Editor:
Barbara Fenton
Art Director:
Ellen Weiss
Designers:
Naomi Kojima, Ellen Weiss
Illustrator:
Naomi Kojima
Publisher:
Thomas Y. Crowell, Inc.
New York, NY
Typographer:
Cardinal Type Services, Inc.
Printer:
The Book Press
Production Manager:
Herman Reiss
Paper:
Willco Opaque Smooth Offset
Binder:
The Book Press
Jacket Designer:
Ellen Weiss
Jacket Illustrator:
Naomi Kojima

Book Title:
Jumanji
Author:
Chris Van Allsburg
Editor:
Walter Lorraine
Art Directors:
Walter Lorraine, Carol
Goldenberg
Designer:
Carol Goldenberg
Illustrator:
Chris Van Allsburg
Publisher:
Houghton Mifflin Co.
Boston, MA
Typographer:
Roy McCoy
Printer:
Thomas Todd Co.
Production Manager:
Janice Pecoraro
Paper:
Mohawk Eggshell 80 #
Binder:
A. Horowitz & Sons
Jacket Designer:
Carol Goldenberg
Jacket Illustrator:
Chris Van Allsburg

"Now remember," Mother said, "your father and I are bringing some guests by after the opera, so please keep the house neat."

"Quite so," added Father, tucking his scarf inside his coat.

Mother peered into the hall mirror and carefully pinned her hat in place, then knelt and kissed both children good-bye.

When the front door closed, Judy and Peter giggled with delight. They took all the toys out of their toy chest and made a terrible mess. But their laughter slowly turned to silence till finally Peter slouched into a chair.

"You know what?" he said. "I'm really bored."

"Me too," sighed Judy. "Why don't we go outside and play?"

Peter stood next to the card table. "Can't we just call the zoo and have him taken away?" From upstairs came the sounds of growling and clawing at the bedroom door. "Or maybe we could wait till Father comes home."

"No one would come from the zoo because they wouldn't believe us," said Judy. "And you know how upset Mother would be if there was a lion in the bedroom. We started this game, and now we have to finish it."

Peter looked down at the game board. What if Judy rolled a seven? Then there'd be two lions. For an instant Peter thought he was going to cry. Then he sat firmly in his chair and said, "Let's play."

Judy picked up the dice, rolled an eight, and moved her piece. "'Monkeys steal food, miss one turn,'" she read. From the kitchen came the sounds of banging pots and falling jars. The children ran in to see a dozen monkeys tearing the room apart.

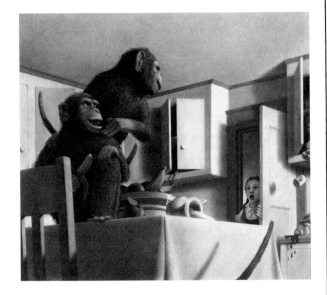

It was hard for Treehorn to find the right table because everyone was reading menus. He walked around with his flashlight until he heard Aunt Bertha's voice.

"I have to have the claim check or I can't get your glasses," said Treehorn.

"That's using your head, Treehorn," said Aunt Bertha. "I like a boy who uses his head." She reached in her purse and handed him the claim check.

"Isn't this a lovely dinner, Treehorn?" asked his mother.

Treehorn started back to the checkroom.

Book Title:
Treehorn's Treasure
Author:
Florence Parry Heide
Editor:
John Briggs
Art Director:
David Rogers
Designers:
Edward Gorey, David Rogers
Illustrator and Letterer:
Edward Gorey
Publisher:
Holiday House, Inc.
New York, NY
Typographer:
American-Stratford Graphic
Services, Inc.
Printer:
The Murray Printing Co.
Production Manager:
David Rogers
Paper:
Willco Vellum Opaque 70 #
Binder:
A. Horowitz & Sons
Jacket Designer:
Edward Gorey
Jacket Illustrator and Letterer:
Edward Gorey

Aunt Bertha said goodbye when they got back to the house. "Not many boys your age are lucky enough to have dinner in a restaurant like that, Treehorn. Your little friends will be green with envy when they hear about it."

After she had left, Treehorn started outside with his flashlight. It wasn't as dark as it had been at the restaurant, but it was pretty dark.

"Where are you going, Treehorn?" asked his mother.

"I'm just going out to see if all the leaves on the tree have finished changing into dollar bills," said Treehorn. "They weren't quite done enough before."

"You know your father doesn't like you to go outside after dark, Treehorn," said his mother. "You'll have to wait until tomorrow morning."

Book Title:
Edith Sitwell

Author:
Victoria Glendinning

Editor:
Judith B. Jones

Art Director:
Betty Anderson

Designer:
Betty Anderson

Photographers:
Various

Publisher:
Alfred A. Knopf, Inc.
New York, NY

Typographers:
Superior Printing, Haber
Typographers

Printer:
The Haddon Craftsmen, Inc.

Production Manager:
William Luckey

Paper:
S.D. Warren Antique Cream
50 #;

Binder:
The Haddon Craftsmen, Inc.

Jacket Designer:
Sara Eisenman

Jacket Artist:
Wyndham Lewis

Edith, aged eleven, with Osbert, baby Sacheverell,
and their nurse, Davis.

Design for *Wheels* by Severini, 1920.

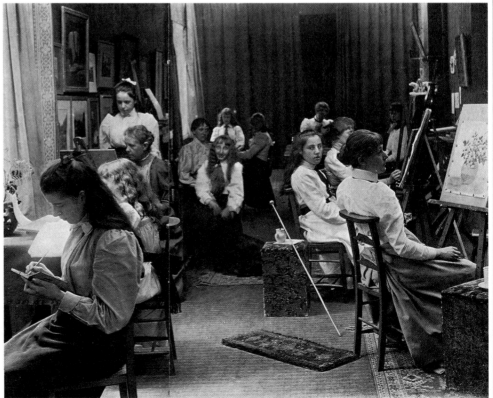

Edith (center, with dog) at her art class in Scarborough.

Er rosario in famijja

Avemmaria . . . lavora . . . grazia prena . . .
Nena, vòi lavorà? . . . *ddominu steco . . .*
Uf! . . . *benedetta tu mujjeri . . .* Nena! . . .
E bbenedetto er frú . . . vva cche tte sceco? . . .

Fruttu sventr'e ttu Jeso. San . . . che ppena! . . .
ta Maria madre Ddei . . . me sce fai l'eco? . . .
Ora pre nobbi . . . ma tt'aspetto a ccena . . .
Peccatori . . . Oh Ssiggnore! e sto sciufeco

De sciappotto laggiú ccome sce venne?
Andiamo: indove stavo? . . . Ah, ll'ho ttrovato:
Nunche tinora morti nostri ammenne.

Grolia padre . . . E mmó? ddiavola! bbraghiera!
Ho ccapito: er rosario è tterminato:
Finiremo de dillo un'antra sera.

Roma, 7 dicembre 1832

26

The Family Rosary

Hail Mary—the work—*full of grace*—
You're not doing the work—*the Lord is with thee*—
Blessed among women—this place—
and blessed the fru—Pay attention to me.—

Fruit of thy womb, Jesus—I won't allow—
Mary Mother of God—But you're the one—
You know I waited dinner—*Pray for us now*—
Sinners—Dear Lord, tell me what I've done

to land in such a fucking mess. Oh, well—
let's get on. Where was I? Wait—all right—
Now and at the hour of our death, amen.

Glory be to the father—Dammit to hell,
I understand, enough. We can just end
this rosary for now. Some other night.

Rome, December 7, 1832

27

Book Title:
Sonnets of Giuseppe Belli
Translator:
Miller Williams
Editor:
Margaret Dalrymple
Art Director:
Albert Crochet
Designer:
Albert Crochet
Publisher:
Louisiana State University Press
Baton Rouge, LA
Typographer:
G. & S. Typesetters, Inc.
Printer:
Thomson-Shore, Inc.
Production Manager:
Joanna V. Hill
Paper:
Warren's Olde Style 60 #
Binder:
John H. Dekker & Sons, Inc.
Jacket Designer:
Albert Crochet

THE AMERICANS, of all nations at any time upon the earth
Have probably the fullest poetical nature. The United States themselves
Are essentially the greatest poem. In the history of the earth hitherto
The largest and most stirring appear tame and orderly
To their ampler largeness and stir.

Here at last is something in the doings of man
That corresponds with the broadcast doings of the day and night.
Here is not merely a nation but a teeming nation of nations.
Here is action untied from strings necessarily blind to particulars and details,
Magnificently moving in vast masses.

Here is the hospitality which forever indicates heroes.
Here are the roughs and beards and space and ruggedness and nonchalance
 that the soul loves.
Here the performance disdaining the trivial—unapproached in the tremendous
Audacity of its crowds and groupings and the push
Of its perspective—spreads with crampless
And flowing breadth, and showers its prolific and splendid extravagance.

One sees it must indeed own the riches of the summer and winter,
And need never be bankrupt while corn grows from the ground,
Or the orchards drop apples, or the bays contain fish,
Or men beget children upon women.

9

Book Title:
American Bard
Author:
Walt Whitman
Foreword:
James D. Hart
Editor:
William Strachan
Art Director:
Beth Tondreau
Designer:
William Everson, Adapted by
Ann Gold
Illustrator:
William Everson
Publisher:
The Viking Press, New York, NY
Typographers:
The Lime Kiln Press, The Press
of A. Colish
Printer:
Rae Publishing Co., Inc.
Production Manager:
Anne Bass
Paper:
Mohawk Vellum 80 #
Binder:
American Book-Stratford Press,
Inc.
Jacket Designer:
George W. Sanders, Jr.
Jacket Illustrator:
William Everson

The Doctor could but cry, "Well, I'll be blessed!"
And with a smile he quickly acquiesced.

And that is why those owls have grown so wise
Up in their towering Brownstone Paradise;
They live and die and raise their fluffy broods
Immune from usual vicissitudes;
Envied by all the other birds of prey,
They read all night and sleep throughout the day,
And quite emboldened by their self-reliance
Nest in the very periwig of science.

(24)

SLEEP TIGHT

Get over that fence, you old ewe, you!
Get over that fence, you old ram . . .
 For I want to sleep,
 You old sheep,
I want to sleep like a lamb.

1 2 3 4 5 6 7
Step lively and get this thing over!
 Believe me, I *have* to sleep,
 You old sheep,
So quit stopping to nibble the clover.

Down there by the path, get a move on!
26 27 . . . 28
 Please, sheep,
 I need sleep . . .
And watch out! You're breaking the gate!

51 52 53
Without doubt you're the slowest and clumsiest
 ovine quadrupeds I've ever seen in all my life,
 And now with the noise of your feet 'n'
 That endless bleatin'
You have woken my wife.

No, I didn't say anything, dearest.
What did you think I said?
 I just can't sleep
 With these damn sheep
Climbing all over the bed.

(25)

CHAPTER **I** LOOMINGS

CALL ME ISHMAEL.
Some years ago—never mind how long precisely—having little or no money in my purse, and nothing particular to interest me on shore, I thought I would sail about a little and see the watery part of the world. It is a way I have of driving off the spleen, and regulating the circulation. Whenever I find myself growing grim about the mouth; whenever it is a damp, drizzly November in my soul; whenever I find myself involuntarily pausing before coffin warehouses, and bringing up the rear of every funeral I meet; and especially whenever my hypos get such an upper hand of me, that it requires a strong moral principle to prevent me from deliberately stepping into the street, and methodically knocking people's hats off—then, I account it high time to get to sea as soon as I can. This is my substitute for pistol and ball. With a philosophical flourish Cato throws himself upon his sword; I quietly take to the ship. There is nothing surprising in this. If they but knew it, almost all men in their degree, some time or other, cherish very nearly the same feelings towards the ocean with me.

2

There now is your insular city of the Manhattoes, belted round by wharves as Indian isles by coral reefs—commerce surrounds it with her surf. Right and left, the streets take you waterward. Its extreme down-town is the Battery, where that noble mole is washed by waves, and cooled by breezes, which a few hours previous were out of sight of land. Look at the crowds of water-gazers there.

Circumambulate the city of a dreamy Sabbath afternoon. Go from Corlears Hook to Coenties Slip, and from thence, by Whitehall, northward. What do you see?—Posted like silent sentinels all around the town, stand thousands upon thousands of mortal men fixed in ocean reveries. Some leaning against the spiles; some seated upon the pier-heads; some looking over the bulwarks of ships from China; some high aloft in the rigging, as if striving to get a still better seaward peep. But these are all landsmen; of week days pent up in lath and plaster—tied to counters, nailed to benches, clinched to desks. How then is this? Are the green fields gone? What do they here?

But look! here come more crowds, pacing straight for the water, and seemingly bound for a dive. Strange! Nothing will content them but the extremest limit of the land; loitering under the shady lee of yonder warehouses will not suffice. No. They must get just as nigh the water as they possibly can without falling in. And there they stand—miles of them—leagues. Inlanders all, they come from lanes and alleys, streets and avenues—north, east, south, and west. Yet here they all unite. Tell me, does the magnetic virtue of the needles of the compasses of all those ships attract them thither?

Once more. Say, you are in the country; in some high land of lakes. Take almost any path you please, and ten to one it carries you down in a dale, and leaves you there by a pool in the stream. There is magic in it. Let the most absent-minded of men be plunged in his deepest reveries—stand that man on his legs, set his feet a-going, and he will infallibly lead you to water, if water there be in all that region. Should you ever be athirst in the great American desert, try this experiment, if your caravan happen to be supplied with a metaphysical professor. Yes, as every one knows, meditation and water are wedded for ever.

3

THE CHILL

Mother and Father have fulfilled their promise:
 the overture, the rise of the curtain, the imagined pomp
of magic and artifice, all
glows, as if music
were made of candle flames, all
flows, as if dancers
were golden oil of music,
the theater's marvelous smell is also
the prickle of crimson velvet on bare skin—but
 at the marrow of all this joy, the child
 is swept by a sudden
 chill of patience: notices wearily
 the abyss that Time
 opens before it.
 Careful, careful—
no one must share
 this knowledge.
The child tenderly, tense with protective love,
guards their innocent happiness,
 kind Father,
 kind Mother.
 Quickly! Back to the long-desired,
the even-better-than-hoped-for treat.
 Has one **not run**
 more than once
back from a strip of woods to open sunlight,
hastily laughing, uttering
not a word about
 white
 bones
 strewn in ivy,
 and old feathers, ragged?

POET AND PERSON

I send my messages ahead of me.
You read them, they speak to you
in siren tongues, ears of flame
spring from your heads to take them.

When I arrive, you love me,
for I sing those messages you've
learned by heart, and bring,
as housegifts, new ones. You hear

yourselves in them,
self after self. Your solitudes
utter their runes, your own
voices begin to rise in your throats.

But soon you love me less.
I brought with me
too much, too many laden coffers,
the panoply of residence,

improper to a visit.
Silks and furs, my enormous wings,
my crutches, and my spare crutches,
my desire to please, and worse—

my desire to judge what is right.

I take up
so much space.
You are living on what you can find,

Book Title:
Wanderer's Daysong
Author:
Denise Levertov
Editor:
Sam Hamill
Art Director:
Tree Swenson
Designer:
Tree Swenson
Illustrator:
Tree Swenson
Publisher:
Copper Canyon Press
Port Townsend, WA
Typographer:
Tree Swenson
Printer:
Tree Swenson
Paper:
Frankfurt
Binder:
Marsha Hollingsworth

Notes Towards a Poem That Can Never Be Written

For Carolyn Forché

i

This is the place
you would rather not know about,
this is the place that will inhabit you,
this is the place you cannot imagine,
this is the place that will finally defeat you

where the word *why* shrivels and empties
itself. This is famine.

ii

There is no poem you can write
about it, the sandpits
where so many were buried
& unearthed, the unendurable
pain still traced on their skins.

This did not happen last year
or forty years ago but last week.
This has been happening,
this happens.

We make wreaths of adjectives for them,
we count them like beads,
we turn them into statistics & litanies
and into poems like this one.

Nothing works.
They remain what they are.

26 27

A Conversation

The man walks on the southern beach
with sunglasses and a casual shirt
and two beautiful women.
He's a maker of machines
for pulling out toenails,
sending electric shocks
through brains or genitals.
He doesn't test or witness,
he only sells. My dear lady,
he says, You don't know
those people. There's nothing
else they understand. What could I do?
she said. Why was he at that party?

Flying Inside Your Own Body

Your lungs fill & spread themselves,
wings of pink blood, and your bones
empty themselves and become hollow.
When you breathe in you'll lift like a balloon
and your heart is light too & huge,
beating with pure joy, pure helium.
The sun's white winds blow through you,
there's nothing above you,
you see the earth now as an oval jewel,
radiant & seablue with love.

It's only in dreams you can do this.
Waking, your heart is a shaken fist,
a fine dust clogs the air you breathe in;
the sun's a hot copper weight pressing straight
down on the thick pink rind of your skull.
It's always the moment just before gunshot.
You try & try to rise but you cannot.

6 7

Book Title:
Notes Towards a Poem That
Can Never Be Written
Author:
Margaret Atwood
Designer:
Glenn Goluska
Publisher:
Salamander Press
Typographer:
Glenn Goluska, The Nightshade
Press, Toronto, CAN
Printer:
Glenn Goluska, The Nightshade
Press
Paper:
Rolland Tints, Curtis Linen
Cover
Binder:
Anne Goluska, The Nightshade
Press

Book Title:
Kill Jim
Author:
Don Cushman
Designer:
Mary Ann Hayden
Illustrator:
Mary Ann Hayden
Publishers:
Sombre Reptiles Press
Berkeley, CA
Mary Ann Hayden, Jerry Ratch
Typographer:
McKenzie-Harris Corp., Mary
Ann Hayden
Printer:
Mary Ann Hayden
Papers:
Mohawk Superfine, Fabriano
Roma
Binder:
The Schuberth Bookbindery
Handmade paper tip-ins:
Kensington Paper Mill

THREE

Where did it all go wrong? There ought to
be a law against Henry. /
Mr Bones: there is. / John Berryman

Book Title:
Country Cloth to Coverlets
Author:
Sandra Rambo Walker
Editor:
Jeannette Lasansky
Art Director:
Constance Timm
Designer:
Constance Timm
Photographer:
Terry Wild
Publisher:
Oral Traditions Project, Union
City, Historical Society
Lewisburg, PA
Typographers:
Centennial Graphics,
Paulhamus Litho., Inc.
Printer:
Paulhamus Litho., Inc.
Paper:
LOE Dull 80 #
Jacket Designer:
Constance Timm

Montour County

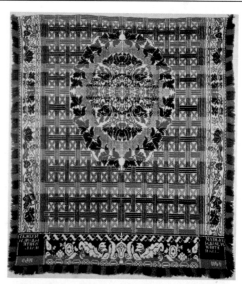

Montour, the smallest of the eight counties surveyed, produced one hundred professional weavers, eleven fullers, and two cloth dyers during the nineteenth century. John Frazier, in *A History of Danville* (1881), commented on two Danville weavers from the first quarter of the nineteenth century; "... Christopher Smith and Peter Goodman. The latter was a most respectable and industrious German from the Fatherland."

When Peter Goodman first moved to Danville in 1815, the community had a population of 740, including thirty-five other weavers. He and his wife, Christiana, came to the area from Reading in Berks County and purchased two lots in Danville from Hugh Flack. The property, purchased from Hugh Flack, was priced at $1,000. It is likely that it was here that Peter opened his weaving business, perhaps with the help of several of his fourteen children. Peter continued to weave until his death in 1829 at the age of seventy-eight.

Daniel, a son of Peter and Christiana, continued the weaving business he had shared with his father since 1823. His own shop was on Market Street adjacent to William Kitchen until 1835. Another neighbor of Daniel was Charles Frazier, a reedmaker. Nancy Simpson Goodman, Daniel's wife, was a granddaughter of

John Sechler, a fuller, and one of Danville's early settlers. Perhaps the opening of the canal through Danville changed the needs of Daniel's clients, or perhaps he and Nancy simply wanted to move to the country. For whatever reasons, they moved, first to Catawissa Township in 1838, then to Luzerne County near Nescopeck where, by 1841, Daniel was weaving jacquard coverlets. His name, his client's name, the date, and the location at which these coverlets were woven appear in the signature panel.

Two sons of Daniel and Nancy Goodman, John S. and Peter, followed their father's occupation. John S. Goodman and his wife, Sarah Ann, lived in Sugarloaf Township, Luzerne County. Several jacquard coverlets bearing his signature were identified in this study; he was weaving in Black Creek Township, Luzerne County, in 1850. Peter lived with his parents and by 1852, at the age of fourteen, was signing his own jacquard coverlets.

Not only were there these three generations of Goodman weavers spanning the period from 1808 to the 1850's and the miles from Danville to Nescopeck, there were other Goodmans involved in textile production in central Pennsylvania. Philip Goodman was a reedmaker and the owner of the Golden Globe Tavern which was located two doors south of the courthouse in Danville. The borough of Milton in neighboring Northumberland County had two Goodman weavers: Richard, who wove at a shop on Lower Market Street from 1820 to 1848, and Frederick, who worked from 1837 to 1843. In addition, William Goodman and George Goodman were weaving in Lower Mahanoy Township, Northumberland County in the first quarter of the nineteenth century. In what way these latter four Goodman weavers are related to the Danville/Nescopeck Goodmans is not certain, although family genealogies suggest that George was Peter Goodman's (1751-1829) son. There are no fabrics or coverlets which can be attributed to them.

While Peter and Daniel Goodman were plying their trade on Market Street, other aspects of the textile industry were occupying the time of some early Danville families. John Montgomery's mill, built in Danville in 1825, included a woolen factory at one end of the building. William Montgomery also built a woolen factory in town at the rear of the Daniel

A Montour County jacquard coverlet by John Gramlyg exhibits characteristics of coverlets woven in the Lehigh County area where Gramlyg had previously lived. The orientation of the signature panel in the lower right rather than the lower left corner was unique to Gramlyg in this area. Red and blue wool weft and white cotton warp. 76" x 74", one piece, applied fringe three sides. Collection of JoAnn G. Weibel.

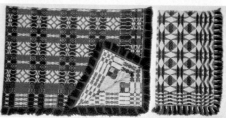

Attributed to a weaver in the Goodman family, these coverlets were expertly woven on a multi-harness loom and are of a wool pattern weft on a cotton ground. The coverlet on the left is an unusual combination weave of Germanic expanded twill work and float work similar to overshot. That on the right is a Germanic expanded twill work coverlet in a Star and Diamond motif. Left to right: 103" x 78", two pieces seamed, applied fringe; and 89" x 78", two pieces seamed, applied fringe. Collection of Mary H. Slusser.

20

Book Title:
Skystones / Las Piedras del Cielo
Author:
Pablo Neruda
Translator:
Ben Belitt
Art Director:
Debra Weier
Designers:
Debra Weier, Bill Bridgers
Illustrator:
Debra Weier
Publisher:
Emanon Press
Easthampton, MA
Typographers:
Debra Weier, Bill Bridgers
Printers:
Debra Weier, Bill Bridgers
Production Manager:
Debra Weier
Paper:
ArchesCovers, Rives BFK,
Canson Mi-Teintes
Binder:
Gray Parrot
Jacket Designer:
Debra Weier
Jacket Illustrator:
Debra Weier

Book Title:
A Happy Book of Happy Stories
Author:
William J. Lederer
Editor:
Eric Swenson
Art Director:
Antonina Krass
Designer:
Antonina Krass
Publisher:
W.W. Norton & Co., Inc.
New York, NY
Typographer:
Vail-Ballou Press, Inc.
Printer:
Vail-Ballou Press, Inc.
Production Manager:
Andrew Marasia
Paper:
S.D. Warren Old Style Wove
60 #
Binder:
Vail-Ballou Press, Inc.
Jacket Designer:
Antonina Krass
Jacket Illustrator:
Antonina Krass

characters are old people, some are children, some are middle-aged, and some are animals. Every story concerns someone who has discovered the joy of being alive, which, of course, is what Christmas is all about. This is a book for children, for young adults, for old people, middle-aged people, and for animals.

It is called, *A Happy Book of Happy Stories*.

There simply is no other title so appropriate.

[10]

IS THERE
A SANTA
CLAUS?

I was the executive officer of the Navy destroyer in which the events of this story took place. It was in the early months of World War II. The rapidly expanding U.S. Navy desperately was seeking trained personnel to man the hundreds of new ships which were being built. The Navy took whoever was available—even the inmates of naval prisons.

There are five major characters in the story. One was our commanding officer—a very shy man who has requested that his real name not be used. The other four have no objections to being identified, and their real names are used.

Also, the names of the motion picture stars are real. They were stars forty years ago. Some of the young people reading this book might not be familiar with these stars. But, take my word for it, they were glamorous, beautiful, and, at that time, among the most famous people in the world.

I did not write this story. One of the men in our ship wrote it shortly after our ship was torpedoed and sunk on the way back from Anzio. He sent it to me and asked me to edit it, which I have done. His reason for writing the story was to send it to all surviving members of our ship as a small Christmas present.

After editing it, and revising it somewhat, I returned his manuscript. It appears in this book in the author's final revision—the way it was when he sent it to me on the following Christmas.

A CHRISTMAS BALLAD FOR THE CAPTAIN

Captain Elias Stark, commanding officer of our destroyer, was a square-shouldered New Hampshire-man, as quiet and austere as the granite mountains of his native state. About the only time the enlisted men heard him talk was when they reported aboard for the first time. He would invite them to his cabin for a one-minute speech of welcome, then question them about their families, and note, with pen and ink, the names and addresses of the sailors' next of kin.

That was the way he had first met the "Unholy K's"—Krakow, Kratch, Koenig, and Kelly. They had arrived with a draft of seventeen men from the naval prison at Portsmouth. Most of the prison group were bad eggs, but the worst were these four sailors from a small coal mining town in Pennsylvania. They had chests and shoulders like buffaloes, fists like sledgehammers, black stubble beards, and manners to match.

They had once been good kids, the mainstays of St. Stephen's

[17]

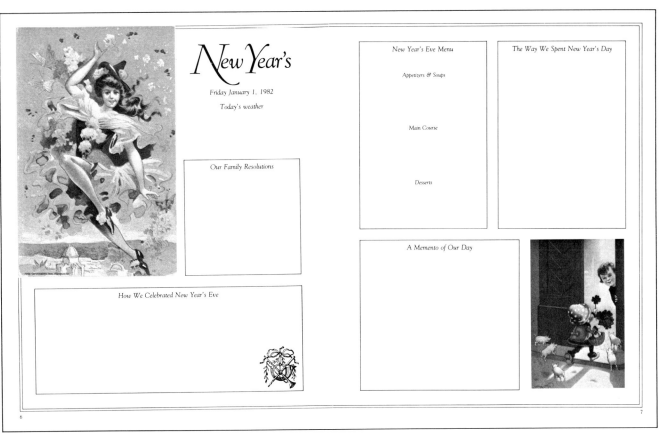

New Year's

Friday January 1, 1982

Today's weather

Our Family Resolutions

How We Celebrated New Year's Eve

New Year's Eve Menu

Appetizers & Soups

Main Course

Desserts

The Way We Spent New Year's Day

A Memento of Our Day

6

7

Book Title:
Our Old Fashioned Country
Diary for 1982
Author:
Linda Campbell Franklin
Editor:
Linda Campbell Franklin
Art Director:
Ronald Gross
Designer:
Sara Bowman
Illustrators:
Various
Publisher:
Tree Communications, Inc.
New York, NY
Typographer:
David E. Seham Associates, Inc.
Printer:
R.R. Donnelley & Sons Co.
Production Manager:
Paul Levin
Paper:
S.D. Warren Old Style 70 #
Binder:
R.R. Donnelley & Sons Co.
Jacket Designer:
Sara Bowman

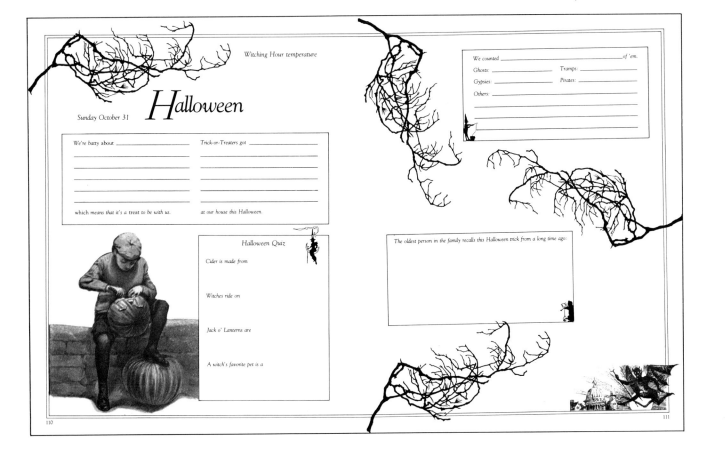

Witching Hour temperature

Halloween

Sunday October 31

We're batty about _____

which means that it's a treat to be with us.

Trick-or-Treaters got _____

at our house this Halloween.

Halloween Quiz

Cider is made from

Witches ride on

Jack o' Lanterns are

A witch's favorite pet is a

We counted _____ *of 'em.*

Ghosts: _____ *Tramps:* _____

Gypsies: _____ *Pirates:* _____

Others: _____

The oldest person in the family recalls this Halloween trick from a long time ago:

110

111

Graphic Explanations:
Charts, Diagrams, Graphs, and Maps

The graphic explainers have as unique an
opportunity today as did the ancient mapmakers:
to help us get from here to there, and to reassure
us that someone, somewhere, understands and
can explain the essential significance of the
information overload.

Chairman
Nigel Holmes
Deputy Art Director
Time Magazine

Jury
Peter Cook
Art Director
Academic American Encyclopedia

Robert Demarest
Director of Medical Illustration
College of Physicians and Surgeons
Columbia University

Jim Dye
Computer Illustrator
Jim Dye International

Samuel Howard
Art Director
Scientific American

Wolf Lieschke
Executive Creative Director
Brouillard Communications
Division of J. Walter Thompson

Robert Lockwood
Editor
News Graphics

Marshall Loeb
Managing Editor
Money Magazine

Charts, diagrams, graphs, and maps are designed to aid the reader's comprehension of complicated, scientific, esoteric, and sometimes just plain boring information. They combine words, numbers, and illustrative devices to make sense out of a body of information.

More than 600 such graphic explanations were submitted to the Institute's competition. They had been published over the last four years in a wide variety of print media: magazines, newspapers, books, annual reports, corporate communications, and advertising. From over 600 entries, 75 were chosen for inclusion in *AIGA Graphic Design USA: 3*. The criteria were straightforward. As much weight was given to effectiveness (does it transmit information clearly?) as to aesthetics. The pieces selected fell into a few predictable categories: finance, business and economics, science, maps, architecture, industrial processes. One category, however, reflected a new direction: graphic explanations of current events.

Particular categories of graphic explanations were notably lacking from those submitted, including those created specifically for children, medical illustrations, graphic depictions of how things work, and "how to" (build, fix, repair).

Those graphic explanations which were most successful succeeded for two reasons: they conveyed specific information clearly by integrating words, numbers, and illustrations into a unified communicative whole, or they clearly suggested a particular point of view in addition to the information presented. Barred from the final selection as "irrelevant" were a vast array of graphic attempts to decorate publications with overdesigned charts and graphs, where the effort seemed to have gone into prettifying rather than clarifying. Some charts and diagrams, in addition to making abstruse information visible, also injected an editorial point of view, extending in a few instances to attempts at humor. This was seen as a positive direction when handled well—making difficult, important concepts more inviting and accessible to the lay reader—as long as humor didn't make an important concept trivial and divert attention from the facts being explained.

The jury observed that the entries as a whole and the selections reproduced here looked dated and more reminiscent of school texts than prescient of tomorrow's communication needs and the new techniques required for meeting them. Here, after all, is a discipline that combines all of the designer's skills—conceptual thinking, organizational ability, access to the full range of communication symbols and techniques—in the fundamental service of making meaning visible and comprehension enjoyable. Moreover, graphic explanation is primarily a print media phenomenon and right at the leading edge of print's struggle to compete with television-screen-based information delivery systems. Information now hurtles at us and mounts upward. More and more of it is statistical, technical, or scientific—the language of the computer. The graphic explainers have as unique an opportunity today as did the ancient mapmakers: to help us get from here to there, and to reassure us that someone, somewhere, understands and can explain the essential significance of the information being conveyed.

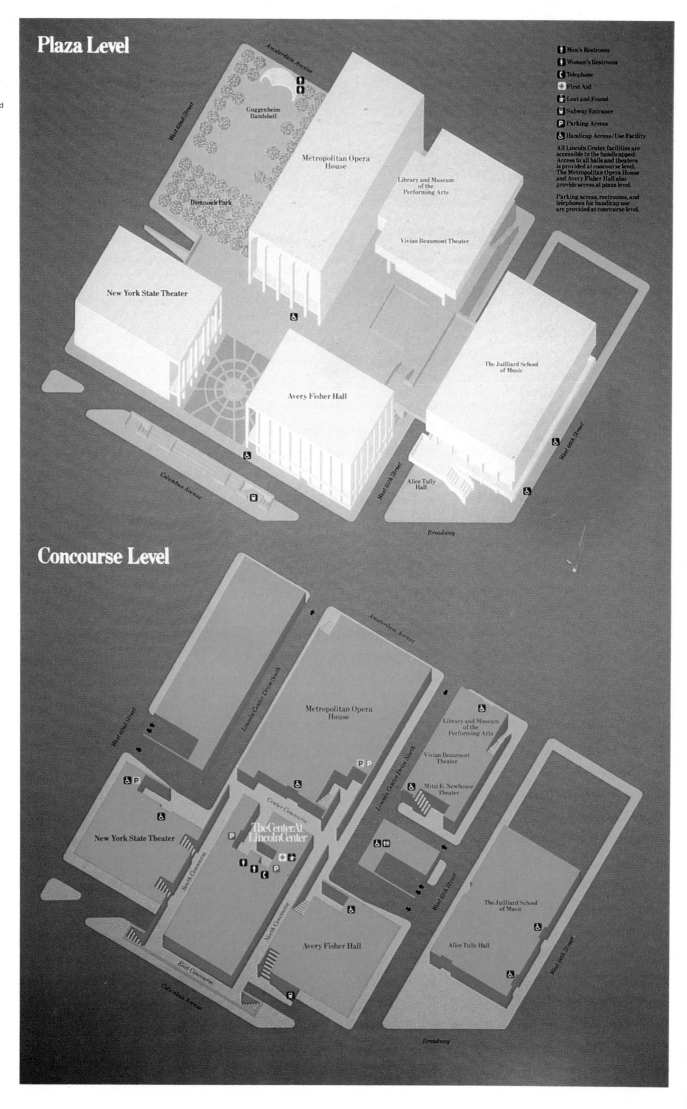

Title:
Lincoln Center Map 1981
Publisher:
Lincoln Center for the
Performing Arts
Art Directors:
Roger Whitehouse, Peter Katz,
Joel Katz
Artists:
Bruce Campbell, Jerome Cloud
Colorist:
Llynne Buschman
Design Firm:
Whitehouse & Katz, Inc.
New York, NY

Plaza Level

Guggenheim
Bandshell

Metropolitan Opera
House

Library and Museum
of the
Performing Arts

Damrosch Park

Vivian Beaumont Theater

New York State Theater

The Juilliard School
of Music

Avery Fisher Hall

Alice Tully
Hall

West End Street

Amsterdam Avenue

Columbus Avenue

West 65th Street

West 62nd Street

West 66th Street

Broadway

Men's Restroom
Women's Restrooms
Telephone
First Aid
Lost and Found
Subway Entrance
Parking Access
Handicap Access/Use Facility

All Lincoln Center facilities are
accessible to the handicapped.
Access to all halls and theaters
is provided at concourse level.
The Metropolitan Opera House
and Avery Fisher Hall also
provide access at plaza level.

Parking access, restrooms, and
telephones for handicap use
are provided at concourse level.

Concourse Level

Metropolitan Opera
House

Library and Museum
of the
Performing Arts

Vivian Beaumont
Theater

Mitzi E. Newhouse
Theater

New York State Theater

The Center At
Lincoln Center

Center Concourse

South Concourse

North Concourse

East Concourse

Avery Fisher Hall

The Juilliard School
of Music

Alice Tully Hall

Lincoln Center Drive South

Lincoln Center Drive North

Amsterdam Avenue

West End Street

Columbus Avenue

West 65th Street

West 66th Street

Broadway

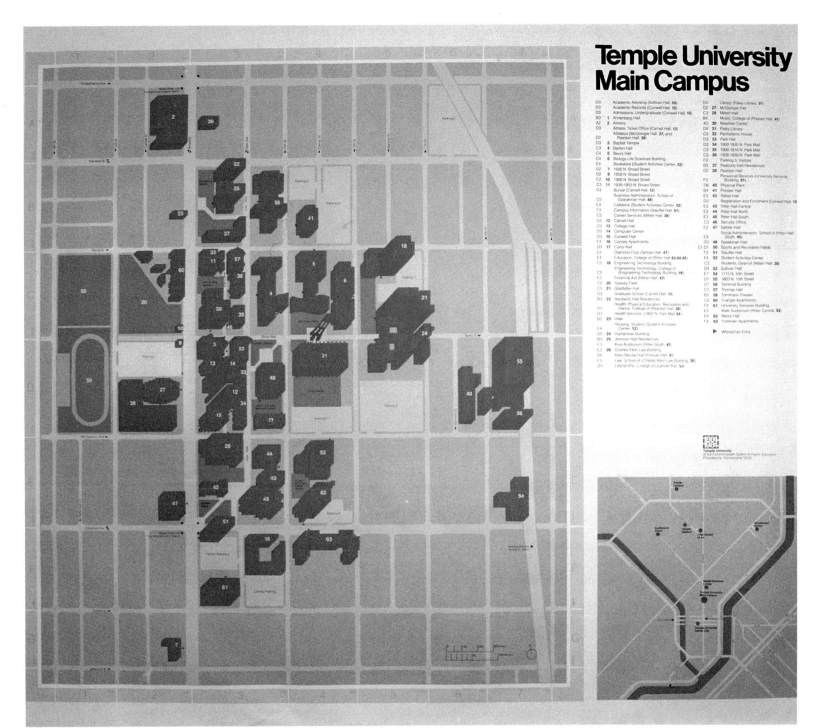

Temple University
Main Campus

Title:
Temple University Campus
Publication:
Temple University Map 1980
Art Directors:
Joel Katz, Jerome Cloud
Artist:
Jerome Cloud
Design Firm:
Katz Wheeler Design
Philadelphia, PA

Title:
Locations of Mills and
Headquarters
Publication:
Champion International
Packaging Division 1980
Brochure
Art Director:
Philip Gips
Designer:
Philip Gips
Artist:
Denys Gustafson
Photographer:
Tom Hollyman
Design Firm:
Gips + Balkind + Assoc., Inc.
New York, NY

Packaging Division Capabilities

The Frenchtown mill is one of four manufacturing facilities within the packaging division network. A national system that also includes 65 converting plants across the United States that manufacture corrugated containers, folding cartons, flexible packaging, grocery bags, retail bags, multiwall sacks and ovenable packaging.

Champion's domestic timberlands base of 3.4 million acres supports our national network of mills and converting plants. Because of this massive resource base and Champion's commitment to invest the enormous amounts of capital to grow, we are aggressively improving our brown paper packaging production capability for the future.

Expanding faster than the industry, we will be the leader in brown paper packaging, now . . . and in the future.

Location of Mills and Headquarters

 Headquarters

Mills

100.000 Acres

Corrugated Converting Plants

World Headquarters
One Champion Plaza
Stamford. Connecticut 06921

Ontonagon Mill
115 Lakeshore Road
P.O. Box 158
Ontonagon. Michigan 49953

St. Paul Mill
2250 Wabash Avenue
P.O. Box 43260
St. Paul, Minnesota 55514

Frenchtown Mill
Drawer D
Missoula. Montana 59806

Roanoke Rapids Mill
P.O. Box 580
Roanoke Rapids, North Carolina 27870

For more information contact:
Manager/Marketing Services
Packaging Division
Champion International Corporation
One Champion Plaza
Stamford. Connecticut 06921
(203) 358-7391

Title:
International Growth
Publication:
Ted Bates & Co. 1980
Art Director:
Nicholas Pappas
Designers:
Philip Gips, Diana Graham
Design Firm:
Gips + Balkind + Assoc., Inc.
New York, NY

Dermaspray Unit Sales—France

"Why should I prefer this product to all others?"

Dermaspray, an antiseptic analgesic product for treating cuts, scratches, first degree burns, and insect bites. The agency's head, Armand de Malherbe, reports:

"Facing the great and increasing mass of advertising, it becomes harder and harder for the consumer to perceive and understand any single advertising message. Basically, the consumer has only one question: 'Why should I prefer this product to all others?' This question has to be answered by advertising in a way that carries conviction. The USP method is a logical and disciplined process for achieving such an objective.

"In the matter of Dermaspray we wished to implant in consumer consciousness the benefit that Dermaspray 'disinfects and relieves pain any time easily and quickly.'

"We checked consumer reactions to radio and TV uses of this USP message. Our tests proved highly favorable. When we had obtained all necessary government clearances for sales through pharmacies, we launched our all-out campaign.

"The first year's objectives were rapidly exceeded. Year Two tripled penetration, doubled awareness, and improved 'intention to repurchase.' The brand, a success in France, is now ready to be rolled out to other European markets through Bates agencies."

Every overseas agency makes its own points in discussing the advantages of an international advertising organization. The German office in Frankfurt, Slesina-Bates, stresses the availability of "market information and guidance for our clients from 53 Bates agencies in 23 countries." It adds, "The Ted Bates advertising agencies throughout the world have one thing in common: they live with the USP concept, they believe in it and they work with it."

Greece, from one client to many in two years.

George Patterson Pty. Limited
Annual Billings 1976-1979
(in millions of dollars)

If he were still alive, Ted Bates (who died in 1972) would have been awed and delighted by the acceptance his philosophy has won throughout the world. He would certainly have been impressed by the growth it stimulated in agencies that joined the Bates organization.

For example, AC & R Hellas in Athens had one client in 1972: Seiko. Later, Colgate-Palmolive, Trident Sugarless Gum, and others took advantage of this new outlet for their advertising. Their sales quickly increased, and the agency became one of the leaders in Greece, with billings exceeding $3,000,000.

At the other end of the spectrum, one of Bates' largest overseas acquisitions was the George Patterson Advertising Agency in Australia. (This reflected a long personal friendship between Ted Bates himself and George Patterson.) The agency's 408 employees in Sydney, Brisbane, Melbourne and Adelaide were then serving 170 clients. Today, the country's population of 14,400,000 offers a considerable market for clients of all Bates agencies. So many have availed themselves of this outlet that Patterson's billings, rising above $110,000,000, showed a remarkable 100% growth in four years.

In the Far East, the Orikomi agency in Japan presented some unique problems. Or should they be called challenges? Writing on behalf of his agency, Yoshi Kawashima said:

"Japan has developed its own culture, customs, aesthetics. These are quite different from the countries of the West. Advertising in Japan requires a unique sales method combining scientific technologies and specific *artistic* approaches."

Lower Manhattan

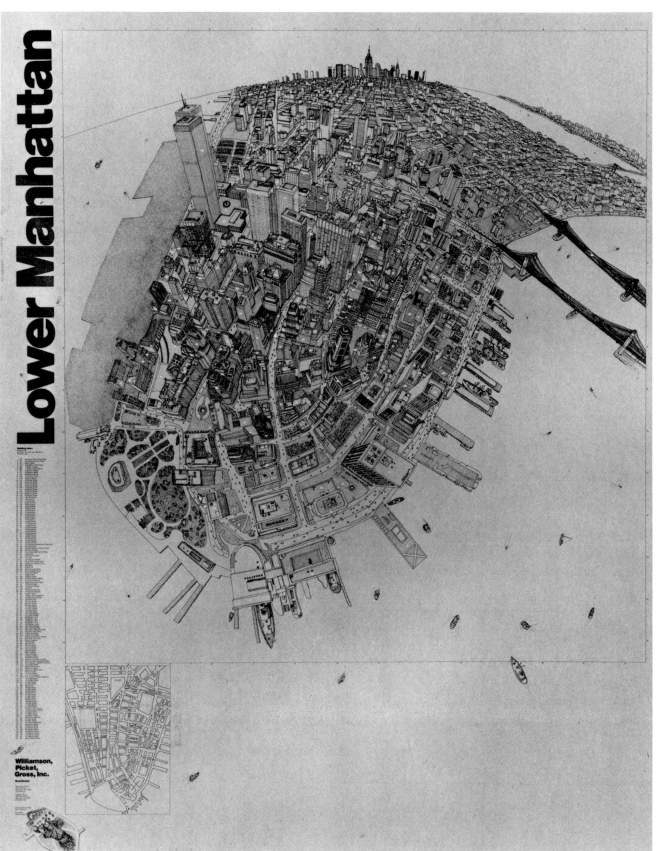

Title:
Lower Manhattan
Publisher:
Williamson, Picket, Gross, Inc.
1979
Art Director:
Diana Graham
Artist:
Al Lorenz
Design Firm:
Gips + Balkind + Assoc., Inc.
New York, NY

Title:
The Spread of Prehistoric
Humans
Publication:
Academic American
Encyclopedia 1980-81
Publisher:
Arete Publishing Co., Inc.
Art Director:
Peter R. Cook
Design Firm:
Donnelley Cartographic
Services
Willard, OH

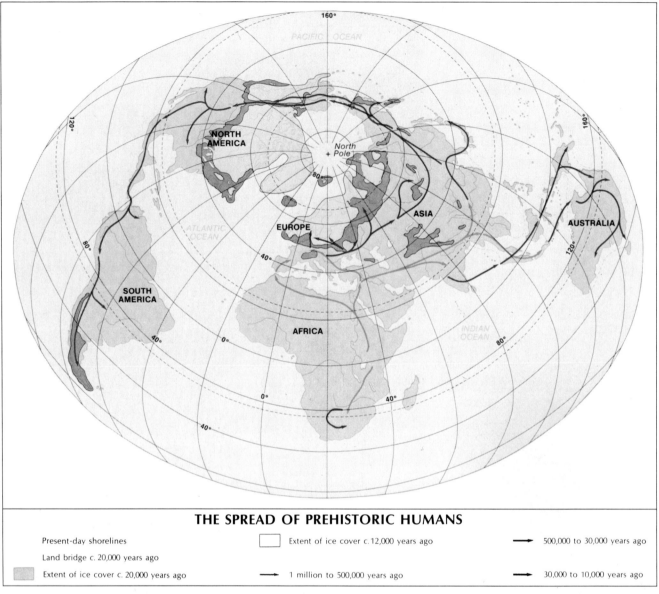

THE SPREAD OF PREHISTORIC HUMANS

Present-day shorelines	Extent of ice cover c. 12,000 years ago	500,000 to 30,000 years ago
Land bridge c. 20,000 years ago	1 million to 500,000 years ago	30,000 to 10,000 years ago
Extent of ice cover c. 20,000 years ago		

Title:
World Ocean Floor
Publication:
National Geographic Magazine,
December 1981
Art Director:
Howard E. Paine
Cartographers:
Richard J. Darley,
John F. Shupe
Design Department:
National Geographic
Cartographic Division
Washington, DC

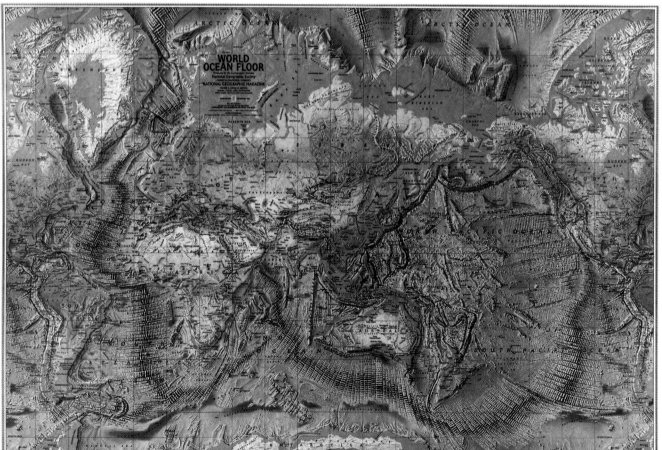

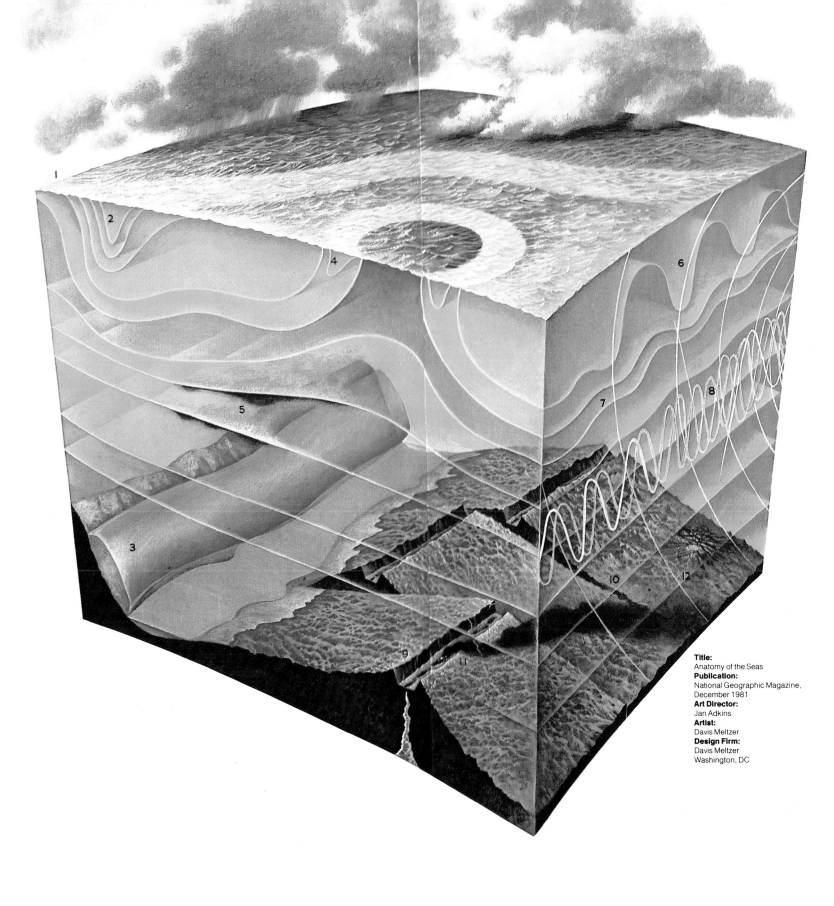

Title:
Anatomy of the Seas
Publication:
National Geographic Magazine,
December 1981
Art Director:
Jan Adkins
Artist:
Davis Meltzer
Design Firm:
Davis Meltzer
Washington, DC

Title:
The Mountain Blows Its Top
Publication:
National Geographic Magazine,
January 1981
Art Director:
Howard E. Paine
Artist:
Susan Sanford
Photographers:
Gary Rosenquist, Earth Images
Design Department:
National Geographic Art
Division
Washington, DC

BULGE
8:27:00 a.m.

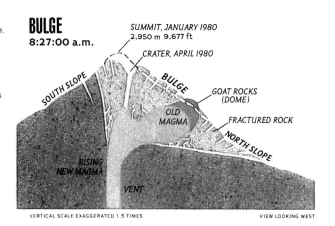

SUMMIT, JANUARY 1980
2,950 m 9,677 ft

CRATER, APRIL 1980

SOUTH SLOPE

BULGE

GOAT ROCKS
(DOME)

OLD
MAGMA

FRACTURED ROCK

NORTH SLOPE

RISING
NEW MAGMA

VENT

VERTICAL SCALE EXAGGERATED 1.5 TIMES

VIEW LOOKING WEST

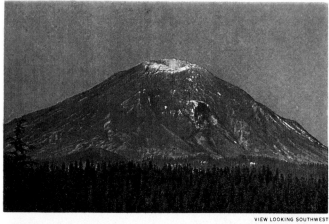

VIEW LOOKING SOUTHWEST

LANDSLIDE
8:32:37

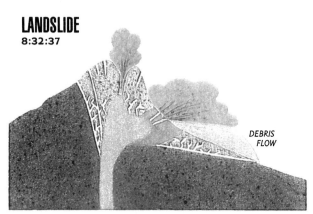

DEBRIS
FLOW

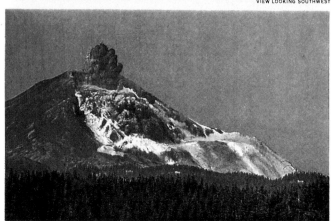

BLAST
8:32:41

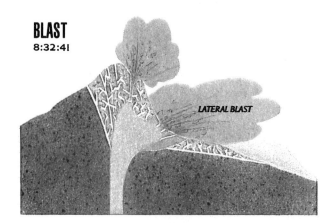

LATERAL BLAST

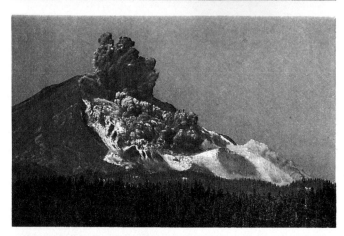

SURGE
8:32:51

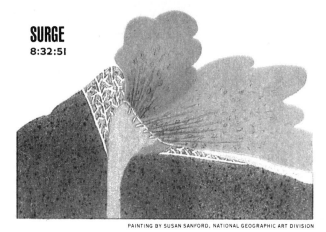

PAINTING BY SUSAN SANFORD, NATIONAL GEOGRAPHIC ART DIVISION

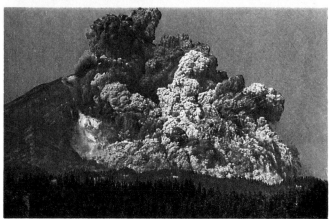

GARY ROSENQUIST, EARTH IMAGES (PAGES 8-10)

Title:
Pest Control and Damage Cost
Billions
Publication:
National Geographic Magazine,
February 1980
Art Director:
Howard E. Paine
Artists:
Paul M. Breeden, Jane Wolfe
Design Department:
National Geographic Art
Division
Washington, DC

state that uses more pesticides than any other: at least 250 million pounds in 1977, the year Andres became totally disabled.

"For years I sprayed almond orchards at $3.36 an hour," Andres said. "Many things were not done right. For instance, I had to spray even when it was windy enough to blow the pesticides all over me.

"Imagine how strong the sprays were: I mixed them in new plastic buckets that began disintegrating in three days. I fought for gloves and a face mask—the fumes gave me bad headaches and I sometimes vomited—but there was never a clean filter for the mask or enough water to wash with.

"I risked my job to complain to my supervisors, but I got nowhere. Now that I am sick, everything is handy for the workers, and they mix sprays with pumps instead of by hand. But if no one had been hurt, probably nothing would have changed. I still hear nothing from the grower."

Andres gestured with his fluttering arm. "I would not will my illness to anyone, not even my greatest enemy. I cannot work, and now my children are deprived of many things I could give them before. That is why I am suing, even though my case may be difficult to prove."

IT IS NO COMFORT to Andres, but his case illustrates the dilemma of pesticides: They protect us from insects, weeds, disease, and hunger, but some pose a risk of cancer, birth defects, genetic mutations, and sterility.

In a predicament, we vacillate. Even as we try to shield ourselves against chemical pollution, we spread a billion pounds of pesticides each year.

Do they work? Farmers seldom doubt it; environmentalists often do. Consider:

• Herbicides cut fuel-consuming tillage, reduce erosion, and conserve soil moisture. During one season, they can reduce from 60 hours to 12 the time it takes to keep an acre of corn free of weeds. We now use more weed killers than insecticides.

• Insect resistance to pesticides is accelerating. Today 400 species of insects and mites are resistant to pesticides, more than twice as many as in 1965. Some can tolerate whole categories of agricultural poisons.

• Two-thirds of agricultural pesticides

148

Pest control and damage cost billions

Plagued by two thousand detrimental insects, weeds, and plant diseases, U. S. farmers and foresters devote more than 2.25 billion dollars a year to pest control. Proponents point out that pests damage one-third of our crops—nearly nine billion dollars' worth each year—and can carry death-dealing disease. But grim counterarguments emerge: pesticide-related illness and death, and warnings of dire ecological consequences.

Grasshoppers ravage the West's rangelands

A 1979 grasshopper plague mowed down forage in 17 states. Ranchers counterattacked by joining with state and federal governments in a ten-million-dollar cooperative control program, delineated by areas of dark tan.

Gypsy moths damage northeastern forests

Gypsy moth caterpillars defoliate hardwood trees. The 1978 timber loss: perhaps 18 million dollars. Control cost: three million. The European import escaped the Massachusetts laboratory of a naturalist in 1869; succeeding generations fanned out over the Northeast.

Red mites ruin fruit across the country

Bane of apple trees, the European red mite also maims peach, plum, and pear trees. Leaf-damaged trees produce lower yields and smaller, discolored fruit. Tree damage is cumulative and difficult to assess.
Spraying aggravates the problem, unleashing infestations of the nearly pesticide-resistant mite by killing off its natural enemies.

Pink bollworms and boll weevils destroy cotton in the South

To finance the weevil wars, farmers enlist 50 to 75 million dollars a year in insecticides against an adversary that has devastated 12 billion dollars' worth of cotton since jumping the Mexican border in 1892. Another cotton nemesis, the pink bollworm, prefers the Southwest's hot, dry fields, where it ruins millions of dollars' worth of crops annually.

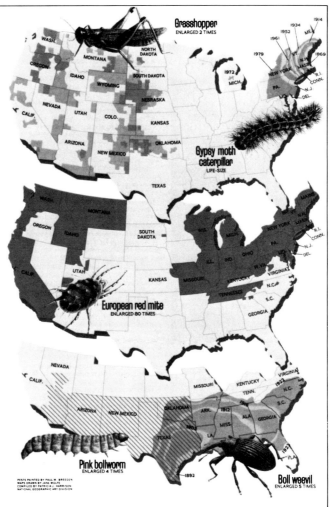

Grasshopper
ENLARGED 2 TIMES

Gypsy moth caterpillar
LIFE-SIZE

European red mite
ENLARGED 80 TIMES

Pink bollworm
ENLARGED 4 TIMES

Boll weevil
ENLARGED 5 TIMES

PESTS PAINTED BY PAUL M. BREEDEN
MAPS DRAWN BY JANE WOLFE
COMPILED BY PATRICIA J. HARRISON
NATIONAL GEOGRAPHIC ART DIVISION

Title:
Design for Survival
Publication:
National Geographic Magazine,
January 1981
Art Director:
Howard E. Paine
Artist:
Paul M. Breeden
Design Department:
National Geographic Art
Division
Washington, DC

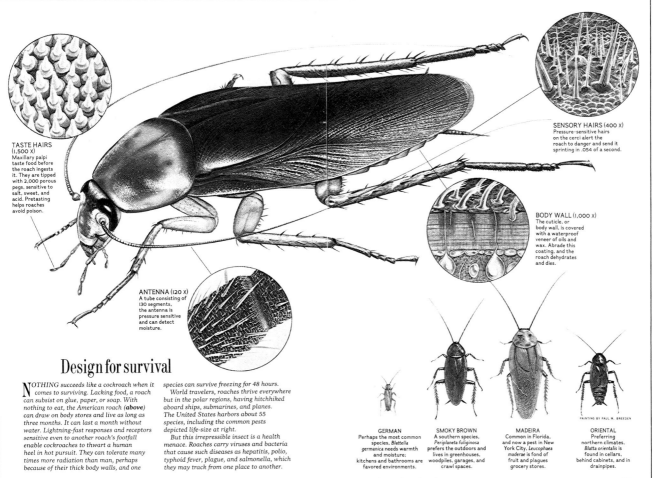

TASTE HAIRS
(1,500 X)
Maxillary palpi
taste food before
the roach ingests
it. They are tipped
with 2,000 porous
pegs, sensitive to
salt, sweet, and
acid. Pretasting
helps roaches
avoid poison.

SENSORY HAIRS (400 X)
Pressure-sensitive hairs
on the cerci alert the
roach to danger and send it
sprinting in .054 of a second.

BODY WALL (1,000 X)
The cuticle, or
body wall, is covered
with a waterproof
veneer of oils and
wax. Abrade this
coating, and the
roach dehydrates
and dies.

ANTENNA (120 X)
A tube consisting of
130 segments,
the antenna is
pressure sensitive
and can detect
moisture.

GERMAN
Perhaps the most common
species, *Blattella
germanica* needs warmth
and moisture;
kitchens and bathrooms are
favored environments.

SMOKY BROWN
A southern species,
Periplaneta fuliginosa
prefers the outdoors and
lives in greenhouses,
woodpiles, garages, and
crawl spaces.

MADEIRA
Common in Florida,
and now a pest in New
York City, *Leucophaea
maderae* is fond of
fruit and plagues
grocery stores.

ORIENTAL
Preferring
northern climates,
Blatta orientalis is
found in cellars,
behind cabinets, and in
drainpipes.

PAINTING BY PAUL M. BREEDEN

Design for survival

NOTHING succeeds like a cockroach when it comes to surviving. Lacking food, a roach can subsist on glue, paper, or soap. With nothing to eat, the American roach (*above*) can draw on body stores and live as long as three months. It can last a month without water. Lightning-fast responses and receptors sensitive even to another roach's footfall enable cockroaches to thwart a human heel in hot pursuit. They can tolerate many times more radiation than man, perhaps because of their thick body walls, and one

species can survive freezing for 48 hours. World travelers, roaches thrive everywhere but in the polar regions, having hitchhiked aboard ships, submarines, and planes. The United States harbors about 55 species, including the common pests depicted life-size at right.

But this irrepressible insect is a health menace. Roaches carry viruses and bacteria that cause such diseases as hepatitis, polio, typhoid fever, plague, and salmonella, which they may track from one place to another.

132

National Geographic, January 1981

The Indomitable Cockroach

133

Three-dimensional seismology – a relatively new innovation – gives Gulf Canada more information about hard-to-understand underground rock formations that have been found to contain oil or gas. With the process, much more data is gathered, giving skilled interpretors a better visual representation of the sub-surface layers of rock. Using a computer, these scientists can view an underground slice from any angle (three possible views are shown at right). With this flexibility and improved information, the Company can, for example, more accurately determine the limits of oil or gas reservoirs, and as a result, place million-dollar wells and billion-dollar production systems in just the right place.

GAS
OIL
WATER

Title:
3-D Seismology
Publication:
Commentator, August 1981
Art Director:
Bruce Mau
Artist:
Bruno Rubeo
Design Firm:
Fifty Fingers, Inc.
Toronto, CAN

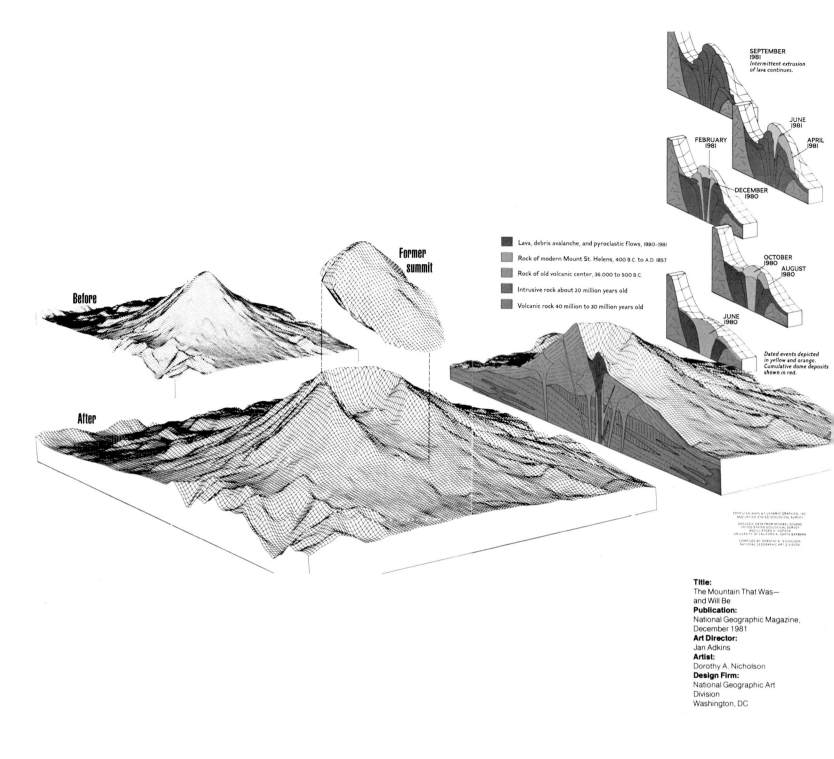

Before

After

Former summit

SEPTEMBER 1981
Intermittent extrusion of lava continues.

JUNE 1981

FEBRUARY 1981

APRIL 1981

DECEMBER 1980

OCTOBER 1980

AUGUST 1980

JUNE 1980

Lava, debris avalanche, and pyroclastic flows, 1980-1981

Rock of modern Mount St. Helens, 400 B.C. to A.D. 1857

Rock of old volcanic center, 36,000 to 500 B.C.

Intrusive rock about 20 million years old

Volcanic rock 40 million to 30 million years old

Dated events depicted in yellow and orange. Cumulative dome deposits shown in red.

COMPUTER MAPS BY DYNAMIC GRAPHICS, INC
AND UNITED STATES GEOLOGICAL SURVEY

GEOLOGIC DATA FROM MICHAEL DOUKAS
UNITED STATES GEOLOGICAL SURVEY
AND CLIFFORD A. HOPSON
UNIVERSITY OF CALIFORNIA, SANTA BARBARA

COMPILED BY DOROTHY A. NICHOLSON
NATIONAL GEOGRAPHIC ART DIVISION

Title:
The Mountain That Was—
and Will Be
Publication:
National Geographic Magazine,
December 1981
Art Director:
Jan Adkins
Artist:
Dorothy A. Nicholson
Design Firm:
National Geographic Art
Division
Washington, DC

Title:
Crown of Tenochtitlan
Publication:
National Geographic Magazine,
December 1980
Art Director:
Howard E. Paine
Artist:
Ned Seidler
Design Firm:
National Geographic Art
Division
Washington, DC

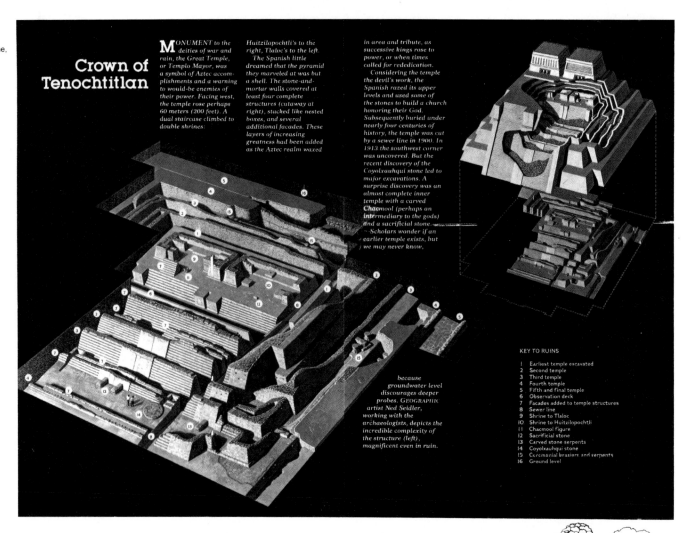

Crown of Tenochtitlan

MONUMENT to the deities of war and rain, the Great Temple, or Templo Mayor, was a symbol of Aztec accomplishments and a warning to would-be enemies of their power. Facing west, the temple rose perhaps 60 meters (200 feet). A dual staircase climbed to double shrines:

Huitzilopochtli's to the right, Tlaloc's to the left.

The Spanish little dreamed that the pyramid they marveled at was but a shell. The stone-and-mortar walls covered at least four complete structures (cutaway at right), stacked like nested boxes, and several additional facades. These layers of increasing greatness had been added as the Aztec realm waxed

in area and tribute, as successive kings rose to power, or when times called for rededication.

Considering the temple the devil's work, the Spanish razed its upper levels and used some of the stones to build a church honoring their God. Subsequently buried under nearly four centuries of history, the temple was cut by a sewer line in 1900. In 1913 the southwest corner was uncovered. But the recent discovery of the Coyolxauhqui stone led to major excavations. A surprise discovery was an almost complete inner temple with a carved Chacmool (perhaps an intermediary to the gods) and a sacrificial stone. Scholars wonder if an earlier temple exists, but we may never know,

because groundwater level discourages deeper probes. GEOGRAPHIC artist Ned Seidler, working with the archaeologists, depicts the incredible complexity of the structure (left), magnificent even in ruin.

KEY TO RUINS

1 Earliest temple excavated
2 Second temple
3 Third temple
4 Fourth temple
5 Fifth and final temple
6 Observation deck
7 Facades added to temple structures
8 Sewer line
9 Shrine to Tlaloc
10 Shrine to Huitzilopochtli
11 Chacmool figure
12 Sacrificial stone
13 Carved stone serpents
14 Coyolxauhqui stone
15 Ceremonial braziers and serpents
16 Ground level

Title:
Two Minutes Over Baghdad:
The Raid
Publication:
Newsweek, June 22, 1981
Art Director:
Thomas R. Lunde
Artist:
Ib Ohlsson
Design Department:
Newsweek Magazine
New York, NY

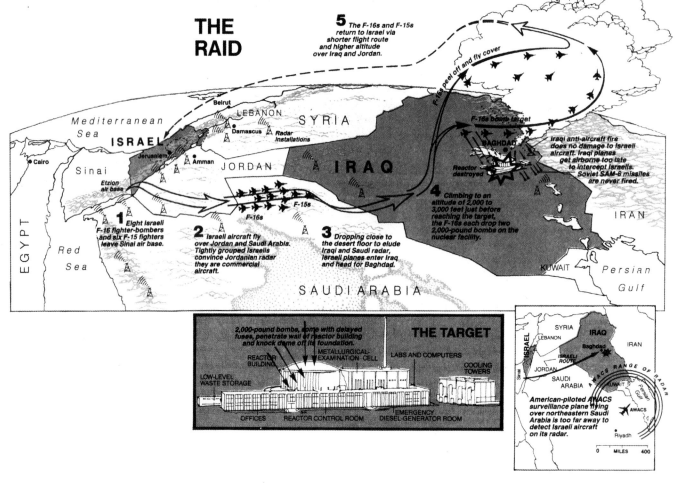

THE RAID

5 The F-16s and F-15s return to Israel via shorter flight route and higher altitude over Iraq and Jordan.

F-15s peel off and fly cover

F-16s bomb target

Iraqi anti-aircraft fire does no damage to Israeli aircraft. Iraqi planes get airborne too late to intercept Israelis. Soviet SAM-6 missiles are never fired.

Reactor destroyed

4 Climbing to an altitude of 2,000 to 3,000 feet just before reaching the target, the F-16s each drop two 2,000-pound bombs on the nuclear facility.

1 Eight Israeli F-16 fighter-bombers and six F-15 fighters leave Sinai air base.

2 Israeli aircraft fly over Jordan and Saudi Arabia. Tightly grouped Israelis convince Jordanian radar they are commercial aircraft.

3 Dropping close to the desert floor to elude Iraqi and Saudi radar, Israeli planes enter Iraq and head for Baghdad.

Mediterranean Sea — ISRAEL — Jerusalem — Etzion air base — Cairo — Sinai — Amman — JORDAN — Red Sea — EGYPT — Beirut — LEBANON — Damascus — Radar Installations — SYRIA — IRAQ — BAGHDAD — IRAN — KUWAIT — Persian Gulf — SAUDI ARABIA — F-15s — F-16s

THE TARGET

2,000-pound bombs, some with delayed fuses, penetrate wall of reactor building and knock dome off its foundation.

METALLURGICAL-EXAMINATION CELL

LABS AND COMPUTERS

REACTOR BUILDING

COOLING TOWERS

LOW-LEVEL WASTE STORAGE

OFFICES — REACTOR CONTROL ROOM — EMERGENCY DIESEL-GENERATOR ROOM

SYRIA — LEBANON — IRAQ — Baghdad — ISRAEL — ISRAELI ROUTE — JORDAN — SAUDI ARABIA — IRAN — KUWAIT — Persian Gulf — RANGE OF RADAR — AWACS — Riyadh

American-piloted AWACS surveillance plane flying over northeastern Saudi Arabia is too far away to detect Israeli aircraft on its radar.

0 MILES 400

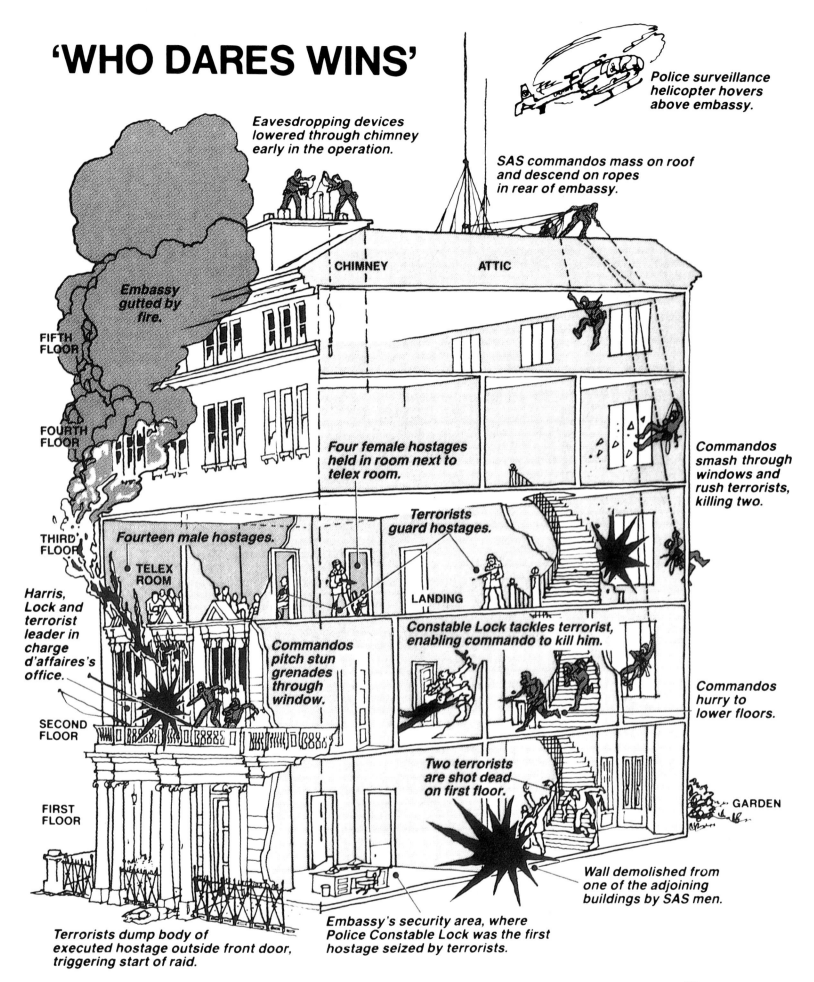

'WHO DARES WINS'

Police surveillance helicopter hovers above embassy.

Eavesdropping devices lowered through chimney early in the operation.

SAS commandos mass on roof and descend on ropes in rear of embassy.

Embassy gutted by fire.

CHIMNEY ATTIC

FIFTH FLOOR

FOURTH FLOOR

Commandos smash through windows and rush terrorists, killing two.

Four female hostages held in room next to telex room.

THIRD FLOOR

Fourteen male hostages.

TELEX ROOM

Terrorists guard hostages.

LANDING

Harris, Lock and terrorist leader in charge d'affaires's office.

Commandos pitch stun grenades through window.

Constable Lock tackles terrorist, enabling commando to kill him.

SECOND FLOOR

Commandos hurry to lower floors.

Two terrorists are shot dead on first floor.

GARDEN

FIRST FLOOR

Wall demolished from one of the adjoining buildings by SAS men.

Terrorists dump body of executed hostage outside front door, triggering start of raid.

Embassy's security area, where Police Constable Lock was the first hostage seized by terrorists.

PRINCE'S GATE

Title:
Who Dares Wins
Publication:
Newsweek, May 19, 1980
Art Director:
Thomas R. Lunde
Artist:
Ib Ohlsson
Design Department:
Newsweek Magazine
New York, NY

Title:
The Seizure
Publication:
The New York Times,
February 4, 1981
Art Director:
David Dunlap
Artists:
John Leinung, The New York
Times Map Group
Design Department:
The New York Times
New York, NY

The Seizure:

When the invasion of the United States Embassy began on the morning of Nov. 4, 1979, not all of those who were soon to be held hostage were in the compound. Kathryn L. Koob and William B. Royer Jr. were at the Iran-America Society and L. Bruce Laingen, Victor L. Tomseth and Michael Howland were at the Iranian Foreign Ministry.

1: A crowd began gathering outside of the main gate at 7:30 A.M. The invasion of the grounds began between 10:15 and 10:30 A.M. **2:** Perhaps as many as 45 Americans were in the embassy's main building, the chancery, at this time. **3:** At least 14 other members of the staff were in the consulate. **4:** Four others were in an apartment building at the north end of the complex. **5:** As the gravity of the situation became evident, a group of about 10 Americans locked themselves behind steel doors in the east wing of the chancery and began shredding documents and smashing electronic equipment. **6:** At the consulate, orders had been received to evacuate the building. Several groups left the area in the rear of the embassy grounds, encountering no resistance at first. One band of about six, including Richard I. Queen, was soon captured but five other consular officials found successive havens first in private homes and then at the Canadian Embassy. They escaped from Iran in January 1980.

7: In the first days and weeks of captivity, nearly all of the hostages were housed in the ambassador's residence, where they were bound to chairs or handcuffed and blindfolded 24 hours a day. **8:** Toward the end of November, several of the Americans were moved to a warehouse basement that had been converted before the seizure into a barracks. These quarters were dubbed the Mushroom Inn. **9:** Other hostages were kept in several small staff houses on the grounds, as well as in the chancery and several other buildings scattered over the 27-acre site.

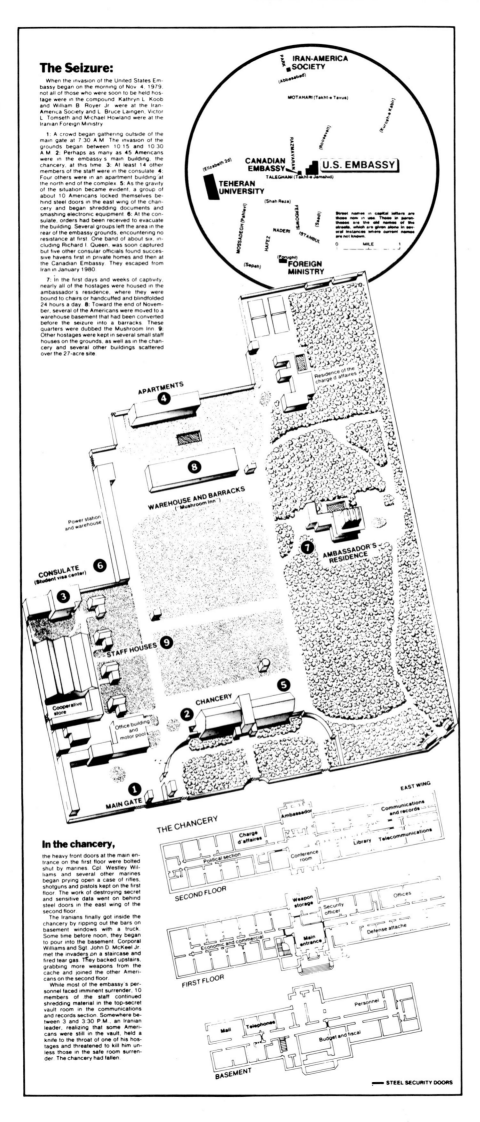

In the chancery,

the heavy front doors at the main entrance on the first floor were bolted shut by marines. Cpl. Westley Williams and several other marines began prying open a case of rifles, shotguns and pistols kept on the first floor. The work of destroying secret and sensitive data went on behind steel doors in the east wing of the second floor.

The Iranians finally got inside the chancery by ripping out the bars on basement windows with a truck. Some time before noon, they began to pour into the basement. Corporal Williams and Sgt. John D. McKeel Jr. met the invaders on a staircase and fired tear gas. They backed upstairs, grabbing more weapons from the cache and joined the other Americans on the second floor.

While most of the embassy's personnel faced imminent surrender, 10 members of the staff continued shredding material in the top-secret vault room in the communications and records section. Somewhere between 3 and 3:30 P.M., an Iranian leader, realizing that some Americans were still in the vault, held a knife to the throat of one of his hostages and threatened to kill him unless those in the safe room surrender. The chancery had fallen.

TEXAS STATE WATERS

The State of Texas extends 12 miles out into the Gulf of Mexico along its coastline. This offshore zone contains a number of prolific oil and gas fields. It is criss-crossed with distribution pipelines that lead to all parts of the United States. Our existing wells in these waters provide more than 25 percent of our revenue.

In October, 1979, we announced a joint venture with Strata Energy, Inc., of Houston, to explore for oil and gas in this region. Strata is the exploration subsidiary of Armco, Inc. The joint venture, oper-

ated by Phoenix Resources, has acquired more than 40,000 acres off the Texas shore. We have now defined 8 drilling sites and are pursuing several promising geological ideas.

Phoenix Resources has contracted for an offshore jack-up drilling rig to use in this joint program over the next three years. The rig, which is under construction in Charleston, South Carolina, will be used for six-month intervals during each year of the commitment at a cost of $35,000 to $45,000 per day. Operations are scheduled to begin in Septem-

ber, and we expect to drill three wells through the end of this year. Our company has budgeted approximately $5 million for this program in 1981.

Most of the wells that we plan to drill in the Texas offshore venture will be relatively shallow, from 5,000 to 10,000 feet. They will penetrate the 25-million-year-old Miocene strata, the major producing sands in this region. The targets of our search generally contain more potential for gas than oil. Because of the high costs involved in offshore activity, we will be looking for oil reserves of 1 mil-

lion barrels or larger and gas reserves of more than 50 billion cubic feet.

Phoenix Resources and Strata, using extensive seismic information, are now seeking additional acreage and drilling prospects off the coast of Texas.

Phoenix Resources and Strata Energy, Inc., have formed a joint venture partnership to explore offshore within the 12-mile boundary of the State of Texas. The orange color blocks depict leases acquired by the companies since 1979. Drilling on 3 of the leases is expected to begin late in 1981. Shown in dark red are Phoenix Resources' main producing fields in the area.

Texas State Waters

Legend
▪ PRODUCING BLOCKS
▪ EXPLORATION BLOCKS

[6] [7]

3 Locating Hard-To-Find Oil and Gas

Stepped up surveying for probable oil and gas producing zones is another important part of the domestic energy drive, as the U.S. seeks to reduce its dependence on imported oil. After three years of fairly steady increase, seismic surveying activity began to climb sharply in 1979 and is now at its highest level in nearly two decades.

Since most of the easy oil and gas deposits in the U.S. have already been tracked down, the emphasis today is on deeper or more remote and difficult locations requiring advanced exploration skills. We have structured a surveying capability specifically to meet these more sophisticated demands. Our major focus is on surveying the marshy, shallow waters of the Gulf Coast shoreline. These hard-to-survey areas have rich potential that has not been adequately searched before.

In addition, we added our first land surveying crews during 1979.

Our technological capabilities include a state-of-the-art "supercrew" that can get more meaningful data from greater depths with double the data retrieval power of ordinary crews. Following the great success of our first supercrew, we are planning to duplicate this capability for another customer in 1980.

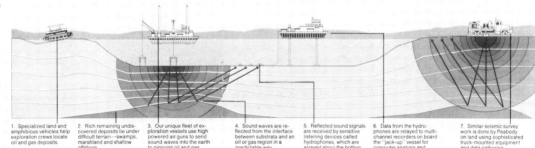

1. Specialized land and amphibious vehicles help exploration crews locate oil and gas deposits.

2. Rich remaining undiscovered deposits lie under difficult terrain—swamps, marshland and shallow offshore.

3. Our unique fleet of exploration vessels use high powered air guns to send sound waves into the earth to pinpoint oil and gas deposits.

4. Sound waves are reflected from the interface between substrata and an oil or gas region in a predictable way.

5. Reflected sound signals are received by sensitive listening devices called hydrophones, which are arrayed along the bottom.

6. Data from the hydrophones are relayed to multi-channel recorders on board the "jack-up" vessel for computer analysis and printout.

7. Similar seismic survey work is done by Peabody on land using sophisticated truck-mounted equipment and data gathering instrumentation.

4 Burning More Coal—Clean and Safe

Coal is America's largest energy resource and will play an expanding role throughout the 1980's in meeting our national energy goals. According to a recent Energy Information Administration forecast, U.S. coal consumption is likely to rise to 1,033 million tons by 1985 from an estimated 799 million tons in 1980.

The big drawback of coal is its high pollution content. That is where Peabody fits in. We don't dig coal. We test coal, supply mine ventilation equipment and provide systems for burning coal efficiently and cleaning up after it—areas of particularly high growth potential.

One of the most dramatic trends in the 80's will be toward increased coal use by electric utilities. The Environmental Protection Agency estimates that 350 new coal-fired power plants will be built by 1995. Every one of these plants will need the type of combustion and clean-up systems offered by Peabody.

Our products for this market include fuel preparation equipment, burners, fabric filters for dust control, electrostatic precipitators for fly ash removal, scrubbers for flue gas desulfurization and tall chimneys for dispersing residual emissions.

Scrubbers promise especially huge market potential. In a major industry advance, Peabody recently introduced its new second generation scrubber. This system trims costs and reduces sludge disposal problems by using the alkali value in one pollutant (fly ash) to react with another (SO₂), minimizing the need to introduce lime/limestone as a reactant.

1. Pulverized coal is burned to power boilers. But, during combustion, coal releases fly ash and sulfur dioxide.

2. Fly ash is removed from boiler flue gases with Peabody radial venturi scrubbers. Water spray captures the ash.

3. Alkali in the fly ash captured in the radial venturi scrubber helps remove sulfur dioxide in the Peabody absorber.

4. Cleaned gases are exhausted to the atmosphere via Peabody reinforced concrete chimneys with acid-resistant liners.

5 Synfuels

Peabody's special focus in the U.S. synthetic fuel program is testing synfuels for heat value and pollutants and helping overcome the tremendous environmental problems that synfuels production can create. We also make specially lined and coated equipment to move and contain corrosives generated in synfuel processing.

Congress is debating a $20 billion synfuels development program. But even without that appropriation, our synfuels business is increasing.

Our testing laboratories are working with many customers in analyzing samples of coal shale, tar sands and other potential synfuel feedstocks.

These feedstocks contain large amounts of sulfur, which must be removed. The preferred removal method is the Peabody Holmes-Stretford process, which reduces hydrogen sulfide (H₂S) in gas streams. This process has been installed at three synfuels plants. A fourth installation is scheduled to start up in May 1980. We also have received two orders for Holmes-Stretford units to remove the H₂S from steam condensates at geothermal power plants.

16

Title:
Texas State Waters
Publication:
Phoenix Resources Co.
1980 Annual Report
Art Directors and Designers:
Ben Carter, Al Clinkenbeard,
Maggy Cuesta, Bob De Leon,
Mark Geer, Terri Otten
Artist:
Jack Uhruh
Design Firm:
Ben Carter & Assoc.
Houston, TX

Title:
Burning More Coal
Publication:
Peabody International
Annual Report 1979
Art Director:
Bob Pellegrini
Artist:
Enno Poersch
Design Firm:
Pellegrini & Assoc., Inc.
New York, NY

Title:
The BART Tunnel:
Buried in the Bay
Publication:
San Francisco Examiner
January 18, 1981
Art Director:
Michael Keegan
Design Department:
San Francisco Examiner
San Francisco, CA

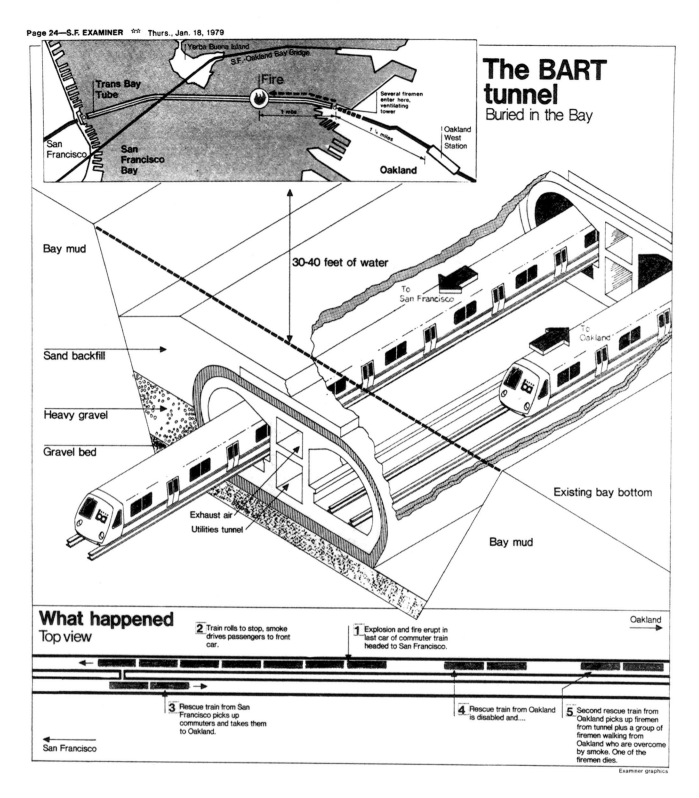

The BART tunnel
Buried in the Bay

Trans Bay Tube

Yerba Buena Island

S.F.-Oakland Bay Bridge

Fire

Several firemen enter here, ventilating tower

1 mile

1¼ miles

San Francisco

San Francisco Bay

Oakland West Station

Oakland

Bay mud

30-40 feet of water

Sand backfill

To San Francisco

Heavy gravel

To Oakland

Gravel bed

Exhaust air

Utilities tunnel

Existing bay bottom

Bay mud

What happened
Top view

2 Train rolls to stop, smoke drives passengers to front car.

1 Explosion and fire erupt in last car of commuter train headed to San Francisco.

Oakland

3 Rescue train from San Francisco picks up commuters and takes them to Oakland.

4 Rescue train from Oakland is disabled and....

5 Second rescue train from Oakland picks up firemen from tunnel plus a group of firemen walking from Oakland who are overcome by smoke. One of the firemen dies.

San Francisco

Examiner graphics

374

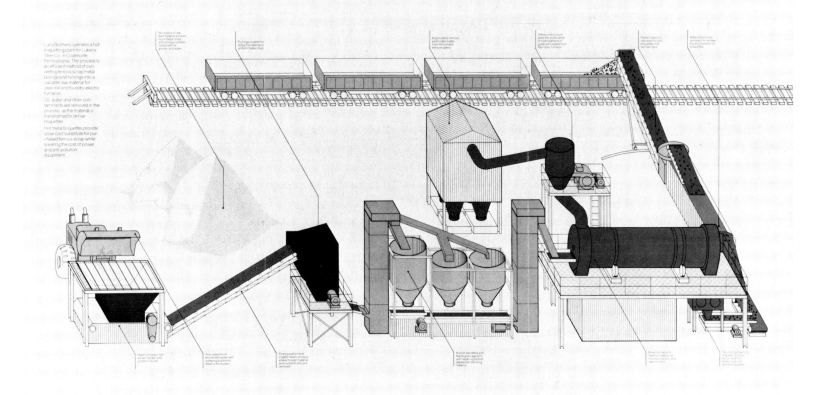

Luna Brothers operates a hot
briquetting plant for Lukens
Steel Co. in Coatesville,
Pennsylvania. The process is
an efficient method of con-
verting ferrous scrap metal
borings and turnings into a
valuable raw material for
steel mill and foundry electric
furnaces.

Oil, water and other con-
taminants are removed in the
process, as the material is
transformed to dense
briquettes.

Hot metal briquettes provide
a low-cost substitute for pur-
chased ferrous scrap while
lowering the cost of power
and anti-pollution
equipment.

Title:
Ogden '78 Hot Briquetting Plant
Diagram
Publication:
Ogden Corporation
1978 Annual Report
Art Director:
Peter Harrison
Designer:
Peter Harrison
Artist:
Peter Harrison
Mechanicals:
Jim Orlandi
Design Firm:
Pentagram Design
New York, NY

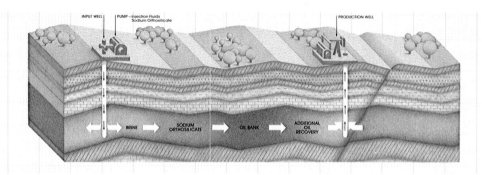

test cores flooded in a simulated reservoir pattern with a surfactant/silicate/10% NaCl system (represented by figures A and C) show substantially better sweep efficiency than cores flooded with a dilute surfactant system (figures B and D).

Title:
Enhanced Oil Recovery
Publication:
PQ Energy Services Brochure,
March 1981
Art Director:
William Milnazik
Artist:
Skip Baker
Design Firm:
Mueller & Wister Studio
Philadelphia, PA

Title:
Enhanced Oil Recovery
Publication:
The Hemisphere Technology
Portfolio, November 1981
Art Director:
Richard Kilmer
Designer:
Richard Kilmer
Mechanicals:
Al Clinkenbeard, Maggy Cuesta,
Mark Geer, Richard Kilmer,
Terri Otten
Design Firm:
Ben Carter & Assoc.
Houston, TX

Advanced drilling and completion techniques. To lower the costs of drilling, completing and maintaining oil wells, Hemisphere has several methods and products available for license. They include:

Water jet drill bit. This tool uses fine jets of high pressure water in conjunction with a special drilling bit to drill a hole to an oil-bearing formation. The water jets can either wear rock away or shatter it. Developed by Dr. Fun-Den Wang of the Colorado School of Mines, the drill bit reduces drilling costs because it: 1) does not require the extensive support equipment of a conventional drilling rig, and 2) drills faster than other techniques. Dr. Wang has demonstrated the water jet drill bit's ability to cut through granite, three times harder than most oil formation rocks. The tool may be ready for field use by 1983 pending results of further tests.

Slim hole drill. This system features a small, down-hole motor that powers a studded drill bit attached to a semi-rigid pipe, which is fed from a reel on the surface. As the hole is drilled, only the motor and bit rotate, and the pipe simply unreels into the hole. Like water jet drilling, this method, developed by Maurer Engineering, Inc., of Houston, will require neither heavy support equipment nor great amounts of energy. It also should offer significant advantages in terms of speed and reduced set-up costs.

Drain hole drill. This drilling system should make it possible, for the first time, to drill horizontally through a formation economically and with precision. Other horizontal drilling techniques, such as those using a whipstock, are costly and often inaccurate. This horizontal drilling system consists of a small motor, a drilling bit, a guide thruster and a length of flexible tubing at the bottom of a length of standard drill pipe. Drilling fluids injected down the well turn the motor and guide thruster. The guide thruster, in turn, supplies forces to change the drill's direction from vertical to horizontal as the bit cuts through the formation. Once a right angle turn has been completed, the drill can continue cutting the hole for more than a thousand feet. These laterally drilled holes expose more surface area and thus augment recovery percentages.

Another important aspect of this tool is its potential for the economical recovery of coal-bed methane in certain areas.

Slim hole drill.

Water jet drill bit.

Drain hole drill.

OGDEN

Title:
Annual Report Cover
Publication:
Ogden Corporation
1978 Annual Report
Art Director:
Peter Harrison
Designer:
Peter Harrison
Artist:
Peter Harrison
Mechanicals:
Jim Orlandi
Design Firm:
Pentagram Design
New York, NY

OGDEN
CORPORATION
1978
ANNUAL
REPORT

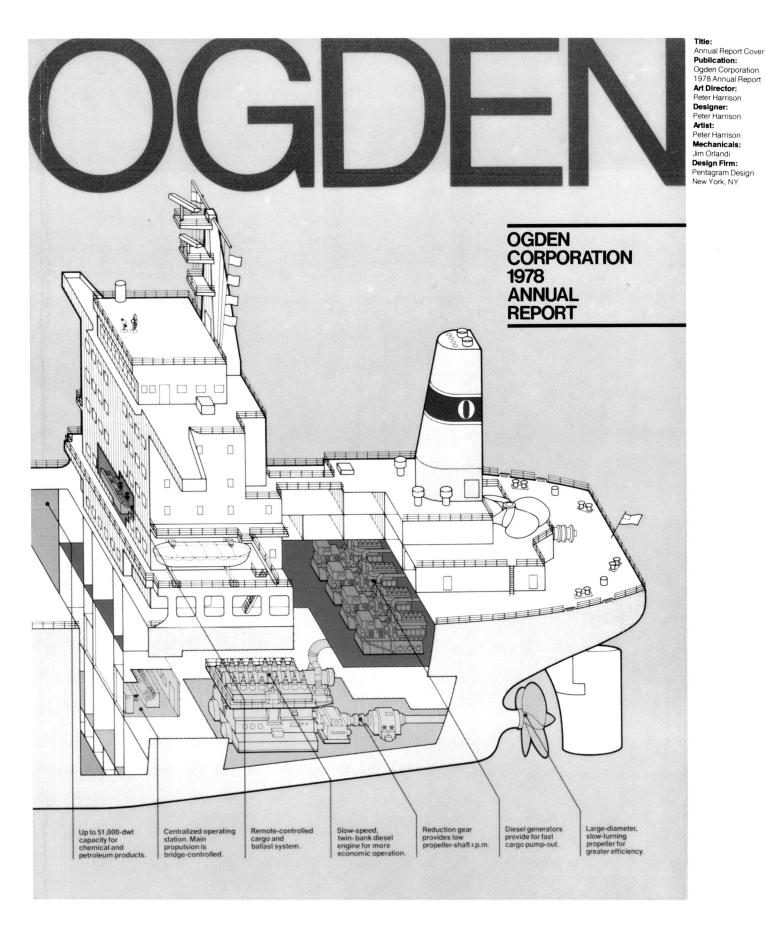

Up to 51,000-dwt capacity for chemical and petroleum products.

Centralized operating station. Main propulsion is bridge-controlled.

Remote-controlled cargo and ballast system.

Slow-speed, twin-bank diesel engine for more economic operation.

Reduction gear provides low propeller-shaft r.p.m.

Diesel generators provide for fast cargo pump-out.

Large-diameter, slow-turning propeller for greater efficiency.

Title:
Step by Step a New Span Over
the Missouri River Will Rise
Publication:
The Kansas City Star
November 22, 1981
Art Director:
Marty Petty
Artist:
Gayland Burke
Design Department:
The Kansas City Star
Kansas City, MO

STEP BY STEP A NEW SPAN OVER THE MISSOURI RIVER WILL RISE

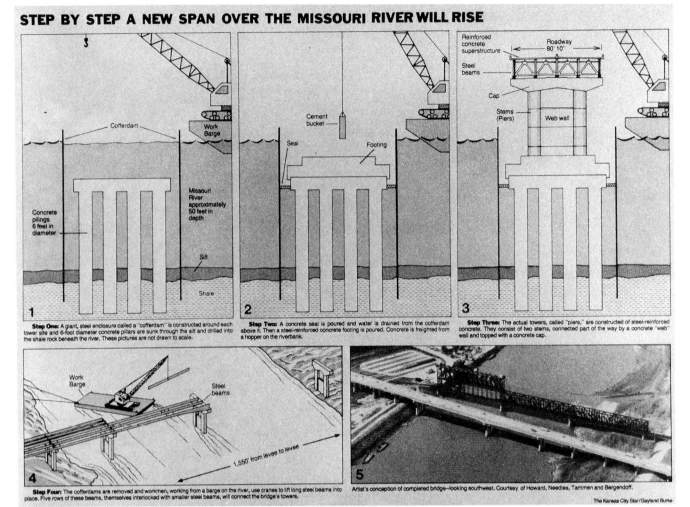

Step One: A giant, steel enclosure called a "cofferdam" is constructed around each tower site and 6-foot diameter concrete pillars are sunk through the silt and drilled into the shale rock beneath the river. These pictures are not drawn to scale.

Step Two: A concrete seal is poured and water is drained from the cofferdam above it. Then a steel-reinforced concrete footing is poured. Concrete is freighted from a hopper on the riverbank.

Step Three: The actual towers, called "piers," are constructed of steel-reinforced concrete. They consist of two stems, connected part of the way by a concrete "web" wall and topped with a concrete cap.

Step Four: The cofferdams are removed and workmen, working from a barge on the river, use cranes to lift long steel beams into place. Five rows of these beams, themselves interlocked with smaller steel beams, will connect the bridge's towers.

Artist's conception of completed bridge—looking southwest. Courtesy of Howard, Needles, Tammen and Bergendoff.

The Kansas City Star/Gayland Burke

Title:
Route of the Transglobe
Expedition
Publication:
The Washington Post,
December 16, 1980
Artists:
David Cook, Richard Furno
Design Department:
The Washington Post
Washington, DC

Route of the Transglobe Expedition

THE NEW YORK TIMES, TUESDAY, APRIL 7, 1981

Copyright © 1981 The New York Times

SPECIAL SHUTTLE ISSUE

Science Times

With
Education,
Arts, Sports C1

The Shuttle: America Poised for a Return to Space

Configuration Of the First True Spaceship

The space shuttle is one of the most complex space vehicles ever built and will usher in a new era in space flight. Launched like a rocket, attached to two booster rockets and a large fuel tank, the Columbia, the first true "spaceship," must re-enter the atmosphere and land like an airplane so that it may be refurbished and sent aloft again.

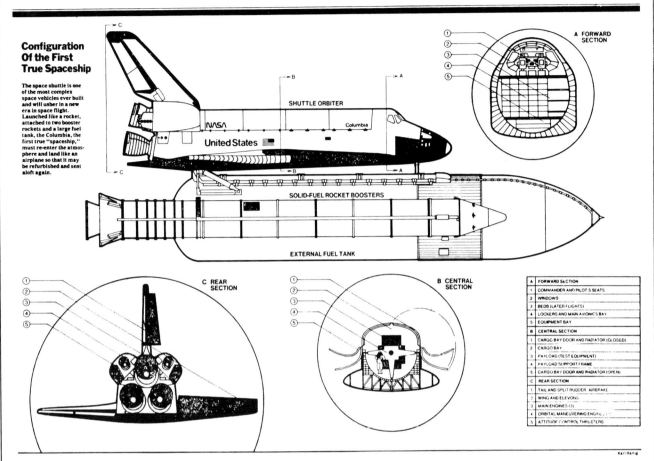

SHUTTLE ORBITER

NASA Columbia

United States

SOLID-FUEL ROCKET BOOSTERS

EXTERNAL FUEL TANK

A FORWARD SECTION

C REAR SECTION

B CENTRAL SECTION

A	FORWARD SECTION
1	COMMANDER AND PILOT'S SEATS
2	WINDOWS
3	BEDS (LATER FLIGHTS)
4	LOCKERS AND MAIN AVIONICS BAY
5	EQUIPMENT BAY
B	CENTRAL SECTION
1	CARGO BAY DOOR AND RADIATOR (CLOSED)
2	CARGO BAY
3	PAYLOAD (TEST EQUIPMENT)
4	PAYLOAD SUPPORT FRAME
5	CARGO BAY DOOR AND RADIATOR (OPEN)
C	REAR SECTION
1	TAIL AND SPLIT RUDDER AIRBRAKE
2	WING AND ELEVONS
3	MAIN ENGINES (3)
4	ORBITAL MANEUVERING ENGINES
5	ATTITUDE CONTROL THRUSTERS

Karl Hartig

A Mission Of Perils And Hopes

By MALCOLM W. BROWNE

THE main goal of Mission STS-1, as the space shuttle's maiden flight is officially called, is to get the Columbia into orbit and back to a safe landing on Earth. If the astronauts John W. Young and Capt. Robert L. Crippen manage to accomplish more than that, possibly the completion of 36 scheduled orbits, space agency officials will consider it a bonus.

The hope is that when the Columbia rises from its launching pad here Friday morning, as plans now stand, it will stay up for an orbital voyage lasting 54½ hours.

But nothing is certain.

If trouble develops before the launching, the astronauts might have to leave their cockpit before their craft even gets off the ground, sliding like trapeze artists down an escape wire to a parked military personnel carrier. With a lot of luck, they would then drive to safety.

If a mishap should occur soon after liftoff, the two men might be forced to fire their spine-wrenching ejection seats, allowing them to parachute into the Atlantic.

And if all problems should arise a bit later, they might turn around and land at the Kennedy Space Center itself. Still further into the mission, they might park their ship in an emergency, low-altitude orbit, or try for a single orbit around Earth, or land quickly. Alternate landing sites have been selected in New Mexico, California, Hawaii, Spain and Okinawa. Or the shuttle might have to put down in other places, including the ocean.

Ideally, however, Mission STS-1 will go this way:

As water sprinklers pour spray into the air around launching pad 39A to reduce the shattering noise of three main engines and two booster rockets, Mission STS-1 will begin. Six seconds later, already traveling 75 miles an hour, the shuttle will clear its support tower at an altitude of 347 feet, with the astronauts pressed by acceleration against their seats.

At eight seconds after liftoff, the shuttle will turn slightly from its vertical flight path toward a trajectory that will put it in orbit. A

critical moment will come 53 seconds into the mission, when the air rushing past the accelerating shuttle will exert its maximum dynamic pressure — 573 pounds per square foot of the spacecraft's cross section. If something is going to come loose or break as the result of dynamic pressure, this is the moment most likely to cause trouble.

Past that point, however, the air thins rapidly and pressures decrease. At 2 minutes 12 seconds after launching, connecting bolts will explode and the shuttle will slough off its two 149-foot solid-fuel rocket boosters.

Each solid-fuel rocket will have consumed its one million pounds of fuel by then. But since the rockets are among the most expensive elements in the Space Transporter System, they were designed to be re-used scores of times. Three huge parachutes will ease each one down into the Atlantic about 7 minutes 13 seconds after the launching, where a ship will be waiting at their calculated splashdown point.

Meanwhile, three hydrogen-powered main engines will continue to accelerate the shuttle, and at 8 minutes 32 seconds after liftoff, the last of the hydrogen and oxygen stored in the huge

external tank will be exhausted. By then the shuttle will be traveling 16,697 miles an hour, 73 miles high and 852 miles out over the Atlantic.

Nineteen seconds later, the external tank will drop off and the orbiter will be on its own. For all future maneuvering, including orbital changes and the "burn" needed to slow the ship for its return to earth, the Columbia will have to rely on its limited supplies of hypergolic propellants — chemicals that ignite spontaneously on contact with one another.

The empty aluminum tank, weighing some 39 tons, will tumble back toward Earth, and is supposed to break up when it hits the atmosphere. Metal chunks of varying sizes will rain down over a swath more than 2,400 miles long in the Indian Ocean.

At 10 minutes 32 seconds after liftoff, the shuttle will fire the first of three maneuvering rocket blasts, each less than two minutes long, designed to smooth the ship's orbit into a circle 173 miles above the earth.

About an hour and 20 minutes after liftoff, the shuttle will complete its first orbit, and if all has gone well so far, the astronauts' work as

Continued on Page C5

An overview of Columbia's maiden flight appears on Pages C2 and C3.

Shuttle could lead to space laboratories, but skeptics wonder if the money should be spent differently. Page C4.

Launching Preparations Still On Schedule, Despite Setbacks

By JOHN NOBLE WILFORD
Special to The New York Times

CAPE CANAVERAL, Fla., April 6 — The countdown for launching the space shuttle Columbia, the world's first reusable winged spaceship, continued around the clock with technicians struggling to make up time lost because of frayed wires and a leaky valve.

Even though preparations were running four hours behind schedule tonight, officials at the Kennedy Space Center here were still aiming for a liftoff at 6:50 A.M. Friday.

If so, the 4.5-million-pound shuttle — the orbiter Columbia, its huge external fuel tank and two solid-fuel rockets — would rise on a tail of flame and vapor, depositing Columbia, piloted by two astronauts, into an orbit 173 miles above Earth.

The plan is for the mission to run 54½ hours, with the Columbia landing Sunday on the hard desert floor at Edwards Air Force Base in California.

To get the countdown preparations back on schedule, however, many technicians will be expected to work through a planned eight-hour rest period tomorrow. They will be repairing wires involved in the short circuit yesterday that caused a propulsion system valve to malfunction.

William Schick, the test director, said, "We hope to be back on the time line by 6 P.M. tomorrow," which would be the end of the rest period, or the countdown "hold."

After a close inspection of the shuttle, Mr. Schick said, engineers discovered a frayed wire with the bare copper showing. This was a wire that led from a control device to a valve in the liquid oxygen piping of Columbia's main propulsion system. It is one of two valves designed to suppress vibrations that, if not damped, could shake the vehicle to destruction.

The defective valve caused a short circuit that blew a fuse in the control device, resulting in the valve sticking in the open position. The wires will be repaired, but that particular circuit will be bypassed, for to have replaced the blown fuse would have caused a postponement in the launching.

Mr. Schick conceded that the result would be a loss of redundancy in the wiring system, but

there would still be two valves, one to take over for the other in case of a malfunction in flight.

"We don't think we'll have any more surprises like that," said Clyde Netherton, chairman of the shuttle countdown working group. "We believe from our checks of each system that if another situation like this existed anywhere else we would have identified it by now."

Mr. Netherton said that it had not been determined how the wire had frayed and gone undetected until yesterday's malfunction.

Another valve created more trouble this morning. While launching crews were pressurizing fuel lines from a ground storage tank to the launching pad, an oxygen valve sprang a leak. It took three hours to change the valve, a further setback to shuttle preparations.

Other activities in the countdown, which began at 11:30 P.M. yesterday, included the cleaning and checking of Columbia's electricity-generating fuel cells, installation of batteries and the warming up of the shuttle's guidance and navigation instruments.

Another eight-hour interruption in the countdown is scheduled for Wednesday and an 11-hour one on Thursday, which should give the launching crews extra time to cope with any new problems that arise.

As launching day approached, officials began casting an anxious eye at the weather. High winds like those that swept through the space center this morning would have forced a postponement, Mr. Netherton said.

Because the astronauts might have to abort the mission shortly after launching and return to a landing on a runway here, flight planners do not want to lift off if headwinds on the runway are more than 25 knots, or if crosswinds and tailwinds are more than 10 knots.

The launching could be held up by weather or other problems Friday morning for more than six hours before it would have to be delayed to another day. Such a delay would be at least 48 hours.

Meanwhile, the astronauts, John W. Young and Capt. Robert L. Crippen of the Navy, spent most of the day practicing descent maneuvers in a shuttle simulator at the Johnson Space Center in Houston. They planned to practice ascent operations tomorrow and are to fly their T-38 jet aircraft to the Kennedy Space Center on Wednesday.

Title:
The Shuttle: America Poised for a Return to Space

Publication:
Science Times,
The New York Times,
April 7, 1981

Art Directors:
Louis Silverstein, Gary Cosimini

Artists:
Karl Hartig, The New York Times
Map Group

Design Department:
The New York Times
New York, NY

Title:
The Shuttle: America Poised for a Return to Space
Publication:
Science Times,
The New York Times,
April 7, 1981
Art Directors:
Louis Silverstein, Gary Cosimini
Artists:
Karl Hartig, The New York Times Map Group
Design Department:
The New York Times
New York, NY

Voyage of the Spaceship Columbia: An Overview

Step by Step

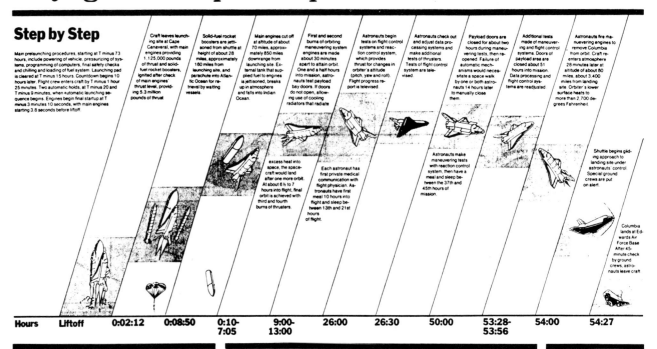

Main prelaunching procedures, starting at T minus 73 hours, include powering of vehicle, pressurizing of systems, programming of computers, final safety checks and chilling and loading of fuel system. Launching pad is cleared at T minus 15 hours. Countdown begins 10 hours later. Flight crew enters craft by T minus 1 hour 25 minutes. Two automatic holds, at T minus 20 and T minus 9 minutes, when automatic launching sequence begins. Engines begin final startup at T minus 3 minutes 10 seconds, with main engines starting 3.8 seconds before liftoff.

Craft leaves launching site at Cape Canaveral, with main engines providing 1,125,000 pounds of thrust and solid-fuel rocket boosters, ignited after check of main engines' thrust level, providing 5.3 million pounds of thrust.

Solid-fuel rocket boosters are jettisoned from shuttle at height of about 28 miles, approximately 160 miles from launching site, and parachute into Atlantic Ocean for retrieval by waiting vessels.

Main engines cut off at altitude of about 70 miles, approximately 850 miles downrange from launching site. External tank that supplied fuel to engines is jettisoned, breaks up in atmosphere and falls into Indian Ocean.

First and second burns of orbiting maneuvering system engines are made about 30 minutes apart to attain orbit. One and a half hours into mission, astronauts test payload bay doors. If doors do not open, allowing use of cooling radiators that radiate excess heat into space, the spacecraft would land after one more orbit. At about 6½ to 7 hours into flight, final orbit is achieved with third and fourth burns of thrusters.

Astronauts begin tests on flight control systems and reaction control system, which provides thrust for changes in orbiter's altitude (pitch, yaw and roll). Flight progress report is televised. Each astronaut has first private medical communication with flight physician. Astronauts have first meal 10 hours into flight and sleep between 13th and 21st hours of flight.

Astronauts check out and adjust data processing systems and make additional tests of thrusters. Tests of flight control system are televised.

Payload doors are closed for about two hours during maneuvering tests, then reopened. Failure of automatic mechanisms would necessitate a space walk by one or both astronauts 14 hours later to manually close them. Astronauts make maneuvering tests with reaction control system, then have a meal and sleep between the 37th and 45th hours of mission.

Additional tests made of maneuvering and flight control systems. Doors of payload area are closed about 51 hours into mission. Data processing and flight control systems are readjusted.

Astronauts fire maneuvering engines to remove Columbia from orbit. Craft re-enters atmosphere 28 minutes later at altitude of about 80 miles, about 3,400 miles from landing site. Orbiter's lower surface heats to more than 2,700 degrees Fahrenheit.

Shuttle begins gliding approach to landing site under astronauts' control. Special ground crews are put on alert.

Columbia lands at Edwards Air Force Base. After 45-minute check by ground crews, astronauts leave craft.

Hours	Liftoff	0:02:12	0:08:50	0:10-7:05	9:00-13:00	26:00	26:30	50:00	53:28-53:56	54:00	54:27

Objectives & Benefits

Applications

Amid some skepticism, NASA expects the shuttle to revolutionize man's use of space. The agency believes the spacecraft will make it possible to loft large payloads, including satellites and heavy equipment, to construct space stations and to serve the needs of industry and medicine. Many of these operations would be accomplished by the craft's ability to carry cargoes up to 65,000 pounds.

Plans for the satellites sent into orbit from the craft envision them assisting scientists in mapping and in the forecasting of weather as well as offering data for agricultural use, collecting solar energy for the earth and performing military tasks. The craft would allow the orbiting of larger satellites, with improved antennas. Astronauts would be able to repair satellites in space and retrieve malfunctioning ones for repair on earth.

Officials believe the near absence of gravity in space will allow several advances in materials processing, particularly of metals, fluids, crystals and biological substances. By the 1980's, it is hoped that new types of glass and alloys, as well as pharmaceutical products and improved crystals for electronic devices, can be made in space.

Companies such as RCA, Western Union and A.T.&T. may make substantial gains in the telecommunications area, if the shuttle succeeds.

International cooperation could benefit since the shuttle would be used to tranport Spacelab, an experimental station being developed by the European Space Agency with NASA.

Although industry is wary, NASA hopes that companies will take advantage of the shuttle for space building. Three companies, Grumman, General Dynamics and Hughes Aircraft, have made studies on construction of solar collectors to provide power for orbiting manufacturing operations.

Drawings by Brad Hamann
Solar power receiving station

Crucial Tests

Many tests and experiments will be made during this and later shuttle flights. In addition to the central task of examining the Columbia's performance during liftoff and landing, the crew will make a number of orbital flight tests, all providing data for evaluation of the vehicle and of ground communications and tracking systems. Experiments on the first mission include the collection of data on the craft's aerodynamics, checks of computers, communications and flight instruments, and a check of life-support systems.

When the craft re-enters the atmosphere, high-resolution infrared images will be taken of the orbiter's lower and side surfaces with a telescope-computer system on NASA's C-141 airborne observatory, a plane that will be at an altitude of approximately 45,000 feet. The data will be used for future improvements in the heat-resistant surface.

Space construction

The Settlement of Space

Space colonies, which once existed only in the fantasies of science fiction writers, are now envisioned by scientists as a way to insure the continuation of the human race in the event of nuclear war or catastrophic pollution on earth.

Some believe the shuttle, by facilitating the movement of workers and materials, could serve as a stepping stone into space. It would allow the construction of orbiting settlements. In this scenario, smaller, lighter shuttlecraft, or "space tugs," would be developed for the movement of lighter loads between the colonies and the earth.

NASA has done much research on the possibility of space settlements. In 1975, the agency's Ames Research Center in Moffet Field, Calif., conducted a joint research project with Stanford University into various aspects of space living, including agriculture, construction, social problems and the effects of weightlessness. Experiments conducted during the Columbia's flight will add to data collected in previous space flights.

A longtime proponent of space colonies is Dr. Gerald K. O'Neill, a Princeton University physicist and author ("The High Frontier"). In 1974, Dr. O'Neill, a participant in the NASA project, organized the First Princeton Conference on Space Colonization.

Text: Joseph Williams

24 Years in Space

1957: Soviets launch Sputnik on Oct. 4.

1958: United States launches first successful satellite Jan. 31.

1961: Soviet Union puts first human in orbit April 12 (Yuri A. Gagarin); Alan B. Shepard Jr. makes first successful United States orbital flight on May 5.

1962: John Glenn, on Feb. 20, becomes first American to orbit the earth.

1963: Air Force's Dyna-Soar manned spacecraft project canceled.

1965: On March 23, first United States two-man mission is launched.

1967: Three Apollo astronauts die in fire on Jan. 27 while training.

1969: Air Force's Manned Orbiting Laboratory is canceled in July; United States lands first men on moon, July 16, 1969.

1970-71: NASA plans shuttle; Congress votes to finance project.

1972: President Nixon authorizes development of shuttle on Jan. 5; Rockwell International made main contractor for shuttle on Aug. 9.

1973: First Skylab crew launched May 25; NASA contracts with European Space Agency to build Spacelab.

1974: Assembly of test shuttle, the Enterprise, begins in summer.

1975: Joint Apollo-Soyuz mission launched July 15 (last scheduled

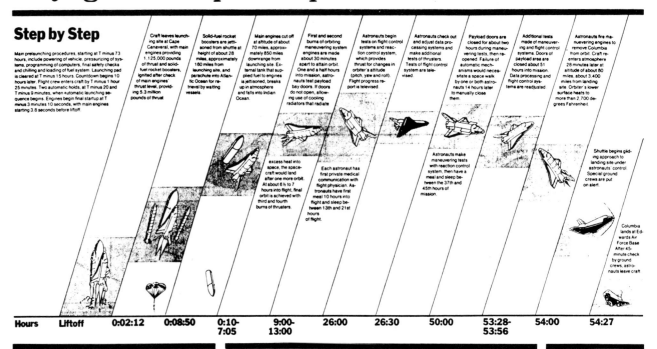

Dr. James Fletcher of NASA and President Nixon in 1972.

United States manned flight before space shuttle); building of the Columbia begins in March. First test of main engines made in October.

1976: Final assembly of Enterprise begins Sept. 17, followed by major checkout of craft's systems.

1977: Manned and unmanned flight tests continue on shuttle orbiter; landing tests begin in August at Dryden Flight Research Center.

1978: Enterprise transported to Marshall Space Flight Center in Alabama. Propulsion tests continue.

1979: Columbia transported from California to Kennedy Space Center, where problems with heat-resistant tiles are found; President Carter promises additional funding, engines pass first full tests Dec. 17.

1980: Shuttle passes simulated flight tests in January; tiles pass critical tests in summer; Columbia moved to launching pad 39A in December.

1981: On March 19, shuttle passes several major tests and accident at launching pad results in death of two workers; on April 2, NASA sets launching date for April 10.

The Future

If the Columbia's flight is successful, shuttle officials hope to have it ready for another test flight in about three months. Eventually, they hope to be able to prepare a craft to return to space two weeks after a mission, but there has been some doubt about this capability.

Plans for regular flights, beginning in late 1982, have already been made by NASA. The next three shuttles, named Challenger, Discovery and Atlantis, are scheduled for completion between late 1982 and early 1985. Future missions depend largely on the success of the Columbia's four test flights, as well as craft modifications, budgetary constraints, flight bookings and the type of cargo to be carried.

The Defense Department started booking flights for its own use in 1973. Except for launching dates, information on Defense Department missions, such as orbit height, cargo and crew size, is classified. More than 20 such military flights are planned by late 1986, representing more than a third of the total number of flights scheduled.

NASA obtained the first commercial booking in 1976. Commercial customers now include the RCA Corporation and A.T.&T. Other clients are foreign governments, such as those participating in the European Space Agency, as well as Australia and Saudi Arabia.

European Space Agency's Spacelab

On the working flights, the most common cargo would be satellites. The shuttle would also be used to carry the European Space Agency's Spacelab, NASA's Space Telescope, Solar Polar satellites and the Galileo probe and orbiter.

The cost for renting the shuttle's entire cargo bay would be some $35 million, but often a number of clients will share the payload area. "Getaway Specials" for small packages, for example one of 60 pounds, would cost about $3,000. Clients have had to make deposits to reserve space.

Most of the shuttle flights, including the next three test flights, would take off from the Kennedy Space Center, but by 1984 the Defense Department hopes to have its launching facility at Vandenberg Air Force Base ready.

There will be various modifications to the craft itself, including the replacement of ejection seats in the Columbia with permanent ones, other changes in crew areas and the upgrading of computer software.

Although the test flights will all carry two-man crews, the number on working flights of the future will be two to six, including mission specialists who would supervise experiments. The usual flight mission will be one to seven days, with flights up to 30 days possible.

Shuttle will launch satellites

Risks

Even with the apparent solution of numerous technical problems and an emphasis on safety in the shuttle's design, there remain a number of potential dangers. For many, uncertainty about safety is increased because all other advanced spacecraft have had precautionary unmanned trials.

One possible problem is a failure in the craft's three main engines in liftoff, which could force a dangerous abort procedure. Another would be the loss of just one of the craft's 30,922 heat-deflecting tiles in re-entry, which could result in the destruction of vital equipment needed for a safe landing.

Columbia test firing, Feb. 20

People

John W. Young, shuttle commander . . . 51 years old . . . graduated from Georgia Tech in 1952 with degree in aeronautical engineering . . . Navy fighter pilot . . . more than 8,000 hours' flying time . . . pilot on first manned Gemini flight on March 23, 1965 . . . command pilot on Gemini 10 July 18, 1966 . . . command module pilot on Apollo 10, May 18-26, 1969 . . . commander of Apollo 16 on April 16-27, 1972 . . . retired from Navy in 1976 . . . married to Susy Feldman . . . children Sandy, 24, John, 22.

Robert L. Crippen, shuttle pilot . . . Navy captain . . . 44 years old . . . aerospace engineering degree from University of Texas in 1960 . . . entered Navy officers program in 1960 . . . attack pilot on aircraft carrier . . . flight instructor in Navy . . . more than 4,275 hours of flight time . . . became NASA astronaut in September 1969 . . . joined NASA in 1969 when project was canceled . . . involved in Skylab project . . . married to Virginia E. Hill . . . children Ellen Marie, 19, Susan Lynn, 17, Linda Ruth, 14.

George F. Page, director of shuttle operations . . . 47 years old . . . served with Army Air Force units in North Africa during World War II . . . worked for Trans World Airlines after the war . . . engineer for Westinghouse Corporation . . . went to Cape Canaveral in 1957 as test engineer with General Dynamics . . . worked on Mercury program . . . joined NASA in 1963 and held several testing positions in Gemini and Apollo programs . . . married to Dorie Price . . . children Steve, 31, Janet, 27, Vicki, 20.

of the Shuttle's Maiden Flight

Anatomy of the Shuttle

1 Space Shuttle System Before Launching

Reusable shuttle orbiter carries two or more crew members

External fuel tank provides liquid hydrogen and liquid oxygen for orbiter's three main engines in ascent. It is 154 feet long with diameter of 27.5 feet

Solid-fuel rocket boosters provide 5.3 million pounds of thrust to lift craft to altitude of 28 miles. The boosters are 149.2 feet long and 12.4 feet in diameter.

2 Dimensions of Orbiter

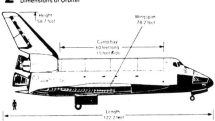

Height 56.7 feet

Wingspan 78.2 feet

Cargo bay 60 feet long 15 feet wide

Length 122.2 feet

3 Major Structures of Orbiter

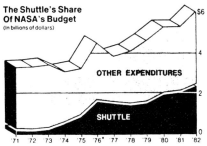

Vertical stabilizer with split rudder/airbrake

Hydraulics systems provide pressure to control pumps, rudder, elevons, landing gear and engine valves

Orbital maneuvering system and reaction control system provide thrust for maneuvers while in space

Doors of payload area open to allow cargo loading or removal

Four hydrogen-oxygen fuel cells provide craft's electrical power

Main engines

Crew compartment includes flight deck and living quarters

Body flaps protect main engines from heat in re-entry

Avionics system includes navigation instruments and six on-board computers to control and monitor craft's operation and provide communications with Earth

Forward thrusters

Wings and elevons provide flight control in landing

Life support system controls air temperature, pressure and quality, and provides drinking water. Radiators on payload bay doors radiate excess heat into space

Main landing gear

Fuselage covered by insulation and almost 31,000 heat-resistant tiles

Nose landing gear

The New York Times / April 7, 1981

Costs

The cost of the program through the first mission was originally set at $5.2 billion, but inflation and technical delays have raised the cost to at least $10 billion. Since the end of the Apollo program, NASA has increasingly focused on the shuttle, with the program now taking about a third of the agency's $6 billion budget as against less than 3 percent of its $3.3 billion budget in the fiscal year 1971.

In addition to the Columbia, three other orbiters are in production, at a cost of more than $600 million each. NASA officials hope that successful test flights will persuade the Reagan Administration and Congress to make further appropriations. In addition, the Defense Department, which would be one of the shuttle's main users, has already spent more than $1 billion in shuttle-related activities and is requesting another $500 million in its budget for fiscal 1982.

The Shuttle's Share Of NASA's Budget
(In billions of dollars)

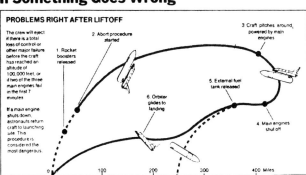

OTHER EXPENDITURES

SHUTTLE

'71 '72 '73 '74 '75 '76* '77 '78 '79 '80 '81 '82

* Includes fiscal year transition cost Source: National Aeronautics and Space Administration

Command Posts

A team of 200 in the firing room of the Kennedy Space Center will control the launching of the shuttle. When the shuttle has cleared the launching tower, flight controllers in the Mission Control Center at the Johnson Space Center in Houston will take over for the flight's duration. During the countdown, the launching and the flight into orbit, experts at the Marshall Space Flight Center in Huntsville, Ala., will monitor data on the main engines, the rocket boosters, and the external fuel tank to detect any problems and provide troubleshooting advice.

NASA's worldwide tracking system, the Spaceflight Tracking and Data Network, will provide voice and computer communications, tracking and telemetry with spacecraft. The system is operated by the Goddard Space Flight Center in Greenbelt, Md., which would also serve as an emergency mission control center if the Houston center were temporarily impaired. All information in the tracking network is routed to the Mission Control Center in Houston.

Political Uncertainties

Defense Secretary **Caspar W. Weinberger** supported the shuttle project when he was director of the Office of Management and Budget in the Nixon Administration. Despite his presence in the current Administration, the Reagan White House has appeared to many **observers** to be noncommittal about the shuttle.

Some of the speculation suggests that Mr. Reagan may have been relatively quiet about the shuttle because he has so far not named a science adviser. His partial disability following the assassination attempt, of course, also would have hindered his involvement in these last days of the project. Uncertainties about the Administration's feelings about the space program extend even to its leadership. There is an acting NASA Administrator, Dr. Alan Lovelace, but no one has yet been named as the permanent Administrator.

Amid all the doubt about this Administration's enthusiasm for the project, one hope of shuttle adherents has already borne fruit: The Administration has in fact proposed an increase in the NASA budget over President Carter's proposals for the fiscal year 1984.

And thus, in the political arena, the shuttle's fortunes seem to be turning. For if this Administration can be described as noncommittal, earlier ones are often described as having been so penurious that they unduly hampered the space shuttle's development.

The possibility that President Reagan will find the program more interesting than did some of his predecessors was given support by a former Apollo astronaut, Harrison H. Schmitt, Republican of New Mexico, who is chairman of the Senate subcommittee on science, technology and space. He recently said that he had met with Mr. Reagan after last fall's election and that he was encouraged by the President's understanding of the importance of space.

United Press International

Caspar Weinberger

Military Significance

Many Defense Department analysts and military strategists, who will be keenly watching the first shuttle flight, believe the re-usable spacecraft will give the nation military superiority in space, especially strengthening its position with respect to the Soviet Union.

Futuristic military scenarios for the shuttle include its use in the construction of manned orbital posts for vehicles that can warn of missile attacks; it might also be used in the assembly of unmanned space stations armed with lasers and other sophisticated weapons.

The space shuttle would carry satellites into orbit for various purposes, including reconnaissance and navigation. An apparatus known as the "inertial upper stage" would be used to boost many satellites to a "geosynchronous" or stationary, orbit, 22,300 miles above Earth.

Military use of the shuttle is advocated by a civilian group, the Alliance for Peace Through Strength, headed by Daniel O.

Graham, a retired general, and a Congressional group headed by Senator Malcolm Wallop, Republican of Wyoming.

There is opposition from some scientists and academics, many of whom fear an arms race in space. Indeed, many opponents, including Dr. James Van Allen of the University of Iowa and Dr. Eric Chaisson of Harvard University, fear the shuttle will be mainly used as a weapon.

Last year, Harold R. Brown, then Secretary of Defense, told the Senate Committee on Commerce, Science and Transportation that the space shuttle was essential to the nation's future military planning. The shuttle's military potential contributed to President Carter's decision to increase its funding.

Weapons of mass destruction are currently banned from space by a 1967 United Nations treaty, but a wide array of lighter weaponry may be possible in the future.

The Soviet Union is known to be developing "killer satellites" that can find and destroy other satellites. A major military impetus for the shuttle was its potential for removing a killer satellite from orbit.

Analysts believe the Soviet Union, which has criticized development of the shuttle, is working on a similar craft of its own, though specialists believe the Soviets are at least a decade away from test flights.

The Air Force plans to build a $450 million space operations center at Peterson Air Force Base in Colorado to direct military shuttle and satellite operations and is requesting $150 million for antisatellite weapons research. The Defense Department is building its own shuttle launching facility at Vandenberg Air Force Base. Research is also under way on laser and particle-beam weapons and sophisticated reconnaissance satellites. The Air Force is seeking additional funding for such research.

If Something Goes Wrong

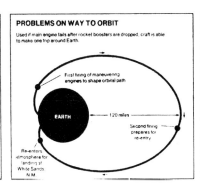

PROBLEMS RIGHT AFTER LIFTOFF

The crew will eject if there is a total loss of control or other major failure before the craft has reached an altitude of 100,000 feet, or if two of the three main engines fail in the first 7 minutes.

If a main engine shuts down, astronauts return craft to launching site. This procedure is considered the most dangerous.

1 Rocket boosters released

2 Abort procedure started

3 Craft pitches around, powered by main engines

4 Main engines shut off

5 External fuel tank released

6 Orbiter glides to landing

0 100 200 300 400 Miles

PROBLEMS ON WAY TO ORBIT

Used if main engine fails after rocket boosters are dropped, craft is able to make one trip around Earth.

First firing of maneuvering engines to shape orbital path

EARTH

120 miles

Second firing prepares for re-entry

Re-enters atmosphere for landing at White Sands N.M.

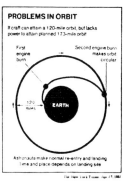

PROBLEMS IN ORBIT

If craft can attain a 120-mile orbit, but lacks power to attain planned 173-mile orbit

First engine burn

Second engine burn makes orbit circular

EARTH

120 miles

Astronauts make normal re-entry and landing. Time and place depends on landing site

The New York Times / April 7, 1981

TUESDAY, JUNE 9, 1981

Copyright © 1981 The New York Times

Science Times

With
Education,
Arts, Sports

The New York Times

L C1

Physicist's Solar Airplane Set to Challenge the English Channel

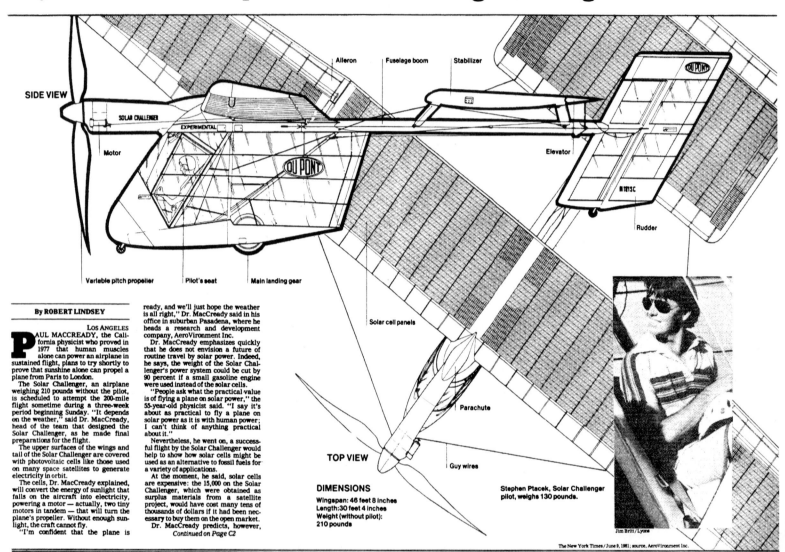

SIDE VIEW

Alleron · Fuselage boom · Stabilizer

SOLAR CHALLENGER

EXPERIMENTAL

Motor

DU PONT

Elevator

Rudder

Variable pitch propeller · Pilot's seat · Main landing gear

DU PONT

Solar cell panels

Parachute

TOP VIEW

Guy wires

DIMENSIONS

Wingspan: 46 feet 8 inches
Length: 30 feet 4 inches
Weight (without pilot):
210 pounds

Stephen Ptacek, Solar Challenger
pilot, weighs 130 pounds.

Jim Britt/Lyons

The New York Times/June 9, 1981; source, AeroVironment Inc.

By ROBERT LINDSEY

LOS ANGELES

PAUL MACCREADY, the California physicist who proved in 1977 that human muscles alone can power an airplane in sustained flight, plans to try shortly to prove that sunshine alone can propel a plane from Paris to London.

The Solar Challenger, an airplane weighing 210 pounds without the pilot, is scheduled to attempt the 200-mile flight sometime during a three-week period beginning Sunday. "It depends on the weather," said Dr. MacCready, head of the team that designed the Solar Challenger, as he made final preparations for the flight.

The upper surfaces of the wings and tail of the Solar Challenger are covered with photovoltaic cells like those used on many space satellites to generate electricity in orbit.

The cells, Dr. MacCready explained, will convert the energy of sunlight that falls on the aircraft into electricity, powering a motor — actually, two tiny motors in tandem — that will turn the plane's propeller. Without enough sunlight, the craft cannot fly.

"I'm confident that the plane is ready, and we'll just hope the weather is all right," Dr. MacCready said in his office in suburban Pasadena, where he heads a research and development company, AeroVironment Inc.

Dr. MacCready emphasizes quickly that he does not envision a future of routine travel by solar power. Indeed, he says, the weight of the Solar Challenger's power system could be cut by 90 percent if a small gasoline engine were used instead of the solar cells.

"People ask what the practical value is of flying a plane on solar power," the 55-year-old physicist said. "I say it's about as practical to fly a plane on solar power as it is with human power; I can't think of anything practical about it."

Nevertheless, he went on, a successful flight by the Solar Challenger would help to show how solar cells might be used as an alternative to fossil fuels for a variety of applications.

At the moment, he said, solar cells are expensive: the 15,000 on the Solar Challenger, which were obtained as surplus materials from a satellite project, would have cost many tens of thousands of dollars if it had been necessary to buy them on the open market.

Dr. MacCready predicts, however,

Continued on Page C2

Title:
Physicist's Solar Airplane Set
to Challenge the English
Channel
Publication:
Science Times,
The New York Times,
June 9, 1981
Art Director:
Gary Cosimini
Artists:
Bob Pasternak,
AeroVironment, Inc.
Design Department:
The New York Times
New York, NY

Space

Putting an Arm on Space

Columbia *is back with upside-down experiments*

Nothing quite like it has ever been attempted in space. As the gleaming white-and-black orbiter hurtles across the skies, a long, mechanical arm, rather like the boom of a cherry picker, will emerge slowly from the spacecraft's cargo bay. Bending and flexing its metallic muscles, the multijointed limb will reach out into space almost as if it were guided by an independent intelligence of its own.

The high-level arm-twisting should be the highlight of the space shuttle *Columbia's* second flight, slated to begin with another thunderous Florida lift-off at 7:30 a.m., E.S.T., this Wednesday.

When the shuttle made its first flight last April, NASA sought to prove to itself and the world that the craft could really roar up into space like a rocket, then glide safely back to earth like a plane. This week the U.S. space agency is engaging in quite another sort of test. Flying "upside down" high above the earth, *Columbia* will try out a $100 million, Canadian-built "arm in space." Unless the Remote Manipulator System, as the huge skyhook is called in NASA jargon, really works, the shuttle will be unable to perform one of its key roles in space: to place satellites into orbit and retrieve them when they fail.

NASA's unsurprising name for the second test of its Space Transportation System is S.T.S.-2. *Columbia* will be piloted by a new crew, Air Force Colonel Joe H. Engle, 49, the lean, affable mission commander who likes to hunt bear with bow and arrow, and Navy Captain Richard H. Truly, 43. Both are veteran pilots who began training as astronauts in the 1960s but who only

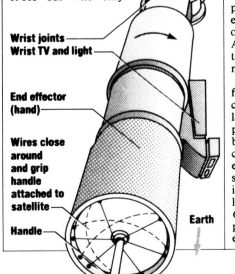

Wrist joints
Wrist TV and light

End effector (hand)

Wires close around and grip handle attached to satellite

Handle

Earth

TV monitors
Shoulder joints
Cargo bay
Spacelab pallet
Upper arm
Elbow joint
Elbow TV
Lower arm

MISSION OBJECTIVES
Testing remote arm

Cabin experiments
1. Filming lightning during thunderstorms on earth
2. Zero-gravity plant growth

Cargo bay experiments
1. Classifying terrain to be studied
2. Mapping geological features
3. Searching for minerals
4. Measuring air pollution
5. Mapping fish and algae distribution

TIME Diagram by Nigel Holmes

now will be making orbital flights. The shuttle will be packed with more fuel and equipment than it was last April, including seven experiments, and it is slated to stay aloft at least five days instead of only two. After 83 complete orbits of the earth, if all goes according to plan, Engle will pilot the orbiter to another dead-stick landing on the dusty, dried-out old lake bed of California's Edwards Air Force Base. Estimated touchdown time: shortly after noon, Eastern time, next Monday, Nov. 9.

For a while it looked like the second flight might never get off the pad. Miscalculations and errors caused repeated delays. In the first flight an unexpectedly powerful shock wave from the initial blast of the shuttle's solid-fuel rockets caused the control flaps on the trailing edge of *Columbia's* delta wings to flutter so wildly that they approached the breaking point. The shock also bent and buckled several of the metal trusses linking *Columbia* to its big external fuel tank. To prevent a recurrence of this near disaster, engineers had to undertake a complete

overhaul of the shock-suppression system, deluging the flame pits on the launch pad beneath *Columbia's* solid-fuel rockets with even more water.

Still another costly delay followed a mishap on the pad that occurred during a supposedly routine fueling operation when a jammed valve caused a back-up of nitrogen tetroxide. The corrosive liquid, which was part of the mix that powers 14 small maneuvering rockets on *Columbia's* nose, spilled down the orbiter's sides, loosening some 50 of the craft's 31,000 heat-shielding tiles and damaging others. In all, 379 tiles had to be detached, cleaned and reglued. One consequence of these nagging mishaps: NASA officials no longer talk of refurbishing, refueling and sending the shuttle back into orbit every two weeks, and have cut the number of flights over the next four years from 44 to only 32.

After reaching an altitude of 158 miles, the astronauts will open the shuttle's big cargo-bay doors, power up their experiments and conduct the usual checkout of the shuttle's systems. Using its maneuvering rockets, *Columbia* will be rolled over, so that the instruments in the cargo

Title:
Putting an Arm on Space
Publication:
Time, November 9, 1981
Designer:
Nigel Holmes
Artist:
Nigel Holmes
Design Department:
Time Magazine
New York, NY

Title:
Columbia Flexes Its Arm
Publication:
Newsweek, November 23, 1981
Art Director:
Thomas R. Lunde
Artist:
Ib Ohlsson
Design Department:
Newsweek Magazine
New York, NY

COLUMBIA FLEXES ITS ARM

Open cargo-bay door

Heat radiators

Arm when stored

Cargo bay

Radar antenna

Over-all length of fuselage: 122 ft.

Over-all length of arm: 50 ft.

TV monitors in cockpit

Shoulder

Upper arm

Elbow joint

Elbow TV

Lower arm

Wrist joint

Air-pollution, geological and ocean-color experiments

Wrist TV and light

Grappling device

Wires

As sleeve is turned, wires close around object.

EARTH

Title:
Columbia Reentry Diagram
Publication:
Science 81, May 1981
Art Director:
Rodney Williams
Designer:
Rodney Williams
Artist:
Frank Krasyk
Design Firm:
Science 81
Washington, DC

Title:
The Long Journey
Publication:
Time, November 24, 1980
Designer:
Paul J. Pugliese
Artist:
Paul J. Pugliese
Design Department:
Time Magazine
New York, NY

Space

MARS
VENUS—SUN—MERCURY
EARTH
Voyager 1 launched Sept. 5, 1977
JUPITER
March 1979

strength of magnetic fields in space) to infrared and ultraviolet spectrometers (used for remote temperature readings and the search for key chemicals). Only one instrument, the photopolarimeter, had failed. By beaming radio signals through planetary clouds and atmospheres, the spacecraft can also use its radio transmitters for scientific investigation. The effect of particles on radio signals, for example,

ten than not cropping up on target exactly in the center of their screens. The secret of this wizardry lies in the lobes of Voyager's electronic brains. Hours before last week's near encounter, the computer memory banks of Voyager 1 were "sequenced" with a series of explicit instructions radioed from earth. So precisely did Voyager 1 carry out these orders that none of its multitude of observations arrived more than 46 seconds off schedule.

Though Voyager 1 was launched from Cape Canaveral, Fla., in 1977, two weeks after an identical twin, Voyager 2, it followed a less curved trajectory and reached Saturn nine months ahead of the other ship. Voyager 2 is not scheduled to pass Saturn until next August. Because it is taking such a different trajectory, Voyager 2 will be able to study some of the moons that had to be bypassed during last week's encounter. It will also be able to sail on

ter's. NASA scientists estimate winds at upwards of 1,300 km (800 miles) per hour.

Saturn's rings also yielded puzzling new findings. Barely had Voyager 1's cameras zeroed in on these thin, elegant discs than scientists spotted two new moons no more than 600 km (370 miles) across at the edge of the ring system. They were designated S-13 and S-14, because they are the 13th and 14th to be discovered. S-13 circles Saturn just outside the so-called F-ring, which is about 80,000 km (50,000 miles) from the planet's cloud tops —the gaseous sphere has no real surface. S-14 revolves just inside that ring. Like dogs herding sheep along a narrow road, the outer moon seems to be keeping ring particles from flying off into space, while the inner moon stops them from falling toward Saturn—as one scientist put it, "controlling an unruly flock."

In pre-Voyager days, astronomers

THE LONG JOURNEY

HYPERION (546,300 miles, Nov. 13, 8:44 a.m.)

TITAN (2,500 miles, Nov. 11, 9:40 p.m.)

TETHYS (258,000 miles, Nov. 12, 2:16 p.m.)

ENCELADUS (125,800 miles, Nov. 12, 5:50 p.m.)

RHEA (44,700 miles, Nov. 12, 10:21 p.m.)

PATH OF VOYAGER 1

DIONE (100,100 miles, Nov. 12, 7:39 p.m.)

MIMAS (55,200 miles, Nov. 12, 5:42 p.m.)

SATURN (77,200 miles, Nov. 12, 3:45 p.m.)

Figures indicate distances and times (in Pacific Standard Time) of Voyager's closest approaches to Saturn and satellites

TIME Diagram—by Paul J. Pugliese

provides clues to such things as the density and makeup of an atmosphere.

Voyager's most useful instruments may be two high-resolution television cameras, one with a wide-angle lens, the other telephoto. The cameras can be pointed in virtually any direction—up, down, to the side, even backward. Their optics are so precise that the cameras can spot features only five miles across from a distance of a million miles. To produce color images, the cameras make successive scans through red, green and blue filters. Transmitted back to earth as three separate sets of signals, the pictures are reassembled by computer from the digital data and combined on color film.

As Voyager 1 soared past Saturn, its eyes constantly twisted and turned, switching their attention back and forth from Saturn itself to its satellites and rings. As a consequence, the scientists watching the television monitors inside J.P.L.'s Building 264 found the images more of-

to Uranus in 1986 and Neptune in 1989. Thus, if the spacecraft's instruments are still functioning, J.P.L. scientists and engineers may eventually achieve a Grand Tour after all.

Even if those ambitions are not realized, Voyager 1's conquest of Saturn is already providing an unexpectedly rich scientific payoff from the $500 million program. Almost as soon as the spacecraft began closing on the Saturnian system, the pace of discovery accelerated dramatically. As early as last August, Voyager 1's cameras picked up a red spot in Saturn's southern hemisphere. Another one soon showed in the northern hemisphere. Though these features remind scientists of Jupiter's Great Red Spot, a great whirling storm that has lasted for at least three centuries, Saturn's spots are smaller, perhaps only 12,000 km (7,500 miles) in diameter. Saturn's atmosphere seems at least as violent as Jupi-

counted no more than about half a dozen rings, all presumed to be composed of icy debris, including snowballs the size of Volkswagens. Though the rings stretched tens of thousands of miles out from the planet, they seemed to be only one or two miles thick. The existence of the F-ring, inferred from sketchy data provided by Pioneer 11, a more primitive spacecraft, was hardly more than a suspicion before Voyager 1. But as the spacecraft's cameras scanned Saturn in ever greater detail, there was an explosive increase in the number of rings visible. Even before the craft passed below the ring plane, the scientists talked of some 90 or so rings. Four days later, when Voyager had started scanning from the underside of the rings, the total rose to at least 500 and perhaps a thousand. The existence of one apparently new ring was deduced in a novel way: from the shadow it cast on the moonlet halves occupying the same orbit.

As more pictures came in, Saturn's

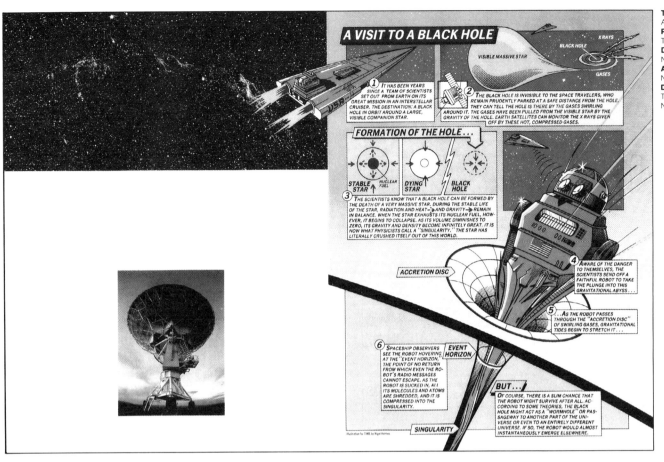

Title:
A Visit to a Black Hole
Publication:
Time, September 4, 1978
Designer:
Nigel Holmes
Artist:
Nigel Holmes
Design Department:
Time Magazine
New York, NY

Title:
Acid Rain: An Increasing Threat
Publication:
Science Times,
The New York Times,
November 6, 1979
Art Director:
Gary Cosimini
Artist:
David Suter
Design Firm:
David Suter
New York, NY

Science Times

With Education, Arts, Sports

The New York Times C1

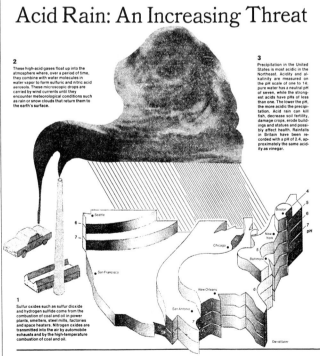

Acid Rain: An Increasing Threat

By BAYARD WEBSTER

TORONTO

THE rapid rate at which rainfall is growing more acidic in more areas has led many scientists and governmental officials to conclude that acid rain is developing into one of the most serious worldwide environmental problems of the coming decades.

Rainfall with an acidity level of vinegar that can have a deleterious effect on aquatic and terrestrial ecosystems has been reported in widely separated areas of the earth in recent years. And the trend toward more acidic rain has been accelerating in eastern Canada, the northeastern and northwestern United States, the southern Appalachians, parts of Florida, and in Europe and sections of Asia.

A three-day conference here last week on acid precipitation and its movement across national boundaries attracted more than 700 scientists, government officials, industrialists and environmentalists from Canada, the United States and Europe. In more than a score of seminars and meetings, discussions and lectures were held on the sources and causes of acid rain, the extent of its air pollution role, possible corrective measures and the outlook for the future.

John Fraser, Canada's Minister of the Environment, who addressed the conference, said in an interview that acid rain was "the most serious environmental problem that Canada faces." He noted that toxic fumes from Canada's smokestacks that caused acid rain were transported across the border to the United States, where they had a damaging impact, just as American emissions carried northward had a major impact in Canada.

"The problem can't be solved without an agreement between the two countries," he said, adding that diplomats were working on a treaty and that President Carter and Canadian Prime Minister Joe Clark were scheduled to discuss joint action when they meet in Ottawa next weekend.

Gus Speth, the chairman of the United States Council on Environmental Quality, told the conference that "too much damage has already been done by acid rain — too many trout lakes and salmon streams have already been rendered lethal to fish, and valuable wilderness areas are beginning to show signs of acidification."

Although many aspects of the physical and chemical actions that occur in the formation of acid rain are not known, scientific research has pinpointed the major events that take place. Acid rain is formed when the gases of nitrogen oxide and sulfur oxide are emitted into the atmosphere and, as they are carried

Continued on Page C2

Scholars Confront the Decline of Technology's Image

By JOHN NOBLE WILFORD

ANN ARBOR, Mich.

IF the symposium had been held a couple of generations ago, or even as recently as 1960, the program title might have been "Technology and Optimism." Those assembled would have peered happily into a wondrous future of endless frontiers, of instant global communications, of more bountiful harvests through chemistry, of longer life and more leisure on earth through technology, and of new worlds to conquer beyond.

But the symposium was held last week — when the experts in Washington were saying there was "no guarantee" against serious nuclear accidents, the political bargain for an arms-limitation agreement seemed to be more money for arms, farms in Michigan were still contaminated with an insidious chemical known as PBB, industrial emissions were causing rain to become more acidic, oil was spilling in the Gulf of Mexico, and a jetliner was crashing — and so the subject under discussion was "Technology and Pessimism."

Whatever their disagreements, the participants agreed that a mood of pessimism is overtaking and may have already displaced the old optimistic view of history as a steady and cumulative expansion of human power, the idea of inevitable progress born of the Scientific and Industrial Revolutions and dominant in the 19th century and for at least the first half of this century. This pessimism is fed by growing doubts about society's ability to rein in the seemingly runaway forces of technology, though the participants conceded

that in many instances technology was more the symbol than the substance of the problems.

The three-day conference was sponsored by the humanities department of the University of Michigan's College of Engineering.

Melvin Kranzberg, professor of the history of technology at the Georgia Institute of Technology, attacked the extreme anti-technology viewpoint and insisted that the very success of technology in the industrial nations has provided people the "luxury" of being able to

Continued on Page C2

387

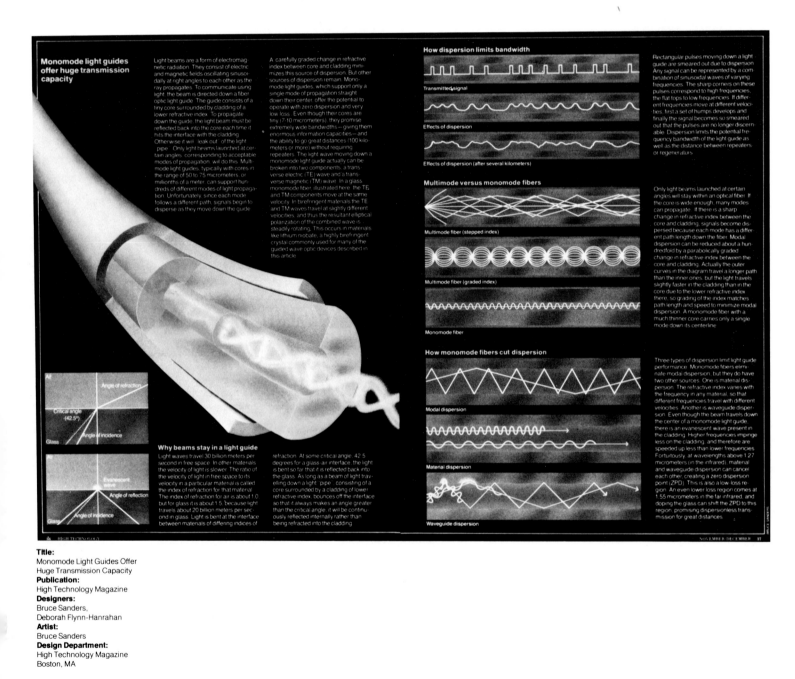

Title:
Monomode Light Guides Offer
Huge Transmission Capacity
Publication:
High Technology Magazine
Designers:
Bruce Sanders,
Deborah Flynn-Hanrahan
Artist:
Bruce Sanders
Design Department:
High Technology Magazine
Boston, MA

The aerodynamics of forward-swept wings

Wing stall: keeping the airflow smooth

A wing stalls when the airflow meets it at too high an angle and can no longer conform to the surface. The higher pressure in this separated flow region results in loss of lift and control effectiveness. These wing cross sections follow the progression of separated flow with increasing angle of attack, from relatively insignificant separation to full stall. Pressure changes seen by the flow moving over the wing cause it to separate and move away from the wing. These pressure differences become greater as the angle increases, and the separated region creeps forward as the angle becomes greater. At the "stall angle," the pressure differences are great enough that this region jumps forward and the entire flow detaches: the wing stalls.

Stall progression spreads stagnant air over wings at low speeds

Looking at the air flow on an actual wing, the stall moves along the wing as well as from back to front with increasing angle of attack. Typical stall progression is shown beginning with the lighter shaded area, increasing to the darker areas. The flow along swept wings confines the initial stall region near the wingtip (aft sweep) or root (forward sweep). Good design places control surfaces in smooth flow where they push against the air. Forward sweep uses ailerons at the tips to maintain roll control.

Using the canard to increase lift

A lifting surface generates a spiralling vortex from its tip as air flowing past curls around from higher pressure below to lower pressure above. The diagram shows this effect for a canard surface ahead of a forward-swept wing. The rotating air mixes with the higher speed air above the aircraft that is not slowed by friction and pressure. This higher energy air is carried down by the vortex to the wing surface and pushes the separated flow region further back, inhibiting stall formation.

Engine nozzle
Base of vertical fin
Greatest span of wings
Start of wing leading edge
Engine inlets
Cockpit
Nose tip

Engine nozzle
Base of vertical fin
Start of wing leading edge
Engine inlets
Cockpit
Nose tip

Area rule: smoothing the profile to slip through the air

The smoother the cross sectional area of an aircraft along its length, the fewer shock waves formed at discontinuities, reducing wave drag. The diagram plots the cross-sectional area below the aircraft, showing that the area curve is much smoother for the forward-swept aircraft. If the conventional design is pinched near the center of gravity to make a wasp-waist, the area distribution is smoothed out at the expense of useful volume. Designers also try to reduce the maximum area that any aircraft presents to the airflow, despite such inconveniences as engines, radar, and crew members.

Shock waves soak up momentum in trans- and supersonic flight

Shock wave patterns generated at aircraft area discontinuities change with the Mach number. The waves are essentially flat planes for an aircraft flying at the speed of sound (Mach 1). For speeds greater than Mach 1, shock waves are tilted back along the aircraft forming conic surfaces. These wind tunnel photographs show a model of the Space Shuttle at Mach 0.95 and Mach 1.2.

Title:
The Aerodynamics of Forward-Swept Wings
Publication:
High Technology Magazine
Designers:
Bruce Sanders,
Deborah Flynn-Hanrahan
Artist:
Deborah Flynn-Hanrahan
Design Department:
High Technology Magazine
Boston, MA

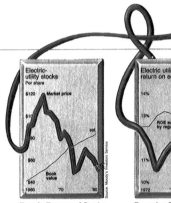
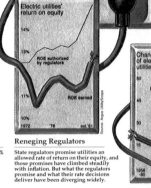
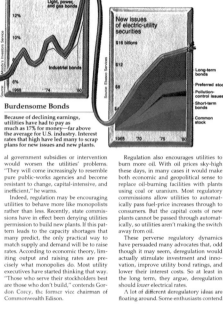

A Financial Overload That Could Lead to Brownouts

Electric-utility stocks
Per share
$120
$100
$80
$60
$40
Market price
est.
Book value
1960 '70 '80
Source: Moody's Investors Service

Electric utilities' return on equity
14%
13%
12%
11%
10%
ROE authorized by regulators
ROE earned
1972 '76 est. '81
Source: Argus Utilityscope

Changes in ratings of electric utilities' debt
60
45
30
15
Downgradings
Upgradings
1956 1966 1976
-60 -70 -80
Source: Moody's Investors Service

Yields of new utility and industrial bonds
Average yields
14%
12%
10%
8%
6%
Light, power, and gas bonds
Industrial bonds
1969 '74 '80
Source: Moody's Investors Service

Nonstop Capital Needs
In 1980 the industry's capital spending hit $26 billion, almost half of which came from cash flow or bank loans. To raise the rest, utilities have relied heavily on volatile short-term borrowing and costly equity financing.

New issues of electric-utility securities
$16 billions
$12
$8
$4
Long-term bonds
Preferred stock
Pollution-control issues
Short-term bonds
Common stock
1965 '70 '75 '80
Source: Edison Electric Services

Deeply Depressed Stocks

Lenders expect utilities to raise about 38% of their capital through common-equity issues. With utility stocks now selling way below average book value, issuing new shares amounts to expropriating the capital of existing investors.

ers to hold the rates down. With no experience in predicting demand and costs in inflationary times, commissioners often did the politically safe thing and denied the utilities' frequent pleas for higher rates. When the regulators did grant relief, it was after months or years of study and testimony, by which time inflation had brought the companies back again with hat in hand.

To the extent that prices were permitted to rise, they caused a demand for electricity to grow at a slower rate—from an average of more than 7% a year during the 1960s to less than half that in the Seventies. That left the companies with more new generating capacity under construction than they could immediately use or pay for. In desperation, they canceled many projects, including some that would have replaced existing plants burning expensive imported oil.

Reneging Regulators

State regulators promise utilities an allowed rate of return on their equity, and those promises have climbed steadily with inflation. But what the regulators promise and what their rate decisions deliver have been diverging widely.

Now the surplus capacity is vanishing. With demand projected to be growing by 3.5% to 4.5% a year, some parts of the country may possibly experience brownouts by the late Eighties—or in less time than it takes to build a new base-load power plant. According to the Edison Electric Institute, the new equipment required in this decade will cost in the range of $500 billion. As the charts above make clear, the utilities aren't in a position to raise that kind of money easily.

Getting the government out

This is the conundrum that has brought the idea of deregulation out of the ivory tower and into the political arena. Until recently, the main alternatives being considered were some form of government subsidy to the private power companies and outright public ownership. In fact, creeping nationalization is already taking

Run-Down Ratings

Once the safest earnings producers around, utilities enjoyed high and rising bond ratings. But raters now regard utilities as increasingly risky enterprises, and more than a third of their new bond issues carry Moody's low rating of Baa.

place. In 1974, New York's Consolidated Edison Co. sold off two unfinished power plants to New York State and will buy back some of their power. Similar trends are visible elsewhere—for example in the Pacific Northwest, where the Bonneville Power Administration underwrites plant construction.

Many wonder whether it wouldn't be better to try to get government further out of the utility business than further in. John Bryson, a former environmental lawyer whom Governor Jerry Brown appointed president of the California Public Utilities Commission, fears that addition-

Burdensome Bonds

Because of declining earnings, utilities have had to pay as much as 17% for money—far above the average for U.S. industry. Interest rates that high have led many to scrap plans for new issues and new plants.

al government subsidies or intervention would worsen the utilities' problems. "They will come increasingly to resemble pure public-works agencies and become resistant to change, capital-intensive, and inefficient," he warns.

Indeed, regulation may be encouraging utilities to behave more like monopolists rather than less. Recently, state commissions have in effect been denying utilities permission to build new plants. If this pattern leads to the capacity shortages that many predict, the only practical way to match supply and demand will be to raise rates. According to economic theory, limiting output and raising rates are precisely what monopolies do. Most utility executives have started thinking that way. "Those who serve their stockholders best are those who don't build," contends Gordon Corcy, the former vice chairman of Commonwealth Edison.

Regulation also encourages utilities to burn more oil. With oil prices sky-high these days, in many cases it would make both economic and geopolitical sense to replace oil-burning facilities with plants using coal or uranium. Most regulatory commissions allow utilities to automatically pass fuel-price increases through to consumers. But the capital costs of new plants cannot be passed through automatically, so utilities aren't making the switch away from oil.

These perverse regulatory dynamics have persuaded many advocates that, odd though it may seem, deregulation would actually stimulate investment and innovation, improve utility bond ratings, and lower their interest costs. So at least in the long term, they argue, deregulation should *lower* electrical rates.

A lot of different deregulatory ideas are floating around. Some enthusiasts contend

that the whole electric-power business—generation, wholesale transmission, and local distribution—could be deregulated at no cost to society. They argue that existing services such as do-it-yourself power production and conservation already offer adequate safeguards against monopoly-style pricing by utilities.

An objection to redundant grids

But the more cautious majority argues only for deregulating the generation end of the business. Many contend that the economy-of-scale justification for regulating may recently have been reversed, partly by safety requirements and licensing delays that roughly double the time it takes to build a big plant and tie up huge amounts of capital. On the other hand, these proponents reason that it would be economically wasteful and aesthetically objectionable to permit duplication of national and local power grids. Under some proposals, transmission companies would operate as regulated common carriers. Under others, they and distribution companies would be regulated buyers and sellers of competitively produced electricity, just as natural-gas pipelines and local gas companies are.

A big point of contention among the deregulators is just how you go about deregulating part of an industry and not the rest. Some think that if you deregulated electricity at the point of generation, utilities would have ample incentive to buy the cheapest power no matter who produced it. But others fear that vertically integrated power companies would prefer their own power to that supplied by others. They advocate requiring such utilities to set up separate generation subsidiaries, or even separate companies, to ensure arm's-length dealing. This approach resembles the one currently being pursued in the government's efforts to restructure AT&T, which wants to get into such businesses as data processing and electronic mail in competition with other companies.

Two years ago, a law student at Yale named Matthew Cohen drew up a fairly

Charts by Joel Naprstek

Title:
A Financial Overload That Could
Lead to Brownouts
Publication:
Fortune, July 13, 1981
Art Director:
Ronald Campbell
Designers:
Jean Held, John Martinez
Design Department:
Fortune Magazine
New York, NY

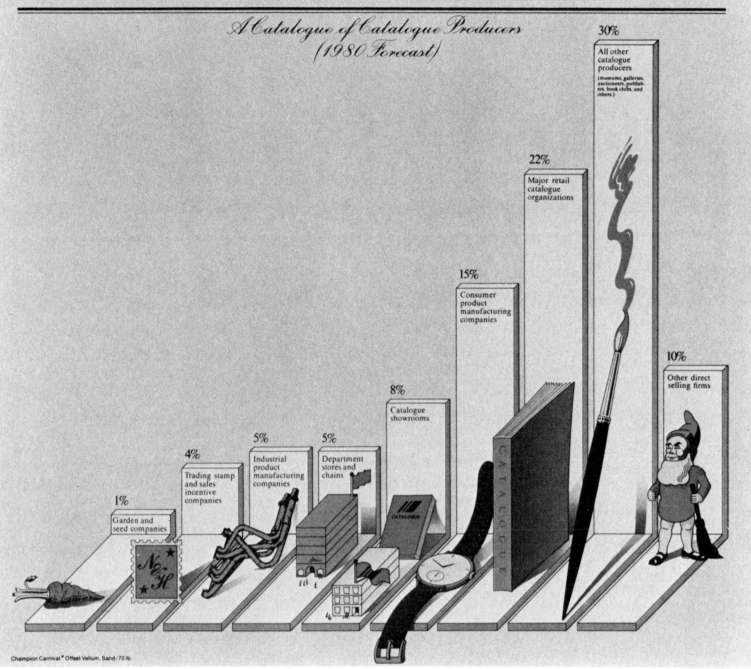

A Catalogue of Catalogue Producers
(1980 Forecast)

1% Garden and seed companies

4% Trading stamp and sales incentive companies

5% Industrial product manufacturing companies

5% Department stores and chains

8% Catalogue showrooms

15% Consumer product manufacturing companies

22% Major retail catalogue organizations

30% All other catalogue producers (museums, galleries, auctioneers, publishers, book clubs, and others.)

10% Other direct selling firms

Champion Carnival® Offset Vellum, Sand/70 lb.

Title:
A Catalogue of Catalogue Producers: 1980 Forecast
Publication:
Champion Papers: Imagination XXIII
Art Director:
James Miho
Artist:
Nigel Holmes
Design Firm:
Nigel Holmes
New York, NY

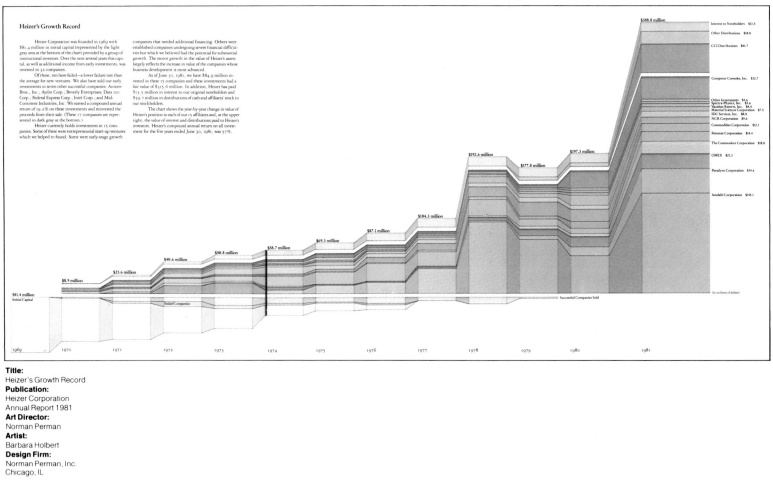

Heizer's Growth Record

Heizer Corporation was founded in 1969 with $81.4 million in initial capital (represented by the light gray area at the bottom of the chart) provided by a group of institutional investors. Over the next several years this capital, as well as additional income from early investments, was invested in 32 companies.

Of those, ten have failed—a lower failure rate than the average for new ventures. We also have sold our early investments in seven other successful companies: Anixter Bros., Inc.; Aydin Corp.; Beverly Enterprises; Data 100 Corp.; Federal Express Corp.; Intel Corp.; and Mid-Continent Industries, Inc. We earned a compound annual return of 19.2% on these investments and reinvested the proceeds from their sale. (These 17 companies are represented in dark gray at the bottom.)

Heizer currently holds investments in 15 companies. Some of these were entrepreneurial start-up ventures which we helped to found. Some were early-stage growth companies that needed additional financing. Others were established companies undergoing severe financial difficulties but which we believed had the potential for substantial growth. The recent growth in the value of Heizer's assets largely reflects the increase in value of the companies whose business development is most advanced.

As of June 30, 1981, we have $84.9 million invested in these 15 companies and these investments had a fair value of $315.6 million. In addition, Heizer has paid $13.5 million in interest to our original noteholders and $59.7 million in distributions of cash and affiliates' stock to our stockholders.

The chart shows the year-by-year change in value of Heizer's position in each of our 15 affiliates and, at the upper right, the value of interest and distributions paid to Heizer's investors. Heizer's compound annual return on all investment for the five years ended June 30, 1981, was 57%.

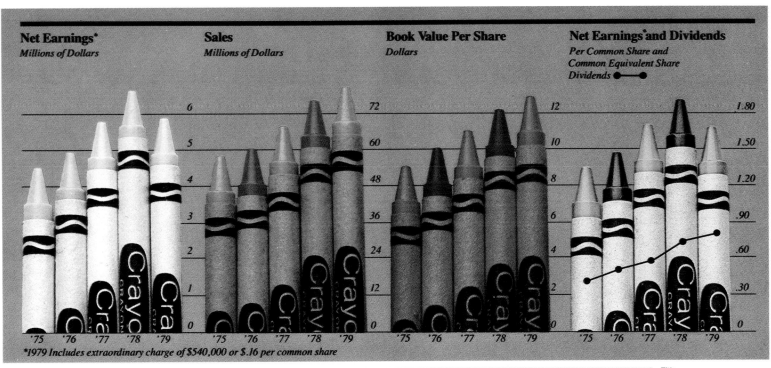

Net Earnings*

Millions of Dollars

6
5
4
3
2
1
0

'75 '76 '77 '78 '79

Sales

Millions of Dollars

72
60
48
36
24
12
0

'75 '76 '77 '78 '79

Book Value Per Share

Dollars

12
10
8
6
4
2
0

'75 '76 '77 '78 '79

Net Earnings*and Dividends

*Per Common Share and
Common Equivalent Share
Dividends ●━━●*

1.80
1.50
1.20
.90
.60
.30
0

'75 '76 '77 '78 '79

**1979 Includes extraordinary charge of $540,000 or $.16 per common share*

Title:
Financial Highlights
Publication:
Binney & Smith Annual Report
1979
Art Director:
Beau Gardner
Artist:
Frank Ziella
Design Firm:
Beau Gardner Assoc., Inc.
New York, NY

Title:
Heavy Weather
Publication:
The Week in Review,
The New York Times,
September 27, 1981
Art Director:
John Cayea
Artist:
Jean-Francois Allaux
Design Firm:
Jean-Francois Allaux
New York, NY

Editorial and Op-Ed pages, 20-21

Education Advertising
Careers in Education and
Health Care Employment

Copyright © 1981 The New York Times

The New York Times

THE WEEK IN REVIEW

Section **4**
Sunday, September 27, 1981

Heavy Weather

Interest Rates Seem in No Hurry to Fall

By JONATHAN FUERBRINGER

WASHINGTON

THE long-awaited decline in interest rates, necessary to give President Reagan's economic program a chance, is still long awaited. Despite a drop in the prime lending rate last week, the rest of the economic signals were a reminder that there are as many forces holding interest rates up as pushing them down; and that Mr. Reagan is caught between these forces even as he adds to the pressures that keep rates up. His outline of future spending cuts, far from reassuring the financial markets, played into the fear that promises of a balanced budget in 1984 will not be made good by Congress.

Worries about future deficits, current inflation and the Federal Reserve Board's restrictive monetary policy combine to create the dour expectations of Wall Street. The dip in the prime, to 19.5 percent, wasn't 24 hours old when Congress responded negatively to the White House's new budget cut notions and the Treasury announced a new round of borrowing. That, together with a draining of reserves from the banking system by the Fed — interpreted as a signal that the money supply may be tightened again — kept short-term rates from falling further; some long-term rates pushed up again.

A sign that interest rates may be declining, such as the one given by the prime last week, can still make headlines. But the declines are not what they used to be. "Interest rates," A. Gilbert Heebner of the Philadelphia National Bank said last week, "will only be coming down in a grudging way." Some economists, like H. Erich Heinemann of Morgan Stanley & Co., call the markets' long wait for proof that the Administration and Congress can cut the budget more than once the "risk premium." The risk is that deficits will continue to grow.

Meanwhile, the decline in the inflation rate has not yet been steep or long enough to turn any heads, as last week's report that August's consumer price increase was eight-tenths of 1 percent demonstrated. Some economists contend that it could be nine months or more before even a moderating trend will be believed.

Perceptions Matter Like Fact

The concerns over deficits and inflation are now feeding one another. But while market expectations and interest rates are actually influenced by inflation prospects, the effect of deficits on rates and inflation is more psychological. For instance, a $75 billion deficit in 1982, as a percentage of the gross national product, would be about the same size as the deficits in 1977 and 1978. Today, however, simply the perceived effect carries weight.

Then there is the Federal Reserve, whose policy of curbing inflation through a slow decline in the rate of growth in the money supply is, in today's climate, a prescription for continued high rates. Officials from chairman Paul A. Volcker on down say the Fed won't ease up now, and even easing would bring only temporary relief. The markets would bet that faster money growth would lead to a new round of inflation. The markets would then play their inflation trump, quickly pushing rates up again.

These are the pressures keeping interest rates high. Working against those pressures is the downward pressure of the economy, which continues to be sluggish if not in recession now or soon, as 53 percent of those attending the National Association of Business Economists last week concluded. A slower economy means less demand for borrowing, and so less pressure on rates. Interest-rate watchers have also expected that the Fed's recent move to bring the closely watched component of the money supply called M-1B up to or just near the bottom of its target range would ease pressure by supplying new credit.

Different analyses bring different results. The Reagan Administration is positive, betting that changing expectations and continued moderation in inflation will bring interest rates down soon. The Congressional Budget Office is somewhat optimistic, following the Administration's overall outlook fairly closely but parting company when it comes to interest rates. Officials at the Fed meanwhile acknowledge that their restrictive policy for 1982 will continue to inhibit economic growth and could keep the prime rate, for instance, at 15 percent or higher.

Many independent economists also don't see much improvement. Wharton Econometrics predicts that the prime rate will be around 20 percent at the end of this year; last week, the business economists put the rate at the end of 1982 at 15.1 percent.

Allen Sinai of Data Resources Inc. sees some hope for his clients now, because of the Fed's recent moves on M-1B and the slow economy. But "it must be remembered," said Mr. Sinai, summarizing the markets' position and Mr. Reagan's bind, "that the bond market normally does not register major improvements on better inflation rates until a year or two after a turn on prices (inflation) has occurred. The bond markets continue to need more evidence of a full-fledged recession, (and) a new round of budget cuts for additional improvements to occur."

Polish brinkmanship felt also in Moscow and Eastern Europe

4,5

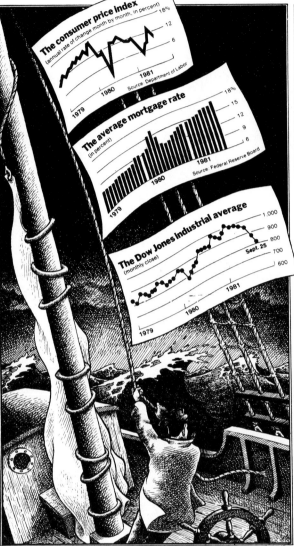

The consumer price index
(annual rate of change month by month, in percent)
18%
12
6
1979 1980 1981
Source: Department of Labor

The average mortgage rate
(in percent)
18%
15
12
9
6
1979 1980 1981
Source: Federal Reserve Board

The Dow Jones Industrial average
(monthly close)
1,000
900
Sept. 25
800
700
600
1979 1980 1981

Jean-François Allaux

Major News

In Summary

President Moves Closer to the Budget Bone

President Reagan almost always *looks* like a winner on prime time, but it remains to be seen how well last week's call for patience and some sacrifice will play in Washington and beyond.

After conceding that Reaganomics wasn't the moral equivalent of a quick fix, he asked the Congress to make deep cuts in domestic programs while giving the Pentagon's share of the budget only the slightest of shavings. And he served notice on the board rooms of the land that he will seek tax code changes designed to bring in an additional $3 billion next year, most of it wrung out of business.

"The important thing now," said Mr. Reagan, "is to hold to a firm, steady course." To reduce Government spending by $13 billion in the 1982 fiscal year and thus hold the deficit to $43.1 billion — making a balanced budget perhaps possible by 1984 — Mr. Reagan asked Congress to cut:

• Spending for such mandated entitlement programs as Medicare and food stamps. (But he backed away from a proposal to delay cost-of-living increases for recipients of Social Security payments, maintaining that "Our feet were never embedded in concrete on this point." [Social Security options, page 3.])

• Discretionary spending—outlays not required by law — by 12 percent in most civilian agencies and programs.

• Nearly $20 billion in Federal loan guarantees, which the President criticized as "back-door, uncontrolled borrowing."

• The number of Federal employees (except for the Pentagon's white-collar legion) by 75,000.

Other revenues will be produced, he said, if Congress follows his advice and permits a crackdown on deadbeats who owe Washington money and increases user fees for a variety of currently free-of-charge Federal services.

Further, Mr. Reagan said he wanted to speed up the timetable for scrapping two Government departments, Energy and Education.

Democrats were predictably critical, and some influential Republicans said they doubted that the President would get the cuts he wants. Senator Jake Garn, the conservative Republican from Utah who heads the Banking Committee, said, "It's unrealistic to think we can cut 12 percent across the board in programs that we've already cut." Senate Majority Leader Howard H. Baker Jr., a Republican from Tennessee, predicted that Congress would "almost certainly" trim the military's budget by more than the $2 billion the White House proposed. (Perhaps coincidentally, the Pentagon plans to make public this week a detailed report on Soviet firepower. Apparently the Administration hopes to impress the Atlantic alliance, and the American Congress, with the unmatched military buildup under way in the East.)

Budget Director David A. Stockman warned that the Administration stood ready to use the veto as "an enforcement tool." But the difficulties of making reductions stick was made clear late in the week. Government spokesmen said that plans for lowering the nutritional requirements for school lunches were being temporarily scrapped.

Koch Redefines 2-Party Politics

Those who find history boring might have dozed off as they watched it being made at the New York City polls last week. In a political coup that capped weeks of utterly bearable suspense, Mayor Koch became the first city candidate to win Democratic *and* Republican nominations.

Disaffected minority voters dampened the accomplishment a bit, turning out in unusual strength to support Mr. Koch's opponents in the primaries, Democrat Frank A. Barbaro and Republican John A. Esposito. The two apparently collected enough black votes to deprive the Mayor of the record majority he sought. Nevertheless, he likened the feat of capturing 60 percent of the Democratic vote and two-thirds of the Republican vote to climbing the World Trade Center, if not Mt. Everest.

While the question of when the races would be held often generated more interest than that of who would win them (the Justice Department having delayed citywide and boroughwide primaries 12 days and councilmanic races for months because of Voting Rights Act violations), some side issues emerged.

Elizabeth Holtzman's victory over Norman J. Rosen, the party leadership's candidate for the Democratic nomination for Brooklyn District Attorney, was seen by some to signal a fading pulse for the Brooklyn Democratic organization.

While Harrison J. Goldin easily defeated John C. Dearie to win renomination as the Democratic contender for City Comptroller, Andrew J. Stein had a rough time beating City Clerk David N. Dinkins for Manhattan Borough President. Mr. Dinkins got 47 percent of the vote despite an early line that said he would be trounced, since the incumbent outspent him by two-to-one. The City Clerk thus laid claim to a pivotal role among the city's black political leaders. (More on the primaries, page 6.)

Reagan Holds To the Course That Brought Him This Far

By ADAM CLYMER

THE pragmatist and the conservative true believer in Ronald Reagan fought over economic policy again last week. The true believer won. Calling for more slashes in domestic spending and just a nick out of defense, he demanded that a weary Congress go back at the budget until they get it right.

Even critics like Charles T. Manatt, chairman of the Democratic National Committee, conceded that the television address was "as always, a good political speech." There was firmness, reassurance, and even an untypical call for sacrifice, along with the $13 billion solution.

But in the capital, there seemed to be dubious prospects that Mr. Reagan would get the cuts he wanted, in the way he wanted them. Mr. Reagan had been told that, however, before his speech. So his response reflected confidence in the correctness of his approach, recognition of the necessity to cut the deficit, and perhaps faith in his ability to confound the conventional thinkers and win, rather than the warnings of the doubters.

Even though Mr. Reagan came to Washington with a reputation for having shrewdly compromised when he was Governor of California, his record here has been one of insisting on major items, and dealing only around the edges. For example, on the tax bill, almost all the "concessions" he made to buy votes lowered taxes he didn't like much anyway. So his response Thursday was not really all that unlikely.

What happens if he loses, if indeed the results are that clear? Democrats would shout that his remarkable winning streak had been broken and that he was on the run. But really, a Presidency succeeds by winning much of the time, not all the time. And he has a lot of crucial victories in his column already.

Mr. Reagan could indeed lose the next fight for budget cuts without irreparable damage to his Presidency, without losing forever the ability to extract more reductions. The argument that the Congress is scarred and tired of politically painful budget cutting now, but could do it again next year if his popularity remains high, is not rendered false because he rejected it Thursday. The argument could turn out to be true next March anyhow, and a fleeting setback might be welcome political ammunition for Republicans in the 1982 elections, as Democratic poll taker Peter D. Hart suggested.

Variations of Firmness

But there is also a risk that if Congress discovers that Mr. Reagan is not invulnerable after all, it will worry more about the political interests of its many constituencies than about the expectations of the national mood it learns from opinion polls and televised speeches. Mr. Reagan may find himself embattled in the ways that most recent Presidents have been.

Clearly, the President was not choosing the only possible course. There were those among the President's advisers who counseled a different tack, one that would have argued that firmness consisted of trying to face down the financiers, not the lawmakers. This camp argued that the markets demanded too much, that substantial cuts had already been made in the budget, that promises had been made on Capitol Hill that had to be kept, and that next year was soon enough to expect more.

Some in the Administration think it should have been more stoical, arguing that the near panic voiced by wavering Republican lawmakers after Labor Day proved contagious. It is Mr. Reagan's argument, of course, that nothing has yet failed to work, since the tax cuts don't begin until this week. Even so, his plan did include the expectation of prompt Wall Street enthusiasm. That hope persisted in the Administration through the summer excitement of passing budget and tax bills, even if there was no evidence that it would come true.

The question of what the Administration might have done about the problems as they developed in August and September is frequently asked, but there are a few obvious answers. Cutting defense spending is an approach Mr. Reagan plainly considers dangerous; slashes in domestic spending generally hurt programs he does not like to tangle with. Seeking to postpone the tax cut voted in July would have amounted to a very quick admission that it was much less than the sound economic maneuver which Mr. Reagan enthusiastically labeled it only two months ago on national television.

A Push Too Soon?

There does seem to have been one thoroughly avoidable White House contribution to the problem — the President's four-week vacation. It dissipated the enthusiasm of the votes on the tax cut and made the Administration of September seem more like a new volume than just the next chapter. And in the process that heightened the impact of the bad news on interest rates.

However they developed there are indeed problems now. Republicans like Representative Jim Leach of Iowa, the new head of the Ripon Society, offer broadsides against the conservatism of the Administration and promised to try to tackle the Pentagon budget. Democrats met last week in Des Moines sounding upbeat, telling themselves that changing their Presidential nominating rules again may matter more than they once thought, for they may be not picking just a nominee but a President.

Pushing Congress for budget cuts so soon again may invite a resistance that will change a summer mood of some real political self sacrifice (not unblemished with opportunism) back to politics as usual, a willingness to talk about budget cuts overcome by an unwillingness to vote for them.

These are some of the short-term risks in the Administration's situation. But they can be exaggerated in their importance. An ABC News/Washington Post poll showed last week that even though there appears to be rising public willingness to consider the budget cuts as already too severe, Mr. Reagan's approval rating is undiminished, steady at 61 percent. Even when public concerns begin to focus on his basic strength, expectations about the economy, they don't yet seem to rub off on him personally.

Mr. Reagan's frequent and consistently successful use of television gives him one critical advantage over his predecessors in their times of trouble. President Nixon could use television effectively in self-defense when he was challenged on foreign policy, but it failed him during the Watergate mess. Presidents Carter and Ford had only rare moments of electronic effectiveness. But Mr. Reagan has used it masterfully, both on the American people as a whole and on a more select audience, such as the House of Representatives in July. However, the early returns from Wall Street on Friday showed that it had not been impressed; bond and commodity prices plunged and the Dow Jones average dropped 11.13 points, closing at 824.01.

That underlined the fact that just as he could lose on this latest round of cuts and still succeed in the end, Mr. Reagan could succeed now and fail ultimately — if his program does not work.

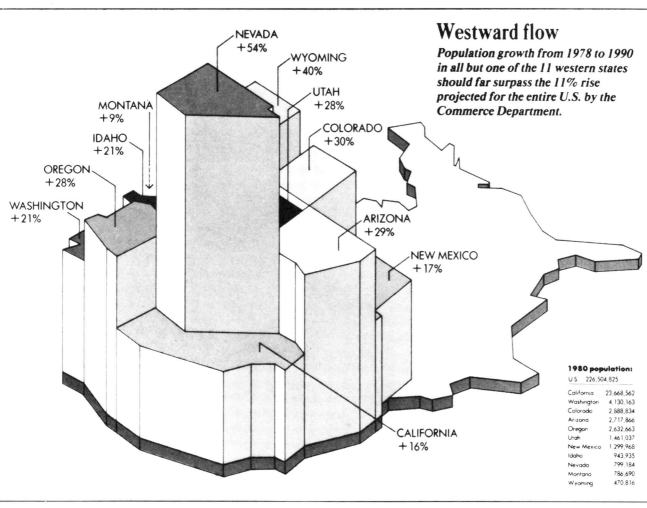

Westward flow

Population growth from 1978 to 1990 in all but one of the 11 western states should far surpass the 11% rise projected for the entire U.S. by the Commerce Department.

NEVADA +54%

WYOMING +40%

UTAH +28%

MONTANA +9%

COLORADO +30%

IDAHO +21%

OREGON +28%

ARIZONA +29%

WASHINGTON +21%

NEW MEXICO +17%

CALIFORNIA +16%

1980 population:

U.S.	226,504,825
California	23,668,562
Washington	4,130,163
Colorado	2,888,834
Arizona	2,717,866
Oregon	2,632,663
Utah	1,461,037
New Mexico	1,299,968
Idaho	943,935
Nevada	799,184
Montana	786,690
Wyoming	470,816

Title:
Westward Flow
Publication:
Money Magazine, November 1981
Art Director:
Robert Dougherty, Bruce Blair
Artist:
Nigel Holmes
Design Departments:
Money Magazine,
Time, Inc.
New York, NY

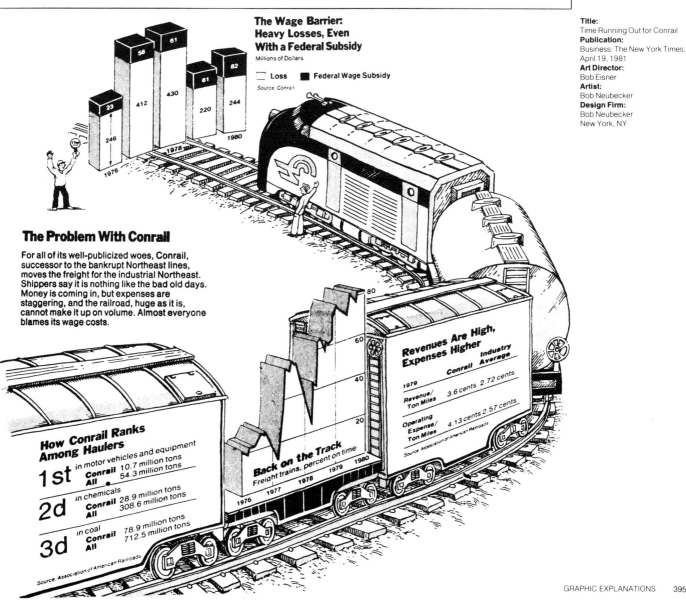

The Wage Barrier: Heavy Losses, Even With a Federal Subsidy

Millions of Dollars

☐ Loss ■ Federal Wage Subsidy

Source: Conrail

23 / 246 / 1976

58 / 412 / 1978

61 / 430

61 / 220

82 / 244 / 1980

The Problem With Conrail

For all of its well-publicized woes, Conrail, successor to the bankrupt Northeast lines, moves the freight for the industrial Northeast. Shippers say it is nothing like the bad old days. Money is coming in, but expenses are staggering, and the railroad, huge as it is, cannot make it up on volume. Almost everyone blames its wage costs.

How Conrail Ranks Among Haulers

1st in motor vehicles and equipment
Conrail 10.7 million tons
All 54.3 million tons

2d in chemicals
Conrail 28.9 million tons
All 308.6 million tons

3d in coal
Conrail 78.9 million tons
All 712.5 million tons

Source: Association of American Railroads

Back on the Track
Freight trains, percent on time
1976 1977 1978 1979 1980

Revenues Are High, Expenses Higher

1979	Conrail	Industry Average
Revenue/ Ton Miles	3.6 cents	2.72 cents
Operating Expense/ Ton Miles	4.13 cents	2.57 cents

Source: Association of American Railroads

Title:
Time Running Out for Conrail
Publication:
Business: The New York Times,
April 19, 1981
Art Director:
Bob Eisner
Artist:
Bob Neubecker
Design Firm:
Bob Neubecker
New York, NY

Title:
The Nation
Publication:
The Week in Review:
The New York Times,
November 2, 1980
Art Director:
John Cayea
Artists:
Steve Hadermayer, The New
York Times Map Group
Design Department:
The New York Times
New York, NY

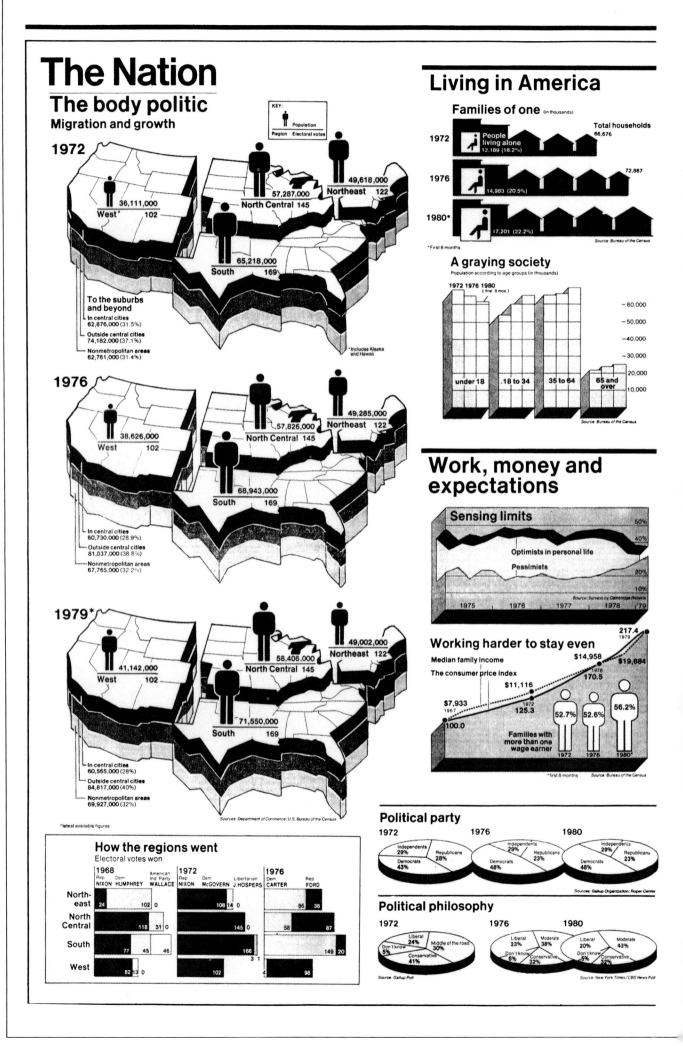

The Nation
The body politic
Migration and growth

KEY:
Population
Region Electoral votes

1972

West* 36,111,000 102
North Central 57,287,000 145
Northeast 49,618,000 122
South 65,218,000 169

To the suburbs and beyond
In central cities 62,876,000 (31.5%)
Outside central cities 74,182,000 (37.1%)
Nonmetropolitan areas 62,761,000 (31.4%)

*Includes Alaska and Hawaii

1976

West 38,626,000 102
North Central 57,826,000 145
Northeast 49,285,000 122
South 68,943,000 169

In central cities 60,730,000 (28.9%)
Outside central cities 81,037,000 (38.8%)
Nonmetropolitan areas 67,765,000 (32.2%)

1979*

West 41,142,000 102
North Central 58,406,000 145
Northeast 49,002,000 122
South 71,550,000 169

In central cities 60,565,000 (28%)
Outside central cities 84,817,000 (40%)
Nonmetropolitan areas 69,927,000 (32%)

*latest available figures

Sources: Department of Commerce; U.S. Bureau of the Census

How the regions went
Electoral votes won

	1968 Rep NIXON	Dem HUMPHREY	American Ind Party WALLACE	1972 Rep NIXON	Dem McGOVERN	Libertarian J.HOSPERS	1976 Dem CARTER	Rep FORD
Northeast	24	102	0	108	14	0	86	36
North Central	118	31	0	145		0	58	87
South	77	45	46	166		3 1	149	20
West	82	13	0	102			4	98

Living in America

Families of one (in thousands)

1972 People living alone 12,189 (18.2%) Total households 66,676
1976 14,983 (20.5%) 72,867
1980* 17,201 (22.2%)

*First 8 months Source: Bureau of the Census

A graying society
Population according to age groups (in thousands)

1972 1976 1980 (first 8 mos.)

under 18 18 to 34 35 to 64 65 and over

60,000
50,000
40,000
30,000
20,000
10,000

Source: Bureau of the Census

Work, money and expectations

Sensing limits

Optimists in personal life
Pessimists

50%
40%
20%
10%

1975 1976 1977 1978 '79

Source: Surveys by Cambridge Reports

Working harder to stay even

Median family income
The consumer price index

217.4 1979
$14,958 $19,684
$11,116 1978 170.5
$7,933 1967 1972 125.3
100.0

52.7% 52.6% 56.2%

Families with more than one wage earner
1972 1976 1980*

*first 8 months Source: Bureau of the Census

Political party

1972 1976 1980

1972: Independents 29%, Republicans 28%, Democrats 43%
1976: Independents 29%, Republicans 23%, Democrats 48%
1980: Independents 29%, Republicans 23%, Democrats 48%

Sources: Gallup Organization; Roper Center

Political philosophy

1972 1976 1980

1972: Liberal 24%, Middle of the road 30%, Conservative 41%, Don't know 5%
1976: Liberal 23%, Moderate 38%, Conservative 32%, Don't know 6%
1980: Liberal 20%, Moderate 43%, Conservative 32%, Don't know 5%

Source: Gallup Poll Source: New York Times/CBS News Poll

The color of poverty

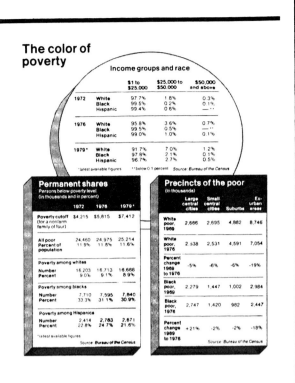

Income groups and race

		$1 to $25,000	$25,000 to $50,000	$50,000 and above
1972	White	97.7%	1.8%	0.3%
	Black	99.5%	0.2%	0.1%
	Hispanic	99.4%	0.6%	— **
1976	White	95.8%	3.6%	0.7%
	Black	99.5%	0.5%	— **
	Hispanic	99.0%	1.0%	0.1%
1979*	White	91.7%	7.0%	1.2%
	Black	97.8%	2.1%	0.1%
	Hispanic	96.7%	2.7%	0.5%

*latest available figures **below 0.1 percent Source: Bureau of the Census

Permanent shares
Persons below poverty level
(in thousands and in percent)

	1972	1976	1979*
Poverty cutoff (for a nonfarm family of four)	$4,215	$5,815	$7,412
All poor	24,460	24,975	25,214
Percent of population	11.9%	11.8%	11.6%
Poverty among whites			
Number	16,203	16,713	16,688
Percent	9.0%	9.1%	8.9%
Poverty among blacks			
Number	7,710	7,595	7,840
Percent	33.3%	31.1%	30.9%
Poverty among Hispanics			
Number	2,414	2,783	2,671
Percent	22.8%	24.7%	21.6%

*latest available figures
Source: Bureau of the Census

Precincts of the poor
(in thousands)

	Large central cities	Small central cities	Suburbs	Ex-urban areas
White poor, 1969	2,666	2,695	4,882	8,746
White poor, 1976	2,538	2,531	4,591	7,054
Percent change 1969 to 1976	-5%	-6%	-6%	-19%
Black poor, 1969	2,279	1,447	1,002	2,984
Black poor, 1976	2,747	1,420	982	2,447
Percent change 1969 to 1976	+21%	-2%	-2%	-18%

Source: Bureau of the Census

The division of labor

Employment by sex (16 years and older, seasonally adjusted)

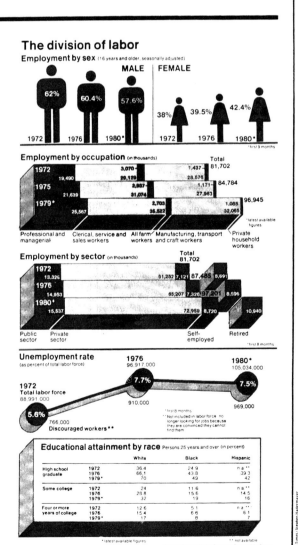

MALE / FEMALE

MALE: 62% (1972), 60.4% (1976), 57.6% (1980*)
FEMALE: 38% (1972), 39.5% (1976), 42.4% (1980*)

*first 9 months

Employment by occupation (in thousands)

	Professional and managerial	Clerical, service and sales workers	All farm workers	Manufacturing, transport and craft workers	Private household workers	Total
1972	19,490	3,070	1,437	28,575		81,702
1975	21,639	29,129	1,171	31,074	27,963	84,784
1979*	25,567	2,937	2,703	35,522	1,088	96,945
					32,065	

*latest available figures

Employment by sector (in thousands)

	Public sector	Private sector	Self-employed	Retired	Total
1972	13,325	61,282	7,121	8,691	81,702
1976	14,953	65,207	7,326	8,596	87,485
1980*	15,537	72,959	8,720	10,940	97,201

*first 8 months

Unemployment rate
(as percent of total labor force)

1972 Total labor force 88,991,000 — 5.6% — 766,000 Discouraged workers**
1976 — 96,917,000 — 7.7% — 910,000
1980* — 105,034,000 — 7.5% — 969,000

*first 8 months
**Not included in labor force: no longer looking for jobs because they are convinced they cannot find them

Educational attainment by race Persons 25 years and over (in percent)

		White	Black	Hispanic
High school graduate	1972	36.4	24.9	n.a.**
	1976	66.1	43.8	39.3
	1979*	70	49	42
Some college	1972	24	11.6	n.a.**
	1976	26.8	15.6	14.5
	1979*	32	19	16
Four or more years of college	1972	12.6	5.1	n.a.**
	1976	15.4	6.6	6.1
	1979*	17	8	7

*latest available figures **not available
Sources: Bureau of Labor Statistics; Bureau of the Census

Black Star / Dennis Brack

U.S. Profile: The Changing Features Also Change Voters

By JOHN HERBERS

WASHINGTON

THE nation that will elect a President, a Congress and thousands of state and local officials this Tuesday is enormously different from the way it was in past Presidential years. Its people are older and less optimistic about their future than in 1972, when Richard Nixon was elected to a second term, or just four years ago when Jimmy Carter won the Presidency.

A somewhat smaller percentage of people are in poverty and most are at least marginally better off materially. There are many millions more who work, due to an influx of women and teenagers into the labor force that outpaced the overall population increase. That stayed relatively low, at about 8 percent during the past decade.

There are more people who live alone, more who are divorced, more who come from families with a female head, more living in retirement and more holding service, clerical or professional jobs.

And many millions of Americans are living in different places, under different conditions and lifestyles, a result of a migration to the South and West and of a dispersal of industry, and so jobs, from the cities to suburban and rural areas.

The 1970's are remembered by most as a period of social stagnation: So many, particularly the young, seemed to turn to political conservatism. But in many respects it was an era of major change, much of which occurred without much public notice. It is a change sure to have an effect on how Americans view the issues, and how they mark their ballots on Tuesday.

At some point in the mid-1970's, a reversal of migration patterns occurred that seemed to indicate that Americans did not want an urban society — or at least that they did not want to live largely in metropolitan areas of high density.

Ever since World War II, the evidence seemed otherwise. Whether they wanted to live there, or whether the need to make a living demanded it, a huge migration of people from the farms and small towns to the metropolitan areas continued through the 1960's. The election of John F. Kennedy, a Democrat from an urban, Roman Catholic base, in 1960, was taken as proof that America at last had become an urban nation. So it seemed at the time.

Away From People, Toward the Sun

But during the 1970's, as national attention turned to political scandals and to economic and foreign disruptions, two highly significant trends developed.

First, people and jobs began to leave the densely populated regions of the Northeast and Middle West and settle in the South and West — under conditions characteristic of the second change that occurred in every region, the dispersal of population away from the old city centers.

In the 1960's, the movement had been from city to suburbs. In the 1970's, it continued, but with a new dimension — the settlement of areas beyond the suburbs, creating new outer suburbs sprawling over several counties into far removed rural ones that had been losing population for most of this century.

The 1980 Census will show that nonmetropolitan counties experienced a net inward migration of about 3 million people during the decade. That is a small fraction of the nation's estimated 220 million people. But the figure tells only a small part of what has happened.

American cities have so spread that about one-fifth of the land in the United States is now officially classified as part of metropolitan areas, even though much of it is in a rural state. Millions of acres of farmland, forests, lakes and mountains are officially classified as metropolitan. Much of the Appalachian Trail lies in metropolitan counties, although no hiker on the trek from Maine to Georgia has a sense of going through a city.

It is into these rural settings surrounding the cities that factories, homes, shopping centers, airports, colleges, office complexes and other developments long associated with an urban environment have been built. It is development that is neither rural nor urban and it has nothing to do with farms,

except that there usually are farms nearby, where some of the new migrants may live.

And as population has increased, each person is taking up more space, both in land area and in housing. Census counters in Chicago, for example, were surprised to find many apartments or houses containing one person.

In this society of scattered population, there is no center in the sense that downtown used to provide a multipurpose center, or a heart, for that city's life. Now there are many centers for many purposes — shopping, financial, entertainment, work and so on. Much of this change, of course, was evident a decade ago but the new Census figures show it to have accelerated greatly in recent years.

What are the implications for political life and thought? What little evidence there is from public opinion polls indicates there is not much change in political persuasion when people move from the central city to the suburbs or to a rural subdivision. But interviews with many of the new migrants in several areas of the nation show that they feel more independent of society in general, less inclined to support centralized government or to join a labor union or to be sensitive to the plight of the poor left behind in the central cities — even if their own life is one of substandard existence in a mobile home along a dirt road.

Optimism Wilts, Conservatism Thrives

A scattered society seems to be a more conservative one in many respects, which may help explain why the major party Presidential nominees are Jimmy Carter and Ronald Reagan, rather than Edward Kennedy and George Bush. And the trend toward conservatism is reinforced by other changes — by the fact that the population is older and contains more retired people living on fixed incomes.

In the past decade, the population of 65 and older grew by more than 24 percent and the median age went up by more than two years. There are now as many people over 30 as under 30. In 1972, there were less than 7 million retired in the United States. Today there are about 11 million. And there is less optimism about the future. A national sample of persons in 1979 saw their present situation a little better, but their future a little bleaker, in terms of "the best possible life," than a similar sample questioned in 1974. Other polls have reinforced the decline of optimism about personal opportunity in America, even though most Americans continue to look to a relatively bright future in terms of their own aspirations.

The percentage of Americans living in poverty has dropped slightly between 1970 and 1980 for all races. But the poor have become more isolated and further removed from jobs and from the growing sectors of society. A recent study by the Department of Housing and Urban Development showed that the decline in poverty has occurred everywhere — in the suburbs and rural areas alike — except in the central cities, and there it has increased. There, the proportion of blacks, Hispanic people and the elderly has increased as the employed middle class of all races has moved out. Renewal of parts of some central cities has not been sufficient to offset the outward trend.

As the labor force — those working or seeking work — has grown faster than the population, unemployment also has increased — from 5.6 percent in 1972 to 7.5 percent for the first eight months of 1980. But it is much worse in the central cities, and much of the nation has come to accept the previously un-American concept of a permanent underclass — people who from generation to generation live on public welfare.

Isolation of the poor has contributed to the growth of the discouraged worker — those people not counted in the labor force because they say they are so convinced they cannot find suitable jobs they have given up looking. In 1972 there were 760,000 such persons. Today there are just under 1 million.

Yet this election will give the Northern states and the central cities a disproportionate voice in the election of public officials. The electoral vote as well as Congressional seats are still apportioned under the 1970 Census. This year, the West, the South and the scattered middle class will add political strength to their economic achievements.

Title:
Telltales of Two Cities
Publication:
Time, June 23, 1980
Designer:
Nigel Holmes
Artist:
Nigel Holmes
Design Department:
Time Magazine
New York, NY

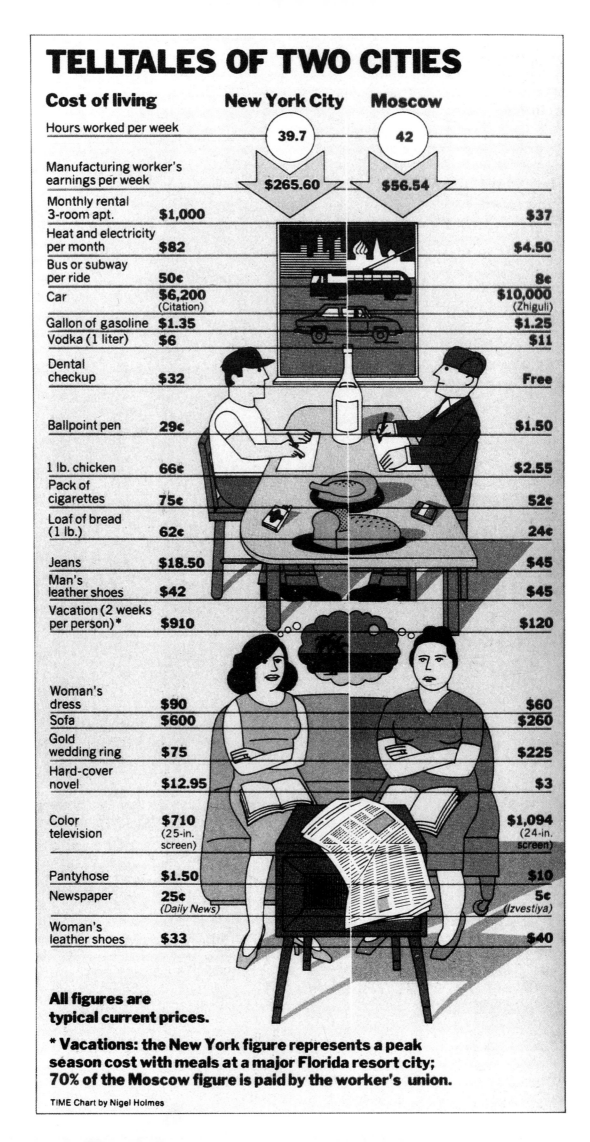

TELLTALES OF TWO CITIES

Cost of living

	New York City	Moscow
Hours worked per week	39.7	42
Manufacturing worker's earnings per week	$265.60	$56.54
Monthly rental 3-room apt.	$1,000	$37
Heat and electricity per month	$82	$4.50
Bus or subway per ride	50¢	8¢
Car	$6,200 (Citation)	$10,000 (Zhiguli)
Gallon of gasoline	$1.35	$1.25
Vodka (1 liter)	$6	$11
Dental checkup	$32	Free
Ballpoint pen	29¢	$1.50
1 lb. chicken	66¢	$2.55
Pack of cigarettes	75¢	52¢
Loaf of bread (1 lb.)	62¢	24¢
Jeans	$18.50	$45
Man's leather shoes	$42	$45
Vacation (2 weeks per person)*	$910	$120
Woman's dress	$90	$60
Sofa	$600	$260
Gold wedding ring	$75	$225
Hard-cover novel	$12.95	$3
Color television	$710 (25-in. screen)	$1,094 (24-in. screen)
Pantyhose	$1.50	$10
Newspaper	25¢ (Daily News)	5¢ (Izvestiya)
Woman's leather shoes	$33	$40

All figures are typical current prices.

*** Vacations: the New York figure represents a peak season cost with meals at a major Florida resort city; 70% of the Moscow figure is paid by the worker's union.**

TIME Chart by Nigel Holmes

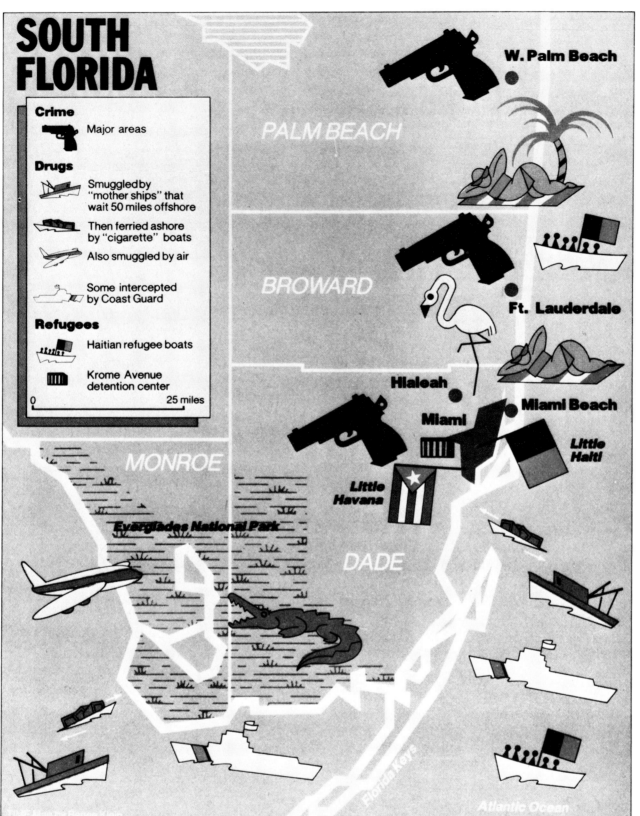

SOUTH FLORIDA

Crime

Major areas

Drugs

Smuggled by "mother ships" that wait 50 miles offshore

Then ferried ashore by "cigarette" boats

Also smuggled by air

Some intercepted by Coast Guard

Refugees

Haitian refugee boats

Krome Avenue detention center

0 25 miles

W. Palm Beach

PALM BEACH

BROWARD

Ft. Lauderdale

Hialeah

MONROE

Miami Miami Beach

Little Haiti

Little Havana

Everglades National Park

DADE

Florida Keys

Atlantic Ocean

TIME Map by Renee Klein

Title:
South Florida
Publication:
Time, November 23, 1981
Designer:
Renee Klein
Artist:
Renee Klein
Design Department:
Time Magazine
New York, NY

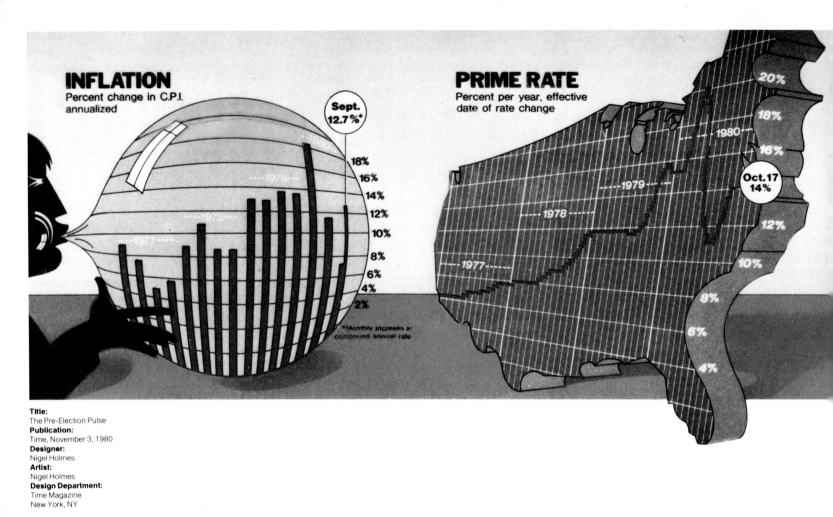

INFLATION
Percent change in C.P.I.
annualized

Sept.
12.7%*

1980
1979
1978
1977

18%
16%
14%
12%
10%
8%
6%
4%
2%

*Monthly increase at
compound annual rate

PRIME RATE
Percent per year, effective
date of rate change

20%
18%
16%
1980
1979
Oct.17
14%
1978
12%
1977
10%
8%
6%
4%

Title:
The Pre-Election Pulse
Publication:
Time, November 3, 1980
Designer:
Nigel Holmes
Artist:
Nigel Holmes
Design Department:
Time Magazine
New York, NY

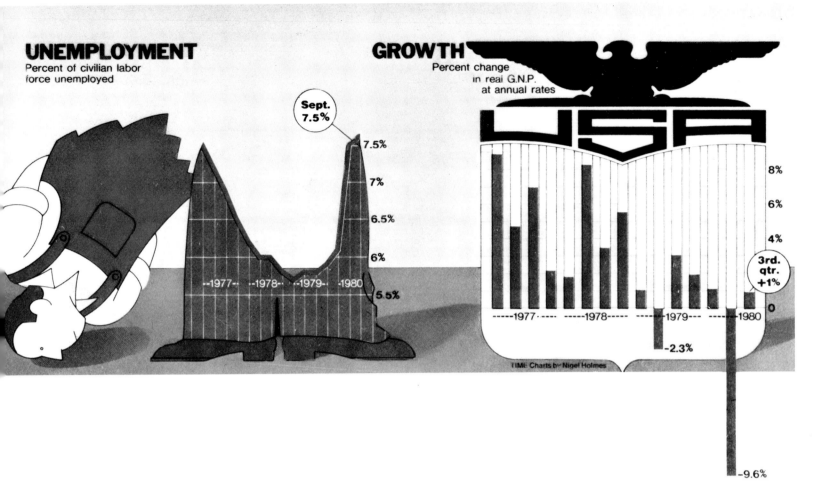

UNEMPLOYMENT
Percent of civilian labor force unemployed

Sept. 7.5%

7.5%
7%
6.5%
6%
5.5%

-1977- -1978- -1979- -1980

GROWTH
Percent change in real G.N.P. at annual rates

USA

8%
6%
4%
3rd. qtr. +1%
0

-1977- -1978- -1979- -1980

-2.3%

-9.6%

TIME Charts by Nigel Holmes

Title:
Inflation: Oil Outruns the Pack
Publication:
U.S. News & World Report,
August 10, 1981
Art Director:
Walter Gretschel
Designer:
Carl Vansag
Design Department:
U.S. News & World Report
Washington, DC

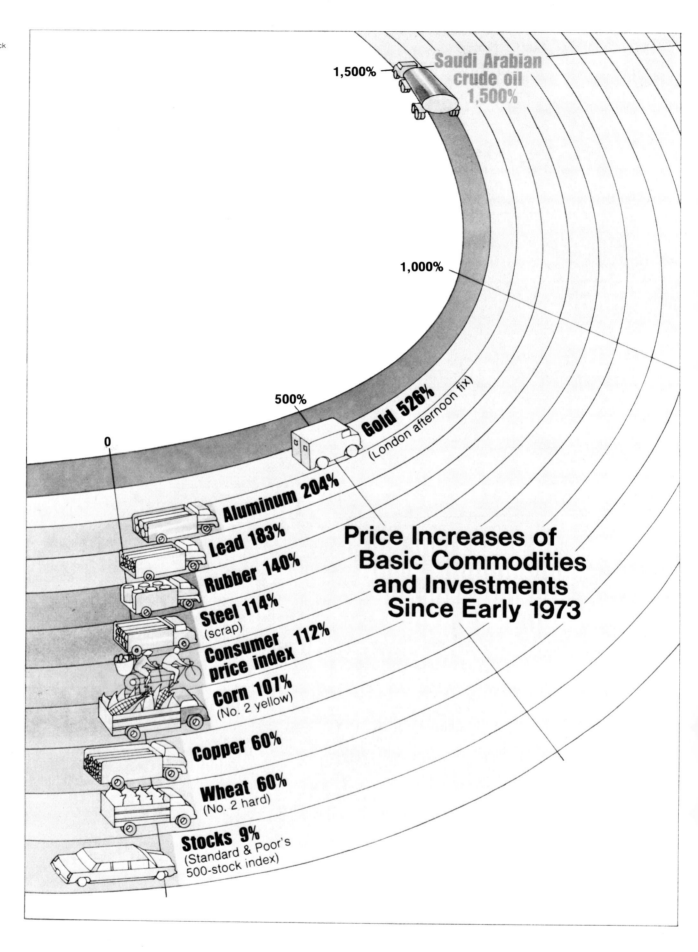

1,500%

Saudi Arabian
crude oil
1,500%

1,000%

500%

Gold 526%
(London afternoon fix)

0

Aluminum 204%

Lead 183%

Rubber 140%

Steel 114%
(scrap)

Consumer
price index 112%

Corn 107%
(No. 2 yellow)

Copper 60%

Wheat 60%
(No. 2 hard)

Stocks 9%
(Standard & Poor's
500-stock index)

Price Increases of Basic Commodities and Investments Since Early 1973

Title:
Trimming Retirement Pay
Publication:
Time, May 25, 1981
Designer:
Renee Klein
Artist:
Renee Klein
Design Department:
Time Magazine
New York, NY

Nation

A Slash at Social Security

The beefs are loud as budget cutters attack a "sacred cow"

In crafting his delicate package of budget cuts, Ronald Reagan carefully corralled a herd of "sacred cows"—Veterans Administration disability benefits and Medicare payments for the elderly, among other programs—that he vowed not to touch. Last week, in a move that ensured debate for months to come, the President proposed to chop away at perhaps the most sacred of all cows: Social Security benefits. The plan not only ignited protests from senior citizens' groups around the nation, but finally gave the badly bruised Democrats in Congress a battle they could enthusiastically join—and perhaps stand a good chance of winning. Proclaimed House Speaker Tip O'Neill: "I will be fighting this every inch of the way, and I hope that will be the position of every member of my party."

The proposals, as unveiled by Secretary of Health and Human Services Richard S. Schweiker at a press conference, would entail little reduction in monthly payments for the 36 million Americans already on the rolls or for those who join them before Dec. 31. Administration officials nevertheless calculate that the program of adjustments could save the Treasury about $9 billion in fiscal 1982 and an accumulated total of about $46 billion by 1987. Highlights of the plan:

▶ Workers who choose early retirement (between the ages of 62 and 65) after 1981 would get only 55% of the benefits they would have received at age 65, rather than the 80% mandated by current law. Those who retire at 62 next year, for example, would receive an average of $126 a month less than the $372 currently collected. Benefits would also be scrapped for children of early retirees (offspring under 18, or under 22 if they are still in school, are now eligible for payments).

▶ The formula for calculating initial benefits for those who retire at 65 or over after 1982 would be jiggered downward over the next five years. The average worker retiring in 1987, for example, would get $719 a month under the present law, but would receive only $691.90 under Reagan's proposal.

▶ Beginning in 1982, the annual cost of living increase in benefits, which is based on the Consumer Price Index, would be paid out in October rather than July each year. Based on a projected inflation rate of approximately 8%, this three-month delay would save the Government about $3 billion in fiscal 1982.

▶ Under present law those who still work after 65 have their benefits cut by $1 for every $2 they earn over $5,500 a year. To encourage people to work longer, the Administration proposes lifting the ceiling to $10,000 in 1983, $15,000 in 1984, $20,-000 in 1985 and then abolishing it completely in 1986.

▶ Federal and some state employees who are not covered by Social Security are now permitted to retire from their government jobs, work in positions covered by Social Security for a few years and then draw these benefits as well as their government pensions. The Administration proposes reducing Social Security benefits for these "double dippers" by taking their pensions into account.

▶ Disabled workers would be declared eligible for benefits only for strictly defined medical reasons; age, education and work experience would not be considered. Workers would also have to prove they had not been able to hold a job for 24 months prior to receiving payments rather than just twelve months, and would have to wait six months instead of five before collecting benefits.

To sweeten the medicine of the benefit cuts, Schweiker pointed out that the savings might eventually snip the payroll tax rate levied on employers and employees alike from a projected 7.15% in 1986 to 7.05%. A worker in his 20s might thus shave about $33,600 off his contribution to the Social Security system by the time he retires at age 65.

Administration officials insisted that the proposals are needed to salvage a system that is teetering on bankruptcy. Created in 1935, the Social Security Administration originally paid benefits only to workers who retired at age 65; coverage was gradually broadened to include wives, children, the disabled and early retirees. In addition, payments were hiked by cost of living increases. With a negligible inflation rate and a high ratio of taxpaying workers to beneficiaries, the system hummed along smoothly and solvently for decades. In the 1970s, however, prices (which determine the level of payments) rose at a faster clip than wages (which determine how much money is paid into the system). As a result, Social Security funds were depleted at a much faster rate than ever anticipated. Without some kind of imme-

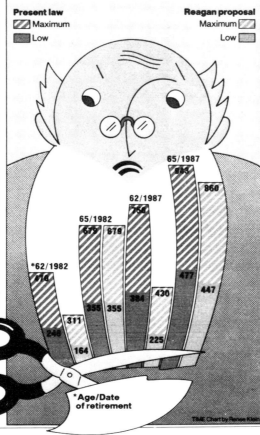

TRIMMING RETIREMENT PAY
Social Security benefits, dollars per month

Present law
◸ Maximum
◼ Low

Reagan proposal
Maximum ◿
Low ◻

*62/1982 — 414, 248, 355, 311, 164
65/1982 — 679, 679, 355
62/1987 — 754, 384, 430, 225
65/1987 — 933, 860, 477, 447

*Age/Date of retirement

TIME Chart by Renee Klein

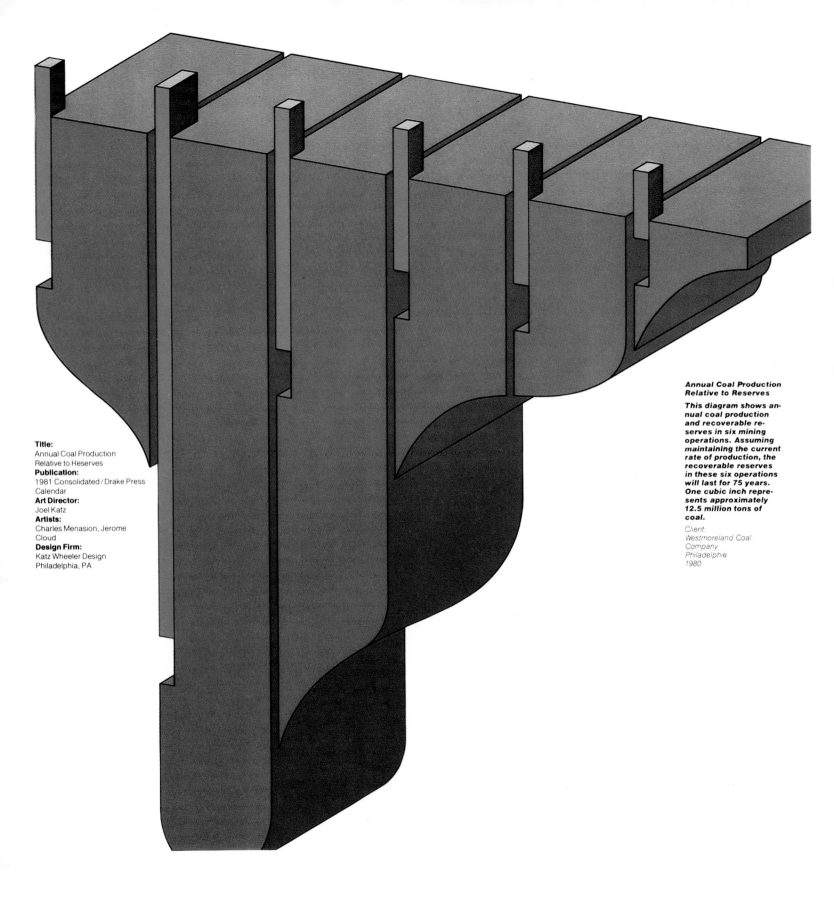

Title:
Annual Coal Production
Relative to Reserves
Publication:
1981 Consolidated/Drake Press
Calendar
Art Director:
Joel Katz
Artists:
Charles Menasion, Jerome
Cloud
Design Firm:
Katz Wheeler Design
Philadelphia, PA

**Annual Coal Production
Relative to Reserves**

This diagram shows annual coal production and recoverable reserves in six mining operations. Assuming maintaining the current rate of production, the recoverable reserves in these six operations will last for 75 years. One cubic inch represents approximately 12.5 million tons of coal.

*Client
Westmoreland Coal
Company
Philadelphia
1980*

Life Insurance Plan income protection

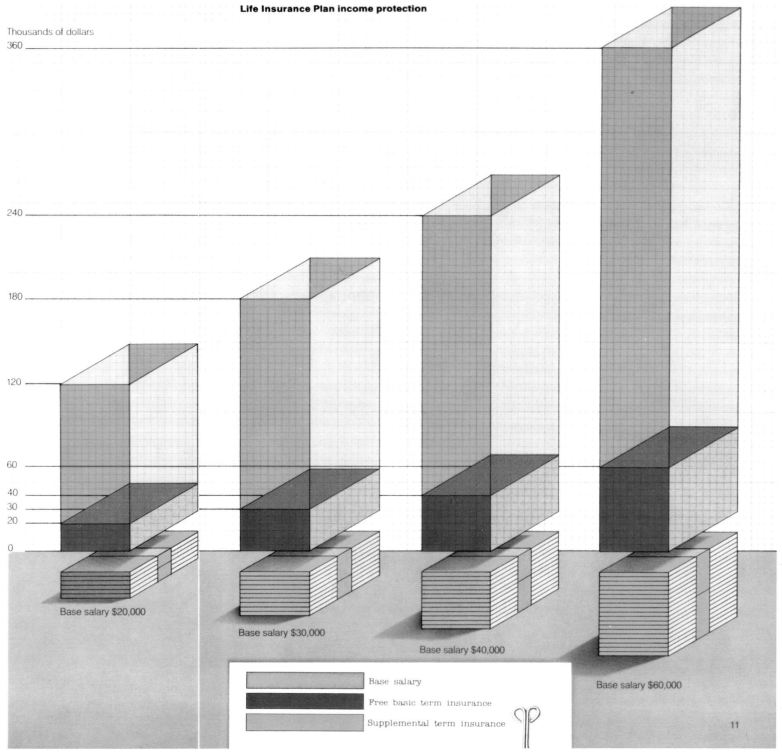

Thousands of dollars

360

240

180

120

60

40

30

20

0

Base salary $20,000

Base salary $30,000

Base salary $40,000

Base salary $60,000

Base salary

Free basic term insurance

Supplemental term insurance

11

Title:
Life Insurance Plan Income
Protection
Publication:
Citibank / Citicorp: MONEY
Art Director:
Bob Warkulwiz
Artist:
Joan Walsh
Design Firm:
Warkulwiz Design
Philadelphia, PA

Title:
Paint Color and Graphic
Identification Markings for
FAA Grumman G-159
Publication:
Federal Aviation Administration
Graphic Standards Manual 1981
Art Director:
Donald Meeker
Designer:
Donald Meeker
Artists:
Reid Martin, Phil Goldberg
Mechanical:
Reid Martin, Phil Goldberg
Design Firm:
Danne & Blackburn, Inc.
New York, NY

Paint Color and
Graphic
Identification
Markings for FAA
Grumman G-159

Scale: ⅛" = 1'
Drawing No. 4110112
Left & Right Side
Views
December, 1981

Revision No. Date

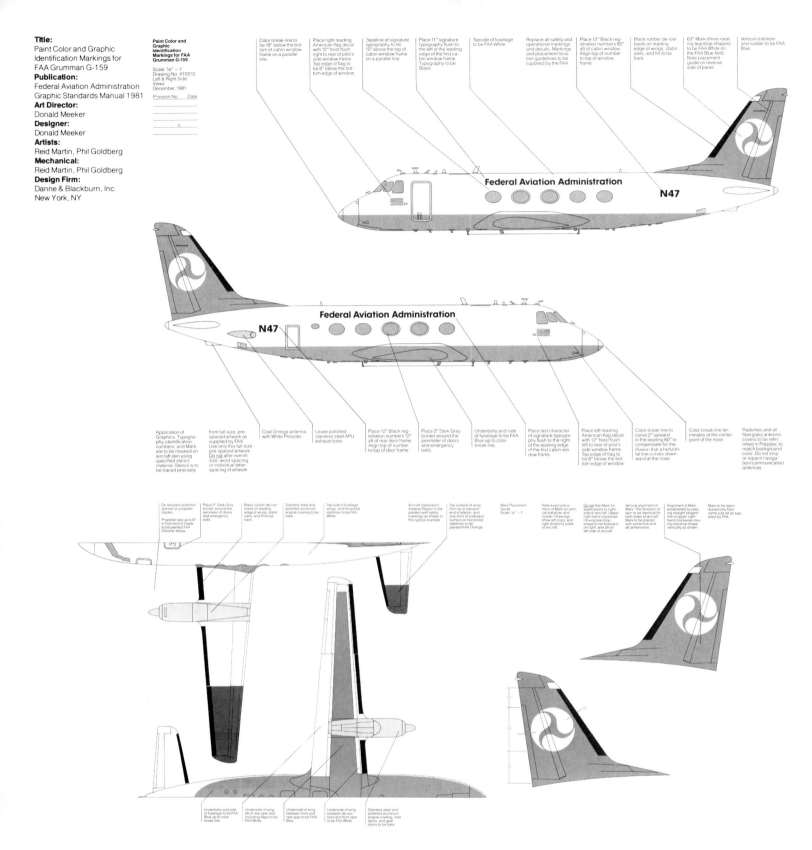

Color break-line to be 18" below the bottom of cabin window frame on a parallel line

Place right reading American flag decal with 12" hoist flush right to rear of pilot's side window frame. Top edge of flag to be 8" below the bottom edge of window.

Baseline of signature typography to be 10" above the top of cabin window frame on a parallel line

Place 11" signature typography flush to the left of the leading edge of the first cabin window frame. Typography to be Black.

Topside of fuselage to be FAA White

Replace all safety and operational markings and decals. Markings and placement location guidelines to be supplied by the FAA.

Place 12" Black registration numbers 80" aft of cabin window. Align top of number to top of window frame.

Black rubber de-icer boots on leading edge of wings, stabilizers, and fin to be bare.

63" Mark (three rotating teardrop shapes) to be FAA White on the FAA Blue field. Note placement guide on reverse side of panel.

Vertical stabilizer and rudder to be FAA Blue.

Federal Aviation Administration
N47

Application of Graphics: Typography, identification numbers, and Mark are to be masked on aircraft skin using specified stencil material. Stencil is to be traced precisely

from full-size, prespaced artwork as supplied by FAA. Use only this full-size pre-spaced artwork. Do not alter overall size, word spacing, or individual letter-spacing of artwork.

Coat Omega antenna with White Presstec.

Leave polished stainless steel APU exhaust bare.

Place 12" Black registration numbers 12" aft of rear door frame. Align top of number to top of door frame.

Place 2" Dark Gray border around the perimeter of doors and emergency exits.

Underbelly and side of fuselage to be FAA Blue up to color break line

Place last character of signature typography flush to the right of the leading edge of the first cabin window frame

Place left reading American flag decal with 12" hoist flush left to rear of pilot's side window frame. Top edge of flag to be 8" below the bottom edge of window.

Color break line to curve 2" upward in the leading 60" to compensate for the illusion that a horizontal line curves downward at the nose.

Color break line terminates at the center point of the nose.

Radomes and all fiberglass antenna covers to be refinished in Presstec to match background color. Do not strip or repaint navigation/communication antennas.

Do not paint polished spinner or propeller blades.

Propeller tips up to 6" in front end of blade to be painted FAA Chrome Yellow.

Place 2" Dark Gray border around the perimeter of doors and emergency exits.

Black rubber de-icer boots on leading edge of wings, stabilizers, and fin to be bare.

Stainless steel and polished aluminum engine cowling to be bare.

Top side of fuselage, wings, and horizontal stabilizer to be FAA White.

Aircraft stationed in Alaskan Region to be painted with safety markings as shown in this typical example.

Top surface of wing from tip to inboard end of aileron, and one-third of outboard surface on horizontal stabilizer to be painted FAA Orange.

Mark Placement Guide
Scale: ¼" = 1'

Note exact placement of Mark on vertical stabilizer and rudder. Drawings show left (top), and right (bottom) sides of aircraft.

Do not top Mark for applications to right side of aircraft. Upper right-hand clockwise moving teardrop shape to be forward on right, and aft on left side of aircraft.

Vertical alignment of Mark. The direction of spin to be identical for both sides of aircraft. Mark to be placed with same fore and aft dimensions.

Alignment of Mark established by placing straight tangent line of upper right-hand clockwise moving teardrop shape vertically as shown.

Mark to be reproduced only from same size art as supplied by FAA.

Underbelly and side of fuselage to be FAA Blue up to color break line

Underside of wing aft of rear spar and including flaps to be FAA White

Underside of wing between front and rear spar to be FAA Blue.

Underside of wing between de-icer boot and front spar to be FAA White

Stainless steel and polished aluminum engine cowling, inlet ducts, and gear doors to be bare.

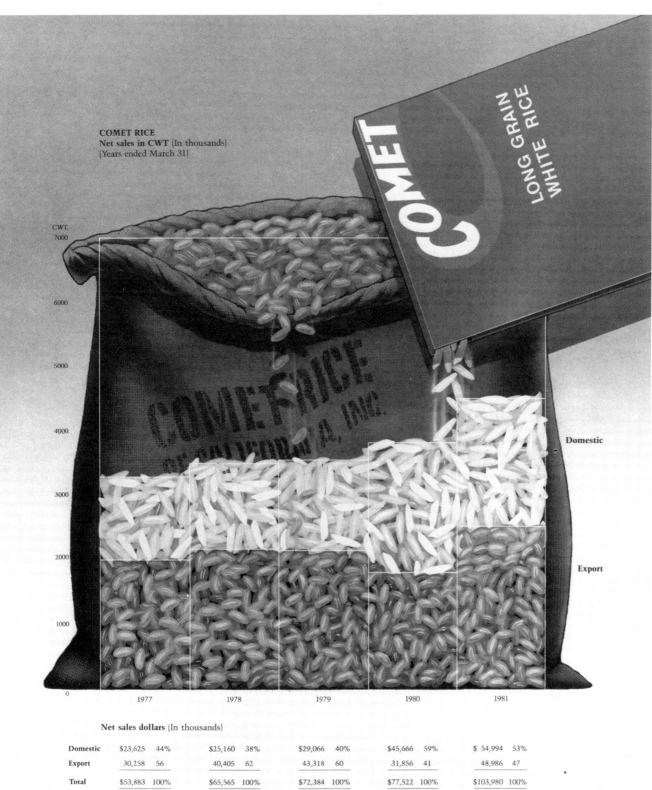

COMET RICE
Net sales in CWT (In thousands)
(Years ended March 31)

Title:
Comet Rice: Net Sales in CWT
Publication:
1981 Annual Report: Early
California Industries, Inc.
Art Director:
Robert Miles Runyan
Designer:
Dennis Tani
Design Firm:
Robert Miles Runyan & Assoc.
Playa del Rey, CA

Net sales dollars (In thousands)

	1977		1978		1979		1980		1981	
Domestic	$23,625	44%	$25,160	38%	$29,066	40%	$45,666	59%	$ 54,994	53%
Export	30,258	56	40,405	62	43,318	60	31,856	41	48,986	47
Total	$53,883	100%	$65,565	100%	$72,384	100%	$77,522	100%	$103,980	100%

Title:
The Orchestra
Publication:
Calendar, The Boston Globe,
October 22, 1981
Art Director:
Lynn Staley
Designer:
Deborah Perugi
Artists:
Deborah Perugi, Roger
Leyonmark
Design Firm:
The Boston Globe
Boston, MA

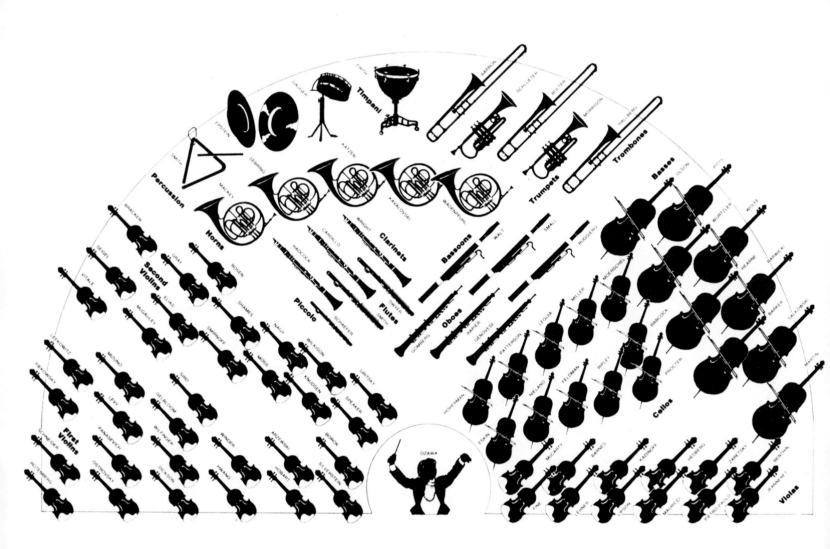

Title:
Cutaway View of a Greek
Trireme
Publication:
Scientific American
Art Director:
Samuel L. Howard
Artist:
George V. Kelvin
Design Department:
Scientific American
New York, NY

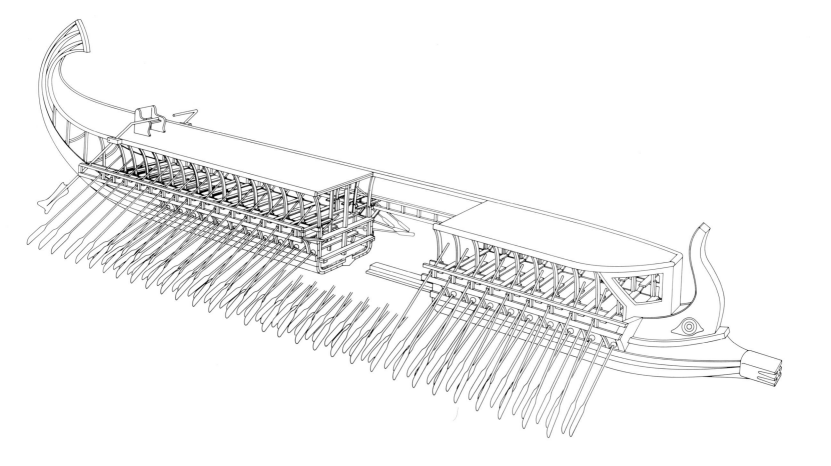

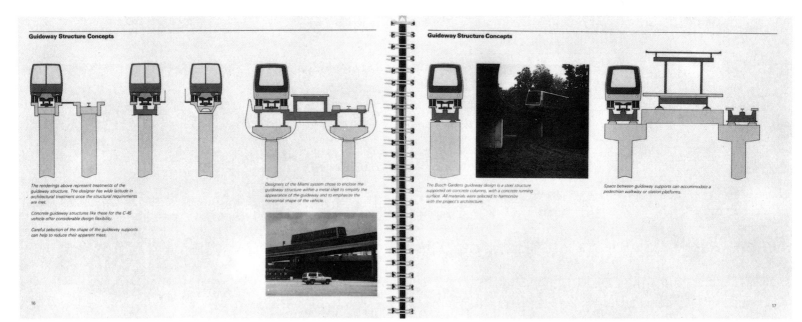

The renderings above represent treatments of the guideway structure. The designer has wide latitude in architectural treatment once the structural requirements are met.

Concrete guideway structures like these for the C-45 vehicle offer considerable design flexibility.

Careful selection of the shape of the guideway supports can help to reduce their apparent mass.

Designers of the Miami system chose to enclose the guideway structure within a metal shell to simplify the appearance of the guideway and to emphasize the horizontal shape of the vehicle.

The Busch Gardens guideway design is a steel structure supported on concrete columns, with a concrete running surface. All materials were selected to harmonize with the project's architecture.

Space between guideway supports can accommodate a pedestrian walkway or station platforms.

16

17

Title:
Guideway Structure Concepts
Publication:
Westinghouse Transportation
Division: Automated Transit
System Planning Guide
Art Director:
Don Moyer
Artists:
Mark Bedel, Paul Adams,
Bob Beckjord
Photographer:
Tom Barr
Design Firm:
Agnew Moyer Smith, Inc.
Pittsburgh, PA

Title:
How to Determine Where Labels
Are Placed
Publication:
Westinghouse Product Safety
Label Handbook
Art Director:
Reed Agnew
Artist:
Leon Ludovici
Design Firm:
Agnew Moyer Smith, Inc.
Pittsburgh, PA

9 — How to Determine Where Labels are Placed

Think chronologically

Imagine the step-by-step process of walking up to the product, operating it, or repairing it. What will you see first? What is the first control or latch you will touch? What panel will be removed first? Don't skip steps as you think.

Safety labels should be placed at appropriate spots in the operation or maintenance sequence. Don't give warnings too early or too late. Thinking chronologically will help you determine where to place labels.

Place labels close to hazards

Generally labels should be located very near the hazard they are describing. It should be possible to re-read or refer to a label as operation, maintenance or repairs proceed. It should not disappear as the product is dismantled.

Some labels will have to be located remotely from the actual hazard. A label warning about suffocating gas should be placed outside the chamber containing the gas. A warning about hazardous voltage should be seen before terminals or live wires are encountered.

In some cases it may be desirable to place labels both outside and inside so that as a cover is removed, a safety label still remains near the hazard.

20

Check reading distance

Labels must be readable. If people can't read a label until they are within one foot of it, they may already be too close to the hazard. Labels should be large enough to be read at an appropriate distance. Tables are provided on Pages 44-49 to help determine the reading distance for different size labels.

Check viewing angle. Viewing angle also affects readability. The best position to read a label is directly in front of it—perpendicular to it. A viewing angle more than 60° from the perpendicular will decrease readability.

21

12 — Vertical Label Format / Horizontal Label Format

Vertical Label Format

This is the preferred label format and should be used unless vertical space is severely limited.

All label formats are based on a grid which is 12 units wide. The depth of the label varies depending on the message length and whether a symbol or pictograph is used.

However, the depth is always measured in whole grid units.

Labels are assembled by placing elements on the grid according to detailed instructions provided in Chapter 13. The example below explains specific guidelines and spacing.

Signal Word Identifies the seriousness of the potential hazard. Signal words are pre-printed and sized to fit the label grid.

Standard Border A ½-unit border surrounds the label on all four sides. This simplifies printing and screening during production.

Alternate Border A 1½-unit border can be used if space is required for mechanical fasteners.

Color Color is used to reinforce the message and seriousness of the hazard. Each signal word has a corresponding color. Colors are specified in label layout kits.

Alert Symbol Appears with signal words Danger, Warning, and Caution. It is pre-printed on the artwork included in the layout kits.

Symbols and Pictographs A symbol or pictograph can be used to reinforce the verbal message. Pre-printed symbols and pictographs are provided with layout kits. They are 10 units wide and 6 units in depth—sized to fit the allotted area.

Hazard Identification The first word message following the signal word. It identifies the type of hazard and is set in bold type. (Helvetica 18 on 20)

Result of Ignoring Warning This message tells what will happen if the warning is ignored. It is part of the first message block and is also set in bold type (Helvetica 18 on 20). In most cases, it begins on the line immediately after the hazard identification.

Space A one-unit space should always separate the signal word from the symbol/pictograph or text area.

Space A one-unit space should always be maintained between the symbol/pictograph and the following text.

Space Always allow a one-unit space between identifying the hazard and the damage or injury it can cause and the following text.

Right Margin The right hand margin of type is not to be aligned (justified). It will end in varying positions according to where lines are broken. This is good. It is more readable. Do not justify type. Do not center type.

Space Two unit spaces always separate the last line of type from the border line at the bottom of the label.

Side and Bottom Rule Extends from edge of signal word panel downward and closes off the label 2 units below the last line of type.

Punctuation Periods should be used after each sentence or sentence fragment. Do not use exclamation points, colons, dashes or other punctuation unless it's absolutely necessary.

Avoiding the Hazard This message tells the reader what precautions to take to avoid the hazard. It is set in regular weight type. It is separated from the preceding message by one unit. This is the last part of the label.

32

Horizontal Label Format

The horizontal format label should be used only when vertical space is limited. This format follows the same basic organizational principles and rules as the vertical label but includes variations to adapt the label elements to the horizontal arrangement.

Horizontal labels can be either 2 columns wide or 3 columns wide. The example below shows a 3-column label which includes a pictograph. Except for the items noted, all layout guidelines are the same as for vertical labels.

Signal Word Signal words are located in the center of the top panel. The precise location is indicated on the layout grids.

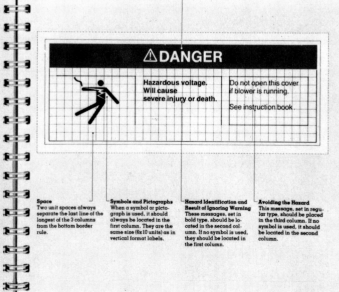

Space Two unit spaces always separate the last line of the longest of the 3 columns from the bottom border rule.

Symbols and Pictographs When a symbol or pictograph is used, it should always be located in the first column. They are the same size (6x10 units) as in vertical format labels.

Hazard Identification and Result of Ignoring Warning These messages, set in bold type, should be located in the second column. If no symbol is used, they should be located in the first column.

Avoiding the Hazard This message, set in regular type, should be placed in the third column. If no symbol is used, it should be located in the second column.

33

Title:
Compartments in the
Development of the Fruit Fly
Publication:
Scientific American, July 1979
Art Director:
Samuel L. Howard
Artist:
Bunji Tagawa
Design Department:
Scientific American
New York, NY

COITUS TOPOGRAPHICUS ILLUSTRATED BY LIZ GUTOWSKI

Title:
Coitus Topographicus
Publication:
Push Pin Graphic,
March / April 1980
Art Director:
Seymour Chwast
Designer:
Richard Mantel
Artist:
Liz Gutowski
Design Firm:
Push Pin Studios
New York, NY

Title:
1st Cell: Destroyed by Virus
2nd Cell: Protected by Interferon
Publication:
Time, March 31, 1980
Designer:
Nigel Holmes
Artist:
Nigel Holmes
Design Department:
Time Magazine
New York, NY

Title:
Medical Care Expenditures
Publication:
Time, May 28, 1979
Designer:
Nigel Holmes
Artist:
Nigel Holmes
Design Department:
Time Magazine
New York, NY

What really happens when a disc "slips"

The human spine is akin to a perilously balanced stack of poker chips: Intricately sculpted interlocking bones, called vertebrae, are cushioned by resilient discs, lashed together with sturdy ligaments and guyed upright by a host of muscles. In a normal, healthy back, the discs, which have the consistency of stale gumdrops, act as miniature shock absorbers, and pairs of small vertebral projections called facets line up, one above the other, to create smoothly functioning joints.

Both the discs and the facet joints show the effects of steady use as the years go by. The discs dry out somewhat and lose a degree of resiliency; the facet joints begin to wear. In people suffering from severe back pain, the process has generally been exaggerated—by disease that speeds up the degeneration, by the trauma of injury or, most commonly, by the stresses that the spine must bear if there is insufficient muscular support. The result may be either what is commonly but incorrectly known as a slipped disc—a disc that has partially collapsed or ruptured under pressure—or painfully grinding facet joints.

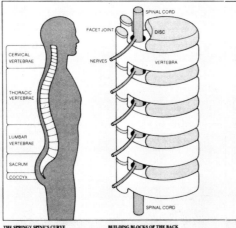

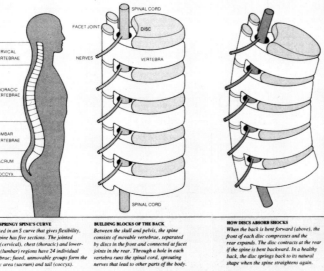

Title:
What Really Happens When a Disc ''Slips''
Publication:
Building Sound Bones and Muscles
Art Director:
Tom Suzuki
Designer:
Albert Sherman
Design Department:
Time-Life Books, Inc.
Alexandria, VA

THE SPRINGY SPINE'S CURVE
Stacked in an S curve that gives flexibility, the spine has five sections. The jointed neck (cervical), chest (thoracic) and lower-back (lumbar) regions have 24 individual vertebrae; fused, unmovable groups form the pelvic area (sacrum) and tail (coccyx).

BUILDING BLOCKS OF THE BACK
Between the skull and pelvis, the spine consists of movable vertebrae, separated by discs in the front and connected at facet joints in the rear. Through a hole in each vertebra runs the spinal cord, sprouting nerves that lead to other parts of the body.

HOW DISCS ABSORB SHOCKS
When the back is bent forward (above), the front of each disc compresses and the rear expands. The disc contracts at the rear if the spine is bent backward. In a healthy back, the disc springs back to its natural shape when the spine straightens again.

THE RUPTURED OR "SLIPPED" DISC
A weak spot in ligaments encasing it lets the disc bulge out; the bulge presses on a nerve and induces the radiating pain of a so-called slipped disc. Eventually, the casing may break, spilling the gel-like nucleus of the disc and compounding the pain.

FAULTY FACET JOINTS
When a disc deteriorates and flattens permanently, the space between vertebrae narrows. The facets abrade each other, wear down cartilage and produce bony spurs that touch nearby nerves. A twisting injury can yield similar results.

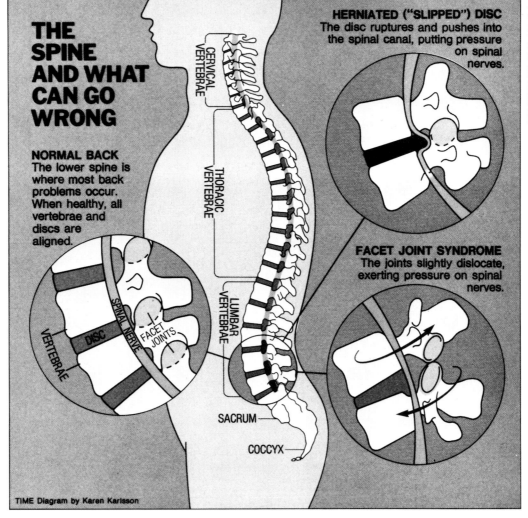

THE SPINE AND WHAT CAN GO WRONG

HERNIATED ("SLIPPED") DISC
The disc ruptures and pushes into the spinal canal, putting pressure on spinal nerves.

NORMAL BACK
The lower spine is where most back problems occur. When healthy, all vertebrae and discs are aligned.

FACET JOINT SYNDROME
The joints slightly dislocate, exerting pressure on spinal nerves.

TIME Diagram by Karen Karlsson

Title:
The Spine and What Can Go Wrong
Publication:
Time, July 14, 1980
Designer:
Karen Karlsson
Artist:
Karen Karlsson
Mechanicals:
Karen Karlsson
Design Firm:
Karen Karlsson
New York, NY

Title:
Curveball
Publication:
Science 81, October 1981
Art Director:
Rodney Williams
Designer:
Mary Challinor
Artist:
Greg Harlin
Design Firm:
Stansbury, Ronsaville, Wood, Inc.
Washington, DC

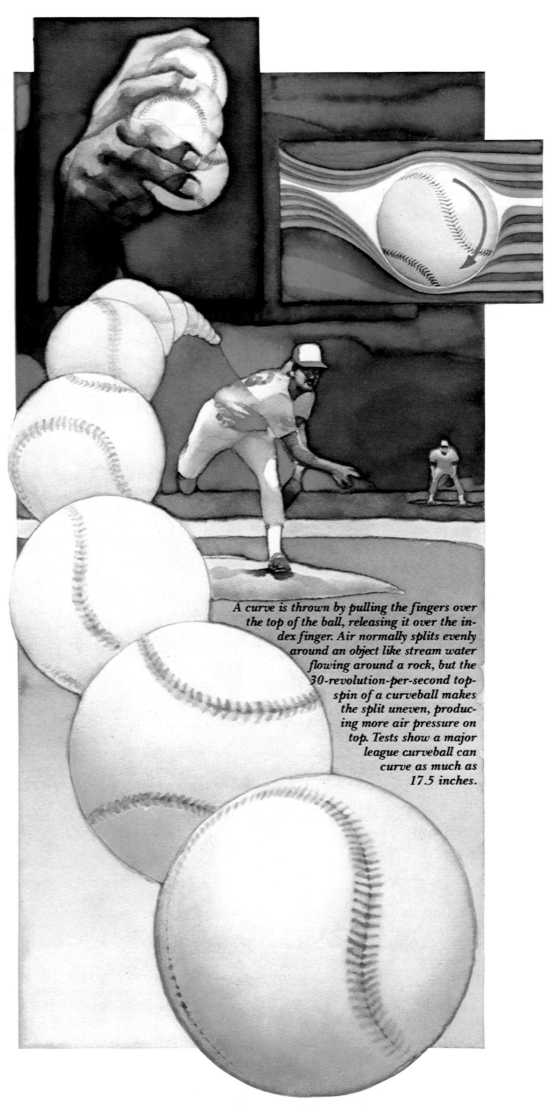

A curve is thrown by pulling the fingers over the top of the ball, releasing it over the index finger. Air normally splits evenly around an object like stream water flowing around a rock, but the 30-revolution-per-second topspin of a curveball makes the split uneven, producing more air pressure on top. Tests show a major league curveball can curve as much as 17.5 inches.

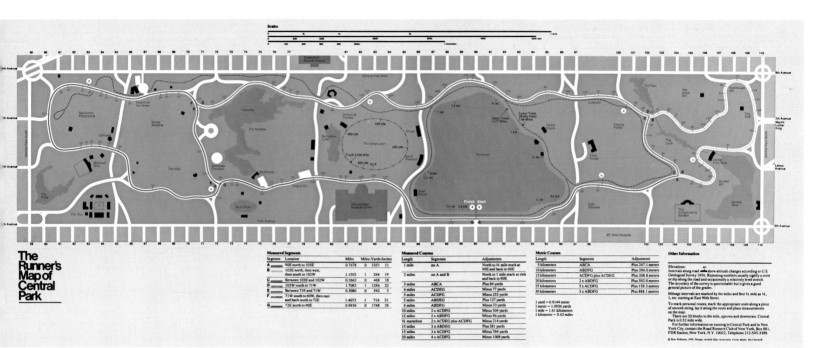

The Runner's Map of Central Park

Measured Segments

Segment	Location	Miles	Miles-Yards-Inches		
A	90E north to 103E	0.7678	0	1351	11
B	103E north, then west, then south to 102W	1.1503	1	264	19
C	Between 103E and 102W	0.2662	0	468	18
D	102W south to 71W	1.7083	1	1246	22
E	Between 72E and 71W	0.3080	0	542	3
F	71W south to 60W, then east and back north to 72E	1.4073	1	716	31
G	72E north to 90E	0.9936	0	1748	26

Measured Courses

Length	Segments	Adjustments
1 mile	on A	North to ½ mile mark at 99E and back to 90E
2 miles	on A and B	North to 1 mile mark at rink and back to 90E
3 miles	ABCA	Plus 84 yards
4 miles	ACDEG	Minus 77 yards
5 miles	ACDFG	Minus 252 yards
5 miles	ABDEG	Plus 127 yards
6 miles	ABDFG	Minus 33 yards
10 miles	2 x ACDFG	Minus 504 yards
12 miles	2 x ABDFG	Minus 96 yards
½ marathon	2 x ACDEG plus ACDFG	Plus 381 yards
15 miles	3 x ABDEG	Minus 214 yards
15 miles	3 x ACDFG	Minus 764 yards
20 miles	4 x ACDFG	Minus 1008 yards

Metric Courses

Length	Segments	Adjustment
5 kilometers	ABCA	Plus 247.1 meters
10 kilometers	ABDFG	Plus 296.0 meters
15 kilometers	ACDFG plus ACDEG	Plus 308.8 meters
20 kilometers	2 x ABDFG	Plus 592.0 meters
25 kilometers	3 x ACDFG	Plus 158.3 meters
30 kilometers	3 x ABDFG	Plus 888.1 meters

1 yard = 0.9144 meter
1 meter = 1.0936 yards
1 mile = 1.61 kilometers
1 kilometer = 0.62 miles

Other Information

Elevations:
Intervals along road show altitude changes according to U.S. Geological Survey 1956. Repeating numbers usually signify a crest or dip along the road and occasionally a relatively level stretch. The accuracy of the survey is questionable but it gives a good general picture of the grades.

Mileage intervals are marked by the miles and first ½ mile as ½, 1, etc. starting at East 90th Street.

To mark personal routes, mark the appropriate scale along a piece of smooth string, lay it along the route and place measurements on the map.

There are 20 blocks to the mile, uptown and downtown. Central Park is 0.52 mile wide.

For further information on running in Central Park and in New York City, contact the Road Runners Club of New York, Box 881, FDR Station, New York, N.Y. 10022, Telephone 212-595-3389.

© Ron Williams, 1979. Design, Arnold Saks Associates. Cover photo, Stu Chernoff.

Title:
The Runners Map of Central Park
Publisher:
Ron Williams
Art Director:
Arnold Saks
Photographer:
Stu Chernoff
Design Firm:
Arnold Saks, Inc.
New York, NY

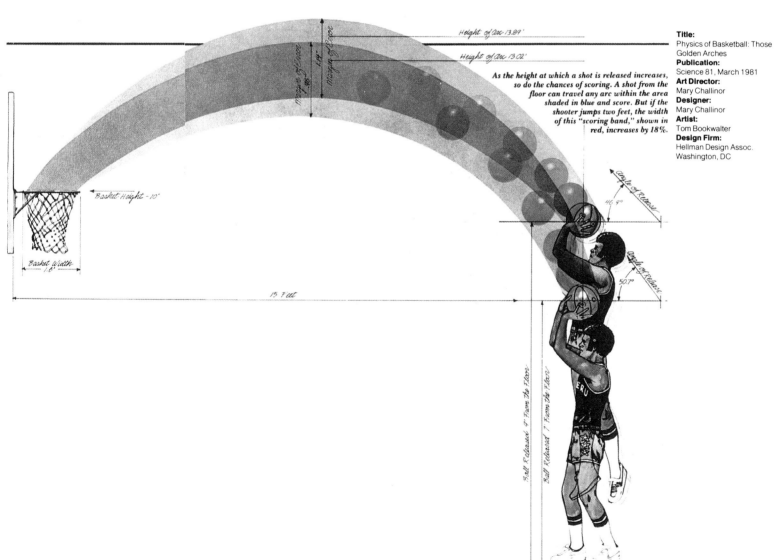

As the height at which a shot is released increases, so do the chances of scoring. A shot from the floor can travel any arc within the area shaded in blue and score. But if the shooter jumps two feet, the width of this "scoring band," shown in red, increases by 18%.

Title:
Physics of Basketball: Those Golden Arches
Publication:
Science 81, March 1981
Art Director:
Mary Challinor
Designer:
Mary Challinor
Artist:
Tom Bookwalter
Design Firm:
Hellman Design Assoc.
Washington, DC

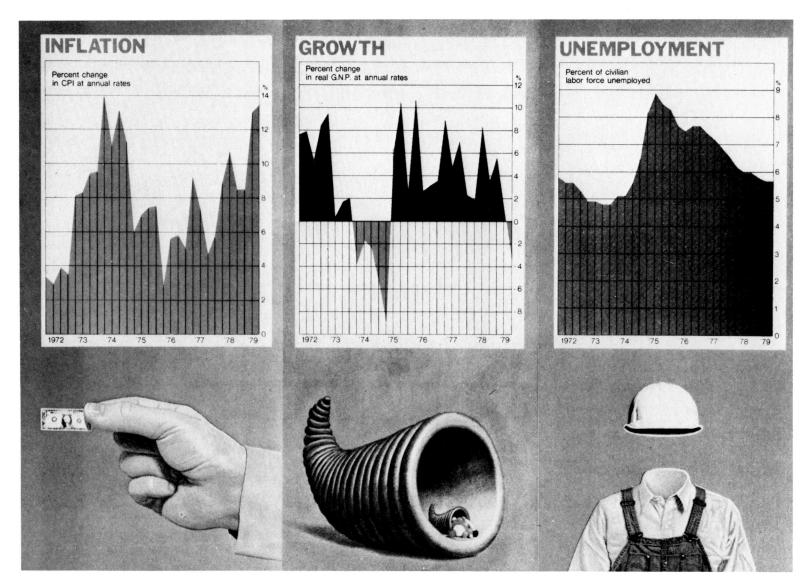

Title:
Inflation, Growth,
Unemployment
Publication:
Time, August 27, 1979
Designer:
Marvin Mattelson
Mechanicals:
Nino Telac
Design Firm:
Marvin Mattelson
New York, NY

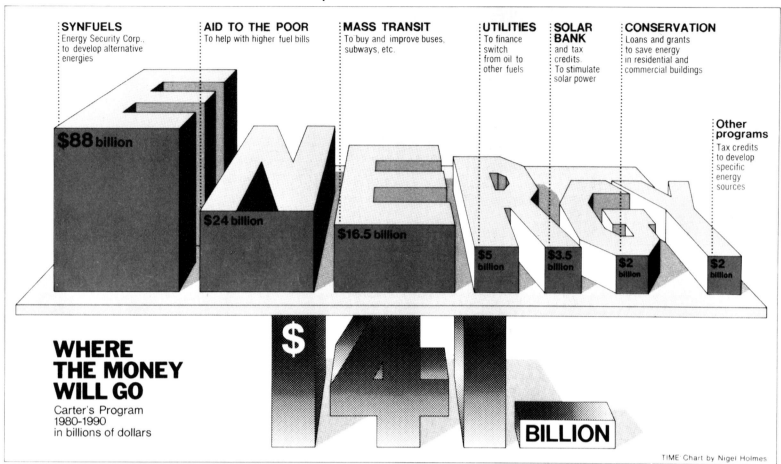

SYNFUELS
Energy Security Corp.,
to develop alternative
energies

AID TO THE POOR
To help with higher fuel bills

MASS TRANSIT
To buy and improve buses,
subways, etc.

UTILITIES
To finance
switch
from oil to
other fuels

**SOLAR
BANK**
and tax
credits.
To stimulate
solar power

CONSERVATION
Loans and grants
to save energy
in residential and
commercial buildings

**Other
programs**
Tax credits
to develop
specific
energy
sources

$88 billion

$24 billion

$16.5 billion

$5 billion

$3.5 billion

$2 billion

$2 billion

**WHERE
THE MONEY
WILL GO**
Carter's Program
1980-1990
in billions of dollars

$ 141 BILLION

TIME Chart by Nigel Holmes

Title:
Where the Money Will Go
Publication:
Time, July 30, 1979
Designer:
Nigel Holmes
Artist:
Nigel Holmes
Design Department:
Time Magazine
New York, NY

Design Firms and Agencies

Publishers and Clients

THE BOOK SHOW

**Art Directors, Illustrators,
Photographers, Authors,
Editors and Production
Managers.**

Printers, Binders and Separators

Publishers

Typographers, Letterers and Calligraphers

GRAPHIC EXPLANATIONS: CHARTS, DIAGRAMS, GRAPHS, AND MAPS

Art Directors, Designers, Artists, Photographers, and Cartographers

Design Firms and Design Departments

Publishers and Clients